DATE DUE

Taste and the Antique

TASTE
AND THE
ANTIQUE

The Lure of
Classical Sculpture
1500–1900

FRANCIS HASKELL
and
NICHOLAS PENNY

Yale University Press
New Haven and London
1981

Designed by Faith Brabenec Hart.
Filmset in Monophoto Bembo and
printed in Great Britain by
BAS Printers Limited,
Over Wallop, Hampshire.

Published in Great Britain, Europe, Africa
and Asia (except Japan) by Yale University Press,
Limited, London. Distributed in Australia and
New Zealand by Book & Film Services, Artarmon,
N.S.W., Australia; and in Japan by Harper & Row,
Publishers, Tokyo Office.

Library of Congress Cataloging in Publication Data

Haskell, Francis, 1928–
 Taste and the antique.

 Bibliography: p.
 Includes index.
 1. Sculpture, Classical—Appreciation.
2. Mythology, Classical, in art. I. Penny,
Nicholas, 1949– joint author. II. Title.
NB85.H34 733 80–24951
ISBN 0-300-02641-2

Contents

For John Fleming and Hugh Honour

Acknowledgements

WE ARE DEEPLY indebted to the many people who have helped us in the preparation of this book. Among them are a number who have most generously allowed us to make use of their own original researches, and, although this will sometimes be apparent from references in our footnotes to unpublished material, this is not always the case and we would like to thank them all here: Bruce Boucher, Yves Bruand, Suzanne Brown Butters, Mauro Cristofani, John Fleming, Edward Goldberg, David Howarth, Hugh Honour, Anne Pingeot, Alex Potts, François Souchal. Hugh Honour and John Fleming have also read part of the typescript in an earlier version and have given us most valuable advice as well as information.

We are also extremely grateful to the following who have patiently answered our questions, brought works of art to our attention, and helped us to obtain illustrations and in many other ways: Ian Campbell, Ulf Cederlöf, Deborah Cherry, Marco Chiarini, Andrew Ciechanowiecki, Howard Colvin, Alessio Crea, Grazia Crea, Caroline Fawkes, Terry Friedman, Martin Frischman, Philip Gaskell, Carlo Ginzburg, David Griffiths, Eileen Harris, John Harris, Larissa Haskell, William Hassall, Charles Hope, Gérard Hubert, Michael Jaffé, André Jammes, Bruno Jammes, Roger Jones, Thomas Da Costa Kaufmann, Rolf Kultzen, David Laing, Douglas Lewis, Pierre Lemoine, Hugh MacAndrew, Romeo de Maio, Elizabeth McGrath, Neil McWilliam, Olivier Michel, Elias Mikoniatis, Arnaldo Momigliano, Jennifer Montagu, Monique Mosser, Giuseppe Olmi, Fiona Pearson, Christiane Pinatel, Dominique Ponneau, Julia Poole, Simon Pugh, Anthony Radcliffe, Olga Raggio, Marianne Roland-Michel, Steffi Röttgen, Lena Savidis, Diana Scarisbrick, Werner Schade, Vera Schuster, Nicola Smith, Ettore Spalletti, John Sparrow, Catherine Stover, Franco Strazzullo, David Udy, Susan Walker, Christopher Ware, Ellis Waterhouse, Zygmunt Waźbinski, Richard Wrigley, Raimond Wuensche, Michael Wynne, Silla Zamboni.

Faith Hart and John Nicoll have given invaluable help with editing this book, and to them too we would like to give our warmest thanks.

The writing of this book would have been impossible but for the facilities offered by libraries in London, Oxford, Cambridge and Manchester; in particular it was made much easier by the magnificent services of the London Library, of the Warburg Institute, and of the Ashmolean, Taylorian and Duke Humphrey (Bodleian) libraries in Oxford.

List of Illustrations

Introduction

FOR MANY CENTURIES it was accepted by everyone with a claim to taste that the height of artistic creation had been reached in a limited number of antique sculptures. These were to be found at first in Rome and, later, in Florence, Naples and Paris. They were repeatedly copied in every medium, and their forms and names thus became familiar to educated people throughout the Western world. Nonetheless, almost without exception those travellers who flocked to Italy agreed that the reality far surpassed the copies on which they had been brought up. In the rapturous literature evoked by these sculptures the only reservation one commonly encounters is a fear of being unable to respond adequately to masterpieces whose fame was so great and unchallenged.

All this has now changed, and with a thoroughness that would have been beyond the imagination of generations of art lovers who looked upon the beauty of the *Apollo Belvedere* and the *Venus de' Medici* as the only bulwarks of absolute values in a world governed by capricious and frequently changing tastes. The crowds in the sculpture halls of the Vatican are today hastening to the Sistine Chapel; art schools everywhere have been discarding the plaster casts that were once their raison d'être; and modern scholars have treated the statues themselves with contempt and distaste: the *Farnese Hercules*, to Addison one of 'the Four finest Figures perhaps that are now Extant', is deemed 'a huge repulsive bag of swollen muscles'.

Classical sculpture is certainly not neglected, but very few people would claim that it provides the standard by which all art should be judged. Moreover, it is the sculpture of fifth-century Greece that is admired, and not what are now recognised to be, for the most part, heavily restored Roman copies of Hellenistic originals.

To study the history of attitudes to ancient art would be to study the history of European culture as a whole. Our purpose is very much more modest and utilitarian. We have wanted only to provide a series of illustrations (which are now often impossible to find except in specialised libraries) of the principal sculptures which were at one time accepted as masterpieces and to demonstrate their standing. Everyone will have seen some reproductions of these sculptures—large-scale marbles in niches, on balustrades or in formal gardens; bronze and porcelain reductions on mantelpieces or in showcases; punctuating the painted views of Roman ruins or coarsely travestied in cheap prints—but not everyone will recognise the originals which once inspired so much attention. The *Laocoon* and the *Barberini Faun* are still greatly admired; the *Winged Victory* and the *Venus de Milo* are still very

well known; but the statues called *Antinous* in the Vatican and Capitoline collections, once as celebrated as are today the 'Mona Lisa' and the 'Birth of Venus', have sunk almost without trace from the general consciousness. How many of those who have read Hawthorne's *Marble Faun* can immediately call to mind the appearance of the statue which inspired that novel? Yet this example should prove that it is not only travel books which lose much of their meaning unless the reader has some familiarity with this and a few dozen other antique sculptures—a familiarity on which, until a hundred years or so ago, writers could safely rely.

Such familiarity was also once expected of the artist and by the artist, and ironically the sculptures discussed in these chapters now live most in the reflections, copies and variants which they inspired. For most people today a small bronze by Giambologna, a marble by Coysevox or a drawing by Rubens will be of much greater significance than the *Lion attacking a Horse*, the *Nymph with a Shell* or the *Seneca* which gave rise to them. Some of our illustrations will be of value to lovers of these and very many other artists, but such considerations have not determined the shape of this book, for painters and sculptors have at all times ranged further than even the best-informed travellers: many a second-rate and battered fragment, unnoticed by Evelyn or Cochin or Goethe, has provided the inspiration for some great masterpiece by a Renaissance, Baroque or neoclassical artist. The tracking down of such sources can be one of the most rewarding (though often one of the most pedantic) tasks of the art historian: it is not one that has concerned us here.

Our selection of antique sculptures is not, however, an arbitrary one. From the thousands of statues constantly being excavated in many parts of Europe, but especially in Italy, a relatively small number acquired a quite special standing which was often acknowledged (and sometimes stimulated) by the way that they were displayed—in the Belvedere courtyard in Rome, in the Tribuna in Florence or in the Musée Napoléon in Paris, between the sixteenth and the nineteenth centuries; in the copies of them that were commissioned for Versailles and St. Petersburg, English country houses and American art academies; in the illustrated volumes devoted to them and in the repetitious and enthusiastic attention paid to them by generations of travellers and writers of guidebooks. Their very repetitions and clichés have been of special value to us, for it is by paying regard to them that we have compiled our list and taken a decision that may surprise many readers: we have excluded sarcophagi (which were always of greater significance to artists and to scholars than to connoisseurs) and even coins and gems (which attracted the collector and antiquarian more than the ordinary traveller).

Sometimes the statues we discuss became famous quickly, at others only after many decades; sometimes fame lasted for centuries, at others for only a few years; sometimes it was universal, at others confined to specific countries; sometimes present-day taste would (were it to show sufficient interest) acknowledge the justice of such fame, at others it would be startled by it. It is often quite impossible to account adequately for these developments, though we have indicated where we believe that particular factors—the praise of an influential artist or connoisseur, the whim of an imaginative restorer, the impact of political power, the accident of an unexpected discovery, a new direction in scholarship—may have been responsible. And, although we have tried to hint at a few of the wider issues arising from our

discussion, the limits of this book are circumscribed: patrons of the eminence of François Ier, historians as distinguished as Winckelmann, are of concern to us only in so far as they have affected the fortunes of the sculptures listed in our catalogue.

This book is designed as a contribution to the history of taste. Neither of us is an archaeologist, and we make no claim whatsoever to any original investigation of the dating or attribution or status of those sculptures we discuss—such matters are of importance to us only in so far as they affected the opinions of people within the time span covered by our book. We have, on the other hand, tried to pay particular attention to two sets of facts which our researches have shown us to be surprisingly elusive—the dates of discovery and changing location of each figure, and variations in nomenclature.

Travellers, guides and scholars frequently referred to the same sculptures under a wide diversity of names: one famous marble group in the Museo Nazionale Romano was called 'Papirius and his mother', 'Hyppolitus and Phaedra', 'La Paix des Grecs', 'Orestes and Electra', 'Marcus Aurelius and Lucius Verus'. We have included in our Index all the names we have been able to trace for the statues we have selected, hoping in this way to make the book as useful as possible.

Such information will be found in our Catalogue, but this Catalogue, although more specific, is also designed to develop the general themes outlined in the introductory chapters. These chapters and the Catalogue entries are thus interdependent.

Because of this we have not, in our introductory essay, supplied notes for those sculptures which are discussed separately in the Catalogue, nor given references to the illustrations of these, which can be found in the Catalogue, except where such a reference is likely to be especially helpful. To make reference convenient, the names of catalogued sculptures (but not other works of art) are printed in italics throughout this book.

A Note on the Presentation of the Catalogue

Sculptures are listed alphabetically under the titles which we believe to have been most current in the years before about 1850, but we have also listed, in alphabetical order, and indexed, other names that were used during the same period. Some of these are in Latin, French and Italian, but foreign names are not given when an English name which is a straightforward translation was also popular. Minor variations in nomenclature are not always recorded: 'Silenus with the Infant Bacchus' is given, but not 'Silenus and the Infant Bacchus' or 'Silenus and Bacchus'.

From about the middle of the nineteenth century Latin names tended to be converted to Greek: 'Cupid' became 'Eros', 'Diana' became 'Artemis' and so on; also the distinction between Satyrs and Fauns (the former having the legs, tails and ears of goats, and the latter only the tails and ears), which had been observed since the Renaissance, was lost. These developments we have ignored.

In many cases the name of a collection or collector is incorporated into the statue's title (the *Belvedere Antinous* and the *Della Valle Satyrs*), but for our purposes alphabetical priority is established by the other part of each composite (*Antinous,*

Satyrs). Very often the title is accompanied by an adjective *Dancing Faun, Weeping Dacia*), in which case alphabetical priority is established by the noun (*Faun, Dacia*). Where two sculptures have the same name (*Dancing Faun*) alphabetical priority is established by the present location of each (Florence before Naples). In the first section of each entry we record the popular names of each sculpture, give its height (and, occasionally, length) in metres, and mention the material—discriminating types of coloured marble, but not types of white marble. We do not provide information on condition or restoration here. But when the type of white marble, the work's condition or the character of the restoration has affected the statue's reputation these are discussed later.

In the next section we attempt to record the documented facts concerning the statue's discovery and ownership and its major movements. This is followed by an account of its rise and (in most cases) fall from favour, during the course of which we mention some of the ways in which it was published and copied, the scholarly (and unscholarly) interpretations given of it, and, where appropriate, the old traditions and recent speculations concerning its origins. In conclusion we paraphrase or quote the opinion of the work which is to be found in the most recent authoritative catalogue of the collection concerned (or in an equivalent source) without recording in full, or in any way contributing to, modern debates as to the dating, the status or the subject matter of the sculpture.

I

'A New Rome'

IN 1528 FRANÇOIS Iᵉʳ, the King of France, began to make modifications to an old hunting lodge at Fontainebleau, some forty miles from Paris. Two years later Aretino, one of his artistic advisers in Italy, seems to have recommended to him the Florentine painter Giovanni Battista Rosso whose brilliant career had been interrupted by the Sack of Rome in 1527. In 1532 the Bolognese painter Francesco Primaticcio left Mantua for Fontainebleau. During the course of the next few years these two artists and their assistants created one of the most remarkable and beautiful decorative schemes of the sixteenth century. The Gothic, and the mixture of Gothic and classical detail, which had hitherto been patronised by the King, his courtiers and the Church, was swept away and the most modern Italian style became the overriding fashion. No one greeted it with more unqualified enthusiasm than the King himself.[1]

François Iᵉʳ had enjoyed his most spectacular victories and suffered his most spectacular defeats in Italy. At the age of twenty-one, within a year or two of his coronation, he had recaptured Milan for the French and had met Pope Leo X in Bologna in order to draw up a highly advantageous concordat[2]—an occasion that was alluded to by Raphael in a fresco (executed by his pupils) in the Vatican which gave to Charlemagne the features of François Iᵉʳ.[3] A decade later, after losing the battle of Pavia, he had been taken prisoner by his great rival, the Emperor Charles V, and it was just after his return from ignominious captivity in Madrid that he undertook the reconstruction of Fontainebleau—'veuf de son rêve, l'Italie, il se fait une Italie française'.[4]

François Iᵉʳ had inherited some great Italian paintings from his father-in-law Louis XII,[5] and during his Italian campaigns he had shown a keen interest in Italian art, claiming later to have seen 'all the best works by the best masters in all Italy'.[6] He had been particularly struck by Leonardo da Vinci's 'Last Supper' and, though he was unsuccessful in his plans to have this fresco taken to France,[7] he was able to attract Leonardo himself. Well before beginning his reconstruction of Fontainebleau he had induced other major Italian artists such as Andrea del Sarto to cross the Alps, and had given important commissions and acquired important works from those who could not, or would not, make the journey—including Raphael and Michelangelo. Yet, in one respect, he remained a provincial. Until about 1540 he failed to appreciate to the full that an essential element of modernity, as the Italians conceived it, lay in the worship of antiquity.

It is true that some years after his triumphal visit to Bologna in 1515 it was rumoured that François I^{er} had on that occasion asked the Pope to give him the great sculpture of *Laocoon* which had been excavated in 1506 and taken to the Vatican, having been immediately recognised as the work said by Pliny to be 'of all paintings and sculptures the most worthy of admiration'.[8] Yet so importunate a request (if it was really made) is likely to have been prompted more by the knowledge that the *Laocoon* was highly treasured by the Pope than by any pressing desire for ownership. In any case by early 1520 the King was asking only for a bronze cast;[9] and when the full-scale marble copy (the first such copy of any large statue since antiquity), which had been commissioned from Baccio Bandinelli later that year as a suitable present for François,[10] was eventually complete, there is no record that he was in any way perturbed to learn that the new Pope (Clement VII—cousin of Leo X) liked it so much that he kept it for himself and his family, and decided to send instead 'some other antique statues'.[11] Antiquities certainly reached the King from various sources,[12] but he himself appears to have devoted little effort to obtaining them.

However, shortly before 1540 François I^{er} suddenly developed an intense interest in classical statuary—an interest which was to have the most far-reaching consequences. Though it is not clear what caused him to change his mind, all the available evidence suggests that the initial stimulus came from the Italians. On his mission to France in 1518 and 1519 Cardinal Bibbiena had noted that the King owned no marble sculpture, ancient or modern, 'though he took much pleasure in it', and had promised to try to procure some through the Pope.[13] Twenty years later the papal legate to France, Cardinal Ippolito d'Este, Cardinal of Ferrara and a great art collector and patron, commissioned, through Benvenuto Cellini, the making of a bronze copy of one of the most famous antiquities in Rome, 'the nude with the thorn' (*Spinario*—Fig. 163), which he presented to the King in December 1540.[14] And by then François's court artist Primaticcio had apparently persuaded the King to send him to Italy in order to draw antiquities and give advice about possible purchases.[15] Primaticcio carried out both these tasks, but the most important result of his mission was very different.[16] In Rome he supervised the taking of moulds of the most famous antique statues to be seen in the city and had them sent back to France. Writing some years later of the King's decision to take so significant a step, Benvenuto Cellini gave a highly revealing though inaccurate account of the whole episode, during the course of which he claimed that the original idea came from Primaticcio himself, for reasons which will be discussed shortly.[17]

If the notion was indeed Primaticcio's—and that is by no means impossible—it is not difficult to see what suggested it to him. Before going to Fontainebleau he had spent six years in Mantua working under Giulio Romano on the decoration of the Palazzo del Tè, and no court in Europe showed a greater interest in the acquisition not only of antiquities but of copies of antiquities than that of Mantua. Even before the end of the fifteenth century the sculptor Pier Jacopo di Antonio Alari Bonacolsi had been employed by the Gonzaga on making small bronze reductions of some of the most famous ancient statues in Rome, and his virtuosity in doing so earned him the nickname of 'l'Antico'. His masterpieces included copies (or variants) of the *Apollo* (Fig. 77) belonging to Cardinal Giuliano della Rovere who, as Pope Julius II,

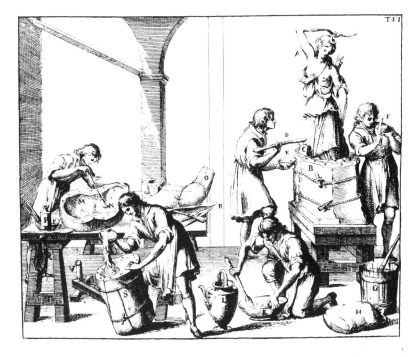

1. The making of a plaster mould—etching (from Carradori's *Istruzione*). To the right the mosaic of plaster is applied to the statue. Here some small pieces (*tasselli*) are applied. Plaster is mixed by the kneeling youth. This is poured into a reassembled mould which has been coated inside with grease in the manner shown on the far left.

took it to the Vatican, and of the *Hercules and Antaeus* (Fig. 119), 'the most beautiful piece of antiquity there ever was', which was also taken to the Vatican under Julius II.[18] In 1512 Duke Francesco Gonzaga commissioned from the famous jeweller Caradosso a hat badge which was to incorporate a golden replica of the *Laocoon*, and the artist tactfully suggested that this might make a very suitable present for the Duke's wife Isabella d'Este (aunt of Cardinal Ippolito)[19] who was a particularly eager collector of all such copies,[20] which would thus have been well known to Primaticcio in Mantua.

Primaticcio's own enterprise, however, was on a far greater scale. As we will see again and again during the course of this book, the taking of plaster casts from an original was an essential step in spreading world-wide appreciation of the most esteemed antique statues, and, although the practice later became habitual, it was in the middle of the sixteenth century an extremely expensive business,[21] requiring not only exceptional skills but, presumably, elaborate negotiations (of which, in this case, we know nothing). The technique itself had been known in antiquity and seems to have been revived in Italy by the early fifteenth century—in Padua the painter Squarcione (1397–1468) is said to have had antique sculptures copied in this way[22]—but it is most unlikely that it had, before 1540, been applied on anything approaching the scale undertaken by Primaticcio assisted by the young (and as yet untried) architect Vignola. As can be seen from a much later illustration of the process (Fig. 1),[23] which had not in essentials changed, each figure had first to be covered with a liquid 'parting agent' whose composition is unknown (but whose stains often, quite rightly, worried the owners of important marbles) and then with a mosaic of quickly drying wet plaster—quite large over the flat surfaces of the back but very much smaller in size to register the curling of hair or elaborate folds of drapery. After being carefully detached from the statue these pieces had to be fitted

3

together and themselves enveloped in a further coating of plaster. The hollow moulds thus created then had to be transported, either complete or in separate pieces, by sea from Civitavecchia in fifty-eight cases and two barrels,[24] after Primaticcio had already been summoned back to France.

On arrival the damaged moulds had to be repaired, and from them bronze copies, the size of the original antiques but (whether by accident or design) not always exactly accurate in stance or detail (Fig. 2), were cast in some secrecy[25] at a specially constructed foundry near Fontainebleau by craftsmen working under the direction of Primaticcio and Vignola.[26] Despite all the difficulties the work was virtually complete by the end of 1543. Shortly afterwards Primaticcio returned to Rome;[27] a second set of moulds was made, but bronzes were not cast from these,[28] probably because of the death of François Ier at the end of March 1547.

Although Vasari relates that Primaticcio managed to obtain some hundred and twenty-five marbles for the King,[29] only one statue which was already famous in Rome reached France in the sixteenth century and this was not among them. It was a Jupiter (now in the Louvre) which was given by Margherita Farnese to Chancellor Nicolas Perrenot de Granvelle for his chateau at Besançon from the Villa Madama where it had been installed by Pope Clement VII.[30] On the other hand, one statue, the *Diane Chasseresse* (Fig. 102), which was acquired by the court, did become celebrated after its arrival in France. However, since this probably did not take place until after the death of François Ier, it was the copies of famous originals that made the immediate impact. Benvenuto Cellini gives us a vivid account of the installation of these great bronzes in the Galerie François Ier, for it was in the same gallery that he was required to show the King the silver Jupiter which he had made for a candelabrum. The King was duly impressed, but then his mistress, the Duchesse

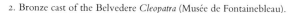
2. Bronze cast of the Belvedere *Cleopatra* (Musée de Fontainebleau).

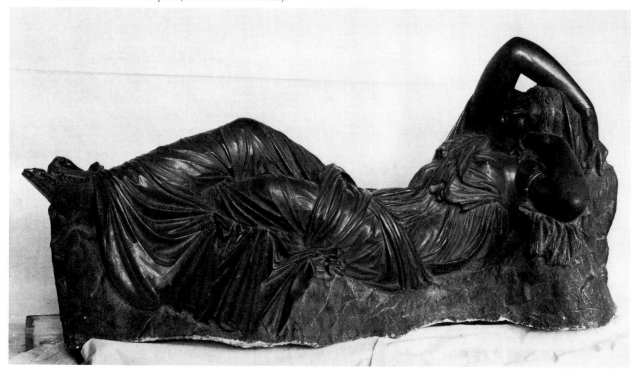

d'Étampes, who had taken a strong dislike to Cellini, said boldly: 'Anyone would think that you were blind! Don't you see all those fine bronzes from the antique set up behind there: That's real quality [*virtù*]—not all that modern trash.'[31] Primaticcio's motive in suggesting the idea of copies in the first place had, according to Cellini, been to discredit the modern sculpture of this rival whom he feared,[32] and when Cellini puts into the King's mouth the reply 'Whoever has wanted to do a disservice to this man has in fact done him a great service, for the comparison shows how much more beautiful and stupendous his work is than these admirable statues', we need not, for once, attribute this only to his inordinate vanity, for (as we have seen) everything we know about François Ier does indeed suggest that he would have preferred the modern to the ancient. In any case the story, whether true or apocryphal, is of deep significance: from now on the values of antiquity were to be used north as well as south of the Alps as a criterion of artistic judgment. And the placing, for a short time, of the modern Jupiter beside the casts of the antique, like the display throughout this period of Michelangelo's Bacchus in a Roman collection amongst the genuine antique pieces with which it was sometimes confused,[33] initiates an approach, lasting at least until Canova, in which juxtapositions of antique and modern sculpture were constantly made, not only in actual collections and illustrated anthologies but in the imagination of art lovers.

Though not all the consequences of Primaticcio's expedition were to be so grave—the King enjoyed exploiting the titillating effects of the nudity of the statues on the ladies of his court[34]—the installation of the bronze copies does in fact mark a crucial milestone in the evolution of European taste and culture. Vasari was to write that Fontainebleau thereby became 'almost a new Rome',[35] and—as we will see— two later rulers of France, Louis XIV and Napoleon, were to try to emulate François's example and transfer the prestige of Rome to France by transferring thither her ancient monuments. Meanwhile, so great was the impact of Primaticcio's copies, that, a few years after the death of François Ier, the sculptor Leone Leoni managed to convince his own patron, the widowed Mary Queen of Hungary, Governor of Flanders and sister of the Emperor Charles V, that she too should have casts made of the antiquities reproduced for Fontainebleau.[36] Realising that the price of resorting to the originals in Rome would be excessive, he hurried to Paris in order to buy Primaticcio's moulds which he had heard were in danger of becoming dilapidated. After an elaborate exchange of courtesies the transaction was concluded satisfactorily,[37] and in fact some copies of famous antique statues, taken presumably from these moulds, were made for the Queen's Italianate palace at Binche, south of Brussels, which was intended to rival the Fontainebleau of François Ier, who had been her brother-in-law.[38] Leoni then stated that the bronze casting would have to be carried out in Milan and he hastened there with the moulds. At the same time he wrote to Ferrante Gonzaga, the governor of that city, proposing to make casts for him so that his estate nearby would become 'another Rome'. It is not clear whether or not these plans were executed,[39] but we will see in a later chapter that Leoni himself possessed in his house in Milan what was probably the largest private collection formed during the sixteenth century of casts after antique sculptures and that some of these passed, after his death, to Cardinal Borromeo's academy of art in the city where they were to attract much attention from foreign visitors.[40] It thus

seems almost certain that the nucleus of both these famous collections, as well as the one at Binche, was derived from Primaticcio's moulds.

In fact the copies at Fontainebleau (which were for the most part placed in the gardens and which were themselves sometimes copied for other collections in France and elsewhere)[41] provided the first example of that international recognition—later to be acknowledged everywhere in the Western world—of a canon of artistic values which was embodied not just in some vague concept of antiquity, but in certain specific works of antiquity. As time passed, additions would be made to these works (Primaticcio's second journey to Rome was carried out partly in recognition of this fact) while others would somewhat decrease in esteem; but for centuries there remained in existence a limited number of sculptures which were used as a touchstone by artists, art lovers, collectors and theorists alike for the gauging of taste and quality. It was the copies at Fontainebleau which demonstrated the possibility of that touchstone eventually becoming accessible to Europe as a whole; the selection and making of these copies thus constitutes a symbolic opening to almost all the themes that we will be concerned with in the following pages.

Though the sources are not in entire agreement and though some problems remain unsolved,[42] it is possible to obtain a fairly clear indication of what were the works that Primaticcio or his advisers chose to have reproduced—most of them works which we will be coming across again and again throughout this book, copied in every conceivable medium and enthusiastically admired in circles far removed from Fontainebleau and Binche, Rome, Mantua and Milan.

Every antique statue of acknowledged excellence was to be found in Rome. On his first visit there Primaticcio seems to have had moulds made of twelve different works, from which ten bronzes were eventually cast.[43] Of these, four were of potentially ornamental figures—Sphinxes and *Satyrs*—which were probably chosen because they could be fitted into the furnishings of the palace and thus bring a note of authenticity to a type of decoration which was not wholly unfamiliar in France even before the redesigning of Fontainebleau. Casts were taken (though bronzes were never made) from very famous public monuments: several sections of Trajan's Column, engravings of which had already been published in Paris,[44] and (probably) the equestrian statue of *Marcus Aurelius* which had recently been installed on the Capitol.[45] The remaining six casts were taken from statues of *Cleopatra* (Fig. 2), *Apollo*, *Laocoon*, *Venus*, *Commodus as Hercules* and the *Tiber*, all excavated during the course of the previous half century, all belonging to the Pope and all kept together in a sculpture court behind the Vatican palace which had been specially designed by Bramante for Pope Julius II and which was attracting much attention from visitors to Rome.

When he went back to the city four years later Primaticcio had moulds taken from one or two other statues in this court (the *Nile*, perhaps the *Mercury*) with which he would have been familiar from his previous visit,[46] as well as from an *Antinous* which had been excavated and placed there in the meantime. Thus, although he may also have approached one well-known private collection in order to procure a copy of a much-admired statue,[47] it is clear that Primaticcio concentrated overwhelmingly on what was to be seen in the small court built by Bramante in the Belvedere on a slope rising behind the Vatican palace.

II

The Public and
Private Collections of Rome

THE STATUE COURT which Primaticcio visited in 1540 was the most complete and satisfying section of a huge enterprise which had been begun nearly forty years earlier, but which had subsequently been much neglected and much altered.[1] In the years following 1485 Pope Innocent VIII had had built and handsomely decorated a villa on the high ground at the back of the old Vatican palace: because of its position the villa was given the name Belvedere, and this was soon extended to apply to the whole area. In 1503, shortly after succeeding to the papacy, Julius II employed Bramante to incorporate this country house into the main architectural complex of the Vatican, and this was to be achieved essentially through the building of two long covered corridors running between the two residences. The enclosed space, bounded by villa and palace to north and south and by the two walls to east and west, was to be divided into a series of courts on different levels, designed originally for the display of sculpture, for a formal garden and for an elaborate theatre. The sculpture court (which alone concerns us here) adjoined Innocent VIII's villa and probably constituted the spur for the whole scheme. Certainly it was given priority over the rest of the building operations, and owing to the interest that it aroused we can form a fairly accurate impression of its appearance.

As he entered the court, the sixteenth-century visitor would have seen first the rows of orange trees symmetrically placed on the paving stones which covered the enclosed space.[2] Opposite him was a loggia, at one end of which was a fountain to water the oranges, and, outside the court itself but well visible from it, there towered above this loggia the tall mulberries and cypresses which grew in an informal garden behind. To his right was the old-fashioned villa of Innocent VIII on to which one could climb by means of a small spiral staircase in order to see the papal palace at the foot of the hill and, in the opposite direction, uninterrupted open countryside. In the centre of the court were two huge reclining marble figures of the *Tiber* and the *Nile*, each mounted as a fountain—and still more fountains were placed elsewhere. It was in this cool, fresh and orange-scented atmosphere that the visitor was able to view the great sculptures placed in elaborately painted and decorated niches (*cappelette*)[3] at the four corners of the court and in the centre of each enclosing wall; around and set into these walls, level with the upper part of the niches, were thirteen antique masks.[4]

The whole concept of displaying art in this way—this very notion of art in itself—was as new as it was unique, and it is hardly surprising that the impact was overwhelming: indeed, the classical antiquities kept in this walled garden with its orange trees and fountains set the standards by which art of all kinds was to be evaluated for more than three hundred years. Yet it was a concept born of faith rather than of exigency. When the statue court was designed for Pope Julius II at least five, and possibly more, niches for sculpture were apparently incorporated into the original plans.[5] At that time he owned only one piece, the *Apollo*, which he considered worthy of placing in this court. Who could conceivably have foreseen the discovery, some three years after his accession to the papacy, of the *Laocoon* which he was able to acquire and place in 'a little chapel' whose site had already been determined, even if the structure was not yet complete?

In the second half of the fifteenth century the collecting of antiquities was far less common in Rome than in Florence,[6] but Julius II could look back to two remarkable, if contrasting, precedents. Pietro Barbo (Pope Paul II, 1464–71) had amassed large numbers of gems, coins and small bronzes, but, although he was interested in restoring the ancient monuments of Rome,[7] he evidently looked upon his collections as being entirely his personal property and he made no provision for their future. At his death they were dispersed by his successor Sixtus IV—and, significantly, the greater part of them were taken to Florence by Lorenzo de' Medici, for demand was still limited in Rome.[8] Sixtus IV (1471–84) responded to antiquities in precisely the opposite way. It would seem that he took very little interest in them for their own sakes, but that at times he appreciated the immense historical and associational importance that they held for the city over which he ruled.[9]

It was presumably this awareness that led him, a few months after his accession, to donate to the palace of the Conservators on the Capitol a number of ancient bronzes,[10] which before then had been displayed, most of them on columns,[11] in or near the papal palace of the Lateran. His deed of gift 'to the Roman people' makes it clear that he thought of these sculptures as constituting a part of their inalienable heritage. The bronzes had been noted by earlier visitors to Rome, but it was only after their removal to the Capitol, where they could be properly seen by artists as well as by ordinary citizens, that they began to achieve widespread fame—a fame that was to be further enhanced by the recent development of engraving and (almost simultaneously) by the revival of the bronze statuette (Fig. 3), so eminently suitable for reproducing the bronzes included in the donation of Sixtus IV. Among these were works which were to retain their authority over the centuries—the *Wolf* (Fig. 178), the *Camillus* (Fig. 86) and the *Spinario* (Fig. 163). At the end of the fifteenth century these and a few others (which were added not long afterwards) made up by far the most impressive group of antique sculptures to be seen anywhere in Rome. Even if Sixtus IV had probably looked upon them as being of chiefly emblematic and historical interest, the prestige that they acquired must have played its part in stimulating not only private collectors in the city, who rapidly increased in number at the turn of the century, but also the creation by his nephew Julius II of a rival museum in the Vatican to contain sculptures of supreme beauty.

That the Belvedere collection began so auspiciously seems to have been due in part to an accident. There is very little evidence to suggest that, as Cardinal Giuliano

3. Bronze statuette of *Spinario* with ink well—height: 18.7 cm (Ashmolean Museum, Oxford).

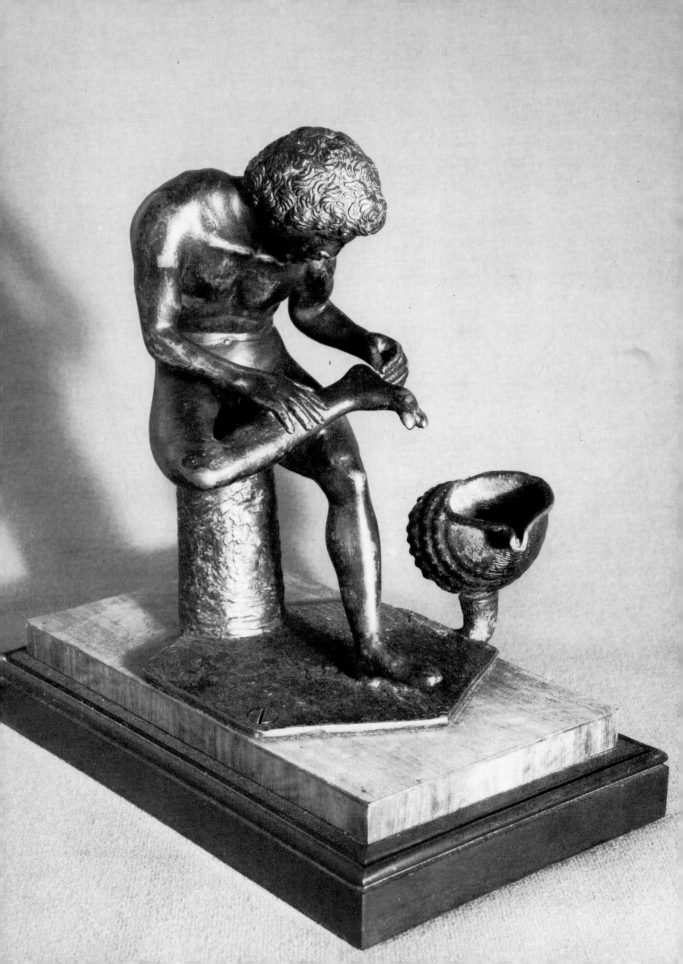

della Rovere, the future Pope Julius II had been particularly interested in the acquisition of ancient sculpture,[12] but the discovery—probably on one of his own estates—of the *Apollo*, which quickly won great fame, may well have encouraged him to take action. For Julius II combined a supremely adventurous taste in the visual arts with an overriding sense of devotion to the institution of the Papacy. Unlike most of his successors he intended that the masterpieces he acquired should remain part of the patrimony of the Church rather than enrich his family.

The demand for antiquities became very pressing in the early years of the sixteenth century. Despite the fact that Julius II was known to be eager to acquire 'all the most wondrous and beautiful antiquities in order to place them in his garden',[13] he still had to overcome keen competition when buying the *Laocoon*;[14] and although the realisation that the Pope was interested in obtaining some statue must naturally have acted as a powerful inducement to the owner to sell or give it to him, it is by no means certain that even in its early days the Belvedere contained all those sculptures that were considered to be of the highest quality. It is true that, after installing the *Apollo* (Fig. 4) and the *Laocoon* in his statue court, the Pope was able to obtain—either from new excavations or from existing collections—the *Commodus as Hercules*, the *Hercules and Antaeus*, the *Cleopatra*, the *Venus Felix* and the *Tiber* and that it is most unlikely that he missed any discovery made during his reign that was thought to be more distinguished than these; yet we know from literary sources and artists' sketches that a number of highly regarded statues were already to be found in private collections and (as we will see) later popes did not always try to maintain the standards that were set by Julius II. To insist too much on the element of chance that certainly played its part in the creation of the Belvedere collection (and thus of European taste as a whole) is, however, to miss its true significance: installation in the statue court was of itself sufficient to act as a consecration of quality. As with some other collections since, the location, and the reputation of the proprietor, provided more of a guarantee than might be warranted by a detailed and impartial observation of what was actually exhibited.

After the death of Julius II the situation of the statue court underwent a significant change. It is true that his successor Leo X (1513–21) transferred to it the reclining figure of the *Nile* which was probably excavated a year or so after his accession, but this had so obviously been designed to accompany the *Tiber* (near which it was found) that it would hardly have been possible for the Pope to have done otherwise. In general, however, Leo X was far more keen to increase his own family collections (which he had certainly begun to build up while still a cardinal)[15] than he was to enrich the Vatican, and the few alterations that he made to the court were of little significance.[16] His cousin and (after the short pontificate of Adrian VI) successor Clement VII (1523–34) was equally determined to enrich the Medici inheritance, but he nonetheless added to the Belvedere both the *Torso* and a third reclining River God, known both as the Tigris and the Arno—the only statue in the court which failed to inspire the imagination of visitors to Rome.[17]

The statue court was already famous, but the symmetry of Bramante's design required the acquisition of further figures of major importance, and when, shortly before 1536, the Governor of Rome presented a *Standing Venus* (Fig. 175) to the Farnese Pope, Paul III (1534–49), it was placed in a niche in the south wall. Seven

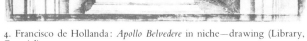

4. Francisco de Hollanda: *Apollo Belvedere* in niche—drawing (Library, Escorial).

5. Hendrik Goltzius: *Farnese Hercules*—engraving.

years later the Pope purchased for the Belvedere the last of the figures to be installed there and one which gained immediate and enduring popularity—the *Antinous* (Fig. 73). Every niche was now worthily filled and the Pope clearly felt that with his obligations to the Vatican complete—to the City of Rome he had had transferred from the Lateran the bronze equestrian statue of *Marcus Aurelius* (Fig. 129) for which Michelangelo provided a noble setting on the Capitol—he could indulge without remorse the possessive love for antiquities felt by himself and his family. In the few years that remained to him after buying the *Antinous* for the statue court, Paul III and his nephews built up the first private collection of classical sculpture in Rome to attract as much attention as the Belvedere itself—just as the architecture, and later the decoration, of their palace rivalled, if not surpassed, that of the official papal residences. In so doing they inaugurated a pattern that survived until the middle of the eighteenth century.

It was in August 1545 that the Farnese took this new step. In that month workmen employed by the authorities in charge of the construction of St. Peter's uncovered, while digging on Farnese property in the Baths of Caracalla, 'a bull, three handmaidens [*ancille*] and a shepherd carved out of a single piece of marble'. This group (which became known as the *Bull*—Fig. 85) was to be identified as the statue of Dirce and her stepsons which had been recorded by Pliny—an honour it shared only

6. Marten van Heemskerck: Courtyard of Palazzo della Valle, Rome—drawing (Kupferstichkabinett, Berlin).

with the *Laocoon*—and the Pope ordered it to be taken to the family palace and the figures 'to be reintegrated as they were before so that it will certainly be the most beautiful thing in Christendom'.[18] Not long afterwards a huge decapitated *Hercules*, signed in Greek, was found in the same area and was also taken to the Palazzo Farnese (Figs. 5 and 118), as were many other antique statues from this and other sites, some of which, like the *Flora* and the *Callipygian Venus*, were to attract universal admiration. By the time of Paul III's death in 1549 his family's collection of antiquities could thus claim to rank with those belonging to the Church and the City.

But though the Farnese sculptures far outdistanced those of all private rivals in terms of quality, many other individuals owned very large numbers of statues, some of which also enjoyed great fame. Ever since the earliest years of the sixteenth century various members of the della Valle family had had the reputation of being the most distinguished private collectors in Rome.[19] Their two armless *Satyrs* carrying baskets of fruit on their heads were among the most frequently drawn of all antiquities in the city (Fig. 6) and were displayed in public during the procession to celebrate the coronation of Pope Leo X in 1513 and were cast in bronze for Fontainebleau in 1540. The Cesi family also, who over a period of a hundred and fifty years gave to the Church five cardinals but never a pope, owned—among many highly admired statues—'an Amazon [*Juno*] . . . praised by Michelangelo as the most beautiful object in the whole of Rome, and the King of France has, on several

occasions, had moulds taken and has wanted them for France'. Nothing—not even the interest of the King of France—was more certain of guaranteeing fame for an antique statue than the report of Michelangelo's admiration, and the special influence exerted by the leading Italian artists in establishing the celebrity of some particular piece lasted until the days of Canova. Similarly, the country house and gardens on the Quirinal of another friend of Michelangelo,[20] Cardinal Rodolfo Pio da Carpi, were described by a contemporary as an 'earthly paradise',[21] and among his 'immense numbers' of antique sculptures was a bronze head of *Lucius Junius Brutus* (Fig. 84) whose subsequent fortunes will be discussed later in our book. A man of much less standing was the Pope's doctor, Francesco Fusconi, who lived just opposite the Palazzo Farnese. But among the few statues in his possession was an Adonis (or *Meleager*—Fig. 137) which was probably the most famous single work in all Rome to remain outside the grasp of the powerful collectors who dominated the market. For, despite the huge increase in the amount of excavation since the beginning of the century and the very sharp competition to acquire what became available, it is nonetheless true that the number of works of universally acknowledged excellence to be found outside the Belvedere, the Capitol and the Palazzo Farnese was, at the time of Pope Paul III's death, very limited indeed, even if the sometimes undiscriminating enthusiasm of artists and antiquarians and the usually obsequious flattery of courtiers and family retainers often convey a different impression.

Under Paul III's immediate successors the structure of the Belvedere underwent a series of important changes but these will only be mentioned when they have a direct bearing on the theme of our book. In the 1550s the *Cleopatra* (Fig. 96) was taken from the statue court and placed in a recently built room, soon to be elaborately decorated, which adjoined it and which became known as the 'Stanza della Cleopatra'—an early (perhaps the earliest) example of a sculpture giving its name to a room in a way which, as we will see, was later to become both frequent and very influential.[22] The Pope had in fact wanted to put a fountain there, but when Michelangelo proposed carving a marble Moses striking the rock, he realised that the operation would take too long and therefore followed Vasari's advice and transferred the *Cleopatra* which had already been laid out as a fountain in the statue court;[23] no attempt seems to have been made to fill the empty niche from which it was removed.

Indeed painful times lay ahead for the Vatican sculpture collections. It was also in about 1550 that Julius III gave Duke Cosimo I of Florence the *Mercury* (Fig. 138), a much restored statue which had stood in a covered gallery just behind the court; and a decade later Pirro Ligorio, architect to Pius IV, fundamentally altered Bramante's design by razing the loggia at the west of the court (which was replaced by part of a new, two-storeyed palace wing) and by destroying the informal garden behind it that had so delighted earlier visitors. New buildings were added here also,[24] and Ligorio's complete reorganisation of the remaining sections of the Belvedere led to an enormous increase in the quantity, but not in the quality, of the antique sculpture that was kept there: statuary was used for decorative purposes only and was ordered wholesale with size the main criterion of choice. For a few months the huge cortile adjoining the statue court thus assumed an impression of extreme magnificence,

dwarfing the still unpretentious garden setting for the *Apollo*, the *Laocoon* and other carefully selected masterpieces. From this garden a further depredation was made when it is likely that yet one more of the most admired figures from the early years of the collection was sent off to Florence. This time it was the *Hercules and Antaeus* (Fig. 119) which was given to Cosimo I—the first significant and highly esteemed work ever to leave the statue court itself where, though much battered and not placed in a niche, it had remained since the days of Julius II. The omens were thus already inauspicious when in 1566 Cardinal Michele Ghislieri was elected pope and took the name of Pius V.

This emaciated Dominican friar, sprung from peasant stock, had always lived a life of the greatest austerity—and he made it clear from the moment of his election that he did not intend to change his habits.[25] Almost the earliest target of his reforming zeal was the sculpture collection of the Belvedere. Within a few weeks of his election it was announced that this was to be dispersed 'because it was not suitable for the successor of St. Peter to keep such idols at home'.[26] Such feelings were by no means new nor was Pius V in any way illogical. During the course of this book we will see that devotion to the classical heritage of Rome could assume some of the fervour of a surrogate religion—a religion, moreover, that was as attractive to the Protestant or totally sceptical visitor to the city as it was to the Catholic. The reputation of the ancients could make respectable the expression of feelings that would hardly have been acknowledged where modern art was concerned; and we need not doubt that it was often the nudity, at least as much as the 'purity' and 'simplicity', of many antique statues that came as a relief to readers of Ovid after the bleak austerity of Calvinism or the elaborate imagery of so much of the art of the Counter-Reformation.

Even the humanists of the early sixteenth century were aware of the temptations, and in 1527 Andrea Fulvio found it necessary to deny, as maliciously inaccurate, the old story that Pope Gregory the Great had 'ordered that all the most beautiful statues . . . should be thrown into the Tiber so that men, captivated by their beauty, should not be led astray from a religion that was still fresh and recent',[27] and this denial may have been prompted by evidence that not everyone shared his delight in antique sculptures and his admiration for those popes and prelates who displayed them. It was the impropriety of such sculpture being exhibited by the Vicar of Christ that caused the real concern. As early as 1512 a visitor to the statue court had conceived a special hatred of the *Venus Felix* (Fig. 172) for this reason and had dreamed of expelling such images from the Vatican.[28] A decade later Pope Adrian VI could comment that the *Laocoon* and other antique sculptures were 'the idols of the ancients'.[29] It has indeed been suggested that the statue court may have been conceived of from the first as an oblique tribute to paganism,[30] and other esoteric implications have been seen in the collection and its arrangement.[31] Hostility, therefore, was not surprising—but hitherto it had always been kept in check by the veneration felt by all educated men for antiquity. Pius V now put that veneration to its hardest test.

The first sculptures to leave the Belvedere were those that had been hastily assembled by Pirro Ligorio for his lavish theatre hemicycle,[32] which less than a year earlier had provided the setting for a magnificent joust. As will be apparent from

what we have said above, their removal to the Capitol hardly involved an aesthetic loss of great intrinsic value, but it deeply alarmed the art lovers of an earlier generation who only just prevailed upon the Pope not to get rid of the masterpieces in the statue court, which had already been partly concealed by shutters placed in front of them.[33] In the end these statues were allowed to remain in place on condition that access to them was forbidden.[34]

Rumours that the Pope was stripping the Vatican of its antique statuary aroused great hopes, which were only in part fulfilled, among other European collectors. The Holy Roman Emperor, the King of Spain and the insatiable and indefatigable Medici all profited from his activities.[35] But in fact when the Pope finally died in 1572 it became apparent that fears and hopes alike had been exaggerated: not a single statue considered to be of the highest excellence had left the city, and, shuttered off though its contents were, the courtyard with its *Venuses* and its *Antinous* survived intact despite a campaign of unprecedented violence against courtesans and sodomites.[36]

In making over the sculptures from the remaining parts of the Belvedere to the Capitol, Pius V was to some extent following well-established precedents. We have seen that a hundred years earlier Sixtus IV had inaugurated the Capitoline collections with a donation of bronzes from the Lateran Palace. Many subsequent popes had followed his example, and the Conservators themselves had been active in the search for suitable antique relics.[37] Already by 1523 visitors could look upon the statues on the Capitol as 'the most beautiful and famous in the world',[38] even though the main impulse behind the collection seems to have been historical nostalgia rather than intrinsic beauty.

Three reliefs originally from the triumphal arch of Marcus Aurelius were presented by Leo X and took their place among the most admired works of antiquity, and, when in 1538 Paul III carried out the original intention of Sixtus IV by having transferred from the Lateran the equestrian statue of *Marcus Aurelius* to the Capitol, it confirmed the status of the collections housed there as almost the equal of those in the Vatican. In 1564 Cardinal Rodolfo Pio da Carpi bequeathed another prodigious memorial of the greatness of ancient Rome—the bronze head (to which we have already referred) claimed to be that of *Lucius Junius Brutus*, the founder of the Republic. In the context of works such as these the hotchpotch of sculptures presented by Pius V from the Belvedere theatre, though accepted by the Roman people with suitable expressions of gratitude,[39] must have come as something of an anti-climax, and—at the time—not one of them attracted much enthusiasm or even attention. And it was not until the eighteenth century that the two official permanent and public collections received any notable increase.

III

Plaster Casts and Prints

A GREAT COLLECTION of bronze copies such as that at Fontainebleau could not be afforded by many people, but plaster casts were less expensive, and we know of at least one private collection which was formed not much later. Vasari tells us that the sculptor Leone Leoni erected in the court of his house in Milan, the Casa degli Omenoni, a cast of the equestrian *Marcus Aurelius*, and had casts elsewhere in the building of 'as many of the celebrated works, carved and cast, antique and modern, as he was able to obtain'.[1] Some of these must have been made from the moulds which, as we have seen, Leoni retrieved from Fontainebleau. The collection was begun before 1550, and it is clear that Vasari considered it to be remarkable.

And yet in 1586 Giovanni Battista Armenini's treatise on painting recommended all students to draw from casts of the finest statues in Rome—'the Laocoon, the Hercules, the Apollo, the great Torso, the Cleopatra, the Venus and the Nile' of the Belvedere, together with the bronze *Marcus Aurelius*, the *Alexander and Bucephalus*, the *Pasquino*, the reliefs on the triumphal arches and on the Trajan and Antonine columns. He had seen a wax model of the *Laocoon* no more than two palmi high and very good, but casts were absolutely reliable replicas, 'trifling' in price, and light, and easily taken to all countries. And with access to them there was no excuse for anyone anywhere failing to follow 'the good and ancient path' (il buono et antico sentiero).[2] Obviously we cannot take this literally: casts of the colossal groups on the Quirinal (the *Alexander and Bucephalus*) cannot have been common; special papal licence was required for Leoni to obtain casts from Rome and we know that they were moved with great care by mule;[3] we also know from the Medici account books that the casts of the *Niobe Group*, sent to Florence in 1588, arrived in parts which needed assembling with a great deal of attention and were also exceedingly difficult to transport.[4] When Armenini claimed that he had seen rooms filled with excellent casts in Milan, Genoa, Venice, Mantua, Florence, Bologna, Pesaro, Urbino, Ravenna 'and other lesser cities', he must (allowing for rhetoric) have been referring essentially to busts and to relatively small-scale work which had indeed been assembled and used by artists at least since the fifteenth century.[5] The fact that travellers bothered, nearly two centuries after Armenini's remarks, to comment on the cast collections then recently formed in Turin, Bologna and Venice,[6] shows that large-scale enterprises were unusual, and we can in any case be quite certain that outside Italy sets of casts from the Belvedere were extremely rare before the eighteenth century.

The first academy of art, the Florentine Accademia del Disegno, mentioned in its original regulations drawn up in 1562 'Una Libreria'—a teaching collection composed of 'disegni, modelli, di statue, piante, di edifizij'—but there is no evidence that casts were included, and since the first mention of life classes comes in 1638 it is not likely that the educational intentions of the institution were matched in practice.[7] On the other hand, the Accademia di S. Luca in Rome was given a set of casts in 1598, five years after its foundation,[8] and Federico Borromeo made some available to the Milanese Academy founded under his patronage in 1620. He acquired these from the collection of a certain Leone of Arezzo—Leone Leoni, of course—who, he believed, had made them for François Ier. Among them 'the Apollo, like the sun, shone most brilliantly; next came the Antinous, so celebrated for its morbidezza; and then are seen, arranged in single file, Pasquino, Hercules, the Gladiator, and Narcissus . . .'[9] These casts were still admired in the eighteenth century.[10] The Roman Academy, despite the intentions of its first principal, Federico Zuccaro, was not at first successful as a school, and, although some teaching was done in the 1620s and 1630s, it was only much later that it really became an educational establishment whose ideals were exemplified in an allegorical drawing by Carlo Maratta which included as models the *Farnese Hercules*, the *Venus de' Medici* and the *Belvedere Antinous*. A fresh set of casts was then supplied.[11] The example followed was that of the French Academy (to be discussed in a later chapter) which would prove to be the model for most of those founded in the eighteenth century and thus the channel whereby drawing from casts after the antique eventually became what Armenini had long since proposed—standard academic training everywhere, and, incidentally, virtually synonymous with popular conceptions and misconceptions about the very nature of such academies themselves until the most recent times.

There can be no doubt that the chief way by which knowledge of the most famous and beautiful statues of Rome was spread throughout Europe during the period of the High Renaissance was the print rather than the cast. Surviving Italian engravings of the fifteenth century are mostly of sacred subjects and playing cards; but after 1500 pagan subjects became increasingly popular and we begin to find prints of the most famous Roman antiquities—above all the *Marcus Aurelius*, but also the *Apollo* and the *Laocoon*. There are prints of at least eight antique statues by Marcantonio Raimondi,[12] and three times as many by other engravers working in Rome during the early sixteenth century, such as Giovanni Antonio da Brescia, Nicoletto da Modena, Marco da Ravenna and Agostino Veneziano.[13]

The artists who issued these prints often also made others of ornaments and architectural detail—grotesques, decorated pilasters, entablatures and capitals—and these constitute perhaps the most popular subjects of the 'Roman sketchbooks' of draughtsmen of the late fifteenth and early sixteenth centuries, which also served to spread information about ancient art (and the new art it inspired). One sketchbook, the Codex Escurialensis, for example, which contains drawings of ancient sculpture (including the *Marcus Aurelius*, the *Apollo Belvedere*, and reliefs on the Arch of Constantine and Trajan's Column)[14] together with ancient architecture and ornament, was being used as a pattern book in Spain in 1509.[15] It is hardly likely to have been compiled with the needs of Spanish masons in mind, but the architectural

elements were successfully copied. The sculpture, however, was a different matter: information about it could be spread by graphic means, but not enough for it to be easily imitated.

Just as the invention of the printed book should not lead us to suppose that poems, and even learned treatises, did not continue to circulate widely in manuscript form, so too we should not consider prints as the sole means whereby knowledge of the Roman collections of antique statues was disseminated even outside Italy. Sketchbooks were in effect often reproductions, or at least included reproductions (that is, copies from other sketchbooks) confusingly mixed with original work.[16] No less confusing is the mixture of careful records (Fig. 7) with fanciful inventions or reconstructions.

The miscellaneous character of most of these sketchbooks suggests that they were made by artists for their own use; but even when this certainly was the case, the sketchbook might still be of service to others—to Spanish masons, for instance, or, in the case of Marten van Heemskerck's drawings made in Rome in the 1530s, to Northern printmakers, both at the time and to others living more than a century later.[17]

Sets of prints after the antique had begun to appear by the late 1540s in the form of groups of the heads of the Caesars and of the great men of antiquity based on herm busts and coins,[18] but one publisher had more ambitious ideas. Antonio Lafreri (Antoine Lafréry)—the scale of whose establishment impressed Vasari[19]—produced a handsome title-page inscribed 'Speculum Romanae Magnificentiae' which could be purchased by those who wished to assemble anthologies of his unnumbered plates. Most of the surviving examples of these anthologies begin with a plan of ancient Rome, continue with reconstructions of ancient Roman architecture and conclude with antique sculpture (Fig. 8). The earliest dated plates belong to the 1540s; fifty plates of antique sculpture are included in a catalogue of Lafreri's stock made in the early 1570s;[20] the latest were added in the 1580s by Claude Duchet, Lafreri's nephew and heir. An important rival was Giovanni Battista de' Cavalieri, better known as Cavalleriis, whose anthology of more than fifty prints devoted exclusively to antique statues appeared in two successive editions in the early 1560s. An enlarged edition of a hundred plates was published before 1584, and a second hundred appeared in 1594. And other anthologies were parasitic on both Lafreri and Cavalleriis.[21]

Cavalleriis confined himself to Rome, but within it he strove to be comprehensive and to reproduce all the major statues in all collections. Although the majority illustrated by him belonged to half a dozen great collections, he also reproduced groups of two or three sculptures, and even single ones, from small collections, as well as others belonging to the mysterious 'Petrus Sculptor' which were no doubt 'on the art market'.

To a certain extent this undertaking may be related to the first published work of the great sixteenth-century Bolognese naturalist Ulisse Aldrovandi, which attempted to make a complete inventory of all the antique statues in Rome 'without omitting a single one'—something which had never previously been attempted. The manuscript was drawn up in 1550, and copies of it were given to the topographer Lucio Fauno and the publisher Ziletti. In 1556 it was printed as an

7. Sheet of drawings after the antique from the Codex Escurialensis (Library, Escorial).

8. The groups of *Alexander and Bucephalus*—engraving (from Lafreri's *Speculum*).

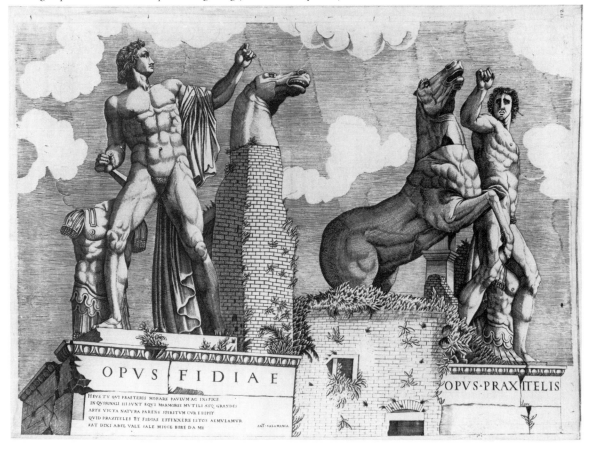

9. François Perrier: *The Nile*—etching (from Perrier's *Segmenta*).

10 François Perrier: Imaginary reconstruction of the *Niobe Group*—etching (from Perrier's *Segmenta*).

appendix to the guides of Rome by Fauno and Lucio Mauro, and additions were made in subsequent editions.[22]

The reader confronted by Aldrovandi's very full lists must have felt an acute need for guidance as to quality, and it is also possible that the comprehensive work of Cavalleriis may have prepared the market for some more select anthology. Certain sketchbooks were perhaps designed with this aim in mind, while others seem to have been adapted to serve the purpose through the addition of explanatory captions.[23] Lafreri's prints of statues can also be thought of in this way. But in fact the earliest illustrated volume to be deliberately restricted to the finest antique sculpture was not published until 1638. This consisted of a hundred prints of fewer than a hundred statues, together with one modern one (Michelangelo's Moses) and was the work of the French artist François Perrier. It was a great success, and a companion volume of antique reliefs appeared in 1645. The idea was imitated by other artists and publishers later in the seventeenth century, most notably by Jan de Bisschop, Sandrart and Bartoli, and, in the late eighteenth century, by Francesco Piranesi; but Perrier's books were cheap,[24] frequently reprinted and were probably more popular than these rival and superior volumes. As late as the 1820s Flaxman was referring his students at the Royal Academy to Perrier,[25] and the presence of a statue in his anthology was likely to establish or confirm a reputation in a way that had not been possible in the earlier, less restrictive compilations.

Cavalleriis, although his images were small, usually reversed and poorly drawn, had attempted to be as accurate as possible (providing, for instance, reliable evidence as to the appearance of the *Niobe Group* and the *Wrestlers* before they were restored—Fig. 11), but most early prints after the antique, in common with drawings in Roman sketchbooks, tend to include whimsical additions, imaginary reconstructions, even imaginary damage, and fanciful architectural or landscape settings. Every print of the *Marcus Aurelius* in the early sixteenth century shows it in a different attitude.[26] Well before being restored, the *Apollo Belvedere* was engraved as a complete figure, in a landscape instead of the statue court; and whilst one artist showed the *Laocoon* in front of a broken wall as if to suggest the first moments of its discovery, another set the group by the shores of Troy with antique temples in the distance.[27] Similarly, although some scholars transcribed ancient inscriptions accurately and in their fragmented state,[28] we can find in the work of epigraphers such as Jean-Jacques Boissard entirely unreliable and fantastic versions.

This attitude did not change in the early seventeenth century: Perrier's prints resemble those by Cavalleriis in that they make no additions to sculpture which had not been restored (thus the children in his print of the *Nile* are shown as the bits and pieces they were—Fig. 9), but he does supply fanciful settings. His *Niobe Group* is imagined in an exceptionally pictorial manner (Fig. 10), his *Wrestlers* fight in front of the Colosseum, and his *Hermaphrodite* lies not on a mattress but beside a stream.[29] The most inconsistent of all the leading anthologists was Sandrart, who published prints by a variety of engravers in 1680, though many must have been based on the drawings he had made during his stay in Italy half a century earlier. Sometimes the statues are shown as he found them; sometimes they are brought to life (his *Seneca*, for instance, has blood spurting from the veins—Fig. 12);[30] sometimes they are half restored by him (as is the case with his *Nile*);[31] frequently they are transposed to

landscape settings (the *Nile* reclines in front of pyramids and palm trees); and on several occasions statues from separate collections are grouped together.[32] By this date, however, new standards were being set in Rome by Pietro Santi Bartoli, although even he was capable of supplying the *Borghese Dancers* with a landscape,[33] and it was also said of him that he 'designs so well that he cannot resolve with himself to design ill . . . and we cannot always be certain that the antique venerable Figures he has engraven have not been mightily embellished by his Tool'.[34]

From Bartoli onwards prints after antiquities improved in reliability, culminating in the folio productions of the early nineteenth century—such as the first volume of the *Specimens of Antient Sculpture* published by the Society of Dilettanti and the section devoted to sculpture in the *Musée Français*. Ironically, however, the increasing dissemination of plaster casts had by then greatly diminished the importance of prints as a source of information. But less sober ways of presenting classical sculpture continued to flourish. As we will see in a later chapter painters and printmakers were to supply *capricci* (Fig. 44) in which we find the most famous and beautiful statues miraculously restored or poignantly mutilated, in unfamiliar company, in fantastic settings.

11. *The Wrestlers*—engraving (from Cavalleriis's *Antique Statue Urbis Romae*).

12. J. von Sandrart: *Dying Seneca*—engraving by R. Collin (from Sandrart's *Sculpturae Veteris Admiranda*).

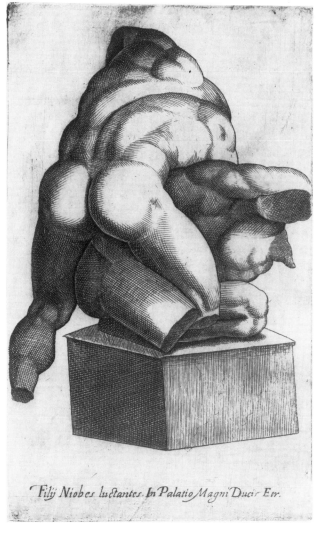

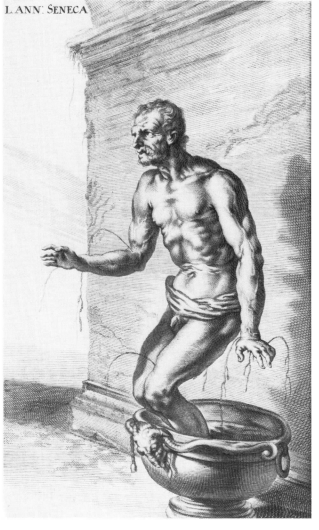

IV

Control and Codification

IN 1704 THE ROMAN publisher Domenico de Rossi produced a large, handsome and lavishly illustrated volume devoted principally to the ancient statues of Rome (Fig. 13). To comment on the plates (which included a few modern works by Bernini and others) he commissioned a text from the antiquarian Paolo Alessandro Maffei. Through his uncle, Maffei was very closely linked to French interests in the city[1] and the majority of the draughtsmen and engravers employed in the enterprise were French, who thus now (as so often) played a preponderant role in spreading knowledge about the appearance of antique sculpture.

De Rossi deliberately set out to illustrate the most highly esteemed statues, though he included also some of lesser quality because of the interest of their subject matter. In its attempt to set up qualitative standards his book was the most authoritative that had yet appeared and it showed little of the waywardness of the earlier anthologies we have been discussing. Although Maffei's text was learned enough, the publication as a whole—like the *Gemme Antiche Figurate* which followed it three years later—was designed for the cultivated art lover, and, unlike the thin folio published by François Perrier seventy years earlier,[2] few independent artists or craftsmen could have afforded to buy it. As the material was arranged entirely by location de Rossi's book gives us a telling picture of the way in which the most celebrated masterpieces of antiquity had by now been both codified and divided among the leading families of Rome.

Perhaps the most significant single point about de Rossi's choice of plates is that, although it was much more extensive than that published by Perrier, only three or four of the additional works included in it which were acknowledged to be of the highest quality had actually been excavated since Perrier's day. The appearance of de Rossi's sumptuous volume amounts almost to a recognition of the fact that the situation had by now stabilised. Indeed, for about a century there was very little increase in the number of antique statues which earned universal acceptance as masterpieces of the first order.

If one looks further at the whereabouts of the most famous and beautiful statues chosen by de Rossi it is immediately clear that the Belvedere statue court retained the pre-eminence it had held for more than a hundred and fifty years and that the Capitoline collections were also well represented. And with very rare exceptions all the major works illustrated belonged to the four families—the Farnese, the Medici, the Borghese and the Ludovisi—which already dominated all other collectors when

23

13. Dedicatory plate of P. A. Maffei's *Raccolte di statue* published by Domenico de Rossi—engraving.

14. (facing page) Gio. Francesco Venturini: Garden front of Villa Medici, Rome—engraving (from Venturini's *Fontane*).

Perrier had published his volume in 1638: second-rate statues clearly stood a much better chance of being noted when placed in the company of acknowledged masterpieces.

We have already stressed the part played by Pope Paul III (and his family the Farnese) in retaining for themselves important pieces of a kind which had hitherto been placed in the Vatican. Although they possessed extensive gardens within the city walls, their principal treasures were kept in their great palace which dominated fashionable Rome, many of them in the courtyard as had been the case with earlier collections. The Medici, on the other hand, displayed their almost equally splendid antiquities in far less urban surroundings.

Although, as we will see, many important sculptures were taken by them to Florence, it had been Medici policy ever since Giovanni (later Pope Leo X) had been made cardinal in 1492 to remain in the closest physical as well as political and cultural contact with the Papacy—a contact that survived until the extinction of the dynasty. There was nearly always one member of the family in the College of Cardinals, and they owned a number of important properties in Rome to give visible expression to their ascendancy and to assert their permanent presence there. Of these by far the most important, in the context of our book, was the handsome villa on the Pincio which had originally been built by Cardinal Ricci (himself a notable collector) and which in 1576 was bought by Cardinal Ferdinando de' Medici, the younger son of

24

Grand Duke Cosimo, for himself and his heirs. He filled both the Villa and its gardens with a striking group of classical sculptures (Fig. 14), among them one hundred and seventy which he acquired from two of the most famous Roman collections, those of the Capranica and the della Valle, which had been combined through marriage.[3] But, above all, his twenty odd years in Rome witnessed the arrival in the Villa Medici of three works which ranked with the most famous in the city—the *Arrotino* (Fig. 80), the *Niobe Group* (Figs. 143–7) and the *Wrestlers* (Fig. 179), making the Medici contribution to the cult of antique sculpture so important that it will have to be considered later in a separate chapter.

By the first half of the seventeenth century it had long been common practice for the pope's nephews and close family to be loaded with immense riches and to devote a large proportion of these to building, patronage and collecting after the pattern established by the Farnese. The Borghese (Pope Paul V, 1605–21) and the Ludovisi (Pope Gregory XV, 1621–3) were exceptional only as regards the taste and lavishness with which they made use of their good fortune, and (after a moment's hesitation)[4] both chose to combine the example of the Farnese in keeping their classical sculptures for themselves rather than for the Belvedere with that of the Medici in preferring to display them in a country setting: the villas they built came to house statues of almost equal splendour to those that were to be found in the Vatican, the Palazzo Farnese and the Villa Medici.

Moreover, the power as well as the wealth at the disposal of these papal families made it almost impossible for any private citizen to acquire ancient sculpture of the highest order. Two cases reveal this very clearly. The Farnese family, which during the papacy of Paul III had purchased much of the Palatine and laid it out in the form

of gardens, refused to countenance any excavations on their property, because—so it was widely believed[5]—they feared that they would be unable to retain for themselves what might be found there. Even more revealing was the position of the enormously rich Vincenzo Giustiniani (1564–1638), the son of a Genoese banker and one of the most imaginative art patrons of his time. His was certainly the largest collection of ancient statues in Rome and, as he had an illustrated catalogue of them published in 1628 and 1631 (the first of its kind ever to appear), they attracted much attention not only in Rome but throughout Europe—an attention that was stimulated also by the quite disproportionate consideration paid to them by the German artist Joachim von Sandrart. But Sandrart was an intimate of the Giustiniani household, and neither his fanciful illustrations[6] nor the original catalogue offer a true reflection of the taste of those travellers who commented on the palace and its contents. For most visitors the collections were clearly of notable importance as an unrivalled repertoire of subjects and themes, but with only two or three exceptions the statues were not in themselves of sufficient quality to be compared with those which could be seen in the villas so far mentioned:[7] the Palazzo Giustiniani was later to be described as 'Rumpelkammer von antiken Nennen'.[8] In fact virtually the only inhabitant of Rome, apart from the various papal nephews, who was in a position to acquire sculpture of real and acknowledged excellence in the seventeenth century was Queen Christina of Sweden, and (as we will soon see) even she, for all the passion she put into the attempt, was not conspicuously successful.

Baroque Rome thus witnessed the increasing concentration within a few hands of the most notable sculpture that became available, even though less significant works were very widely distributed. What is much harder to determine is the extent to which the patrimony had actually been increased.

Two of the most famous sculptures belonging to Cardinal Borghese were certainly new discoveries: the *Gladiator* (Fig. 115), which was found at Nettuno in 1611, and the *Hermaphrodite* (Fig. 120), which was excavated either shortly before or shortly after this date during the building operations connected with the church of S. Maria della Vittoria. However, some other much admired works—such as the *Vase* (Fig. 166) and the *Silenus with the Infant Bacchus* (Fig. 162)—were acquired from previous owners, and in many cases we cannot be certain of the origins of sculptures that became celebrated in their villa, for the Borghese often bought en bloc: two hundred and seventy-eight statues, for instance, in 1607 from the Ceuli family who had been among the richest bankers in Rome before their sudden collapse,[9] and another batch which had belonged to Giovanni Battista della Porta, himself a sculptor (related to the much more famous Guglielmo), but above all a restorer and collector of antiquities, who had been extensively employed by Cardinal Farnese.[10] Though few of della Porta's statues were of great importance,[11] it is possible that other sculptures which won great fame after being publicised by the Borghese and their clients had already belonged to earlier collections without attracting attention.

The problem is made particularly difficult by the very personal nature of Borghese patronage. Few previous owners had been at once so ruthless and so imaginative in the 'restoration' which they had meted out to their antique sculptures, so that a colourless and battered fragment in some previous collection may well have been changed out of all recognition by the time that it was displayed

in the Villa Borghese. Such appears to have been the case with the *Zingara*, a headless marble trunk 'vestita alla moresca' noted in a private collection without particular enthusiasm by Aldrovandi and subsequently—to the indignation of present-day archaeologists but to the unqualified delight of generations of travellers to Rome— fitted up with a charming head, hands and feet of bronze to emphasise her Oriental aspect. A taste for the exotic is noticeable in other Borghese statues, some of which were, ironically enough, acknowledged to be wholly modern (such as the *Moro* by Nicolas Cordier) but later assumed to be antique.[12] The *Seneca*, also in black marble, is not recorded for certain until it belonged to the Borghese, but the original head and torso were known though not much regarded. It was the addition (perhaps also by Cordier) of emaciated limbs, a basin and porphyry to represent the blood of the Stoic philosopher that really made the statue famous. And, although the *Centaur with Cupid* must presumably have been excavated some time between 1605 (when Cardinal Borghese acquired wealth and power) and 1613 (when it is first definitely recorded in his collection) because it has not been so drastically treated and because it is surely too striking to have escaped earlier notice, the extravagantly admired *Curtius* would appear to be a very successful but largely modern refashioning of some fragmentary antique which may well have been dug up a century earlier.

Like Cardinal Borghese, Cardinal Ludovisi, his successor as papal nephew, bought up or (more usually) was given a number of existing collections:[13] it was, for instance, from the Cesi that he acquired the *Pan and Apollo* which had been well known since the middle of the sixteenth century, and he also gained possession of a number of antique sculptures which had adorned the gardens of the Cesarini.[14] Cardinal Ludovisi was, on occasion, prepared to have his antiquities 'restored' just as radically as had been Cardinal Borghese; however, none of those pieces in his collection which were to be regularly included among his most beautiful statues—

15. G. B. Falda: The Villa Ludovisi, Rome—engraving. The 'Palazzo Grande' is to the left and the 'Palazzetto' or Casino on the horizon.

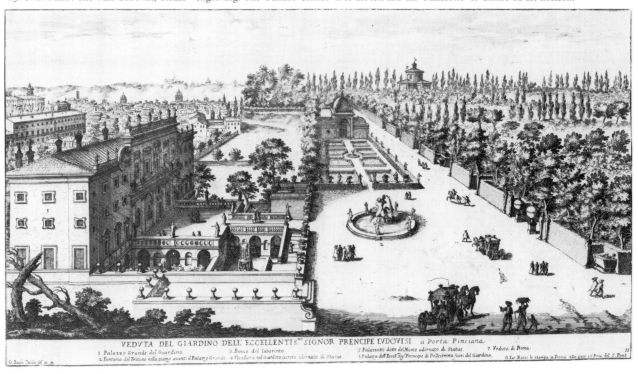

VEDVTA DEL GIARDINO DELL'ECCELLENTIS.^o SIGNOR PRENCIPE LVDOVISI *a Porta Pinciana*.

the *Mars* (Fig. 135), the *Pan and Apollo* (Fig. 151), the *Castor and Pollux* (Fig. 90), the *Paetus and Arria* (Fig. 149), the *Dying Gladiator* (Fig. 116) and the *Papirius* (Fig. 152)—required such extensive treatment as to turn them into virtually new creations. As all these statues were large works, often groups, of a highly distinctive kind, it is most unlikely that they could have passed unnoticed by earlier observers. We must assume therefore that most of them were excavated for Cardinal Ludovisi himself during the construction of his villa (Fig. 15) which was situated in part of what had been the famous gardens first of Sallust and then of the emperors and thus a rich source of important works of art. The Ludovisi sculptures therefore represented a genuine addition, of the utmost significance, to the most admired statues in Rome.

The great villas and gardens that these cardinals built for themselves, situated immediately outside or sometimes even within the walls of Rome (those of the Medici, the Borghese and the Ludovisi were all adjoining), were often conceived of as semi-public 'museums', far more accessible than the more formal palaces in the centre of the city. It was in these estates that all the more important sculptures were displayed, both inside—where rooms might be named after especially famous pieces (such as the Stanza dell'Ermafrodito and the Stanza della Zingara in the Villa Borghese)—or outside, as in the 'bosco delle statue' specially designed for the Villa Ludovisi. The foreign visitors who came to Rome in greatly increasing numbers never failed to marvel at the enchantment of these villas whose owners were themselves keen to boast of their possessions, as can be seen from the catalogue of the contents of the Villa Borghese published in 1650 by the custodian and dedicated to the heir of Cardinal Scipione, its founder.[15]

The sculpture collections of the Borghese and the Ludovisi were certainly the most admired to be formed in seventeenth-century Rome, but succeeding papal nephews were naturally keen to rival them. Yet under Urban VIII (1623–44), the Barberini, with greater resources and more time available than both the earlier families combined, were only able to find one work, a sleeping *Faun*, which won universal acceptance as a statue of the highest excellence (Figs. 16 and 105). The Barberini collection was a huge one, but despite one or two rich hauls, it now seemed impossible to discover more masterpieces in Roman soil, and some major speculative excavations were later to uncover nothing of interest or value.[16]

In these circumstances it is not surprising that visitors should have looked with envy, as well as with admiration, at the Borghese and Ludovisi collections. The Borghese appeared to be secure enough and it remained almost intact for nearly two centuries; but the great-nephew of Cardinal Ludovisi was a reckless spendthrift[17] and for many years it seemed as if the family treasures were to be drastically redistributed. In 1670 a 'sale catalogue' was drawn up, with *Paetus and Arria* valued at ninety thousand scudi, followed by the *Dying Gladiator* at seventy thousand;[18] two years later there was a rumour (which proved false) that the Altieri, the ruling family of the day, had succeeded in acquiring the finest statues in the grounds of the Villa.[19] Thus the leading collectors of the time lived in a state of constant excitement. The King of France, as we will see, was very attentive to stories about the forthcoming dispersal of the sculptures and was determined not to miss any chance that might come his way—especially when the Ludovisi were at one stage reported to be selling their greatest treasures to Spain.[20] The Grand Duke of Tuscany was more successful

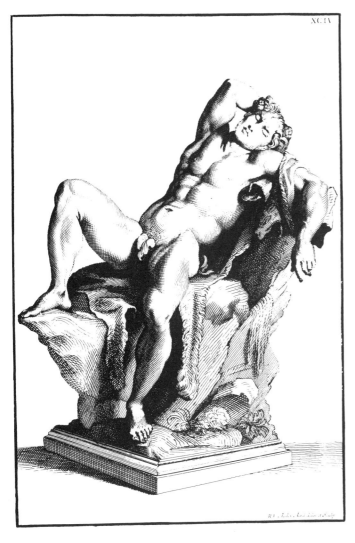

R.A. delin. et sculp.

16. Robert Auden-Aert: *The Barberini Faun*—engraving (from Maffei's *Raccolta di statue*).

than either the French or the Spanish and was actually able to buy a number of pieces, one of which—a Hermaphrodite—was to win fame as something of a rival to the more famous version of the subject in the Villa Borghese.[21] Before going to Florence, however, it had not been particularly noted, and, despite all the tension, only two of the really celebrated pieces left the Ludovisi collection in these years, though the remarkable group of small bronze reproductions of the antique from the Susini studio which had been acquired by Cardinal Ludovico was dispersed before 1670.[22]

The Queen of Sweden was desperate to obtain masterpieces,[23] and she did her best to make the world believe that she had done so by having her defective set of eight, much-restored, Muses (acquired from a sixteenth-century collection) placed in a lavishly draped room in her palace with a specially carved Apollo to accompany them.[24] The sculptures were duly reproduced by de Rossi, although Maffei's accompanying text did not show much enthusiasm,[25] but these were not the really famous works in her collection. In 1678 she managed to acquire, through the

intervention of the painter Carlo Maratta who was anxious to prevent it going abroad, one of the most admired marbles in Rome: the *Castor and Pollux*. And eleven years later she bought the *Faun with Kid* which was found during the building of a new road adjoining the Chiesa Nuova.

All these works were eventually bought by the King of Spain, after passing through the Azzolini and Odescalchi collections. One great statue from the Villa Ludovisi narrowly missed export in the same transaction. But in fact the *Dying Gladiator* was only temporarily forfeited to the Odescalchi in bond for a debt, and (after being kept hidden for a generation) it was in 1715 returned to the last surviving member of the Ludovisi family, though it did not go back to the Villa.

It can thus be seen that the last two thirds of the seventeenth century were more a period of consolidation than of discovery; but it was during this time that access to the great Roman collections became relatively simple not only to clients and to privileged guests but to gentleman travellers and to foreign artists (including an increasing number from Protestant countries) who could therefore appraise for themselves the full extent of what antiquity had to offer. In 1700, just four years before de Rossi's publication, the Abbé Raguenet (author of a life of Cromwell) produced an anthology of the leading masterpieces to be seen in the city. This was unillustrated, but in melodramatic prose he expounded what it was about them that attracted admiration from all over the world. It was, he concluded, the range of expression which was most remarkable:

> Life, Death, Agony, the suspension of Life, the image of Death—all that is nothing; but states which are neither Life, nor Death, nor Agony, such as the Niobe who is neither alive nor dead nor dying but turned to stone. Two kinds of Sleep—natural sleep, as in the Faun in the Palazzo Barberini and drunken sleep as in the Ludovisi Silenus. Reverie—as in the figure which one sees on the Palatine [the Farnese Agrippina]. Lassitude—as in the Farnese Hercules. Agony—as in the Seneca in the Villa Borghese. Finally, the very moment from Life to Death, the instant of the last breath, as in the Myrmillo [*Dying Gladiator*].[26]

These observations are then elaborated in some detail. Though many of them have a touch of the absurd, we will find sentiments similar to his expressed again and again by visitors to Rome; for Raguenet's rhapsodies, themselves deeply influenced both by late antique authors and by the emotionalism of Baroque art, reflect the changes made to previous notions of antiquity through the sculpture collections and 'restorations' of the papal families of the seventeenth century: dramatic narrative, exoticism and heart-rending sentiment certainly counted for more with the growing number of travellers than did formal perfection.

The situation was not to change in any significant manner until the middle of the 1730s. Not until then were a limited number of works to acquire the same degree of fame as that already earned by the sculptures published by Perrier and de Rossi—and, as will be seen, with one or two exceptions all were to be of rather different character to those we have been discussing in this chapter and were to come from Hadrian's Villa outside Rome where, despite sporadic explorations, no important discoveries had been made since the excavation of the Barberini Candelabra in 1630.[27]

V

Casts and Copies
in Seventeenth-Century Courts

CHARLES I OF ENGLAND on his succession to the throne in 1625 'amply testified a Royall liking of ancient statues, by causing a whole army of Old forraine Emperours, Captaines, and Senators all at once to land on his coasts, to come and do him homage, and attend him in his palaces of Saint James, and Sommerset house'.[1] A few of his statues came from Greece and the Levant where the agents of other English collectors— the Earl of Arundel, the Duke of Buckingham and the Earl of Pembroke—had been busy for some time; more came from Mantua; but the King knew that the best statues could only be obtained in casts and copies. By 1629 'ingenious Master Gage', who had been a secret agent of James I in Rome earlier in the decade, had managed to obtain moulds of Cardinal Borghese's *Gladiator*. By 1630 the *Gladiator* was being cast in bronze and a pedestal was completed for its display in the Privy Garden at St. James's Palace.[2] In the following year the bronze-founder Hubert Le Sueur ('Praxiteles' Le Sueur as he sometimes styled himself) was dispatched to Italy to purchase 'the moulds and patterns of certain figures and antiques there'.

One of the King's secret agents, Walter Montagu, had these packed up in Rome and their transport to England was organised by Inigo Jones through an English factor in Livorno.[3] By 1634 half a dozen bronze copies had been cast by Le Sueur, and others were being prepared.[4] We know that these included the *Antinous* and the *Commodus as Hercules* of the Belvedere, and the *Diane Chasseresse* then in the Louvre, which still survive. There was also a copy of the *Spinario* ('The Boy or Pickthorne') and perhaps copies of a Venus and of *Cleopatra*, but these cannot be traced.[5]

In 1642 civil war broke out and in 1649 Charles was beheaded. All the bronze copies listed above were sold in 1650 or 1651 and were among the most valued items in the royal collection (although no statues, ancient or modern, were to be ranked with 'that incompareable head in marble of ye late King's, done by Cavaliere Bernino').[6] Oliver Cromwell withdrew some sculptures from the sale 'on account of their antiquity and rarity' and he bought back the copy of the *Antinous*. These statues were kept at Whitehall, where some, in the Privy Gardens, were defaced in an attack by a Quaker armed with a hammer. The fanatic was apprehended only after he had smashed down a door leading to the Volary Garden where he intended to assault the *Antinous*.[7] After the restoration of the Monarchy in the following year, the *Diana*

and the *Commodus as Hercules* were reunited with the *Antinous*, only to be damaged by the Whitehall fires of 1691 and 1698. The *Gladiator* also returned to the royal collection and was set up at the end of the Long Water in St. James's Park until 1701 when it was taken with the Whitehall bronzes to Hampton Court. The fire damage was then repaired[8] (although *Diana*'s stag was never replaced). George IV later removed the statues to the east terrace garden of Windsor Castle,[9] where they were joined by a cast of the Warwick Vase.

In addition to the full-scale bronze copies whose fortunes we have just traced, King Charles also owned a number of smaller pieces which might have been copies after the antique, and one which certainly was: 'Laocoon w^th his two Sonns killed by the great serpents w^ch my Lo: Marquess [of Hamilton] bought from Germany'.[10] But the large bronzes were much more unusual. They suggest that the English King wished to emulate the achievement of François I^er at Fontainebleau a century earlier.

The French had certainly not forgotten that achievement, and it was in order to continue François I^er's projects[11] that Roland Fréart, Sieur de Chambray, and his brother Jean, Sieur de Chantelou, were ordered in 1640 by M. de Noyers, Louis XIII's Surintendant des Bâtiments, to secure the services of the leading French artist in Italy, Nicolas Poussin, and, in Chambray's words, translated by Evelyn,

> to get made, and collect together all that the leisure and opportunity of our Voyage could furnish us of the most excellent *Antiquities*, as well in *Architecture* as *Sculpture*; the chief pieces whereof were two huge *Capitals* . . . from within the *Rotunda* . . . *Two Medails* . . . taken from the *Triumphal Arch* of *Constantine*; threescore and ten *Bas-reliefs* moulded from *Trajan's Column*, and several other of particular *Histories*, some of which were the next year cast in *Brass*.[12]

Among those which were cast 'in brass' were a relief from the Villa Medici and two from the Borghese collection,[13] but, as Chambray explains, most of the casts were used as stucco relief ornaments 'about the *Compartiment* of the arched *Ceiling* of the *Louvre* great *Gallery*, in which M. Le Poussin most ingeniously introduc'd them', partly it seems as an expedient prompted by his patron's haste and economy, and partly because he was disinclined to collaborate with other painters.[14]

In 1643 Chantelou returned to Italy with royal offerings to the Madonna of Loreto for the successful birth of the Dauphin (later Louis XIV), and he took advantage of his trip to order casts of 'other medails from the same Arch of Constantine' and also of the colossal Farnese *Flora* and *Hercules* and of the still larger '*Colosses* of *Montecavallo* with their *Horses*, the greatest and most celebrated works of *Antiquity*, which *M. de Noyers* designed to have also cast in Copper to place them at the principal Entry of the Louvre'. Poussin, who had by now returned to Rome, seems to have helped organise the making of these casts, and the problems involved with the moulds taken from the *Farnese Hercules* are discussed by him in letters to Chantelou of 1645 and 1647,[15] but by then 'all these mighty Projects', as Chambray called them, had been abandoned, for after the death of Cardinal Richelieu in 1642 and the fall of de Noyers, and the death of the King in 1643, there were no powerful statesmen in France who supported them.

In 1650, a few years after the French had abandoned these 'mighty Projects', Diego Velázquez, the Spanish court painter, travelled for the second time to Italy. His visit

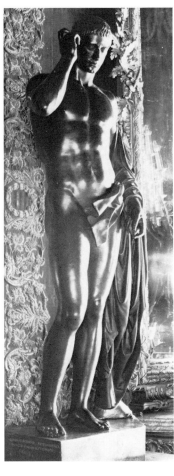

17. Bronze cast of *Germanicus* made by Cesare Sebastiani and Giovanni Pietro del Duca (Royal Palace, Madrid).

was made in connection with the furnishing of the new apartments of the fortress of the Alcazar, recently converted by Philip IV into a palace, over which the painter had been given general charge. He returned to Spain in the following year, having secured the services of two fresco painters, Colonna and Mitelli, and with numerous sixteenth-century paintings to swell the royal collections.[16] But to contemporaries Velázquez's most important achievement in Italy was to acquire, through the favour of the pro-Spanish Pope Innocent X, a set of plaster casts, together with some bronze copies, of the most beautiful antique statues in Rome.[17] The fact that a series of busts of the Caesars and a replica of the *Spinario* (presented to Philip II in 1561) already existed in Spain cannot have diminished the impact made by the arrival of these casts and copies. The palace inventory of 1666 valued the casts of the Farnese *Flora* and *Hercules* as each worth more than Velázquez's 'Bacchus' and twice as much as any of his portraits, while only Velázquez's 'Las Meninas' and a few Titians were more highly valued than the bronze copy of the *Hermaphrodite*.[18]

The two most spectacular rooms in the royal palace were the Hall of Mirrors (Salon de los Espejos) and the Octagon (Pieza Ochavada). In the former twelve gilt bronze lions (today divided between the Prado and the throne room of the royal palace), probably modelled by Finelli and certainly cast by Bernini's assistant Matteo Bonarelli, supported porphyry slabs, forming side-tables beneath the mirrors. They were inspired by the *Medici Lions*, but were not imitations of them. The other room, the Pieza Ochavada, in shape and height and in precious marbles and valuable

pictures, resembled the Tribuna in the Uffizi, which will be discussed in a later chapter. However, unlike the Florentine room, it was intended for the display of large sculptures. The seven bronze gods, known as the 'planets', which had been captured by the Cardinal-Infante Don Fernando in the Low Countries, were to be seen here, as were bronze copies of antique busts and of the *Spinario*, probably cast in Spain, and the full-size copies of three antique statues, now in the royal palace, the *Germanicus* (Fig. 17), the standing Discobolus, and the Giustiniani resting Faun, ordered by Velázquez from the Roman bronze-founders Cesare Sebastiani and Giovanni Pietro del Duca. In a smaller neighbouring room there were the full-size copies, now in the Prado, of the *Hermaphrodite* and the *Nymph with a Shell* modelled by Finelli (the former, certainly, and the latter, probably, cast by Bonarelli) together with a small bronze copy of the *Farnese Bull*.[19] The *Nymph* is a freer copy than the other Italian bronzes, but most have some additions, often made in the interests of modesty, and the lively finish given to all of them, and the gilding of parts, such as the tassels of the *Hermaphrodite*'s mattress, or the discus, put them into quite a different class from the relatively dull and mechanical reproductions made for Charles I.

The plaster casts which greatly outnumbered the bronze copies at the Alcazar

18. W. van Haecht: The Picture Gallery of Cornelis van der Geest (Rubens House, Antwerp).

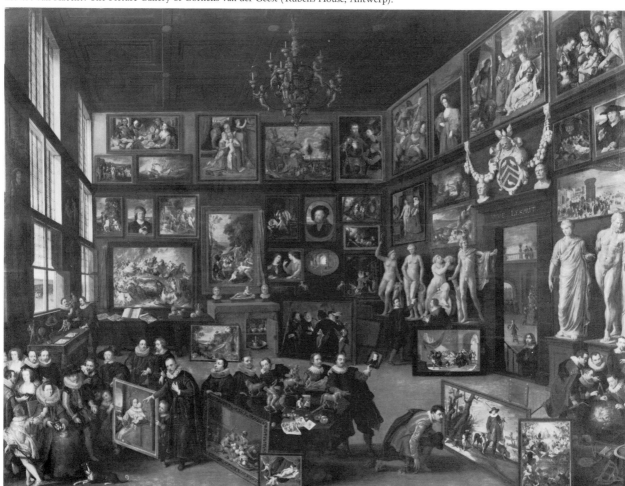

seem probably to have perished in the fire which destroyed the palace in 1734, but we know that in 1686 the Galeria del Cierzo contained casts of the *Cleopatra*, the *Wrestlers*, the *Dying Gladiator*, the Farnese *Flora* and *Hercules*, and that the Bovedas del Tiziano contained casts of the *Laocoon* and the *Nile*. From Palomino's biography we can be fairly sure that Velázquez had casts made of at least nine other antique statues.[20] Reviewing the entire list the choice contains no real surprises save the distinction given to the standing Discobolus and the resting Faun, both of which were significantly in collections (the Villa Montalto and the Palazzo Giustiniani) of pro-Spanish families.

The casts and copies which we have been describing were made for kings. And when we consider the difficulty and expense of exporting moulds of whole figures, let alone the diplomacy often involved in having them made in the first place—to say nothing of the cost of bronze casting—we should not be surprised that private collectors, even those who could acquire great numbers of genuine antique marbles, do not seem to have competed with royalty in this particular field. The fourth Earl of Pembroke seems to have been permitted, as a special favour, to have Le Sueur cast a duplicate of Charles I's bronze copy of the Borghese *Gladiator*—and this was placed in the 'great ovall', as the focal point of the formal gardens at Wilton. As 'the most famous statue of all that Antiquity hath left' it was given a separate plate in Isaac de Caus's prints of the garden,[21] and there were other isolated full-size copies in bronze and marble of this sort, but not, it seems, whole sets of copies or even of plaster casts in private ownership—at least in England, France and Spain.

Small bronze copies of antique statues are almost as common as parrots and piles of coins and sea-shells in the numerous Flemish paintings of *cabinets d'amateurs*; and, more surprisingly, in such pictures we sometimes glimpse distant galleries of casts.[22] In the painting signed in 1628 by Willem van Haecht (Rubens House, Antwerp), which purports to portray the gallery of Cornelis van der Geest in Antwerp when the Archduke Albert visited it in 1615,[23] six large plaster casts or possibly marble copies—among them the *Apollo Belvedere*, the *Farnese Hercules* (reduced to life-size), and the Capitoline Urania[24]—are to be seen in the foreground (Fig. 18). The picture may not be an entirely reliable record of the contents of van der Geest's collection, but it shows that such replicas were considered plausible possessions for a wealthy art lover in the Spanish Netherlands. And later in the century in the United Provinces, Prince Frederick Hendrick seems to have kept copies of antique statues at The Hague and in his palaces of Ryswick and Honselaarsdijk.[25]

Full-scale bronze copies would have been impossible in an artist's collection, and large-size plaster casts unlikely—we would rather expect casts of heads or hands or limbs, such as appear in pictures by Michael Sweerts (in the Rijksmuseum and at Detroit—Fig. 19) during the 1650s showing artists at work in their studios, and such as we know that Nicholas Stone the Younger made in Rome and sent back to England in the late 1630s. Stone's account books also mention, among much that is unidentifiable, 'the Laocont' and 'the Wrastlers', but there is evidence to suggest that these were not casts (although he did have some made) but terracotta models, and therefore likely to have been relatively small.[26] The 'one antique Laocoon' recorded in 1656 in the inventory of Rembrandt's collection might well have been a model of this sort, or, if a cast, then possibly of the head of *Laocoon* rather than of

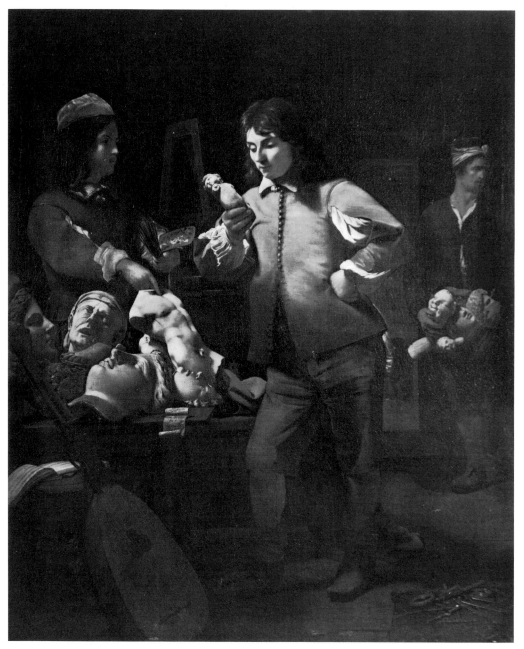

19. Michael Sweerts: In the Studio (Detroit Institute of Arts).

the whole group.[27] Of course some artists had access to the royal collections of casts and copies, but these were not formed with the artist's education in mind: Anton Rafael Mengs would deplore the fact that those assembled by Philip IV had been 'buried' in his palace in Madrid.[28] The collection of casts and copies made in the last quarter of the seventeenth century by Louis XIV was, however, not only much larger than those discussed so far, but was also novel in that didactic intentions did play a part in its formation, and for both these reasons it merits separate attention.

VI

'Tout ce qu'il y a de beau en Italie'

LOUIS XIV's ASSUMPTION of power in 1661 and his decision to convert his father's hunting lodge at Versailles into a palace led to the most spectacular attempt yet made anywhere to acquire the originals or copies of the most famous antique sculptures in Rome. We have already seen that in itself the idea was not a new one. François Ier and Louis XIII of France, Charles I of England and Philip IV of Spain had all sought to own such sculptures; moreover, for nearly half a century every French minister rich or powerful enough to do so—Richelieu, Mazarin, Foucquet—had lavishly decorated town and especially country houses with such genuine antiquities as could be extracted from Italy as well as with replicas of works which were universally acknowledged to possess special excellence or significance.[1] But these collections had, for the most part, been essentially private. Louis XIV's ambitions were of quite a different order. Just as, under his auspices, the architect Antoine Desgodetz was to go to Rome and there make the most careful measured drawings of those ancient buildings which could obviously not be removed (drawings which were engraved on Colbert's instructions)[2], so too Colbert's order that 'nous devons faire en sorte d'avoir en France tout ce qu'il y a de beau en Italie'[3] was a declaration of public policy as much as a concession to royal taste.

During his visit to Paris in 1665 Bernini repeatedly stressed how essential it was for young art students to copy from casts taken from 'all the most beautiful statues, bas-reliefs and busts of antiquity' before learning to draw from nature.[4] He also made it clear enough that he was not very impressed by the number of original antique sculptures to be found in France;[5] as a boy he himself had, when faced with problems, been able to 'consult the Antinous as an oracle'. No one referred to the bronze casts at Fontainebleau, which seem to have been quite forgotten by now, but Chantelou reminded the King of his own expedition to bring back casts from Rome more than twenty years earlier and suggested that these might still be found somewhere; he also pointed out that there was in Paris a plaster of the *Farnese Hercules*, and Colbert said that he had already ordered that this should be handed over to the Academy.[6] However, it was clearly felt that such makeshift remedies were not nearly adequate, and a few months later, early in 1666, the King decreed that a new art academy was to be established in Rome. This would extend to French artists the advantages which (as Bernini enjoyed rubbing in) had long been available to the Italians. In fact, however, from the point of view of the royal administration, the main attraction of the new scheme was that the pupils sent to Rome to study

sculpture could make marble reproductions (or plaster casts for the guidance of others) of the principal antique statues in the city in order to adorn the extensive grounds of the palace of Versailles.

The director, meanwhile, could also prove useful in helping to procure some of the most admired originals. There had long been a possibility that the *Meleager* might find its way to France; at one time it looked as if the *Farnese Bull* itself might be transported there; and no one kept a keener eye on the wavering fortunes and hesitations of the Ludovisi than members of the French Academy in Rome.[7] Louis's wealth and rapacity were legendary throughout Italy—'for as soon as any Picture or Statue of great value is offered to be sold, those that are imploied by the King of France, do presently buy it up'[8]—and he showed few scruples about the methods he was ready to use. But it was not until 1685 that he was able to lay his hands on two major works. No ancient statues as famous as the *Germanicus* (Fig. 114) and *Cincinnatus* (Fig. 95) had left Italy before this date, and as their removal came only a few years after the dismantling of the Villa Medici (to be discussed in Chapter VIII) it required all Louis XIV's combination of bullying and diplomacy to force the reluctant Pope to authorise their export.[9] Such was the ill feeling aroused that even the taking of moulds by French students was strongly resented for a time.[10] Ironically it was this very practice which helped to keep alive in Rome the fame of the exiled statues. When, seventy years after they had been installed at Versailles, a Venetian nobleman was collecting copies of the most celebrated sculptures of antiquity he was forced to seek permission (which was granted) to have a mould of the *Germanicus* made from the cast which had been retained in the French Academy in Rome.[11]

Originals such as the *Germanicus* and the *Cincinnatus* were kept in the state apartments of the palace itself, and to them were added some of the other classical marbles which were already in France (the much-travelled *Diane Chasseresse*, for instance, and the Venus d'Arles which was brought from that town and restored by Girardon) or which were acquired with some difficulty in Italy.[12] But attention was concentrated chiefly on the provision of copies for the grounds.

Wars and economic crises frequently interrupted the campaign of copying, and even marble figures were often held for years in packing cases before being sent to France. At the same time dozens of plaster casts began to accumulate—haphazardly and, at first, quite inaccessibly—in the temporary residences that were rented for the Academy in Rome.[13] By 1684 there were well over a hundred, and they included nearly all the most famous works known by that time which are included in our catalogue.[14]. Some years later, after a drastic reorganisation had been carried out, the very magnitude of the achievement appeared to render superfluous the ostensible aim of the Academy itself. Writing in 1707, at a moment when the delay in receiving his salary was becoming more than usually intolerable, one director suggested that the Academy should be closed down since the casts of antique sculptures that had already reached France were quite sufficient in number to satisfy the needs of artists there. 'The proof', he added, 'is that since I have been in Rome I have seen neither Italians nor any foreigners copying the actual marbles. They prefer to draw or model after the casts, which is more easily done.'[15] The Academy survived, however, and during the eighteenth century, after it had been installed in splendid new premises,

its collection of copies became an important attraction for visitors to the city.

The need for decorative statuary at Versailles meant that imitation—even of the most famous models—was not enough in itself: the work produced by students at the Academy must, if possible, be 'more perfect than the antique'.[16] Propositions of this kind gave rise to much theoretical debate in the eighteenth century, but at this time little more was implied than that the original must be adapted to make it fit its new site. The King did not like 'draped figures'[17]—though early in the eighteenth century Barois's copy (Fig. 20) of the *Callipygian Venus* (Fig. 168) seems to have been covered in such a way as to render meaningless her very raison d'être.[18] Above all, the sculpture he wanted had to be free standing so that particular attention had to be paid to the back which was often considered to be too unfinished.[19] The King's Surintendant des Bâtiments insisted personally on certain pieces (such as sets of the *Borghese* and *Medici Vases*),[20] and on his second visit to Rome in 1668 the sculptor François Girardon was told to give advice on what should be moulded.[21] On the whole, however, the choice of antiquities to be copied was left to the director of the Academy,[22] who had to take account both of the difficulties of getting permission from certain owners and also of the ever-present fear that a new pope would refuse to allow casts to be taken of the principal antiquities in the Vatican.[23]

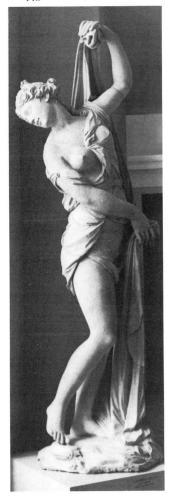

20. François Barois: Marble copy of *Callipygian Venus* (Louvre).

21. Gérard Audran: Measured engraving of *Callipygian Venus* (from Audran's *Proportions*).

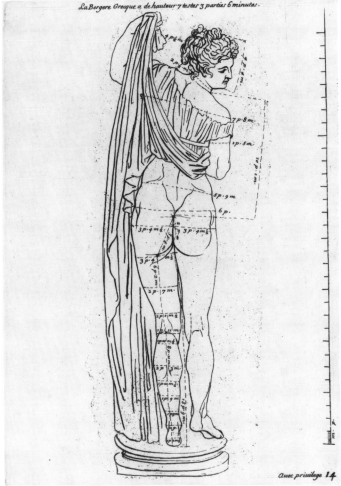

Where there was uncertainty in Paris over some proposal, reference could always be made to the illustrations in Perrier, though it was acknowledged that these were sometimes unreliable and additional drawings might have to be sent for approval.[24] Frequently it was the pupils of the Academy who themselves asked to copy some particular work: Pierre Legros, for instance, initiated a controversy about the nature of copying that was still reverberating over a century later by producing a version of a statue, then in the Villa Medici and known as Vetturia (the mother of Coriolanus),[25] which was held to be far superior to the original. A legend developed (probably falsely) that he had deliberately chosen a comparatively feeble piece so as to give free rein to his own genius; and it is not surprising that such a notion was later to tempt other restless students.[26]

It can thus be seen that Colbert's campaign to 'have in France everything that is beautiful in Italy' was, however extensive, not entirely methodical in its procedures. Similarly the copies themselves were produced in the most varied ways. Of those that were in Versailles and Marly under Louis XIV, only a small proportion were actually carved in Italy and then shipped to France. Many more were made either in Versailles or Paris from casts provided by pupils at the Rome Academy which had been sent to the King's Magasin des Antiques in the Palais Royal. Frequently these copies were made by sculptors who had actually been to Rome and had therefore known the originals. Thus Clérion, who between 1666 and 1673 copied the *Venus de' Medici* in Rome, found himself in 1684 back in France making a copy of the *Callipygian Venus* from a cast.[27] At other times versions after the antique were made by sculptors who had never seen the originals inasmuch as they had never travelled outside France. The case of Antoine Coysevox is perhaps the most remarkable. With some assistance from his studio he made four copies for Versailles.[28] Of these, the

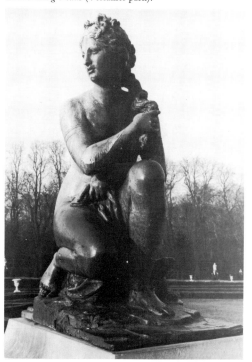

22. Antoine Coysevox: Bronze version (cast by the Kellers) of *Crouching Venus* (Versailles park).

23. R. Charpentier: Detail of Galerie de Girardon—engraving by Chevallier.

Venus de' Medici has disappeared, but the *Castor and Pollux*, and *Crouching Venus* and the *Nymph with a Shell* all survive. The first of these is a very faithful copy of the original except for two changes:[29] the addition of a tree trunk and some foliage in the interests of modesty and the radical transformation of the facial features which may, of course, have been due to the cast on which the artist was forced to rely. On the other hand, both the *Crouching Venus* (Fig. 22) and the *Nymph with a Shell* are so strikingly different from the models (Figs. 148 and 171) on which they were based, in detail, composition and spirit, that it is clear that the artist made deliberate variations to suit his own taste (or that of his patrons). This was far from counting against him. Coysevox, like Legros, won great admiration for his free copies, and the fact that the one artist worked from casts in France and the other from the originals in Rome suggests that no clear distinction can be drawn between the two sets of copyists, just as no clear distinction can be drawn between the copies themselves and the original compositions often produced by the very same artists.[30]

The overwhelming majority of full-size copies after the antique were of marble, but certain special favourites—such as the *Apollo Belvedere*, the *Antinous*, the *Silenus with the Infant Bacchus* and the *Crouching Venus* (copied by Coysevox)[31]—were also cast in bronze at the foundry of the Keller brothers (Fig. 22). War, however, seriously interfered with the completion of further casts—in 1701, for instance, the foundry contained moulds of the *Laocoon*, the *Commodus as Hercules* and the *Faun with Kid*,[32] but from none of these were casts actually made for Versailles, and the *Laocoon* was later acquired in Paris by the elder son of Sir Robert Walpole and taken to Houghton Hall in Norfolk where it still remains.

Bronze continued to be in great demand for the small reductions of ancient statues, both antique and modern (particularly those of Giambologna), which were used in interior decoration. The King owned a large number of these himself, but the most famous collection formed in France during his reign belonged to his principal sculptor, François Girardon.[33] The handsome illustrations of this collection that were published in 1709 (six years before his death) show the small-scale realisation of a typically seventeenth-century 'musée imaginaire' (bearing no relation to the actual arrangement of his bronzes) in which the most famous masterpieces of classical antiquity were grouped according to size and symmetry with, for instance, the *Arrotino* and the *Spinario* facing each other across the *Marsyas* (Fig. 23); and where necessary to the overall design two examples of the same group (the *Wrestlers*) would be engraved, one of them in reverse.

Well before this the King had been anxious to give publicity to his success in transferring the most potent images of ancient Rome to his new palace at Versailles. As early as 1669 Claude Mellan (who nearly forty years before had helped to record the sculptures belonging to Vincenzo Giustiniani) was working on the plates of a volume, published ten years later under royal auspices, designed to illustrate the busts and statues which were then kept at the Tuileries.[34] But although the resulting book was very splendid, only one figure—the *Diane Chasseresse*—was of much more than local interest. In 1694, however, this situation was reversed when Simon Thomassin, one of the more feeble artists to be enrolled into the French Academy in Rome, published a small but bulky book of engravings from drawings he had made five years earlier of the 'figures, groups, terms, fountains and other ornaments at

Versailles'.[35] The two hundred and fourteen plates included a number of the works already engraved by Mellan, as well as such important accessions since his day as the *Germanicus* and the *Cincinnatus*, and also the fine new garden sculptures by Girardon and others. And there were twenty-eight copies after the antique—enough (despite some curious gaps) to demonstrate to the world that Versailles could now boast full-size marble copies of many of the most famous masterpieces to be found in Rome, in both public and private collections. More copies were later to be installed at Versailles and Marly.

From the first the provision of copies had been intended to be educational as well as decorative, but this aspect of the royal programme was somewhat lost sight of in the general cult of grandeur. Most of the plaster casts sent from Rome were kept in the royal collection with relatively few finding their way to the Académie Royale de Peinture et de Sculpture. The thirty or so which the Académie owned in 1715[36] constituted only a small fraction of those kept in its sister academy in Rome, and this shortage presented something of a problem for those artists who were required to lecture on the beauties of antique sculpture. Paintings could be discussed in front of the originals in the royal apartments, but no such arrangements could be made for the garden sculptures. However, we know that when the Académie did not own some cast, Colbert (who himself often attended the lectures) was prepared to lend—or even donate—an example from the royal collections.[37] Even this was not always adequate. Thus in 1667 the sculptor Gérard van Opstal was able to have transported to the Académie 'only the figure of Laocoon, made of plaster, about eighteen inches high, and without his sons', though fortunately he found that he and some members of his audience had enough to say about the expression and musculature of Laocoon without having to worry about the group being incomplete.[38] Three years later, Sebastien Bourdon, when discussing the *Commodus as Hercules*, the *Farnese Hercules*, the *Dying Gladiator* and one of the river gods in the Belvedere, appears to have provided for the students marked drawings instead of relying on such casts as might have been available to him.[39]

Perhaps it was Bourdon's example (which proved extremely popular) that inspired the most systematic attempt yet made to extract all the lessons to be derived from a close study of ancient sculpture. In 1683 the engraver Gérard Audran published *Les Proportions du corps humain mesurées sur les plus belles figures de l'antiquité*. From his elaborate and somewhat pedantic plates (for which there had been some less thorough precedents) the budding young sculptor anxious to avoid the risks of falling into a 'mannered style' could learn the exact distance between the hip and kneecap of the *Antinous* or the buttocks and ankle of the *Callipygian Venus* (Fig. 21); just as from Desgodetz's *Les Édifices de Rome*, published one year earlier, the young architect could find out the precise size of the capitals on the columns supporting the portico of the Pantheon or the width of the entablature of the Arch of Constantine. Many more copies were to arrive, many more illustrations were to be published, but already by 1682 the *Mercure Galant* could proclaim, in words which appear to echo those of Colbert quoted earlier in this chapter, 'on peut dire que l'Italie est en France et que Paris est une nouvelle Rome'.[40]

VII

Erudite Interests

WHILE LOUIS XIV was securing for France 'tout ce qu'il y a de beau en Italie', and the gardens of Versailles and Marly were being filled with copies of the most beautiful statues, it occurred to Bernard de Montfaucon, a young French scholar from the learned Benedictine congregation of Saint Maur, to gather all available images of antique art together in one single work, *L'Antiquité expliquée*. After over a decade of preparation five folio volumes (each one of two parts) of this book were published in Paris in 1719. Another five volumes of Supplément were added in 1724. Before the Suppléments Montfaucon estimated that he had collected thirty or forty thousand images. It was the largest corpus of reproductions of ancient art ever assembled and would serve for over a century as an indispensable reference book for all serious students of the antique.

Montfaucon's folios were ranked by his contemporaries with the thesauruses of Graevius and Gronovius (both of German origin working in Holland) which began appearing in the mid-1690s, but his enterprise had much more in common with an unprinted work, the 'Museum Chartaceum', or paper museum, which Cardinal Barberini's librarian Cassiano dal Pozzo had assembled during the second quarter of the seventeenth century:[1] a collection of drawings after the antique, arranged thematically, which passed, in Montfaucon's youth, to the Albani family who eventually sold most of them, in 1762, to George III.[2] Montfaucon's comprehensive ambitions also recall the work of the sixteenth-century painter, architect and antiquarian Pirro Ligorio who had, by 1553, compiled an illustrated anthology of antiquities in forty volumes intended for publication.[3]

Ligorio was his own draughtsman; Cassiano dal Pozzo, also resident in Rome, set half a dozen artists to draw after the antique; but Montfaucon employed engravers who copied from plates in Boissard, Perrier, Spon, Bartoli and de Rossi, from drawings in Lebrun's Roman sketchbook, and from those sent to Saint Maur by antiquarians all over Europe. As a result *L'Antiquité expliquée* gives no sense of scale, reproduces modern works and forgeries, and includes as originals statues at Versailles even when they were copied from originals of which plates had earlier been included (Fig. 24).[4] On one occasion, confronted by two slightly different plates of the *Minerva Giustiniani*, Montfaucon confessed that he was at a loss to know whether these were two similar statues or one statue, inaccurately drawn by one, or another, or both, artists.[5] When in Italy between 1698 and 1701 Montfaucon's visual curiosity had never matched his literary researches, and his *Diarium Italicum* shows

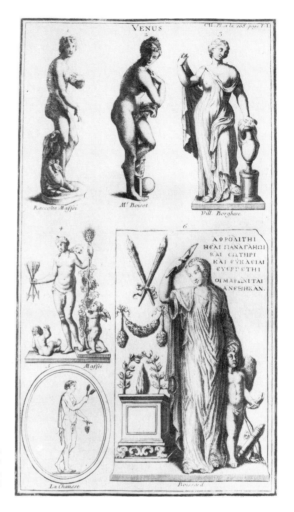

24. Illustrations of Venus published by Montfaucon (from Montfaucon's *L'Antiquité*, Vol. I, part 1). The antique Venuses, taken from life-size marble statues, small marble reliefs, and a gem, are shown with a modern bronze statuette (centre top).

him to have been sceptical as to the adequacy of every library catalogue, but confident that other scholars had reliably recorded the contents of sculpture galleries.

Montfaucon's *L'Antiquité expliquée* was in time replaced as a collection of reproductions of statues—but of statues only—by the more reliable work of another Frenchman, the Comte de Clarac, the last part of whose *Musée de sculptures* appeared in 1853, thirty-three years after he had begun to work on it and six years after his death. And this eventually served as the first volume of Salomon Reinach's *Repertoire de la statuaire grecque et romaine* of 1897,[6] which is still in regular use. But Montfaucon was not concerned only with establishing a corpus: like Cassiano dal Pozzo and Ligorio before him, he intended his illustrations to provide a basis for a history not only of ancient art, but of the religious, political, military and social life of the ancients.

Monfaucon's interpretations of ancient art are always sensible and modest. He even, and quite often, says that he does not know what something represents, or suggests that it has no meaning.[7] He intended his book to be free from the pedantry and whimsy of so much specialist literature dealing with problems such as the secrets of the hieroglyphs,[8] the existence of spectacles in antiquity,[9] or the noise made by the sistrum,[10] but he resembled other antiquarians and, perhaps, most highly

educated men of the fifteenth, sixteenth, seventeenth and eighteenth centuries in studying antique sculpture more for the light that it shed on history or literature than for its artistic merit. The amount of writing describing the beauties, discriminating the styles and assessing the artistic value of classical sculpture is negligible compared to the number of books devoted to topography, epigraphy and iconography for which taste was irrelevant. It is worth remembering that the 'founders of critical archaeology' in mid-sixteenth-century Rome—among them Pirro Ligorio—belonged to the circle of Don Antonio Agustin, a very erudite scholar but a man who doubted whether it was worth excavating nude figures because they yielded 'no new information' and who scorned the Villa of Pope Julius—that is, the Belvedere—with its 'Venuses and other salacious figures'.[11]

Nonetheless, even the early antiquarians continued to attract attention from the more sophisticated connoisseurs of later times—and not just (as is the case today) because they could provide information about works which were subsequently destroyed. Thus Ligorio's researches into Hadrian's Villa were copied out and published in the seventeenth and eighteenth centuries,[12] and the Comte de Caylus had the highest regard for 'the famous' Cyriac of Ancona, whom he took to be a contemporary of his own,[13] but who had in fact died three hundred years earlier.

It was Caylus who, in 1715, implied a distinction between those statues which were only beautiful in form and those which in addition commanded the attention of the learned, such as a Cupid in the Uffizi whose style of quiver explained a tricky passage in Homer.[14] Throughout the travel literature of the seventeenth and eighteenth centuries it is striking how stale and repetitive, if usually sincere, are the 'undistinguishing general encomiums' on the former, and how lively are the passages on the latter class of statue. The visual appetite and discrimination of the Richardsons are quite exceptional, and very few other authors looked as consistently at ancient art with artistic value as their prime concern. What detained Misson longest on the Capitol was the 'Milliarium'; and for Addison the 'Arringatore' in Florence was of interest because it reminded him of a line in Juvenal.[15]

Statues such as the *Spinario*, the *Paetus and Arria*, the *Dying Seneca*, the *Commodus as Hercules*, the *Papirius*, and the *Arrotino*, which were famous for their beauty and which were also of interest to the learned were all commonly interpreted as illustrating episodes in Roman history. Caesar was supposed to have been assassinated at the feet of the *Pompey* in the Palazzo Spada, and visitors to the Capitol were shown the scorched leg of the *Wolf* which Cicero recorded as having been struck by lightning at the time of the Conspiracy of Catiline.

In the second half of the eighteenth century a traveller could write that 'Rome is the first world which we have known, and a world which History, Eloquence, Poetry and all the most seductive arts vied with each other to embellish. It is a world in which the only foreigners are those who are foreigners also to letters and all useful and agreeable knowledge',[16] and he quoted the famous lines from Montaigne's *Essays* written nearly two hundred years earlier: 'I was familiar with the affairs of Rome long before I was with those of my own house. I knew the Capitol and its position before I knew the Louvre, and the Tiber before the Seine. I have meditated more on the conditions and fortunes of Lucullus, Metellus and Scipio than I have about many of our own men.'[17]

To visitors who came to the city in this frame of mind—and who did not?—the evidence of their eyes and even of common sense counted as little compared to what they expected to see and feel. Anyone looking closely at the black marble figure in the Villa Borghese or even reading standard guidebooks to the collection[18] could have observed that the bath which made of him a *Seneca* was a modern addition, and not very much expertise was required to note that the *Papirius*, supposed to be withholding from his mother the secrets of the Roman Senate, was nude in the Greek manner. But although this was pointed out by learned authors, even they never asked themselves who would have commissioned a statue of a slave overhearing a conspiracy or of the Empress Faustina conducting an illicit affair with a gladiator—the supposed subjects of two much-admired statues. Topical narrative of this type was never found in contemporary sculpture, and it is therefore very surprising that it should have been supposed common in antiquity.

As suggested by Montaigne, it was on the Capitol that historical associations were most overwhelming. No one was in any doubt that the 'trophies of Marius', displayed on the balustrade there, were illustrations of a major episode in Roman history even though there was considerable uncertainty as to whether they belonged to Trajan, or Octavian, or Domitian.[19] Antiquarians were seldom concerned to challenge the status of relics but only to change their labels. Thus the head, hand, arm, knee, calf and feet of a colossal marble statue of Constantine and the bronze head of his successor, all of them also on the Capitol,[20] were considered by different experts to be fragments of statues of Apollo, Augustus, Nero, Commodus or Domitian. Their size, of course, was considered as proof of their importance as well as being responsible for the awe that they inspired—the great toe being, as Burney noted, 'as big as the body of the Abbé Grant, who is rather corpulent'.[21] Popular superstitions also clung to these fragments. They still cling today to the 'Bocca della Verità, and the glamour of this relic was further promoted by some antiquarians who maintained that it came from the sacrificial altar of the Temple of Jupiter or that it was a personification of Pallore or Terrore. But it was never among the antiquities most admired as works of art, and most writers from the late seventeenth century onwards recognised it as nothing more than a drain or 'gutter spout'.[22]

For men who had read so much about Roman warfare the reliefs on the two great storiated columns had a documentary value impossible to imagine today. Some of the reliefs on Trajan's Column, which was the more admired of the two, were reproduced in early sixteenth-century engravings of the school of Marcantonio Raimondi and in a learned French treatise of the same period.[23] It was first drawn in its entirety by Jacopo Ripanda (a pupil of Marcantonio), who was suspended in a basket for the purpose, and over one hundred and thirty plates of the entire frieze by Girolamo Muziano (Hieronymus Mutianus) were made to illustrate Alonso Chacon's learned commentary on the Dacian Wars of 1579.[24] But the seventeenth-century Roman publisher Giovanni Giacomo de Rossi, recognising the inadequacy of these prints, had the column etched by Pietro Santi Bartoli and reprinted Chacon's text with addenda by Bellori;[25] after luncheon on 3 June 1665 Pope Alexander VII eagerly went through each of Bartoli's hundred and fourteen plates, 'folio a folio fino al fine'.[26] The book was still being reprinted in the early nineteenth century after Piranesi had attempted to replace it with his set of prints.[27] It was

possible for de Rossi to have the reliefs properly drawn because Louis XIV (to whom his book was dedicated) had erected scaffolding in order to cast not just some of the reliefs (as had been done for both François Ier and Louis XIII) but the whole frieze—casts which Piranesi later acquired and which perhaps helped him to make his prints.[28]

The reliefs were admired first and foremost because, as La Teulière wrote in 1694 regretting that the moulds had only just come out of storage, they were so informative about 'the customs and manners of the ancients in all that related to civilian and military life, matters neglected and ignored by most painters, as is clear enough from their works'.[29] But this neglect was not always regretted. Charles Perrault ridiculed Bernini for overestimating the merit of the column and noted with satisfaction that although nearly all sculptors owned plaster casts 'which are just as good as the originals' of the reliefs at the base, yet not a single painter or sculptor had bothered to copy the remainder 'although the moulds were taken for this purpose only'.[30]

However, the idea and proportions of the column were almost universally admired. Indeed of all antique buildings Trajan's Column was the one most copied in reduced versions, especially in the late eighteenth century. The most celebrated example is the replica (two metres tall) with silver gilt figures on a lapis lazuli ground, begun in 1774 and signed in 1780 by Luigi Valadier and purchased three years later by Elector Karl Theodor of Bavaria, which is in the Schatzkammer of the Residenz in Munich (Fig. 26).[31] Cavaceppi, in the same period, began to carve a reduced marble copy which was acquired by Henry Blundell together with Cavaceppi's model, a wooden column painted in grisaille,[32] and later the column was reproduced on a smaller scale in dark bronze, with details gilt, as a neoclassical mantel ornament (there are two examples in the Sala d'Ercole of the Palazzo Pitti in Florence). In 1810 came the greatest tribute of all: the full-scale imitation, erected on the foundations of the destroyed statue of Louis XIV, in the Place Vendôme, to commemorate the victories not of Trajan's legions, but of the Grande Armée.[33]

Of very much less interest to most visitors to Rome were the abundant sarcophagi. The sides of many of these had been sawn off and incorporated into the walls of Roman palace courtyards. Others were left whole and used either as basins for fountains or as pedestals for statues. But though some were of great fascination to artists and antiquarians, we will not find them copied or cast for the gallery or garden, nor adapted to serve as a frieze for a chimney-piece, nor commonly included in *capricci* painted for the eighteenth-century tourist market, nor described at length by many of the less learned travellers. Even the best-known sarcophagus reliefs such as the Meleager sarcophagus in the Villa Borghese or the supposed sarcophagus of Alexander Severus and Julia Mammea in the Capitoline collection, were probably less admired on artistic grounds and also less imitated in actual tombs than the fluted sarcophagus of Cecilia Metella which was to be seen from the late sixteenth century onwards in the court of the Palazzo Farnese.[34] But the two best-known sarcophagi were those of Marcus Agrippa (in fact a basin from the Baths[35]) and of St. Costanza. Both were admired not only for their artistic merit (which was invariably found in the former and often in the latter), but for the porphyry out of which they were made, and for the great names with which they were associated.

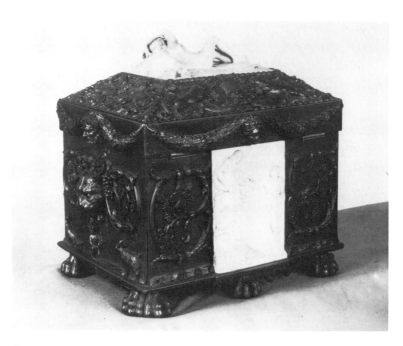

25. Mahogany chest modelled on the 'Tomb of Bacchus' (Society of Dilettanti, London).

The sarcophagus of Marcus Agrippa was found, when the Piazza della Rotonda was paved under Eugenius IV (1431–8), together with the fragments of a bronze quadriga and the Egyptian granite lions later taken by Sixtus V to the Acqua Felice. At least one Renaissance scholar recognised that the 'sarcophagus' was—as Winckelmann was to point out—a basin from the Baths, but others thought that all the objects had been ornaments of the pediment and attic of the Pantheon[36] (which Agrippa was recorded as having built). The sarcophagus stood at first in the Piazza with a lion on either side of it,[37] but it was moved into the portico in the second half of the seventeenth century and was taken to S. Giovanni in Laterano in the 1730s when it was incorporated into the tomb of Pope Clement XII in the Corsini Chapel. It was imitated in numerous marble sarcophagi from the fifteenth-century tomb of the Cardinal of Portugal in the church of S. Miniato in Florence[38] onwards, and also in minature—by Benvenuto Cellini as the basis for a silver salt cellar which he made when he first came to Rome,[39] and much later as a neoclassical mantel ornament, often fashioned out of antique marble (for which purpose the tomb of L. Cornelius Scipio Barbatus, found in 1780, was also very popular).

The gigantic sarcophagus of St. Costanza originally stood in the centre of her mausoleum, but was moved into one of the niches to serve as an altar when it was declared a shrine in 1255. In the Renaissance, however, the church was believed to have originated as a temple to Bacchus, and the sarcophagus was generally known as the Sepolcro di Bacco on account of its vine ornament. It was much admired, and Pope Paul III was said to have wanted it for his own tomb.[40] During the mid-seventeenth century the convivial society of Northern artists in Rome—the bentveughels—made special pilgrimages to the tomb to perform 'baptismal' ceremonies dedicated to Bacchus, and left their names in graffiti on the walls of the church,[41] and in 1737 the English Society of Dilettanti commissioned a copy of the sarcophagus in mahogany as a chest for their 'books, papers and money' (Fig. 25).[42]

By then the technical achievement of its carving in porphyry was still marvelled at, but the style was often considered poor. The work's late antique and Christian status was acknowledged when Pope Pius VI had it moved to the Vatican as a companion for the even larger porphyry sarcophagus believed to be of St. Helena, grandmother of Costanza,[43] which had stood in the cloisters of S. Giovanni in Laterano since its discovery in the seventeenth century.[44]

No one with any knowledge of the old travel literature on Rome can have failed to notice the impact made by the granite monoliths of the Pantheon and colossal basins of Piazza Farnese, by the porphyry sarcophagi we have just discussed, and by the coloured marbles, jaspers, onyxes and alabasters with which the city abounded. And the celebrity of even some of the most admired antique statues—the *Faun in Rosso Antico* (Fig. III), the *Furietti Centaurs* (Figs. 91 and 92)—was certainly enhanced by the rarity and splendour of the material out of which they were cut; but there were other statues such as the Augustus in the Odescalchi collection 'transparent as amber',[45] the porphyry bust of Caligula on a pillar of Oriental agate in the Chigi collection,[46] or the Diana of Oriental alabaster in the Villa Borghese,[47] which were chiefly admired as stones rather than as carvings.

One antique object which owed much of its fame to the material out of which it was made was the better preserved of the two thrones of rosso antico in S. Giovanni in Laterano, later removed by Pius VI to the Vatican and by Napoleon to the Louvre, where it remains today—but this owed even more to the legends and controversies which surrounded it. It had been used for papal coronations in the Middle Ages, and during the late sixteenth and throughout the seventeenth century the story was circulated that it had a hole in the seat so that a deacon could feel for the 'surest marks of virility' in the seated pontiff and so prevent the scandal of a second Pope Joan. Protestants persisted in calling it the 'groping chair' even after learned Catholics, such as Montfaucon, had tried to explain that it was a Roman 'bathing chair'.[48]

It becomes most difficult to determine whether a work of art was valued more as a carving or as a stone when we turn our attention to cameos and gems. Some of these were very celebrated, as indeed their names reveal: the Tazza Farnese (a double-sided cameo acquired by Paul III and formerly in the treasury of Lorenzo de' Medici);[49] the Grand Camée de France or Gemma Tiberiana (a gigantic oval cameo carved with an apotheosis of a Roman emperor discovered by Peiresc in 1620 in the treasury of the Sainte Chapelle);[50] the Marlborough Gem (a sardonyx of the marriage of Cupid and Psyche which had belonged to Lord Arundel and for which Louis XIV was said to have offered four thousand pounds—Fig. 27);[51] the Strozzi Medusa (a clouded chalcedony with a highly dubious Greek signature found early in the eighteenth century and acquired by Count Strozzi after it had passed through the hands of Cardinal Albani);[52] the Barberini or Portland Vase (a carved glass vessel believed to have contained the ashes of Alexander Severus and also believed to be of precious stone, acquired from the Barberini by James Byres and sold to Sir William Hamilton who in turn sold it in 1784 to the Dowager Duchess of Portland).[53] In these cases there can be no doubt that art was esteemed as well as nature. They were reproduced in the numerous books of prints after gems and also as paste impressions. Byres and Tassie issued a limited edition of plaster replicas of the Barberini Vase,

which Wedgwood later copied, as he also did the immensely popular Marlborough Gem.[54] There would have been little point in these reproductions if only the material was admired, but it is hard all the same to consider this class of object as equivalent to the most admired antique statues. They belonged in the Middle Ages to the ecclesiastical treasuries together with Christian relics. By the seventeenth century those who marvelled at the Grand Duke of Tuscany's turquoise head of Tiberius saw it in the company of the 'Rhinoceros Horn of an unusual bigness' and a diamond weighing $139\frac{1}{2}$ carats.[55] And the Dowager Duchess of Portland acquired the Vase later named after her family for a natural history museum which, apart from four or five other gems and cameos and some 'curious snuff boxes', consisted of shells, insects, ores, corals, flours, crystals and petrifactions.[56] Interest in these works of art was also greatly stimulated by the iconographical problems that they usually posed.

If the value of a gem as a product of art was hard to separate from its value as natural curiosity, then the aesthetic value of a portrait was no less hard to distinguish from its significance as the likeness of a great man. 'I could not return oft enough to look upon it', wrote Burnet of a bust of Socrates in the Farnese collection, 'and was delighted with this more then with all the wonders of the Bull'.[57] But it is not at all clear to us—and was probably not clear to Burnet—to what extent the bust impressed him on account of its artistic merit. It is very rare to meet with self-analysis of the kind we find much later in Visconti when he concedes that he has perhaps overestimated the beauty of a statue because of his delight in recognising it as a portrait of Phocion.[58] What was true of heroes was also true of gods. There were so few surviving statues of Jove, the first of all the gods, that the best of them, that in the Verospi palace, was given a distinguished place in anthologies of prints and in the Museo Pio-Clementino when it was moved there. One can sense the reluctance with which connoisseurs concurred in the conclusion that it was not up to 'the first class of ancient statues'.[59]

The great collections of busts of emperors in the Uffizi, the Palazzo Farnese, and the Capitoline Museum (coming from the Giustiniani collection via the Albani), were of course esteemed principally as illustrations of ancient history—'a most excellent commentary upon the Roman historians, particularly Suetonius and Dion Cassius', Smollett remarked of the set belonging to the Medici.[60] In the words of Northall, 'to see the emperors, consuls, generals, orators, philosophers, poets, and other great men, whose fame in history engaged our earliest notice, standing as it were in their own persons before us, gives a man a cast of almost 2000 years backwards, and mixes the past ages with the present'.[61] It was commonly considered as an edifying exercise to trace art 'declining step by step with the decadence of the empire', both in marble busts and coin portraits, and almost everyone was sure that the characters of the great men and women of antiquity could be read in such representations.[62] Certain antique busts, however, which were admired for their expression—the stern *Brutus* (Fig. 84), the *Dying Alexander* (Fig. 70), the frowning *Caracalla* (Fig. 89)—would have been admired for this quality even if they had been considered anonymous. And when the names of Brutus, Alexander and Caracalla were added the expression became part of the history of the ancient world, and the busts more celebrated than any others.

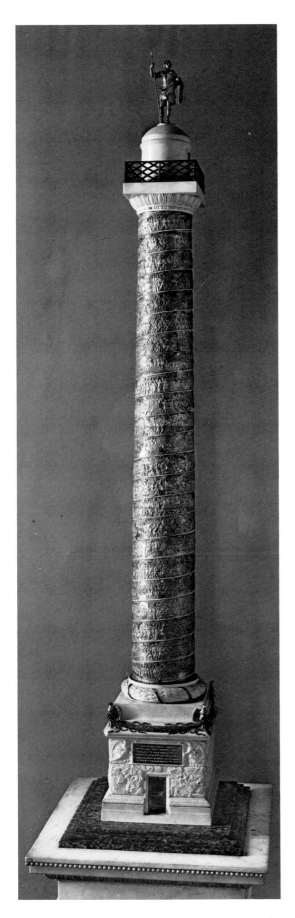

27. T. Netscher: 'The Marlborough Gem'—engraving by Bernard Picart (from Stosch's *Gemmae Antiquae*).

26. (left) Luigi Valadier (with Bartholomäus Hecher and Peter Ramoser): Model of Trajan's Column in marble, granite, lapis lazuli, silver-gilt and gilt bronze (Schatzkammer der Residenz, Munich).

28. A. van Ravensteyn: Portrait of Jacob Cats (The Hague—Dienstvoors' Rijks Verspreide Kunstvoorwerpen, on loan to Catshuis). A bust of 'Seneca' is on the table.

Busts of 'ancient worthies' such as Seneca, Marcus Aurelius, Cicero and Homer which were frequently copied in marble and cast in plaster—especially in the eighteenth century as library ornaments, just as Cicero was known to have acquired busts for his library[63]—were valued more because they represented great men (as did death masks which inspired similar veneration) than because they reproduced works of art. It is in any case often hard to discover the originals of these replicas because the antique portraits of such figures existed in many versions—for instance, about a dozen examples of the type of bust now called the 'pseudo-Seneca' were known in the seventeenth century, and as many have been discovered since.[64]

It was Andrea Fulvio, humanist, poet, archaeologist and adviser to Raphael in his attempted 'reconstruction' of ancient Rome, who, in 1517, was the first man to publish a repertoire of portraits of illustrious figures of antiquity. Most of the more than two hundred heads reproduced in his elegant pages were of Romans and were derived from coins, but he also included some wholly imaginary portraits and he carried his compilation into the age of Charlemagne. Fulvio's book was widely admired, plagiarised and imitated.[65] The importance of his method for the study of ancient sculpture was quickly apparent, and well before the hesitant and cautious Fulvio Orsini published his authoritative selection of herm portraits and coins in 1570[66] it was customary for collectors to 'baptise' their Roman busts on the basis, presumably, of their resemblance to the documented images reproduced in such engravings.

The identification of Seneca (based by Orsini on evidence which no longer survives) was first published in 1598,[67] and thereafter the learned all over Europe looked with awe and devotion at the Stoic philosopher, emaciated, even uncouth, disdainful of the corruption and luxury of Nero's court, and soon to commit suicide (Fig. 28). They continued to do so until 1813, when an inscribed herm portrait of Seneca with quite different features was discovered (Staatliche Museum, Berlin) and even after that date many scholars were reluctant to admit that their devotion had been misplaced.[68] However, once people no longer felt that they were face to face with one of the greatest men of antiquity, it must have been easier to think about the portraits as works of art with intrinsic merits. Perhaps that is why the superlative quality of the bronze version of the bust discovered at Herculaneum in 1754 only came to be widely recognised a century later,[69] despite the prompt and wholehearted acclaim of Winckelmann.[70]

Our intention to distinguish the 'most beautiful statues' from those that were 'curious' on account of historical associations, antiquarian controversy, or the rare material of which they were made or the person whom they were believed to represent is one which would have been understood in the period we are concerned with. But it would also have been considered astonishing to have had a taste for the beauty of ancient art without erudite interests as well. Everyone who was deeply stirred by the beauty of the statues published in de Rossi's anthology and copied in Versailles would have been able to identify the heads of all the Caesars, would have been interested in the shapes of shields and the styles of sandals on the frieze of Trajan's Column, would have enjoyed the exegesis of inscriptions on coins and tombs, and would have welcomed the publication of Montfaucon's *L'Antiquité expliquée*.

VIII

Florence: The Impact of the Tribuna

WE HAVE SEEN that Louis XIV's attempts to acquire some of the great original masterpieces of antique sculpture for Versailles met with only the most qualified success, and that on the whole he had had to content himself with a remarkable series of copies. With considerably less financial and diplomatic resources at their disposal successive rulers of Florence were able to achieve more than he had, and by the beginning of the eighteenth century they managed to make of their city a rival to Rome itself.

The Medici had been enthusiastic collectors of antique sculpture since the second half of the fifteenth century, but—for all the retrospective fame that was to be given to their collections—it is impossible now to form any precise idea as to what were the sculptures actually owned by Cosimo and, later, Lorenzo de' Medici for which such important claims were made in Vasari's *Lives* of Michelangelo and other artists. Although highly thought of locally and although restored by sculptors of the calibre of Donatello and Verrocchio, it is most unlikely that they included any pieces of real consequence, and, while the disappearance of some sculpture during the family's temporary falls from power was certainly regretted, no individual piece was recorded as a major loss.[1]

Although ancient sculptures were constantly being imported from Rome it was not until the second half of the sixteenth century, with the Medici now in undisputed command of Tuscany, that we first hear of acquisitions which become significant in the context of our book. Cosimo I, who assumed control of Florence in 1537, quickly developed into a passionate collector of antiquities—at first of locally found Etruscan pieces, which gratified the nationalist spirit of his new state, and thereafter of sculptures which he succeeded in procuring from Rome. In about 1550 his standing was recognised by a remarkable gift. As has already been mentioned, Pope Julius III presented him with a figure (admittedly much battered and much restored) of *Mercury* (Fig. 138) which stood in a covered gallery just behind the statue court of the Belvedere. Some years later, after Cosimo had conquered Siena, he was able during the course of two triumphal visits to Rome to acquire many other sculptures, a few of which were to be numbered among the most admired antiquities in Italy: the *Dying Alexander* (Fig. 70); probably the *Wild Boar* (Fig. 83); the *Hercules and Antaeus* (Fig. 119—a subject of special significance to Florence and the Medici)[2] which also came from the Belvedere and which he transferred to the courtyard of the Palazzo Pitti, recently bought by his wife; and two of the three fragmented

versions of a group nicknamed *Pasquino*, one of which was much later to be converted into part of a fountain and placed by the Ponte Vecchio where it became very well known under a bewildering variety of names.

But although by the time of his death as Grand Duke of Tuscany in 1574 Cosimo had thus made Florence one of the only cities outside Rome which could boast of owning major antiquities, and although his policy was then enthusiastically followed by his elder son, Grand Duke Francesco I, nonetheless most of the more famous sculptures acquired by the Medici remained in Rome (where they had been found) displayed in their superb villa on the Pincio (Fig. 14).

A few years after succeeding to the Grand Duchy in 1574, Francesco, a secretive and melancholy figure with arcane and elaborately refined tastes,[3] began to convert three galleries above the city offices (Uffizi) to accommodate the sculpture which he, like his younger brother Ferdinando in Rome, was actively collecting.[4] To these galleries he added in 1584 an octagonal room, the Tribuna, which was, a hundred years later, to be of overwhelming significance in enhancing the acclaim given to antique sculpture. In this early stage however, its purpose was so very different that some brief description of it is essential if we are to understand its subsequent importance.[5]

In essence the Tribuna was a rather grander version of the intricate and delicate little room (later called the Studiolo) which Francesco had had built for himself in the Palazzo Vecchio before he became Grand Duke; and he now brought his small bronzes and other treasures from that room to this new and much more luxurious setting. The cupola was encrusted with shells of mother-of-pearl against a background of scarlet lacquer. The great pictures he had inherited were arranged by size and hung on red velvet, the larger ones above and the smaller ones below an ebony ledge out of which opened small drawers crammed with jewels and precious objects. Dozens of little statuettes stood on this ledge which, at six points in its circuit round the room, was interrupted by elegant consoles supporting the bronze sculptures of pagan deities which had been in the Studiolo. Framing these were stepped arches also adorned with little figures and crowned with six Labours of Hercules cast in silver from models by Giambologna. Running around the base of the wall was a skirting board painted by Jacopo Ligozzi with a frieze of birds, fishes, water and plants; while in the centre of the polished polychrome marble floor was a walnut stand on which was placed an extraordinarily elaborate octagonal ebony jewel case, whose proportions echoed those of the room itself, in the form of a temple: the surfaces of its drawers were decorated with golden bas-reliefs by Giambologna, set against semi-precious stones, depicting the achievements of the Grand Duke—to whose glory the whole room was a sophisticated tribute of dazzling richness. Also in the room were a very few antique sculptures, but as even the fulsome and undiscriminating guidebook of Francesco Bocchi could single out only one of these (a sleeping Cupid) for rather perfunctory praise,[6] it is hardly surprising that most of the awe-struck visitors to the Tribuna failed to notice them at all.

The most famous pieces collected by the Medici remained in the family villa in Rome, perhaps because of Cardinal Ferdinando's dislike of his elder brother, perhaps because of the reluctance of the Pope to grant export licences, but more

probably because the Medici understood the prestige that would accrue to them by keeping such a magnificent collection in the cosmopolitan city whose European significance far surpassed that of their own capital. Even when in 1587 Ferdinando, who had devoted such energy and expense to acquiring antiquities, renounced his ecclesiastical career in order to succeed his brother as Grand Duke, he left his sculptures behind him in Rome, though he did have plaster casts of the *Niobe Group* sent to Florence.

During the seventeenth century the Grand Dukes added a number of famous antique statues to those that they had already assembled in Florence, but at first these were mostly acquired outside Rome: the *Idol* (Fig. 123) was sent from Urbino in 1630 as part of the inheritance of Grand Duke Ferdinando II's wife, Vittoria della Rovere, and the *Celestial Venus* (Fig. 170) was bought in Bologna in 1658. Perceptive visitors noted the arrival of these and other admired works, but on the whole even native Florentines seem to have felt that although the collection was expanding rapidly in size it was not being enriched very significantly in quality. Thus, when in 1677 the antiquarian doctor Giovanni Cinelli reprinted with additional notes of his own the guidebook to Florence by Francesco Bocchi which had first been published nearly a century earlier, he commented that the number of antique statues was much greater than it had been and promised to publish separately a full description of them (a promise which he never fulfilled),[7] but neither he nor anyone else could yet realise that the whole nature of the collection of antiquities in the Uffizi was, in that very year, being radically transformed.

As the Papacy declined in power and as the cultural and scientific reputation of Tuscany became well established throughout Europe, with more and more travellers writing enthusiastic, but on the whole generalised, accounts of the collections in the Uffizi, the Grand Dukes showed increasing signs of wishing to bring their trophies directly to Florence rather than leaving them in the Villa Medici: the arrival from Rome of a Cupid and Psyche in 1666,[8] and three years later (in some secrecy) of a statue from the Ludovisi collection which we have already mentioned, the Hermaphrodite[9]—later to be given a special room named after it in the Uffizi—were indicative of this trend. So too was Cosimo III's acquisition for Florence in 1674 of an unfinished Pietà by Michelangelo which had remained in Rome.[10] By then it was already apparent that this policy formed part of a new initiative in Florentine patronage.

In 1673, only three years after succeeding as Grand Duke, the priest-ridden and much derided Cosimo established an art academy in Rome. He was aware that 'little by little the fine arts of sculpture and statuary are declining in Florence',[11] where, since the death of Giambologna early in the century, only a rather repetitive and small-scale provincialism could be matched against the revolutionary achievements of Bernini and his contemporaries in Rome. Following the precedent set a few years earlier by Louis XIV, Cosimo sent a number of promising students to his family's Palazzo Madama to study antiquity, as he himself had done as a boy (Fig. 29), and more recent developments under the guidance of two established artists:[12] the painter Ciro Ferri (who was well known in Florence as the collaborator of Pietro da Cortona in the decoration of the Palazzo Pitti) and the sculptor Ercole Ferrata (an associate, at different times, of both Algardi and Bernini).

ROMÆ IN HORTIS MEDICÆIS. VAS MARMOREVM EXIMIVM

29. Stefano della Bella: Portrait said to be of the young Cosimo III with the *Medici Vase*—etching.

30. (far right) Johan Zoffany: The Tribuna (Her Majesty the Queen). The room as it appeared in 1772 but with many Medici treasures which were never in it added (including the Medici Cupid and Psyche) and some which were there omitted.

In 1676 Giovanni Battista Foggini, the new Academy's first and most brilliant pupil, returned from Rome to Florence, and in the following year three of the most famous antique statues in the Villa Medici were sent to the Uffizi. The occasion could hardly have been more banal. Cosimo's doctors decided that exercise would be good for his health and the Grand Duke thought that such a cure would be more agreeable if his galleries where he walked were adorned with suitable grandeur.[13] The consequences of this caprice were felt throughout Europe, for among the statues chosen for the purpose was one which acquired huge symbolic importance.

At some time in the late sixteenth or early seventeenth century the Medici had acquired a *Venus* and taken it to the family villa on the Pincio. It is astonishing that we should know so little about the circumstances of its discovery, because before very long it was to rival, almost to eclipse, the fame of the *Apollo Belvedere* and the *Laocoon*: it was indeed the last statue to be granted a place in this particularly hallowed sanctuary of the 'musée imaginaire'.

In 1638 François Perrier devoted three illustrations to the *Venus de' Medici*, and six years later Evelyn found that 'certainly nothing in Sculpture ever approached this miracle of art'.[14] Yet it seems not to have been among the replicas which Velázquez obtained for the King of Spain. There were strong doubts about the morality of this *Venus*, and it required the sophistry of much later writers to discover her deep spirituality. We are told that her more obvious attractions caused particular embarrassment during the pontificate of the austere Innocent XI (1676–89) and that it was for this reason that in 1677 he gave permission for her removal to Florence[15]

56

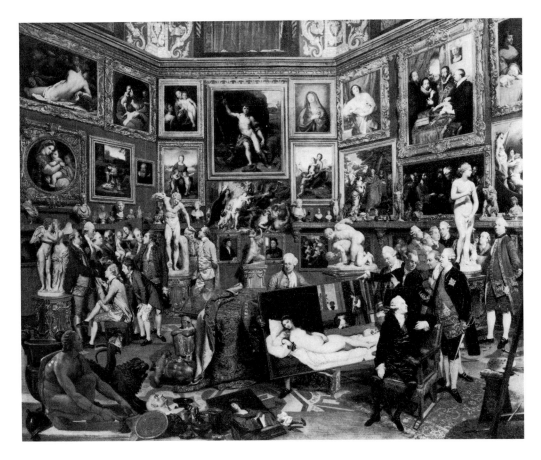

where (the equally bigoted) Cosimo III surprisingly gave her a place of honour in his gallery.

The export of the *Venus* and two of the other most famous statues in the Villa Medici—the *Arrotino* and the *Wrestlers*—caused distress and outrage in Rome (the Queen of Sweden asked for one last chance to see them before they left), though everything had been done to smuggle them out as surreptitiously as possible,[16] and a story was spread that the Pope had been tricked into authorising it.[17] Soon afterwards Ercole Ferrata was persuaded to come to Florence and supervise the unpacking of these statues (which had travelled by sea to Livorno and then along the Arno), and once there he was given rooms in the Palazzo Vecchio so as to be able to undertake a thorough campaign of inspection and restoration, not only of the new arrivals from Rome, but also of the other sculptures which had long been in the Medici collection. An indecisive, almost simple-minded character and a rather plodding, colourless sculptor whose gifts were best displayed in executing or imitating the conceptions of more imaginative artists, Ferrata nonetheless enjoyed a deserved reputation as an authority on the antique.[18] We frequently come across examples of his exceptional talents as a restorer—it was he, for instance, who 'created' the *Faun with Kid* (Fig. 109)—and his impact on the collections of the Medici was considerable. Among the sculptures he found there was a somewhat battered Venus (the *Venus Victrix*) which, through some cunning detective work, he claimed to be a very famous statue which had once been placed in the Belvedere statue court. And it may have been Ferrata who drew particular attention to the

57

beauty of another statue in the Uffizi, which in recent years had begun to interest artists and antiquarians: the *Dancing Faun* (Fig. 106).

The Pope was very soon to regret his ill-considered action in releasing the *Venus de' Medici* 'parce que ces sortes de statües antiques sont considérées come un des plus grands ornemens de la ville'.[19] He was right. To accommodate the figures which he had brought from Rome and so unexpectedly discovered in his own collection Cosimo made use of the Tribuna which now entirely changed its character. The large jewel cabinet in the centre had, some forty years previously, been replaced by a table worked in pietre dure which left far more space for the display of sculpture. Around this table were placed six figures: the *Venus de' Medici*, the *Wrestlers* and the *Arrotino* from Rome; the *Dancing Faun* and the *Venus Victrix* (now fully restored), neither of which had hitherto been much noticed; and the *Celestial Venus* which had been acquired in Bologna. With Titians and Raphaels and Rubenses hanging around the walls and with much of the elaborate decoration still in place the Tribuna retained the prestige which derived from the exquisite luxury of its earlier incarnation and to this it added the distinction of housing statues of unrivalled importance. It is no exaggeration to say that as a result of Cosimo's development of it the Tribuna became the most famous room in the world (Fig. 30). For many visitors its contents were clearly of greater interest than anything to be seen in Rome. In 1739 the Président de Brosses, that lover of the provocative *boutade*, found himself in the unexpected position of having to defend an older orthodoxy and to reassert the superiority of the statue court in Rome: 'Vous m'avouerez que le

31. Antonio Susini: Small bronze copy of the *Farnese Bull*—height: 47.5 cm (Galleria Borghese, Rome).

32. Giovanni Francesco Susini: Small bronze copy of *Ludovisi Mars*—height: 34.1 cm (Ashmolean Museum, Oxford).

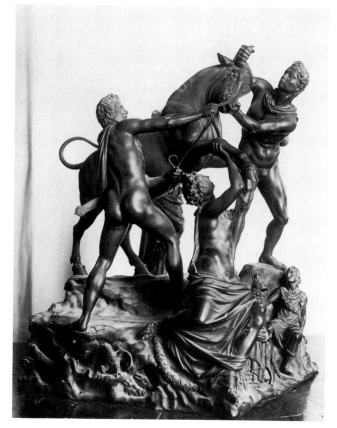

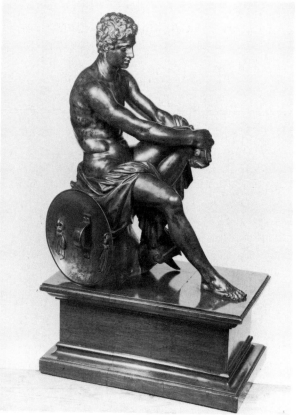

Laocoön, l'Apollon, l'Antinoüs, le Torse, la Cléopâtre, etc., ne doivent rien à la Vénus de Medicis, au Faune qui danse, au Remouleur, aux Lutteurs, etc.'[20]

It was not long before foreign potentates, fully as much as ordinary travellers, became aware of the new significance of the Tribuna and began to try to acquire copies of the masterpieces to be found there as well as of some of the 'Emperors . . . Philosophers, Heroes, Consuls, Muses, Deities, and other Figures interspers'd'[21] lining the three corridors of the gallery outside. The combination of Cosimo's enlightened policy of training native talent and of long standing Florentine traditions ensured that the quality of such copies would be of the highest order.

Even during the least creative phase of Florentine sculpture, the production of small and very refined bronzes after the antique by craftsmen from the studios of Giambologna, the Taccas and the Susinis had remained constant and distinguished and such statuettes had circulated widely, though it is exceedingly difficult today to associate surviving examples with specific workshops or even specific periods. Sometimes these copies could acquire great celebrity. For instance in a guidebook to Rome of 1625 one of the very few sculptures mentioned by name in the Villa Borghese (which then included such famous works as the *Gladiator* and the *Hermaphrodite*) is a small bronze reduction, made by Giambologna's pupil Antonio Susini, of the *Bull* in the Palazzo Farnese (Fig. 31)[22]; and it is recorded that of the five casts made by this sculptor of the *Hercules* in the same palace, three were exported to France. It seems likely that during the first half of the seventeenth century most of the finest small bronze versions of the most admired antique sculptures in Rome were made by Florentines (Stefano Maderno is a notable exception) and although these statues were very expensive the large numbers still surviving suggest that the demand must have been considerable (Fig. 32).

We have seen, however, that the production of large copies was a far more complicated affair which could tax the resources of even the most powerful or extravagant sovereigns. Nonetheless, as the century drew to a close and as the effects of the wars which had devastated so much of Central Europe abated, the demand for rather more substantial replicas than those turned out by the Susini and other Florentine workshops began to spread more widely than it had done fifty years earlier. And the new generation of sculptors, trained in Rome through the munificence of Cosimo III, eagerly seized the opportunity of providing bronze versions—sometimes of the size of the original—of the most celebrated antiquities, many of which were now to be found in Florence itself. Before very long their copies were being used to decorate German palaces and English country houses.

The approach of these new patrons and new artists to such commissions can be gauged from their attitude to the interminable enterprise of Louis XIV which now began to seem rather old-fashioned. It is true that, because his Academy was firmly centered on Rome, the King was forced to acknowledge the special position of Florence by calling on local talent (Foggini and his workshop) rather than on French artists to copy the *Arrotino*, the *Dancing Faun* and the *Boar*.[23] But these copies were of marble, and, as Soldani (another pupil to emerge from Cosimo's Roman Academy) emphasised, marble copies 'are not, and never can be, as correct [*giuste*] as those of bronze'.[24] Certainly Prince Johann Adam Liechtenstein (1666–1712), one of the greatest collectors of the period, had no doubts about the superiority of bronze, and

the Florentine artists whom he employed responded with enthusiasm. 'Your Highness has truly been very wise', Soldani wrote to him in 1695, 'to reflect that to copy these statues in marble is not a good idea, because one can never in that way manage to copy them with that softness [*tenerezza*] and grace of contours which are to be found in the originals, and, besides, marble copies are difficult to transport without breaking.'[25] A glance at the beautiful bronze versions (or sometimes variants) produced by Soldani himself of the most famous marble antiquities proves how true was his feeling. These works, and many others created in Florence at the time, are among the most satisfying of all the attempts, made in so many materials over so long a period, to reproduce the most famous and admired statues of the ancient world. Long before connoisseurs ceased to admire indiscriminately the dull surfaces of many of the works discussed in our book, Soldani and his colleagues in Florence had acquired a more vital understanding of the quality of antique sculpture than was usual in the eighteenth century: implicitly, they had even anticipated much later theories that many of the most famous Roman marbles were themselves copies of bronze originals.

The *Venus de' Medici* had already been frequently reproduced when in Rome, and its fame was so great that it could never thereafter be omitted from any set of copies of the most excellent antiquities; and to a lesser extent this was true also of the *Arrotino* and the *Wrestlers*. Nonetheless, the reorganisation of the Tribuna and the presence of gifted artists in Florence did lead to a special Florentine subdivision of the most widely admired masterpieces—a subdivision which also embraced selected works of the Renaissance, above all by Giambologna, Sansovino and Michelangelo (a copy of whose Bacchus horrified Prince Liechtenstein).[26] In particular it introduced to international attention the *Dancing Faun*, a work little known abroad until 1684 when a copy was commissioned for Versailles. Within eleven years Soldani could describe it to Prince Liechtenstein as 'the most beautiful statue that can be found', and he acutely pointed out that it would make an excellent companion for the *Venus de' Medici*[27]. And as the *Wrestlers* paired well with the *Arrotino*, these four statues from the Tribuna were quite frequently copied together for collectors who appear either not to have acquired other reproductions of the antique or at least to have confined their interest to the Grand Duke's collection. Prince Liechtenstein, for instance, seems to have looked only to statues in the Uffizi for terracotta copies from which stone versions could be carved in Vienna and placed in his gardens there.[28] The da Passano family in Genoa owned a set—cast in bronze by an unknown sculptor—of the four masterpieces in the Tribuna, and also of the *Idol* and of a Mercury (probably by Giambologna)[29]; the Duke of Marlborough had four superb bronzes made by Soldani of the *Faun* (Fig. 33), the *Venus*, the *Arrotino* and the *Wrestlers*;[30] in the 1720s Lord Parker (later, as the Earl of Macclesfield, to be 'one of the greatest mathematicians and astronomers in Europe')[31] commissioned from Cipriani, a pupil of Soldani, bronze copies of the *Faun* and *Venus* and of two Roman busts also in the Uffizi.[32]

The list of such collectors could be extended,[33] but it was naturally not only through the making of splendid copies that the new, special importance of Florence became well known to the world. Travellers paid increasing attention to the city, and of such travellers none was more perceptive or influential than Jonathan

33. Massimiliano Soldani
Benzi: Bronze copy of the
Dancing Faun (Blenheim
Palace, Oxfordshire).

Richardson the Younger (son of the portrait painter) who visited Italy in 1721. The description of what he saw on his journey was written, on his return to England, in collaboration with his father, and was first published in 1722, and then revised and translated into French six years later (an unheard-of distinction for an English book on the arts). Winckelmann, not a man given to generous praise of his predecessors, was later to damn the book for haste, carelessness and omissions, and yet to acknowledge that, for all that, it was one of the best of the kind that had yet appeared;[34] and we will see later how often the Richardsons anticipate the theories of subsequent archaeologists. Certainly no one before 1721 had looked with such aesthetic imagination and speculative intelligence at the great antique sculptures in Florence. Jonathan Richardson spent more than ten hours in the Tribuna 'considering the beauties of the Statues there, and continually found something new to admire'.[35] His comments on the paintings and sculptures in the Grand Duke's gallery show him to have combined two qualities which were rarely associated in contemporary writing on the arts: a deep culture and a lack of pedantry. Yet, for him as for all travellers, Rome was still the most exciting city in Italy, though (as we will see in the next chapter) there were signs that the situation there was going to change rapidly at much the same time that Richardson arrived.

IX

Museums in Eighteenth-Century Rome

ON 10 DECEMBER 1728 Nicolas Wleughels, director of the French Academy in Rome, wrote to the Duc d'Antin, Surintendant des Bâtiments du Roi, in Paris: 'The King of Poland has sent someone here who has bought all the antique statues that belonged to Prince Chigi and a large proportion of the collection formed by Cardinal Alessandro Albani. Some time ago the King of Spain removed the collections of Don Livio Odescalchi, which were considerable. So it is that, bit by bit, this unfortunate country is being stripped.'[1] In some ways the situation was even bleaker than Wleughels indicated: he could, for instance, also have mentioned that when in Rome in 1716–17 an Englishman, Mr. Thomas Coke of Holkham in Norfolk, had been able to acquire at least two statues of importance—a 'Lucius Antonius' and a Diana. The heads of both these statues were admitted to be additions—the former, improbably, ascribed to Bernini, the latter, plausibly, to Rusconi—and in any case the statues were not equivalent to the *Farnese Hercules* and *Venus de' Medici*, which may just be discerned behind Coke in the portrait which Trevisani painted of him when in Rome, but they had been illustrated only a dozen years previously in the anthology published by de Rossi of the finest sculptures in the city.[2] Against such depredations the popes put up a tough, but not always successful, resistance. Rumour had it that Mr. Coke had been arrested for a time;[3] Pope Clement XI was said to be adamant, in the face of extreme pressure, in withholding an export licence from the Duc d'Orleans who had hoped to remove the Odescalchi sculptures (which had formerly belonged to Queen Christina of Sweden) as well as the Old Master paintings:[4] and his successor's acquiescence, when pressed by the King of Spain, must certainly have been motivated by the desire to ease some exceptionally troublesome negotiations in which he was currently engaged.[5] And so the *Faun with Kid* and the *Castor and Pollux*, of which the Richardsons had said that 'there are no Finer Statues in Rome', left the city for ever, as the *Germanicus* and the *Cincinnatus* had done forty years earlier, and—so it seemed—as many more masterpieces might well be doing in the next few years.

One palliative to this state of affairs lay in the hands of Wleughels himself. In 1725 the Academy, over which he presided, took an eight-year lease on the palace of the Marchese Mancini in the Corso opposite the Palazzo Doria, and in this large, handsome building (which was purchased twelve years later) the casts after the antique, on which so much store had been set by successive directors, could at last be properly installed.[6] As the visitor climbed up the staircase to the first floor, he saw

the *Farnese Hercules* in a well-lit niche on his left; a little further up, along rather a dark corridor, was the *Farnese Flora*; flanking the door in the first room were the *Lion* and the *Boar*; beyond, could be seen *Paetus and Arria*, and next to them Niobe clutching her young daughter from the *Niobe Group*. And so the visit continued: in one large room were the *Dancing Faun*, the *Commodus as Hercules*, the *Antinous*, the *Germanicus*, the *Cincinnatus*, the children of *Niobe*; elsewhere were portraits of the King and Queen of France, copies of Raphael's frescoes in the Vatican, splendid tapestries and painted columns—and everywhere, elegantly placed, were plaster versions of those statues whose proportions had been measured and whose features had been analysed by artists and scholars from all over Europe: the *Laocoon*, the *Dying Gladiator*, the *Spinario*, the *Hermaphrodite*. . . . As statues were uncovered in fresh excavations, so casts were added, even though in Paris the authorities were no longer interested in buying marble copies for the royal household.[7] Only in the Palazzo Mancini could the full range of the most famous antique statues be examined at leisure and in comfort, and it was to this collection that foreign connoisseurs were often forced to resort for advice and sometimes to have copies (at one remove from the originals) made for themselves.[8]

Among the visitors to the Academy was Cardinal Alessandro Albani, the most enthusiastic and spendthrift of eighteenth-century Roman art patrons, who particularly pressed the director to include casts of the principal antiquities to be found in France, 'for in some way or another it is essential to bring back to Rome what has been removed from the city'.[9] Cardinal Albani had good reason to urge such a policy. Having already sold many of his own antiquities to Augustus the Strong of Poland, he was soon trying to dispose of the remainder. Although the French were not interested in 'curiosities of this kind',[10] it must have seemed inevitable that most of the several hundred 'statues, busts, heads, bas-reliefs, herms, urns with bas-reliefs, Egyptian antiquities, decorated vases, lions and columns'[11] assembled by the Cardinal would go abroad—probably to England where Albani was advised to sell them.[12] And then, in 1733, Pope Clement XII made a move which changed the nature of Roman sculpture collections more than anything that had been done since Julius II had established the Belvedere statue court in the first years of the sixteenth century. He bought all the Albani antiquities and made them the nucleus of a new museum on the Capitol.[13]

We have already pointed out that the first sculptures to be seen on the Capitol since antiquity had been donated by Pope Sixtus IV in 1471. During the early sixteenth century important additions were made to these, culminating in the installation of the *Marcus Aurelius* in 1538, which was followed by some purchases and private gifts, and above all by the transference to the Conservators of large numbers of statues from the Vatican in 1566 and the next few years. In the middle of the seventeenth century Michelangelo's project of a twin palace on the other side of the piazza from that of the Conservators was completed and a certain number of statues were placed in it. In 1720 Pope Clement XI bought from the Cesi family a group of well-known statues—the Rome seated above the *Weeping Dacia* with the two Barbarian Captives—and these were placed in the courtyard of the palace of the Conservators. But it was only with the purchase of Cardinal Albani's sculptures that the Capitoline collections were radically transformed.

Albani had managed to acquire from various sources a few sculptures which had once been very famous (above all the *Della Valle Satyrs* and the *Cesi Juno*), though they had been a little neglected in more recent years. The real attraction of his collection, however, consisted of a statue of *Antinous* (Fig. 74), excavated at Hadrian's Villa, and a very large group of ambitiously identified portrait busts. Although there can be no doubt that these Philosophers and Emperors, placed in rooms named after them, were enthusiastically inspected by foreign visitors to Rome, they are not included in our catalogue, for—as has already been mentioned—the interest they aroused depended more on their historical than their aesthetic distinction, as is made clear in a rapturous letter from the Abbé Barthélemy to the Comte de Caylus:

> The first time that I went into the Capitoline Museum I felt a shock of electricity. I do not know how to describe to you the impression made on me by the bringing together of so much richness. This is no longer just a collection: it is the dwelling place of the gods of ancient Rome; the school of the philosophers; a senate composed of the kings of the East. What can I tell you of it? A whole population of statues inhabits the Capitol; it is the great book of antiquarians.[14]

The Albani sculptures had hardly been installed before new demands began to be made on the available space, for it was now that a barely explored treasure trove began to be extensively exploited, and, as a result, the next few years recalled the time a century earlier when the great Roman families had vied with each other in adding to the patrimony of recognised masterpieces.

The ruins of the villa which the Emperor Hadrian had built for himself about twenty miles from Rome had been known and discussed ever since the fifteenth century.[15] Occasional excavations brought statues to light, but it was not until 1550 that Cardinal Ippolito II d'Este, governor of the adjoining town of Tivoli, began to pursue these with some vigour in order to decorate his beautiful Villa d'Este, while Pirro Ligorio, his antiquarian and part-time architect,[16] wrote various treatises about Hadrian's Villa which gave it real fame among scholars.[17] However, of the many statues which were excavated at this time none acquired true celebrity. During the seventeenth century excavations continued sporadically, but as the property was divided among some forty-five separate owners little could be done on a systematic scale. In 1724, however, an elusive collector and amateur dealer, Count Fede, began buying up as much of the estate as he could; when he had accumulated a substantial portion he beautified it by planting the great cypresses which are still such a feature of the Villa[18] and undertook more thorough investigations than had yet been possible, and in this he was followed by the other principal landowners on the site—the Jesuits, and the Bulgarini family who, however, rather rashly sold their rights to the ambitious and erudite Monsignor Furietti.

A series of spectacular discoveries followed in quick succession. Among the earliest must have been the full-length *Antinous* which Cardinal Albani sold to the Pope in 1733; some two years after this transaction had been completed the Cardinal got hold of a bas-relief of Hadrian's favourite (Fig. 75)—both these representations of Antinous were quickly ranked with the most famous works to have survived from antiquity; in 1736 the *Faun in Rosso Antico* (Fig. 111) was dug

64

34. Carlo Marchionni: Project for installation of the *Antinous Bas-Relief* in the Villa Albani, Rome—drawing (Cooper-Hewitt Museum, New York).

up, and in the same year Furietti excavated the two *Centaurs* (Figs. 91 and 92) and, shortly after, a mosaic which aroused great interest; in 1744 the *Flora* (Fig. 112) came to light. All these were much publicised and engraved after only a short delay, and thus, in little more than a decade, about half a dozen statues of world-wide fame (but, for the most part, notably different in character from the ones to be seen in the Borghese and Ludovisi Villas) had been added to the stock of those which had been attracting universal attention for more than a century.

It is hard to determine to what degree such a very distinguished provenance must be held responsible for the great celebrity of these works. Hadrian was well known as an art lover, and to some extent his villa could be thought of as the Belvedere statue court of ancient Rome—and thus as a guarantee of quality. Though scholarly opinion was sometimes critical of what had been found there (the *Furietti Centaurs*, for instance), public enthusiasm, and hence the repeated copies which were so essential for establishing the fame of a work, must have been fired by the reflection that these sculptures had belonged to the Emperor himself; and indeed from the 1730s onwards the lure of Hadrian's Villa was to be a potent one for art lovers and speculators of all kinds.

No one played a greater part in exploiting its resources than Cardinal Albani (1692–1779), whose name has already been frequently mentioned in this chapter and who for more than half a century dominated the international world of collectors and scholars who flocked to Rome. But though his informed love of art was never in doubt and though the beautiful villa–museum built for him by Carlo Marchionni on the Via Salaria attracted great enthusiasm (Fig. 34) not only through its huge collection of antique (including Egyptian) sculpture but also through its ceiling fresco of Parnassus by Anton Rafael Mengs, Albani's direct influence on the theme of our book was limited by doubts about his personal integrity. Like many people

who traffic in works of art he was suspected of being 'tant soit peu fripon',[19] of charging extortionate prices,[20] and of giving his enthusiastic endorsement to evident duds.[21] And the fact that, unlike the great collecting cardinals of the seventeenth century, he was as much concerned with selling as with buying helped to bring an element of notoriety to two related practices which had hitherto been accepted virtually without question: the automatic 'baptism' of anonymous portraits and figures, and their drastic restoration. As early as 1728, when the first of Albani's collections was on the market, Montesquieu was told that 'in Rome, when they see a serious-looking man without a beard, he is a consul; with a long beard, a philosopher; and a young boy, an Antinous'.[22] Later travellers repeated again and again the opinion that 'Cardinal Albani is in our days the restorer-in-chief of Antiquity. The most mutilated, disfigured, incurable pieces are, through him, given back the flower of youth, *nova facit omnia*; the fragment of a bust which, even if it were whole, would have been *una testa incognitissima* to all the antiquarians receives from him both a new life and a name which indelibly settles its destiny.'[23] And it is notable that such mocking charges were launched well before the overriding impact made on current ideas of nomenclature and restoration (which we will be discussing in Chapter XIII) by the man whose support by Albani has given the Cardinal his greatest fame in the eyes of posterity: his librarian Johann Joachim Winckelmann.

Following the purchase of Albani's first set of marbles, successive popes bought regularly for the Capitoline Museum both from old collections and from new excavations—in 1752, for instance, Benedict XIV acquired from the Stazi family, which had owned it for nearly a century, a *Venus* (Fig. 169) soon to become one of the most admired sculptures in Rome; and his successor Clement XIII was able to buy the already famous *Centaurs* from the heirs of Cardinal Furietti. Nevertheless, the threat of outside competition grew ever more dangerous. Charles Bourbon, King of newly independent Naples, needed classical statuary to decorate the palaces he was having built, and, as nothing unearthed at Herculaneum could begin to rival in prestige the famous sculptures to be seen in Rome, he toyed with the idea both of having copies made of many of the heads in the Capitoline Museum and also of purchasing some of the well-known collections which were rumoured to be unofficially on the market—those of the Este, for instance, and of the Mattei. But there was a far more ominous threat: as early as 1755, Luigi Vanvitelli, the architect Charles had invited from Rome to design his palace at Caserta, dropped a clear hint that, just as the King had taken the Farnese pictures from Parma to Naples, so too he could do the same with the Farnese sculptures which he had also inherited.[24]

More immediately pressing was the menace of the English. In 1749 Matthew Brettingham the Younger was in Rome to buy more sculptures—with the active encouragement of Cardinal Albani who used his influence to annul inconvenient export regulations[25]—for the same Mr. Coke (by now Earl of Leicester) who, nearly forty years earlier, had taken back to England the Diana and other distinguished pieces;[26] and it was not long before two Englishmen, Thomas Jenkins and Gavin Hamilton, were shipping home large quantities of antique sculpture, much of it from Hadrian's Villa. Under the licensing system then in force, the popes were entitled to one-third of any excavation carried out within their dominions and could also prevent the export of any other specific pieces which were considered to

be of great importance.[27] This right was frequently exerted— but also frequently evaded, the more easily so as Cardinal Albani was only one among many highly placed individuals keen to make a profit from the fabulously rich English.[28]

The legendary fame (or notoriety) enjoyed by these English collectors in the second half of the eighteenth century and the extraordinary number of sculptures imported by them and their agents into England[29] makes it particularly necessary to estimate with some care the importance of their activities in the context of our book, which is concerned with the creation, the diffusion and the eventual dissolution of a 'canon' of universally admired antique statues. When we do this we realise that the part played by the English in this process was a comparatively small one. Despite what appeared to be unlimited wealth, no English collector was able to buy any of the really celebrated antiquities in Rome. Sculptures were acquired from almost every established collection—but they were not the most famous pieces: it is in fact impossible to trace to an English collection any piece of antique sculpture which had previously been illustrated in an Italian anthology of the most famous and beautiful statues with the exception of Mr. Coke's Diana and 'Lucius Antonius'. Nor were the English any more successful in acquiring really well-known sculptures which had recently been excavated. Huge sums, for instance, were said to have been offered for the *Furietti Centaurs*—but in vain. Only in the last third of the eighteenth century when English dealers (such as Gavin Hamilton) were themselves conducting excavations at Hadrian's Villa and elsewhere in the papal territories did it become possible to remove sculptures acknowledged to be of the highest quality, among them the colossal marble vase discovered in 1771. This was purchased by Sir William Hamilton and sold after restoration to the Earl of Warwick, who for a long time forbade casts to be made of it (although he did encourage Lord Lonsdale to make a full-scale replica in solid silver); but bronze and cast-iron replicas of the Warwick Vase (which is now in the Glasgow Museum) were eventually made, and it was copied on a reduced scale in silver, bronze, marble, porcelain and terracotta by artists using the prints made by Gavin Hamilton's business associate Piranesi—and these helped to establish it as perhaps the most famous antique marble vase after those in the Borghese and Medici collections and the first item, it was reported, on Napoleon's list of the works of art to be expropriated after the conquest of Great Britain.[30]

The two most highly esteemed statues to be exported from the papal states to England were versions of works which had long been among the most famous in Europe: the *Cincinnatus* (by then known as Jason) and the *Belvedere Antinous* (by then known as Meleager). Both were excavated by Gavin Hamilton, the former at Hadrian's Villa in 1769 and the latter at Tor Colombaro two years later; after the Pope had declined to purchase the Cincinnatus because it was too expensive and the Antinous because he already owned the one in the Vatican, both were sent to join Lord Shelburne's collection in London.[31] Even though Canova is said to have supported the view expressed in Rome at the time of its export that the new Antinous (now in the Ludington collection, Santa Barbara) was superior to the old, and even though modern scholars have often agreed with Gavin Hamilton that the same could be said of the new Jason (now in the Ny Carlsberg Glyptothek, Copenhagen, as Hermes), neither statue had a chance in the late eighteenth and early

nineteenth centuries of competing with rivals in the public collections of Rome and Paris. A group of casts of notable works which had been exported from Rome was displayed in the Accademia di S. Luca and elsewhere, but these were not sufficient to keep the memory of the statues themselves alive among men of taste.[32]

Sculptures in the British Museum clearly stood a better chance of achieving international celebrity than those in private houses whether in London or the country (Fig. 35)—a fate so obscure, according to a German visitor to Italy, that they might as well never have been excavated.[33] There was great enthusiasm among English connoisseurs for a Venus which came to the Museum with the Townley collection in 1805 and this might have been more widespread if the statue had been at all noted in Rome before its export, but its discovery by Gavin Hamilton at Ostia in 1775 had been deliberately concealed and it had been shipped to England as two separate fragments.[34] Even more popular was a female bust also from Charles Townley's collection which, under the name of Clytie,[35] was extensively reproduced in marble, plaster and parian ware. Goethe owned two casts of this,[36] but in general its fame does not seem to have spread much beyond England.

No European man of taste keen to study the most beautiful and famous antique statues would, before 1800, have thought of crossing the Channel to visit England, but the scholar scanning the index of Carlo Fea's Italian edition of Winckelmann's *History of Ancient Art* would have noted how many more works were mentioned in English than in French, Spanish or German collections, and might well have feared in 1768 when the Barberini sold to Charles Townley the 'Youths quarrelling over a Game of Knuckle-Bone' (a much noted group which some had even connected with Polyclitus)[37] that other even more valued treasures would be disposed of—the Barberini Vase, for instance, which did in fact go to England, and the *Barberini Faun*. Indeed it was in 1768 that Bartolommeo Cavaceppi, the Pope's chief restorer, published a large illustrated volume of antique statues that had been repaired in his studio. Of the sixty plates, thirty-four reproduced works already belonging to Englishmen, while seventeen showed others in German collections. The remainder were divided between Cardinals Albani and Furietti and Count Fede.[38] A year later Cavaceppi published a second volume. This time all sixty works illustrated were for sale. The message was clear enough. The popes might intervene, of course, but with the Capitoline Museum already full, where would they be able to place all the statues that might at any time come on the market from half the collections in Rome, let alone those that were being dug up every day?

Meanwhile once again the situation within Italy became desperate. In about 1769 Pietro Leopoldo, the Lorenese Grand Duke of Tuscany, inaugurated a long campaign to rationalise the Medici collections which had been left to Florence, and during the course of this he decided— on the advice of Anton Rafael Mengs[39]—to establish a cast gallery for the Accademia delle Belle Arti and to bring to the city the most famous works of art that were scattered throughout Tuscany and elsewhere— actions which, it was hoped, would help to revive the arts and give birth to 'nuovi Bonarroti'.[40] Among these works of art were the antiquities that still remained in the Villa Medici, some of which (the *Niobe Group*, the *Apollino*, and even the *Lion*) were among the principal sights of Rome. Pope Clement XIV protested vigorously, but there was nothing he could do. By June 1770 the *Niobe Group* was already in

35. Newby Hall, Yorkshire—the sculpture gallery designed by Robert Adam, with the Jenkins Venus.

Florence, to be installed some ten years later in a specially built room in the Uffizi. Soon after, the other antiquities from Rome were displayed in Florence.

The Pope's impotence did not pass unnoticed in Náples, where the King's chief minister, the Marchese Tanucci, was engaged in bitter controversy with the Papacy over the political and ecclesiastical independence of the kingdom.[41] 'Doubtless so as to make these negotiations easier and to put the Pope in a better mood', as Cardinal de Bernis commented sarcastically,[42] Tanucci brought up once again the possibility of removing the Farnese antiquities—the most celebrated private collection in Europe. In fact the threat did not materialise for another fifteen years or so, when the terms of Cardinal Farnese's will of 1587 that the collections should remain for ever in Rome were finally set aside, and the *Hercules*, the *Flora*, the *Bull*, the *Callipygian Venus* and many more were removed from the family's palaces in the city. Already, however, there seemed a strong possibility that the collections of Florence (which had been an outstanding centre for visitors ever since the first removals from the Villa Medici nearly a century earlier) and of Naples (where the excavations at Herculaneum and Pompeii had begun to attract very great interest) would soon rival, if not actually surpass, those of Rome—at the very time when enthusiasm for antiquity was everywhere rising to a peak.

It was in these circumstances that Pope Clement XIV, who had been enthroned in 1769, decided on drastic action. Almost simultaneously he began to buy whatever became available—the *Meleager*, for instance, was acquired in August 1770—and to build a new museum behind the Vatican palace to house the acquisitions he was already making and planning to extend on an ever increasing scale.[43]

Little of real importance had been done to the Vatican collections since the reign of Pius V, though a huge porphyry vase had been added to the statue court[44] and parts of the Library had been used to accommodate various private gifts, bequests and purchases which had been split up into a 'Museo Cristiano' and a 'Museo Profano'. Clement XIV's project envisaged two major steps: the ground floor of the

36. Vincenzo Feoli: The Belvedere Courtyard of the Museo Pio-Clementino—engraving.

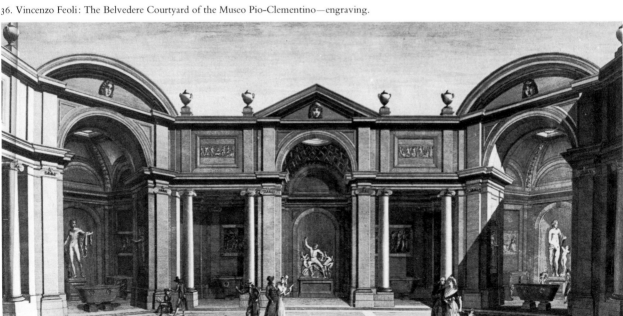

medieval villa of Innocent VIII, which remained intact and more or less deserted behind the statue court, was to be refurbished as a museum, and the dignity of the statue court itself was to be enhanced by the building of a handsome octagonal loggia (Fig. 36) so devised as to provide a series of frames for the most famous sculptures. These arrangements and the extensive campaign of restoration and of purchases (which required the cooperation of every dealer in Rome) were in the hands of the antiquarian Giambattista Visconti and his brilliant son Ennio Quirino, whose catalogue of the new museum, published over a period of many years, made an impact on eighteenth-century archaeological studies second only to that of Winckelmann.

It is not, however, our intention to discuss here what soon became the most famous museum in the world except in so far as it impinged on the most celebrated sculptures displayed in it and the responses aroused by them. Such issues are not easy to assess, for Clement XIV's museum only survived for a short time before it was drastically altered and extended by his successor Pius VI, and at no period did Visconti reveal very much about his principles of display. Moreover, the guidebooks and travellers of the period veer between copying and contradicting each other, often so blatantly that it is tempting to deduce that during these years frequent changes were made in 'grading' some of the sculptures in the statue court. Certain features emerge clearly: the *Nile* and the *Tiber*, which had reclined in the centre of the court since the early sixteenth century, were now removed from it and separated.[45] This did not imply any doubts about their quality, for each was given a small room of its own fashioned out of the loggia of Innocent VIII's villa. The principal figures—the *Apollo*, the *Laocoon*, the *Antinous*, the *Commodus as Hercules* and the *Venus Felix*—were left in the monumentalised court, but the *Standing Venus* and the Tigris were taken out of it. On the other hand, the Seated Paris, a statue recently acquired from the Altemps family, in whose palace it had been much admired throughout the eighteenth century, was given a niche of its own in the court[46]—a momentary glory, for this arrangement was soon to be changed.

Clement XIV died in 1774, much derided (like the Renaissance popes) for his supposed attachment to paganism[47]—not surprisingly, perhaps, for he had done more for the public appreciation of antique sculptures than any of his predecessors for two and a half centuries. His successor Gianangelo Braschi, who took the name of Pius VI, had as treasurer always been the moving force behind the new museum. Once in power he extended it with lavish and ruthless efficiency, pulling down Innocent VIII's little chapel (with its frescoes by Mantegna) which had been carefully preserved under Clement. Once again, however, our only interest here is in the fate of those sculptures with which we have been concerned in this book. The basic structure of the statue court remained unchanged, but it seems that Pius VI found it as difficult as his predecessor to decide which figures, apart from the five which had survived the previous alterations, were worthy of special prominence. The Altemps Paris was removed, and the scanty evidence at our disposal suggests that two other recently acquired statues were successively put in its place: first, a standing Lucius Verus,[48] and then a Genius of Augustus.[49] In the event the new arrangement lasted for not much longer than the previous one, for the French armies saw to it that the most important statues were all taken to Paris; but, confused as it is,

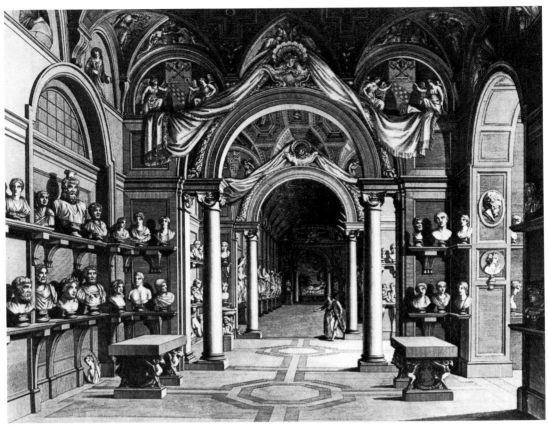

37. Vincenzo Feoli: Galleria dei Busti of the Museo Pio-Clementio—engraving. At the end of the gallery beyond is the *Cleopatra*.

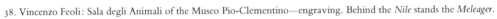

38. Vincenzo Feoli: Sala degli Animali of the Museo Pio-Clementino—engraving. Behind the *Nile* stands the *Meleager*.

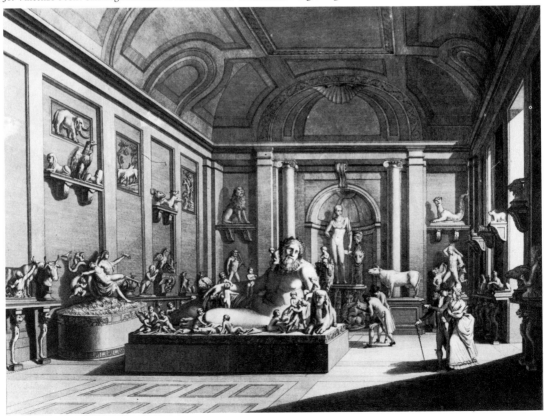

this episode of the reappraisal of the statue court is of notable interest, demonstrating as it does some of the practical consequences for a great museum director of those changes in taste which (as we will see in Chapter XIII) he himself had helped to bring about.

Yet such moving around of sculptures constituted only a small aspect of the reorganisation of the collections. Each one of the great standing statues, hitherto solitary in a garden setting, was now surrounded by herms and sarcophagi, bas-reliefs and columns, often let into the imposing new walls and always arranged for decorative effect (Fig. 37)—it being sometimes acknowledged that they were of little aesthetic merit.[50] The reclining *Nile* and *Tiber* now presided over rooms teeming with sculptures of the most varied kinds from the venerated *Meleager* to dogs recently dug up from Hadrian's Villa (Fig. 38). Some visitors deplored this dilution of quality;[51] others were enthusiastic about

> the most magnificent and grand combination that perhaps has ever been beheld or can almost be imagined. Never were the divinities of Greece and Rome honoured with nobler temples; never did they stand on richer pedestals; never were more glorious domes spread over their heads; or brighter pavements extended at their feet. Seated each in a shrine of bronze or marble, they seemed to look down on a crowd of votaries and once more to challenge the homage of mankind; while kings and emperors, heroes and philosophers, drawn up in ranks before or around them, increased their state and formed a majestic and becoming retinue.[52]

Yet, in many ways, little enough had changed. Not one antique statue gained lasting additional fame in the new museum. Visitors still hurried, as they had been doing for so long, to enthuse over the *Apollo*, the *Antinous* and the *Laocoon* and in so doing scarcely paused to comment on the vast wealth of freshly acquired statuary. And the impulse felt by so many of them to express in print their very conventional feelings about masterpieces that had already been described countless times before clearly enhanced the prestige of old favourites rather than drew attention to new discoveries. Familiarity bred not contempt but an irresistible urge to rhapsodise, and never were the disclaimers (which had become conventional as early as the beginning of the seventeenth century) about the need for yet another account of the most famous antique statues so frequently repeated and so little heeded as they were by the end of the eighteenth century. By then there can have been few people in the Western world with even moderate claims to taste still unaware that, in the words of an earlier writer,

> there are some statues which the connoisseurs have established as examples and rules, each of its own kind: the Venus de' Medici, the Dancing Faun [le petit Faune], the Arrotino [le paysan qui écoute] and the Wrestlers (these four pieces are in the palace of the Grand Duke of Florence), and (in Rome) the Apollo Belvedere, the Farnese Hercules, the Laocoon. And these statues cannot be sufficiently looked at, for it is from them that the Moderns have built up their system of proportions, and it is they which have virtually given us the arts.[53]

This consciousness was heightened by the reproductions of these works that were by now to be found all over Europe and were beginning to spread to the United States.

X

The New Importance of Naples

Visitors to Naples in the late seventeenth century record among the collections of antiquities, coins, inscriptions, marble fragments, 'Egyptian Deities of Touchstone' and the head of a bronze horse, sometimes now described as a quattrocento imitation, but then regarded as genuinely antique and popularly believed to be a fragment of a magical horse made by Virgil.[1] But these were not considered works of the first importance, and in 1752 one writer, repeating the words of another half a century earlier, declared that a traveller giving an account of the city was 'obliged to confine himself to modern curiosities'.[2] By then, however, a really well-informed visitor could not have written such words. For the situation had been entirely transformed; and students of antique art—that is virtually all lovers of art—would have felt bound to go to Naples, as they were bound to go to Florence and Rome.

Carlo di Borbone, later Charles III of Spain, assumed the throne of the Kingdom of the Two Sicilies in 1734, aged eighteen. Four years later, in 1738, the excavation of the buried city of Herculaneum, begun over twenty years before by the Prince d'Elbeuf, was systematically resumed under court control. Ten years later Pompeii began to be properly investigated (although it was not identified as such for certain until 1763 and was known simply as Civita).[3] And in 1750 Charles decided to build a suite of rooms in his new palace at Portici specially to house the finds. In 1775 the court antiquary Ottavio Antonio Bayardi after exasperating the learned world with turgid Prodromi disappointed it with his catalogue.[4] In the same year Bayardi's cousin and protector, Count Fogliani, fell from power. Under the next chief minister (later Regent), the Marchese Tanucci, the Royal Herculaneum Academy was founded, and it supervised the production, between 1757 and 1796, of the nine lavish illustrated folios of the *Antichità di Ercolano*, of which two volumes (nos. V and VI—1767 and 1771) were devoted to the bronzes. The projected volume on marble sculpture did not appear.

There was criticism of the methods of excavation (Fig. 39), restoration and cataloguing,[5] but the facts which we have given show that both Charles and his son Ferdinand IV, who succeeded him in 1759, knew the value of their collection, although the latter took little personal interest in it. The extravagance of Prince d'Elbeuf's way of life had prevented him from keeping his finds: the marble statues of the three maidens, then known as the Vestal Virgins, were secretly exported to Vienna as a diplomatic gift for Prince Eugene of Savoy (from whose niece they were purchased in 1736 for Dresden by the Elector of Saxony), whilst a small bronze bust

39. Hubert Robert: Imaginary scene of the discovery and excavation of Herculaneum—engraving by Charles Guttenberg (from Saint-Non's *Voyage pittoresque*, Vol. I).

of Caligula found its way to Horace Mann in Florence who gave it in 1767 to Horace Walpole.[6] But neither Charles nor Ferdinand permitted any sales. And from the start of the royal interest in the excavations a jealous guard was kept over the sites. This did not prevent Caylus from acquiring, and proudly publishing (despite threats that the Neapolitan government might put pressure on the French), some small items, including pieces of mural paintings smuggled out for him by Soufflot.[7] Later Goethe was to raise his eyebrows at some of the objects he spied in the cellar of Sir William Hamilton's villa.[8]

The security measures at Portici itself were almost carried to the fantastic lengths associated with the protection of the royal game in those years, and numerous visitors, from de Brosses in 1739 onwards, described the difficulties that they had in obtaining permission to see the antiquities, and the prohibition against sketches or even taking notes.[9] As a consequence, the illustrations provided by Cochin the Younger and Bellicard for their book on the antiquities of Herculaneum in 1754 were made from memory,[10] as were the illustrations in Caylus's *Recueil*, some of which were drawn by Boutin, others by an artist whose name Caylus thought it prudent to conceal.[11]

The Bourbons were never concerned to encourage wide popular knowledge of the collection. Within their kingdom there could be no rival collectors to outshine and it was perhaps beneath them to take special steps to encourage wealthy foreign travellers. At first the official *Antichità di Ercolano* was for presentation only, but in

1773, after the failure to suppress the first (and, as it turned out, only) volume of Martyn and Lettice's translated edition, the first five volumes were made available for sale. From 1789 Piroli issued relatively cheap volumes of copies of the official plates. Once published, the antique paintings were quickly reproduced, imitated and adapted. Very few antique pictures (as distinct from painted wall decorations) were known at an earlier date, with the notable exception of the 'Aldobrandini Wedding' discovered in 1606. That painting had excited great curiosity, but was not universally admired (despite Padre Resta's claim that it was by Apelles), and in fact the paintings from Herculaneum disappointed many connoisseurs and provoked elaborate apologias from others.[12] The sculpture—especially the *Equestrian Balbus* (Figs. 81 and 82)—was far more fervently and widely admired. But it was impossible to make good copies of it and it was therefore less influential than were the paintings.

The appeal of the royal collection at Naples during most of the second half of the eighteenth century may easily be imagined by those art lovers today who enjoy penetrating the few remaining private collections which contain excellent works of art enjoying great reputations but not familiar through reproduction. But in the last years of the century the collection also became important because some of the most familiar and reproduced works of art in the world were added to it. The Farnese marbles were removed from Pàlazzo Farnese, the Farnesina, the Orti Farnesiani and the Villa Madama in Rome and sent on to Naples between 1787 and 1800 after cleaning and restoration by Carlo Albacini. The operation was organised by Domenico Venuti and Jacob Philipp Hackert, antiquary and painter to the Bourbon Court.[13]

In the winter of 1796 some of the royal antiquities were in the English Garden at Caserta, others in the Bosco at Portici, or the Boschetto at Capodimonte, but most of the antiquities from Herculaneum and Pompeii were still in the palace at Portici, and most of the Farnese antiquities inside the palace at Capodimonte.[14] A few works from both collections—including the most famous from them all, the *Farnese Hercules*—had, however, been moved to the new museum where Ferdinand, acting on Hackert's advice, had, since 1787, planned to combine his collections.[15] The new museum was situated in the Palazzo dei Vecchi Studi, originally designed as the vice-regal stables, later altered and extended to serve as a university, and now transformed, to fulfil its new function.[16] A solemn procession of statues was envisaged (Fig. 40).

The Farnese statues were in fact gradually moved from Capodimonte, into the new museum, mostly by 1805. However, in December 1798, as the French army approached, the more portable of the treasures from Portici, perhaps including the famous *Seated Mercury* (Fig. 139), together with the royal jewels, were conveyed through a subterranean passage to the shore under the direction of Emma Hamilton, and were removed, with the Court, to Palermo by the British navy.[17] Some of the remaining antiquities were taken by the French to Rome, where in 1801 they were reclaimed by the Neapolitan army.[18] In 1805 when the Bourbons again retreated before the French army more was removed to Palermo,[19] including new items which had been excavated by the French at Pompeii. To make up for this, and in exchange for French sporting firearms, Ferdinand sent a selection of bronzes, terracottas and mosaics to Napoleon.[20] The new rulers in Naples, Joseph Bonaparte

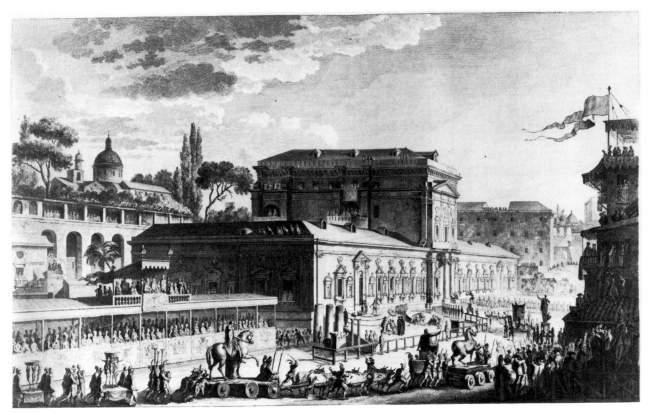

40. Louis-Jean Desprez: Imaginary scene of the 'Transport des Antiquités d'Herculanum, du Musœum de Portici, au Palais des Études à Naples'—engraving by Duplessi-Bertaux and Daudet (from Saint-Non's *Voyage pittoresque*, Vol. I).

and his successor Joachim Murat, and their queens, took a keen interest in protecting and extending the collections which remained.[21] It was Murat who began the negotiations which eventually, after his fall, led to the acquisition of the Borgia collection.[22] The Bourbons, however, on their return to the city, made it quite clear that the Museo Nuovo dei Vecchi Studi was theirs and on 22 February 1816 it was named the Museo Borbonico. In the following years antiquities from Portici and Palermo were steadily added to it. The transfer was finally completed by 1822.[23]

Even the *Equestrian Balbus* and the *Seated Mercury*, the two most celebrated statues excavated at Herculaneum during the eighteenth century, did not enter the visual consciousness of educated Europe, as did the *Capitoline Antinous*, the *Furietti Centaurs*, the *Faun in Rosso Antico* and the *Capitoline Flora* so soon after their discovery at Hadrian's Villa in the same period. And there can be no doubt that if the Kings of Naples had wished they could quickly have made not only the *Balbus* and the *Mercury* but at least half a dozen other statues preserved in their palace at Portici—certainly the Drunken Faun and the Athletes—fully as acclaimed and familiar as the masterpieces displayed in the Capitoline Museum. But, as we have seen, they actively discouraged the means by which such 'promotions' could be made. Indeed, for the decoration of the palace and gardens of Caserta, Luigi Vanvitelli (and, later, his son Carlo) commissioned marble copies, from sculptors specially summoned to Naples, of many of the most important antique statues to be

seen in Europe—except for those which were actually within the Kingdom of the Two Sicilies.[24] The *Germanicus* in Versailles, the *Castor and Pollux* in San Ildefonso, the *Venus de' Medici* in Florence, as well as both the *Belvedere* and *Capitoline Antinouses*, the *Centaur with Cupid*, and the *Apollino*, still in the Villa Medici, were all copied (evidently from casts though sometimes from small models)[25] between 1759 and 1779,[26] as too was the *Farnese Hercules* to which the Bourbons laid claim by family inheritance; their own treasures, however, remained concealed. In their extreme possessiveness the Bourbons were not alone: the heirs of the Ludovisi in eighteenth-century Rome resisted almost all attempts to have casts taken from their statues,[27] but these had been so extensively reproduced in earlier years that their fame remained as great as ever, and in fact a copy of *Papirius* was among those made for the grounds of Caserta.[28]

The attitude of the Bourbons changed slightly in 1782 when the French obtained, as a special concession, a plaster cast of the *Mercury*.[29] All the same, the extensive lists of bronze statuettes after the antique cast by Righetti and Zoffoli in the 1790s in Rome included no figures from Herculaneum and Pompeii (although Righetti did sell copies of the famous Sphinx tripod[30]). Even at the royal porcelain factory in Naples miniature biscuit reproductions made were much more commonly of the Farnese than of the Portici antiquities.[31]

By the end of the Napoleonic Wars, perhaps chiefly on account of Canova's admiration for it, the fame of a marble statue of a draped orator, the so-called *Aristides* (Fig. 79), had almost equalled that of the *Balbus* and the *Mercury*, and in 1819 a cast was being made at the special request of the Prince Regent of England. Finati, who recorded this, noted that it would be a crucial step in establishing the statue's reputation as equal to the finest in Rome.[32] He clearly hoped that this would set a precedent and that other casts would be permitted; but they were not, and even the seated *Mercury* does not appear in the most extensive lists of the mid-nineteenth-century plaster-cast sellers.[33] And when the Comte de Clarac was compiling his *Musée de sculpture* between 1820 and 1847 his draughtsman, Féron, a pensioner of the French Academy in Rome, was obliged to sketch the seventh-eight statues then 'unpublished or reserved in the vaults of the Herculaneum Academy' in secret.[34] Only after 1860, when the Museo Borbonico became the Museo Nazionale, did the most admired statues from Herculaneum and Pompeii—especially the *Seated Mercury*, the *Dancing Faun* and the *Narcissus*—begin to be reproduced as extensively as the *Apollo Belvedere* or the *Venus de' Medici*.

XI

The Proliferation of Casts and Copies

Louis XIV's initiative in commissioning marble copies of all the finest antique statues in Italy and the provision of a complete set of plaster casts for the French Academy in Rome could not be rivalled by any subsequent sovereign, but both the gardens of Versailles and the premises of the Academy continued to attract widespread admiration and international imitators. A set of casts was sent soon after 1682 to the Hague Academy.[1] Nicodemus Tessin obtained special permission to use the French moulds, and twenty-four large cases of casts were despatched to Sweden in 1698 and displayed in a special gallery. They would, almost a century later, in 1780, serve the function Tessin had intended and adorn the revitalised Academy of Art.[2] Earlier, in the 1690s, John Sobieski III had copies of antique statues made for the gardens at Villanuova (Wilanów), his Polish Versailles near Warsaw, half a dozen of which survive, and projected a Polish Academy of Art[3]—an ambition later realised by Stanislas Poniatowski.[4] A print made between 1696 and 1701 shows casts of the *Farnese Hercules*, the *Laocoon*, the *Venus de' Medici*, the *Dancing Faun* and the *Belvedere Antinous*, installed in the royal Akademie der Künste in Berlin.[5] In Rome in 1713, despite the war and the high wages demanded by Roman craftsmen, the Elector Palatine had a collection of casts made after the antique for an academy in Germany ('où le bon goût est absolument inconnu') which, when seen a few years later in Düsseldorf, was considered comparable with that of the French Academy.[6]

In England, however, there was no great patron of the arts stirred to emulate Colbert's achievement. Although several artists formed small academies which in at least two cases owned some plaster casts, and although at least one duke arranged for students to have access to his private set,[7] it was not until 1768 that the Royal Academy was founded by George III. The most interesting developments in early eighteenth-century England were due more to private enterprise than to public patronage.

Soon after 1700 foreign craftsmen began to pioneer the commercial production of lead garden statuary and plaster casts after the antique in England.[8] Copies of at least eight of the statues in our catalogue are mentioned in the studio sale of the elder John van Nost in 1712[9] and a similar number appear in a list sent by his pupil André Carpentière to Lord Carlisle in 1723.[10] These lead statues—which were available to men who could not afford full-size bronze copies—were most commonly employed to animate the skylines of great houses and to adorn the formal gardens of houses such as Timon's in Pope's satire, where 'Gladiators fight, or die, in flowers'.[11] These

were not all of high quality and some, which are reversed, must have been made from prints (Fig. 41).

The English taste for 'artful wildness' in gardens meant that after 1730 they were likely to use fewer statues than there had been at Versailles or Hampton Court. But statues remained popular, exposed at first as at Rousham in Oxfordshire but protected later on by garden temples as at Stourhead in Wiltshire and as in the fictional garden in Spence's *Polymetis*. Whereas French gardens in the eighteenth century tended to be adorned by modern sculptures, these English garden statues were usually copies of the antique (Figs. 42 and 43). The chief producer of lead garden statuary, and also plaster casts, bronzed plaster statuettes and plaster library busts in mid-eighteenth-century England was John Cheere. He sent casts and copies to all corners of the country and even exported lead statuary to Portugal.[12] It also seems that his yards at Hyde Park Corner in London were much visited. By this means, as Hogarth commented in his *Analysis of Beauty*, the most admired antique statues were 'more generally known' than any of the equally good modern ones.[13] Cheere's moulds were still in existence in 1792, when Flaxman's father bought some.[14]

There are several startling testimonies to widespread familiarity with antique statues in the mid-eighteenth century. As a child, wrote Diderot in 1763, Bouchardon's first glances fell upon the *Laocoon*, the *Venus de' Medici* and the *Gladiators*—for those figures are to be found 'in the studios of the learned and the ignorant'.[15] And a little later Smollett remarked of the *Laocoon* that it was well known from 'innumerable copies and casts of it, in marble, plaister, copper, lead, drawings, and prints'.[16] But the opportunities in the provinces were not the same as those in London and Paris. Nor were the opportunities the same in all countries.

Mengs studied from casts after the antique in Dresden before his first visit to Italy—but these were not whole figures and had been specially acquired by his father.[17] And in 1769 when Herder wrote with rapture of the *Apollo*, *Laocoon*, *Antinous* and *Venus*—those 'models of Beautiful Nature' (Vorbilder der schönen Natur)—he had not seen casts in Germany, let alone the originals in Rome and Florence, but was responding to the marble copies at Versailles made for Louis XIV.[18] Goethe in his autobiography describes his excitement in reading Lessing and Winckelmann at Leipzig in his late teens, but the only casts available to him in this 'little Paris' were the *Dancing Faun* and the *Laocoon* (without his sons) which was all that the 'academy' of Winckelmann's friend and mentor Adam Friedrich Oeser possessed. Only later, on visiting the Antikensaal at Mannheim in 1769 (the same year that Herder was at Versailles) did Goethe see—suddenly and in blinding succession—casts of most of the masterpieces of which he had read so much.[19] This superb gallery had been formed two years earlier by the Elector Karl Theodor, and we know from Schiller's account in his *Brief eines reisenden Dänen* of 1785 that it then contained casts of over a dozen full-size statues and groups, and numerous heads, among them portraits of Homer and Voltaire (a juxtaposition which Schiller found ludicrous).[20] Some of these casts had come from the collection at Düsseldorf.

At Frankfurt in 1773 Goethe was to purchase 'a fairly good head of the *Laocoon*' and 'a few other things'.[21] Ten years later he had seen the collections at Cassel where, between 1760 and 1785, the Landgraf Friedrich II followed the example of his

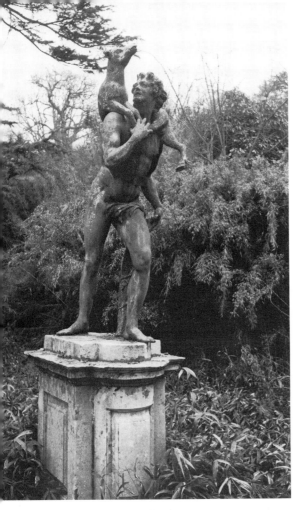

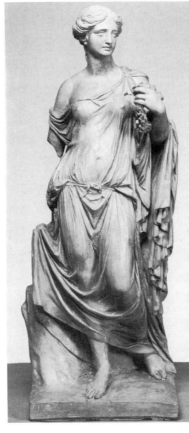

41. (far left) Reversed copy in lead of *Faun with Kid* (Chatsworth, Derbyshire), probably based on Thomassin's print of the marble copy of the statue at Versailles.

42. (below) John Cheere: Copy in white enamelled lead of the *Cleopatra* (The Grotto at Stourhead, Wiltshire).

43. (left) Michael Rysbrack: Terracotta model for the copy of the *Farnese Flora* made for Stourhead—height 57.3 cm (Victoria and Albert Museum).

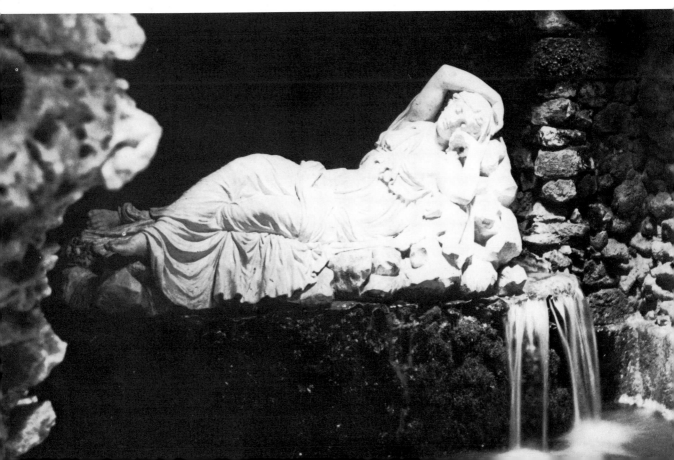

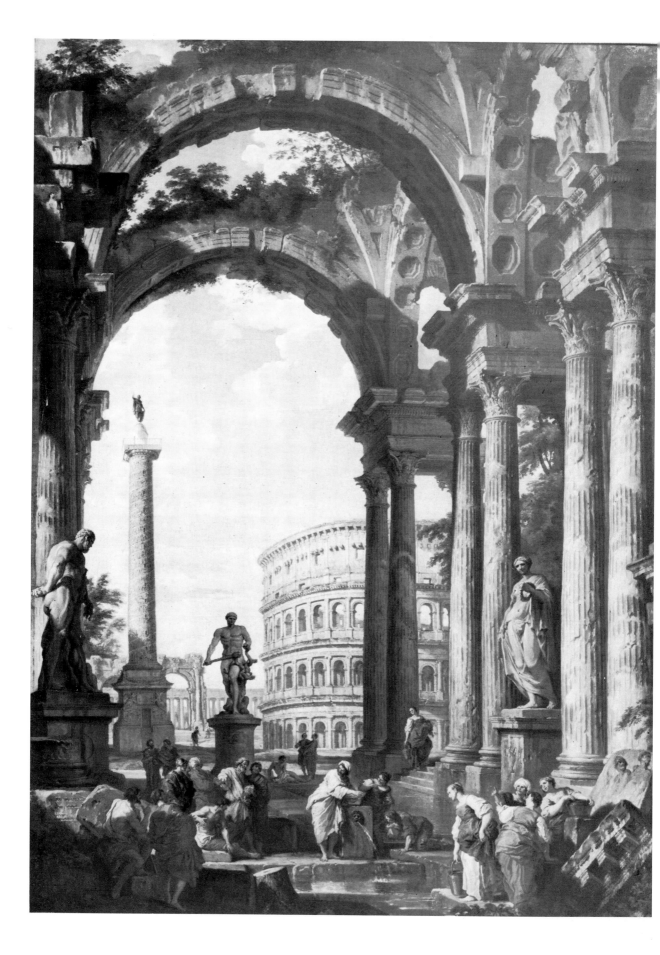

immediate predecessors in acquiring casts, marble replicas and small bronze copies of the most famous antiques on a lavish scale,[22] and had also seen the casts at Gotha. Some casts had also been made at his suggestion by the court sculptor at Weimar.[23] When eventually he fled from Weimar to Italy in 1786, and before he reached either Florence or Rome, he visited what was one of the most comprehensive collections of casts formed in the second half of the eighteenth century, that in the Palazzo Farsetti in Venice. A number of these had been made in the early 1750s only by the special intervention of Abate Filippo Farsetti's cousin, the future Pope Clement XIII, and Goethe noted that much of what he saw there was quite new to him.[24] Once in Rome itself he described the wonders of the plaster cast workshops where a succession of pure white limbs came from the moulds and where the most beautiful statues were assembled together as they could never be in reality.[25]

The cast galleries at Mannheim and Venice were both inspired by the collection of the French Academy in Rome. It was after a visit to the Academy in the late 1730s that the Président de Brosses toyed with the idea of buying a 'belle douzaine' of the best casts available. Considering how moulds damaged and discoloured the original

44. (left) Gian Paolo Panini: *Capriccio* of Roman monuments (Ashmolean Museum, Oxford).

45. Gian Paolo Panini: Imaginary gallery of ancient Roman art (Staatsgalerie, Stuttgart).

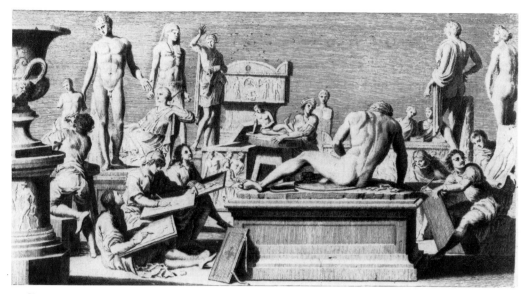

46. Giovanni Domenico Campiglia: Students drawing and modelling from casts of statues in the Capitoline collection (from Bottari's *Musei Capitolini*, Vol. III).

marbles he reckoned that good casts would be less easy to acquire in the future. But he was deterred by the reflection that he had no gallery suitable to receive them back in France.[26] A compromise might have been found in the *capricci* just then being made popular by Gian Paolo Panini. In works of this sort, which were already being painted in the seventeenth century,[27] accurate depictions of some of the most famous buildings and statues in Rome—the Colosseum, Trajan's Column, the Farnese *Hercules* and *Flora*, for example—were placed together in an invented setting (Fig. 44). The statues in these souvenir pieces could be selected by the client to form a sort of ideal cabinet, as was the case, much later, in about 1780, with the set of eight tall canvases which Hubert Robert, a disciple of Panini, provided for the dining room of the Hôtel Beaumarchais.[28] In 1756 Panini was in fact commissioned by the Duc de Choiseul, who was the French Ambassador in Rome, to paint an imaginary palatial gallery stocked with the greatest treasures of ancient Rome (Fig. 45). The painting, which was repeated twice in the following two years, with minor variations, included over a dozen antique statues, and a few more if one counts those portrayed in paintings on the walls.[29] More than any description of the Palazzo Mancini, this fantasy enables one to appreciate the ideals which were embodied there in the French Academy's cast collection.

The Duc de Choiseul also commissioned from Panini a pendant showing the greatest treasures of modern Rome. But some arbiters of taste disapproved of such catholicity. In 1763 Diderot, who had never been to Italy, counselled art lovers to replace their Virgins by Raphael and Guido with the *Hercules*, the *Venus*, the *Apollo*, the *Torso*, the *Gladiator*, the *Antinous*, the *Laocoon* and the *Silenus*—'les apôtres du bon goût chez touts les nations'.[30] It is unlikely that anyone took him at his word, but one important French patron, the prodigal *fermier-général* Étienne-Michel Bouret, was at that date in the process of forming a collection of antiques copied by Guiard—although his emphasis on erotic works is alien to the values implied by Diderot's selection.[31]

As has already been mentioned, Matthew Brettingham the Younger was in

Rome in the early 1750s buying up antique sculpture for the Earl of Leicester. He was also sending back plaster casts, and in some cases moulds, of the most beautiful statues in the city of which he boasted that 'the greatest part have never made their appearance in England'.[32] Many of these seem to have been obtained by special arrangement with the agents of 'a certain Venetian abby'—Farsetti—who had Benedict XIV's permission to take new moulds of all the best statues, apparently on condition that a set of casts from them was supplied to the Pope's native city of Bologna.[33] Brettingham wanted to raise subscriptions for an English academic cast collection with forty or fifty of 'ye noblest statues antique and modern' gathered together in a great square room more splendid even than the cast rooms of Rome and Paris.[34] He also hoped to supply an academy in Dublin.[35] It was, however, a private house—Holkham Hall, the Norfolk seat of the Earl of Leicester—which Brettingham filled with casts. At least twenty of them were distributed in the Garden Temple and around the state rooms, chiefly under the portico and in the niches of the great hall, a room based on Palladio's interpretation of a hall described by Vitruvius, with ornaments carefully copied from Desgodetz.[36]

One would not be surprised to find one or two casts in the hall of an English country house of the early eighteenth century, but there is evidence that the owners and decorators of such houses would have liked to have had more. Around the great staircases of Moor Park, Raynham, Houghton Hall and Kensington Palace niches filled with famous antique statues were painted in grisaille. Jervas painted a set for Alexander Pope and the taste was promoted by William Kent, the protégé of Pope's friend Lord Burlington.[37] The Duke of Marlborough of course had his four bronze copies by Soldani and at least as early as 1714 the Earl of Strafford was planning to have marble copies made for Wentworth Castle in Yorkshire. Four were in the gallery there by 1749 when the Marquess of Rockingham, a neighbour and relative of Lord Strafford, encouraged his son to commission twice as many for the hall at Wentworth Woodhouse.[38] Sets of five casts of statues from the

47. Pompeo Batoni: Portrait of Peter Beckford (Royal Museum of Fine Arts, Copenhagen).

48. John Singleton Copley: Portrait of Mr. and Mrs. Ralph Izard (Museum of Fine Arts, Boston).

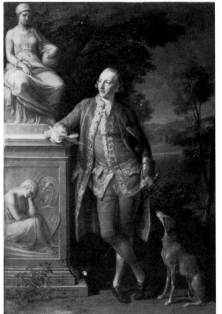

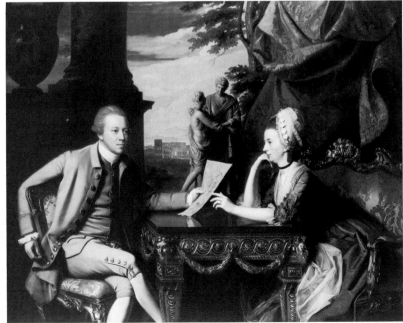

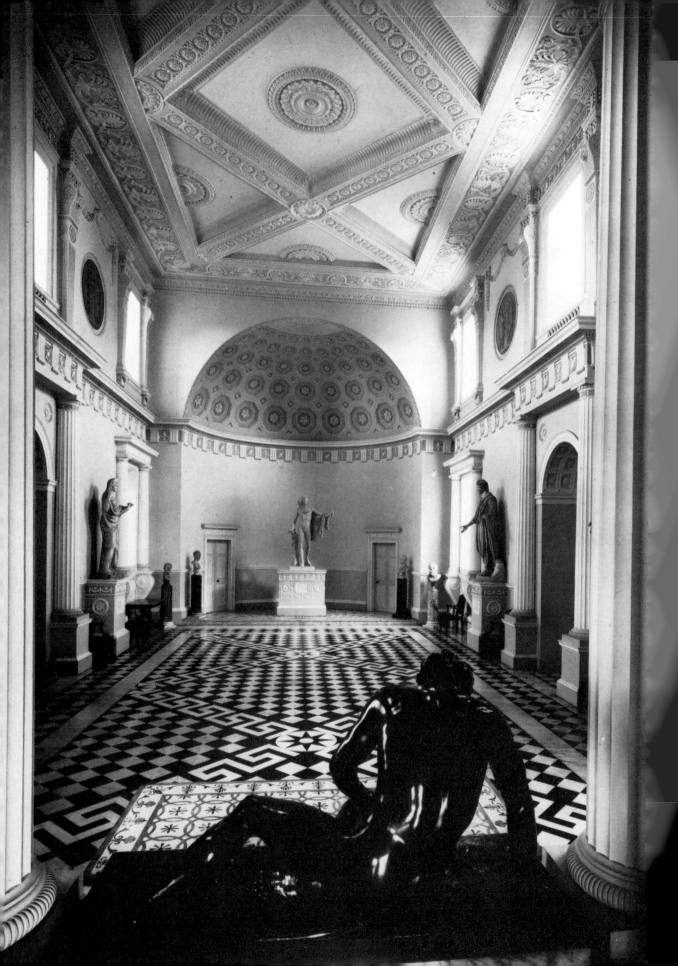

Uffizi had been ordered from Florence by Horace Walpole just before and just after Brettingham's visit to Rome;[39] at the same period Simon Vierpyl was making casts in Rome for Lord Charlemont in Ireland and terracotta copies of busts and statues in the Capitoline Museum (Fig. 46) for Charlemont's tutor:[40] and in March 1758 a set of casts, assembled in the Duke of Richmond's house in Whitehall under the direction of Joseph Wilton, was made available to artists.[41] It also became increasingly the custom for travellers to have themselves painted in Rome more (Fig. 47) or less (Fig. 48) at ease in the company of famous antique statues.

By the early 1760s, when Diderot was recommending that proper shrines be made for the 'apostles of true taste', Holkham Hall was finally completed and another great hall had been projected by Brettingham for Kedleston in Derbyshire, which was eventually built to the designs of Robert Adam and was surrounded, as was Adam's gallery at Croome Court in Worcestershire, with a set of casts after the antique. At Kedleston there were also stone copies of the antique on the skyline of the house and lead copies in niches on the facade.

More remarkable even than Holkham, Kedleston, or Croome, are Adam's rooms at Syon House in Middlesex. In the hall there is a plaster cast of the *Apollo Belvedere* and a bronze copy by Valadier of the *Dying Gladiator* (Fig. 49). In the adjacent ante-room

49. (left) Syon House, Middlesex—the entrance hall designed by Robert Adam.

50. Syon House, Middlesex—the ante-room designed by Robert Adam.

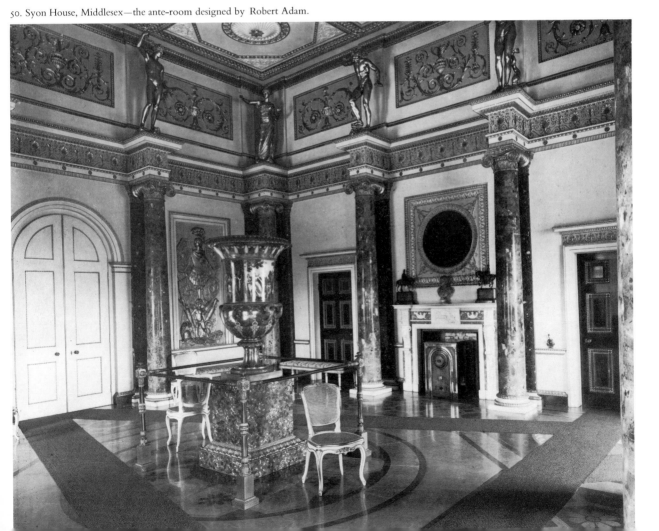

(Fig. 50) are bronze copies of the *Belvedere Antinous* and the *Borghese Silenus* cast by the same founder and twelve verde antico columns support a projecting entablature crowned by a series of twelve gilt casts, all of antique statues (except one, of Canova's Hebe, which must be a later replacement). In the next room five marble copies of antique statues (together with a copy by Wilton of Michelangelo's Bacchus) stand sentinel opposite the state dining table. Furthermore, in all the rooms there are reliefs in stucco and simulated reliefs in grisaille copied or adapted from sources such as the 'Aldobrandini Wedding', the Trophies of Marius, and the roundels of the Arch of Constantine. There had been no domestic interiors since the royal apartments at the Alcazar in Madrid a century earlier so filled with casts and copies of the antique.

What became common in fashionable English interiors in the 1760s was emulated in the following decades all over Europe. The Hall of Mirrors in the Royal Palace of Stockholm was adorned by 1782 with marble copies by Sergel of the *Apollino* and the *Callipygian Venus*.[42] About a decade later the ballroom of the palace of Lazienski in Poland, designed by Kamsetzer, was enriched with copies by Antonio d'Este and Angelini of the *Apollo Belvedere* and the *Farnese Hercules*.[43] A little later copies after the antique as well as real antiques decorated the gallery of Princess Lubomirska at Lancut.[44] And even in Italy, where the originals themselves were still mostly to be seen, this fashion prevailed. The casts in the Galleria of Palazzo Sacchetti in Rome were probably supplied during the course of the eighteenth century,[45] and in the 1820s Prince Borghese decorated the Salone of his newly built palace in Florence with reproductions of the most famous antique statues in the city and placed above a fountain in the courtyard a colossal marble copy of the *Capitoline Venus*.[46] Academic collections flourished alongside domestic ones. As has already been mentioned royal academies with proper cast collections had been established by the 1780s in England, Sweden and Poland. Mengs had also by then supplied the Madrid Academy with what he believed was the best and most extensive collection in Europe.[47] But there is no space here to explore the situation in every country. Instead we will confine ourselves to the extreme east and the extreme west of the 'Western world'.

By the second decade of the eighteenth-century Peter the Great was acquiring from Rome copies of the most admired antique statues (among them the *Belvedere Antinous* and the *Faun with Kid*),[48] but the main imports into Russia came later. The Imperial Academy of Fine Arts was founded at St. Petersburg by the Empress Elizabeth in 1758, and was given its constitution under Catherine the Great in 1764. Kokorinov's building for the new institution was commenced in the following year and completed in 1768. Casts of the 'best antique masterpieces'—including the colossal *Hercules* and *Flora* from the Farnese collection which stood in the entrance hall—were collected during the late 1760s by General Schouvalov, who obtained special permission to have new casts made of the Uffizi statues, and by Winckelmann's friend Reiffenstein.[49] By the early 1780s Gordeyev, using these casts, had begun to make copies of the *Apollo*, the *Furietti Centaurs*, the *Niobe Group*, the *Farnese Flora*, the *Medici Mercury* and the *Callipygian Venus*—and also the set of Muses discovered at Tivoli in 1774.[50] These were cast by Vassili Mozhalov and Edmé Gastecloux and erected in the gardens of Pavlosk, firstly at key points in

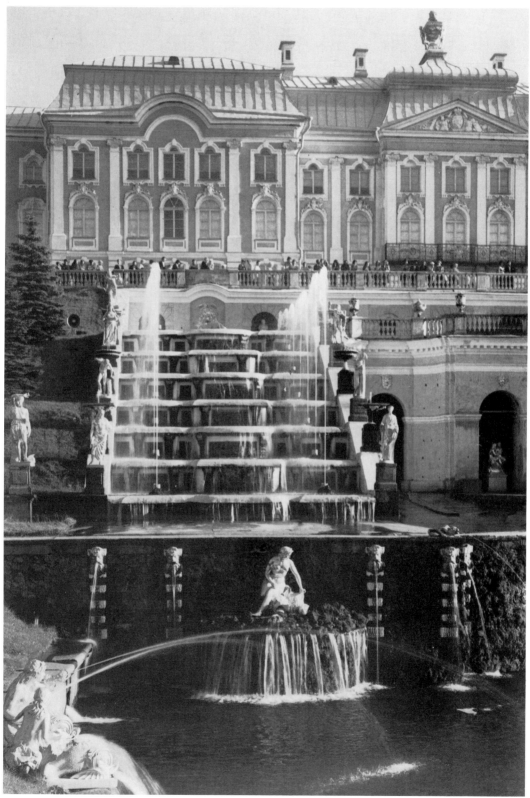

51. The Great Cascade at Peterhof.

Cameron's English landscape garden and then in the early 1790s in Brenna's formal gardens.[51] The palace itself was also filled with casts and with marble copies large and small.[52] In the same period bronze copies of the Farnese *Hercules* and *Flora* were used to flank the entrance of the colonnade and baths which Cameron added to the Imperial palace of Tsarkoe Selo.[53] Even richer in copies of some of the most famous antique statues were the gardens of Peterhof which began to be laid out for Peter the Great between 1714 and 1716. The decoration of these gardens with statuary continued for some hundred and fifty years, and the many lead copies which were already in place during the eighteenth century were, in the period around 1800, replaced by others of marble and of gilded bronze which in the company of modern works (as at Versailles) make a spectacular effect on the terraces of the grand cascade (Fig. 51).[54] In fact the cumulative impact of the replicas of many of the finest statues in Florence, Rome and Naples which were to be seen in and around these three royal palaces near St. Petersburg was probably more impressive than anything of the kind outside Versailles; and numerous other palaces in Russia, such as Arkhangelskoye, built in 1780 for Prince Golitsin and refashioned for Prince Yusupov in 1810–11, were also supplied with casts and copies.[55] But the story is not a complicated one and is relatively well documented because the 'apostles of true taste' were invited into the country by the Court. In America there was no Court.

When John Smibert arrived in Boston in 1729 with the intention of establishing himself as a portraitist he brought with him what seem to have been the first casts of the antique to enter the New World—a bust of Homer, a *Venus de' Medici* and, probably, a *Laocoon*. They remained in his house for nearly thirty years after his death in 1751 and were visited there by John Singleton Copley and by Charles Wilson Peale; John Trumbull rented the house partly because of them.[56]

In about 1771 Thomas Jefferson jotted down a list of thirteen sculptures, reproductions of which he considered to be desirable ornaments for his new house, Monticello. He seems to have been working from travel books and anthologies of prints, for he had not yet visited Europe and two of the statues cannot be identified for certain—another is a Renaissance group, Giambologna's 'Rape of the Sabines', but the remaining items are all familiar antique statues of the sort which the St. Petersburg Academy had just acquired as casts.[57] However, Jefferson cannot have been very enthusiastic about his project because there is no record of any reproductions on any scale or in any medium of the listed sculptures in the 1809 inventory of his art collection—and it was the finest in North America—although there was a marble copy of the Vatican *Cleopatra*.[58] By then two large sets of casts after the antique had arrived in American institutions.

In 1801 Robert Livingstone, the American ambassador in Paris, was struck by the idea of acquiring for New York a set of casts of the antique statues in the Louvre and began to raise funds for this purpose. As a result the first meeting of the Society of Fine Arts was held in New York in December of the following year under the presidency of his brother Edward, and sixteen casts arrived in 1803.[59] They were placed in the Greenwich Street Pantheon and moved in 1805 to the former Governor's residence. By then the Society was known as the American Academy of the Arts.[60] It was also in 1805 that the printer Charles Wilson Peale and others managed to found the Pennsylvania Academy of the Fine Arts in Philadelphia. Eleven years

earlier, when he had made an abortive attempt to start an academy in the city, Peale had a cast of the *Venus de' Medici* in his possession (it had come to Pennsylvania in 1783 with the artist Robert Edge Pine). Now, inspired by the casts in New York, he and his co-founder, Joseph Hopkinson, contacted Nicholas Biddle, then secretary to the American ambassador to France, who, taking the advice of Houdon, arranged for over fifty casts to be made in the Musée. These were on display in Philadelphia in 1807. The works reproduced were all, it seems, antique with the exception of Houdon's *écorché*. Many must have been destroyed by fire in 1845, but several may still be in use today.[61]

Not long after the New York casts had arrived fig leaves were affixed and a separate day set aside for female viewing. In 1818 railings were erected around two of the Venuses which had been indecently disfigured,[62] and twelve years later Mrs. Trollope found that it was not considered proper for the casts at Philadelphia to be inspected by mixed society, and noted that indecent marks had been made on these as well.[63] In America then, as at Fontainebleau well over two centuries before, the masterpieces shocked and excited many who beheld them. But veneration was expected from the sophisticated, many of whom must have been painfully aware of the nation's reputation for philistinism—a reputation neatly conveyed by Stendhal's rhetorical question of 1819: 'Can one find anywhere in that so prosperous and rich America a single copy, in marble, of the Apollo Belvedere?'[64]

One might have expected the writers and artists of the new world to object to this veneration for the sacred relics of the old. But they did not object. Well before he had intoxicated Europeans with his tales of Red Indians, James Fenimore Cooper (born in 1789) had 'imbibed the respect of a child' for his father's prints of the most famous antique statues, and their 'forms had become familiar by years of observation' before, between 1828 and 1830, he stood in the Tribuna 'hat in hand, involuntarily bowing to the circle of marble figures that surrounded me'.[65]

It is hard in fact to discover anyone in the eighteenth or early nineteenth century who seriously challenged the esteem enjoyed by the statues which we have catalogued in this book. Chardin did complain about the tyrannical discipline of drawing from casts—'you haven't witnessed the tears which this satyr, this gladiator, this Venus de' Medici, this Antinous have exacted', he wrote.[66] But he was not denying that these statues were masterpieces. Hogarth complained about the pretensions of antiquarians and the huge prices fetched by indifferent restored antiquities, but he nevertheless illustrated his treatise on art by reference to the 'twenty or so' antique statues which 'may justly be called *capital*',[67] and Smollett, although he had dared to refuse to worship the *Venus de' Medici*, yielded to none in his praise of the other statues in the Tribuna.[68] Similarly Falconet, another artist who never went to Italy, and who resented the repetitive and thoughtless admiration of antique art at the expense of the modern and who was bold enough to attack the reputations of the *Niobe*, the *Bull*, the *Furietti Centaurs*, Trajan's Column and the *Marcus Aurelius*,[69] admired above all other works the *Borghese Gladiator*, the *Apollo*, the *Laocoon*, the *Farnese Hercules*, the *Torso*, the *Antinous*, the *Castor and Pollux*, the *Hermaphrodite* and, with some reservations, the *Venus de' Medici*.[70] He approved of the Empress Catherine acquiring casts for her academy in St. Petersburg,[71] and even described visiting the collection alone and being moved to tears by the *Apollo*.[72]

91

XII

New Fashions in
the Copying of Antiquities

PANINI'S IDEAL GALLERIES of ancient sculpture were populated both by the amateur and by the art student; careful drawings after antique statues (Fig. 52) not only served as academic exercises, but were cherished by connoisseurs; and domestic and pedagogic collections of casts were often interchangeable in the eighteenth century, although there were certain pieces such as the *Belvedere Torso* which were unlikely to be found in the former. The cast collections of New York and Pennsylvania were, we know, visited by society as well as studied by academic students, and the same was true at Mannheim, in the Palazzo Farsetti and in the Palazzo Mancini, headquarters of the French Academy in Rome. There were, however, also reproductions of antique sculpture, which were purely domestic—lead garden sculptures, for instance, and bronze or ceramic statuettes.

Famous antique sculpture was reproduced in bronze before it was reproduced in any other form—Filarete's statuette of *Marcus Aurelius* dedicated to Piero de' Medici in 1465 being at least thirty-five years earlier than engravings after this or any other antique statue.[1] But, although Antico, in a letter of 1519, could write to Isabella d'Este that he was prepared to have replicas made of the little bronzes which he had cast for Lodovico Gonzaga[2] and although a great many small bronze copies after the antique were made in the seventeenth and eighteenth centuries, especially in Florence (as we have seen), and in Paris, these were luxuries—according to Baldinucci a *Farnese Hercules* by Antonio Susini fetched as much as five hundred scudi[3]—and it will be remembered that full-size bronzes were among the most highly valued objects in seventeenth-century royal collections. More than a hundred years later such copies were still available and we know that the Duchess of Northumberland paid three hundred pounds for the *Dying Gladiator* at Syon (Fig. 49) which was cast for her by the goldsmith and founder Luigi Valadier who also made copies of the *Apollo Belvedere* and the *Ludovisi Mars*.[4] Valadier's pupil, rival and successor, Francesco Righetti, produced similar casts, a set of which apparently went to Holland in 1781.[5] It was in Rome in these years that a new development seems to have taken place with the commercial production of a wide range of small bronze copies at a price attractive to the ordinary gentleman traveller. In this business Righetti was the leading figure, but he had a rival in Giovanni Zoffoli (who took over Giacomo Zoffoli's foundry in 1785). To judge from their catalogues in 1795 the two firms sold statuettes of the same size, but Zoffoli's were cheaper, and some, cheaper still, were made by the obscure Giuseppe Boschi.[6] The much larger

52. Pompeo Batoni: Count Fede's version of Cupid and Psyche—drawing (Topham collection, Eton College).

53. Johan Zoffany:
Portrait of Sir
Lawrence Dundas with
his grandson (Marquess
of Zetland collection).

list of Righetti included, in addition to copies of many antique and some modern statues, busts, vases, animals, ormolu clock ornaments, and marble pedestals.[7]

Righetti's and Zoffoli's small bronzes were generally bought in small sets suitable for the chimney-piece, and a remarkably early record of such a display is provided by Zoffany's portrait of about 1770 of Sir Lawrence Dundas and his grandson (Fig. 53). Here the *Borghese Gladiator* and the *Faun in Rosso Antico*, the *Capitoline Antinous* and the *Apollo Belvedere*, and the *Furietti Centaurs* flank Giambologna's Mercury—bronzes probably supplied by the elder Zoffoli. A similar set survives at Alnwick in Northumberland, and another may still be seen on a chimney-piece at Saltram in Devon.

Before his death in 1785 the Roman goldsmith Luigi Valadier, whose bronze copies have already been mentioned, introduced lavish desserts consisting of miniature reproductions of antique statues and temples.[8] It later became fashionable for such desserts to be made of Tuscan alabaster. Vases and statuettes of this material were being manufactured at Prato and sold in Florence both before and after the Napoleonic Wars.[9] These are sometimes mistaken for porcelain which was, of course, the usual material for desserts.

In the summer of 1739 when the rococo was the height of fashion, Count Algarotti, writing of the ceramic factory at Meissen, envisaged white porcelain versions of antique reliefs, medallions of emperors and philosophers and figurines of 'the most beautiful statues, such as the Venus, the Faun, the Antinous, the Laocoon' sufficient to adorn all the cabinets and desserts of England.[10] As usual, Algarotti was ahead of his time, and cases in which designers in the ceramic industry turned for inspiration to the antique were at first rare. In the 1740s and 1750s a number of models and waxes which had been made by Soldani and Foggini after some of the most famous antique statues in Florence were acquired from the sons of these artists by the Marchese Carlo Ginori's porcelain factory at Doccia, and under the direction of Gaspero Bruschi ceramic versions—in very varying sizes, some of them exceptionally large for the material—were produced of the *Arrotino*, the *Venus de'*

94

54. (left) Mid-eighteenth-century copy of the *Venus de' Medici* in glazed earthenware (Museo di Doccia, Sesto Fiorentino).

55. Companion figurines of Mark Anthony and *Cleopatra* in coloured earthenware by Enoch Wood of Staffordshire (Museum of Fine Arts, Boston).

56. Biscuit figurine by Volpato of the *Barberini Faun* (Palazzo dei Conservatori, Rome).

Medici (Fig. 54) and other figures in the Uffizi.[11] There are also very crude Staffordshire salt-glazed earthenware figurines which date from the 1750s, modelled, it seems, after a distorting print of the *Spinario*,[12] and some time before 1759 the Capodimonte factory in Naples had produced a porcelain *Laocoon* covered in mauve drapery and green snakes.[13] In the 1760s Beyer modelled a rococo version of the *Venus de' Medici* (supplied with a greatly inflated blue, orange and green dolphin) for the Ludwigsburg factory,[14] and there are other copies, either in rococo porcelain, such as those made at Bow, or, comic, in polychrome glazed earthenware (Fig. 55), such as those made in Staffordshire by the Wood family, dating from the following decades,[15] but they are hardly what Algarotti had in mind. He would have been more appreciative of the biscuit statuettes after the antique made by the Sèvres factory between 1768 and 1770, but the fact that only a limited number were produced suggests that such an initiative was still premature.[16]

One of the things Algarotti had envisaged was a ceramic equivalent to the sets of little bronzes which were to be profitably produced by Roman founders in the last decades of the century, and it was not until 1785 that Giovanni Volpato, a leading engraver, and a friend of Gavin Hamilton, Angelica Kauffman and Canova, opened a factory in the Via Pudenziana in Rome with the intention of doing just that. He specialised in biscuit porcelain reproductions of the same size and in many cases of the same subjects as the statuettes sold by Righetti and Zoffoli (Fig. 56). Encouraged by 'Madame Angelica', C.H. Tatham sent a list of the firm's products to Henry Holland in 1795 remarking that the porcelain was similar in quality to the French but 'very superior as to design, workmanship and art'. 'At this depot', noted the Baron d'Uklanski, 'you may now have the finest things of this description which interest the dilettante and do not disgrace even an elegant drawing-room'.[17] Volpato also established, two years before his death in 1801, a factory at Civita Castellana producing coarser and cheaper figures, also after the antique, which continued under his grandson's management until the mid-nineteenth century (although the factory in the Via Pudenziana closed in 1818).[18] Even before Volpato opened his first factory, the Ludwigsburg porcelain factory had taken some steps in the same direction, as had the new royal porcelain factory at Naples under the direction of Domenico Venuti.[19] Another Neapolitan factory—that of the Giustiniani—also later produced figures of this type.[20]

Algarotti's other ideas anticipated the works of the Staffordshire potter Josiah Wedgwood, who established a reputation in the 1760s with his creamware inspired by the 'chaste simplicity' of antique art. By the mid-1770s he was imitating 'Etruscan' vases in a new black porcelain bisque (basaltes), producing small busts of Homer, Cicero, the *Zingara* and the like in the same material, and had devised a new body (jasper) which he was beginning to use for 'intaglios, cameos, medallions and tablets' adorned with copies of antique reliefs and statues ranging from the *Dacia* to the *Farnese Hercules* (Fig. 57).[21]

Innovation and experiment in ceramic technology also coincided with neoclassical taste in the artificial stone products of Mrs. Coade's factory at Lambeth in London, in the last third of the century. The Coade factory produced some copies of antique vases and reliefs and statues suitable for interior or exterior use[22]—much the same statues in fact as the earlier London lead-founders, whose business seems to

57. (left) Oval plaque of the *Farnese Hercules* in blue and white jasper by Wedgwood and Bentley—height: 18.2 cm (Wedgwood Museum, Barlaston, Staffs.).

58. (above) Cameo with *Papirius*—enlarged (Private collection, London).

59. (below) Nathaniel Marchant: Half of 'One hundred impressions of gems' (Sir John Soane's Museum, London).

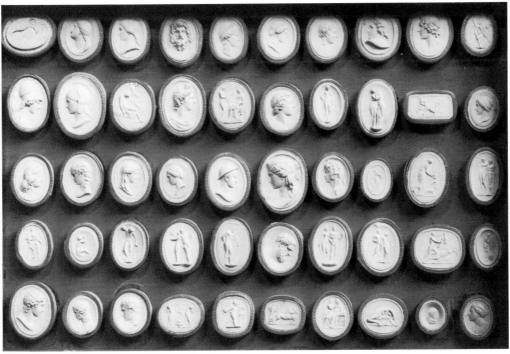

have declined with the rise of this rival alternative to costly bronze and vulnerable marble. In fact Coade stone copies were intended for the same places as copies in lead, bronze or plaster. On the other hand, the display of copies after the antique on the dining-room table and chimney-piece was a new idea. And so too was their popularity on an even smaller and more intimate scale, on snuff boxes, and in rings, chatelains, bracelets and necklaces (Fig. 58).

During the eighteenth century it became an increasingly popular hobby among dilettanti to collect and even to make their own paste impressions from gems. In the mid-century, Philipp Daniel Lippert, working in Dresden, invented a type of white paste for this purpose, and by 1756 he offered for sale impressions of two thousand gems.[23] In Rome, where Baron Stosch's former servant Christian Dehn sold pastes and sulphurs, German travellers on the Grand Tour were also given evening classes by Hofrat Reiffenstein in matters such as making replicas of variegated cameos.[24] In London at the same time James Tassie, a Scottish wax portraitist at first employed by Wedgwood, began to achieve an international reputation for his work in this field. Among the long catalogues, which he published in 1775 and 1791, of the cameos and intaglios which he cast 'in coloured pastes, white enamel and sulphur'[25] were numerous modern works by artists such as the Sirlettis or the Pichlers, and of these many were copies of antiques such as the *Laocoon Group*, *Antinous*, *Agrippina*, *Zingara*, *Papirius* and the *Apollo Sauroctonus*. Among the cameos and intaglios listed by Wedgwood in 1779 such statues also featured prominently.[26] The greatest English gem-engraver, Nathaniel Marchant, during his residence in Rome (when he was also very active exporting plaster casts to England)[27] specialised in reproducing antique statues on gems for wealthy travellers, and when he returned to England he sold impressions of these in competition with James Tassie, whose business was continued into the nineteenth century by his nephew William.[28]

In addition to the settings provided by jewellers, sulphurs or pastes—or *impronte*, as they were called in Italy—were arranged in boxes shaped like books (Fig. 59). Dolce's treatise on ancient gems was illustrated by four boxes of this sort in 1792,[29] and, in the early nineteenth century, travellers to Rome could buy from dealers such as Francesco Carnesecchi in the Via Condotti or later from Pietro Paoletti in the Via della Croce[30] sets of *impronte* showing 'uomini illustri', a selection of the best loved works by Canova and Thorvaldsen, the most admired antique statues, and Renaissance paintings. Samuel Rogers when in 1798 he blessed the 'mechanic skill'

> That stamps, renews, and multiplies at will;
> And cheaply circulates, thro' distant climes,
> The fairest relics of the purest times

was thinking as much of 'sulphurs' as of engravings and plaster casts.[31] The souvenir boxes could be afforded by those who would not have bought bronze statuettes, and—as is often the case with reproductions intended for a very wide market—they failed to take account of changes of taste crucial to the learned, and illustrated a range of antique statues which differed hardly at all from the sculpture found in cast collections of the mid-eighteenth century. And yet in the interval new standards of appreciation and new interpretations of antiquity had been proposed and debated with quite unprecedented energy.

XIII

Reinterpretations of Antiquity

THE REMARKABLE ACCOUNT of art in Italy which the Richardsons produced in 1722 was translated into French six years later and published (together with the elder Richardson's other writings on art) in Amsterdam. Since the authors gratefully acknowledged the help received both from their translator (A. Rutgers the Younger) and from the Dutch connoisseur L. H. ten Kate, the additions which they made to the text of 1722 were perhaps not entirely their own—in any case these additions included a highly original reinterpretation of antique sculpture.

No doubt stimulated by some very perceptive comments published by Addison in 1705,[1] the Richardsons were the first modern writers to give due emphasis to the significance of the antique sculpture which has been lost. They likened surviving statues to a few volumes washed ashore after a great library had perished at sea. Furthermore those few volumes were damaged and imperfect editions of earlier texts. The Richardsons reached this conclusion by reading the most elementary sources for the study of ancient art and by asking simple questions about the signatures of ancient artists and about the repetitions of antique statues.

Some half dozen of the most famous were inscribed in Greek. This was not in itself enough to guarantee fame—the name Lysippus on the small Florentine version of the *Farnese Hercules* (itself inscribed Glycon) was never widely accepted as genuine, and by the end of the eighteenth century it was understood that copies were often inscribed with the names of the creator of the prototype rather than with those of the copyists.[2] It was true that the ancient (but renewed) inscriptions on the pedestals of the groups of *Alexander and Bucephalus* attributed those statues to Phidias and Praxiteles, but since the seventeenth century there had been scholars who were sceptical of these; and, if they were left on one side, a puzzling fact became apparent: none of the other names found on famous statues (the *Torso*, the *Papirius*, the *Germanicus*, the *Borghese Gladiator*, the *Venus de' Medici* and so on) were of men who had been singled out as great artists by Pliny or Pausanias. The conclusion to be drawn from this seems obvious: the statues by the most famous artists had not survived. The Richardsons appear to have been the only writers to state this clearly. Others ignored the problem or confronted it in a less honest way, casting doubt, for instance, on the signature of the *Venus de' Medici* in order to claim that she was the creation of Phidias or Praxiteles.

Another problem was posed by the survival of numerous antique versions of the same sculpture, not only busts of Marcus Aurelius or 'Seneca', but statues of the

Hermaphrodite, the *Belvedere Antinous*, some of the *Niobe Group*, the *Farnese Hercules* and the *Venus de' Medici*. Provided that there was one superior version scholars could convince themselves that it was the original of which the others were copies. When there were two or three versions of similar quality and with a few variations scholars could even suggest that two or three artists had competed in the treatment of the same theme. But the more obvious conclusion was the one bluntly stated by the Richardsons: all surviving versions were copies, some good, some bad, of lost originals—for, after all, when one considered the looting and iconoclasm of the Late Empire it would have been extraordinary if many of the originals had survived. And quality was no guarantee of originality: if some of the most exquisite drawings could be copies, why should not this also be the case with the most beautiful gems and statues?[3]

The Richardsons were also aware of repetitions of celebrated antique statues on gems and coins—Stosch too was to emphasise this—and numismatic evidence enabled them to recognise, fifty years before Mengs and Visconti, that a *Standing Venus* in the Vatican was a copy of the Cnidian Venus by Praxiteles. This seems to have been the first case of a masterpiece of antique sculpture being consciously studied at second hand through an antique marble copy.

The conclusions arrived at by the Richardsons' common sense only began to be accepted—indeed only began to be considered seriously—at the very end of the eighteenth century when they were supported by an erudition to which the Richardsons never laid claim. By then new standards in antiquarian scholarship had been established chiefly through the achievement of one man—Johann Joachim Winckelmann.

The son of a poor Prussian cobbler, deprived until he was nearly forty years old of almost all first-hand knowledge of the masterpieces of ancient art, Winckelmann had, by the time he was murdered at Trieste on 8 June 1768, at the age of fifty, established himself as the greatest European authority on Greek and Roman sculpture (Fig. 60). His literary career began in 1755 when he published his essay on the imitation of Greek painting and sculpture. In the winter of the same year he arrived in Rome; in 1758 he became Cardinal Albani's librarian and antiquary; and in 1763 he was appointed Prefect of Papal Antiquities. Despite his association with Albani, Winckelmann steered clear of the shady world of art dealing which had compromised the scholarly respectability of such brilliant, if much less systematic, antiquarians as Francesco Ficoroni and the Baron Stosch (who was also a part-time spy). It was, however, Winckelmann's edition of Stosch's gems that brought him fame among the learned—fame that spread throughout educated Europe with the appearance of his *History of Ancient Art*, published in German in 1763–4 and speedily translated into French.

It was Winckelmann's great poetic passages—on the *Apollo*, the *Laocoon*, the *Torso*—which made the most immediate impact and which were soon imitated, plagiarised (and eventually derided) in numerous guidebooks and travel diaries. But these sculptures had long been favourites, and Winckelmann's *History* also gave sudden fame to a number of formerly neglected or newly discovered works such as the Albani Leucothee (Munich); the colossal bust of Juno (now considered to be a portrait of Antonia Augusta) in the Ludovisi collection (Rome, Museo Nazionale);

60. Anton von Maron: Portrait of Winckelmann (Schlossmuseum, Weimar).

61. Tirsi Capitini: Portrait of Ennio Quirino Visconti—engraving by L. Rados.

the winged Genius of the Villa Borghese (Louvre); the colossal bust of Antinous at the Villa Mondragone (Louvre); and the bust of a young laughing Faun in the Villa Albani (Rome, Villa Torlonia/Albani).[4] None of these, however, became truly established favourites, and even though it was Winckelmann who first drew attention to the Praxitelean character of the *Marble Faun* in the Capitoline collection, it was only much later that it became one of the most famous statues in the world.

Winckelmann's most significant and lasting achievement was to produce a thorough, comprehensive and lucid chronological account of all antique art—but chiefly sculpture—including that of the Egyptians and the Etruscans. No one had done this before. There had, of course, been a general understanding that certain pieces, such as the Capitoline *Wolf* (Fig. 178), were primitive, and that others, such as some of the reliefs on the Arch of Constantine, were decadent, but the celebrated statues of the Belvedere or the Tribuna were simply considered, vaguely, to belong to the 'best period'. De Brosses was surely not exaggerating, even if he was intending to be provocative, when he confessed himself puzzled as to whether the *Niobe Group* was by Phidias or Praxiteles—'Dieu me damne si je me souviens lequel des deux.'[5] Such an attitude became far less likely after the publication of Winckelmann's *History of Ancient Art*. Many readers were deeply impressed by Winckelmann's stylistic categories and chronological sensitivity. Goethe even felt able to reproach Winckelmann himself for not having made sufficient use of them in appraising the *Minerva Giustiniani* (Fig. 140) which he placed at the end of the 'austere high style at the moment of its transition to the beautiful style: the bud is about to open'.[6] To the

Richardsons some fifty years earlier this statue had simply seemed stiff—and yet characteristically it is in their book that we find one of the few passages to anticipate Winckelmann's awareness of stylistic development, for they noted in the *Spinario* (Fig. 163) a charm analogous to that of quattrocento sculpture.[7] Half a century was to pass before any antique sculptures other than Roman portrait busts were arranged chronologically in a major European collection (the Glyptothek in Munich), but after the appearance of Winckelmann's *History* it became possible not just for Goethe but for more and more people to arrange sculpture in this way in their minds and eventually in certain publications—such as the *Specimens of Antient Sculpture* of 1809 sponsored by the Society of Dilettanti in which the statues were classified by date rather than by ownership or iconography.

Winckelmann's chronological account depended on an analysis of successive stylistic phases, and there were no precedents for such an approach to classical art. Apart from the passages of quasi-religious fervour devoted to a few statues his analysis is dispassionate, even clinical.

His generalisations about the treatment of gods and heroes in sculpture are always based on the scrutiny of separate parts of individual works, and this technique was probably encouraged by the fashion, in the decades following his death, of examining statues by torch light. This not only enabled the sculpture to be seen as it must have been in the dark interiors of the Roman Baths, but also isolated the work of art from its familiar context, and above all isolated each part of each figure by turn[8] and thus further sharpened in his readers that alertness to minute particulars which art historians today are taught to believe was first propagated by Morelli a century later. Winckelmann's observations on the size of nipples and knees; his fastidious anxiety about the depth of the *Venus de' Medici*'s navel; the enormous importance he attached to the scarcely detectable flaring of the *Apollo*'s nostrils—are all highly characteristic:[9] 'he catches the thread of a whole sequence of laws in some hollowing of the hand, or dividing of the hair'.[10] We sense his influence immediately when we read in Goethe of a group of German art students discussing the *Apollo*'s ears,[11] or when we hear a French connoisseur pointing out that the merit of the *Capitoline Antinous* (Fig. 74) was demonstrated by the fact that the undercutting of the testicles was so fine that a piece of paper slipped between them and the thigh would be held in place,[12] or, later, when—as described by an indignant traveller—'so many people who know nothing at all of muscles or veins' are to be found holding forth for hours about the surface of the *Torso* (Fig. 165).[13]

Similarly although Winckelmann himself had no objection to the restoration of antique sculpture provided that it was not confused with original work—he was in fact a close friend of Bartolomeo Cavaceppi, the leading Roman craftsman in the field—the minute care with which he scrutinised the state of even the most famous statues eventually led to a dramatic fall in the reputations of many, including the *Farnese Bull*, the *Dying Seneca*, the *Zingara*, the *Curtius*—though it took many years for Winckelmann's approach to such issues to be fully assimilated by ordinary travellers to Italy. Cavaceppi himself, perhaps as a result of his friendship with Winckelmann, helped to make self-conscious a profession formerly noted for its lack of inhibitions;[14] and within a couple of generations there would be a perceptible reaction against restoration of any kind.

The restoration of antique statues was first carried out systematically in the 1520s and 1530s under the auspices of Lorenzetto when he was arranging the sculpture courtyard for the palace he was designing for Cardinal Andrea della Valle.[15] Thereafter it became standard practice to restore the better antique statues— although the picturesque appeal of medleys of architectural and sculptural fragments continued to be valued. It is true that one or two of the best statues were never restored because Michelangelo was alleged to have felt unequal to the task, but Cellini was acting in a more typical manner when, confronted in the 1540s with the broken statue of a boy, he told Duke Cosimo that he admired the work so much that, despite his contempt for the bunglers usually employed to patch up such things, he would feel honoured to 'restore' it as a Ganymede—which he promptly did by repairing the extremities and adding an eagle.[16]

Stories were also often told of how a great sculptor's restorations had surpassed the antique. Thus when the original legs of the *Farnese Hercules* were discovered the modern ones which had been added by della Porta were said (by Michelangelo, it was reported) to be preferable. A later example is provided by the Hercules and Hydra acquired by Clement XII from the Verospi collection and presented to the Capitoline Museum in 1738—a statue which was famous enough to have a room there named after it and which appeared in the same period in *capricci* by Panini (Fig. 44).[17] The advancing leg and the hydra added by Algardi were received with such enthusiasm that they were retained even after the discovery, not much later, of what was believed to be the original leg which was displayed (as it still is) beside the statue.[18] But such stories would have been unlikely in the late eighteenth century when della Porta's legs were removed from the *Farnese Hercules* and the antique ones fixed in their stead.

In 1809 Edward Daniel Clarke wrote with pride that the fragment of a colossal Greek statue of Ceres which he had placed in the vestibule of the University Library at Cambridge (it is now in the Fitzwilliam Museum as a Caryatid) would not be 'degraded by spurious additions', and he contrasted his attitude with that which prevailed in France—where indeed, only the year before, Vivant Denon had ordered the sculptor Cartellier to convert an antique torso ('a fragment of the most beautiful work but insignificant in its present condition') into a statue of Napoleon.[19] At exactly the same time in the *Specimens* published by the Society of Dilettanti, sculpture was illustrated either without modern additions and repairs or with dotted lines (such as had been employed much earlier by Picart in his plates of gems)[20] to indicate where they were. Lord Elgin originally hoped that his marbles from the Parthenon would be restored, but both he and the British Museum which acquired them in 1818 were dissuaded from this course by Flaxman and Canova,[21] though the fragments which reached the Louvre were in fact repaired.[22] The ethics of restoration were hotly debated in the nineteenth century, and though Thorvaldsen restored the pedimental sculpture from Aegina which had been bought in 1812 by Ludwig I for Munich, and the *Venus de Milo* (which arrived in Paris in 1820) would have been restored had the experts agreed as to what form this should take, as the century progressed attitudes became much more cautious.

Restoration also ceased to be a precondition of popular appreciation. Thus in 1817 Mrs. Eaton could declare that the battered group of the Three Graces which had for

centuries adorned the Piccolomini Library in Siena Cathedral was 'universally allowed to be the finest representation' of the subject in the world, although during the seventeenth and eighteenth centuries the highly restored Graces in the Villa Borghese had attracted much more interest.[23]

It was Winckelmann who first insisted that Greek sculpture of the finest period was a product of the very highest excellence, brought about under geographical, political and religious circumstances which could never be recreated; and although Winckelmann had hoped to see the art of Greece revived, or at least imitated, in modern Europe, many of his successors, especially in Germany, stressed the impossibility and inconsistency of this.[24] Clearly if Greek sculpture could not be imitated, it could not be restored. As reverence for the Greeks increased, so too did awareness of our distance from them.

Whatever they wrote or said about Greek art most antiquarians before Winckelmann had been far more familiar with Roman than with Greek history and literature, and a majority of the most admired antique statues had therefore been given Roman titles. Though some of these had long been questioned—in 1669, for instance, Leonardo Agostini had made use of evidence from a gem to demonstrate that the *Arrotino* was not a loyal Roman slave eavesdropping on the details of a conspiracy directed against the State but an executioner about to flay Marsyas—doubts had been confined to limited circles, and it was Winckelmann and his followers who radically (and effectively) revised titles and stories which had been familiar to generations of art lovers. *Cleopatra* now became a Nymph (and, later, Ariadne); *Cincinnatus* now became Jason (and, later, Hermes); both the *Dying* and *Fighting Gladiators* ceased to be gladiators; *Papirius* became Orestes; *Seneca* became a slave (and, later, a fisherman); *Commodus* in the guise of Hercules became simply Hercules.

It was, however, not unusual for writers before Winckelmann to insist on the superior quality of Greek sculpture (and Piranesi's claims for the Romans could never have been made had he concentrated on sculpture rather than on architecture).[25] It was well known that the Romans employed Greek slaves as their better statuaries and that, as Spence put it, 'a Roman workman in the Aemilian square was probably pretty near on a level with our artists by Hyde-park-corner'. But neither Spence, nor Mariette, who believed Roman art to differ from Greek in the same way that Flemish painting differed from Italian, saw any reason why Greek sculptors working for Roman masters should be inferior to their ancestors working in freer conditions.[26]

It is in fact usually hard to tell what is meant by Greek as distinct from Roman in eighteenth-century criticism. For Maffei, as for most earlier antiquarians, who took their views from Pliny himself, it was simply a matter of the costume or the lack of it;[27] for de Brosses it seems quite arbitrary;[28] and the Richardsons only occasionally hint at stylistic differences.[29] Caylus divided the works of art discussed in his *Recueil d'antiquités* into Egyptian, Etruscan, Roman and Romano-Gallic categories. The confusion between Etruscan and Greek strikes us most today; but Caylus's distinctions between Greek and Roman are also curious. He included most of the art of Herculaneum as Greek because that city had once been a Greek colony.[30] He anticipated Winckelmann in claiming both that the genius of the Greeks was stifled

when they lost their liberty and that Greek art under the Romans could never be more than a shadow of what it had been under Alexander the Great.[31] In practice, however, he greatly admired much that was produced under the Romans—for instance a gem showing Hadrian slaying a lion, and some terracotta reliefs—and classed both of these as Greek; anticipating the objection that the latter were found in the Roman Baths he pointed out that one would not suppose a Leonardo to be French just because it was found at Fontainebleau.[32] His criterion, in fact, was based essentially on quality: very good Roman art was Greek. It is only with Winckelmann that we find a consistent and systematic attempt to characterise the successive stages of Greek sculpture, although he himself had only a limited knowledge of genuine Greek works.

At the very moment when interest in classical antiquity had revived in the fifteenth century the Turks had become masters of the Eastern Mediterranean, and in subsequent years only sporadic and fragmentary indications of Greek art reached the West, such as the notes and drawings made by the learned merchant and diplomat Cyriac of Ancona;[33] the heads, torsoes and stele which entered north Italian collections as by-products of the Levantine trade;[34] the acquisitions made in the Greek islands and in Asia Minor by the agents of English collectors in the early seventeenth century;[35] the drawings of the Parthenon marbles made in 1674 for the French ambassador to the Porte and eventually reproduced in dreadful engravings by Montfaucon.[36] In 1764, however, the year in which Winckelmann published his *History of Ancient Art*, William Pars set out on the expedition to Ionia funded by the Society of Dilettanti and drew the Parthenon reliefs from close up, but engravings from these were only published after Winckelmann's premature death,[37] which also prevented him seeing the casts commissioned from Athens by the Comte de Choiseul Gouffier in 1795, just ninety-nine years after the director of the French Academy in Rome had recommended the taking of this very step.[38]

In the absence of such evidence (let alone, of course, of the marbles themselves from the Acropolis and from Bassae and Aegina which only arrived in London and Munich early in the next century), Winckelmann cited as an example of the austere, early stage of Greek sculpture the Vestal in the Giustiniani collection (now in the Villa Torlonia as the Hestia Giustiniani); he illustrated the sublime period with the *Niobe Group* (Figs. 143–7) which he took to be either by Scopas or a very close imitator of his style; and in the succeeding period, dominated by Praxiteles, he felt that the Albani version of the *Apollo Sauroctonus* (Fig. 78) was good enough to be a work by the master himself.[39] All these were later acknowledged to be copies, and, of other important originals or reflections of Greek art found in Italy, the beautiful relief of Orpheus and Eurydice in Naples seems only to have come to his notice at the end of his life and he was aware more of its iconographic than of its aesthetic importance,[40] while the Diadumenos and Doryphoros after Polyclitus, were not recognised, and the Apoxyomenos after Lysippus and the Ludovisi Throne were not excavated until long after his death.

The great poetic passages in Winckelmann are reserved for the *Laocoon*, the *Apollo* and the *Torso*, and although he is careful to stress that these were not products of a decadent society—the *Torso*, for example, being executed just before the final subjection of Greece to Roman rule[41]—it is clear from his scheme that they were not

of the very highest rank, or would not have been had more originals of the sublime style survived. Winckelmann's values evolved when he was a close friend of the German painter Mengs, and Mengs's own criticism is characterised by the same methodical stylistic analysis of anatomical parts,[42] develops the same idea that political freedom was a precondition for the finest achievements of Greek art, and displays the same confidence that Roman culture was inferior.[43] But, after Winckelmann's death and shortly before his own, Mengs went much further. Among his papers were found (and quickly published) two replies—only one of which had been sent—to Angelo Fabroni who had requested advice for his treatise on the *Niobe Group*. Here Mengs proposed that this group consisted of copies.[44] This proposal was drastic enough (and certainly much more daring than an earlier suggestion by Caylus that numerous antique gems and small bronzes were copies), but Mengs then took a further step and claimed that even the *Laocoon* and the *Apollo* were not original creations.[45]

Mengs's idea was too radical to meet with favour at first, but it was not ignored as the similar ideas of the Richardsons' had been. Thus when Pope Pius VI tried to persuade the King of Naples not to remove the Farnese *Hercules* and *Flora*, he pointed out that the case of the *Niobe Group*, whose export to Florence he had earlier allowed, was quite different as 'the celebrated Mengs' had demonstrated that these were only copies.[46] But it was only some time later that the full implications of Mengs's theories sank in, and by 1813 it was possible for an English traveller to assert blandly that 'more than half of the ancient sculpture existing is copy'.[47] By then the leading English connoisseur was Richard Payne Knight who had proved himself a severe investigator of the authenticity of ancient inscriptions and of the purity of editions of the classics before he turned his attention to ancient sculpture. His own collection of coins and small bronzes was one of the most remarkable ever formed and his sensitivity to the special quality of work in metal enabled him to detect how copyists imitated in marble the conventional treatment of hair which was appropriate to bronze.[48] He showed himself prepared to entertain the notion that the *Torso*, the *Wrestlers*, the *Venus de' Medici*, the *Belvedere Antinous*, the *Apollo*, the *Niobe Group*, the *Farnese Hercules* and both the *Fighting* and the *Dying Gladiators* were copies.[49] Furthermore Knight considered that the 'prodigious superiority of the Greeks over every other nation, in all works of real taste and genius', was one of the 'most curious moral phaenomena in the history of man', and he described the rise of Roman influence in the Mediterranean in terms reserved by earlier generations for the coming of the Dark Ages.[50]

But in Knight's day the leading authority in Europe was Ennio Quirino Visconti (Fig. 61), whose father had succeeded Winckelmann as Prefect of Papal Antiquities, and who was himself eventually keeper of the Musée Napoléon. Visconti played a larger part than any other single archaeologist in identifying the true subjects of the classical statues to be seen in Rome. He was unusual in his profession in combining an astonishing range of learning with a very keen eye and a great deal of common sense, but his profound reverence for the antique statues which he had known since very earliest childhood made it impossible for him to accept that they could be nothing more than inferior copies (even though he had actually seen and catalogued Greek originals). Thus, despite his preference for solving particular problems rather

than establishing general rules, he eventually arrived at the compromise that the most famous and beautiful statues, the *Farnese Hercules* and the *Apollo Belvedere*, for instance, had indeed been adapted from earlier works—but that in the process they had been improved and should be regarded as 'imitations perfectionnées' made for Roman collectors. Together with his collaborator in writing the catalogue of the Musée Napoléon, Éméric-David (whose earlier writings give no hint of this point of view),[51] Visconti arrived at the conclusion that, despite his respect for the 'learned antiquary' who saw after the death of Alexander the Great nothing but decline, artists working in the following four centuries had equalled and sometimes surpassed the great early masters in whose paths they followed, just as Virgil had equalled the achievement of Homer, and Racine that of Euripides.[52] Visconti was also supposed to have endorsed the views of the Comte de Saint-Victor who not only insisted that sculpture had flourished consistently from the age of Pericles to that of the Antonines but also made a strong attack on Mengs.[53]

It cannot be entirely coincidental that these views found most favour with the French who would not have welcomed any theory likely to devalue the contents of their newly established Musée whose formation will be discussed in our next chapter; in fact the only notable French dissenter was Quatremère de Quincy who also opposed the acquisitions of the Musée. The overwhelming supremacy of Greek art over Roman was espoused by German scholars—Herder, Heyne, Meyer, Goethe, the Schlegels and Müller—and also by Englishmen who were exasperated by Nelson's failure to capture Napoleon's booty on its way to France and consoled themselves with relics of 'purer times': 'Etruscan' vases, coins and small bronzes from Sicily and Paramythia, and above all the marbles from Bassae and from the Parthenon (although Payne Knight destroyed his reputation by failing to appreciate the significance of the latter).[54]

In the end the priorities of Winckelmann prevailed throughout Europe and America—'The national history of Greece ends with the Macedonian conquest. Our narrative, however, must still proceed. Not that we suppose true art capable of surviving such a disaster', we read in a typical late nineteenth-century history of Greek sculpture.[55] But there was no question of old favourites being instantly demoted anywhere in the Western world. The *Apollo*, the *Torso*, the *Laocoon* and the *Alexander and Bucephalus* were consistently invoked by artists and scholars attempting to evaluate the Parthenon sculptures, and Haydon was exceptional in feeling that the defence of the latter required the abuse of the former.[56] As late as 1869 a popularizing book could acknowledge the supreme merits of the marbles from Aegina and the Parthenon, while still claiming with no sense of strain that *Niobe and her Children* were works 'whose sublime beauty renders them worthy of the greatest names of antique statuary' and that the '*Farnese Bull* can be ranged alongside the most beautiful works of Greek antiquity to have come down to us'.[57] Eight years earlier in Athens itself it had been hoped that the projected archaeological museum might one day receive works as beautiful as the *Venus de Milo* and the *Apollo Belvedere*, and in fact a copy of the *Apollo*, together with copies of the Diadumenos and the Albani Leucothee, was placed on the roof of the National Museum in Athens which was completed in 1889.[58]

XIV

The Last Dispersals

IN JULY 1798 the French Minister of the Interior wrote to the authors of a popular vaudeville of the day asking them to compose 'a light song to celebrate the conquest of the masterpieces of art [in Italy]. This should be arranged to some tune well known to the populace so that it can be sung by everyone during the procession, as this will add to the interest of the ceremony.' The authors obliged and came up with a ditty whose refrain was

> Rome n'est plus dans Rome
> Elle est tout à Paris[1]

The sentiment will not be unfamiliar to readers of our book. Both François I^{er} and Louis XIV had been acclaimed for creating a new Rome in France. But they had had to be satisfied with copies. Now, as the *Apollo* and the *Laocoon*, the *Spinario* and even the *Horses of St. Mark's* were wheeled past the crowds in the Champ de Mars, it must have seemed like the realisation of a dream that had obsessed French rulers over two and a half centuries. In part this was indeed the case, and yet—despite appearances—there were certain rules which governed, even restricted, the choice of what was taken from Italy to France during the years between 1796 and 1814.

It was during the campaign of 1794 in the Low Countries that the Revolutionary administration in Paris first proclaimed the principle that the Louvre, newly established as a public museum, was the rightful home for such masterpieces of art as could be seized from conquered territory—just as the Bibliothèque Nationale and the Jardin des Plantes were to be supplied with books, manuscripts and specimens of natural history. In the vast amount of rhetoric that this decision stimulated it is impossible to disentangle fully the parts played by brutal greed, high-minded idealism and the appeal to antique precedent—though most historians have been ready enough to choose which to emphasise. In any case the motives need hardly concern us. A series of committees was set up, and with great efficiency and aesthetic discrimination these supervised a form of looting for which no exact legal framework yet existed.

The states of Italy were still at peace, though tense, when on 31 August 1794 the Abbé Grégoire, a member of the Comité d'Instruction Publique, announced ominously: 'Certainly, if our victorious armies penetrate into Italy, the removal of the Apollo Belvedere and the Farnese Hercules would be the most brilliant conquest.'[2] In April 1796 the French armies, under the command of Bonaparte, did

penetrate into Italy and a series of brilliant victories followed in quick succession. Plunder was now legalised by being incorporated into peace treaties with the various Italian princes who were forced to surrender, and an elaborate mechanism was established for choosing and transporting the works of art which were to be taken to Paris. Certain principles as to what could be taken seem to have been applied from the first, though they were codified only a little later.[3] The property of a ruler was entirely at the disposal of the conqueror; museums belonged to this category but, as they were also of benefit to the public, it would be prudent to choose sparingly from them; churches should be treated with reserve, even though the clergy 'can be looked upon as being in a state of permanent war with France'; private collections were absolutely sacred.

These regulations were to prove of great importance when, having invaded the papal states on 18 June 1796, Bonaparte signed an armistice five days later with the Pope's delegates at Bologna. Under Article 8 one hundred works of art were to be handed over, and of these two were singled out by name: the bronze head of *Lucius Junius Brutus* and the marble head of Marcus Brutus, both in the Capitoline Museum.[4] Two months later the Commissioners appointed for the purpose had chosen the remaining ninety-eight objects, and of these, eighty-one were antique sculptures.[5] Clearly there was no squeamishness about infringing the status of public museums. The Pio-Clementino, the Palazzo dei Conservatori and the Capitoline were to be denuded of all their most famous masterpieces: the *Apollo*, the *Laocoon*, the *Torso*, the *Commodus as Hercules*, the *Cleopatra*, the *Antinous*, the *Nile*, the *Tiber*, the *Spinario*, the *Cupid and Psyche*, the *Dying Gladiator* . . .

The choice of these presented no problem. It is, however, a little surprising that some of the bronzes given to the City of Rome by Sixtus IV were not seized: the *Wolf* (of great symbolic significance, as will be seen), the *Hercules* and, above all, the *Camillus* (which was still highly regarded in the late eighteenth century). It is just possible that reasons of tact prevailed here as in a few other instances. On the other hand the decision not to seize the *Furietti Centaurs* or the *Faun in Rosso Antico* was probably taken because Lalande (whose authoritative *Voyage en Italie* provided the fullest up-to-date account in French of the antiquities in the city) had not been very enthusiastic. And the diminished standing of some of the sculptures that had been in the Belvedere statue court is shown by the neglect of the *Venus Felix* and the *Standing Venus*. But with these and only one or two other exceptions almost every single statue or group that has been referred to in our book and that was available to the Commissioners was earmarked for Paris: the plunder chosen implied a tribute to consecrated taste, and as a gesture to scholarship it was agreed to allow Visconti to have drawings made immediately of those sculptures that had not yet been engraved for his catalogue of the Museo Pio-Clementino.[6] Meanwhile plaster casts were set up in the Vatican and on the Capitol in place of the original marbles.[7]

But, of course, not everything was available to the Commissioners. Two categories had perforce to remain untouched: public monuments such as *Alexander and Bucephalus* on the Quirinal and *Marcus Aurelius* on the Capitol, and sculptures in private hands such as the Albani *Antinous Bas-Relief*, the Borghese *Gladiator* and the Ludovisi *Paetus and Arria*. Works such as these were of far greater consequence than the many lesser ones that the Commissioners had to choose from the Vatican to

make up the quota to which they were entitled, and it was later agreed that moulds should be taken from them if ones of good quality were not already available in Paris.[8] While the papal collections had hitherto been considered inviolate and foreign ambitions had been concentrated on what remained in private hands, the Revolution brought about exactly the opposite effect.

Not everyone was satisfied. General Pommereul was later to claim that not nearly enough had been taken from the Pope, that all the best pieces in the Villa Borghese should be seized, that the *Alexander and Bucephalus* would be far more suitably placed in Paris, and that no one should imagine that it would be particularly difficult or expensive to transport Trajan's Column to the Place Vendôme or Raphael's frescoes to the Louvre.[9] The inhabitants of Rome not surprisingly thought that things were bad enough as they were, and although some preliminary packing was done nothing was actually moved.[10] And then in February 1797 Bonaparte pounced again. The terms of the Treaty of Tolentino insisted that the works chosen by the Commissioners should be sent without further delay;[11] in his letter recording this he echoed the exact instructions that had been issued to less effect by Colbert more than a century earlier: 'Nous aurons tout ce qu'il y a de beau en Italie.'[12] Events moved swiftly. On 10 April the first of four convoys left Rome. It consisted of ten specially constructed wagons, each one of which carried two sculptures, and an eleventh with paintings (Fig. 62).[13] Three more convoys followed at intervals of about a month each, and by 2 August all had reached Livorno,[14] whence they set sail for Marseilles a week later.[15] Some particularly large pieces were temporarily stored in the Vatican.[16]

At just the time that this spoliation of the museums of Rome was first being planned, it was denounced in an eloquent pamphlet by the historian and theorist Quatremère de Quincy who claimed to find it difficult to believe that the eighteenth century could revive the 'absurd and monstrous right of conquest of the ancient Romans, which made men and chattels the property of the strongest'. Quatremère's protest won some (but not enough) support in surprising quarters, but it deserves to be recorded in our book because it constitutes just as powerful a tribute to the enduring appeal of the most famous and beautiful statues as the incredibly complex organisation needed to transport those very statues from Rome to Paris. 'The true museum of Rome', he pointed out,

> the museum of which I am speaking, is, it is true, composed of statues, of colossi, of temples, of obelisks, of triumphal columns, of baths, of circuses, of amphitheatres, of triumphal arches, of tombs, of stucco decoration, of frescoes, of bas-reliefs, of inscriptions, of ornamental fragments, of building materials, of furniture, of utensils, etc., etc., but it is also composed fully as much of places, of sites, of mountains, of quarries, of ancient roads, of the placing of ruined towns, of geographical relationships, of the inner connections of all these objects to each other, of memories, of local traditions, of still prevailing customs, of parallels and comparisons which can only be made in the country itself.

Only now, since the appearance of Winckelmann, had true scholarship been devoted to the world of antiquity, a world which engaged the whole history of the human spirit. Break up the unity of that world, as the English had tried to do by

62. Departure from Rome of the third convoy of works of art ceded under the terms of the Treaty of Tolentino—engraving by Martin and Baugean.

removing all they could to their scattered country houses, and you destroy a whole network of patterns and associations which were of equal value to the artist and the historian.[17]

The French Commissioners in Rome heard (with some surprise) of Quatremère's protest a few days after they had made their choice.[18] And two years later, in July 1798, the bulk of the pictures and antiquities they had selected reached Paris.[19]

There it was decided that their arrival should be marked by a ceremonial procession[20] timed to coincide with the fourth anniversary of the fall of Robespierre. Despite the speeches and military band, despite the popular song, the experience cannot have been a very exhilarating one for the art lover since nearly all the statues remained in their grandiloquently inscribed packing cases. The only ones which were actually visible (preceded by caged lions and followed by dromedaries) were the four bronze *Horses of St. Mark's* which had been removed from Venice in December 1797 under mysterious circumstances, for they were not among the booty which had been demanded from the Republic.[21] When the procession was over, the *Horses* were placed in an inner courtyard of the Invalides,[22] and the other sculptures were left (still unpacked) in some downstairs rooms in the Louvre for almost eighteen months.

There they might have remained but for two crucial developments which took place at the end of 1799: Bonaparte came to power, and Visconti fled to Paris from Rome where he had been deeply involved with the Jacobin republic which had displaced the Pope. Napoleon visited the Musée on 1 December (just three weeks after the coup d'état of 18 Brumaire) and expressed some dismay at the conditions under which his plunder was stored there.[23] On 20 December Visconti was put in charge and (with the architect Raymond) he immediately began to rearrange for Napoleon those very same masterpieces which not long before he had arranged for

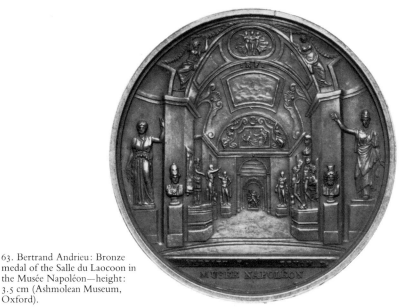

63. Bertrand Andrieu: Bronze medal of the Salle du Laocoon in the Musée Napoléon—height: 3.5 cm (Ashmolean Museum, Oxford).

Pope Pius VI (who had died in exile at Valence a month after the procession).[24] The principles behind the grouping remained much the same. Nine rooms were envisaged on the ground floor of the Louvre, and each one was arranged thematically—in theory at least: the Hall of the Seasons (dominated by the *Diane Chasseresse*) led to the Hall of Illustrious Men which led to the Hall of the Romans; but certain works of special significance were to have rooms specially named after them—the *Torso*, the *Laocoon*, the *Apollo*, the *Muses*.[25] Although the rooms were not yet quite ready, it was decided to inaugurate the new galleries (Fig. 63) on 18 Brumaire An IX (9 November 1800), the first anniversary of Napoleon's seizure of power: he himself with Josephine and a select group of courtiers had paid a private visit two days earlier, during the course of which he attached to the base of the *Apollo* a bronze plaque with a commemorative inscription specially devised by Visconti.[26]

The Galerie des Antiques was frequently rearranged (and therefore frequently closed to the public) during the fifteen years of its existence because it was constantly being enriched. The same revolution in Rome which had given Visconti a brief moment of political power—he, too, like Napoleon, knew what it was to be a Consul—was responsible for some important changes (as well as the use of the Spada *Pompey* (Fig. 156) and the Capitoline *Wolf* (Fig. 178) as stage props for a performance of Voltaire's *La Mort de César*). Among the most implacable opponents of the armistice of Bologna had been Cardinal Gianfrancesco Albani, nephew and heir of the great collector.[27] When the French arrived in Rome in the summer of 1798 and papal sovereignty was ended, the Villa and all its contents were confiscated,[28] and among much that was selected for the Musée in the following year was the enormously admired *Antinous Bas-Relief* (Fig. 75). But perhaps an even more significant result of the chaos in Rome was the removal of a *Pallas* (Fig. 150) which had been excavated in Velletri in 1797. Its exact ownership was in doubt, though among the claimants was the nephew of the 'Prince de Rome', Duke Braschi, whose important collection was now also expropriated. It belonged for a time to the sculptor and dealer Vincenzo Pacetti (who also temporarily gained possession of the *Barberini Faun*), and the extraordinary determination shown by the

French to procure this gigantic statue for Paris makes it one of the very rare instances in which the creation of the Galerie des Antiques can be held at least partly responsible for an important addition to the limited number of the most venerated antiquities. It was temporarily stored in Rome, along with the *Tiber*, the *Nile* and certain other works which it had not been possible to transport with the original convoys to Livorno. When the Neapolitans captured Rome in October 1799 they seized the *Pallas*, and its restitution to the French was expressly stipulated in the peace treaty of March 1801, just as, a year later, the King of the Two Sicilies agreed, after extensive negotiations, to hand over the *Venus de' Medici* which had been sent to Palermo by the Florentines who trusted the King to keep it safely for them, having turned down an English offer to store it at Gibraltar.[29] The arrival in the Louvre of the *Venus de' Medici* in 1803 led to another visit from Napoleon and to much whimsical comment about the idyll between her and the *Apollo* which could now be conducted under the same roof.[30] The arrival of the *Pallas* less than six months later encouraged Napoleon to come again and, as with the *Venus*, this gave occasion to the minting of a special medal.[31] Thereafter, although much thought was given to seizing all the greatest antiquities in Naples[32] and elsewhere and although at least two of the statues taken from Berlin were important,[33] it was not until after 1807, with the purchase of the Borghese antiquities, that the next (and last) major additions were made to this department of what was now the Musée Napoléon.

The initiative to acquire the sculptures seems to have come from the Emperor himself. He was anxious to save from embarrassment his impoverished brother-in-law Prince Camillo Borghese, who had already approached possible English buyers,[34] and as Napoleon tended to combine generosity to members of his family with a somewhat casual attitude to their possessions, he paid considerably more than the estimated value of the collection.[35] It seems likely that Visconti and Vivant Denon (director of the Musée) may have had rather mixed feelings about the whole transaction. They had actively and unsuccessfully urged Napoleon to acquire the finest treasures of the Florence and Naples museums.[36] By these standards the Villa Borghese now seemed to belong to a distinctly lower rank. It is true that the *Gladiator* was one of the most famous antiquities in the world; but only two pieces (the *Silenus with the Infant Bacchus* and the *Vase*) were reckoned to be worth even a fifth of the value of a million francs estimated for that masterpiece; while such celebrated sculptures as the *Centaur with Cupid* and the *Dancers* were thought to be worth very much less; the *Curtius* was not taken at all.

Among the Borghese statues which came to Paris (after a long and expensive journey by land owing to the cancellation of original plans to send them by sea for fear of English interception)[37] were a number which had been excavated by Gavin Hamilton for the Prince's father at the ancient city of Gabii, near Rome, in 1792. These included a marble *Diana* (Fig. 103), which had certainly been noted when still in Rome, but which only achieved true celebrity after its arrival in Paris where, following three quarters of a century of growing admiration, it was to be described as 'one of the pearls of the Museum, among the most esteemed masterpieces of Greek sculpture'. In thus being 'promoted' only after its departure from Italy, the fame of the *Diane de Gabies* echoed that of the *Diane Chasseresse* some two hundred and fifty years earlier.

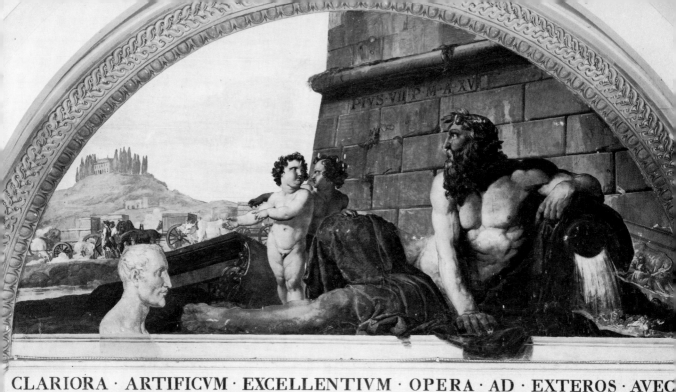

CLARIORA · ARTIFICVM · EXCELLENTIVM · OPERA · AD · EXTEROS · AVEC
VRBI · RECVPERATA

It was not merely novel circumstances of display and the lavish official catalogue which might help exalt such statues. The Musée incorporated an 'atelier de moulages' from which casts continued to be supplied throughout the nineteenth century. As we have seen, sets were despatched to the United States and not long afterwards thirty-six crates were sent to the Royal Academy of Art at The Hague, containing not only casts of the statues in the Musée, but others of the head of the *Niobe* and of the feet and hands of the *Farnese Hercules*—both works which the French still coveted.[38]

When the Allies reached Paris after Waterloo the antiquities in the Louvre were placed in twelve mostly tall and well-lit rooms. The walls were generally lined with dark coloured marbles and most of the ceilings had recently been painted with allegorical frescoes. Nearly all the statues and busts were close to the walls—a feature that was sometimes criticised—though it was just possible to walk behind the *Apollo*, which was placed in a niche, with red granite Sphinxes (from the Capitol) on each side and ornamental rails in front. In another room the *Venus de' Medici* stood to the left of the *Laocoon*; moving on, one could see the *Dying Gladiator* opposite the *Torso*; and, yet further, the *Borghese Gladiator* near the *Meleager*.[39] Two minutes away, on the Arc de Triomphe du Carrousel, glittered the *Horses of St. Mark's*.

Canova (whose earliest successes had been enjoyed within a few hundred yards of St. Mark's, who had been to visit the Museo Pio-Clementino within hours of his first arrival in Rome,[40] and whose most emotionally acclaimed work had been a *Venere Italica* to replace the *Venus de' Medici* in the Tribuna) arrived in Paris on 28 August 1815.[41] By then the dismantling of the Musée Royal was already well under way and it was his duty to complete it by supervising the restitution to the Papacy of the pictures and sculptures which had been seized nearly twenty years earlier. On 2

114

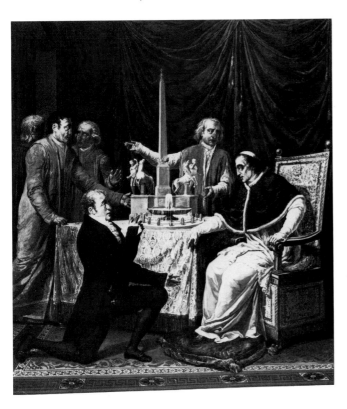

64. (far left) Francesco Hayez: Return to Rome of the works of art taken to Paris under the terms of the Treaty of Tolentino—fresco (East wall of Galleria Chiaramonti in the Vatican Museum).

65. Domenico de Angelis: Pope Pius VII being shown a model of the new fountain for the *Alexander and Bucephalus* groups on the Quirinal—fresco (Galleria Clementina in the Vatican Library).

October, the day after the *Horses* had been removed from the Arc du Carrousel to be taken back to the Austrian provincial city of Venice,[42] Canova, backed by complicated legal arguments, by Allied bayonets, and above all by the friendship of the English diplomat William Hamilton, began his operations.[43] After difficulties of every kind, the wagons carrying what were still the most famous sculptures in the world arrived in Rome on 4 January 1816.[44] By June 1817 Francesco Hayez had painted a lunette in the new wing of the Vatican museum, which had been founded by Pius VII, depicting this very scene (Fig. 64).[45] It was only three years earlier that Vivant Denon had commissioned from François Gérard a mural for the Louvre which was to show 'the arrival in Paris of the masterpieces of art conquered by the Treaty of Tolentino'.[46]

In fact Canova had not brought back everything from Paris. The Pope, despite his enthusiasm for continuing the antiquarian enterprise of his predecessors (Fig. 65), was anxious not to antagonise the restored Bourbons who were giving the most encouraging evidence of their determination to reverse the anti-clericalism of the Revolution and the Caesarism of Napoleon, and many pictures from Italy were left in France as a token of appreciation. Others were considered too difficult to collect and dispatch. Similarly, certain pieces of sculpture were ceded to the Musée, though it is not quite clear on what principles, and a bitter controversy developed about Canova's own role in the affair.[47] Thus the *Nile* was taken back despite all the attempts made by the French to retain it, whereas the *Tiber* was left in Paris. Prince Borghese's hopes of annulling the sale of his antiquities were unavailing, and to the Braschis it was pointed out that they had already been compensated in 1802 for the removal of their possessions. The Albani found the expense of transporting their antiquities to Rome to be prohibitive, and contented themselves with bringing back

the *Antinous Bas-Relief*. Many of their remaining possessions were sold in Paris to Crown Prince Ludwig of Bavaria, and among these was the marble bust, slightly stained by rust, of a laughing Faun which Winckelmann had much admired and which was kept by Cardinal Albani in his bedroom:[48] for a time it had been much copied.

It is fitting that Prince Ludwig should have been the last man able to adorn his capital with some of the most admired statues both of the traditional kind (with which our book has been concerned) and of the true Greek style (which was soon to replace them in esteem), for few (if any) of the collectors we have been discussing loved them more.

Born in 1786 he had already travelled in Italy before the age of twenty. He then fought for the French but in 1813 he turned against Napoleon and he was thus one of the victorious sovereigns to enter Paris after the Emperor's downfall. There, and in Italy soon after, he was able to indulge to the full his passionate and sensitive love of the arts. He demonstrated his esteem for Goethe by buying the antiquities which the poet had particularly admired in the Bevilacqua palace in Verona,[49] and above all by purchasing from the heirs of the Marchese Rondinini the head of Medusa of which Goethe had written that 'the mere knowledge that such a work could be created and still exists in the world makes me twice the person I was'.[50] In 1812 Ludwig was able, through his agent Wagner, to purchase against strong competition from the English and the French the great Greek sculptures from the Temple of Aegina which had been discovered only a year or two earlier. His enterprise in this and other ventures of the kind is in striking contrast to the dithering of the English government over the acquisition of the Elgin marbles which Ludwig also hoped to obtain.[51] After nine years of the most complicated negotiations he was, in 1819, able to remove from Rome the *Faun* (Fig. 105) which he bought from the Barberini: this was the last of the great sculptures discussed in our book to leave the city for good—and it was certainly the finest.

It is hardly an exaggeration to claim that Ludwig rebuilt Munich to make it worthy of these and the many other treasures that he was able to acquire as Crown Prince and, from 1825, as King. The sculptures were installed in the museum (called the Glyptothek) which Leo von Klenze began to build for him in 1816 after winning the competition organised by a special commission.[52] Both men wanted it to be splendid in character rather than austere, and the Nazarene painter Peter Cornelius was summoned from Rome to decorate the entrance hall with a vast decorative fresco celebrating the relationship between man and the gods. As has already been pointed out these galleries broke with convention, for the sculptures were arranged not thematically but chronologically, ranging from the ancient Egyptian to contemporary German. But, in other ways, old eighteenth-century habits reasserted themselves: gradually, as the museum began to dominate its contents, size and symmetry became more important in the purchase of antiquities than did aesthetic discrimination. Nonetheless, Ludwig succeeded in his aim of making Munich a centre for the appreciation of those classical values with which we have been concerned in this book, and it was only by the time that he was forced to abdicate in 1848 that clear signs were beginning to appear throughout the world suggesting that many of those values were losing the force that had inspired him in his youth.

XV

Epilogue

IN 1864, ABOUT forty years after the family business had first been established in London, D. Brucciani opened a hundred foot long gallery of plaster casts in Covent Garden. It could be viewed gratis, and was considered by the *Art-Journal* to be 'a capital refresher to the memory of the scattered sculptures of the continent, and a useful preparatory school to those who purpose seeing them'.[1] Exactly the same might have been said of the gallery at Mannheim visited by Goethe a century before, where the same classical statues were the chief attractions. This gallery, however, was neither established by private munificence nor supported as a national institution (although Brucciani was officially *formatore* to the British Museum), but by private enterprise, and for commercial purposes.

Brucciani, of course, offered some novel attractions. Mannheim had a cast of a Corinthian capital (and the Palazzo Farsetti a cast of the frieze of the Temple of Antoninus and Faustina),[2] but Brucciani had casts of Byzantine, Gothic and Renaissance, as well as of Greek and Roman, ornament. Goethe would not have been surprised to find modern sculpture alongside the antique, but he would have been surprised to see Michelangelo's David. The first cast of this colossal statue to enter England, and one of the first ever taken, was presented to Queen Victoria by the Grand Duke of Tuscany in 1856.[3] Today it is perhaps the most famous statue, ancient or modern, in the world, but in the seventeenth and eighteenth centuries it was less celebrated than the same sculptor's Bacchus, Risen Christ or Moses, and was never thought of in the same terms as the statues in the Belvedere or the Tribuna (although in the sixteenth century Vasari claimed that it surpassed the colossal figures of antiquity—the *Alexander and Bucephalus*, the *Nile*, the *Tiber* and the *Marforio*).[4]

The cast galleries of Mannheim and the Palazzo Farsetti were intended to instruct both the amateur and the art student, and Brucciani also had both the home and the academy in mind, though by now a distinction was made between the two: his 'figures adapted to holding gas lights' and his 'busts of literary and historical characters' were intended for the former; his *écorché* of the *Dying Gladiator*, his feet and noses ('from the antique and nature'), his geometrical solids and his blackberry bushes were intended for the latter; while casts of antique statues were suitable for both.[5] But in 1914 the firm published a photographically illustrated catalogue 'of casts for schools, including casts of most of the statues which the Board of Education have approved in their regulations for Art Examinations' (Fig. 66), and it was issued

from their warehouse in the Goswell Road. By then they were clearly only supplying an educational market, as seems also to have been the case at that date with the even larger firm of August Gerber in Cologne and with the cast department of the Louvre (established a century earlier under Napoleon).[6] In 1922 Brucciani's business was taken over by the Board of Education and by 1939 it had been absorbed into the Victoria and Albert Museum.

Some new casts were prominently included in Brucciani's catalogues of the late nineteenth century: among them the Adorante in Berlin; the *Winged Victory of Samothrace* in the Louvre and the Prima Porta Augustus in the Vatican (both found in 1863); and also the Praxitelean Hermes discovered at Olympia in 1877. But just as important was a quite new category of sculptures—those which were from the first acknowledged to be copies of lost masterpieces rather than masterpieces themselves.

In 1781, when Mengs had made the learned world much more conscious than ever before of the problems posed by marble replicas, a statue of the *Discobolus* (Fig. 104) was excavated and identified by the Viscontis and by Carlo Fea (the editor of Mengs) as a copy of a bronze original by Myron.[7] In 1849 a statue was discovered which, despite the claim of the Roman archaeologist Canina that it was an autograph work by Lysippus, was quickly admitted (but never proved) to be a copy of the bronze Apoxyomenos by that master.[8] In 1863 the Doryphoros of Polyclitus was recognised[9] in a marble copy and in a bronze head which had been excavated, at Pompeii and Herculaneum, in the eighteenth century.[10] And soon afterwards the learned world acknowledged that a statue in the British Museum was a replica of the same sculptor's Diadumenos.[11]

There can be no doubt that these statues appealed to those members of the enlightened public who were likely to have had a sepia photograph of the Parthenon on their mantelpieces as well as those on the Board of Education who compiled the 'Regulations for Art Examinations'. But, with the exception of the *Discobolus* (which has acquired potent ideological associations in this century) and the *Winged Victory of Samothrace* (Fig. 177)—which Madame Verdurin considered, together with 'the Ninth' and the 'Night watch', as a supreme masterpiece of the Universe[12]—it is extremely unlikely that any of these entered as deeply into the visual consciousness of educated Europe as had the *Spinario*, the *Apollo Belvedere*, the *Venus de' Medici* and the *Apollino* in the fifteenth, sixteenth, seventeenth and eighteenth centuries. And it is quite certain that we could not claim for any of them, as we did for those statues which François Ier had had copied for Fontainebleau, that they were 'used as a touchstone by artists, art lovers, collectors and theorists alike for the gauging of taste and quality'.

Indeed, for all the new discoveries that had been made (and these included major pieces of authentic Greek sculpture to be found in London, Paris and Munich) and for all the scholarly blows that had been dealt, the old favourites retained immense and lasting prestige. It is true that in 1858 we find Nathaniel Hawthorne, who had at first been almost afraid of actually seeing the *Venus de' Medici*, 'for I somewhat apprehended the extinction of another of those lights that shine along a man's pathway', slowly, reluctantly, painfully being won round by Hiram Powers who proclaimed in front of one of the two full-size casts of her that he kept in his studio in Florence that 'It is rather a bold thing to say, isn't it, that the sculptor of the Venus de'

66. (left) Page from Brucciani's *Catalogue of Plaster Casts*, 1914, including eight items in our catalogue, together with the Prima Porta Augustus (no. 4, top row), the Berlin Adorante, the Hermes of Olympia, a version of the C nidian Venus, the Apoxyomenos, the Standing Discobolus (nos. 1–5, second row) and the Doryphorus (no. 3, third row).

67. (above) Edgar Degas: *The Borghese Gladiator*—sheet of studies (Sterling and Francine Clark Art Institute, Williamstown, Massachusetts).

68. (below) Adolph Menzel: The store-room of the cast gallery, Berlin—drawing with watercolour (Staatliche Museen zu Berlin).

Medici did not know what he was about?'[13]—but ever since the end of the eighteenth century modern artists had enjoyed making such provocative remarks, and Hawthorne's taste was uncertain at best. No such charge could be made against Jacob Burckhardt, the most cultivated of all nineteenth-century travellers to Italy. Yet, five years earlier, he had proclaimed that with the *Venus* 'art has achieved the greatest sublimity in her power . . . This is one of the greatest joys which Italy can offer the visitor.'[14] In his extremely influential *Cicerone* Burckhardt certainly discussed the Apoxyomenos and other recent discoveries and he certainly showed that he was fully aware of the problems of copies and variants, restorations and divergences of quality. Yet hardly any of the statues whose celebrity we have described in earlier chapters failed to win his admiration.

The situation is much the same with other travellers. In 1864 Taine found the body of the *Meleager* 'one of the finest I have ever seen', and of the *Antinous* (now called the Mercury) he commented that 'if one excludes the Venus de Milo and the statues of the Parthenon I know nothing to equal it'.[15] Augustus Hare, writing at the end of the nineteenth century, discarded even these qualifications: to him the figure was 'perhaps the most beautiful statue in the world'.[16] For the English-speaking traveller of the late nineteenth and earlier twentieth centuries Hare's *Walks in Rome* (which ran into seventeen editions between 1871 and 1905) and similarly titled guides to other Italian towns were probably as persuasive as had been the works of Richardson or Lalande for cultivated connoisseurs of long before. It is therefore salutary to find Hare (who indeed quoted very extensively from the opinions of earlier writers) singling out for special admiration, whether in the Vatican or in the Villa Ludovisi, almost the identical statues that they had done. What had changed most drastically was not the choice of statues that were appreciated but the fact that—if one excluded Rome—it became perfectly possible to write about Italy without mentioning antique sculpture at all.

Although studying casts of classical sculpture (Figs. 67 and 68) was more important than ever before in the training of an artist, it was early Italian painting which most attracted the mid-nineteenth-century connoisseurs who visited Italy. After the death of Canova in 1822 no living sculptor anywhere could command the attention, sometimes admiring, sometimes scornful, that was paid for instance to contemporary German painting with its self-conscious reminiscences of 'Christian art', and similar emotions were aroused by that art itself. The excitement that had once been caused by visiting a city 'where it is hardly to be believed what is constantly being found in Rome and its surroundings, for barely a day passes without one coming across a statue, a cameo, an engraved stone, a precious piece of marble . . .'[17] now gave way to the search for rapidly decaying frescoes by Benozzo Gozzoli or Signorelli in the smaller towns of Tuscany and Umbria. Some travellers rejoiced at this displacement of values, but more sensitive art lovers were anguished by a choice that they felt was demanded of them but which, as they were fully aware, conflicted with all the traditions of taste they had inherited.

As men cannot rise above their principles, so the artists of Greece never rose above the religious and moral sentiments of the age. Their Ideal was that of youth, grace and beauty, thought, dignity and power; Form consequently, as the expression of

Mind, was what they chiefly aimed at, and in this way they reached perfection.—Do not for a moment suppose me insensible to Classic Art—the memories of Greece and of the Palatine are very dear to me—I cannot speak coldly of the Elgin marbles, of the Apollo, the Venus, the Dying Gladiator, the Niobe, the Diana of Gabii, the Psyche of Naples—which comes nearer the Christian ideal than aught else of Grecian growth. But none of these completely satisfy us. The highest element of truth and beauty, the Spiritual, was beyond the soar of Phidias and Praxiteles; it is true, they felt a want—they yearned for it, and this yearning, stamped on their works, constitutes their undying charm. But they yearned in vain—Faith, Hope and Charity, those wings of immortality, as yet were not.[18]

Not everyone shared Lord Lindsay's austere sense of the spiritual (to the extent that he was willing retrospectively to imbue Phidias with a tormented agnostic conscience), but even for those whose interest in 'Christian art' of any kind scarcely extended beyond a hurried visit to the Sistine Chapel there was another Italy whose charms more than rivalled the appeal exerted by the Tribuna or the Museo Pio-Clementino. This was the Italy of mountains and olive groves and sun inhabited by simple 'children of nature'. It was an Italy that had never constituted a major attraction for previous generations (though the occasional reference to the singing gondoliers of Venice or the shoeless lazzaroni of Naples shows that it had not been wholly ignored), but which now began to assume great significance, and it was to this Italy that Flora Finching casually and in passing linked the sculptures that had been so mournfully admired by Lord Lindsay. 'In Italy is she really?' said Flora,

> with the grapes growing everywhere and lava necklaces and bracelets too that land of poetry with burning mountains picturesque beyond belief though if the organ-boys come away from the neighbourhood not to be scorched nobody can wonder being so young and bringing their white mice with them most humane, and is she rarely in that favoured land with nothing but blue about her and dying gladiators and Belvederes.[19]

In different ways the devout searcher of early frescoes and the tourist accumulating picturesque but vague sensations combined to throw into the shade the classical Italy of Montaigne and Addison, Winckelmann and Goethe, and, although it is true that in the second half of the century more and more North Europeans on holiday seem to have been attracted by carefree Mediterranean boys and by the less Christian aspects of Italian fifteenth-century art, such a taste encouraged a renewed appreciation of only a few of the statues in our catalogue—most notably the *Marble Faun* (Fig. 108) in the Capitoline Museum.

During the previous four centuries artists, art lovers, collectors and theorists would all have been likely to take a keen interest in the latest archaeological writings, but the great archaeologists of the second half of the nineteenth century, working for the museums of London, Paris, Berlin, Dresden and Vienna and for the national archaeological institutes, announced their discoveries and destroyed each other's theories in specialist journals, often in German—a language more familiar outside Germany to the learned than to the merely educated. For these archaeologists the reproductions supplied by Brucciani or Gerber were of enormous value, not only

because they enabled them to compare statues in different collections, but because they made it possible to add a cast of a copy of a head in one collection to a copy of a trunk in another or to assemble casts of different parts of different copies in order to obtain a better idea of a lost original.[20] The collection of casts in Berlin included nearly a thousand pieces in 1868 and the guide to it by Carl Friederichs served as a basic textbook for all students of ancient art. By 1885 this collection had more than doubled in size and included casts of the finds at Olympia where the excavations were carried out with unprecedented thoroughness between 1875 and 1881 under direction from Berlin.

The emphasis on absent originals was widespread in archaeological writing of the second half of the nineteenth century. Indeed, for the serious traveller who relied on Friederichs's *Bausteine* or Helbig's *Fuhrer* rather than Burckhardt's *Cicerone* or Hare's *Walks*, the antiques to be seen in the Vatican (or the Uffizi or Naples) were themselves mostly inferior copies, and the distinction in the mind of such a traveller between the Belvedere and a cast gallery was no longer as great as it had been—the more so as among these casts a number, bronzed, and with their supports removed, were held to give a better idea of the Greek originals than the statues to be seen in Italy.[21]

The problems posed by the techniques of reproduction used by firms such as Brucciani and Gerber are also of great consequence. Thus it is possible that the promiscuous familiarity encouraged by these techniques may have unintentionally diminished the glamour of the statues reproduced. To Josiah Wedgwood, addressing his customers in 1779, it was self-evident that multiplying copies of ancient masterpieces would, like the printing of scientific discoveries, prevent 'the Return of Ignorant and barbarous Ages'. Through copies 'good Taste' would be diffused, 'the publick Eye . . . instructed' and 'all the Arts receive Improvement'. Nor, he added, 'can there be any surer way of rendering an exquisite Piece, possessed by an Individual, famous without diminishing the Value of the Original: for the more Copies there are of any Works, as of the Venus Medicis, for instance, the more celebrated the Original will be'.[22] Ironically, however, it was when the *Venus de' Medici* was most multiplied that we can trace the first significant indications of a decline in her reputation.

But Wedgwood was, of course, thinking of high quality and accurate copies and he would not always have been impressed by the products of the plaster-cast makers, the marble workshops and the bronze-founders of the nineteenth century. Thus J. M. Blashfield, a London manufacturer of terracotta replicas of classical statuary who seems to have sold in the 1850s much the same range of figures as the Coade factory (some of whose moulds, dating from fifty years earlier he had purchased when the factory finally closed in the 1840s),[23] was proud of the fact that *his* products were hand finished and taken from the best moulds. His version of the *Apollo Belvedere*, for instance, was moulded from the cast taken from the original for 'the gallery of the late Mr. Nash', whereas the plaster-cast makers sold casts of broken casts so that bits of the god's hair were missing and his neck was thick because of the expansion of the plaster each time a cast was made. 'If a few trustworthy persons were employed to measure the casts sold for schools of art in this country, and compare them with the first casts taken from the originals, the most astounding

facts would come out', he declared, 'and it would be discovered that many thousand pounds had been squandered.'[24]

This was not a new problem with plaster casts: there are numerous references to their varying quality in the eighteenth century.[25] One aspect of the business that was new, however, was the variety of sizes available. Brucciani, for instance, not only offered casts of the *Apollo Belvedere* and casts of his head and shoulders, but casts of 'machine reductions' of both, as well as three sizes of statuettes 'copied from the antique'. The machines involved were reducing machines, and their development in the nineteenth century, alongside improvements in pointing machines and mechanical carving machines, also affected the copying of antique statues in marble.

Even though, as has already been said, the huge-scale operations to provide marble copies for Versailles was never to be equalled, far more marble copies had been made by sculptors in the eighteenth century than ever before, and leading sculptors had often been involved: there are examples, for instance, by Guillaume Coustou, Camillo Rusconi, Adam l'aîné, Scheemakers, Delvaux, Rysbrack, Bouchardon, Pigalle, Nollekens, della Valle, Wilton, Beyer, Houdon and Sergel. The practice was indeed required by students at the French Academy in Rome (which was attended by nearly all the finest sculptors of the century except Lemoyne and Falconet), even though some of them were reluctant to undertake a task which they considered to be 'mechanical'. Canova, however, refused to do such work and his example was very widely followed. When in 1855 a large series of copies was commissioned for the Cours Carré of the Louvre from the French pensioners in Rome, the job was passed on to an Italian mason. There were protests from unemployed French artists, but no sculptor of standing wanted such work.[26]

By the nineteenth century in fact copying had become a mechanical task, in the most literal sense of the words, thanks to improved pointing machines and the industrialised conditions introduced in the Carrara 'academy' by Napoleon's enterprising sister, Elisa Baciocchi (Princess of Lucca from 1805 and Grand Duchess of Tuscany from 1809), for the mass production of copies of antique statues, together with busts of her brother and architectural ornament. Casts of the antique were sent to her in Lucca from both Rome and the Musée in Paris,[27] and Tuscany with its great quarries and armies of skilled workers remained the centre of the marble copying business throughout the century. James Fenimore Cooper was horrified by the 'attenuated Nymphs and Venuses, clumsy Herculeses, hobbledehoy Apollos and grinning Fauns' which he saw in a shop in Livorno which specialised in exporting such marble copies 'principally to the English and American markets: I dare say Russia, too, may come in for a share'.[28] The premises of a firm of marble copiers still survive at Porta Santa near Serravezza, and the Florentine showrooms of two important manufacturers (Raffaello Romanelli on the Lungarno Acciaioli and Antonio Frilli in the Via dei Fossi) founded in 1860 can still be visited. Copies of different sizes in bronze and in the local serpentine (verde di Prato) and in moulded alabaster dust are sold as well as copies in marble, and so too are onyx, alabaster and marble eggs.

It is, however, unlikely that these mechanical copies were purchased by many of the leading art collectors of the nineteenth century, as the higher quality copies had been in the eighteenth, and they generally served as ornaments for the garden or

conservatory, rather than the gallery or entrance hall. And it is indeed in two gardens at the opposite ends of Europe—the Villa Chiaia in Naples and Chatsworth in Derbyshire—laid out in the 1830s and 1840s that we find some last reflection of what Louis XIV had achieved at Versailles.

During the eighteenth century leading sculptors not only copied antique statues; they also restored them as they had done since the Renaissance. But, as has already been mentioned, restoration gradually fell from favour, and Tenerani, who repaired the replica of the Apoxyomenos and supervised the restoration of the Prima Porta Augustus for the Vatican Museum was the last major European sculptor to be involved in this practice.[29] By 1890 restorations were being systematically removed from the statues in the Dresden Museum.[30]

Bronze copies, like marble copies, were affected by new technology, for, although we have seen that statuettes were produced in large quantities in late eighteenth-century Rome, it only became easy for founders to produce virtually unlimited editions when sand casting replaced the lost-wax method in the early nineteenth century. The centre of such mass production was Paris and in particular the factory established in 1838 by Ferdinand Barbedienne who, by first putting into practice the reducing machinery invented by Achille Colas and by employing several hundred workmen, was able to reproduce some twelve hundred originals[31]—among them the *Germanicus*, the *Apollo Sauroctonus*, the Venus d'Arles, and the *Silenus with the Infant Bacchus* given by the Prince Consort to Queen Victoria for Christmas in 1847 and still to be seen at Osborne House on the Isle of Wight.[32]

Sand-cast bronzes generally have a less lively and interesting surface because the casting was exact enough for hand finishing not to be needed. Detail tends to be less sharp because the file and chisel were not used, while hairlines betray the separate casting of limbs which this method necessitated. Thus there are certainly many more dull, and downright bad, bronze copies after the antique in the nineteenth than in previous centuries, but those made in large quantities in Naples by three leading firms (De Angelis et fils, founded in 1840; J. Chiurazzi et fils, which had merged with De Angelis to form the Fonderie Artistiche Riunite by 1915; and G. Sommer)[33] well into this century are often of high quality—and some at least were cast by the lost-wax process.[34] The most popular items on their lists were the *Dancing Faun* (Fig. 107) and the *Narcissus* (Fig. 141), small bronze statuettes which had been discovered in 1830 and 1862 in Pompeii. These were never regarded by archaeologists with the same interest as the Hermes of Olympia or even the replicas of the Apoxyomenos or the Doryphoros, but they were nonetheless the last antique statues to capture the popular imagination in the way that so many others had done since the fifteenth century. But by 1900 even they did not have an appeal which could match that already enjoyed by the Mona Lisa, by Michelangelo's David, or by Botticelli's Venus.

Notes to the Text

Notes to Chapter I

1. Adhémar, 1954; *L'École de Fontainebleau*.
2. Pastor, VII, pp. 135–46.
3. Dussler, p. 84.
4. Michelet, VIII, p. 285.
5. *La Collection de François I^er*.
6. Cellini, p. 391 (*Vita*).
7. Vasari, IV, pp. 31–2.
8. Venetian Ambassadors, 1523, in Albèri, p. 116.
9. Vasari, 1962–6, VI, p. 27, note 1.
10. *Ibid.*
11. Vasari, VI, pp. 145–6.
12. Dimier, 1900, p. 57; La Coste Messelière; Favier, 1974.
13. Vasari, VI, p. 145.
14. Dimier, 1899.
15. Cellini, pp. 444–5 (*Vita*); Pressouyre, 1969 ('Fontes').
16. Jestaz, pp. 439–42.
17. Cellini, p. 445 (*Vita*).
18. Hermann, pp. 236ff., 264ff.
19. Plon, 1883, nouvel appendice, pp. 29–30 (letter from Ippolito Tebaldo of 14 September 1512); but Pastor, VI, p. 489, says the patron was Federigo Gonzaga.
20. Hermann, pp. 215–17; *Lo Studiolo d'Isabella d'Este*, p. 14; Brown, 1976.
21. Plon, 1887, p. 48 (letter from Leoni).
22. Vasari, III, p. 385—quoted with other pertinent material by Candida.
23. Carradori, plate VI.
24. Jestaz, p. 452, note 7.
25. Cellini, p. 452 (*Vita*).
26. Casotti, I, pp. 25–8; Pressouyre, 1969 ('Fontes'), p. 224, note 3.
27. Jestaz, pp. 441, 445.
28. Pressouyre, 1969 ('Fontes'), pp. 225–6.
29. Vasari, VII, p. 407; Favier, 1974.
30. Fröhner, pp. 63–4; Brown, 1979.
31. Cellini, pp. 452–4 (*Vita*).
32. Cellini, pp. 444–5 (*Vita*); but see Dimier, 1900, p. 69.
33. Vasari (*Michelangelo*), II, p. 165.
34. Dimier, 1900, p. 62; Pressouyre, 1969 ('Fontes'), p. 230.
35. Vasari, VII, p. 408.
36. Plon, 1887, p. 48.
37. Ferrarrino, pp. 57–62.
38. Boucher.
39. *Ibid.*
40. Breval, II, p. 136; Montesquieu, II, p. 1026 (*Voyage d'Italie*).
41. Pressouyre, 1969 ('Fontes'), p. 230, also 231ff.
42. Thus Cellini, p. 445 (*Vita*), says that the *Camillus* ('Zingana'—*sic*) was to be copied.
43. Pressouyre, 1969 ('Fontes'), p. 223.
44. Dorez, p. 86; see also the letter to the reader in Chacon.
45. Vasari, VII, p. 407 (wrongly implying that it was cast in bronze); but see Adhémar, 1949.
46. Lanciani, 1902–12, I, p. 157.
47. Aldrovandi, 1556, p. 123 (referring to the *Cesi Juno*).

Notes to Chapter II

1. Ackerman, 1954.
2. Venetian Ambassadors, 1523, in Albèri, pp. 114–15.
3. Brummer, p. 41.
4. *Ibid.*, pp. 38–42.
5. Ackerman, 1954, p. 33.
6. Michaelis, 1890, p. 9; Weiss, 1969, pp. 180–92.
7. Weiss, 1958, p. 24.
8. Müntz, 1878–82, III, pp. 14–15; *Il Tesoro di Lorenzo il Magnifico*.
9. Weiss, 1969, p. 100.
10. Michaelis, 1891; Stuart Jones, 1912, pp. 1–2.
11. Hecksher.
12. Gaye, I, p. 285; Weiss, 1969, p. 192.
13. Michaelis, 1890, p. 16, note 39.
14. Renier, p. 210; Pastor, VI, p. 488.
15. Müntz, 1896.
16. Michaelis, 1890, p. 25.
17. Amelung and Lippold, II, pp. 36–8.
18. Lanciani, 1902–12, II, p. 181.
19. Michaelis, 1891–2, ii, pp. 218–38.
20. De Maio, p. 380.
21. Aldrovandi, 1556, p. 299.
22. See Vasari (*Gentile de Fabriano e il Pisanello*), p. 38, for the 'Stanza di Cesare' in the Este palace in Ferrara in 1441 named after a 'Divi Julii Caesaris effigiem' given to Lionello d'Este by Pisanello: this is unlikely to have been an antique bust.
23. Canedy, 1967; Brummer, pp. 254–64.
24. Ackerman, 1954, pp. 87–97.
25. Pastor, XVII, pp. 46–64.
26. *Ibid.*, XVII, p. 111, note 1; but see also Mercati, A.
27. Fulvio, 1527, fol. lxxxi recto (for lxxvi).
28. Gombrich, pp. 105–6.
29. Pastor, IX, p. 73.
30. Gombrich, pp. 104–8.
31. Brummer, pp. 216–51.
32. Michaelis, 1890, p. 42.
33. *Ibid.*, p. 41.
34. Pastor, XVII, p. 114.
35. Michaelis, 1890, pp. 63–6.
36. Pastor, XVII, pp. 91, 331–2.
37. Michaelis, 1891.
38. Venetian Ambassadors, in Albèri, pp. 108–9.
39. Pastor, XVII, p. 112.

Notes to Chapter III

1. Vasari, VII, pp. 35, 540–1.
2. Armenini, pp. 61–3.
3. Nebbia, pp. 57–9.
4. Mandowsky, 1953, pp. 255–8.
5. Candida, pp. 94–5 (for references to Squarcione, Mantegna and others).
6. Wright, II, p. 440; Lalande, I, pp. 152, 235 and note.
7. Pevsner, 1940, p. 62; Reynolds, T., pp. 83, 206, 231.
8. Pevsner, 1940, p. 62; but Alberti, p. 5, only mentions 'opere di rilievi in cera, creta'.
9. Borromeo, pp. 35–8, 71–3; Boucher.
10. Richardson, 1722, p. 28.
11. Bellori, pp. 629–31; Goldstein.
12. Gardey, Lambert and Oberthur, nos. 104–6, 112, 126, 192–3, 231.
13. Bartsch, XIII, p. 282, no. 50; p. 290, no. 64; p. 326, no. 15; XIV, nos. 202–5, 243, 299, 309, 328–9, 340–1, 353, 480, 514–15; Hind, plates 536, 539–40, 656, 659, 802, 869.
14. Egger, fols. 31v, 45, 53, 60v–64.
15. Knift.
16. Canedy, 1976, pp. 9–14.
17. Michaelis, 1891–2, i, pp. 127, 169–71; ii, pp. 219–21.
18. Vico, 1550; 1554; 1557; Statius.
19. Vasari, V, p. 431.
20. Ehrle, pp. 11–25 and appendix; Lowry.
21. Ashby, 1920.
22. Urlichs, L. H.; Aldrovandi, 1907, p. 26.
23. Michaelis, 1891–2, v, pp. 93–4; Battelli; Dhanens.
24. For the cost in 1642, see Stone, p. 199.
25. Flaxman, p. 134.
26. Hind, plates 656, 802, 869.
27. Bartsch, XIV, nos. 243, 353 (for *Laocoon*); Hind, plate 659 (for *Apollo*).
28. Mandowsky and Mitchell, pp. 26–8.
29. Perrier, 1638, plates 35, 87, 90, 93–5.
30. Sandrart, 1680, p. 26—engraved by R. Collin, 1676.
31. *Ibid.*, p. 58.
32. *Ibid.*, pp. 53–4, 64.
33. Bartoli, 1693, plate 63.
34. Misson, 1739, II, i, p. 172; see also Richardson, 1722, pp. 264–5.

Notes to Chapter IV

1. *Raccolta di Elogi*, IV, pp. dcx–dcxvi.
2. Thirion.
3. Müntz, 1896; Lanciani, 1902–12, III, pp. 103–22; Boyer, 1929.
4. Orbaan, p. 89.
5. Addison, p. 335.
6. Sandrart, 1680.
7. Richardson, 1728, III, i, p. 255; [de Guasco], p. xx.
8. Kotzebue, III, p. 116.
9. Amayden, I, pp. 309–10; Orbaan, pp. 89–90; della Pergola, 1962, p. 6.
10. Felini, p. 335; Baglione, p. 74; Orbaan, p. 155; Faldi, 1954, pp. 49–51.
11. Graeven.
12. Pressouyre, 1969 ('Le "Moro"').
13. Schreiber; Bruand, 1959, pp. 22–30.
14. Aldrovandi, 1556, pp. 221–4; Schreiber, pp. 6, 11, 25–6.
15. Manilli.
16. Fea, 1790, p. clxvii ('Ficoroni' Mem. 101); Boselli, fol. 28v, pp. 22, 83.
17. Felici, p. 323.
18. Bruand, 1959, p. 83.
19. *Roma*, 1930, VIII, p. 443 (for *avviso* of 10 September 1672).

20. Montaiglon (*Correspondance*), I, pp. 23, 27 and other references.
21. Schreiber, p. 16; Mansuelli, I, pp. 82–3.
22. Bruand, 1959, pp. 75ff.
23. Mabillon and Montfaucon, I, pp. 201–2, 222.
24. Boyer, 1932 ('Christine de Suède'), pp. 261–2.
25. Maffei, plates CXI–CXX.
26. Raguenet, pp. 321–6.
27. Winnefeld, p. 152; but see Cavaceppi, III (1772), plates 58–9.

Notes to Chapter V

1. Peacham, pp. 107–8.
2. *Ibid.*; Revill and Steer; Whinney, 1964, p. 240, note 22.
3. Stopes, p. 282; Howarth, p. 255.
4. Peacham, pp. 107–8.
5. British Library, Harleian MS. 4898, fols. 295v, 302; Harleian MS. 7352, fols. 119, 122v; 'Papers Relating to the Late King's Goods', p. 90 (section XXVII, part 3).
6. British Library, Harleian MS. 4898, fols. 295v, 301v; Harleian MS. 7352, fols. 119, 122, 122v; 'Papers Relating to the Late King's Goods'.
7. 'Papers Relating to the Late King's Goods', p. 89 (section XXIV); p. 90 (section XXV); Michaelis, 1882, p. 30; Colvin, V, pp. 271–2.
8. 'Papers Relating to the Late King's Goods', pp. 88–90 (for the return of the statues to the royal collection); Gunnis, pp. 280, 284; Colvin, V, pp. 171, 173, 297 (for subsequent damage and removal).
9. Whinney, 1964, p. 28.
10. Van der Doort, pp. 92–6, 211–12; British Library, Harleian MS. 4718, fol. 10, no. 26; Chiffinch MS., no. 96; but see also Harleian MS. 4898, fol. 286.
11. Bellori, pp. 443–4.
12. Fréart, 1664, dedicatory epistle.
13. Bellori, pp. 443–4; Fréart, 1664, dedicatory epistle; Blunt, 1951, pp. 369–76.
14. Blunt, 1951, pp. 360–76.
15. Poussin, pp. 306, 349.
16. Justi, 1888, II, pp. 194–7; Hallo, pp. 200–3; Harris, E.
17. Palomino, pp. 910–18; Bottineau.
18. *Ibid.*
19. *Ibid.*; Harris, E.
20. Palomino, pp. 910–18; Bottineau.
21. De Caus, plate 20, and, for position in garden, plate 4.
22. Speth-Holterhoff, plates 28, 47, 50–1.
23. *Ibid.*, pp. 100ff., plate 32.
24. For the Urania, see Stuart Jones, 1926, pp. 20–1; and, for indications of its fame, Perrier, 1638, plate 74; Thomassin, plate 51.
25. Sandrart, 1675–9, I, ii, p. 41; van Gelder, 1963, p. 51.
26. Stone, pp. 193–200.
27. Clark, p. 208, no. 329.
28. Mengs, p. 271 (*Frammento d'un discorso sopra i mezzi per far fiorire le belle arti nella Spagna*).

Notes to Chapter VI

1. Boislisle; de Cosnac; Bonnaffé.
2. Desgodetz.
3. Montaiglon (*Correspondance*), I, p. 24 (6 September 1669).
4. Chantelou, pp. 134, 147.
5. *Ibid.*, p. 138.
6. *Ibid.*, pp. 138, 147.
7. Montaiglon (*Correspondance*), I, p. 27 and many other references.
8. Burnet, p. 246.

9. Montaiglon (*Correspondance*), I, pp. 153ff., VI, pp. 390ff.
10. Mabillon and Montfaucon, I, p. 134.
11. Montaiglon (*Correspondance*), X, pp. 434, 438. The nobleman was Filippo Farsetti.
12. Thomassin, p. 12.
13. Montaiglon (*Correspondance*), I, p. 318 and many other references.
14. *Ibid.*, I, pp. 129–41.
15. *Ibid.*, III, p. 209.
16. *Ibid.*, I, pp. 115–16.
17. *Ibid.*, I, p. 343.
18. Souchal, 1977, I, p. 32.
19. Montaiglon (*Correspondance*), I, p. 342.
20. *Ibid.*, I, pp. 90, 94, 96 and many other references.
21. Francastel, 1928, pp. 43–6.
22. Montaiglon (*Correspondance*), I, p. 117.
23. *Ibid.*, I, p. 22 and other references.
24. *Ibid.*, I, pp. 351, 370–2.
25. Perrier, 1638, plate 76. Also known as a Sabine, Thusnelda, Germania and Medea—Carpenter, pp. 63–7.
26. Montaiglon (*Correspondance*), I, p. 280 and frequent references; also XIV, pp. 130–1, 140; and d'Argenville quoted in Enggass, I, p. 124.
27. Souchal, 1977, I, pp. 103–4, 106.
28. *Ibid.*, I, pp. 190–1, 195.
29. Benoist, pp. 50–1.
30. Francastel, 1930.
31. Souchal, 1977, I, p. 191–3.
32. Francastel, 1928, p. 83.
33. Souchal, 1973.
34. [Félibien], 1679; for the payments to Mellan, see Guiffrey, I, pp. 278, 468–9. Many more engravings by Baudet were published in later parts of the book.
35. Thomassin, p. 3.
36. Fontaine, pp. 28–9.
37. Montaiglon (*Procès-verbaux*), I, p. 366.
38. Jouin, pp. 19, 26.
39. *Ibid.*, p. 140.
40. Quoted in de Nolhac, 1901, p. 238 (p. 174, note 3).

Notes to Chapter VII

1. Vermeule, 1956 ('Dal Pozzo-Albani'); Haskell, 1963, pp. 101–2.
2. Vermeule, 1956 ('Dal Pozzo-Albani'); Fleming, 1958.
3. Mandowsky and Mitchell, pp. 1–6.
4. Compare Montfaucon, 1719, I, i, plate LXXI, with 1724, I, plate XXXVII; or 1719, I, ii, plate CLXXXIII, with 1724, I, plate LXVII.
5. *Ibid.*, 1724, I, p. 104, plate XXXIX.
6. Clarac, 1826–53; Reinach, 1897–1930, I.
7. Montfaucon, 1702, p. 143; Montfaucon, 1719, I, i, p. 74.
8. E.g. Kircher.
9. Spon, p. 213.
10. Bacchini; Misson, 1739, II, i, p. 171.
11. Mandowsky and Mitchell, p. 31.
12. *Ibid.*, pp. 40–1.
13. Caylus (*Correspondance*), I, pp. 342–3.
14. Caylus, 1914, p. 314.
15. Misson, 1691, II, pp. 99–102; Addison, p. 413.
16. [Grosley], II, p. 254.
17. Montaigne, III, Chapter 9 ('De La Vanité').
18. Manilli, p. 62; Montelatici, pp. 254–5.
19. Lafreri (British Museum copy), fols. 24–5; Bellori in Bartoli, 1665, plates 118–19; Piranesi, 1753; Winckelmann (ed. Fea), II, p. 366.
20. Stuart Jones, 1926, pp. 5–6, 11–14, 172–4.
21. Burney, p. 137; see also Miss Berry, I, p. 303, who thought the toe as thick as Mr. E. Conway's body.
22. Lassels, II, p. 82; Montfaucon, 1702, pp. 186–7; Ficoroni, 1744 (*Vestigia*), pp. 26–8; Venuti, R., 1763, II, p. 28.
23. Bartsch, XIV, nos. 202–5. There are also engravings by Lazare de Baïf after François de Dieuterville in *De Re Navali*, Paris 1536—for which, see Lanciani, 1902–12, II, pp. 12–13.
24. Chacon.
25. Bartoli, 1665.
26. Krautheimer and Jones, doc. 848 (3 June 1665).
27. Piranesi (*Trofeo*).
28. See de Rossi's letter to the reader included in several eighteenth-century editions of Bartoli, 1665; also Montaiglon (*Correspondance*), I, pp. 23–4, 121, 167; II, p. 16; XI, p. 93; XIII, pp. 387, 392–3, 395.
29. *Ibid.*, II, p. 18.
30. Perrault, 1759, pp. 108–9.
31. Valadier was assisted by the goldsmiths Peter Ramoser and Bartholomäus Hecher—Honour, 1971, p. 210.
32. [Blundell], 1803, p. 163.
33. Tardieu.
34. Bell, C. F., plate IV; Penny, 1977, p. 53.
35. Vasari, I, p. 109; Winckelmann (ed. Fea), II, p. 20.
36. Aldrovandi, 1556, p. 313; Vacca, Mem. 35.
37. Lafreri (British Museum copy), fols. 5, 6—both signed by Van Aelst and dated 1553.
38. Hart and Kennedy, pp. 80–1.
39. Cellini, pp. 86–7 (*Vita*).
40. Boissard; Visconti (*Pio-Clementino*), VII, plates XI, XII; Venetian Ambassadors in Albèri, p. 106; Hoogewerff.
41. Hoogewerff.
42. Harcourt-Smith, plate VI, pp. 34–40.
43. Misson, 1691, II, p. 116 (but see also 1731, II, p. 247, note); Ficoroni, 1744 (*Vestigia*), pp. 176–7; Winckelmann (ed. Fea), II, p. 411; Visconti (*Pio-Clementino*), VII, plates XI, XII; de Brosses, II, pp. 45, 243.
44. Venuti, 1763, I, p. 125; Vasiliev, pp. 21–2.
45. Misson, 1691, II, p. 35.
46. Richardson, 1728, III, ii, p. 524.
47. Winckelmann (ed. Fea), II, p. 16.
48. 'True Description', p. 23; Misson, 1961, II, pp. 64–73; Montfaucon, 1702, p. 137; de Blainville, II, pp. 561–2. For the latest explanation, see d'Onofrio, 1978, pp. 124–56.
49. Mariette, I, pp. 398–401.
50. *Ibid.*, I, pp. 345–53; Stern.
51. Spon, p. 87; Stosch, pp. 94–7, plate LXX; Richardson, 1728, III, i, p. 6.
52. Stosch, plate LXIII; de Brosses, II, p. 91; Walters, p. 195.
53. Vacca, Mem. 36; Misson, 1731, II, pp. 288–90; Ficoroni, 1744 (*Vestigia*), p. 169; Foggini, plates 1–4; Winckelmann (ed. Fea), I, pp. 40–1; II, pp. 403–4; Walters, pp. 376–8; Haynes.
54. Wedgwood, 1779, class I, section I, no. 1674, and (as a medallion in six sizes) class II, 30; Gray, J., pp. 15–16; Hobson, p. 186 (no. 1573–also nos. 1630, 1644, 1696, 1826, 2161, 2190, 2193).
55. Misson, 1691, II, pp. 149, 151.
56. Portland Catalogue, especially p. 194.
57. Burnet, p. 243.
58. Visconti (*Pio-Clementino*), II, plate XLIII.
59. Maffei, plate CXXXV; Spence, p. 46; Visconti (*Pio-Clementino*), I, plate I.
60. Smollett, p. 233 (letter XXVIII).
61. Northall, p. 362.
62. Haskell, 1976, p. 219.
63. Venuti, F., 1783, especially pp. 11–19; and see Pliny, XXXV, 9.
64. Robertson, I, pp. 526–7; Prinz.
65. Weiss, 1959; Fulvio (ed. Weiss).
66. Jongkees.
67. Gallaeus, no. 131; Faber, p. 74; Visconti (*Iconografia Romana*), II, pp. 409–10.
68. *Ibid.*, II, pp. 410–14.
69. *Antichità di Ercolano*, V, 1767, pp. 125–9.
70. Winckelmann, 1764 (*Lettere*), pp. 37–8.

NOTES TO CHAPTER VIII

1. Mansuelli, I, p. 8; Müntz, 1888.
2. Ettlinger; for Cosimo's acquisitions, see Müntz, 1896; Cristofani, 1980 (with references to earlier articles); *Firenze e la Toscana dei Medici*, pp. 19–42.
3. Berti.
4. Lessmann, p. 237.
5. Heikamp, 1963; 1964.
6. Bocchi, p. 51.
7. Bocchi (ed. Cinelli), p. 101.
8. Mansuelli, I, pp. 90–1.
9. Florence, Archivio di Stato; CDA, X (18 May 1669).
10. Florence, Archivio di Stato, Med. Princ. 3941 (17 November 1674).
11. *Twilight of the Medici*, p. 26 (alluding to the Life of Foggini by F. S. Baldinucci in Lankheit, p. 233 (doc. 48)).
12. Lankheit.
13. Boyer, 1932 ('Transfert'), p. 212.
14. Evelyn, II, p. 286.
15. Baldinucci, V, pp. 383–4.
16. Florence, Archivio di Stato, Med. Princ. 3397 (letters from and to the Tuscan Resident in Rome, Count Montauti, June to August 1677); Boyer, 1932 ('Transfert').
17. Mabillon and Montfaucon, I, p. 134.
18. Baldinucci, V, p. 390.
19. Montaiglon (*Correspondance*), VI, p. 413 (28 January 1687).
20. De Brosses, II, p. 200.
21. Wright, II, p. 396.
22. Crulli de Marcucci, fol. 50v; *Giambologna* (London), no. 180.
23. Alazard, pp. 132ff.; Lankheit, p. 72.
24. Lankheit, pp. 329–30 (doc. 647).
25. *Ibid.*, p. 329 (doc. 644).
26. *Ibid.*, p. 335 (doc. 673).
27. *Ibid.*, p. 329 (doc. 645).
28. *Ibid.*, p. 333 (doc. 665).
29. Hallo.
30. Ciechanowiecki and Seagrim.
31. Lord Chesterfield—quoted in *Dictionary of National Biography*.
32. Wright, II, p. 412.
33. Corke and Orrery, p. 77; Neale, I (Knowle); Keutner, pp. 141–3.
34. Winckelmann (ed. Fea), I, p. xxviii.
35. Richardson, 1722, p. 56.

NOTES TO CHAPTER IX

1. Montaiglon (*Correspondance*), VII, p. 480.
2. Maffei, plates CXLV, CXLVII; Michaelis, 1882, pp. 59, 308–9, 313–14.
3. Brettingham, 1773, p. 4.
4. Montaiglon (*Correspondance*), V, pp. 368–91 (many references).
5. Pastor, XXXIV, pp. 35–7.
6. Montaiglon (*Correspondance*), VII, pp. 333–7.
7. *Ibid.*, IX, p. 489.
8. *Ibid.*, X, p. 434 (Filippo Farsetti, 1753).
9. *Ibid.*, VII, p. 381.
10. *Ibid.*, VIII, p. 258.
11. Stuart Jones, 1912, pp. 385–98.
12. Lewis, p. 92.
13. Stuart Jones, 1912, p. 6.
14. Barthélemy, p. 95 (10 February 1756).
15. Winnefeld, pp. 4–5.
16. Coffin.
17. Mandowsky and Mitchell.
18. Aurigemma, 1961, p. 28.

19. Paciaudi, p. 318.
20. Montaiglon (*Correspondance*), VIII, p. 396.
21. Vanvitelli, I, pp. 583, 590, 592ff., 601.
22. Montesquieu, II, p. 1317 (*Voyage d'Italie*).
23. [Grosley], II, pp. 294–5; see also [de Guasco], p. xxiii; Justi, 1866–72, II, p. 305.
24. Vanvitelli, I, pp. 115, 440, 446, 505, 516; II, pp. 176, 300, 366.
25. Lewis, pp. 151–4.
26. Brettingham MS.; Michaelis, 1882, p. 71.
27. Pietrangeli, 1951–2, pp. 89–90.
28. Lewis, pp. 154ff.; Justi, 1866–72, III, pp. 32–8.
29. Michaelis, 1882, pp. 55–128.
30. Dallaway, 1816, p. 186; Udy, pp. 829–30; *Burlington Magazine*, 1979, p. 141.
31. Michaelis, 1882, pp. 454–5, 466.
32. Goethe, XXXII, p. 323 (*Italienische Reise*); Winckelmann (ed. Fea), II, p. 199; Visconti (*Pio-Clementino*), II, plate XLIII; Kotzebue, III, p. 23.
33. Kotzebue, III, p. 23.
34. [Knight], 1809, plate XLI.
35. Smith, A. H., 1892–1904, III, pp. 28, 147–9.
36. Erlich, pp. 16, 20.
37. Richard, VI, p. 73; Winckelmann (ed. Fea), II, p. 196; Dallaway, 1800, pp. 311–12; Michaelis, 1882, p. 97.
38. Another two belonged to the Capitoline Museum and the Bailli de Breteuil.
39. Puccini, pp. 20–1.
40. Fabroni, p. 21.
41. Pastor, XXXVIII, p. 162.
42. Montaiglon (*Correspondance*), XII, p. 318.
43. Pietrangeli, 1951–2; Howard, 1973.
44. Michaelis, 1890, p. 54.
45. Rossini, 1776, I, pp. 275–7.
46. *Ibid.*
47. Pastor, XXXVIII, p. 543.
48. See the plan at the beginning of Vol. I (1782) of the folio edition of Visconti's *Pio-Clementino*; Berry, I, pp. 111–12 (22 April 1784).
49. Vasi, 1792, p. 9; Massi, p. 25. The Lucius Verus was presumably Visconti (*Pio-Clementino*), I, plate IX, and the Genius of Augustus, *ibid.*, III, plate II.
50. Vasi, 1792, p. 9.
51. Lalande, III, p. 197.
52. Eustace (*Tour*), I, p. 291.
53. Montesquieu, I, p. 1318 (*Voyage d'Italie*).

NOTES TO CHAPTER X

1. Burnet, p. 200; Misson, 1691, I, pp. 290–1; Winckelmann (ed. Fea), II, p. 47; Filangieri; Crutwell, pp. 192–200; *Cavalli di San Marco*, p. 34.
2. De Blainville, III, p. 271; Northall, p. 219.
3. Winckelmann, 1764 (*Nachrichten*), pp. 2–3.
4. Bayardi.
5. Winckelmann, 1764 (*Lettre*), pp. 17–18 (on excavation); pp. 24–6 (on restoration); pp. 47, 79, 105 (on cataloguing).
6. Michaelis, 1882, p. 69.
7. Caylus, 1752–67, I, 1752, pp. 149–52; II, 1756, pp. 321, 332; Caylus (*Correspondance*), I, pp. 101, 112–14, 120, 128; Paciaudi, pp. 258–61.
8. Goethe, XXXI, p. 251 (*Italienische Reise*).
9. De Brosses, I, p. 315; Burney, pp. 177, 187.
10. Cochin and Bellicard, p. 34.
11. Caylus, 1752–67, II, 1756, p. 120; III, 1759, p. 143; VII, 1767, pp. 168–80.
12. De Blainville, II, p. 445; Richardson, 1722, p. 306; Cochin, I, p. 209; Mengs, pp. 397–9; Winckelmann (*Briefe*), I, pp. 336–9.
13. De Franciscis, 1944–6; De Franciscis, 1963 (*Museo Nazionale*).

14. *Documenti inediti*, I, pp. 166–274.
15. Goethe, XXXII, pp. 6–7 (*Italienische Reise*).
16. De Franciscis, 1963 (*Museo Nazionale*), pp. 12–27.
17. Nelson, III, p. 211.
18. Boyer, 1970, p. 193.
19. Filangieri di Candida.
20. Boyer, 1970, pp. 193–6.
21. *Documenti inediti*, IV, pp. 274–328.
22. De Franciscis, 1963 (*Museo Nazionale*), p. 42.
23. *Ibid.*, p. 43.
24. Petrelli; Maderna; *Civiltà del'700 a Napoli*, I, pp. 108–25.
25. Petrelli, p. 208 (no. 20).
26. Moore, who was in Italy in 1775–6, says that they were then 'kept in a storehouse till the gardens are finished'— Moore, II, p. 305.
27. Montaiglon (*Correspondance*), X, p. 442.
28. Maderna, p. 168 (no. 54).
29. Montaiglon (*Correspondance*), XIV, p. 256. An earlier plan to send casts to Spain is mentioned in Winckelmann, 1764 (*Lettre*), p. 104.
30. Righetti (see Appendix).
31. Lorenzetti, p. 190.
32. Finati, I, ii, p. 128, note.
33. Brucciani, 1864.
34. Reinach, 1897–1930, I, p. xxxv of the *Notice historique sur le Comte de Clarac*.

Notes to Chapter XI

1. Van Gelder, 1963, p. 58.
2. Säflund, pp. 19, 63.
3. Karpowicz, pp. 97–121.
4. Tatarkiewicz, pp. 465–76.
5. *Berlin und die Antike*, pp. 95–6.
6. Montaiglon (*Correspondance*), IV, p. 235; see also Richardson, 1722, p. 351.
7. Edwards, 1808, pp. xvi–xix.
8. Gunnis, pp. 279–82.
9. Van Nost.
10. Gunnis, pp. 82–3.
11. Pope, *Epistle to Richard Boyle, Earl of Burlington*, line 124.
12. *The Man at Hyde Park Corner*, p. 9.
13. Hogarth, pp. 64, 66.
14. British Library, Add. MS. 39780, fol. 57.
15. *Correspondance littéraire*, V, p. 241.
16. Smollett, p. 286 (letter XXXIII).
17. Mengs, p. xv (introductory memoir by d'Azara).
18. Herder, VIII, p. 103.
19. Goethe, XXVIII, pp. 84–7 (*Dichtung und Warheit*). See Trevelyan, pp. 37–9, for the date of Goethe's visit to Mannheim.
20. Schiller, XX, pp. 101–6; XXI, pp. 146–50; Sitte.
21. Goethe, XXXII, p. 324 (*Italienische Reise*).
22. *Aufklärung und Klassizismus*, pp. 119–27.
23. Trevelyan, pp. 66, 104, 118.
24. Goethe, XXX, pp. 134–5 (*Italienische Reise*); for Farsetti's copies, see Montaiglon (*Correspondance*), X, pp. 434, 438, 442; XI, p. 159.
25. Goethe, XXX, pp. 238–40 (*Italienische Reise*).
26. De Brosses, II, pp. 85–6.
27. See for example the painting by Goubau in the Antwerp Museum.
28. De Nolhac, 1910, pp. 72–3 (two of these—*Farnese Hercules* and *Venus de' Medici* are in the Petit Palais).
29. Arisi, figs. 305, 310, 315.
30. *Correspondance littéraire*, V, p. 248.
31. Montaiglon (*Correspondance*), XI, p. 295; XII, pp. 75, 133.
32. Brettingham MS., p. 135.
33. *Ibid.*, pp. 136ff.; [Grosley], I, pp. 223–4.
34. Brettingham MS., pp. 139–43.
35. *Ibid.*, pp. 133–5.

36. Brettingham, 1773, pp. 2, 12, 15, 19, 20; Dawson, pp. 22–4, 28–32, 59–60.
37. Hagstrum, pp. 224–5.
38. Honour, 1958, pp. 222–4.
39. Walpole (*Correspondence*), XIX, p. 34; XX, pp. 539, 547.
40. Charlemont Papers, pp. 221, 322.
41. Walpole (*Correspondence*), XXI, p. 173 and note; Edwards, 1808, pp. xvi–xix.
42. Säflund, pp. 13–14, 59–60.
43. Kwiatkowski, pp. 16–17; Mankowski.
44. Majewska-Maskowska, pp. 324–9.
45. Salerno, Spezzaferro and Tafuri, p. 304, plate XIV, fig. 215.
46. Corsini, p. 219; Ginori Lisci, 1972, II, pp. 565–72.
47. Mengs, pp. 286, 383, 408–10; Mengs (*Briefe*), pp. 39–57.
48. Neverov, pp. 46–53.
49. De Reimers; Bencivenni Pelli, I, pp. 431–2; Burney, p. 208.
50. Pietrangeli, 1958 (*Scavi*), p. 140.
51. Kuchumov, plates (of the park) 32, 35, 64–80.
52. *Ibid.*, plates (of the palace) 16, 23–5, 58, 60, 70.
53. Rae, plates 13, 14, 16.
54. Znamenov.
55. Poznansky, plates 1, 3, 47.
56. Foote, pp. 121–2, 125–6; Hodge, pp. 11–12.
57. Howard, 1977.
58. *Ibid.*, p. 587.
59. Sizer, pp. 1–12; Dunlap, II, p. 105.
60. After 1817 known as American Academy of the Fine Arts. Sizer, pp. 12–20; McCook, p. 45.
61. Dunlap, I, pp. 160–1; II, pp. 104–5, 106–10; MSS. in Pennsylvania Academy Library.
62. Sizer, pp. 12, 23.
63. Trollope, pp. 228–9.
64. Stendhal, 1908, II, p. 123—but the letter is not included in the Pléiade edition of Stendhal's correspondence.
65. Cooper, I, pp. 43–4.
66. Diderot, p. 58.
67. Hogarth, pp. 91–2.
68. Smollett, pp. 236–8 (letter XXVIII).
69. Falconet, I, pp. 51, 157ff.; II, pp. 1–2, 235, 326; IV, pp. 377–81.
70. *Ibid.*, I, pp. 27, 150, 175, 273; II, pp. 287, 315; IV, p. 358.
71. *Ibid.*, I, p. 266, note.
72. *Ibid.*, IV, p. 126, note.

Notes to Chapter XII

1. Bartsch, XIV, nos. 514–15; Hind, plates 656, 802, 869.
2. Hermann, pp. 211–12.
3. Baldinucci, IV, p. 110.
4. *Syon House*, p. 40; *Apollo* at Versailles and *Mars* in the Louvre.
5. Righetti, R., p. 7.
6. Honour, 1961; Honour, 1963; and, for Boschi, *Dizionario biografico degli Italiani*.
7. Zoffoli; Righetti (see Appendix).
8. Righetti, R., pp. 3–4; Honour, 1971, p. 211.
9. Beckford, I, p. 224; Starke, 1800, I, p. 298; Frye, p. 203.
10. Algarotti, VI, pp. 166–7 (*Viaggi di Russia*).
11. Ginori Lisci, 1963, pp. 58–64.
12. Examples in the Victoria and Albert Museum and elsewhere.
13. Example in the Ceramic Museum, Palazzo dei Conservatori, Rome.
14. Rackham, I, p. 410, no. 3189; II, plate 262.
15. E.g. *The Man at Hyde Park Corner*, p. 19, plate 3 (no. 35); Rackham, I, p. 124 (no. 944); II, plate 71.
16. Bourgeois, nos. 48, 124, 292, 298, 370, 483, 608, 609–10.
17. Victoria and Albert Museum, Tatham MSS., D. 1479–1898, p. 17; D'Uklanski, II, pp. 106–7.

18. Honour, 1967; Molfino, II, plates 90–8.
19. Lorenzetti, pp. 190–1; Molfino, II, plates 344–5.
20. Rotili, pp. 12–13.
21. Mankowitz, 1953.
22. Coade, 1777–9; Coade, 1784; Coade, 1799.
23. Mariette, I, pp. 92–3; Lippert, 1753; Lippert, 1755–63.
24. Stosch, p. xix; Goethe, XXXII, p. 96 (*Italienische Reise*).
25. Raspe.
26. E.g. Raspe, II, nos. 9475ff., 10764–5, 14719, 15613; for the Sirlettis, see Mariette, I, pp. 140–1; see also Dalton, pp. xlix, liv, lxxi; Wedgwood, 1779, class I, sections 1, 2.
27. British Library, Add. MS. 39780, fol. 45.
28. Marchant; Gray, J., pp. 51–6.
29. Dolce.
30. Sets in the National Museum of Wales, Cardiff, and elsewhere. For Paoletti's presumed father Bartolomeo, see *Curiosità di una reggia*, p. 104, note 27.
31. Rogers, *An Epistle to a Friend*, lines 66–9.

NOTES TO CHAPTER XIII

1. Addison, pp. 339–41.
2. Montaiglon (*Correspondance*), XVI, pp. 484–5.
3. Richardson, 1728, III, i, pp. 100–1, 205–8, 218–20; ii, pp. 581–93.
4. Winckelman (ed. Fea), I, pp. 191, 419 (Leucothee); p. 292 and note (young faun); p. 295 (genius); p. 317 (Juno); II, p. 386 (Antinous).
5. De Brosses, II, p. 33.
6. Goethe, XXX, pp. 250–1 (*Italienische Reise*); Goethe (*Briefe*), VIII, pp. 130–1.
7. Richardson, 1728, III, i, p. 180.
8. Goethe, XXXII, pp. 147–51 (*Italienische Reise*); Starke, 1820, pp. 325–6; Matthews, I, p. 151; Whitely.
9. E.g. Winckelmann (ed. Fea), I, pp. 386, 392; II, p. 357.
10. Pater, 1873, p. 164.
11. Goethe, XXXII, p. 98 (*Italienische Reise*).
12. [La Roque], II, pp. 177–8, note.
13. Galiffe, I, p. 247.
14. Cavaceppi, I, 1768, introductory essay; for Winckelmann and restoration in general, see Justi, 1866–72, II, pp. 296–307.
15. Vasari, IV, pp. 579–80.
16. Cellini, p. 505 (*Vita*).
17. Arisi, no. 180 (fig. 235), also no. 123.
18. Maffei, plates CXXXVI, CXXXVII; Stuart Jones, 1912, pp. 134–6.
19. Paris, Archives Nationales, AF IV, 1050, 4ème dossier; Clarke, p. iii.
20. Stosch, plates IV, VII, X, XI, XIV, etc.
21. Hamilton, pp. 39–41; Smith, A.H., 1916, p. 297; Rothenberg, pp. 185–9, 351.
22. Clarac, 1820, p. 66.
23. [Eaton], I, p. 48; for the provenance of the Piccolomini group, see Lanciani, 1902–12, I, pp. 82, 114; for the Borghese group, see Pressouyre, 1968.
24. Potts, I, i, pp. 238, 268–76; II, i, pp. 455–6, 510–65.
25. Piranesi, 1761.
26. Spence, p. 5; Mariette, I, pp. 73–5, 95, 110.
27. Pliny, XXXIV, 18; Maffei, plates LXII, LXIII.
28. De Brosses, II, p. 171.
29. Richardson, 1728, III, i, pp. 83, 202, note.
30. Caylus, 1752–67, I, 1752, pp. 149–54; III, 1759, p. 141; VII, 1767, pp. 168–80.
31. *Ibid.*, I, 1752, p. 159; V, 1762, p. 200.
32. *Ibid.*, I, 1752, p. 138; IV, 1761, pp. 149–50.
33. Weiss, 1969, pp. 131–44.
34. Montfaucon, 1702, pp. 69–70; Luzio, 1886 ('Lettere inedite'); Brown, 1978, pp. 76–7.
35. Michaelis, 1882, pp. 10–26.

36. Montfaucon, 1719, III, i, plate I, nos. 3, 4; plate XV, no. 1.
37. Stuart and Revett, II, 1787, plates II–XXX.
38. Montaiglon (*Correspondance*), II, p. 254.
39. Winckelmann (ed. Fea), I, pp. 181, 356; II, pp. 199–201, 224.
40. Winckelmann, 1767, II, pp. 114–15.
41. Winckelmann (ed. Fea), II, pp. 282–4, 286.
42. Mengs, p. 145 (*Riflessioni*).
43. *Ibid.*, pp. 106, 141 (*Riflessioni*); pp. 326–8 (*Lettera . . . sopra il principio, progresso e decadenza delle arti del disegno*).
44. *Ibid.*, pp. 357–62 (first letter); pp. 362–8 (second letter).
45. *Ibid.*, pp. 360, 364–7; compare Caylus, 1752–67, I, 1752, p. 125; II, 1756, pp. 275, 281; III, 1759, pp. 180, 249; IV, 1761, p. 189.
46. De Franciscis, 1944–6, p. 172.
47. Forsyth, p. 254.
48. [Knight], 1809, I, pp. xxiii, xxv and the text accompanying plates V–VIII.
49. *Ibid.*, pp. xliii–xlvii, lii and the text accompanying plates XXXV–XXXVII, XLV–XLVI.
50. *Ibid.*, pp. x, liii; see also Knight, 1818, p. 194.
51. Éméric-David, 1805, pp. 395–6, shows that he then accepted Winckelmann's view of when, even if not exactly why, art declined.
52. *Musée Français*, Discours, pp. 89, 97 and the text accompanying the unnumbered plate of the *Apollo*.
53. Saint-Victor, I, Discours préliminaire, pp. 3, 21–2.
54. For Nelson's failure, see Knight's letter to Lord Aberdeen, 28 September 1812, British Library, Add. MS. 43229, fols. 149–50; for Knight's reputation, see [Croker].
55. Murray, II, p. 358.
56. Rothenberg, pp. 293–7, 416–28.
57. Viardot, pp. 70, 113, 139, 164.
58. Kokkoy, pp. 227, 244.

NOTES TO CHAPTER XIV

1. Blumer, pp. 240–1.
2. Grégoire, p. 277.
3. Boyer, 1970, p. 79.
4. Montaiglon (*Correspondance*), XVI, p. 419.
5. *Ibid.*, XVI, pp. 462–7.
6. *Ibid.*, XVI, pp. 468–9.
7. *Ibid.*; Flaxman, p. 21.
8. Boyer, 1970, p. 83.
9. Milizia, pp. 313–16.
10. Montaiglon (*Correspondance*), XVI, p. 471.
11. *Ibid.*, XVI, p. 498.
12. Lanzac de Laborie, VIII, p. 235.
13. Montaiglon (*Correspondance*), XVI, pp. 511–13, 525–6.
14. *Ibid.*, XVII, pp. 79–80.
15. *Ibid.*, XVII, p. 83.
16. *Ibid.*, XVII, pp. 51–2.
17. [Quatremère de Quincy], pp. 7, 22, 24–5, 48–9.
18. Montaiglon (*Correspondance*), XVI, p. 470.
19. Blumer, p. 241.
20. Saunier, pp. 35–6.
21. Blumer, pp. 146–50.
22. Biver, 1963, p. 250; *I Cavalli di S. Marco*, p. 127.
23. Lanzac de Laborie, VIII, p. 240; Biver, 1963, p. 292.
24. Lanzac de Laborie, VIII, p. 244.
25. Aulanier, pp. 62–80, fig. 36.
26. Lanzac de Laborie, VIII, p. 245.
27. Pastor, XL, p. 310; *Roma Giacobina*, p. 34 (no. 9).
28. Montaiglon (*Correspondance*), XVII, pp. 126–7, 158–9.
29. Dallaway, 1816, pp. 217–18; Boyer, 1970, pp. 183–92.
30. Zobi, III, p. 518; Lanzac de Laborie, VIII, pp. 275–9.
31. *Musée Français*; Lanzac de Laborie, VIII, p. 280.
32. Boyer, 1970, pp. 236–7.

33. *Musée Français* ('Adorante' and 'Joueuse d'osselets'—for the latter, see *Nymph with a Shell*).
34. Dallaway, 1800, p. 226, note r; della Pergola, 1962, p. 26.
35. Boyer, 1970, pp. 197–202.
36. *Ibid.*, 1970, pp. 184, 236–7.
37. Paris, Archives Nationales: F²¹ 573 (letter to the Minister of the Interior, 26 September 1809).
38. Paris, Archives Nationales: A F IV 1050, 3ème dossier (Denon to Napoleon, 6 October 1807).
39. Milton, pp. 3–20.
40. Canova, p. 28 (5 November 1779).
41. Honour, 1972.
42. Saunier, pp. 140–2.
43. *Ibid.*, p. 149.
44. *Diario di Roma*, 6 January 1816.
45. Hiesinger, 1978 ('Canova'), p. 659.
46. Lanzac de Laborie, VIII, p. 237.
47. Pavan, 1974.
48. *Memorie Enciclopediche Romane*, IV, p. 9; Furtwängler, 1900, pp. 213–16.
49. Goethe, xxx, p. 70 (*Italienische Reise*); Franzoni, pp. 35–6.
50. Goethe, xxxii, p. 39 (*Italienische Reise*).
51. Michaelis, 1882, p. 147; Rothenberg, p. 332.
52. Pevsner, 1976, pp. 123–6.

NOTES TO CHAPTER XV

1. *Art Journal*, 1864, p. 330.
2. Goethe, XXX, pp. 134–5 (*Italienische Reise*).
3. The cast is in the Victoria and Albert Museum—for its history, see David Robertson, *Sir Charles Eastlake*, Princeton, 1978, p. 149.
4. Vasari, VII, p. 156.
5. Brucciani, 1864; 1870.
6. *Ibid.*, 1917; Gerber; *Catalogue des moulages*, introduction.
7. Cancellieri, 1806.
8. Amelung, 1903–8, I, pp. 86–7.
9. Friederichs, 1863; and see Michaelis, 1878.
10. *Antichità di Ercolano*, V, 1767, pp. 183–7 (as Lucius, son of Agrippa).
11. Michaelis, 1878; and see Furtwängler, 1895, p. 238.
12. Proust, *Du coté de chez Swann* (Pléiade edition, I, p. 255).
13. Hawthorne, pp. 289, 291, 302, 304–5, 311, 348, 399, 404.
14. Burckhardt, pp. 450–1.
15. Taine, I, pp. 141, 143.
16. Hare, 1887, II, p. 352.
17. Montaiglon (*Correspondance*), VIII, p. 324 (Wleughels to Duc d'Antin, 21 April 1732).
18. Lindsay, I, pp. xiv–xv.
19. Dickens, *Little Dorrit*, part II, chapter 9.
20. E.g. Amelung, 1906, pp. 41, 47; Bieber, p. 78.
21. E.g. Amelung, 1906, pp. 10, 123.
22. Wedgwood, 1779, in Mankowitz, 1953, pp. 228–9, 253.
23. Blashfield, 1855; 1857; 1858; Gunnis, p. 56.
24. Blashfield, 1855, p. 24.
25. Goethe, XXX, pp. 238–40; XXXII, pp. 321–4 (*Italienische Reise*); Bottari (ed. Ticozzi), IV, pp. 236–7; but see also Algarotti, III, p. 278 (*Saggio sopra l'Accademia di Francia*); Falconet, I, pp. 271, 314–17; II, pp. 141–2.
26. Pingeot.
27. Marmottan, pp. 30, 47; Hubert, 1964, pp. 333–4.
28. Cooper, I, p. 177. The leading workshop at Livorno was owned by the firm of Micali and son.
29. Amelung, 1903–8, I, pp. 27, 86.
30. Furtwängler, 1895, p. 4.
31. *Dictionnaire de biographie française*, V, pp. 254–5.
32. *Osborne*, nos. 410, 437, 482, 517.
33. De Angelis; Fonderie Artistiche Riunite; Sommer.
34. Trinity College Cambridge, MS. (letter from G. P. Bidder to the Master of Trinity, 18 February 1922).

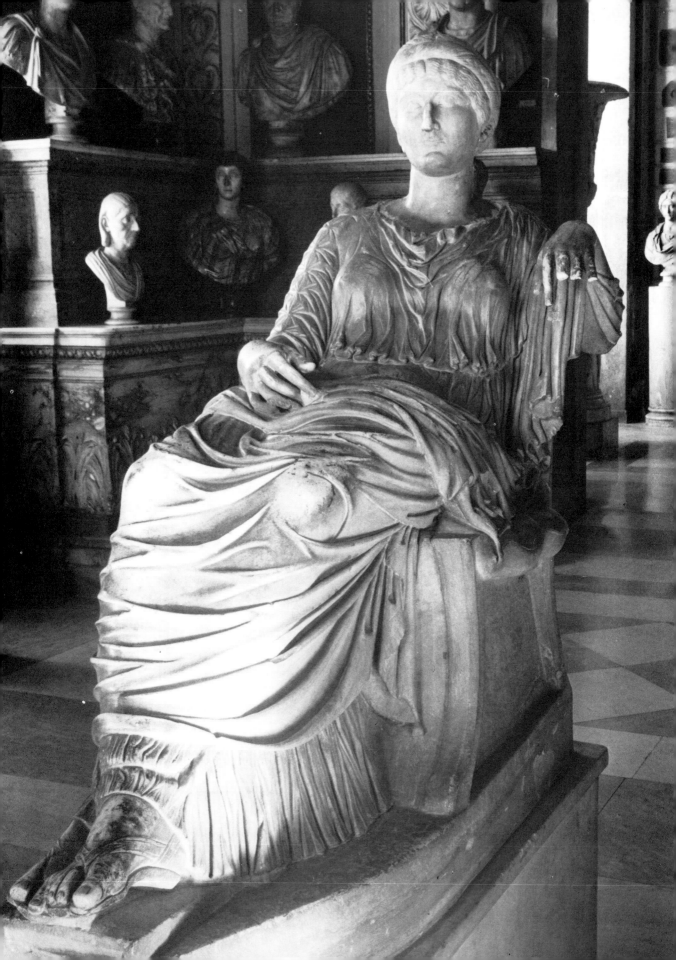

Catalogue

1. Seated Agrippina

(Fig. 69)

ROME, MUSEI CAPITOLINI

Marble
Height: 1.21 m
Also known as: Agrippina Capitolina, Poppea
Sabina

The *Agrippina* is recorded in the Palazzo dei Conservatori by Mortoft in 1659[1] and appears in a catalogue of the 'nuovo museo' in 1671.[2] However, it has been convincingly identified with a figure listed as 'Securità, a Sedere' in the inventory of the works given in 1566 to the Palazzo dei Conservatori by Pope Pius V.[3]

The statue was not celebrated in the sixteenth century, nor in the seventeenth (when, however, it was sometimes praised[4]), and it is not included in either of the two most influential anthologies of the most admired antique statues published by Perrier in 1638 and by de Rossi in 1704. However, less than ten years later it was described by Caylus as 'le plus beau morceau' in the Capitoline collection,[5] and by the mid-eighteenth century its fame was well established. Burney in 1770 noted that it possessed 'such drapery and expression as I never saw in sculpture'.[6] A plaster cast, apparently dating from the eighteenth century, survives in the Academy at Bologna and small copies both in bronze and biscuit were offered for sale in Rome at the end of the century[7] when an intaglio of the figure was also on Wedgwood's lists.[8] In the early nineteenth century the *Agrippina* was paid a still greater tribute when Canova's famous portrait of Napoleon's mother (Chatsworth, Derbyshire) was widely recognised to have been closely modelled—some thought too closely—upon it, a charge that was denied by the artist.[9]

To Mortoft writing in 1659 the statue represented Agrippina the younger, the mother of Nero.[10] The Museum inventories of 1671 and 1692, however, described it as a seated woman,[11] and in the 1720s the Richardsons thought that both this statue and a similar seated one in the Orti Farnesiani on the Palatine represented Poppea Sabina, mistress and later wife of Nero, whom the tyrant killed with a kick during her pregnancy.[12] When the Capitoline statue was most admired, however, it was generally considered, and was catalogued, as Agrippina the elder,[13] grand-daughter of Augustus, daughter of Marcus Agrippa and of Julia, the wife of Germanicus and the mother of both Caligula and Agrippina the younger. Some writers—including Lucatelli, the anonymous author of the 1750 catalogue—remained cautious,[14] and the identification was reasserted by Antoine Mongez in 1824.[15] In Tofanelli's catalogues the statue was still Agrippina—but, once again, Agrippina the younger.[16] Not surprisingly some writers were muddled: Mrs. Starke, for instance, wrote of it as Agrippina, mother of Germanicus.[17]

The *Agrippina* of the Capitol was often compared and may easily be confused with the statue which we have already mentioned as adorning the Orti Farnesiani (it was to be found in the portico of a grotto there). This was already well known in the seventeenth century[18] and, especially after its transfer to Naples,[19] it attracted almost as much attention as the Capitoline statue: Winckelmann preferred it;[20] it was also copied as a small bronze;[21] the French were anxious to acquire it for the Musée, although they did not take the Capitoline statue.[22]

The Farnese Agrippina was considered as Agrippina the younger by Ficoroni,[23] but was later described by travellers and in catalogues as Agrippina the elder.[24] Finati pointed out that the head (which in fact comes from another statue) was prematurely aged in relation to the body,

perhaps a consequence of the elder Agrippina's deep mourning, perhaps because she was portrayed patiently awaiting death by starvation, when exiled by Tiberius to the island of Pandataria.[25] The latter idea was repeated in popular guides.[26] Mrs. Starke, however, who awarded the statue three exclamation marks believed that she recognised the younger Agrippina and noted the 'mild, pathetic, deep despair' she displayed at the very moment her lunatic son 'doomed her to death'.[27] Much later in the century scholars as eminent as Friederichs and Wolters also considered it as a poignant character study of Nero's mother,[28] but by 1911 it was no longer believed to be a portrait of either Agrippina.[29] By then the Capitoline statue had long since ceased to be considered as an illustration of one or another tragic (or lurid) episode in Roman history and had become a 'lady of the Antonine period'.[30]

Today the Capitoline statue is catalogued in Helbig as representing Helena, mother of Constantine, and contemporary with her ascendency (A.D. 324–9).[31]

1. Mortoft, p. 68.
2. Stuart Jones, 1912, pp. 214–15, 382.
3. *Ibid.*, p. 364.
4. Mortoft, p. 68.
5. Caylus, 1914, p. 181.
6. Burney, p. 137.
7. In bronze by Righetti (see Appendix) and biscuit by Volpato (Victoria and Albert Museum, Tatham Papers, D1479–1898, p. 17).
8. Wedgwood, 1779, class I, section II, no. 302.
9. Quatremère de Quincy, 1834, pp. 141–5; *The Age of Neo-Classicism*, pp. 206–7.
10. Mortoft, p. 68.
11. Stuart Jones, 1912, p. 382.
12. Richardson, 1722, pp. 113–14, 151 (alluding to Suetonius, VI, 35).
13. [Bottari], plate LIII; Rossini, 1771, I, p. 21.
14. [Lucatelli], 1750, p. 30; repeated [Lucatelli], 1771, p. 53.
15. Mongez, II, p. 94.
16. Tofanelli, 1823, p. 59; 1829, p. 59; 1843, p. 53.
17. Starke, 1820, p. 274.
18. Acton, p. 46.
19. *Documenti inediti*, III, p. 192; IV, p. 174.
20. Winckelmann (ed. Fea), II, p. 350.
21. Zoffoli, Righetti (see Appendix); a signed Zoffoli is illustrated by Honour, 1961, p. 198.
22. Boyer, 1970, pp. 85, 237.
23. Ficoroni, 1744 (*Vestigia*), p. 31; cf. Rossini, 1771, II, p. 265.
24. Northall, p. 250; *Documenti inediti*, IV, p. 174.
25. Finati, I, i, pp. 102–4 (alluding to Suetonius, III, 53).
26. Monaco, p. 39.
27. Starke, 1800, II, p. 89, note; Starke, 1820, p. 413, note (but neither in Suetonius, VI, nor in Tacitus, *Annals*, XIV, is she reported as receiving her death or a warning of it when seated).
28. Müller and Wieseler, I, p. 81, no. 371; Friederichs and Wolters, p. 666.
29. Ruesch, p. 235.
30. Stuart Jones, 1912, pp. 214–15.
31. Helbig, 1963–72, II, pp. 153–4.

2. The Dying Alexander (Fig. 70)

FLORENCE, UFFIZI

Marble
Height: 0.72 m (0.42 m excluding modern bust)

This head is recorded as belonging to the Medici in Florence by 1579 when Giambologna was commissioned to fit it onto a statue, and it has been in the Uffizi since at least the end of the seventeenth century, but probably longer.[1] Drawings of what is almost certainly the same head appear in the sketchbook of Girolamo da Carpi made in Rome between 1549 and 1553,[2] and it is probable that the Uffizi head was acquired by the Medici in Rome and is the head of Alexander which Aldrovandi, in a publication of 1556 (based on notes made in Rome six years earlier) described as in the collection of Cardinal Rodolfo Pio da Carpi.[3] This collection was dispersed soon after his death in 1564.[4]

The influence of this sculpture has been detected, convincingly, in early sixteenth-century art and was later the model for numerous ecstatic or inspired figures[5]—Winckelmann, in fact, noted its influence on Domenichino's celebrated fresco of St. John the Evangelist (in one of the pendentives of the dome of S. Andrea della Valle).[6] The earliest replica is probably one in porphyry made in the sixteenth century and kept at the villa of Poggio Imperiale (probably identical with the one today displayed in the Museo dell'Opificio delle Pietre Dure in Florence).[7] Queen Christina of Sweden who commissioned a bronze copy from Soldani requested permission to have the marble moulded in 1681.[8] A plaster cast was amongst those in the Antikensaal at Mannheim opened by the Elector Karl Theodor in 1767,[9] and by 1781 there was one in the Royal Academy in London (where it was considered by some to be a head of Achilles).[10] There were also numerous marble copies, many of which were made in the eighteenth century[11] when the bust was admired in rapturous terms by almost all visitors to the Uffizi.[12]

The identification of this upturned head as a portrait of Alexander the Great probably stemmed from Plutarch's statement that Lysippus, who alone among contemporary sculptors was permitted to take the likeness of the Conqueror, portrayed him with leonine hair and melting eyes, looking up to the heavens.[13] Lomazzo,

writing in 1590, claimed that fragments of the statue by Lysippus were known and that the head was recognised by the 'intendenti' to be the most rare and artful in existence, with a hollowing of the eyes and 'quadratura' of the nose which Polidoro, Michelangelo and Raphael had imitated.[14] But (assuming that this was the head that had been in Pio da Carpi's collection) Aldrovandi had accounted for the intense expression by stating that it showed Alexander on his deathbed permitting his soldiers to kiss his hand.[15] Aldrovandi must have had in mind how Alexander, too weak to speak, raised his head with difficulty and greeted with a look each of his officers as they filed through his tent.[16] Later accounts of the head after its installation in the Uffizi suggest that the Emperor had been shown wounded (as he was believed by some to be in the *Pasquino* group) and swooning because of the blood he lost in battle with the Oxydracae;[17] or feverish after bathing in the icy waters of the Cydnus;[18] or lamenting that there were no more worlds to conquer;[19] or in agonies of remorse for killing Clitus, a warrior who had saved his life, during a quarrel at a banquet ('a personal memorial ... of the terrible effects of intemperance and midnight hours').[20] *The Dying Alexander* remained, however, the most popular title. The various interpretations not only reflected the desire to find in ancient sculpture illustrations of ancient history, but also the recognition that the movement and the expression of this head were more dramatic than one would expect in a portrait—even in a portrait by Lysippus. The head is now in fact believed to be a fragment of some heroic narrative group.

Although the head was clearly admired for its expression, and not simply as the likeness of Alexander, once that likeness was disputed, the celebrity of the sculpture did slowly decline. Bianchi was not certain that it was a portrait of Alexander[21] and the discovery of the inscribed herm portrait at Tivoli in 1779 ('the Azara Herm' presented to Bonaparte and today in the Louvre) convinced most scholars that it was not.[22] All the same, it was still popularly known as the 'Dying Alexander' a century later, and some scholars still believed it might represent Alexander.[23] But Amelung, aware of the Altar of Zeus excavated at Pergamon and displayed in Berlin, proposed that it was a copy of a work of the Pergamene school and labelled it as a 'dying giant'[24]—a view which is adhered to in Mansuelli's catalogue.[25]

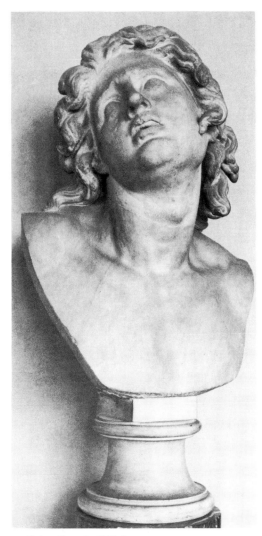

70. *Dying Alexander* (Uffizi).

1. Mansuelli, I, pp. 94–5.
2. Canedy, 1976, pp. 102, 116, 118 (T109, T161, T173).
3. Aldrovandi, 1556, p. 205.
4. Lanciani, 1902–12, III, p. 185.
5. Schwarzenberg, pp. 399–400.
6. Winckelmann, 1968, p. 151 (*Erinnerung*).
7. Bencivenni Pelli, I, p. 139, note; Schwarzenberg, pp. 400–1; Martelli, pp. 20–1.
8. Lankheit, pp. 259–60 (doc. 169); Schwarzenberg, p. 401.
9. Schiller, XX, p. 105.
10. Baretti, p. 27.
11. Lami, 1910–11, I, p. 64; Schwarzenberg, pp. 400–1.
12. E.g. Addison, pp. 412–13; Cochin, II, p. 45; Corke and Orrery, pp. 159–64; Dupaty, I, p. 134; Beckford, I, p. 166; Caylus, 1914, p. 314; Burney, p. 109.
13. Plutarch, *On the Fortune or Virtue of Alexander*, II, 2; *The Life of Alexander*, IV, 1.
14. Lomazzo, p. 15.
15. Aldrovandi, 1556, p. 205.
16. Arrian, *Anabasis Alexandri*, VII, 26.
17. Bianchi, pp. 134–6; Bencivenni Pelli, I, p. 141; Smollett, p. 235 (letter XXVIII); Arrian explains that the battle

over the city of the Mallians was often said to be a battle with the Oxydracae—*Anabasis Alexandri*, VI, 9; see also Plutarch, *The Life of Alexander*, LXIII.

18. Bianchi, Bencivenni Pelli, Smollett (as in Note 17) thinking of Plutarch, *The Life of Alexander*, XIX.

19. Addison, pp. 412–13 (taking the idea from the elder Bianchi according to Bianchi, p. 136); [Jameson], pp. 96–7; Burney, p. 109. This idea probably came from the epigram quoted by Plutarch (*On the Fortune or the Virtue of Alexander*, II, 2).

20. Corke and Orrery, pp. 159–64; Moore, II, pp. 361–2 (thinking of Plutarch, *The Life of Alexander*, L-LII).

21. Bianchi, pp. 137–8.

22. Winckelmann (ed. Fea), II, p. 253, note; Visconti (*Iconografia Greca*), II, plate II.

23. Perry, W.C., p. 484.

24. Amelung, 1897, p. 96.

25. Mansuelli, I, pp. 94–6; Bieber, pp. 119–20.

3. Alexander and Bucephalus (Figs. 71–2)

ROME, PIAZZA DEL QUIRINALE

Marble

Height (figures): 5.6 m; (obelisk): 14.74 m

Also known as: Achilles, Castor and Pollux, Colossi, Dioscuri, Horses of Diomedes, Horse Tamers, Marble Horses

These two huge groups were recorded standing on the Quirinal Hill in the popular pilgrims' guide to Rome, the *Mirabilia Urbis Romae*, which was composed in the mid-twelfth century and copied with variations and additions for several centuries.[1] It is almost certain that they had remained standing there since antiquity (for neither the machinery nor the motivation existed to move them, or to erect them, had they been excavated). Between 1589 and 1591, Pope Sixtus V had them restored and set up on pedestals with a fountain between them—an arrangement designed by Domenico Fontana.[2] An earlier plan of Pope Paul III to erect them at the entrance of the Piazza del Campidoglio may be recorded in a print,[3] but came to nothing—nor did Bernini's idea of incorporating the group into an extravagant triumphal arch for Pope Alexander VII.[4] However, in 1783, under Pope Pius VI, Carlo Antinori, to the astonishment of Rome, moved the sculptures so that they were at an angle to each other, and in 1786, supervised the erection of the obelisk (recovered five years earlier from the Mausoleum of Augustus) between them.[5] In 1818 the earlier fountain was replaced by a massive granite basin which had served between 1593 and 1817 for watering cattle in the forum (qv. *Marforio*)[6]—an improvement (Fig. 65) which had also been planned earlier by Pope Pius VI.[7]

The ruins which served as a support for the two groups (Fig. 8) before they were restored incorporated the Latin inscriptions 'Opus Fidiae' and 'Opus Praxitelis' which dated from late antiquity[8] (perhaps from after the earthquake of 442).[9] The *Mirabilia Urbis Romae* proposed that these were the names of two seers who arrived in Rome under Tiberius, naked, to tell the 'bare truth' that the princes of the world were like horses which had not yet been mounted by a true king. The raised hands of the men were thought to be gestures appropriate to prophets, and a neighbouring statue of a woman with a snake was ingeniously interpreted as Ecclesia. This theory was much repeated in subsequent centuries.[10] 'Magister Gregorius', however, called the figures simply 'compotistae' (literally, 'calculators') whose quick wits were symbolised by their horses.[11] In the Renaissance, it was of course appreciated that the names were those of the two most celebrated sculptors of antiquity. It was also realised that 'Fidiae'[12] should have been 'Phidiae' (and the inscriptions were corrected accordingly when the statues were restored between 1589 and 1591).[13]

It was realised that the Baths of Constantine had been situated on the Quirinal and the learned Onofrio Panvinio in 1558 published the idea that Constantine had erected the sculptures in the middle of his Baths, having removed them from Alexandria—the subject, appropriate to that city, being, in both cases, Alexander and his horse Bucephalus.[14] This interpretation quickly became popular[15] and was referred to in Pope Sixtus V's inscriptions.[16] Not everyone approved, however, and the inscriptions were removed by Pope Urban VIII in 1634 because of their 'falsità d' Historia'.[17] Four years later, Perrier in his prints of the most admired statues in Rome recorded that some believed that Alexander and Bucephalus were portrayed and others that the statues were of the Dioscuri or twin-gods, Castor and Pollux.[18] A theory current in the 1590s that the statues represented the man-eating horses of Diomedes which were tamed by Hercules, had, it seems, been forgotten by then.[19] As Castor and Pollux (and since 1800 any other interpretation has been unusual) the statues were liable to be confused with the colossal figures, also accompanied by horses, which were dug up during the pontificate of Pius IV in about 1560 and set up on either side of the entrance to the Capitol where Pope Paul III had intended moving the Quirinal statues.[20]

Official references to Alexander the Great

71. *Alexander and Bucephalus* (Piazza del Quirinale, Rome).

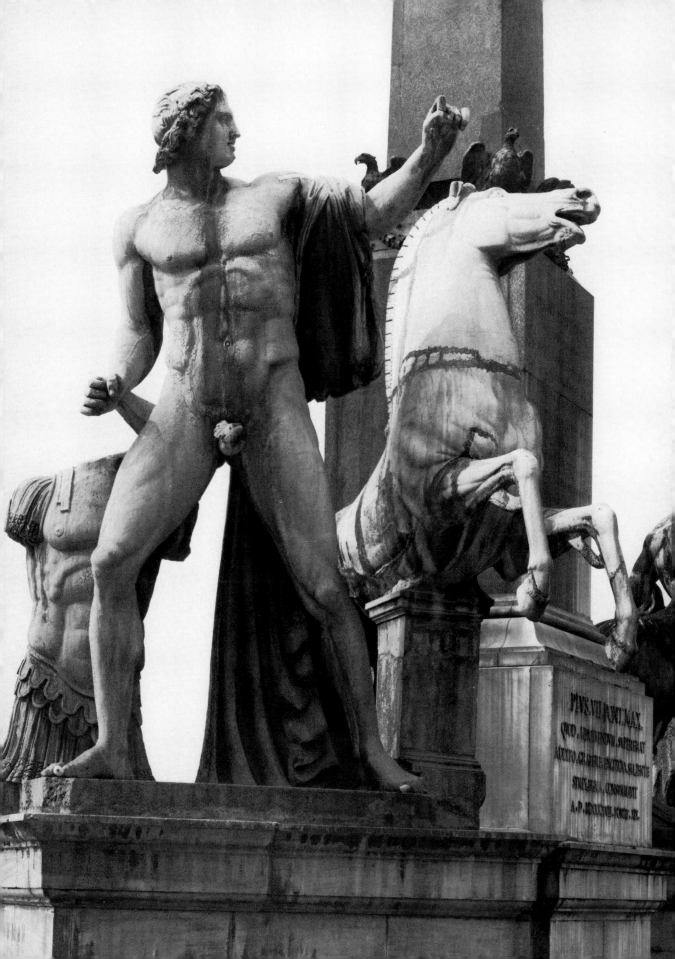

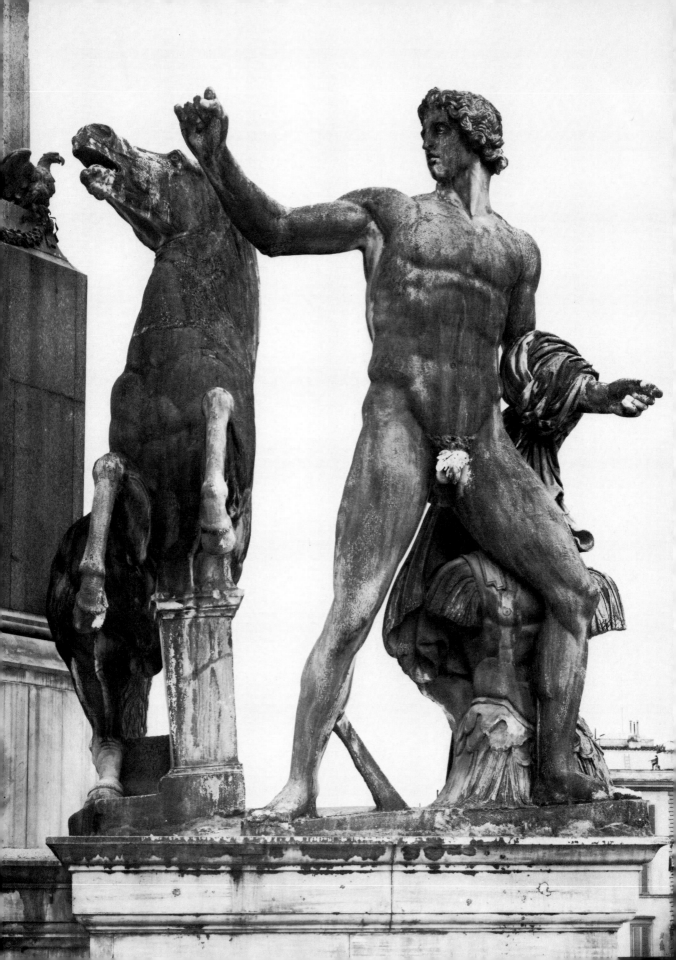

were not stopped by Pope Urban VIII and may be discovered in the inscription placed behind the pedestal of the obelisk by Pope Pius VI.[21] On a popular level, it was believed that the two statues were portraits of Alexander made by Phidias and Praxiteles 'at strife for fame'.[22] However, one did not have to be very learned to point out that Phidias lived before Praxiteles, and both before Alexander. Maffei ingeniously suggested that they might have been earlier statues which were rededicated to Alexander.[23] Ficoroni, on the other hand, was prepared to abandon the attributions to Phidias and Praxiteles, insisting at the same time that the statues were, nevertheless, Greek and of the finest quality.[24] Clearly, in any case, no one favoured the idea that such works had been carved under Constantine, even if they did adorn his Baths.

Maffei, like Panvinio, thought that Constantine might have brought the groups from Alexandria.[25] Other writers suggested that they came to the Quirinal from the Palatine[26] or, more particularly, the Golden House of Nero.[27] This latter idea was compatible with the theory that they were the horses presented to Nero by Tiridates, King of Armenia—a theory formulated by Biondo in the 1440s which was highly popular for more than a hundred years.[28] The ruins in the Villa Colonna near the Piazza del Quirinale were popularly identified in the sixteenth and seventeenth centuries as the Frontispizio di Nerone, and Flaminio Vacca believed that he had recognised some architectural elements from these ruins in the substructure supporting the groups when he helped to restore them in 1589–91.[29] The idea that the groups were connected with the Colonna ruins has received some support in modern times,[30] but the ruins, as some had recognised by the seventeenth century,[31] were of Aurelian's great Temple of the Sun and had nothing to do with Nero. Moreover, as early as 1639, Alessandro Donati pointed out that the horses presented by Tiridates to Nero were of metal, and later he furnished numismatic evidence in support of the theory that the figures represented Castor and Pollux.[32]

Although both horses were much repaired they seem to have been more admired than their superhuman companions in most Renaissance accounts of the group. The men are sometimes described as naked slaves in attendance on the horses and are often not mentioned at all,[33] and the Quirinal Hill was, after all, named Monte Cavallo after the horses. However, in the first years of the eighteenth century, it was possible for de Blainville to declare that the excellence of the horses was 'only perceptible to a Parcel of Italian Pedants',[34] and thereafter it was typical of travellers to ignore or disparage the horses and to admire the men.[35]

It was after Winckelmann had praised the austerity of the earlier phases of Greek sculpture that the figures were most enthusiastically described: Goethe was overwhelmed by them;[36] Flaxman felt that they must, like the Parthenon frieze, have been executed under the direction of Phidias;[37] Canova was said to have been seen studying them at dawn both when he first arrived in Rome and at the height of his fame and to have considered them comparable with the Parthenon marbles;[38] for Galiffe in 1820, the 'Praxitelean' figure seemed 'superior even to the Apollo of the Belvidere'.[39]

For obvious reasons, the statues were usually reproduced on a reduced scale. The horses, for instance, were included with the 'horse' of the Capitol—that is, the *Marcus Aurelius*—the *Farnese Hercules*, the *Belvedere Antinous* and the *Apollo Belvedere*, in the set of little bronzes arranged on a wooden cabinet made by 'Guglielmo Tedesco' (Willem Danielsz. van Tetrode) and presented by the Count of Pitigliano to Duke Cosimo I of Tuscany.[40] And in 1792, the entire ensemble, including the recently erected obelisk, was reproduced in silver, silver-gilt, lapis lazuli and rosso antico as an inkstand made by Vincenzo Coacci and presented by Luigi Ercolano to Pope Pius VI.[41] At about the same date, the Roman bronze-founder Righetti sold bronze reductions of the heads of the men alone,[42] and these were also reproduced on gems by Nathaniel Marchant.[43] However, in the 1640s it was proposed to erect bronze replicas of the statues at the entrance to the Louvre and some moulds were made for this purpose.[44] Much later, Goethe saw casts of the heads in Cavaceppi's studio,[45] and in 1788 an Englishman was reported to have moulded one of the figures.[46] Casts were also ordered by the French in 1799 when they realised that it was impossible to transport the originals to Paris.[47] In the same period, Paolo Triscornia carved what seem to have been the first full-scale replicas of the groups for the entrance of the Manège (the riding school of the royal guards) in St. Petersburg.[48] By 1815, the decision had been taken to commission Sir Richard Westmacott to make what was believed to be the largest bronze cast since antiquity—a replica of the 'Phidian'

139

statue. This was erected by the 'Ladies of Great Britain' as a tribute to the Duke of Wellington near Hyde Park Corner (which was not the intended site) in 1822. Some French writers thought that it was the Duke himself who was portrayed in this statue, 'toute nue et toute noire', but in fact it was intended to represent Achilles. It was supplied with a shield, and later, a sword, whilst the companion horse was not included in the monument, not only for reasons of economy but also because the relationship between the horses and figures was disputed.[49]

Even in the sixteenth century not everyone had been convinced that the horses belonged to the figures.[50] As was pointed out in the eighteenth century, however, a disparity in scale between horses and figures was common in antique art.[51] What caused most worry was the way they should have been arranged. Hubert Robert in a drawing even tried turning the horses round.[52] Canova proposed that they should be placed on the same plane as if in relief with the horses facing towards the turned heads of the men.[53] The copies which flank the entrance of the Royal Manchester Institution in Charles Barry's presentation drawing of 1825[54] are so arranged, and so are the cast-iron copies made by Christian Friedrich Tieck for the skyline of Schinkel's Altes Museum, Berlin, in the following year (and imitated in the same material as desk ornaments).[55] Tieck's cast-iron copies dispense with the props and struts supporting the legs of the Quirinal statues, perhaps because it was accepted that these were added by a copyist in antiquity. However, Visconti's theory that the statues were copies of the bronze Dioscuri by Hegesias described by Pliny as standing before the Temple of Jupiter Tonans on the Capitol[56] was not accepted by many scholars and was dismissed by Johann Martin Wagner,[57] a German sculptor and archaeologist, at the very moment that the copies for the Altes Museum were being planned.

For Visconti, the statues were of great importance, as they were for Furtwängler at the end of the last century when he proposed that they were copies of originals by Phidias and by the elder, less famous, Praxiteles, which had once stood before the gates of the Tarentum[58]—but the sculpture was, in these accounts, no longer admired for its own sake. However, the originals certainly retained a good deal of glamour in the mid-nineteenth century when they were described in Clough's *Amours de voyage* by Claude (who was on the whole disappointed by Rome) as 'instinct with life in the midst of immutable

manhood,—/ O ye mighty and strange, ye ancient divine ones of Hellas'.[59] Robertson expresses no enthusiasm for these 'clumsy monsters', but he concedes that the poses do reflect the Hephaestus which once dominated the east pediment of the Parthenon, so that some link between them and the name of Phidias has survived.[60]

1. Valentini and Zucchetti, III, p. 30; also pp. 93, 130–1, 193–4.
2. Del Piazzo, pp. 241–2 (documents); Donini, pp. 68–9.
3. Ackerman, 1964, catalogue, p. 51, citing a print by É. Dupérac, dated 1569 and a letter of 1537.
4. Fagiolo dell'Arco, p. 71 and scheda 207.
5. Pietrangeli, 1942; del Piazzo, p. 263.
6. Rossi, 1929 ('Tazze'), pp. 272–3; Rossi, 1929 ('A proposito').
7. [Cancellieri], 1789, p. 5.
8. Michaelis, 1898; Rowland.
9. Michaelis, 1898, p. 274.
10. Valentini and Zucchetti, III, p. 30; also pp. 93, 130–1, 193–4.
11. Rushworth, pp. 26, 51.
12. Bracciolini in Valentini and Zucchetti, IV, p. 241; Biondo, *ibid.*, IV, p. 283.
13. Donini, p. 67.
14. Panvinio, p. 142.
15. E.g. Vaccaria, plates 17, 18.
16. Donini, p. 67.
17. Lanciani, 1902–12, IV, p. 156. Totti, 1638, p. 282, gives 1639 as the date for this change but this must be a misprint (IX for IV), and the correct one is given on p. 281.
18. Perrier, 1638, plates 22–5.
19. Fynes Moryson, I, p. 292.
20. Ackerman, 1964, catalogue, p. 51.
21. Donini, p. 67.
22. Stone, p. 174.
23. Maffei, plates XI–XIII.
24. Ficoroni, 1744 (*Vestigia*), p. 128.
25. Maffei, plates XI–XIII.
26. Venuti, R., 1763, I, p.84.
27. Vacca, Mem. 10.
28. Biondo in Valentini and Zucchetti, IV, p. 283; Fulvio, 1527, fol. xxiii recto (for xxxiii); Aldrovandi, 1556, p. 311; Sandrart, 1680, p. 7; Evelyn, II, p. 237; Lassels, II, p. 152.
29. Vacca, Mem. 10; del Piazzo, p. 241.
30. Fea, 1790, pp. lviii–lix, note c; Lanciani, 1897, p. 432; Lanciani, 1902–12, IV, p. 98.
31. Lauro, 1612–15, plate 49.
32. Donatus, 1639, pp. 267–8; Donatus, 1665, p. 363.
33. E.g. Aldrovandi, 1556, p. 311; Mortoft, pp. 77–8; Evelyn, II, p. 237; Lassels, II, p. 151.
34. De Blainville, II, pp. 425–6.
35. E.g. Montesquieu, II, p. 1134 (*Voyage d'Italie*); Beckford, II, p. 234; Gray, T., (ed. Mitford), IV, pp. 253–4; Starke, 1820, p. 253.
36. Goethe, XXX, p. 200 (*Italienische Reise*).
37. Flaxman, pp. 94, 226–7.
38. Memes, p. 291; Wagner, pp. 388, 390–1.
39. Galiffe, I, p. 291.
40. Vasari, VII, pp. 549–50; see also Devigne, pp. 91–2.
41. Minneapolis Institute of Art; Parsons; see also *Curiosità di una reggia*, p. 160, no. 19.
42. Righetti (see Appendix).
43. Marchant, p. 8.
44. Bellori, p. 443.
45. Goethe, XXXII, p. 291 (*Italienische Reise*); cf. Wagner, p. 374.
46. Montaiglon (*Correspondance*), XV, pp. 240, 245.
47. Boyer, 1970, p. 83.
48. Campori, p. 254.

49. *Gentleman's Magazine*, 1815, LXXXV, i, p. 127; 1822, XCII, i, pp. 355–6; ii, pp. 70–1, 105–6; Viardot, pp. 246–7.
50. Aldrovandi, 1556, p. 311.
51. Galt, pp. 107–9.
52. Cailleux, no. 102.
53. Wagner, pp. 390–1; Petersen, p. 310.
54. City Art Gallery, Manchester, lent by Tabley Estate Committee of Management, M9450.
55. *Berlin und die Antike*, pp. 241–2.
56. Visconti (*Pio-Clementino*), I, plate XXXVII, note 2.
57. Wagner, p. 388.
58. Furtwängler, 1895, pp. 95–102.
59. Clough, *Amours de voyage*, canto I, letter X, Claude to Eustace, lines 1–6.
60. Robertson, I, p. 304.

4. Belvedere Antinous (Fig. 73)

ROME, MUSEI VATICANI (BELVEDERE COURTYARD)

Marble
Height: 1.95 m
Also known as: L'Admirable, Admirandus, L'Antin (sometimes abbreviated to Lantin), Hercules, Meleager, Mercury, Milo, Theseus

This sculpture was apparently recorded for the first time on 27 February 1543 when a thousand ducats was paid to 'Nicolaus de Palis for a very beautiful marble statue . . . which His Holiness has sent to be placed in the Belvedere garden'.[1] By April 1545 it was certainly in the statue court.[2] Writing a few years later Aldrovandi said that it had been found 'in our time' on the Esquiline near S. Martino ai Monti,[3] but Mercati in the 1580s said that it had come from a garden near Castel S. Angelo—where the Palis family seems to have owned property.[4] It remained in the statue court until 1797 when it was ceded to the French under the terms of the Treaty of Tolentino.[5] It reached Paris in the triumphal procession of July 1798[6] and was displayed in the Musée Central des Arts when it was inaugurated on 9 November 1800.[7] It was removed in October 1815,[8] arrived back in Rome on 4 January 1816,[9] and was returned to the Belvedere courtyard before the end of February.[10]

The statue won immediate fame and it was already known as Antinous (a title frequently given to figures of male youths)[11] in 1545 when Primaticcio, on his second visit to Rome from Fontainebleau, had a mould made from it for François Ier.[12] Alternative theories that it might represent Milo or the Genius of a Prince were suggested not long afterwards but won little support.[13] The *Antinous* was mentioned (usually with enthusiasm) in virtually all accounts of the most famous statues in Rome, was reproduced in all the leading anthologies and was also much

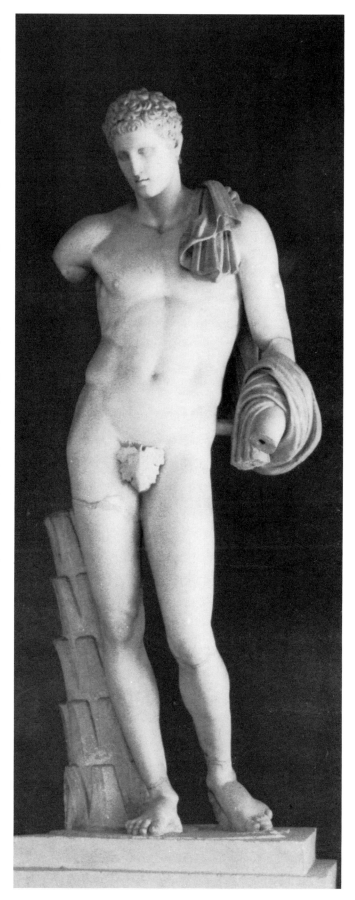

73. *Belvedere Antinous* (Vatican Museum).

drawn by visiting artists. A bronze cast was made for Charles I of England,[14] and one of the bust only (a practice that was to become very common) for Philip IV of Spain.[15] For Versailles it was copied both in marble[16] and in bronze.[17] During the eighteenth century the *Antinous* continued to be reproduced in a variety of different sizes and materials, with both arms complete,[18] though in fact only a right arm was attached to the stump of the shoulder of the original (at an early stage in its display)[19] and no left hand was added. In the catalogue of the sculptures of the Musée in Paris it was described as 'one of the most perfect statues that has come down to us from antiquity'[20]—an opinion that continued to be very widely held for most of the nineteenth century.

Moreover, the *Antinous* was as popular with artists of all persuasions as it was with collectors and connoisseurs. Bernini[21] was as enthusiastic as Duquesnoy[22] and Poussin who (possibly with the assistance of Charles Errard) made measured drawings of it which were reproduced in Bellori's *Lives of the Modern Painters, Sculptors and Architects*.[23] Two more measured engravings were published by Audran in his prints, made for the use of artists, on the proportions of the ideal human body,[24] and in his portrait of Charles Lebrun (now in the Louvre) which Largillière presented to the Académie Royale de Peinture et de Sculpture in 1686 a reduced version of the *Antinous* (and also one, in bronze, of the *Borghese Gladiator*) was prominently displayed in front of the president's easel. Nearly seventy years later in his *Analysis of Beauty* Hogarth (who, of course, never saw the original) claimed that in regard to the '*utmost beauty of proportion*' it 'is allowed to be the most perfect . . . of any of the antique statues'.[25]

Before he saw the marble itself Winckelmann agreed that 'our Nature will not easily create a body as perfect as that of the Antinous admirandus';[26] and though, after his arrival in Rome, he commented sharply on the lack of beauty of the legs, the gross carving of the feet and the inadequate indication of the navel, he continued to express passionate admiration of the statue for its sweetness and innocence of expression[27] which, following a critical commonplace,[28] he contrasted with the godlike majesty of the *Apollo* nearby. It was Winckelmann, however, who challenged the theory that the statue portrayed Antinous, suggesting instead—with not much force and with no evidence—that it was a Meleager. A number of alternative hypotheses were also made. Mengs proposed verbally that it

was a beardless Hercules;[29] for others it was a Theseus;[30] while Visconti (who greatly admired the figure)[31] produced a strong case, which won general acceptance in his own day[32] and has retained it ever since, that the *Antinous* was in fact a representation of Mercury, as had been proposed much earlier by Stosch and rejected by Winckelmann.[33]

Visconti's most cogent argument depended on the existence of another version of the same figure wearing winged sandals and holding a caduceus.[34] This version (since 1546 in the Farnese collection and acquired for the British Museum in 1864)[35] had been noted without special enthusiasm by some writers[36] and draughtsmen[37] since the sixteenth century, but it seems not to have been related to the *Belvedere Antinous* before the Richardsons:[38] they, however, accounted for the fact that it was 'the very same Figure' on the grounds (which they deduced from numismatic evidence) that Antinous was sometimes identified with Mercury.[39] Three more versions were known to Visconti in the Mattei collection,[40] while another (now in the Ludington collection, Santa Barbara, California)[41] was—not surprisingly—described by Gavin Hamilton who excavated it in 1771 as being equal in quality to that in the Vatican.[42] It was purchased by Lord Shelburne (later Marquess of Lansdowne), and by the 1840s English tradition credited Canova (who before coming to Rome had modelled a reduction of the *Belvedere Antinous* from the cast in the Farsetti collection)[43] with having declared the Lansdowne version to be superior.[44] By the end of the nineteenth century, however, it was the Farnese statue in the British Museum which attracted most scholarly attention, but this in turn was eclipsed by the replica found at a tomb in Andros (now in the National Museum in Athens). Some scholars consider that these statues are copies of a work by Praxiteles,[45] but the *Belvedere Antinous* is catalogued in Helbig as a Hadrianic copy of a bronze original possibly by one of his pupils.[46]

1. Brummer, p. 212 (with document).
2. Lanciani, 1902–12, I, p. 157 (for Primaticcio's mould).
3. Aldrovandi, 1556, p. 117. Fulvio, 1527, fol. xxxvi verso (for xlvi), had already written thirty years earlier of the discovery near S. Martino ai Monti of two statues of Antinous which had been placed in the Vatican by Pope Leo X (1513–21). Michaelis, 1890, p. 25, points out that neither of these can refer to the sculpture here under discussion, but Fulvio's text may have been the source used by Aldrovandi.
4. Mercati, M., I, p. 363; Brummer, p. 212.
5. Montaiglon (*Correspondance*), XVI, pp. 462, 498.
6. Blumer, pp. 241–9.
7. *Notice*, An IX (1800), pp. 57–9.

8. Saunier, p. 149.
9. *Diario di Roma*, 6 January 1816.
10. *Ibid.*, 24 February 1816.
11. Michaelis, 1890, p. 25.
12. Pressouyre, 1969 ('Fontes'), p. 225, note 5.
13. Cavalleriis (2), plate 5, and Pighius—see Brummer, p. 212.
14. British Library, Harleian MS. 4898, fols. 295v, 300; Harleian MS. 7352, fol. 119; 'Papers Relating to the Late King's Goods', p. 90 (items XXV and XXVII–3).
15. Harris, E., p. 121.
16. The marble which was being carved in 1682 seems to have been by Lacroix—Montaiglon (*Correspondance*), I, p. 115—and not by Le Gros as stated on plate 36 of Thomassin.
17. The bronze placed on the garden facade of the chateau was cast by the Kellers in 1685.
18. As in the bronze statuettes by Zoffoli and Righetti (see Appendix).
19. See drawing by Goltzius reproduced in Brummer, p. 213.
20. *Notice*, An IX (1800), pp. 57–9.
21. Chantelou, pp. 134–5.
22. Bellori, p. 300.
23. *Ibid.*, pp. 474–7; Thuillier, fig. 3 and p. 168, note 21.
24. Audran, plates 11, 12.
25. Hogarth, pp. 81–3.
26. Winckelmann, 1968, p. 153 (*Erinnerung*).
27. Winckelmann (ed. Fea), II, pp. 387–8.
28. E.g. Raguenet, pp. 296–303.
29. This is reported by Visconti (*Pio-Clementino*), I, plate VII.
30. *Ibid.*
31. *Ibid.*
32. Vasi, 1791, II, p. 696.
33. Winckelmann (*Briefe*), I, pp. 255–6.
34. Visconti, (*Pio-Clementino*), I, plate VII.
35. Smith, A. H., 1892–1904, III, pp. 37–9.
36. Aldrovandi, 1556, p. 151 (as Marcus Aurelius).
37. Michaelis, 1891–2, i, pp. 171–2.
38. Richardson, 1722, p. 132.
39. Richardson, 1728, III, i, pp. 218–19.
40. Visconti (*Pio-Clementino*), I, plate VII.
41. Vermeule and Von Bothmer, 1956, p. 335.
42. Michaelis, 1882, pp. 454–5.
43. *The Age of Neo-Classicism*, p. 196.
44. Jameson, p. 335, note.
45. Rizzo, pp. 75–6; Bieber, p. 17.
46. Helbig, 1963–72, I, pp. 190–1.

5. Capitoline Antinous (Fig. 74)

ROME, MUSEI CAPITOLINI

Marble
Height: 1.801 m

This statue is recorded in Cardinal Albani's collection in 1733,[1] having been found—so it was stated in 1750[2]—at Hadrian's Villa. It was among the large number of figures from Albani's collection bought by Clement XII in 1733 and (after being given a left arm and leg by Pietro Bracci[3]) it was displayed in the newly established Capitoline Museum. In 1797 it was ceded to the French under the terms of the Treaty of Tolentino[4] and it reached Paris in the triumphal procession of July 1798.[5] It was displayed in the Musée Central des Arts from its inauguration on 9 November 1800.[6] It was removed in October 1815,[7] arrived back in

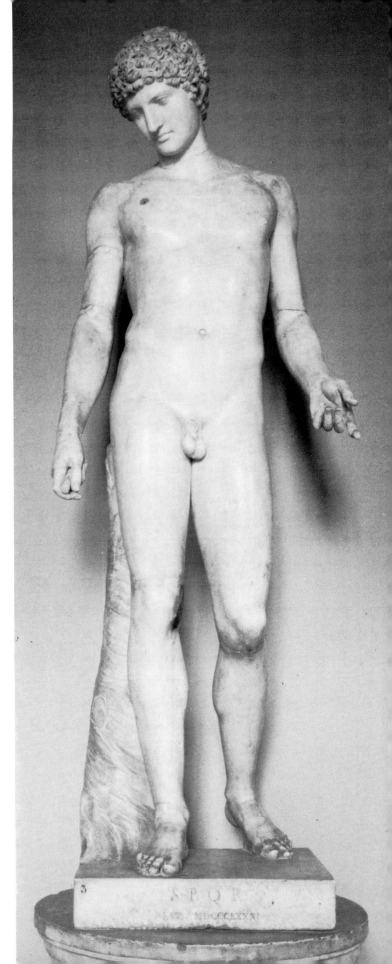

74. *Capitoline Antinous* (Capitoline Museum).

Rome in the first half of 1816, and during the course of the year was returned to the newly reorganised Capitoline Museum.[8]

The figure was described as an Antinous in the Albani inventory of 1733 and the compiler (the sculptor Agostino Cornacchini), whose comments are rare, added that it was priceless and worthy to rank with the finest antiquities.[9] In 1750 Mariette wrote that 'in the approximately thirty years since this was discovered, it would almost have led to the Belvedere Antinous being forgotten, had the latter not had the privilege of appearing first and always being rightly considered as the rule for studying the proportions of a handsome young man'.[10] By 1770 we know that some people certainly preferred this to the Vatican *Antinous*,[11] while others—such as Smollett[12]—confused the two and thought that it was this statue that Poussin had studied 'as the canon or rule of symmetry'—an indication at least of how quickly it had become established. In the carefully weighed opinion of Lalande the head of the *Capitoline Antinous* was finer than that of the one in the Belvedere, though 'on préfere en total ce dernier'.[13] Gibbon took a view that is more current among the archaeologists of our own day than it was of his when he claimed that 'this statue is the triumph of meer mechanical Sculpture'.[14]

Winckelmann—as much to the surprise of Carlo Fea, his Italian editor, as to our own—failed to mention it at all in his published works, perhaps because, as we know from a letter of 1756, he had little admiration for it, except for the head.[15] Visconti seems to have been the first to propose that the statue shows Antinous in the guise of Mercury.[16] This theory is now generally accepted, despite Helbig's 'unfortunate' suggestion in 1899 that the broken caduceus might have been a fishing rod:[17] 'a naked fisher is improbable', as Stuart Jones pointed out.[18]

The statue was much copied. A marble version made for the King of France, begun by Marchand in 1741 and completed six years later by Jacques Saly, was claimed by De Troy, director of the French Academy in Rome, to be equal in quality to the original and as good as any ever made at the Academy;[19] in 1753 the King gave it to the *fermier-général* Etienne-Michel Bouret, a notable collector of reproductions after the antique, and it is now lost.[20] Both Zoffoli and Righetti sold reduced bronzes of the *Antinous*,[21] and plaster casts and marble copies are common in the late eighteenth and in the nineteenth century.[22] In England Brucciani, the leading

Victorian supplier of plaster reproductions, offered a wider range of casts, busts and statuettes of this figure than of the *Antinous* in the Belvedere.[23]

The statue is catalogued in Helbig as a Hadrianic copy of a figure of Hermes of the early fourth century B.C.[24]

1. Stuart Jones, 1912, p. 396.
2. [Lucatelli], 1750, p. 34.
3. Gradara, p. 99.
4. Montaiglon (*Correspondance*), XVI, pp. 464, 498.
5. Blumer, pp. 241–9.
6. *Notice*, An IX (1800), p. 35.
7. Saunier, p. 149.
8. Either in the consignment of statues which arrived on 4 January (*Diario di Roma*, 6 January 1816) or among those which had reached Civitavecchia from Antwerp on board H.M.S. *Abundance* by 19 June (*ibid.*, 19 June 1816); Stuart Jones, 1912, p. 8.
9. Stuart Jones, 1912, p. 396; see also p. 398, where the compiler's name has been printed as Comachini.
10. Mariette, I, p. 150.
11. Burney, p. 137.
12. Smollett, p. 288 (letter XXXIII).
13. Lalande, IV, p. 183.
14. Gibbon, p. 241.
15. Winckelmann (ed. Fea), II, p. 388, note A; Winckelmann (*Briefe*), I, p. 259.
16. Visconti (*Opere Varie*), IV, p. 327.
17. Helbig, 1899, I, p. 358.
18. Stuart Jones, 1912, p. 352.
19. Montaiglon (*Correspondance*), IX, pp. 395–6, 445; X, pp. 31, 33, 117, 137, 139–40.
20. Lami, 1910–11, II, p. 323.
21. Zoffoli, Righetti (see Appendix).
22. Brettingham MS., p. 68; Brettingham, 1773, p. 2.
23. Brucciani, 1864.
24. Helbig, 1963–72, II, pp. 230–1.

6. Antinous Bas-Relief (Fig. 75)

ROME, VILLA ALBANI (TORLONIA)

Marble
Height 1.02 m

This relief was recorded in an engraving after a drawing by Pompeo Batoni published in 1736.[1] It belonged to Cardinal Albani and had been excavated the year before in Hadrian's Villa.[2] The relief was restored and placed above a chimney-piece in a room named after it and designed around it on the piano nobile of the Villa Albani, which was completed by October 1762 and the drawings for which had probably been prepared by Carlo Marchionni before 1756 (Fig. 34).[3] In 1798 the relief was expropriated by the French together with the best of the antiquities in the Villa and it was recorded as on display in the Musée in Paris by 1802–3, by which date a cast could be seen in the Villa.[4] It was removed from the Musée in October 1815,[5] restored to the Albani and reincorporated in the

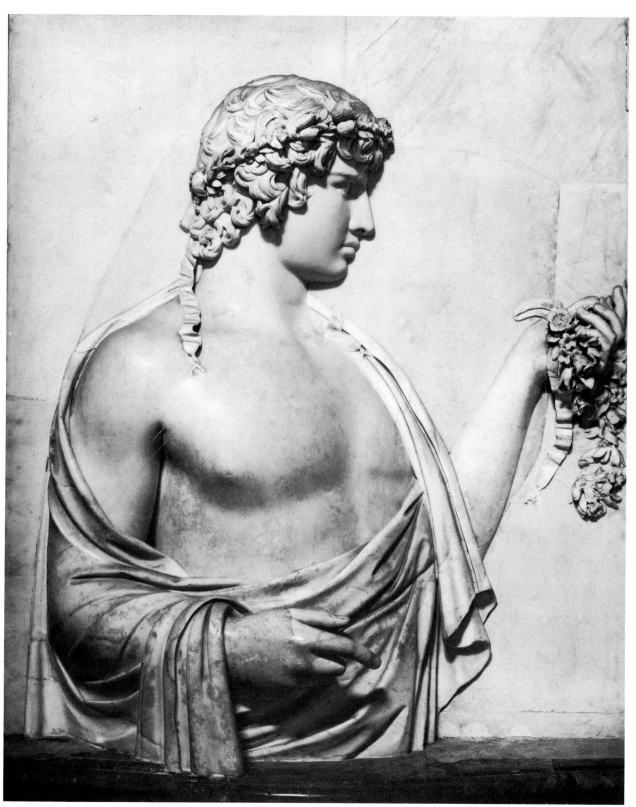

75. *Antinous Bas-Relief* (Villa Albani/Torlonia, Rome).

room from which it had been removed by 1820.[6] It was not moved from there when the Villa and its contents were acquired in 1866 by the Torlonia.[7]

From the moment of its discovery the *Antinous* was acclaimed as a masterpiece, and, with the possible exception of the *Laocoon* whose quality it was sometimes felt to equal,[8] no other sculpture in this catalogue was 'published' more promptly. In 1736 Ridolfino Venuti called it 'very excellent'[9] (but to the irritation of Winckelmann he was less enthusiastic about Hadrian's relationship with the youth).[10] A little over a decade later the director of the French Academy in Rome, De Troy, writing to the Surintendant des Bâtiments to ask permission for the sculptor Challes to make a copy, described it as 'of its kind one of the finest pieces of antiquity that can be found'.[11] Casts were obtained for noblemen in England and Ireland in the 1750s,[12] and one was 'in great request' in the Royal Academy in 1781.[13] Batoni painted a gentleman traveller standing beside it[14] and Marchant engraved it in intaglio on a sardonyx for the Duke of Marlborough.[15] Visitors to Rome agreed that it was the finest work in the Albani collection, although it was praised for different qualities: Gibbon found it 'admirably finished soft well turned and full of flesh';[16] Winckelmann stressed the melancholy expression.[17]

It is indeed with Winckelmann that the *Antinous* is especially associated. He holds an engraving of it in the portrait that Anton von Maron painted of him in 1768 (Fig. 60).[18] A print of the relief appeared in his *Monumenti antichi inediti* of 1767[19] which, together with another showing it prior to restoration, was also included in a French edition of his *History of Ancient Art* published between 1794 and 1803.[20] Winckelmann in fact believed that the right hand had been restored wrongly and should have held a pair of reins rather than a garland of flowers, for the relief was a fragment of an apotheosis in which Antinous was conducted by chariot to the heavens. He also discussed the symbolism of the lotus crown.[21] Together with a colossal head of Antinous (then in the Villa Mondragone and now in the Louvre) which he admired even more and ranked immediately after the *Apollo Belvedere* and the *Laocoon*, Winckelmann considered that the *Antinous* relief represented the highest peak attained by art under Hadrian. Such sculpture was worthy, in fact, of the 'best times'.[22]

The relief continued to be admired by nineteenth-century travellers.[23] And, although Hawthorne who saw it in May 1858 could not agree that it was 'the finest relic of antiquity next to the Apollo and the Laocoon', his comment shows how much of a cliché Winckelmann's estimation had become.[24] It was also one of the relatively few reliefs of which casts were commonly available.[25] However, the extreme difficulty of gaining access to the Villa in recent years makes it one of the least familiar of all the sculptures in this catalogue. Furthermore, few if any modern scholars approve even when they admire this piece which trembles on the brink of 'sweet ornamental banality'.[26] It is catalogued in Helbig as typical of the high quality but academic productions of the studio attached to Hadrian's court and dated now, as always, to the years between the death of Antinous (A.D. 130) and Hadrian (A.D. 138).[27]

1. Venuti, R., 1736, pp. 7–8, plate IX.
2. Fea, 1790, p. cxxxxiii (Ficoroni, Mem. 51).
3. Winckelmann (*Briefe*), II, p. 263; Berliner, plate 58.
4. *Notice*, supplément, An XI (1802–3), pp. 169–70; Morcelli and Fea, p. 61.
5. Saunier, p. 149.
6. Starke, 1820, p. 373.
7. Helbig, 1963–72, IV, p. 231.
8. Poncelin, p. 131—cited by Potts, I, i, p. 296.
9. Venuti, R., 1736, p. 7.
10. Winckelmann, 1767, II, p. 236.
11. Montaiglon (*Correspondance*), X, p. 126, also p. 404.
12. Brettingham MS., p. 120; Charlemont Papers, p. 221.
13. Baretti, p. 10.
14. Metropolitan Museum of Art, New York.
15. Marchant, p. 31.
16. Gibbon, p. 236.
17. Winckelmann, 1767, II, p. 237.
18. Weimar Museum.
19. Winckelmann, 1767, I, plate 180.
20. Winckelmann, 1794–1803, II, 1794, plate VI; III, 1803, plate I.
21. Winckelmann, 1767, II, p. 236.
22. Winckelmann (ed. Fea), II, p. 385.
23. Starke, 1820, p. 373; Valery, III, p. 207.
24. Hawthorne, p. 200 (12 May 1858).
25. Brucciani, 1864.
26. Clairmont, p. 47 (no. 25).
27. Helbig, 1963–72, IV, p. 231.

7. Apollino (Fig. 76)

FLORENCE, UFFIZI (TRIBUNA)

Marble
Height: 1.41 m
Also known as: Little Apollo, Medici Apollo

The *Apollino* is recorded as in the Villa Medici in Rome in 1704 by Maffei in his notes to Domenico de Rossi's anthology of plates.[1] It is probably identical with the Medici Apollo

recorded in December 1684 as amongst those statues of which the French Academy had had casts made[2] and of which a copy was carved by Frémery (now lost or unidentified).[3] It was taken to Florence in 1769–70 with the *Niobe Group*, the decision to consign it to the care of the restorer Spinazzi was made by the end of 1770, and in November of the following year it was placed in the Tribuna.[4] It was removed to Palermo in September 1800 together with other treasures to escape the French, but was returned in February 1803.[5] It was damaged in 1840 when a painting fell on it.[6]

The early history of the *Apollino* is obscure,[7] but it is clear that it quickly increased in popularity in the eighteenth century. By 1722 the Richardsons could call it 'famous', and although they disliked the way it had been restored they admired 'the sweep, and the whole Contour of the Body'.[8] Later in the century it was one of the most highly praised and, as Winckelmann noted, one of the most frequently copied, antique statues.[9] Denon, in 1806, mentioned the statue, together with the *Farnese Hercules* and the *Borghese Gladiator*, as a superlative masterpiece much needed for the Musée Napoléon.[10]

The *Apollino* was described by Northall as 'a figure well worthy to accompany the Venus de Medicis' even before it stood beside her in the Tribuna.[11] Later it was even suggested that they were the work of the same artist.[12] Marble copies of the two statues were often paired, as, in miniature, on the chimney-piece of the painted room of Spencer House, London,[13] and, full-size, in the gallery of Thomas Hope's house, the Deepdene, in Surrey.[14] Other partners were, however, possible and in the royal palace in Stockholm a marble copy gazed across the Hall of Pillars at the *Callipygian Venus*.[15] It was also linked, in literature, at least, with the *Apollo Belvedere*. The Vatican statue represented the god as an adult or the sun in full splendour: the Medici statue 'adolescence', or the sun at dawn.[16] The size of the figure was not always admired,[17] and it had to be enlarged in order for Harwood's wretched copy of it to be 'en suite' with the other statues commissioned for Syon House in Middlesex by James Adam. The latter considered the *Apollino* to be 'in the most agreeable attitude that could be confined in the niche'.[18] Although Lagrenée was keen that Lamarie, who was copying the damaged cast in the French Academy in Rome in 1781, should 'correct' the original from nature, he made no

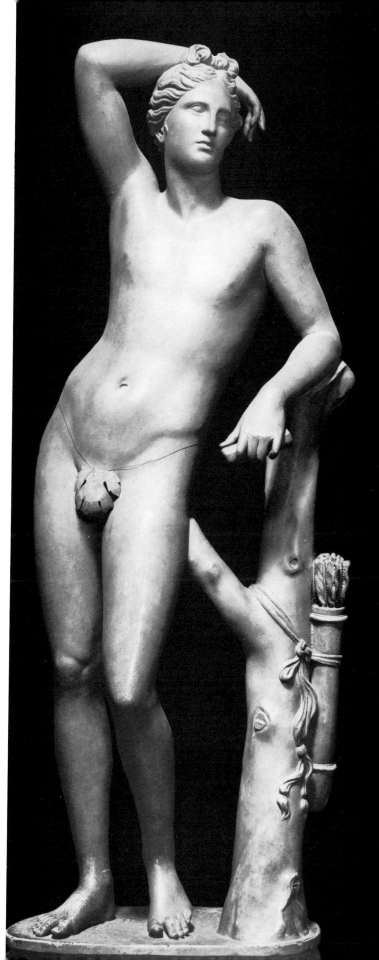

76. *Apollino* (Uffizi).

criticism of the antique,[19] and the statue's gradual fall from popular favour during the last century was not prepared for in the eighteenth.

Scholars have long considered it as an adaptation—or as a copy of an adaptation of a statue by Praxiteles[20]—but, as Mansuelli points out, not everyone is agreed that the prototype was even Praxitelean.[21]

1. Maffei, plate XXXIX.
2. Montaiglon (*Correspondance*), I, p. 129.
3. Souchal, 1977, I, 301.
4. Nardini, IV, p. xxxviii (editorial note by Andreoli in 1771); Villani, pp. 61–2; cf. Mansuelli, I, p. 76 (document).
5. Paris, Archives Nationales, F²¹ 573 (letter from L. Dufourny to Minister of the Interior, 9 fructidor, an 9); Florence, A.G.F., Filza XXX, 1800–1801, n. 23; *Galerie Impériale*, p. 10; Boyer, 1970, pp. 187–91.
6. Mansuelli, I, pp. 74, 76.
7. *Ibid.*, pp. 74–6; Maffei, plate XXXIX, supplies a misleading provenance.
8. Richardson, 1722, p. 128.
9. Winckelmann (*Briefe*), IV, p. 27.
10. Boyer, 1970, pp. 199, 200, 202.
11. Northall, p. 346.
12. Zannoni quoted in Mansuelli, I, p. 75.
13. Crook, plate 58.
14. Watkin, plate 65.
15. Säflund, pp. 13–14, 59–61.
16. Lanzi, p. 175; Éméric-David, 1805, p. 337.
17. Hazlitt, p. 261.
18. Fleming and Honour, I, p. 512.
19. Montaiglon (*Correspondance*), XIV, pp. 131, 140, 244, 266.
20. E.g. Bieber, p. 18.
21. Mansuelli, I, pp. 74–6.

8. Apollo Belvedere (Fig. 77)

ROME, MUSEI VATICANI (BELVEDERE COURTYARD)

Marble
Height: 2.24 m

A drawing of the *Apollo* in the Codex Escurialensis made before 1509[1] records the statue as being in the 'garden of S. Pietro in Vincoli', that is, in the garden of Cardinal Giuliano della Rovere (Pope Julius II, 1503–13) whose titular church was S. Pietro.[2] It is recorded in the Vatican by 1509[3] and in the Belvedere by 1511.[4] It was certainly in a niche (Fig. 4) in the Belvedere statue court by 1523[5] and remained there until ceded by Pope Pius VI to the French under the terms of the Treaty of Tolentino in February 1797.[6] It reached Paris in the triumphal procession of July 1798, in a garlanded case,[7] and was displayed in the Musée Central des Arts when it was inaugurated on 9 November 1800.[8] It was removed in October 1815,[9] arrived back in Rome on 4 January 1816,[10] and was returned to the Belvedere courtyard before the end of February 1816.[11]

At some time between 1568 and 1583 (the year of his death) Pirro Ligorio suggested that the *Apollo* had been discovered at Anzio,[12] but there were rival theories,[13] and both the provenance and date of the discovery of the statue remain uncertain. There is, however, good evidence that it had been in the collection, or at least the possession, of Cardinal Giuliano della Rovere since the turn of the century.[14] The earliest, and rather free, copy is probably the bronze statuette (now in the Ca d'Oro in Venice) upon the model for which Antico appears to have been at work in 1498,[15] but the marble doubtless only became 'famoso nel mondo' (as it was described in 1523[16]) when it was displayed in the Belvedere courtyard. In 1540 moulds were made for François Ier, and soon after a bronze replica was cast for Fontainebleau.[17] Thereafter, until well into the nineteenth century, no sets of prints or casts or copies claiming to represent the most famous works of antiquity failed to include this statue, and numerous passages of rapturous prose were inspired by it. No one was more rapturous than Schiller who considered that no mortal, no 'Sohn der Erde' could describe 'this celestial mixture of accessibility and severity, benevolence and gravity, majesty and mildness'.[18]

In early drawings of the *Apollo* much of the left forearm and some of the right hand are missing,[19] but Antico in his statuette completed the extremities; and after his arrival in Rome in about 1532 or 1533 Montorsoli made additions to the marble itself,[20] which were observed with hardly any comment and invariably reproduced in prints and casts and copies for over three centuries, but which became the subject of intense controversy in the second half of the nineteenth century[21] and have recently been removed.

Five plates are devoted to the *Apollo* in Audran's frequently republished *Proportions du corps humain* of 1683,[22] but by Hogarth's time some unconventional enlargement and elongation of the legs and thighs were noted as contributing to the awe-inspiring character appropriate to a god.[23] Reynolds was anxious to refute the idea that the anatomy was distorted, but he too stressed that the statue was ideal.[24] Winckelmann did so too in his immensely influential panegyric during the course of which he also suggested that the statue had been removed from Greece by Nero[25] (an earlier theory—still repeated in the late eighteenth century—held that Augustus had had it taken from the site of Apollo's oracle at Delphi).[26]

77. *Apollo Belvedere* (Vatican Museum), prior to the removal of the restorations.

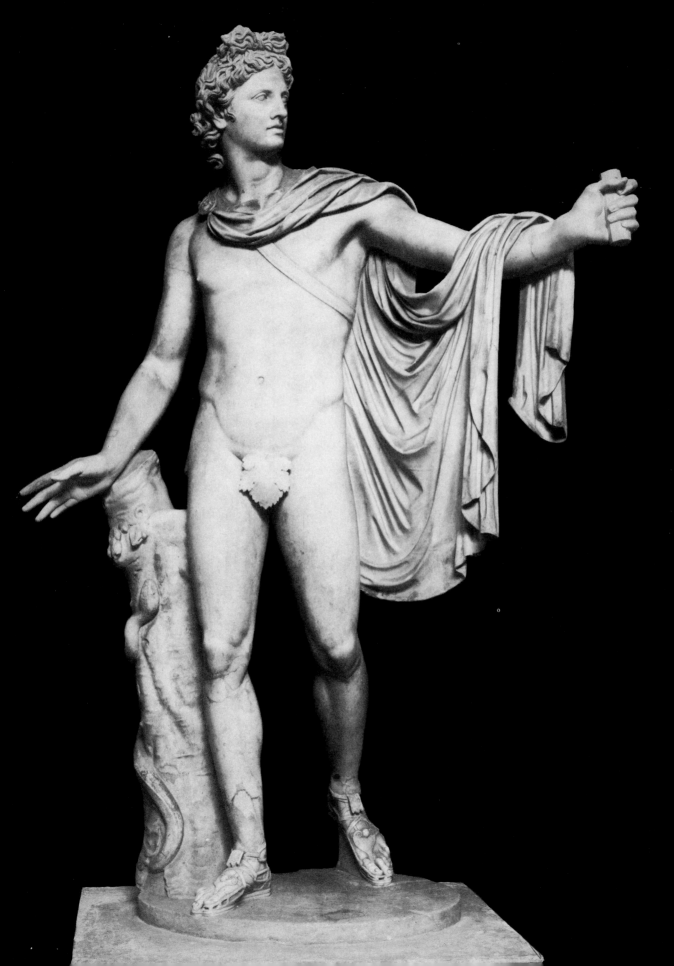

Throughout the nineteenth century copies of the *Apollo* and of the *Diane Chasseresse* were paired—in bronze in the gardens at Malmaison,[27] in marble in the gardens at Chatsworth[28] and Saint-Cloud, in plaster in John Nash's gallery in London[29] and, much later, in the Museum of Archaeology in Cambridge. The idea that these two statues are related was most discussed when they were together in the Musée Napoléon[30] but it can be traced back as far as the mid-seventeenth century when Chantelou suggested to Bernini that they were the work of the same artist.[31] The idea that they were originally imagined 'converging to slaughter the children of Niobe' seems to have been adumbrated early in the nineteenth century[32]—the Niobids being considered as more exalted victims than the python of Delphi at which Apollo was more usually held to have just discharged his arrow. Alternatively the action of the statue was visualised in more general terms, as appropriate to the sun god whose arrows are his rays[33] or to Apollo Venator, god of the Chase.[34]

Surprising support to the interpretation of the *Apollo* as a hunter was given by the young American painter Benjamin West on his arrival in Rome in the summer of 1760. The Romans, who considered all Americans as uncivilised (and some of them supposed West actually to be a Red Indian), stood him in the Belvedere courtyard and threw open the doors of the niche in which the *Apollo* stood in order to witness the impression made by such perfection on the untutored mind. 'My God,' exclaimed West, 'how like it is to a young Mohawk warrior.'[35]

In the following decades when veneration for the 'purity' of the Greeks began to replace admiration for the 'politeness' of the ancients, and when Homer was appreciated for, rather than despite, the 'rude' and simple manners of his heroes, this supposed similarity between the marble statue and a noble savage was remarked by ethnographers and celebrated by poets.[36] Mrs. Starke when she saw the statue even thought of Adam as he appeared in Eden before the Fall.[37] Taine, however, later commented on the evident high breeding of the god, remarking that he was sure that he had servants.[38]

Anton Raphael Mengs, shortly before his death in 1779, argued forcefully that the *Apollo* was a Roman copy, claiming that it was made of Italian marble.[39] This Visconti denied absolutely in 1782 and he called in expert witnesses to testify that the material was Greek. Visconti went on to suggest that the *Apollo* might be the one attributed to Kalamis by Pliny.[40] By 1800, however, confronted by the evidence of the celebrated geologist and mineralogist Dolomieu he was prepared to concede that the marble might well have been Italian.[41] In the following years he tended more to the view that it was an 'improved' version made for the Romans of an earlier bronze statue (perhaps by Kalamis)—and that a Greek original is here not copied but 'selectively modified by an unknown artist and his patron to satisfy their own contemporary Roman taste' has been proposed by at least one modern scholar. The tree trunk support, the block under the raised foot and the character of the drapery suspended from the arm all supported the idea of it being copied from, or inspired by, a bronze.[42] Flaxman seems to have observed to Visconti in Paris in September 1802 the fact he had noted at least seven years earlier in London—that the folds in front of the drapery do not correspond with those behind as would have been possible had the drapery been executed in bronze.[43] The leading authorities had decided that the *Apollo*—a masterpiece which only the most accomplished students should dare copy—was itself not original.[44]

Many educated people with no profound archaeological knowledge quickly picked up these ideas,[45] which however did little at first to impair the statue's reputation, for even though it was a copy, the *Apollo* was held to be a 'higher' work of art than the incontestably original 'Theseus' of the Parthenon because of its 'ideal beauty', as Flaxman argued,[46] and its 'character and feeling', as Croker proposed.[47] James Fenimore Cooper, who found that the sculpture surpassed all his expectations when he saw it between 1828 and 1830, noted that the 'suspicion' that the work was a copy was 'whispered so loud that anyone may hear'.[48] Whispering was necessary, for even as late as 1850 the *Apollo* was certainly still widely considered to be among the half dozen greatest works of art in the world. The disparagements of men such as Hazlitt[49] or Bartolini[50] were not at all typical, nor was the objection of young French artists in Rome at the end of the eighteenth century that it was a 'scraped turnip'.[51]

Since 1892 the idea that the original sculpture of which the *Apollo Belvedere* is a copy was the Apollo by Leochares mentioned by both Pliny and Pausanias has been frequently repeated.[52] It is catalogued in Helbig as a copy of the early Hadrianic period of a bronze original by Leochares.[53]

1. Knift.
2. Egger, fol. 53—'nelorto disapiero in vinhola'.
3. Albertini (*De Statuis*) in Valentini and Zucchetti, IV, p. 490.
4. Ackerman, 1954, p. 153 (doc. 8e).
5. Venetian Ambassadors in Albèri, p. 115.
6. Montaiglon (*Correspondance*), XVI, pp. 462, 498.
7. Blumer, pp. 241–9.
8. *Notice*, An IX (1800) pp. 73–7.
9. Saunier, p. 149.
10. *Diario di Roma*, 6 January 1816.
11. *Ibid.*, 24 February 1816.
12. Brummer, p. 44, note 2.
13. Brummer, pp. 44–6; see also Richardson, 1722, pp. 275–6.
14. Brummer, pp. 44–6.
15. *Ibid.*, pp. 50–1; Hermann, p. 208.
16. Venetian Ambassadors in Albèri, p. 115.
17. Pressouyre, 1969 ('Fontes'), pp. 223–4.
18. Schiller, XX, p. 103.
19. Brummer, pp. 49–57.
20. Vasari, VI, p. 633.
21. Furtwängler, 1895, pp. 405–7.
22. Audran, plates 17–20, 27.
23. Hogarth, p. 88.
24. Reynolds, J., p. 179 (Discourse X).
25. Winckelmann (ed. Fea), II, p. 355; see also Winckelmann, 1968, pp. 267–79.
26. Sandrart, 1680, p. 13; Richardson, 1722, p. 276; Hogarth, p. 90 and note; Beckford, II, p. 272.
27. Hubert, 1977, p. 36.
28. By Francesco Bienaimé, 1841—Chatsworth MS., Sculpture Accounts of the Sixth Duke, p. 23.
29. Davis, plate 63.
30. Farington, V, pp. 1820, 1831, 1851.
31. Chantelou, p. 202.
32. Clarac, 1820, p. 87; Flaxman, p. 28; cf. Robertson, I, p. 460.
33. Aldrovandi, 1556, p. 119; Hogarth, p. 90.
34. Spence, p. 87.
35. Galt, pp. 103–6, 115.
36. Knight, 1795, p. 3, note; Winterbottom, I, p. 200.
37. Starke, 1820, p. 331.
38. Taine, I, p. 143.
39. Mengs, pp. 360, 364.
40. Visconti (*Pio-Clementino*), plate XIV (citing Pliny, XXXVI, 36; Pausanias, I, iii, 3).
41. *Notice*, An IX (1800), p. 76.
42. *Musée Français*; Brilliant, p. 12.
43. 'Report on Lord Elgin's Marbles', p. 29; Farington, II, p. 442; V, p. 1837.
44. Montaiglon (*Correspondance*), XIV, pp. 261, 281, 345–6.
45. E.g. Matthews, II, pp. 8–9.
46. 'Report on Lord Elgin's Marbles', p. 29.
47. [Croker], p. 545.
48. Cooper, II, pp. 188–9.
49. Hazlitt, pp. 148, 260.
50. Tinti, I, p. 217, note.
51. Haskell, 1976, p. 6.
52. Winter; Furtwängler, 1895, p. 409; Amelung, 1903–8, p. 264; Bieber, p. 63; Robertson, I, p. 460 (all citing Pliny XXXIV, 79; Pausanias, I, iii, 4).
53. Helbig, 1963–72, I, pp. 170–2.

9. Apollo Sauroctonus (Fig. 78)

PARIS, LOUVRE

Marble
Height: 2.5 m
Also known as: Lizard Apollo

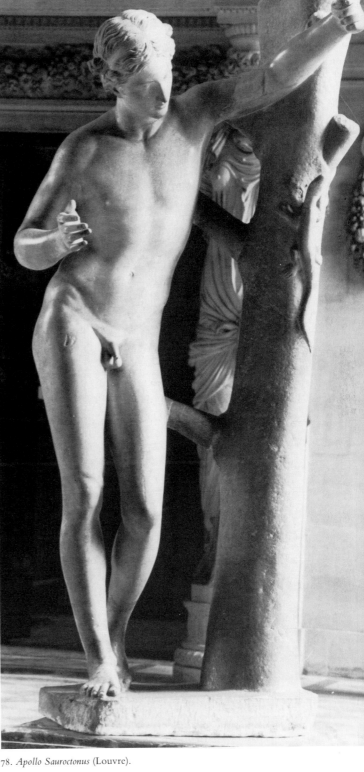

78. *Apollo Sauroctonus* (Louvre).

This statue was certainly in the Villa Borghese in 1760[1] and can plausibly be traced back in that collection to 1650, though the relevant descriptions are not precise enough to make this certain.[2] On 27 September 1807 it was purchased (together with the bulk of the Borghese antiquities) by Napoleon Bonaparte, brother-in-law of Prince Camillo Borghese.[3] It was sent from Rome between 1808 and 1811[4] and was displayed in the Musée Napoléon by the latter year.[5]

Like the *Discobolus* some years later, this statue became very famous despite the fact that it was nearly always acknowledged to be a copy; but unlike the *Discobolus* it had almost certainly been accessible to connoisseurs well before its significance was recognised. The first man to allude to its probable identity was Winckelmann when commenting in 1760 on a paste in Baron Stosch's collection of gems;[6] interestingly Stosch himself had in 1724 suggested that an emerald in a Dutch collection reproduced the famous statue by Praxiteles of a young Apollo as a lizard killer known only through a description by Pliny.[7] Stosch's 'discovery', which he did not reproduce, had been referred to by Mariette in 1750,[8] so it is perhaps even more astonishing that the identification of the Borghese statue was so long delayed. In fact it was not until 1764 that Winckelmann discussed it in a little more detail, referring as well to another (smaller) version also in the Borghese collection and to a reduced bronze belonging to Cardinal Albani. In the face of Pliny's evidence he claimed that the original by Praxiteles had been of marble and that the better of the Borghese sculptures was 'worthy of being the original'—but he stopped short of saying that it actually was the original.[9] Three years later he turned to the problem once again and published the first reproduction of the statue: he still insisted, in the most cautious language, that 'it would not be unreasonable to think' that it could be by Praxiteles and pointed out that if a copy—and he implies that it was—it was of sufficient quality to convey a true impression of the art of Praxiteles.[10] Only at the very end of his life did he acknowledge that Pliny had quite clearly implied that the original *Sauroctonus* had been of bronze, and this now led him to suggest that the Albani version was 'probably' by Praxiteles, though he admitted that when excavated it had not been complete.[11] Winckelmann was never quite happy with this statue and his unqualified enthusiasm was limited to the legs and the knees.[12] He pointed out,

moreover, that the positioning of the legs conflicted with the ideal stance of a god, and he explained that Apollo must have been represented in mortal guise when serving King Admetus as a shepherd.[13]

None of these hesitations worried the Borghese. The statue which had been ignored for so long was now placed on a magnificent base,[14] and, although it never won the great popularity that came with rapturous accounts in the guidebooks[15] and the production of small bronze copies, discriminating travellers began to single it out and reported that it was 'one of the finest Greek works in Rome'.[16] Visconti began his excited account of the statue with the words 'Here is the first simulacrum of which it can be said with absolute certainty that we have the image of one of the most famous works of the most famous sculptor of the century of Alexander'. However, it is interesting to note that when the *Apollo* was acquired for the Musée some French commentators, surprised perhaps that so much attention was being paid to an acknowledged copy, were far more qualified in their admiration.[18]

By then a number of other versions had been excavated besides the three which had been known to Winckelmann.[19] The most famous of these was found by Gavin Hamilton in 1777 and was acquired for the Museo Pio-Clementino after being restored to conform to the Borghese statue which Visconti (followed by all later writers) considered to be superior;[20] it was not confiscated by the French in 1797 even though at that date they could not have known that the Borghese marble would be acquired for Paris. And three more (not all of which have stood up well to the scrutiny of later specialists) entered very famous English collections: those of Lord Lansdowne, of Henry Blundell of Ince Hall and of Thomas Hope of the Deepdene.[21] To the sophisticated all this demonstrated the popularity of the original work in antiquity, but there is little evidence to suggest that admiration was very widespread outside the world of scholars.

Pliny's description of the statue by Praxiteles was unusually explicit[22] but it gave rise to much controversy. Winckelmann argued that 'puberem' (adult) must have been an error for 'impuberem'.[23] More important was the question of whether the phrase 'quem sauroctonon vocant' applied to the statue or to the god himself.[24] The first hypothesis, which seemed to be supported by a playful epigram by Martial,[25]

suggested that the work was no more than a light-hearted fantasy. Many held to this including Fröhner who in his catalogue entry nonetheless found it necessary to add that among the ancients lizards played an important role in pharmacology:[26] 'this explanation may make people laugh' he commented—prophetically.[27]

Others laid much stress on the symbolic attributes of the god. Visconti reported the notion that the sun god Apollo may perhaps have been portrayed cleansing the air of putrid impurities,[28] while in a paper read to the Académie des Inscriptions et Belles-Lettres in 1824 Éméric-David agreed that Apollo symbolised the sun but suggested that far from trying to kill the lizard the god was merely stimulating it with a dart so as to rouse it from its winter hibernation.[29] Other, more recondite, theories were produced later in the century,[30] for, as Visconti himself drily observed, 'when one ventures into symbolic mythology it is difficult to restrict oneself'.[31]

Robertson accepts the statue as a copy ('of rather repellent quality') of the bronze original by Praxiteles described by Pliny.[32]

1. Winckelmann, 1760, p. 190 (no. 1120).
2. Manilli, p. 30; Montelatici, pp. 260–1.
3. Boyer, 1970, p. 202.
4. Arizzoli-Clémentel, pp. 13–14, note 60.
5. *Magasin Encyclopédique*, 1811, III, p. 387.
6. Winckelmann, 1760, p. 190 (no. 1120).
7. Stosch, pp. xviii–xix (alluding to Pliny, XXXIV, 69–70).
8. Mariette, I, p. 37.
9. Winckelmann, 1764 (*Geschichte*), p. 343.
10. Winckelmann, 1767, II, p. 146; I, plate 40.
11. Winckelmann (ed. Fea), II, pp. 222–4.
12. Winckelmann (ed. Fea), I, pp. 382–3.
13. Winckelmann, 1767, I, p. xlii; II, p. 46.
14. Lalande, III, p. 476.
15. Vasi, 1791, I, p. 285, notes it without comment.
16. Ramdohr, I, pp. 321–2; Lalande, III, p. 476.
17. Visconti (*Monumenti Borghesiani*), plate XXI, no. 3.
18. Filhol, VI, 1809, 70ème livraison, plate 6 (no. 420).
19. Winckelmann, 1767, II, p. 46.
20. Visconti (*Pio-Clementino*), I, plate XIII; Helbig, 1963–72, I, pp. 91–2.
21. [Blundell], 1809, I, plate 36; Michaelis, 1882, pp. 280, 339–40, 447–8.
22. Pliny, XXXIV, 69–70.
23. Winckelmann (ed. Fea), II, pp. 222–4.
24. Rayet, 1881 ('Apollon'), p. 3.
25. Martial, XIV, 172.
26. Fröhner, pp. 94–6.
27. Rayet, 1881 ('Apollon'), p. 4.
28. Visconti (*Monumenti Borghesiani*), plate XXI, no. 3; cf, Knight, 1818, p. 99.
29. Éméric-David, 1862, pp. 235–50.
30. Rayet, 1881 ('Apollon'), pp. 8–12.
31. Visconti (*Monumenti Borghesiani*), plate XXI, no. 3.
32. Robertson, I, pp. 388–9.

10. Aristides (Fig. 79)

NAPLES, MUSEO NAZIONALE

Marble
Height: 2.10 m
Also known as: An Orator, Aeschines

The statue was found at Herculaneum in 1779[1] and is recorded in an official inventory of the royal palace of Portici in the winter of 1796.[2] It was said in a catalogue of 1819 to have been moved to the Museo degli Studi (later Museo Borbonico, now Museo Nazionale) eight or nine years before[3] and had certainly been moved there by 1813.[4]

The statue was described in 1796 as 'un filosofo'[5] but by the early nineteenth century it was generally known as Aristides, a name, retained by catalogues out of convenience rather than conviction,[6] which continued to be popular and is found on marble copies such as the one in the garden at Chatsworth in Derbyshire and in lists of plaster casts sold in the second half of the century.[7] Pistolesi recorded the theory that he was shown just prior to denouncing Themistocles, but added that he fancied him to be engrossed in patriotic prayer.[8]

By the end of the nineteenth century, the statue was catalogued either as an Orator or, specifically, and correctly, as the fourth-century Athenian orator, Aeschines, on account of the head's similarity with inscribed herm portraits.[9]

Although it was highly valued by the end of the eighteenth century,[10] the Aristides was most praised in the first half of the nineteenth. The fact that Canova, 'the Phidias of our time', was reported to have admired it more and more every time he beheld it certainly helped to establish its fame,[11] and the English traveller John Mayne reported in January 1815 that Canova had 'marked the several points from which it may be studied to the greatest advantage'.[12] Giovambattista Finati in his catalogue of 1819 even classed it with the Farnese Flora, the Hercules, the Venus de' Medici, the Gladiators, the Apollo and the Laocoon. No one had dared to do this before, he said, because it was so much harder for a statue to achieve fame in Naples than it was in Rome, especially when poorly displayed at Portici; but, he added, the Prince Regent of England had requested a cast (the first ever to be made from it) and this would soon reach London—'the first step', he believed, which Aristides would take on the path to international

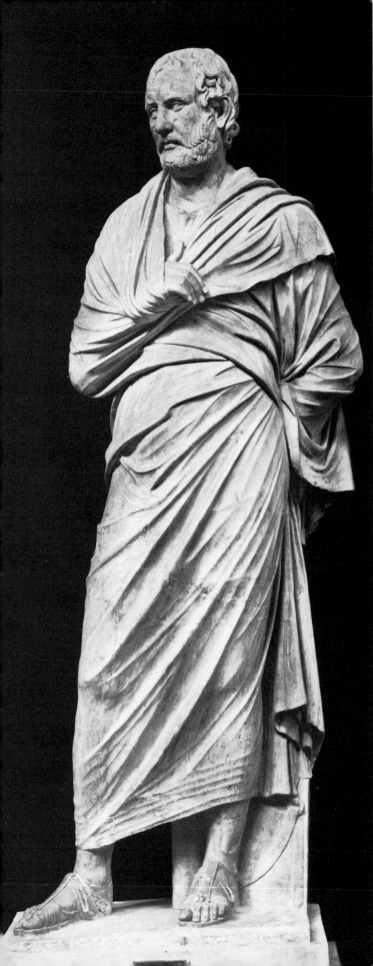

fame.[13] This fame, however, probably owed more to guides and to travel writers such as Mrs. Starke, who bestowed four exclamation marks upon it,[14] or Galiffe who preferred it to the *Farnese Hercules* on account of its 'real nature',[15] than to copies or casts which seem at first to have been severely limited. In fact several years before Finati mentioned the cast made for the Prince Regent, John Mayne commented that it was 'so much injured by fire as to render it impossible to make a cast from it, and this adds in no slight degree to its intrinsic worth'.[16]

The 'grave yet graceful simplicity', which made the statue one of the most striking in Naples for Mrs. Jameson,[17] was never more admired in sculpture than in the first decades of the nineteenth century, and such simplicity generally meant a static pose. Indeed Count D'Orsay, who believed it impossible to admire statues in action for longer than he could himself stand in the same attitude, wrote, in 1841, that he felt able to admire the *Aristides* for hours[18]— Galiffe suggested 'days and nights'[19]—whereas 'the Apollo with his arm stretched out with a heavy blanket on it tires me after 5 minutes'.

The statue is described by Robertson as a copy made before A.D. 79 of an original bronze portrait of Aeschines of the fourth century B.C.[20]

1. *Real Museo Borbonico*, I, 1824, plate L.
2. *Documenti inediti*, I, p. 239.
3. Finati, I, ii, pp. 125–30.
4. Vasi, 1813, p. 108.
5. *Documenti inediti*, I, p. 239.
6. Verde, Pagano and Bonucci, pp. 158–60.
7. Brucciani, 1864.
8. Pistolesi, 1842, I, p. 91.
9. Monaco, pp. 37–8; de Angelis; Ruesch, p. 271.
10. *Documenti inediti*, I, p. 239.
11. *Real Museo Borbonico*, I, 1824, plate L.
12. Mayne, p. 262; see also [Montaran], p. 173.
13. Finati, I, ii, pp. 125–30.
14. Starke, 1820, p. 416; cf. Giustiniani and Licteriis, p. 31.
15. Galiffe, II, p. 96.
16. Mayne, p. 262.
17. [Jameson], p. 267.
18. Westmacott Papers, II, p. 175.
19. Galiffe, II, p. 96.
20. Robertson, I, p. 511.

11. Arrotino (Fig. 80)

FLORENCE, UFFIZI (TRIBUNA)

Marble
Height: 1.05 m
Also known as: Attius Navius, Clown whetting his scythe (or knife), Naked Gladiator, The Grinder, M. Manlius, Milichus, Le Rémouleur, Il Rotatore, Listening (or Roman) Slave, Scythian Slave, The Spy, Il Villano, The Whetter

79. *Aristides* (Museo Nazionale, Naples).

This statue is first definitely recorded in a drawing (which does not show the head) by Marten van Heemskerck, who was in Rome between 1532 and 1536.[1] By 1556 it belonged to Niccolo Guisa[2] and in 1561 to Paolantonio Soderini[3] (owner of one of the versions of *Pasquino*), both of whom lived in Rome. In 1567 Duke Cosimo de' Medici was trying to buy it through the agency of Vasari,[4] and in 1578 it was acquired (after the price had been lowered) from the Mignanelli family by Cardinal Ferdinando de' Medici.[5] It is unlikely that it was ever sent, as intended, to Pratolino, the country house of the Cardinal's elder brother, Duke Francesco de' Medici, who himself had hoped to buy the statue seven years earlier,[6] and it was certainly in the Villa Medici in Rome by 1594, when it was engraved,[7] and it is recorded there in an inventory of 1598.[8] In August 1677 it was sent to Florence (with the *Venus* and the *Wrestlers*).[9] It is not recorded in the Uffizi until 1680,[10] but by 1688 it was certainly displayed in the Tribuna.[11] In September 1800 it was sent, with other treasures, to Palermo to escape the French, but it was returned to the Tribuna in February 1803.[12]

This very widely admired statue was invariably included in both luxurious and popular anthologies of reproductions and noted with enthusiasm by travellers to Rome, and later to Florence. In 1684 it was copied for Versailles by Foggini;[13] in 1871 this copy was removed to the Tuileries[14] and replaced, above the steps leading to the Parterre Nord, by a bronze which had been cast by the Kellers in 1688—it is there paired with one of the *Crouching Venus*. Soldani made a bronze (with three other famous statues in the Tribuna) for the Duke of Marlborough in about 1710 which is still at Blenheim;[15] there was a cast of the 'Schleifer' in the Antikensaal at Mannheim which was opened in 1787;[16] and Jefferson included a copy of the 'Roman slave whetting his knife', along with twelve other celebrated sculptures (then known to him only through prints and descriptions), among those which he wished to acquire for his projected art gallery at Monticello.[17] Small reductions were also very popular: Girardon himself made a terracotta which he kept, as well as a bronze statuette, in his private 'Musée',[18] and other bronze reductions were later offered for sale by Zoffoli[19] (though not, surprisingly, by Righetti).

Winckelmann showed no particular enthusiasm for the quality of the work,[20] and another rare discord in the general chorus of praise can be noted in 1781 when the sculptor Louis-Pierre Deseine at the French Academy in Rome asked permission to copy the *Arrotino*, because, like Legros who had deliberately selected for his widely admired copy (now in the Tuileries) a secondary sculpture (the 'Vetturie' now in the Loggia dei Lanzi in Florence), he too wished 'to study his after nature and make a second original more perfect than the first if he can, and this would be impossible if he chose a more perfect original'.[21]

The earliest references describe the figure in the most neutral terms: 'a knife sharpener',[22] a 'villano' (peasant),[23] etc. Many people stuck to this simple nomenclature, sometimes with slight embellishments,[24] and indeed the name most commonly adopted towards the end of the seventeenth century was (and still remains) that of 'Arrotino' (knife grinder). But either the expression of the figure itself or a belief that all statues must represent some specific individual very quickly encouraged scholars and connoisseurs to search for a more satisfying designation, and as the alternatives multiplied, so too did admiration for the convincing manner in which the chosen subject had been portrayed. Like other figures (such as the *Spinario* and *Cincinnatus*) the *Arrotino* was recruited into the ranks of those heroes, sometimes anonymous but sometimes with names recorded in classical texts, who had deserved well of ancient Rome and had—it was supposed—been rewarded with a statue. In 1594 Cavalleriis identified the figure as 'Manlius Capitoli propugnator'[25] (the Marcus Manlius whose sleep had been disturbed by the cackling of Rome's sacred geese and who had successfully defended the Capitol against a night attack by the Gauls), but this theory met with no success, as it did not adequately explain what were seen as the three basic characteristics of the statue: the plebeian countenance, the attentive expression and the sharpening of the knife.

By the middle of the seventeenth century it was generally agreed that the *Arrotino* portrayed a serf who, while engaged at his work, was overhearing a plot against the State. A barber who had apparently revealed the conspiracy of Catiline was especially popular[26]—despite Sallust's assertion that a woman of good birth had been responsible.[27] Other candidates included another barber who had spied on a conspiracy against Julius Caesar in Alexandria;[28] the recently freed Milichus who showed to Nero the dagger which he had been instructed by his master Flavius Scaevinus to sharpen in prepara-

tion for the Emperor's murder;[29] and a servant called Vindicius who, while whetting his knife—'the proper Business of a Butler, very likely, in those days as well as now'—overheard, and then revealed, the plot of Brutus's sons to restore the Tarquins to the Roman throne.[30] A quite different theory that gained currency in the early eighteenth century was that the *Arrotino* represented the famous augur Attius Navius[31] (in whose memory both Pliny and Livy recorded the existence of a statue)[32] who opposed the project of Tarquinius Priscus to increase the size of the army—challenged by the King to divine whether his intentions could be carried out, the augur succeeded in cutting a whetstone with a razor as proof of his powers. Though 'the learned have objections to this latter explanation'[33] (Livy had said that the statue's head was covered), as they did to all the others, the temptation to try to identify the figure continued to prove irresistible to antiquarians and visitors alike, despite Maffei's devastating observation in 1704 that 'to tell the truth we are in the dark, without any hope of finding light, as regards everything that concerns the statue' and his remarkable suggestion that 'it may well be that the sculptor had nothing else in mind than to provide convincing proof of his artistic prowess'.[34]

In fact, however, what is now accepted as the correct solution had been reached—and published—more than thirty years earlier by Leonardo Agostini who had recognised from the composition of an antique gem that the *Arrotino* was awaiting instructions from Apollo to begin flaying alive Marsyas who had been defeated by the god in a musical contest and that it therefore belonged to a sculptural group.[35] Gronovius,[36] Stosch, Winckelmann[37] and certain other scholars accepted that the figure was indeed the Scythian executioner, but—as we have seen—this made little impact on cicerones or guidebooks (and hence on travellers), and right until the middle of the nineteenth century the makers of plaster versions of this still very popular sculpture referred to it as 'the listening slave'.[38]

Controversy about the subject left little energy for discussing the date of the *Arrotino*, and even Carlo Fea claimed only that as it belonged to 'the best period' it could not have anything to do with a plot against Julius Caesar.[39] In 1680, however, Sandrart had mentioned in passing that the figure was by Michelangelo.[40] No evidence was provided for a suggestion that flew in the face of all existing evidence, and probably because Sandrart was a notoriously unreliable

writer no one paid any attention to his idea. However, in the nineteenth century certain German scholars (of whom Burckhardt was by far the most distinguished) once more put forward the theory that the *Arrotino* was a work of the Renaissance which, because of its quality, could only be attributed to Michelangelo.[41] Again the hypothesis won little serious acceptance, nor does its recent resurrection by a writer[42] who has tried to add historical to stylistic arguments seem likely to convince scholarly opinion, which generally accepts that the statue is, as implied by Mansuelli, an original Pergamene marble of high quality.[43]

1. Hülsen and Egger (Text), I, p. 31; and (Tafeln), I, fol. 57r.
2. Aldrovandi, 1556, pp. 166–7.
3. Parronchi, p. 348.
4. Gaye, III, pp. 240–1; Lanciani, 1902–12, II, p. 64.
5. Boyer, 1929, p. 260, note.
6. *Ibid*; Bencivenni Pelli, II, p. 50.
7. Cavalleriis (3), plate 90.
8. Boyer, 1929, p. 260 (no. 26).
9. Florence, Archivio di Stato, Med. Princ. 3943 (24 August 1677).
10. Bencivenni Pelli, I, p. 290, note.
11. Baldinucci, II, pp. 497–8 (life of Buontalenti, first published in 1688).
12. Paris, Archives Nationales: F²¹ 573 (letter from L. Dufourny to Minister of the Interior, 9 fructidor, an 9); Florence, A.G.F., Filza XXX, 1800–1801, n. 23; *Galerie Imperiale*, p. 10.
13. Thomassin, plate 46, attributed this signed copy to Frémery, for which he was ridiculed by Piganiol de La Force—Alazard, p. 136.
14. Alazard, p. 136, note 3 (the signature is no longer visible).
15. Ciechanowiecki and Seagrim.
16. Schiller, XX, pp. 104–5.
17. Howard, 1977, pp. 593–4.
18. Souchal, 1973, p. 78, no. 178. This bronze is now perhaps in the Wallace Collection—Mann, p. 71.
19. Zoffoli (see Appendix).
20. Winckelmann, 1767, II, p. 50.
21. Montaiglon (*Correspondance*), XIV, pp. 130–1, 165.
22. Aldrovandi, 1556, pp. 166–7.
23. Gaye, III, pp. 240–1 (Cosimo I to Vasari, 17 March 1567).
24. Evelyn, II, p. 286; Mortoft, p. 120.
25. Cavalleriis (3), plate 90 (alluding to Livy, V, 47).
26. Lassels, II, p. 176; Misson, 1691, II, p. 151; Caylus, 1914, p. 315.
27. Sallust, *Catiline*, XXIII—as noted by Maffei, plate XLI.
28. Lanzi, pp. 174–5 (with qualifications and doubts—alluding to Plutarch, *Caesar*, XLIX).
29. Thomassin, p. 18; Smollett, pp. 237–8 (letter XXVIII—alluding to Tacitus, *Annals*, XV, 54–5).
30. Wright, II, pp. 410–11 (alluding to Livy, II, 4).
31. Wright, II, pp. 410–11; Bianchi, pp. 199–203.
32. Pliny, XXXIV, II, 22–3; Livy, I, 36.
33. Corke and Orrery, pp. 77–8.
34. Maffei, plate XLI.
35. Agostini, II, pp. 21–2—the passage was omitted in the second (posthumous) edition of 1686.
36. Gronovius, II, 1698, p. 86.
37. Winckelmann, 1760, pp. 193–4; Winckelmann, 1767, II, p. 50.
38. Brucciani, 1864.
39. Fea in Winckelmann (ed. Fea), II, p. 314, note b.
40. Sandrart, 1680, p. 41.
41. Burckhardt, pp. 491–2.
42. Parronchi.
43. Mansuelli, I, pp. 84–7.

80. *Arrotino* (Uffizi).

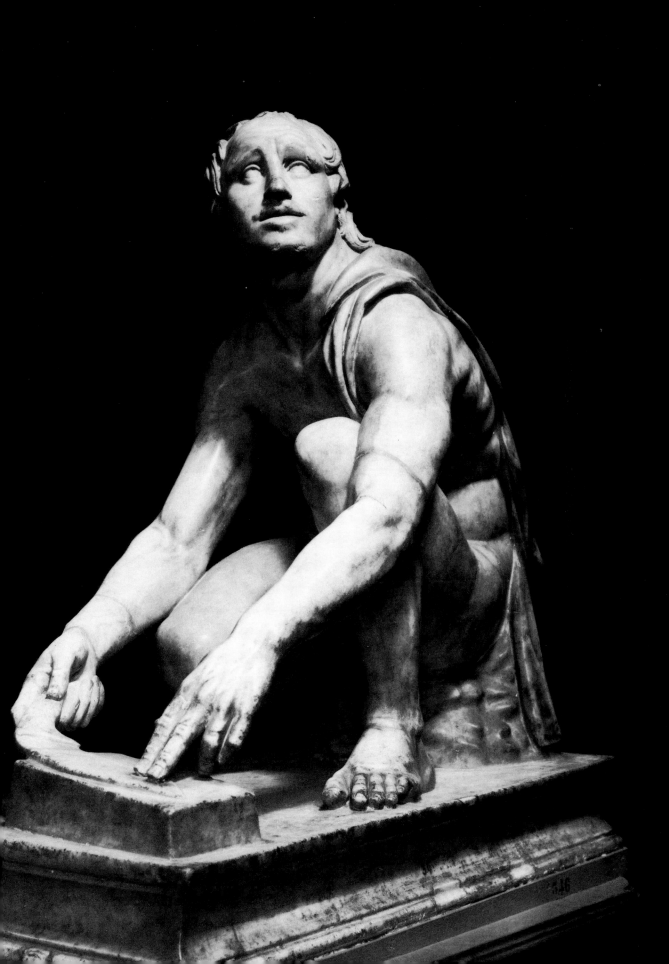

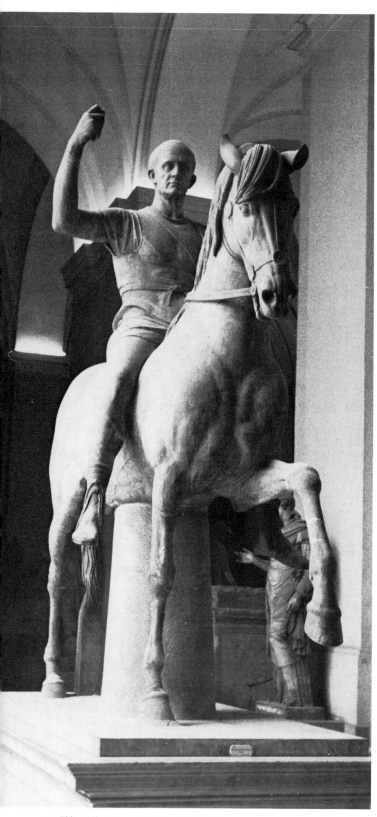

12. Equestrian Balbus (Figs. 81–2)

NAPLES, MUSEO NAZIONALE

Marble
Height (younger): 2.56 m; (elder): 2.52 m
Also known as: Marcus Nonius Balbus

The equestrian statue of the younger Balbus was excavated in 1746[1] at Herculaneum in an area where many other busts, statues and inscriptions relating to him and his family had already been discovered and this has led to some confusion (originating in the 1740s and repeated ever since) about the date of discovery of this statue which is so often wrongly given as 1739.[2] By 1748 it had been placed under military guard and enclosed within elaborately worked iron barriers in the courtyard at the entrance to the royal palace of Portici.[3] Soon after the discovery of the younger Balbus, another equestrian statue, claimed to be of his father, was found.[4] This took three years to restore and during the course of 1751 it too was installed at the entrance of the palace and both flanking statues were protected by glass.[5] During the Revolution of 1799 the head of the younger Balbus was smashed by a cannon ball and was later replaced by a copy (made by Angelo Brunelli) based on the existing fragments.[6] By 1813 both statues were in the Museo degli Studi (later Museo Borbonico, now Museo Nazionale).[7]

The statue of the younger Balbus was believed by contemporaries to have been found in very good condition, while that of his father had to be largely reconstructed by the court sculptor and restorer Joseph Canart who made for it a completely new head which he copied from a bust.[8] Despite this, by no means all connoisseurs agreed with the majority in preferring the younger Balbus. De Guasco thought that it did 'not offer the same degree of perfection',[9] Burney found the father to have 'by far the most agreeable countenance',[10] while Dupaty considered that the son was ignoble in appearance and held himself 'like a peasant'.[11] In fact, by the time that the sculptures were catalogued in 1825 the elder was thought to be superior and to be much better preserved.[12] When therefore reference is made (as it frequently is) merely to 'Nonius' or 'Balbus', it is not always possible to be sure which of the two statues is under discussion, and from the 1760s onwards they can be more conveniently considered together.

Until the discovery of the bronze *Mercury* in 1758, these were by far the most important

81. *Elder Balbus* (Museo Nazionale, Naples).

82. *Younger Balbus* (Museo Nazionale, Naples).

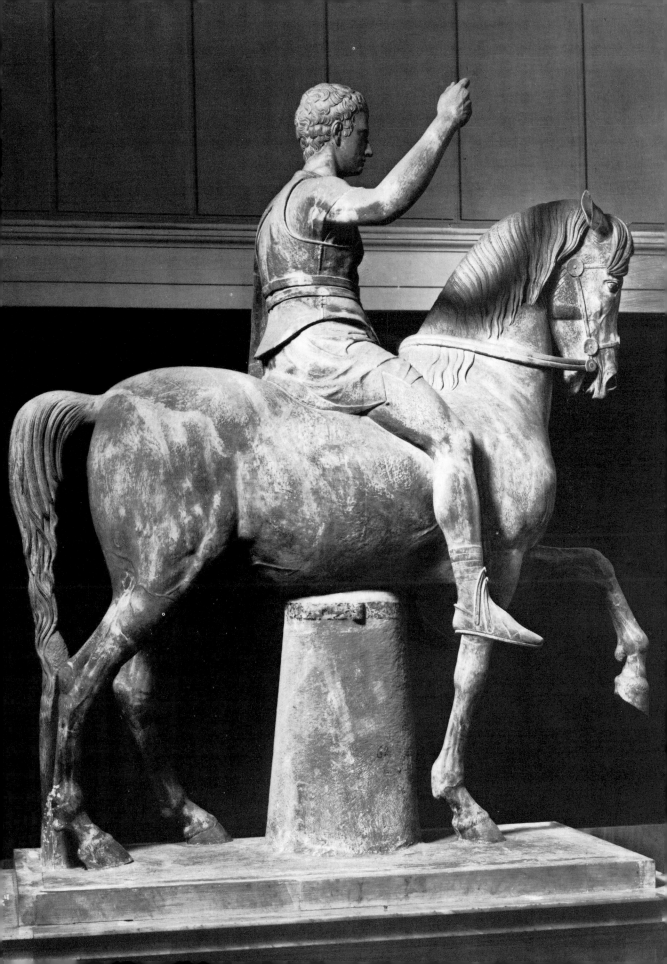

statues to emerge from the new excavations at Herculaneum; and, partly because they were relatively accessible to the public, they remained better known than any of the other sculptures associated with these excavations. The younger Balbus was welcomed partly because the cloak over his shoulder was quite different from 'the usual drapery of the ancients, floppy and commonplace like soft rags'. Here the folds were beautiful in the manner of Guido or Lanfranco, and it was claimed that those who had seen it were in no doubt that it was the finest equestrian statue in the world, superior in quality to the *Marcus Aurelius* on the Capitol in Rome.[13]

Yet for those who could not see the original such praise was not easy to evaluate, 'for it is forbidden to make drawings even of those things which are exhibited to the public'.[14] The first illustrations of the younger Balbus began to circulate in 1748. A certain 'learned and excellent' painter made 'an exact sketch' from memory—though it was said that even Raphael would not have been capable of catching the full beauty of the statue[15]—and this was sent to Florence to be engraved,[16] only to be followed by an amended version, by warnings about the distortions caused by the artist's viewpoint and by revisions to the inscription found on the pedestal which had been copied out incorrectly.[17] Other free-lance versions were published at much the same time by James Russel,[18] and later, by Cochin and Bellicard.[19] It is not surprising that these differed so extensively from each other that few convincing conclusions could be drawn from them.

In 1756 the sculptor Laurent Guiard managed to smuggle out two sketches which he too had made in secret, and he used these in order to construct a model of the horse which was cast in bronze and much admired by French diplomats and antiquarians in Rome.[20] Twenty-six years later it was Guiard's models, and not the originals, which were used by the engraver for his plate of the elder and younger *Balbus* in the Abbé de Saint-Non's magnificently illustrated *Voyage pittoresque ou description des royaumes de Naples et de Sicile*[21]. In 1787 Lalande was still forlornly hoping that moulds could be taken 'in order to provide models for those who are chosen to make equestrian statues to the glory of our kings in the towns of France'.[22] Some time later the situation must have improved, though it is difficult to believe that Mrs. Jameson was not somewhat exaggerating when on her arrival in Naples in 1821–2 she claimed to find the statues

of *Balbus* among those works 'familiar to my imagination, from the numerous copies and models I have seen'.[23]

The debate as to the relative merits of the *Balbus* and the *Marcus Aurelius* aroused strong passions: two French sculptors, Guiard (very discretely)[24] and Falconet (very flamboyantly)[25] claimed to prefer the former; while the Abbé Richard said that only the novelty of the discovery could account for so eccentric an opinion.[26] Winckelmann had no very decided views on the matter and confined himself to contrasting the different ways in which ancient (and modern) sculptors had represented the movement of horses,[27] and these matters, as well as others concerning the distribution of weight and the question of dressage, were much discussed by later connoisseurs:[28] so too was the light that the figures (and their inscriptions) were able to throw on Roman costume and habits.[29] Indeed Visconti, who expressed passing admiration for the statues, was interested essentially in the sociological issues raised by such honours being paid to provincial officials[30]—Dupaty found the practice a characteristic example of the prostitution of the art of the time.[31] General appreciation of these sculptures is, however, reflected by Mrs. Starke's popular guidebook in which, between the end of the eighteenth century and 1820, she increased the number of approving exclamation marks she awarded the elder *Balbus* from none to three, and to his son from three to four—a distinction granted otherwise only to the *Aristides*, the *Flora* and the *Hercules*.[32]

It has never been disputed that, as recorded by the inscriptions, these statues were erected to members of the Balbus family but it has been proposed that the much restored 'elder' *Balbus* is in fact also a portrait of his son.[33] This family enjoyed great power in Herculaneum in the period just before the town was buried by lava during the volcanic eruption of A.D. 79.

1. Gori, 1748 ('Admiranda'), p. 159: 'Equestris vero Statua filii eiusdem M. Nonii Balbi eruta est circa finem MDCCXLVI e ruinis herculanensibus . . .'
2. This is stated on the print published in the same book: 'Statua Equestre trovata l'anno 1739 negli Scavi fatti presso la Real Villa di Portici'. The statement is repeated in the catalogue of the Museo Borbonico, II, 1825, plate XXXVIII, and thereafter in nearly all subsequent literature. However, Gori's statement, cited in Note 1, is unambiguous and is supported by all the available evidence. The statue is never mentioned before 1746 and is then always referred to as a new discovery (see the documents published by Gori, *ibid.*). Moreover, it is not recorded in Venuti's very thorough 'Diario delle scoperte nell'Estate del 1739', which despite its title covers the

period up till the summer of 1740 (Venuti, M., 1748, p. 136). However, it must be acknowledged that it is surprising not to find so blatant an error on the print pointed out by contemporaries, and it is just possible that the statue was seen in 1739 and only excavated in 1746.

3. Gori, 1748 ('Admiranda') includes many references, especially on pp. 61, 86; Venuti, M., 1748, p. 94.

4. Gori, 1752, II, p. 96 (for a reference to the second statue dated 15 July 1747); and Venuti, M., 1748, pp. 137–8 (for reference to both statues). This must have been published later than Gori's 'Admiranda' of the same year.

5. Winckelmann, 1764 (*Lettre*), p. 26.

6. *Real Museo Borbonico*, II, 1825, plate XXXVIII.

7. Vasi, 1813, p. 108.

8. Gori, 1752, II, p. 143; [de Guasco], pp. xxii–xxiii.

9. [De Guasco], p. 446.

10. Burney, p. 187.

11. Dupaty, III, p. 47.

12. *Real Museo Borbonico*, II, 1825, plate XXXIX.

13. Gori, 1748 ('Admiranda'), pp. 61, 85–6.

14. *Ibid.*, p. 59.

15. [Gori], 1748 (*Notizie*), pp. 67–9.

16. *Ibid.*, p. 77.

17. *Ibid.*, pp. 67–8, 77, 80; Gori, 1752, II, p. 98.

18. [Russel], II, facing p. 290; and see Gori, 1752, I, p. xi, note.

19. Cochin and Bellicard, plates 24–5.

20. Montaiglon (*Correspondance*), XI, pp. 127, 166, 168.

21. Saint-Non, II, p. 36.

22. Lalande, VI, p. 75.

23. [Jameson], p. 269.

24. Barthélemy, p. 82.

25. Falconet, I, p. 189.

26. Richard, IV, p. 463.

27. Winckelmann (ed. Fea), I, p. 390.

28. *Real Museo Borbonico*, II, 1825, plates XXXVIII, XXXIX.

29. Gori, 1748 ('Admiranda'), pp. 85–6.

30. Visconti (*Iconografia Romana*), II, pp. 436ff.

31. Dupaty, III, p. 47.

32. Starke, 1800, II, pp. 122–3; Starke, 1820, p. 412.

33. Maiuri, 1950, p. 277.

13. The Wild Boar (Fig. 83)

FLORENCE, UFFIZI

Marble
Height: 0.95 m; Length: 1.51 m
Also known as: Calydonian Boar, Il Porcellino

The *Boar* was recorded as in the courtyard of the house of Paolo Ponti by Aldrovandi in his account of the ancient statues of Rome published with Fauno's guide of 1556,[1] but not in the account published with Mauro's guide of the same year (to later editions of which, however, it was added).[2] By 1568 it was in Florence, in the Pitti Palace,[3] and by 1591 in the Uffizi.[4] It was severely damaged by the fire in the Uffizi in 1762 but was quickly restored.[5]

Early accounts differ as to how the *Boar* came from Rome to Florence, and also as to how and where and when exactly it came to light in Rome, but agree that Ponti found it and agree in thinking of it as the Calydonian Boar killed by Meleager,[6] an idea repeated by Gori in the eighteenth century.[7] According to Ligorio it was excavated together with other figures which formed a hunting scene,[8] and when the *Boar* was displayed in the Uffizi in the late sixteenth century two dogs were placed near it[9] and it was confronted by the statue of a man who appeared to be attacking it.[10] This 'peasant' or 'soldier'—one of the Medici statues destroyed in the fire of 1762[11]—was also identified as Meleager and had it seems been copied by Antico in the early sixteenth century.[12] The idea of grouping the *Boar* with Meleager is also found in the version which Nicolas Coustou made for Marly[13] (and which is still to be seen there), but most copies show the *Boar* alone, or accompanying another animal (at Chatsworth in Derbyshire the companion is a similarly seated Wolf), and eighteenth-century cataloguers and travellers described the *Boar* separately[14] and tended to interpret it not as at bay with a hunter facing it but just alerted from indolence to the coming danger, 'as if in his den, angry, roused, half rising, and showing his formidable tusks'. Thus it was described by the exacting anatomist John Bell, who continued: 'His hair is stubby and clotted, his paws broad, coarse, and heavy, the whole finely expressing the growling ire kindling in an irritated animal.'[15]

The *Wild Boar* was considered in Aldrovandi's day as one of the most notable statues in Rome—Ponti was said to have refused an offer of five hundred gold scudi for it[16]—and the praise of travellers for its naturalism was consistent throughout the seventeenth and eighteenth centuries. As well as being elaborated by Coustou, it was copied by Foggini for Louis XIV.[17] This copy (now in the Tuileries Gardens) may be the one that Lalande described as tired when compared with the original,[18] but copies were, according to Northall's editor in 1766, 'in most collections of famous pieces of Sculpture'.[19] Some of these were full-scale (as in the private eighteenth-century garden at Grimston Park in Yorkshire or in the nineteenth-century public arboretum at Derby), others were small—in bronze,[20] in ceramic[21] and in plaster.[22] A statuette, doubtless in the latter material, can be seen in the studio of Subleyras (in a painting of the 'Studio of the Artist' in the Akademie der Bildenden Künste in Vienna).

The *Boar* was far less attractive after the fire of 1762 (significantly it was not to be selected for removal to Palermo when the plunder of the French was feared) and it was probably by then

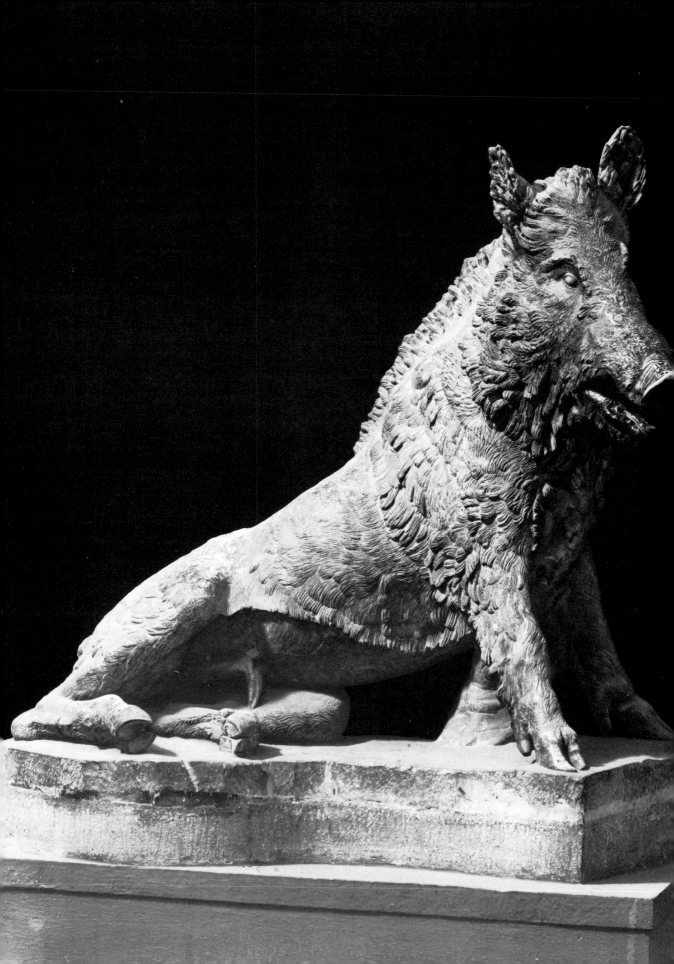

already less familiar (as today it is far less familiar) to most visitors to Florence than the copy of it by Pietro Tacca which adorns a fountain in the Mercato Nuovo. This bronze version was the subject of a short story by Hans Christian Andersen ostensibly inspired by a painting of a beautiful urchin lit by the lamp of a shrine of the Madonna as he slept by the animal's side.[23]

Tacca's copy was commissioned by the Grand Duke Cosimo II (who died in 1621, but it was in fact only made shortly before 1634).[24] Its striking verisimilitude was said by Tacca's biographer Baldinucci to have been due partly to his checking a recently killed boar against the marble; and the sculptor's ingenuity in making a secret cast of the mouth was much admired.[25] The copy was set on a base covered with plants and animals, the worn-out original of which is preserved in the Lapidario of the Museo di S. Marco, having been replaced by the present base in 1857. The nose of this bronze boar is, like the *Spinario*'s foot, shiny with incessant handling, showing that few can resist the temptation (mentioned by Smollett of the original in the eighteenth century)[26] to stroke the bristles.

The *Wild Boar* has been catalogued by Mansuelli as a copy of a Lysippic bronze.[27]

1. Mansuelli, I, p. 78; for Ponti, see Lanciani, 1902–12, III, p. 160.
2. Aldrovandi, 1558, pp. 193–4.
3. 'Un porco cigniale in atto di Sospetto' in the unpaginated list of 'Anticaglie, che sono nella Sala del Palazzo de' Pitti' among table of contents in Vol. III of the 1568 edition of Vasari's *Vite*.
4. Bocchi, pp. 49–50.
5. Mansuelli, I, pp. 78–80.
6. Aldrovandi, 1558, pp. 193–4; Ligorio in Lanciani, 1902–12, III, p. 160.
7. Gori, 1734, plate LXIX.
8. Lanciani, 1902–12, III, p. 160.
9. Mansuelli, I, p. 77 (nos. 48–9).
10. Bocchi, pp. 49–50; Bocchi (ed. Cinelli), p. 105; Misson, 1691, II, p. 149.
11. Mansuelli, I, p. 264.
12. Montagu, p. 30.
13. Souchal, 1977, I, p. 166.
14. Bianchi, pp. 105–6; Caylus, 1914, p. 314.
15. Bell, J., pp. 266–7.
16. Aldrovandi, 1558, p. 194.
17. Alazard, pp. 133, 141, 145.
18. Lalande, II, p. 191.
19. Northall, p. 48.
20. *Giambologna* (London), no. 187; Righetti (see Appendix).
21. Barrett and Thorpe, plate 19.
22. Harris, C., p. 8.
23. Hans Andersen, 'The Bronze Hog' in *A Poet's Bazaar*, translated by Charles Beckwith, I, London 1846.
24. Torriti, pp. 39, 62–4, note 37.
25. Bocchi (ed. Cinelli), pp. 216–17; Baldinucci, IV, p. 87.
26. Smollett, p. 235 (letter XXVIII).
27. Mansuelli, I, pp. 78–80.

83. (left) *Wild Boar* (Uffizi).

84. *Lucius Junius Brutus* (Palazzo dei Conservatori).

14. Head of Lucius Junius Brutus (Fig. 84)

ROME, MUSEI CAPITOLINI (PALAZZO DEI CONSERVATORI)

Bronze
Height (head): 0.32 m; (with bust): 0.69 m

The head is first definitely recorded in 1556 by Aldrovandi (in an account of the ancient statues of Rome based on notes made six years earlier) when it was in the collection of Cardinal Rodolfo Pio da Carpi,[1] but we can be almost certain that this is the head drawn by Heemskerck who was in Rome between 1532 and 1536.[2] It was bequeathed by the Cardinal to the City of Rome in 1564.[3] From the end of the sixteenth century it is known to have been kept on the Capitol and from 1627 onwards it was in the Sala della Lupa in the Palazzo dei Conservatori. In 1797 it was ceded to the French under the terms of the Treaty of Tolentino,[4] and it reached Paris in the triumphal procession of July 1798,[5] where it remained until October 1815.[6] It arrived back in Rome in the first half of 1816 and was returned to the Palazzo dei Conservatori.[7]

The fame of this striking head certainly depended to a notable extent on the belief that it portrayed the legendary founder of the Roman Republic. The first printed reference to it appears to take this for granted,[8] but supporting evidence was later published, based on the resemblance of the features to those found on an inscribed silver coin (in the collection of Fulvio Orsini) minted many centuries later by Marcus Junius Brutus.[9] Ancient historians recorded that in remote antiquity a bronze statue of Brutus, holding a dagger, had been placed on the Capitol.[10] Knowledge of this may well have prompted Cardinal Pio da Carpi's bequest—indeed, by the beginning of the seventeenth century it was being suggested that the head, then on the Capitol, was a fragment of this very statue.[11]

As a work of art the *Brutus* was generally admired—Coyer, for instance, thought that it had 'great character: melancholy, deep thought, firmness of soul, severity'[12]—though the enamelled eyes aroused some conflicting opinions. Thus the Richardsons found that this sort of 'caprice' produced a most disagreeable effect,[13] whereas the Abbé Richard thought that so singular an idea gave the head an expression of the greatest austerity.[14]

No one symbolised the virtues of ancient Rome more vividly than Lucius Junius Brutus, and it was doubtless this that spurred Piranesi to depict the bust as part of the initial letter of his *Della magnificenza ed architettura de' Romani* of 1761—a defiant challenge to his enemies who overestimated the Greek contribution to architecture.[15] Naturally enough the fame of the bust grew, and somewhat changed in character, with the coming of the French Revolution. In November 1790 the painter David lent what was almost certainly a copy of it which he had brought back from Rome to be displayed during a stormy production in Paris of Voltaire's *Brutus*;[16] and—along with a marble head of Marcus Brutus the tyrannicide (whose killing of Caesar had, so it was claimed by Plutarch, been inspired by the statue of Lucius Junius Brutus on the Capitol)[17]—this was the only work of art to be specifically named among the hundred that the Pope agreed to hand over to the French Republic under the terms of the armistice signed in Bologna on 23 June 1796 and ratified by the Treaty of Tolentino in the following year.[18] When it arrived in Paris it was placed in a specially inscribed wagon in the procession of 9 and 10 Thermidor of the Year VI (27–8 July

1798) commemorating the downfall of the tyrant Robespierre.[19] Many busts, paintings and book illustrations were directly based on it. In 1800 it was apparently placed in the Tuileries,[20] but soon afterwards it was more or less politically neutralised by being displayed—among a very miscellaneous group of Emperors, Priestesses, Muses, and Fauns—in the Salle des Romains of the Musée Central des Arts.[21]

More than two generations before any of these events Winckelmann had hinted that he had reservations about the name traditionally given to this head.[22] Within a short time of its return to Rome, Visconti too exercised scholarly caution when trying to determine whether or not it really represented the hero who had been so largely responsible for its fame. In the end he merely emphasised that, as everyone knew, the bust on which the head had been placed was clearly of a different date, and he left open the question of its identity.[23] Few travellers to Rome were, however, prepared to attend to such scruples and thereby to forego the potent fascination exerted by the 'stern inexorable severity' of Lucius Junius Brutus.[24]

Some twentieth-century scholars have acknowledged that the head may indeed be an ideal portrait of Brutus,[25] but its date and place of origin are still controversial. It is catalogued in Helbig as a central Italian work inspired by Greek portrait busts of the first half of the third century B.C.[26]

1. Aldrovandi, 1556, p. 209.
2. Hülsen and Egger (Tafeln), I, fol. 39v.
3. Stuart Jones, 1926, p. 43.
4. Montaiglon (*Correspondance*), XVI, pp. 465, 498.
5. Blumer, pp. 241–9.
6. Saunier, p. 149.
7. Either in the consignment of statues which arrived on 4 January (*Diario di Roma*, 6 January 1816) or among those which had reached Civitavecchia from Antwerp by 19 June on board H.M.S. *Abundance* (*ibid.*, 19 June 1816); Stuart Jones, 1926, p. 43.
8. Aldrovandi, 1556, p. 209.
9. Gallaeus, no. 81; Faber, pp. 49–50.
10. Dio Cassius, XLIII, 45; Plutarch, *Life of Brutus*, I.
11. Faber, pp. 49–50.
12. Coyer, I, p. 265.
13. Richardson, 1728, III, i, pp. 176–7.
14. Richard, VI, p. 20.
15. Penny, 1978, p. 70.
16. Herbert, R. L., pp. 76–7.
17. Plutarch, *Life of Brutus*, IX.
18. Montaiglon (*Correspondance*), XVI, p. 419.
19. Herbert, R. L., p. 118.
20. *Ibid.*, p. 120.
21. *Notice*, An XI (1802–3), pp. 73–4.
22. Winckelmann (ed. Fea), II, p. 44.
23. Visconti (*Iconografia Romana*), I, pp. 25–32.
24. Matthews, I, p. 137.
25. Robertson, I, p. 597.
26. Helbig, 1963–72, II, pp. 268–70.

15. Farnese Bull (Fig. 85)

NAPLES, MUSEO NAZIONALE

Marble
Height: 3.70 m
Also known as: The Fable of Dirce

The group was excavated in the Baths of Caracalla in August 1545[1] and by 4 January 1546 it was in the Palazzo Farnese.[2] By 1550 or not long after it had (on the advice of Michelangelo) been partially restored and placed in the second courtyard of the palace where it was to serve as a fountain.[3] By 1588 this proposal had certainly been abandoned and the group was protected by some sort of enclosure (later described as a 'shed'),[4] though permission to inspect it could be obtained without difficulty.[5] In 1788 it was taken to Naples by sea (escorted by a battleship) and after further restoration it was erected in the Villa Reale (Chiaia) in May 1791[6] where it served as the centrepiece of a fountain.[7] By 1818[8] it was hoped to move it to the museum to preserve it from the sea air which was causing anxiety,[9] and the actual process of transportation was begun in 1824. By 1826 it was exhibited in the Museo Borbonico (later Museo Nazionale).[10]

The subject of the group, in the condition in which it was found, was far from obvious. The earliest references are to 'a bull',[11] 'a Hercules, a bull, a shepherd and three women',[12] and (in the Farnese inventory of 1568) to 'the mountain with the Bull, and four statues around it'.[13] Aldrovandi and Vasari interpreted it as a Labour of Hercules.[14] By the 1580s, however, it had certainly been restored in line with Pliny's account of a large marble group carved by Apollonius and Tauriscus of Rhodes which represented the fable of Dirce who, as punishment for her bad treatment of Antiope whom she succeeded as wife of Licus King of Thebes, was tied to a wild bull by Antiope's sons Letus and Amphion.[15] Although the group does not correspond exactly to the one briefly described by Pliny as having been brought to Rome at the time of Augustus,[16] no serious doubts were entertained in the seventeenth century that the two were identical, even though the story was sometimes garbled—one English traveller called it simply 'a mighty ox, and three statues; a dog, a shepherd and a concubine',[17] and we cannot of course be sure of what was told to visitors by 'the snaffling fellow that keeps this *Bull*, or rather, whom this *Bull* keeps'.[18]

At first the group was praised enthusiastically by even the most sophisticated connoisseurs: thus Federico Zuccaro described this 'marvellous mountain of marble' as being, with the *Laocoon*, 'the most remarkable and marvellous work of the chisel of the ancients, showing what the art of sculpture can achieve at its most excellent'.[19] This opinion continued to be held by many travellers and guides,[20] but doubts about its quality were expressed with increasing frequency as the century advanced,[21] though there was never any dispute that it was one of the most famous pieces of sculpture in the world—not least because it was one of the largest. This was probably the reason for Louis XIV's determined efforts to buy it in 1665;[22] a little later, however, Chantelou and Bernini seem to have agreed, while talking with the Papal Nuncio in the Louvre, that it was 'considerable only because of its large size and the quantity of figures all carved out of one stone',[23] and on his visit to Rome in 1671 Colbert's son came to much the same conclusion.[24]

It was frequently pointed out that the various parts of the *Bull* differed in quality and interest. The Richardsons, for example, accepted the general verdict that the survival of the carved rope was 'one of the Miracles of Rome', but thought it 'very poor'; they considered the animals to be 'but Indifferent . . . but the Airs of the Heads of the Principal Persons are Exquisite';[25] Edward Wright, on the other hand, found Dirce's expression 'quite without Passion'.[26] Other criticisms were to go much further. Caylus, who did not think very highly of the *Bull* when he first saw it in 1714–15,[27] later claimed that Pliny's failure to point out the feebleness of the composition demonstrated his inadequacies as a critic.[28] By then, however, the Roman antiquarian Francesco Ficoroni had made use of some rather dubious numismatic evidence to publish the remarkable theory[29] (which he elaborated some years later)[30] that the *Farnese Bull* could not be the work described by Pliny as the number of figures did not correspond to those mentioned in that writer's account of the statue; the original by Apollonius and Tauriscus was, however, shown on a coin which he reproduced. Ficoroni argued that the Farnese group must have been carved by Roman sculptors and he pointed out that such elaborated versions were not unusual. This theory is in fact favoured by leading contemporary historians of ancient art,[31] but it passed largely unnoticed at the time, except for a derisive dismissal by Winckelmann who thought the work to be

85. *Farnese Bull* (Museo Nazionale, Naples).

Greek, although dating from after the death of Alexander the Great.[32]

Winckelmann did, however, emphasise how very extensive had been the restoration, ignorance of which, he suggested, had been responsible for so many absurd ideas about the work. There had long been anxieties on this score[33]—anxieties which had clearly prompted Maffei's claim[34] (also jeered at by Winckelmann) that only repairs of existing fragments had proved necessary and that nothing new had been added; and controversy continued about the degree of restoration, the authenticity and the quality of the *Bull*. With only a few exceptions—as late as 1802 a traveller called it 'the very finest group of ancient art, and superior even to the Laocoon'[35]—opinion hardened against it, despite the most vigorous efforts of Neapolitan museum officials to sustain its declining reputation,[36] and this decline continued throughout the nineteenth century.

For obvious reasons the *Farnese Bull* was not copied full size, but it was frequently reproduced on a small scale and such reproductions were much in demand in Rome itself. The most famous was a greatly admired bronze of 1613 by Antonio Susini which was in the Villa Borghese by 1625 (and is still there today—Fig. 31),[37] and there were other copies in the Villa Ludovisi[38] and elsewhere in the city.[39] Antonio's nephew Gianfrancesco Susini sold his bronzes of the group at a high price[40] and it was probably one of these that Thomas Gray saw in the Orleans collection in Paris in 1740.[41] Later in the century Righetti charged one hundred and eighty zecchini for his small version of the *Bull*.[42] In Naples the royal porcelain factory produced reproductions in biscuit.[43]

A late reflection of this 'mountain of marble' which had once aroused such wonder and enthusiasm was the plaster group of the 'Punishment of Dirce' by Sir Charles Lawes-Wittewronge shown at the International Fine Arts Exhibition in Rome in 1911.[44]

Robertson considers the *Bull* to be an enlarged and elaborated version, specially made for the Baths of Caracalla in the early third century A.D., of the group mentioned by Pliny, in which 'there may have been merits'.[45]

1. Angelo Massarelli's reference on 1 September 1545 (quoted in de Navenne, p. 436, note 2) to letters recording the discovery of 'three very beautiful marble statues of a Hercules, a bull and [word missing]' almost certainly refers to this group.
2. Lanciani, 1902–12, II, p. 181 (letter from Prospero Mocchi to Pier Luigi Farnese).

3. Aldrovandi, 1556, pp, 162–3 (based on notes made six years earlier); Vasari, VII, p. 224; Barbieri and Puppi, pp. 904–5.
4. Richardson, 1722, p. 146.
5. Ferrucci in Fulvio (ed. Ferrucci), fols. 190–1.
6. Correra, pp. 46–8.
7. Celano, 1792, IV, Giornata nona, p. 260; Vasi, 1816, pp. 90–1.
8. Ruesch, p. 83.
9. Croce, p. 39.
10. Correra, pp. 48–9.
11. De Navenne, p. 436, note 2—though, as mentioned in Note 1, Massarelli is almost certainly referring to this group when he mentions a Hercules as well as a bull.
12. Lanciani, 1902–12, II, p. 181 (Mocchi's letter of 1546).
13. *Documenti inediti*, I, p. 75.
14. Aldrovandi, 1556, pp. 162–3; Vasari, VII, p. 224. However, as early as 1545, Massarelli seems to have thought that one of the figures was Hercules—see Note 1.
15. Lafreri (British Museum copy), fol. 80—dated 1581; Vaccaria, plate 21; Cavalleriis (3), plate 3 (for engravings). See also de Navenne, p. 450, note 1, for Louis de Montjosieu's publication of this theory in 1585.
16. Pliny, XXXVI, 37.
17. 'True Description', p. 28.
18. Lassels, II, p. 223.
19. Zuccaro, pp. 259–60.
20. Felini, p. 331; Balfour, p. 129.
21. Burnet, p. 243: 'one seeth it hath not the exactness of the best times'.
22. Lanciani, 1902–12, II, p. 162.
23. Chantelou, p. 26.
24. Seignelay, pp. 149–50.
25. Richardson, 1722, pp. 146–8.
26. Wright, I, p. 284.
27. Caylus, 1914, p. 257.
28. Caylus, 1759, pp. 325–6.
29. Ficoroni, 1730, pp. 28–30.
30. Ficoroni, 1744 (*Singolarità*), pp. 43–4.
31. Bieber, p. 134; Robertson, I, p. 608.
32. Winckelmann (ed. Fea), II, pp. 261–4.
33. Celio (writing in 1620), p. 132 (of facsimile), said it was 'alquanto restaurata'.
34. Maffei, plate XLVIII.
35. [Engelbach], p. 140.
36. G. B. Finati in *Real Museo Borbonico*, XIV, 1852, plates V and VI.
37. *Giambologna* (London), p. 193 (nos. 180–1) with references.
38. Mortoft, p. 125.
39. At Palazzo Colonna, for instance.
40. Baldinucci, IV, p. 118.
41. Gray, T. (ed. Tovey), p. 205.
42. Righetti (see Appendix).
43. There is one in the Museo di S. Martino in Naples—*The Age of Neo-Classicism*, p. 691 (no. 1472).
44. *International Fine Arts Exhibition*, p. 461 (no. 1152).
45. Robertson, I, p. 608.

16. Camillus (Fig. 86)

ROME, MUSEI CAPITOLINI (PALAZZO DEI CONSERVATORI)

Bronze (with silver eyes)
Height: 1.41 m

Also known as: The Sacrificer, Servo, Zingara

The statue is recorded (as 'una zingra') in an upper room of the Palazzo dei Conservatori in 1499–1500[1] and had most probably formed part

of the donation of Pope Sixtus IV in 1471.[2] By the beginning of the eighteenth century it had been taken to the Capitoline Museum and it was returned to the Palazzo dei Conservatori at the end of the nineteenth.[3]

The first references to this statue describe it as a gipsy woman (zingara) and this name, inspired by the long hair and skirtlike tunic,[4] remained popular even after it had become generally accepted that the figure was a male.[5] As early as 1527 Fulvio pointed out that the statue portrayed a young serving man,[6] but it seems not to have been until the end of the seventeenth century that it was recognised as a Camillus (a sacrificial acolyte chosen from the noblest families): the conclusion was reached by comparing this bronze to similar figures that could be seen on Roman bas-reliefs and in certain episodes of Trajan's Column, many of which became more easily accessible through large-scale publication in these very years.[7] By 1704 the name of Camillus had been carved on the base of the statue, and the granting of such authority to what could only be 'conjecture' aroused the scorn of the antiquarian Maffei who, with a mixture of defiance and caution, proposed that the figure was, after all, a woman[8]—a proposal that won no further support. Despite his great interest in representations of ancient sacrifices, Montfaucon refused to commit himself when discussing whether or not the Capitoline statue portrayed a Camillus.[9]

This figure was very highly admired. Benvenuto Cellini went so far as to include it with the *Laocoon*, the *Cleopatra*, the *Apollo*, the *Commodus as Hercules* and an unidentified *Venus*—'the most beautiful things in Rome'.[10] The Richardsons called it 'exquisite . . . as perfectly fine a figure as any in Rome'.[11] Many others wrote with similar enthusiasm,[12] often linking it to the *Spinario* in the same collection.

A number of other versions and replicas of the *Camillus* were known and admired in Rome: in the sixteenth century Aldrovandi noted one belonging to Monsignor Archinto,[13] and in the eighteenth the Richardsons singled out another in the Palazzo Farnese.[14] The most spectacular, however, were unquestionably a modern pair (now in the Louvre), in the most sumptuous Borghese taste, fashioned of coloured antique marbles and alabasters to which were fitted bronze casts of the head and limbs of the Capitoline original.[15]

A cast was made for the French Academy in

Rome, and by 1684 a marble copy carved by Jean Baptiste Goy (between the ages of fourteen and eighteen) had been sent to France;[16] this was later placed in the grounds of Marly and is now lost.[17] Plaster casts appear quite frequently in eighteenth-century sets—at Holkham Hall in Norfolk,[18] for instance, at Croome Court in Worcestershire[19] and in the Duke of Richmond's academy in his house in Whitehall.[20] Although the statue was not taken to Paris under the terms of the Treaty of Tolentino, it was still sometimes copied in the nineteenth century and in 1834 Basevi planned to include a cast of it in a niche at the top of the staircase hall in the Fitzwilliam Museum in Cambridge.[21]

The *Camillus* is catalogued in Helbig as dating from the middle of the first century A.D.[22]

1. By 'Prospettivo Milanese'—see Govi, p. 51 (stanza 63).
2. Michaelis, 1891, pp. 14–15.
3. Stuart Jones, 1926, pp. 47–8.
4. Aldrovandi, 1556, p. 274; Canedy, 1976, p. 43 (R 37).
5. Totti, p. 406.
6. Fulvio, 1527, fol. XXI recto.
7. Bartoli, 1665, plate 67; Bartoli, 1693, plate 9.
8. Maffei, plate XXIV.
9. Montfaucon, 1719, II, i, pp. 165–7; Montfaucon, 1724, II, pp. 14–15.
10. Cellini, p. 445 (*Vita*).
11. Richardson, 1722, pp. 115–16, 150.
12. Wright, I, p. 325; Lalande, IV, p. 172.
13. Aldrovandi, 1556, pp. 192–3.
14. Richardson, 1722, p. 150.
15. Visconti (*Monumenti Borghesiani*), plate VII.
16. Montaiglon (*Correspondance*), I, p. 129.
17. Perhaps Piganiol de La Force, II, p. 252.
18. Brettingham MS., p. 145; Brettingham, 1773, p. 15.
19. *The Man at Hyde Park Corner*, no. 78 (wrongly identified).
20. Edwards, 1808, p. xviii.
21. *The Triumph of the Classical*, plate 24.
22. Helbig, 1963–72, II, pp. 270–2.

17. Farnese Captives (Figs. 87–8)

NAPLES, MUSEO NAZIONALE

Marble
Height: 2.38 m; 2.34 m
Also known as: King of Armenia, Dacian Kings, Parthian Kings, Dacian Slaves, Parthian Slaves, Roys Esclaves, Tigranes King of Armenia, Tiridates

These statues are recorded in 1544 by Guillaume Philandrier (who went to Rome in 1539–40 in the suite of Georges, later Cardinal, d'Armagnac)[1] as belonging to the Colonna who had a palace in Piazza SS. Apostoli.[2] In a publication of 1556 (based on notes made in Rome six years earlier) Aldrovandi wrote that they had been taken from SS. Apostoli to the

86. *Camillus* (Palazzo dei Conservatori).

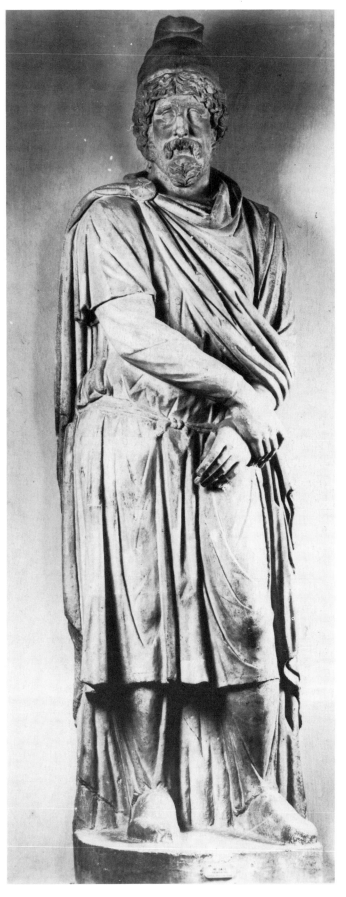

Palazzo Farnese,[3] in which by 1594 they stood on the piano nobile at the top of the stairs flanking the entrance to the great hall.[4] They were transferred to Naples in 1790, having been three years in the studio of the restorer Carlo Albacini in Rome,[5] and by the end of 1796 they were at the palace of Capodimonte.[6] By 1819 they were in the Museo Borbonico (later Museo Nazionale).[7]

There were a number of well-known statues of captive barbarians in Rome, however, the *Captives* catalogued here, which had been famous ever since entering the Farnese collection, had by the end of the seventeenth century outstripped all their rivals, and these were the ones that were copied for Versailles by Lespagnandelle and André.[8] One of the *Captives* was sometimes called the King of Armenia and the other the King of Parthia,[9] but Maffei argued that both were Dacians[10] because (so Vacca had suggested on plausible but vague evidence)[11] they had been found in Trajan's Forum. Montfaucon and most later scholars have accepted this theory.[12] Maffei also (like Philandrier a hundred and fifty years earlier)[13] noted that it was to such statues of 'barbarians' that Vitruvius was referring in his discussion of the 'Persian portico' in which they were used to support the entablature.[14] Some sixteenth-century editions of Vitruvius illustrated these (or similar) *Captives* on the relevant page,[15] and Fréart introduced one of them in the same role in his *Parallèle de l'architecture antique et de la moderne* of 1650.[16]

Appropriately therefore marble variants of the statues are used to support the massive overmantel of a mid-eighteenth-century chimneypiece formerly at Northumberland House in London.[17] On a smaller scale François-Nicolas Delaistre made reduced terracotta copies (now in the Besançon Museum) which were acquired by the architect and collector Adrien Pâris[18] who had himself made a fine drawing of the *Captives* in situ in the Palazzo Farnese.[19] There were also terracotta copies by Pacetti in the Blundell collection at Ince,[20] and bronze statuettes of them were offered by Righetti in late eighteenth-century Rome.[21]

The statues are described in a current guide of the Museo Nazionale in Naples as Dacian prisoners from Trajan's Forum.[22]

87–8. *Farnese Captives* (Museo Nazionale, Naples).

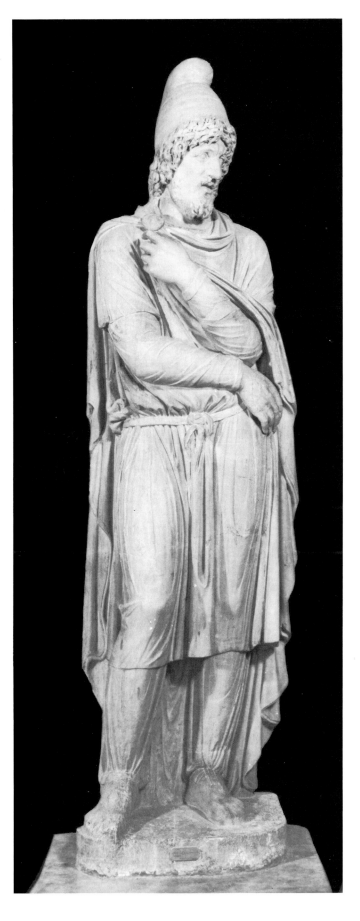

Other captives were also very well known.

1. The most prominent were the eight colossal free-standing figures crowning the columns attached to each side of the Arch of Constantine. In 1530 Lorenzo di Pierfrancesco de' Medici ('Lorenzaccio') was forced to leave Rome after having removed their heads—undeterred by a ringing denunciation of this behaviour by the humanist Francesco Maria Molza[23] he was later to decapitate most of the figures of the Last Judgment on Nicola Pisano's pulpit in the Baptistery of Pisa[24]—and the statues remained in this mutilated state until 1732 when Pietro Bracci made substitute heads, as well as assorted arms and hands and one entire new figure.[25]

2. Another four figures of this type (three of porphyry and one of marble) were in the Villa Medici by the end of the sixteenth century;[26] two of these had been in the della Valle collection[27] where they had been very highly valued,[28] and one was reproduced by Perrier as 'Captivus' among the most celebrated statues in Rome.[29] They were taken to Florence in 1788[30] and are today in the Boboli Gardens with their added white marble extremities much damaged.[31]

3. Even better known were the Captives of dark grey marble—also colossal in size, and with cut-off hands—which stand in the courtyard of the Palazzo dei Conservatori. They appear, when still in the Cesi collection, in the dedicatory plate of de Rossi's anthology of the most famous statues (Fig. 13), and Pope Clement XI (the recipient of that dedication) acquired them for the Capitoline collection in 1720.[32] As they had done in the Cesi Gardens,[33] so too on the Capitol they flank a statue of Roma seated above a relief of *Dacia*, and like the *Farnese Captives* discussed above) these were certainly copied.[34] In addition Piranesi reproduced both these and the *Farnese Captives* in two frontispieces to his series of illustrations of Trajan's Column.[35] In common with at least one seventeenth-century writer[36] and also, surely, with the original designer of the ensemble in the Cesi Gardens, he considered that the arrangement of these Captives, the weeping *Dacia* and the triumphant Roma was a celebration of imperial conquest.

1. Vitruvius (ed. Poleni), I, i, pp. 41–4; and for d'Armagnac see *Dictionnaire de biographie française*, III, pp. 677–9.
2. Philander, p. 5.
3. Aldrovandi, 1556, p. 152.
4. Vacca, Mem. 44; *Documenti inediti*, I, p. 74.
5. De Franciscis, 1946, p. 98.
6. *Documenti inediti*, I, pp. 180–1.
7. Finati, I, i, p. 8.
8. Souchal, 1977, I, p. 2.
9. Cavalleriis (2), plates 30–1; Vaccaria, plates 23–4; Episcopius, plate 75.
10. Maffei, plate LVI.
11. Vacca, Mem. 44.
12. Montfaucon, 1719, III, i, p. 82.
13. Philander, p. 5.
14. Vitruvius, I, i.
15. Vitruvius (trs. Martin), 1547, fol. 3v; Vitruvius (ed. Barbaro), 1567, p. 10.
16. Fréart, 1650, pp. 54–5.
17. Victoria and Albert Museum—A 60 and A 60A.
18. Lami, 1910–11, I, p. 261; *Besançon*, p. 92 (no. 206—Inv. D.863.3.2—1 and 2).
19. Estignard, plate 45.
20. [Blundell], 1803, pp. 32–3.
21. Righetti (see Appendix).
22. De Franciscis, 1963 (*Guida*), p. 34.
23. Varchi, III, p. 184; *Lorenzino de' Medici*, pp. 135–49.
24. Seidel.
25. Gradara, pp. 98–9.
26. Boyer, 1929, pp. 264–5 (nos. 184–5, 201–2).
27. Aldrovandi, 1556, p. 220; Vasari, I, p. 109; Michaelis, 1891–2, ii, p. 229.
28. Michaelis, 1891–2, ii, p. 228.
29. Perrier, 1638, plate 16.
30. *Documenti inediti*, IV, p. 81.
31. Gurrieri and Chatfield, plates 31–2.
32. Stuart Jones, 1926, pp. 15–17.
33. Aldrovandi, 1556, p. 128.
34. Brettingham MS., p. 88.
35. Piranesi (*Trofeo*).
36. Borboni, p. 121.

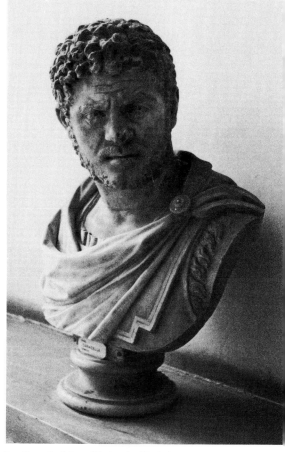

89. *Caracalla* (Museo Nazionale, Naples).

18. Caracalla (Fig. 89)

NAPLES, MUSEO NAZIONALE

Marble
Height: 0.60 m
Also known as: Frowning Caracalla

'Una Testa di Caragallo sul suo sgabello' is recorded in the inventory of Cardinal Alessandro Farnese's antiquities in 1568.[1] The bust remained in the Palazzo Farnese in Rome until it was removed in 1786 to the studio of the Roman restorer, Carlo Albacini, who sent it on to Naples in the following year.[2] It was recorded at Capodimonte in 1796[3] but by 1805 it was in the Museo degli Studi (later Museo Borbonico, now Museo Nazionale).[4]

Numerous versions of this type of bust were known by the early eighteenth century[5]—four were recorded in the Albani collection for instance when it was acquired for the Capitoline Museum[6]—and still more had come to light by 1800, but the highest claim ever made for any of these versions during the seventeenth or eighteenth century was that it was the equal of the superb example in the Farnese collection.[7] It is not known where the Farnese *Caracalla* came from—perhaps from one of the two great collections of Imperial heads whose discovery was recorded by Vacca writing in 1594 or earlier,[8] perhaps from another collection; for Aldrovandi, in 1556, recorded examples in five Roman palaces,[9] and one version, probably the Farnese one, was sufficiently well known for a cast (which survives in the Museo del Liviano, Padua) to be taken of it for Marco Benavides, and copies appear to have been made from this later in the century.[10]

The Farnese possessed another antique bust of the same emperor of the same type, and what was believed in 1805 to be a fifteenth or sixteenth-century bronze copy.[11] A reduced bronze copy was in the collection of Girardon at the end of the seventeenth century[12] and in the eighteenth century marble copies of the bust

172

were highly popular (examples by Laurent Delvaux,[13] Francin[14] and Harwood[15] may be cited, but many are unsigned), as were plaster casts.[16]

The impact of the turned head and ferocious gaze of this bust was given great historical resonance by the fact that it represented an emperor whose murder of his own brother and whose ruthless rule were familiar to every educated European. As one looked at the bust, or rather was looked at by it (de Brosses claimed that it quite frightened him),[17] the past suddenly and dramatically became present. The bust was believed to be the last, or one of the last, great works of art of antiquity—'the last effort of Roman Sculpture',[18] 'le dernier soupir de la Sculpture Romaine'[19]—and it was considered puzzling that such a work should have been created after the coinage of Pertinax and Septimius Severus, and the relief sculpture on the Arch of Septimius Severus, both of which were agreed to represent a drastic decline in quality:[20] this suggested to some scholars that portraiture was the last branch of the sculptor's art to decline.[21] Writing of the Farnese bust, Winckelmann conceded that Lysippus could not have produced a better portrait.[22] This was high praise indeed from such a Hellenist—and quoted a hundred years later in guidebooks[23]—but he proceeded to argue that the sculptor of the *Caracalla* could not have approached the ideal creations of Lysippus.

Busts of this type are acknowledged as portraits of Caracalla (joint emperor A.D. 211–12 and emperor A.D. 212–17). During the last century, scholars, pointing to the ancient accounts of the Emperor's ambitions and iconography, have suggested that the busts are intended to display the sublime distraction of a self-styled successor to Alexander the Great.[24] It is no longer supposed that the Emperor intended to exhibit his bestial nature 'to the dismay and horror of his subjects'.[25] The Farnese version is still the best-known and probably the most admired example.[26]

1. *Documenti inediti*, I, p. 73.
2. De Franciscis, 1946, p. 99.
3. *Documenti inediti*, I, pp. 177–8.
4. *Ibid.*, IV, p. 186.
5. Richardson, 1722, p. 282 (Chigi collection); *Documenti inediti*, IV, p. 332 (Odescalchi collection).
6. Stuart Jones, 1912, pp. 105, 204, 300.
7. Visconti (*Pio-Clementino*), VI, plate LV.
8. Vacca, Mems. 14, 96.
9. Aldrovandi, 1556, pp. 137, 144, 196, 204, 267; see also Franzoni, pp. 29, 92–3, for a version in the Cesarini collection, formerly belonging to Cardinal Bembo.
10. Candida, pp. 35–9.

11. *Documenti inediti*, I, pp. 178–9.
12. Souchal, 1973, no. 187.
13. Gunnis, p. 126.
14. Montaiglon (*Correspondance*), VIII, p. 407; Lami, 1910–11, I, p. 356.
15. Fleming and Honour, I, p. 511; II, plate CCXXIII.
16. Richardson, 1722, p. 150; Brettingham MS, pp. 2, 4, 54; Dawson, p. 72.
17. De Brosses, II, p. 106.
18. Kennedy, p. xxviii; see also Richardson, 1722, p. 285.
19. Du Bos, II, p. 182.
20. Vico, 1555, p. 53.
21. Falconet, I, p. 190, note.
22. Winckelmann (ed. Fea), II, p. 131.
23. De Lauzières and d'Ambra, I, p. 619; Pistolesi, 1842, I, p. 107.
24. Ruesch, p. 236; Smith, A.H., 1892–1904, III, p. 166. The ancients cited are Herodian, IV, 8; Aurelius Victor, *Epitome*, XXI.
25. Merivale, p. 548.
26. Bernouilli, II, iii, pp. 47–65.

19. Castor and Pollux (Fig. 90)

MADRID, PRADO

Marble
Height (without plinth): 1.58 m
Also known as: The Decii, Odescalchi Dioscuri, Two Genii, The San Ildefonso group, Two Lares, Orestes and Pylades, La Paix des Grecs

The group was recorded in the Ludovisi collection in an inventory of 1623.[1] Ten years later it was recorded, placed on pedestals of breccia marble, framing a relief of a battle, in the Palazzo Grande in the family estates on the Pincio.[2] It is probable that it was discovered during building operations on these estates in 1621 or 1622, for this area, the site of the Gardens of Sallust, proved to be particularly rich in antiquities when developed at the end of the nineteenth century. The group was acquired from the Ludovisi by Cardinal Massimi and, after his death, it was bought in 1678 by Queen Christina of Sweden and is recorded in the inventory of her collection probably drawn up before her death in 1689, above the same battle relief but this time on a pedestal of gilt wood.[3] It was bequeathed with the rest of her collection to Cardinal Azzolini who died a few weeks after she did and whose heir, Marchese Pompeo Azzolini, sold most of its contents in 1692 to Don Livio Odescalchi, nephew of Pope Innocent XI and (from 1693) Duke of Bracciano. Don Livio died in 1713 and his cousin and heir, Baldassare d'Erba (who assumed the name Odescalchi), sold the *Castor and Pollux* with the other antiquities to Philip V of Spain on 4 September 1724.[4] The group was kept in the country palace of San Ildefonso until 1839 when it was taken to the Prado.[5]

The group must have been celebrated by 1638 when Perrier published it in his anthology of the most admired statues in Rome.[6] He entitled it 'Decii sese pro patria devoventes', an interpretation, given in the 1713 inventory of the Odescalchi collection[7] and also by Caylus a little later,[8] which derived from two episodes vividly described by Livy in which the Roman Consuls Publius Decius and his son of the same name took solemn oaths and then sacrificed themselves by charging headlong into the enemy lines, thus inspiring the flagging Roman army to victory in battles against the Latins (in 340 B.C.) and against the Samnites and Gauls (of 295 B.C.).[9] But the idea that the two figures represented the Dioscuri—Castor and Pollux—mentioned in the 1633 inventory[10] was certainly well established by the late seventeenth century. Audran, however, gave to a print of one of the two figures the caption 'La Paix des Grecs',[11] a name also given to the *Papirius* group—another sculpture in the Ludovisi collection; Maffei recorded with respect the theory of the 'eruditissimo Abate' Filippo del Torre (later Bishop of Adria) that two genii were portrayed sacrificing to Isis, although he preferred the idea that Vesper (the evening star) and Lucifer (the morning star) were intended[12]—the torches were considered appropriate for such personifications—but Montfaucon, thinking of the sacred fires kept burning in Roman homes, proposed that the subject was perhaps a pair of Lares or Penates (household gods associated with ancestors and the hearth). He also ridiculed the title of 'Castor and Pollux'[13]—which nevertheless remained popular.

It is ironic that the group should have left Rome, for Carlo Maratta had energetically encouraged the Queen of Sweden to acquire it in order to keep it in the city.[14] To the Richardsons, shortly before it went, there seemed no finer statue in Rome.[15] A copy of the group had been made by Coysevox for Louis XIV and this is now placed in the hemicycle at the entrance to the Tapis Vert at Versailles companion with the *Papirius* group,[16] and a cast, probably made in connection with this copy, remained in the French Academy in Rome after the group's departure to Spain. This enabled other casts to be taken (including perhaps the example in the Antikensaal at Mannheim which the Elector Karl Theodor opened in 1767),[17] and more copies to be made (including one in marble by Nollekens for Lord Anson of Shugborough also of 1767,[18] one in biscuit de Sèvres of 1770,[19] and

one in bronze by the Roman founder Righetti).[20] It was also this cast rather than the original which was known by Winckelmann who, late in his life, published the idea that the sculpture showed Orestes and Pylades at the tomb of Agamemnon—an illustration to the *Electra* of Sophocles.[21] He had supplied a similar interpretation to the *Papirius* group and there was perhaps still a tendency to think of these groups together. The *Castor and Pollux* was during the early nineteenth century particularly popular in Germany. A cast features very prominently in Martens's view of the Charlottenburg cast gallery of 1824;[22] a bronzed cast may still be seen in Goethe's house,[23] and there are bronze copies at Weimar[24] and Potsdam.[25] The sculptor Friedrich Tieck suggested that the group represented Antinous with the Genius of Hadrian. This idea was elaborated by leading German scholars in a variety of ways later summarised by John Addington Symonds,[26] and was still current in 1935 when a biographer of the Emperor asked 'Is it impossible that it was Hadrian himself who sculptured the group, and sent it, unsigned, to his native land of Spain?'[27]

Nonetheless, there is no agreement as to the subject of what is now recognised as an extensively restored group. In Blanco's catalogue it is considered as a creation of the first century B.C.[28]

1. Bruand, 1959, p. 140.
2. Schreiber, p. 30.
3. Florence, Archivio di Stato, Med. Princ. 3944 (Falconieri to Bassetti, 12 November 1678); Boyer, 1932 ('Christine de Suède'), p. 265 (no. 107).
4. *Documenti inediti*, IV, p. 334; Montaiglon (*Correspondance*), VII, p. 59; *Christina Queen of Sweden*, pp. 433–4, 438.
5. Blanco, p. 8.
6. Perrier, 1638, plate 37.
7. *Documenti inediti*, IV, p. 334.
8. Caylus, 1914, p. 279.
9. Livy, VIII, 9; X, 28.
10. Schreiber, p. 30.
11. Audran, plate 13.
12. Maffei, plate CXXI.
13. Montfaucon, 1724, I, p. 208, plate LXXVI.
14. Bellori, pp. 638–9.
15. Richardson, 1722, p. 166.
16. Souchal, 1977, I, p. 195.
17. Schiller, XX, pp. 104–5.
18. Victoria and Albert Museum, A.59—1940; Whinney, 1971, p. 114.
19. Bourgeois, p. 10 (no. 124).
20. Righetti (see Appendix).
21. Winckelmann, 1767, I, pp. xxi–xxii.
22. Thorvaldsen Museum, Copenhagen; *The Age of Neo-Classicism*, pp. 122–3, plate 44.
23. Ehrlich, p. 15.
24. Ladendorf, plate 42, no. 153.
25. *Ibid.*, no. 154.
26. Friederichs, 1868, pp. 460–2; Symonds, pp. 84–8.
27. Ish-Kishor, pp. 138–40.
28. Blanco, pp. 30–2.

90. *Castor and Pollux* (Prado).

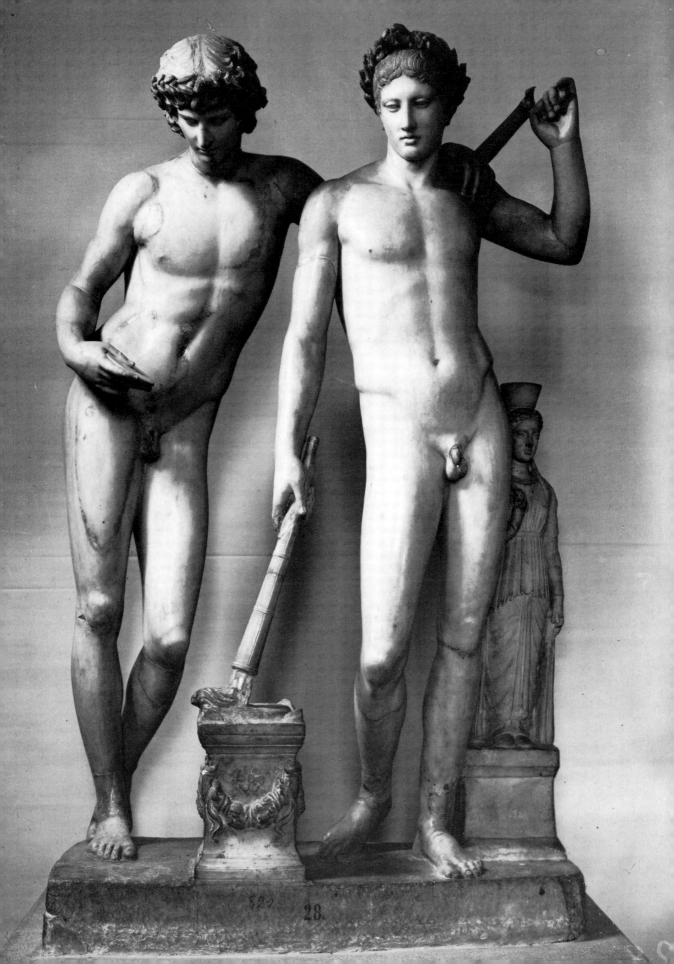

28.

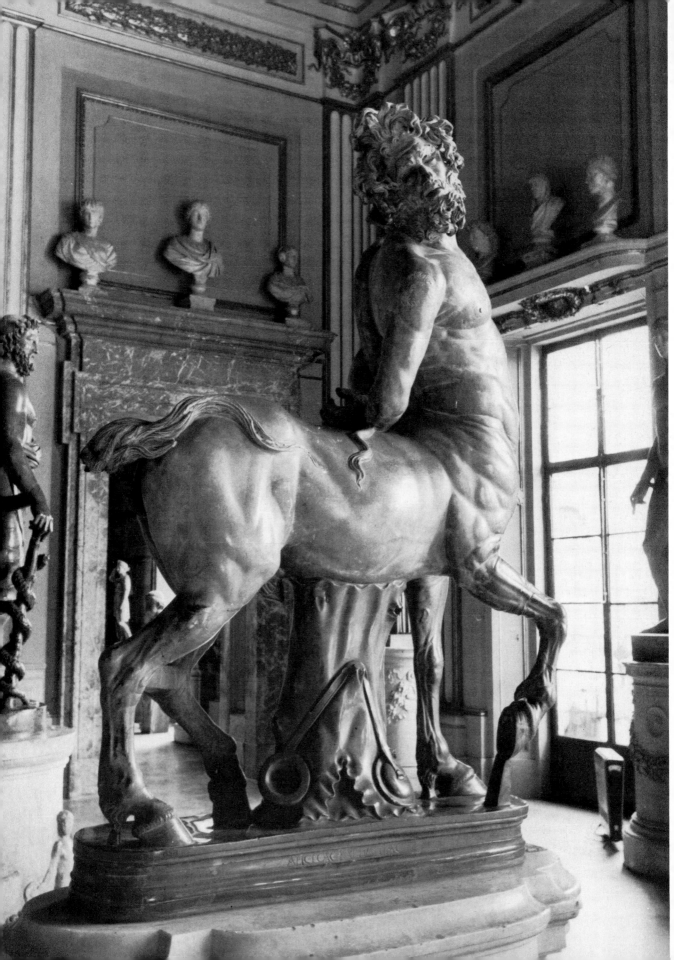

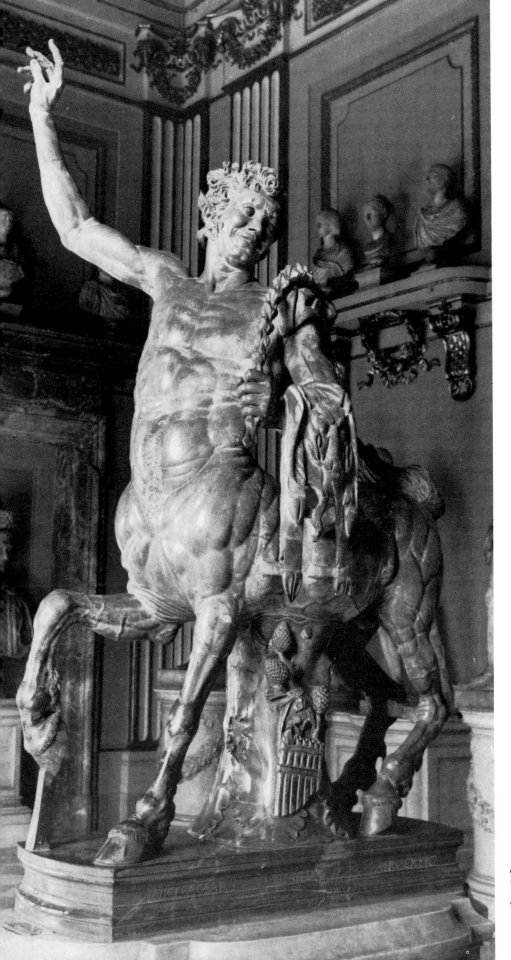

91. *Elder Furietti Centaur*
(Capitoline Museum).

92. *Younger Furietti Centaur*
(Capitoline Museum).

20. Furietti Centaurs (Figs. 91–2)

Bigio Morato

Height (young centaur): 1.56 m; (old centaur) 1.34 m

Each inscribed: ΑΡΙϹΤΕΑϹ · ΚΑΙ ΠΑΠΙΑϹ ΑΦΡΟΔΕΙϹΕΙϹ (partially disfigured in one case)

The two *Centaurs* were engraved in 1738 and 1739 in their present extensively restored condition,[1] and both there and in a book published in 1741 they are said to have been found in December 1736 in the excavations carried out by Monsignor Furietti at Hadrian's Villa,[2] where they apparently stood in the domed hall of the small palace.[3] All the early sources agree about this provenance,[4] and in 1739–40 they were seen in Furietti's rooms in the Palazzo di Montecitorio.[5] Together with a famous mosaic of pigeons, the *Centaurs* were bought not long before 19 June 1765 for thirteen thousand scudi by Pope Clement XIII from Furietti's heirs and placed in the Capitoline Museum.[6]

The celebration of the new-found *Centaurs* by means of engravings by Girolamo Frezza after drawings by Nicolo Onofri and Pompeo Batoni[7]—prints of exceptionally high quality and accuracy, anticipating those of the de luxe folios of the late eighteenth and early nineteenth centuries—was an exceptional step for a collector to take. The 'bronzetti' of 'centaurs' which (together with the *Gladiator*, the *Silenus* and the *Antinous*) were sent from Rome to Lord Charlemont in 1755[8] were probably small copies of the *Furietti Centaurs*, but it is perhaps significant that the earliest known casts to be taken from the statues seem to be those which Nollekens acquired from Cavaceppi in the year that they ceased to be private property and entered the Capitoline Museum (these still adorn the entrance hall at Shugborough in Staffordshire).[9] Cavaceppi himself offered full-scale copies in white marble for sale in 1768.[10] Bronze copies were employed to frame a bridge leading to the park at Malmaison,[11] and two pairs (originally in marble) framed each end of a bridge in the park at Pavlovsk.[12] The decorative possibilities offered to copyists by the existence of a pair clearly enhanced the appeal of the *Centaurs* not only for the garden bridge or the entrance hall, but for the chimney-piece where numerous small copies in bronze (Fig. 53)[13] and in biscuit[14] were arranged. Casts in plaster and in bronze of the heads are also recorded.[15]

The provenance of the statues was highly distinguished and the Greek inscriptions by Aristeas and Papias of Aphrodisias were indisputably genuine. Pope Benedict XIV was said to have been so irritated by Furietti's refusal to present the *Centaurs* to the Capitoline Museum that he passed him over for a cardinal's hat.[16] In 1763, by which time Furietti had his hat, Cardinal Albani was reported as offering him six thousand scudi for the statues. He was in fact negotiating on behalf of Pope Clement XIII and it was then hoped to place the statues at the entrance to the Museo Profano in the Vatican.[17] A year later the English were reported as offering vast sums to Furietti's heirs,[18] but in 1765 they were finally secured for the Capitoline Museum. Although casts of the statues were acquired for major academies (one of the younger *Centaur* survives in the Accademia at Bologna and by 1781 a pair flanked a cast of the *Medici Vase* in the staircase vestibule of the Royal Academy in London),[19] scholars tended to be less enthusiastic than collectors. Few went so far as Falconet who ridiculed them,[20] but Winckelmann made it clear that he did not esteem them highly,[21] and almost everyone who compared the elder *Furietti Centaur* with the *Centaur with Cupid* did so to the advantage of the latter.[22] Émeric David and Visconti agreed with Winckelmann that the Borghese statue was an improved copy of the *Furietti Centaur*, which seemed to be original because it was signed,[23] while others believed the *Furietti Centaur* to be a drier copy of the Borghese one.[24] The younger *Furietti Centaur* was also compared by Visconti with a white marble version excavated in 1779 and restored under his direction for the Museo Pio-Clementino by Gaspare Sibilla, with a riding cupid holding a dead hare.[25] It was generally accepted that in their original state the Furietti pair like the Borghese statue would also have been ridden by cupids but these were generally believed to symbolise the sexual desires which torment the old and delight the young and not connected with the chase.

It has recently been suggested by Robertson that the prototype of these *Centaurs* was itself Hadrianic,[26] but they are catalogued in Helbig as copies commissioned by Hadrian of earlier original bronzes from the Eastern Mediterranean.[27]

1. Macandrew, fig. 4, p. 138; also pp. 137, 143, note 19.
2. *Rome Antica*, 1741, p. 271 ('Ficoroni').
3. Winnefeld, p. 152.
4. Foggini, plates XXXII, XXXIII.
5. De Brosses, II, p. 41.
6. Winckelmann (*Briefe*), III, p. 103; Stuart Jones, 1912, p. 277.

7. Macandrew, fig. 4, p. 138, also pp. 137, 143, note 19.
8. Charlemont Papers, pp. 218, 221.
9. Shugborough, p. 13.
10. Cavaceppi, I, 1768, plates 26–7.
11. Hubert, 1977, p. 38.
12. Kuchumov, plate 35 (Gardens)—the originals were replaced in 1972 with copies in epoxy-resin.
13. Zoffoli, Righetti (see Appendix); a pair signed Francesco Righetti in the Victoria and Albert Museum (1784); Honour, 1963, plate 6.
14. Molfino, II, plate 101.
15. Brettingham MS., p. 6; [Blundell], 1803, p. 53.
16. [De Guasco], p. xxi.
17. Winckelmann (Briefe), II, p. 285.
18. Montaiglon (Correspondance), XII, p. 47.
19. Baretti, p. 15; see also Hutchison, plate 20.
20. Falconet, I, pp. 266–73.
21. Winckelmann (ed. Fea), II, pp. 384–5.
22. Lalande, IV, p. 184; Ramdohr, I, pp. 224–5.
23. Visconti (Monumenti Borghesiani), plate LII, no. 2; Musée Français, discours, p. 95, note.
24. Lalande, IV, p. 184.
25. Visconti (Pio-Clementino), I, plate LI; Pietrangeli, 1958 (Scavi), p. 24 and note.
26. Robertson, I, p. 608.
27. Helbig, 1963–72, II, pp. 203–4.

21. The Centaur with Cupid (Fig. 93)

PARIS, LOUVRE

Marble
Height: 1.47 m
Also known as: Centaur tamed by Bacchus, Borghese Centaur, Centaur in love, Centaur Nessus led by Love

The group was described in a poem by Francucci in 1613 as in the Borghese collection.[1] Drawings by Rubens who was in Rome on two occasions between 1600 and 1608 suggest that it was known at least five years before.[2] Writing between 1660 and 1663, Fioravante Martinelli said that it had been found on the estates of the Fonseca adjoining the Lateran.[3] It is recorded in the Villa Borghese in 1638[4] and by 1650 was on the upper floor of the Villa in a room named after it.[5] On 27 September 1807 it was purchased, together with the bulk of the Borghese antiquities, by Napoleon Bonaparte, brother-in-law of Prince Camillo Borghese.[6] It was sent from Rome between 1808 and 1811[7] and was displayed by the latter year in the Salle des Fleuves of the Musée Napoléon.[8]

The Centaur with Cupid must have been highly esteemed by 1638 when Perrier devoted two plates to it in his anthology of the most celebrated statues in Rome.[9] It was copied in marble for Louis XIV (formerly at Marly)[10] and a century later by Chinard (now in the Lyon Museum),[11] and by Solari for the gardens at Caserta.[12] There were also reduced versions in biscuit, plaster,[13] terracotta[14] and bronze.[15]

When the Furietti Centaurs came to light in 1736, the elder of the two was frequently compared with the Borghese Centaur, generally to the latter's advantage,[16] although there was some discussion as to which had provided a model for the other. Éméric-David and Visconti followed Fea in believing the Borghese group to be a copy of higher quality of the Furietti Centaur.[17] The head of the Borghese Centaur was especially admired and it was likened in character to that of the Laocoon.[18]

To some the group was only a 'jeu d'esprit', to others a moral allegory,[19] but it was generally agreed to represent the invincible force of love. Visconti, however, pointed out that the child rider was crowned with ivy and carried no bow or quiver and might represent bacchic intoxication rather than erotic power,[20] but the latter interpretation prevailed. Indeed among the intaglios listed for sale by Wedgwood is the 'Centaur Nessus led by love',[21] and this is probably to be identified with the Borghese statue, which had been labelled as this fatally enamoured Centaur much earlier in the eighteenth century in the caption to the plates published by de Rossi.[22] Brigentius in his poem on the Borghese collection of 1716 also toyed with the idea.[23]

The Centaur with Cupid is now generally thought to be a Hadrianic copy of a bronze original of the second century B.C., but it has also been suggested by Robertson that the prototype was itself possibly Hadrianic.[24]

1. Francucci, stanzas 454–9.
2. Jaffé, p. 82, plate 316.
3. D'Onofrio, 1969, p. 308; see also Bartoli, Mem. 52.
4. Perrier, 1638, plates 7, 8.
5. Manilli, p. 103; cf. Montelatici, p. 291.
6. Boyer, 1970, p. 202.
7. Arrizoli-Clémentel, pp. 13–14, note 60.
8. Notice, supplément, 1811, p. 3.
9. Perrier, 1638, plates 7, 8.
10. Montaiglon (Correspondance), III, pp. 341, 350, 352, 366, 374–5, 477–8; IV, pp. 6, 7, 10, 34, 84, 96, 153–4, 418.
11. Lami, 1910–11, I, p. 200.
12. Civiltà del settecento a Napoli, p. 124.
13. In biscuit by Volpato, together with the Centaur with a hare mentioned in Catalogue 20 (Victoria and Albert Museum, Tatham Papers, D1479–1898, p. 17) and in plaster by Charles Harris (p. 9).
14. Vertue, III, p. 45 (by Peter Scheemakers).
15. Righetti, Zoffoli (see Appendix); Souchal, 1973, p. 52.
16. Lalande, IV, p. 184.
17. Fea in Winckelmann (ed. Fea), I, p. 306, note a; II, pp. 384–5, note c; Visconti (Monumenti Borghesiani), plate II, no. 2; Musée Français, Discours, p. 95, note.
18. Winckelmann (Briefe), I, p. 257.
19. Moore, I, p. 495.
20. Visconti (Monumenti Borghesiani), plate II, no. 2.
21. Wedgwood, 1779, class I, section II, no. 121.
22. Maffei, plates LXXII, LXXIII, LXXIV.
23. Brigentius, p. 81.
24. Robertson, I, p. 608.

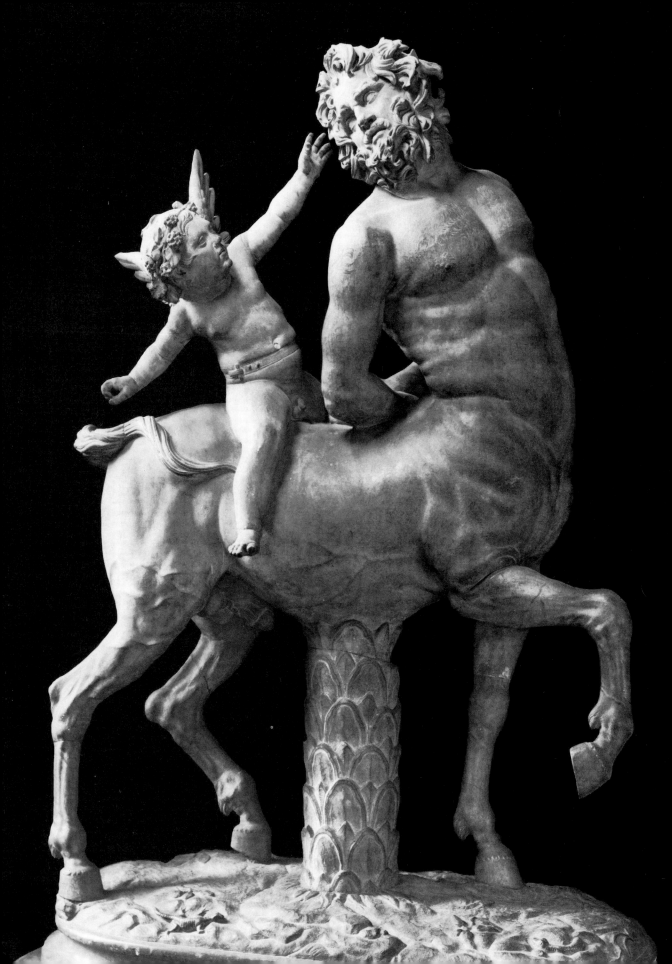

22. Mattei Ceres (Fig. 94)

ROME, MUSEI VATICANI (GALLERIA DEI
CANDELABRI)

Marble
Height: 1.065 m
Also known as: La Petite Cérès, Clio, Crispina,
 Demeter, Faustina, Julia Domna

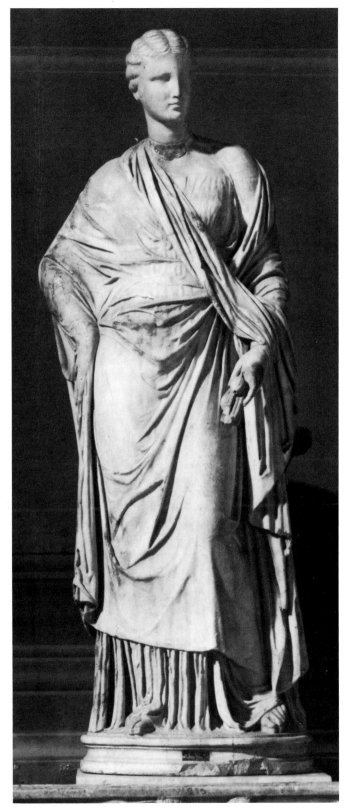

This statue was published in 1704 in de Rossi's
anthology of the most admired antique sculp-
tures when it was in the Mattei collection.[1] It had
been copied at least twenty years earlier[2] and
drawn, it seems, much before that.[3] It is likely to
have been among the statues recorded in an
inventory of the Mattei collection drawn up in
1614 in accordance with the will which Ciriaco
Mattei made four years earlier forbidding his
heirs to alienate any of the contents of the family
villa on the Celio ('daily visited and praised by
foreigners as well as Romans').[4] It is also likely
that the sculptures in this collection had been
found on the family's Roman estates.[5] Ciriaco's
fidecommisso was overruled by Pope Clement
XIV and this statue (together with the other
highly valued pieces in the collection) was sold
by Don Giuseppe Mattei to the Pope in Septem-
ber 1770. The *Ceres* was restored in the following
year and then placed in the Museo Pio-
Clementino.[6] It was ceded to the French under
the terms of the Treaty of Tolentino in 1797,[7]
reached Paris in the triumphal procession of July
1798,[8] and was displayed in the Musée Central
des Arts when it was inaugurated on 9 Novem-
ber 1800.[9] The *Ceres* was removed in October
1815,[10] arrived back in Rome in the first half of
1816[11] and was certainly on display in the
Vatican (in the Galleria delle Miscellanee) by
1822.[12]

The *Ceres* was not included in Perrier's an-
thology of the most admired antique statues
published in 1638 and an enlarged copy made by
Frémery for Versailles, probably before 1684[13]
(when Frémery left Italy for France), is the first
certain indication of its fame. Although much
later it was known as Faustina,[14] the copy at
Versailles was at first known as 'Ceres'[15] which
remained the most popular name during the
eighteenth century. However, since there were
theories that the statue was a portrait of Crispina,
the wife of Commodus,[16] or Julia Domna,[17] or
Clio, the Muse of History,[18] it is easy to be
confused, especially since the nomenclature of
another admired draped female statue in the
Mattei collection (the *Pudicity*) also varied.

94. *Mattei Ceres* (Vatican Museum).

93. *Centaur with Cupid* (Louvre).

During the eighteenth century, the *Ceres* was reproduced in coade stone,[19] and in plaster[20] and was given prominence in one of Panini's *capricci*.[21] The statue itself may, however, have been less familiar than such reproductions. It was not much noticed by travellers to Rome and was not discussed in Winckelmann's *History of Ancient Art*. But Baretti in his account of the casts in the Royal Academy described it as 'an excellent Greek performance of the best times',[22] and Visconti was also enthusiastic[23] and may have encouraged the French to demand it for the Musée.[24]

Marble copies (such as that in the gardens at Chatsworth in Derbyshire)[25] and fine biscuit statuettes (such as the example from the Meissen factory in the Fitzwilliam Museum, Cambridge)[26] testify to the interest in the figure in the nineteenth century. The leading plaster-cast merchant in Victorian London sold casts and three sizes of plaster statuettes of the 'Ceres from the Vatican', and also adapted the figure to hold gas lights.[27] The statue was considered 'one of the most exquisite remains of antiquity'[28] chiefly on account of its drapery which Visconti believed had been 'nowhere near approached by even the best modern sculptors'.[29] For this it is still highly admired by experts, and it is catalogued in Helbig as an original work of the third century B.C. or as a somewhat later classicising Hellenistic work.[30]

1. Maffei, plate CVIII.
2. Souchal, 1977, I, pp. 300–1.
3. *Rubens: Drawings and Sketches*, no. 19.
4. Lanciani, 1902–12, III, pp. 83–6 (will); pp. 88–97 (inventory).
5. Lanciani, 1902–12, III, pp. 86–7.
6. Amelung and Lippold, p. 555 (document); Hautecoeur (as 'statuetta di Cerere').
7. Montaiglon (*Correspondance*), XVI, pp. 463, 498.
8. Blumer, pp. 241–9.
9. *Notice*, An IX (1800), p. 24.
10. Saunier, p. 149.
11. Either in the consignment of statues which arrived on 4 January (*Diario di Roma*, 6 January 1816) or among those which had reached Civitavecchia from Antwerp by 19 June on board H.M.S. *Abundance* (ibid., 19 June 1816).
12. Fea, 1822, I, p. 130.
13. Souchal, 1977, I, pp. 300–1.
14. E.g. Baedecker, 1865, p. 199.
15. Thomassin, plate 49—where the copy is attributed to Renaudin (Regnaudin).
16. Maffei, plate CVIII
17. Venuti, R., 1779, I, pp. 24–5, plate XXX.
18. *Musée Français*.
19. Coade, 1777–9, plate 4.
20. Brettingham MS., p. 76; Harris, C., p. 3; Baretti, p. 20.
21. Arisi, fig. 48.
22. Baretti, p. 20.
23. Visconti (*Pio-Clementino*), I, plate XL.
24. Montaiglon (*Correspondance*), XVI, p. 463.
25. Probably from Bienaimé's Carrara studio which supplied the statues placed in the gardens between 1841 and 1844

and seems to have continued to do so for some years—Chatsworth MS., Sculpture Accounts of the Sixth Duke, p. 23; [Cavendish], p. 168.
26. C. 3169–1928, Rackham, I, p. 406.
27. Brucciani, 1864.
28. [Croker], p. 544.
29. Visconti (*Pio-Clementino*), I, plate XL.
30. Helbig, 1963–72, I, p. 447.

23. Cincinnatus (Fig. 95)

PARIS, LOUVRE

Marble
Height: 1.54 m
Also known as: Jason, L. Quinctius

A print of this statue was published in 1594.[1] The caption described it as the property of Cardinal Montalto and it was doubtless already in the Villa Peretti-Montalto (later Negroni) which Pope Sixtus V had built between 1586 and 1589. It was recorded there in 1655 when the Villa and its collections were inherited by Prince Savelli from the Peretti family.[2] In 1685 it was sold to Louis XIV together with the *Germanicus*[3] and was displayed at Versailles in the Salle des Appartemens, later known as the Salon de Vénus.[4] At the end of 1792, the statue's removal to the Musée Central des Arts (now Musée du Louvre) in Paris was decreed,[5] and it was on display there when the Musée was inaugurated in 1800.[6]

There is no evidence that this statue was much celebrated before 1664 when Bellori distinguished it and the *Germanicus*, also in the Villa Peretti-Montalto, with a special mention,[7] and when Skippon referred to the 'L. Quinctius with his plough-share by him' among the most notable statues there.[8] Ten years later, Spon and Wheler also picked it out,[9] and in 1685–6 there were vigorous protests at its purchase by Louis XIV.[10] At Versailles it was not exhibited in the Grande Galerie together with the other masterpieces in the royal sculpture collection, but this was probably because its stooping pose made it unsuitable for display with standing figures. It was in fact, after the *Diane Chasseresse*, the most admired antique statue in France, and thanks to prints,[11] and to the cast in the French Academy in Rome, it was not forgotten in Italy during the eighteenth century.

In 1769 a slightly different version, more broken, but with its original head, was discovered at Hadrian's Villa by Gavin Hamilton. The Pope declined to buy it (although not long afterwards his successor did acquire a smaller, poorly preserved and mediocre version)[12] and so

95. *Cincinnatus* (Louvre).

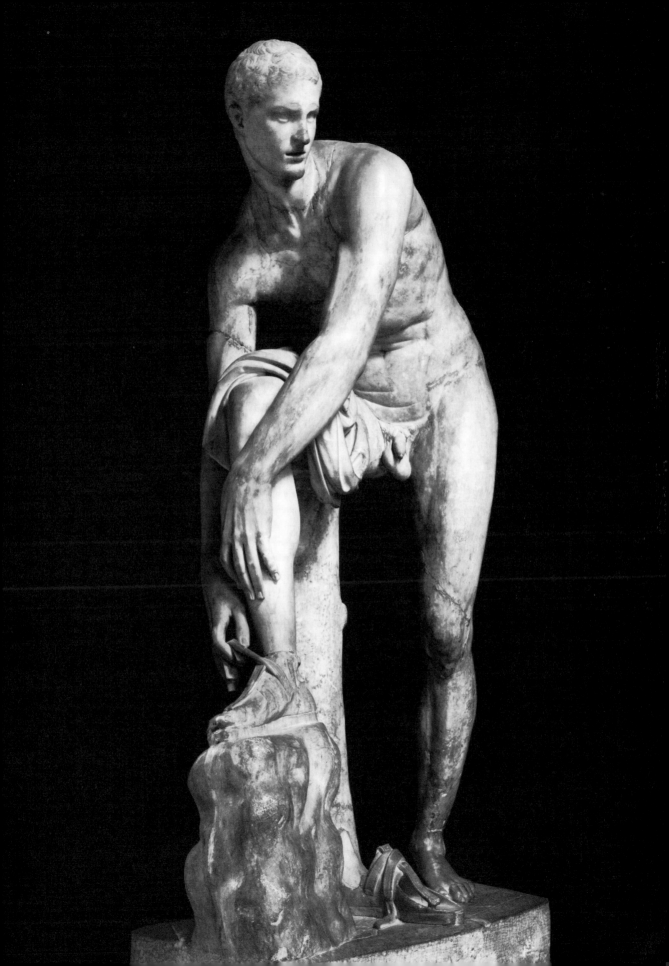

it was sold instead in 1772 to the Marquess of Shelburne (later Earl of Lansdowne). This was much admired,[13] and, not surprisingly, a cast of it was presented to the Royal Academy,[14] but even in England throughout the nineteenth century it was the statue in the Louvre, not the one in Lansdowne House, which was discussed by scholars and reproduced by plaster cast merchants.[15] Yet another version also found at Hadrian's Villa was sold in 1809 by Duke Braschi-Onesti to the Crown Prince Ludwig (later King of Bavaria) and is still in Munich.[16]

The base of the *Cincinnatus* was restored with a ploughshare on it and the statue was believed from the sixteenth to the eighteenth century to represent Lucius Quinctius Cincinnatus, the patriot, whom Livy describes as summoned from his small farm to take command of the Roman armies against the Sabines and become dictator of the city.[17] However, to Winckelmann (who pointed out that nudity would have been incongruous for Cincinnatus) and to Visconti, the statue represented the travelling hero Jason who is described at the start of the first book of the *Argonautica* as alarming Pelias by wearing, as the Oracle foretold, only one sandal.[18] In the second half of the nineteenth century, it was argued that the statue represented Hermes, the messenger of the gods, pausing to receive Zeus's instructions whilst fastening his sandal—the subject of a bronze statue described by Christodoros.[19] This idea has never met with general acceptance, however, and the statue, or rather the type, is now usually described, Germanically, as the 'sandalbinder'. The move from a specific to a general narrative interpretation is as typical as the move from a Roman to a Greek one.

Today, the Lansdowne version which was acquired in 1930 by the Ny Carlsberg Glyptothek in Copenhagen[20] is more famous and more admired than the statue in the Louvre. Both are believed by Robertson to be copies executed under the Roman Empire of a bronze original of the early third century B.C. by a pupil of Lysippus.[21]

1. Cavalleriis (3), plate 91, mistakenly identified by Ashby, 1920, p. 153, with a statue in the Vatican (see Note 12).
2. *Documenti inediti*, IV, p. 4.
3. Montaiglon (*Correspondance*), I, pp. 153ff.
4. Thomassin, plate 10, p. 12.
5. Soulié, I, p. lxv.
6. *Notice*, An IX (1800), pp. 37–8.
7. [Bellori], 1976, p. 51 (of facsimile).
8. Skippon, p. 670.
9. Spon and Wheler, I, p. 404.
10. Montaiglon (*Correspondance*), I, pp. 153–4, 156; VI, pp. 390–405.
11. Maffei, plate LXX.
12. Visconti (*Pio-Clementino*), III, plate XLVIII.
13. Michaelis, 1882, pp. 464–6.
14. Baretti, p. 20.
15. E.g. Brucciani, 1864; Pater, 1895, p. 296.
16. Caprino.
17. Livy, III, 26.
18. Apollonius Rhodius, I, lines 4–14; Winckelmann (ed. Fea), II, pp. 327–8; Visconti (*Pio-Clementino*), III, plate XLVIII; Clarac, 1820, pp. 266–7.
19. Fröhner, pp. 210–13; Michaelis, 1882, pp. 464–6 (citing Christodoros, *Greek Anthology*, II, 297–302).
20. Poulsen, pp. 203–4.
21. Robertson, I, p. 516; II, plate 163b (caption).

24. Cleopatra (Fig. 96)

ROME, MUSEI VATICANI (GALLERIA DELLE STATUE)

Marble
Height: 1.62 m; Length: 1.95 m
Also known as: Ariadne, Dido, Nymph

The statue is first recorded on 2 February 1512 as having recently been acquired by the Pope (Julius II) from Angelo Maffei and taken to the Belvedere.[1] By August of the same year it was in a corner of the statue court and had been installed as a fountain on an antique marble sarcophagus.[2] By the 1530s the niche in which it had been placed was elaborately decorated to create the illusion of a grotto.[3] In the early 1550s the *Cleopatra* was (on the advice of Vasari) taken to a room adjoining the courtyard and again set up as a fountain in a niche which formed the visual climax to a long corridor.[4] Though the arrangement was rather different, the close connection with a grotto was retained[5] and the room, known as the 'Stanza della Cleopatra', which had originally been intended for a Moses, was decorated by Daniele da Volterra with frescoes illustrating biblical references to water.[6] Between 1613 and 1619 the design of the fountain was once again substantially altered without, however, affecting its general character.[7] By 1704 Pope Clement XI (1700–21) had made known his concern at the damage being caused to the statue by the water which flowed from it and his intention to move it,[8] but travellers and guidebooks of the later eighteenth century continue to describe the *Cleopatra* as a fountain,[9] though there are some indications that the water was turned off.[10] With the creation of the Museo Pio-Clementino the statue was given a new setting at the end of the Galleria delle Statue (Fig. 37)[11] where it was flanked by two columns of giallo antico and placed on a sarcophagus with a relief of fighting Titans.[12] In 1797 it was ceded to the French under the terms

96. *Cleopatra* (Vatican Museum).

of the Treaty of Tolentino[13] and it reached Paris in the triumphal procession of July 1798.[14] It was displayed in the Musée Central des Arts when it was inaugurated on 9 November 1800.[15] It was removed in October 1815[16] and must have arrived back in Rome in the first consignment of statues on 4 January 1816,[17] for it was in the Museo Pio-Clementino by the end of May that year.[18] Its dignity at the end of the Gallerie delle Statue was soon to be further enhanced by the placing of the celebrated Barberini candelabra on each side of the flanking columns.[19]

The *Cleopatra* was admired from the first by writers, artists and connoisseurs. Isabella d'Este owned a small marble copy set above a cupboard in her 'Grotta',[20] and Primaticcio had a bronze (Fig. 2) cast for François Ier, in which—whether by accident or design—the reclining stance of the figure was greatly exaggerated and other changes were also made: as late as the nineteenth century this version was used as the basis for a number of further casts.[21] A plaster cast was made for Philip IV of Spain,[22] and two marble copies were carved for Louis XIV—one by Jean-Baptiste Goy in Rome,[23] and the other, of 1684–5, by Corneille van Cleve (still at Versailles) who used the Fontainebleau bronze as his model.[24] We are told that the mould taken from the statue in the Vatican was not very satisfactory because the water from the fountain had covered it with tartar.[25] Poussin made a small wax copy (now in the Louvre) which, according to an old tradition, he gave to his friend and admirer Chantelou,[26] and in the eighteenth century bronze statuettes were offered by both Zoffoli and Righetti.[27] Righetti suggested that a copy of another suicidal heroine, an (unidentified) bronze of 'Lucretia' by Giambologna could be paired with the *Cleopatra*, and a reclining 'Mark Anthony' in coloured earthenware was copied from an earlier figure of Rinaldo as a companion to the *Cleopatra* produced by Enoch Wood of Staffordshire (Fig. 55).[28] Nathaniel Marchant copied the statue on a sard intaglio[29] and it was also reproduced in many other media[30] as well as being engraved in all the leading anthologies.

Many poems were written about the *Cleopatra* in the sixteenth and seventeenth centuries, and three of these—by Baldassare Castiglione (1478–1539), by Bernardino Baldi (1553–1617) and by Agostino Favoriti (1624–82)—were so much admired that they were carved into the pilasters which framed the statue, despite the fact that the first and last were very long.[31] When the *Cleo-*

patra was moved into the Galleria delle Statue, the Latin poems by Castiglione and Favoriti were inscribed on two large marble slabs, one of which was placed on each side of the statue.[32] Castiglione's poem (which was translated into English by Pope) associated the Belvedere figure with the effigy of the dead Cleopatra on a couch which, according to Dio Cassius,[33] had been carried in triumph to Rome by Octavian after his victory at Actium. As the serpent-bracelet entwining the upper part of the left arm was generally assumed to be the asp whose poison had killed the Queen, Castiglione's poetic conceit was enthusiastically followed by later writers who often supposed that the statue was the effigy itself.[34]

However, a few sixteenth-century writers and artists noticed the resemblance of the pose to a popular convention for the representation of sleeping nymphs, and the persistence with which those responsible for arranging the Vatican sculpture collections retained the motif of the grotto, despite so many changes in the placing of this statue, shows that they too recognised the analogy.[35] The final identification with a nymph was, however, only explicitly made in the eighteenth century. For the grounds of his country house of Stourhead in Wiltshire Henry Hoare commissioned from John Cheere a white enamelled lead copy of the Belvedere statue[36] and (perhaps on the advice of Rysbrack)[37] had it placed in the grotto (Fig. 42) on the floor of which was carved Pope's translation of the late fifteenth-century Latin poem 'Hujus nympha loci . . .'[38]

Nymph of the Grot, these sacred Springs I
 keep,
And to the Murmur of these Waters sleep;
Ah spare my Slumbers, gently tread the Cave!
And drink in silence, or in silence lave!

At much the same time Winckelmann (who did not think very highly of the statue) pointed out that as the serpent was only a bracelet there was no reason to believe that the figure represented either Cleopatra or, as Stosch had proposed, Semele.[39] It was, he thought, a sleeping nymph or a Venus.[40] Visconti reluctantly acknowledged that the name of 'Cleopatra', so steeped in valuable literary associations, was irrelevant, but he claimed that the figure (which he deeply admired) was too well dressed, too melancholy and too dignified to be a nymph, and, relying in part on the evidence provided by a newly

discovered relief, he proposed that it was an abandoned Ariadne.[41]

Painters had frequently used a reclining figure (perhaps ultimately derived from this statue) to portray some abandoned heroine, and it may therefore be of special significance that in 1774, more than a decade before Visconti published his suggestion (which is now universally accepted), Pompeo Batoni should have included the statue in his beautiful portrait of Thomas William Coke (Holkham Hall, Norfolk): the picture was commissioned by the unhappy Countess of Albany, who had recently married the claimant to the English throne (a drunken failure more than twice her age) but who was said to be in love with the twenty-year-old Coke who stands nonchalantly in front of the languishing woman, elegant in his Van Dyck fancy dress of salmon pink and silvery white.[42] And many years later, 'when George the Fourth was still reigning over the privacies of Windsor, when the Duke of Wellington was Prime Minister', Dorothea Casaubon, neglected during her Roman honeymoon by a husband just as unsatisfactory in his very different way as the Young Pretender, was sighted by Will Ladislaw as, 'clad in Quakerish grey drapery', she stood 'where the reclining Ariadne, then called the Cleopatra, lies in the marble voluptuousness of her beauty, the drapery folding around her with a petal-like ease and tenderness'.[43] George Eliot is correct in pointing out that, at the time she is describing, the statue was still popularly known as Cleopatra—but so it was also even when *Middlemarch* was published in 1871–2 as we know from the plaster casts of it being supplied by Brucciani in these very years.[44]

Though the Vatican *Cleopatra* was the better known, another version of the statue, in the Villa Medici until 1787[45] (and now in the Museo Archeologico in Florence)[46] was, for a number of years, considered by many connoisseurs to be of higher quality. Thus in 1694 La Teulière, director of the French Academy in Rome, regretted that this 'incomparably better' version had not been copied for the King of France instead of the one belonging to the Pope.[47] And Richardson, who did not mention the Belvedere *Cleopatra* (which was probably not easily accessible at the time of his visit to the Vatican) 'clamber'd up a piece of the ancient Wall of Rome' to see the one in the Medici garden which touched him more than any other figure there, the head being 'of the greatest Greek Taste'.[48] Winckelmann, however, dismissed the head as

modern,[49] and it was not long before the statue was totally discredited.[50]

The Vatican *Cleopatra* is catalogued in Helbig as a copy of the late Hadrianic (or early Antonine) period of a masterpiece of the Pergamene school dating from the second century B.C., and originating in the workshop of Dionysos.[51]

1. Brummer, p. 154 (with document).
2. Ackerman, 1954, p. 46; Brummer, p. 154.
3. Ackerman, 1954, p. 37; Brummer, pp. 156–61.
4. Ackerman, 1954, pp. 77–8.
5. Brummer, pp. 254–6.
6. Canedy, 1967.
7. Ackerman, 1954, p. 113; Brummer, p. 263.
8. Maffei, plate VIII.
9. [Roisecco], I, p. 77; Taja, p. 385.
10. Richard, V, p. 371.
11. Visconti (*Pio-Clementino*)—folio edition of 1782, I, with plan of the galleries, facing p. x.
12. Vasi, 1792, p. 28—also engraved by Feoli.
13. Montaiglon (*Correspondance*), XVI, pp. 463, 498.
14. Blumer, pp. 241–9.
15. *Notice*, An IX (1800), pp. 8–9.
16. Saunier, p. 149.
17. *Diario di Roma*, 6 January 1816.
18. Friedländer, II, p. 147.
19. The candelabra seem to have been moved after 1822 (Fea, 1822, I, pp. 115, 130) and before 1829 (Pistolesi, V, 1829, p. 35 and plates XXVII, XXIX).
20. Brown, 1976, p. 329.
21. Pressouyre, 1969 ('Fontes'), pp. 229–30 (with references).
22. Palomino, p. 914; Bottineau, p. 178.
23. Montaiglon (*Correspondance*), I, p. 134; Lami, 1906, p. 222.
24. Pressouyre, 1969 ('Fontes'), p. 230, note 1.
25. Montaiglon (*Correspondance*), I, p. 149.
26. Poussin, 1960, p. 187; Blunt, 1967 (Text), pp. 31–2, 229.
27. Zoffoli, Righetti (see Appendix).
28. Fitzwilliam Museum, Cambridge—Rackham, I, p. 120 (nos. 908–9); II, plate 70F; Museum of Fine Arts, Boston (95.250 and 95.251); and, for the pair in black basalt ware made at the Swansea factory, see Victoria and Albert Museum (3501–1901).
29. Marchant, p. 29; Dalton, p. lvii.
30. *Berlin und die Antike*, p. 239, for cast-iron paper weight.
31. Taja, pp. 388–98.
32. Vasi, 1792, p. 28; Pistolesi, 1829–38, V, pp. 26–8.
33. Dio Cassius, LI, 21.
34. Perrier, 1638, plate 88; [de Guasco], p. 257.
35. Brummer, pp. 168–84; Kurz, p. 174.
36. *The Man at Hyde Park Corner*, no. 3.
37. Sotheby's, 1979, p. 29 (no. 63).
38. Kurz.
39. Winckelmann (*Briefe*), I, p. 255.
40. Winckelmann (ed. Fea), II, pp. 329–30.
41. Visconti (*Pio-Clementino*), II, plate XLIV.
42. *Eighteenth-Century Italy and the Grand Tour*, pp. 11–12; Stirling, I, pp. 108–9. Batoni, of course, frequently included this statue in his portraits of Grand Tourists without intending any emblematic significance—see Hassall and Penny, p. 211, note 29.
43. George Eliot: *Middlemarch*, chapter 19.
44. Brucciani, 1864.
45. *Documenti inediti*, IV, p. 77.
46. Milani, p. 313.
47. Montaiglon (*Correspondance*), II, p. 17.
48. Richardson, 1722, p. 126.
49. Winckelmann (ed. Fea), II, p. 330.
50. *Documenti inediti*, IV, p. 78.
51. Helbig, 1963–72, I, pp. 109–10.

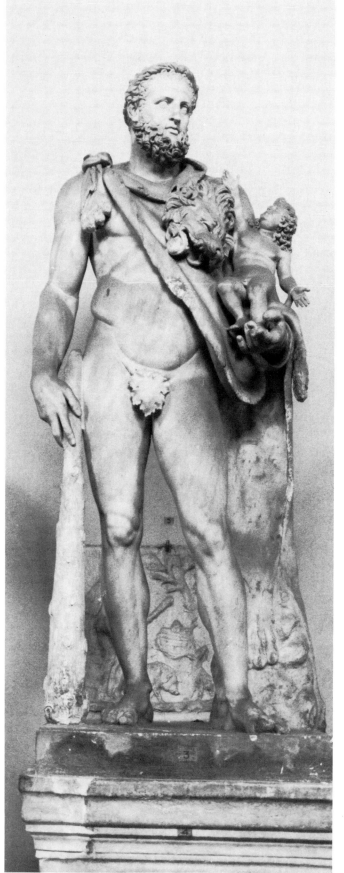

25. Commodus as Hercules (Fig. 97)

ROME, MUSEI VATICANI (GALLERIA CHIARAMONTI)

Marble
Height: 2.12 m
Also known as: Hercule–Commode, Hercules
and Ajax, Hercules and Hylas, Hercules and
Telefos

From letters to Cardinal Ippolito I, and Isabella, d'Este written by Ludovico Fabriano and Giorgius de Negroponte in Rome on 18 and 19 May 1507 we learn that this statue was found on 15 May of that year in the garden of a house in Campo dei Fiori.[1] 'One day it was found,' observed Giorgius, 'the next our Lordship [the Pope, Julius II] had it taken to his Palace rewarding the finder, so it is said, with a benefice worth 130 ducats a year.'[2] It was placed in a niche in the Belvedere courtyard where it was recorded in 1536.[3] The *Hercules* was ceded to the French under the terms of the Treaty of Tolentino in February 1797,[4] reached Paris in the triumphal procession of July 1798[5] and was displayed in the Musée Central des Arts when it was inaugurated on 9 November 1800.[6] In October 1815 it was removed[7] and it must have arrived back in the first consignment of statues on 4 January 1816,[8] for by 28 January the decision had been taken not to restore it to the Belvedere courtyard but to place in its niche instead Canova's Perseus which (despite the sculptor's protests) had occupied the niche of the *Apollo*.[9] In 1818, a statue of Hercules was recorded as on display in the Sala Rotonda of the Vatican Museum[10] and the Hercules in the identical place in 1822 was certainly the *Commodus as Hercules*.[11]

Ludovico Fabriano in the earliest reference to the statue mentions that it represented Hercules but that the learned were puzzled by the child whom he held. A day later, Giorgius de Negroponte reported that 'Fedra' (the nickname of Tommaso Inghirami) had identified the statue as a portrait of Commodus in the guise of Hercules.[12] The child was not fully explained, however, for Giorgius added: 'It truly is a beautiful piece, but it is strange to see so ferocious a figure holding a little boy on his arm.'[13] Commodus was said by ancient historians to have postured as Hercules[14] (although the famous bust of him with the attributes of this god was not discovered until 1874).[15] In 1597 Boissard published the idea that the boy held by Commodus has in play just dropped out of a window a list of eminent

97. *Commodus as Hercules* (Vatican Museum).

Romans to be condemned. As he dallies with his minion, the Emperor is unaware that the discovery of this list has already sealed his own fate.[16] This fantastic idea was still being refuted in the eighteenth century[17]—by Winckelmann, among others, who also dismissed the idea that it was a portrait. Instead he suggested that it showed Hercules with Ajax.[18] Visconti on the other hand suggested Hercules with his son Telefos.[19] Others preferred the old idea of Hercules with Hylas,[20] but Visconti's interpretation has, in this case as in so many others, been followed by scholars ever since.

The fact that the statue was copied in bronze both for François I[er 21] and for Charles I,[22] and in marble (by Nicolas Coustou) for Louis XIV,[23] provides sufficient evidence for its reputation in the sixteenth and seventeenth centuries. However, Coustou 'took what was good in the statue and added what he saw the antique lacked . . . always keeping his eyes on nature',[24] and in his fine copy executed between 1683 and 1686 (on the Rampe de Latone at Versailles) the apples of the Hesperides are substituted for the child—a remarkable anticipation of the modern theory that the child in the Vatican statue is an awkward addition made by a copyist.[25] Coustou's liberties reflect his own great reputation but also the beginnings of doubts about the quality of the *Hercules*, which was not much reproduced in any medium in the eighteenth century, although an exact marble copy by Tommaso Solari may be seen in the gardens of the Villa Chiaia in Naples which were laid out in the 1830s.[26] Travellers also began to have reservations,[27] and, although Dallaway, as late as 1816, singled it out with the *Gladiator*, the *Torso* and the *Laocoon* as of 'superior excellence'[28] and although Visconti's admiration of the head[29] was briefly echoed,[30] the statue was not able, once it had left the Belvedere courtyard and had ceased to represent one of the most delinquent rulers in history, to command the popular imagination.

It is catalogued in Helbig as a Roman copy of a type of Herakles derived from a fourth century B.C. original although the boy apparently dates from a later period.[31]

1. Borsari, pp. 19–20; Luzio, 1886 (*Lettere inedite*), pp. 93–4, note 3.
2. *Ibid.*
3. Brummer, p. 133 (quoting Fichard).
4. Montaiglon (*Correspondance*), XVI, pp. 462, 498.
5. Blumer, pp. 241–9.
6. *Notice*, An IX, (1800), pp. 82–3.
7. Saunier, p. 149.
8. *Diario di Roma*, 6 January 1816.
9. Quatremère de Quincy, 1834, pp. 102–3.

10. Vasi (rectifié Nibby), II, p. 478.
11. Fea, 1822, I, pp. 122–3.
12. Borsari, pp. 19–20.
13. Luzio, 1886 (*Lettere inedite*), pp. 93–4, note 3; cf. Fichard quoted by Brummer, p. 133.
14. Herodian, I, 14, 8.
15. Stuart Jones, 1926, p. 142.
16. Boissard, p. 13 (alluding to stories in Herodian, I, 17, 4, and Scriptores Historiae Augustae (Commodus Antoninus), IX).
17. Lalande, III, pp. 207–8.
18. Winckelmann (ed. Fea), II, p. 400, note 1.
19. Visconti (*Pio-Clementino*), II, plate IX.
20. Lalande, III, pp. 207–8; cf. Albertini (*De Statuis*) in Valentini and Zucchetti, IV, p. 491.
21. Pressouyre, 1969 ('Fontes'), pp. 223–4.
22. Now at Windsor Castle. British Library, Harleian MS. 4898, fol. 301v; Harleian MS. 7352, fol. 122v; 'Papers Relating to the Late King's Goods', p. 88 (item X); p. 90 (item XXVII—3).
23. Souchal, 1977, I, p. 153.
24. [Cousin de Contamines], pp. 4–5.
25. Amelung, 1906, p. 51.
26. Croce, p. 53.
27. Northall, p. 157; Lalande, III, pp. 207–8.
28. Dallaway, 1816, p. 205.
29. Visconti (*Pio-Clementino*), II, plate IX.
30. Hoare MS., p. 22.
31. Helbig, 1963–72, I, p. 243.

26. Cupid and Psyche (Fig. 98)

ROME, MUSEI CAPITOLINI

Marble
Height: 1.25 m

According to a catalogue of 1750 the group was given by Pope Benedict XIV to the Capitoline Museum in 1749 having been discovered in the estate of the Canonico Panicale on the Aventine Hill in February of that year.[1] In 1797 it was ceded to the French under the terms of the Treaty of Tolentino,[2] and it reached Paris in the triumphal procession of July 1798,[3] and was displayed in the Musée Central des Arts from its inauguration on 9 November 1800.[4] It was removed in October 1815,[5] arrived back in Rome in the first half of 1816, and during the course of the year it was returned to the newly reorganised Capitoline Museum.[6]

The theme of Cupid embracing Psyche was familiar from sarcophagi long before the discovery of the Capitoline group,[7] and a notable free-standing treatment of it had also been acquired at a considerably earlier date by the Medici.[8] They removed it to Florence soon after its discovery near S. Stefano Rotondo in 1666, and, although it was not at first much noticed, it was certainly reproduced in earthenware at the Doccia factory by Gaspero Bruschi in 1746 (an example is in the Museo Ceramico di Faenza)[9]

and by plaster casts (one is in one of the Gothic niches of the dining-room at Arbury Hall in Warwickshire,[10] another was at Holkham Hall in Norfolk).[11] But after 1750 the Capitoline *Cupid and Psyche* (or the 'graceful group of a man and woman tenderly embracing' as it was described in that year)[12] was soon preferred. It was the sentiment that most appealed to both travellers and scholars—'the first burst of youthful loveliness',[13] the 'innocent fondness',[14] the 'virginal' and ingenuous gesture of Psyche.[15] But there were also many learned discussions of the philosophical allegory of the soul which the group might embody,[16] and the execution was not always admired—Saint-Victor thought it was but a poor reflection of some earlier and superior work;[17] Lalande had hoped it might well inspire some superior group from a modern sculptor.[18]

The *Cupid and Psyche* was much reproduced, especially on a small scale, as a gem by Marchant,[19] as an intaglio by Wedgwood,[20] in bronze by Zoffoli,[21] in biscuit de Sèvres (with garlands added for modesty),[22] and much more crudely in lead-glazed earthenware perhaps by Enoch Wood.[23] As can be seen at Cobham Hall in Kent and Ickworth in Suffolk copies of the group were sometimes coupled with copies of another standing and embracing pair, the Bacchus and Ariadne at Marbury Hall in Cheshire (the most celebrated item of the Smith Barry collection formed at Rome in the 1770s;[24] today in the Museum of Fine Arts, Boston, as a 'Priapos and a Maenad').[25]

Doubts that the female figure in the Capitoline group should be interpreted as Psyche are comparatively recent,[26] as is the beautiful idea that the group shows the invention of the kiss and the grotesque notion that Cupid is counting Psyche's teeth.[27] Its 'singular charm' and 'very cunning formal composition' are still admired'[28] and the Capitoline group continues to arouse special interest since it shows the children without the wings they have in bronze and terracotta versions (as also in the marble version in the Uffizi). The work is now described in Helbig as a Roman copy of a late Hellenistic work of the second or first century B.C.[29]

* * *

An additional note about another version of the Capitoline group is worth adding here. It was drawn by Batoni between *c.* 1725 and 1730 and captioned on the back as belonging to Count Fede (Fig. 52),[30] one of the chief excavators of

98. *Cupid and Psyche* (Capitoline Museum).

Hadrian's Villa, where Ficoroni, writing in 1741, noted that Fede had discovered it.[31] A beautiful marble copy of the group by Delvaux at Woburn Abbey in Bedfordshire was probably based on a model made in Rome shortly before 1730,[32] and a cast is recorded at Düsseldorf in 1731.[33] Jean-François de Troy described the group in October 1740 as 'one of the most beautiful morcels of the antique' and arranged for it to be copied and cast.[34] Travellers and connoisseurs noted that it was 'exceedingly fine',[35] 'incomparable'[36] and 'd'eccellente lavoro'.[37] It was still in Fede's collection, in Palazzo Fiorenza, Campo Marzo, in 1752,[38] by which year the Capitoline group had already become famous. The only differences between the groups seem to have been that the male figure in the Fede version has turned his head away and repelled his companion with his hand—differences due to a restorer which explain why it was most commonly thought to represent either Caunus repelling the incestuous advances of his twin sister Biblis,[39] or the blushing Hermaphroditus rejecting the ardent Salmacis.[40] Ficoroni, however, had recognised the figures as Cupid and Psyche by 1741[41] and after the discovery of the Capitoline group this was the more usual name. Righetti, for instance, in his price-list of bronze statuettes included the 'Amor et Psiche de Comte Foy'.[42] As was the case with copies of the Capitoline group, copies of this one also were sometimes paired with copies of the Marbury Hall Bacchus and Ariadne (as for example in statuettes by Francesco Carradori in the Palazzo Pitti, Florence).

Although still reproduced at the end of the eighteenth century,[43] the Fede group had by then been overshadowed by the far more accessible one in the Capitoline Museum. Its location at that date is unknown; and it is not mentioned in scholarly surveys of the variants and prototypes of the Capitoline *Cupid and Psyche*.[44] Of all the antique statues admired in the eighteenth century but now untraced it was probably the most celebrated.

1. [Lucatelli], 1750, p. 30.
2. Montaiglon (*Correspondance*), XVI, pp. 464, 498.
3. Blumer, pp. 241–9.
4. *Notice*, An IX (1800), pp. 7–8.
5. Saunier, p. 149.
6. Either in the consignment of statues which arrived on 4 January (*Diario di Roma*, 6 January 1816) or among those which had reached Civitavecchia from Antwerp by 19 June on H.M.S. *Abundance* (*ibid.*, 19 June 1816); Stuart Jones, 1912, p. 8.
7. E.g. Bartoli, 1693, plate 68.
8. Mansuelli, I, pp. 90–1.

9. Ginori Lisci, 1963, pp. 61, 62, fig. 40.
10. Hussey, p. 46, plate 73.
11. Brettingham, 1773, p. 12.
12. [Lucatelli], 1750, p. 30.
13. Bell, J., p. 333.
14. Burney, p. 137.
15. Éméric-David, 1805, pp. 387–8.
16. [Bottari], plate XXII; *Musée Français*; Flaxman, pp. 96, 231.
17. Saint-Victor, I, unpaginated.
18. Lalande, IV, p. 187.
19. Marchant, p. 19.
20. Wedgwood, 1779, class I, section II, nos. 134, 208.
21. Zoffoli (see Appendix).
22. Bourgeois, p. 12 (no. 48).
23. Fitzwilliam Museum, Cambridge—Rackham, I, p. 124 (no. 944); II, plate 71.
24. Michaelis, 1882, p. 504.
25. Comstock and Vermeule, p. 127.
26. Petersen, 1901.
27. Helbig, 1899, I, p. 306; altered in Helbig, 1912, I, p. 445, but repeated by Bieber, p. 150.
28. Robertson, I, pp. 555–6.
29. Helbig, 1963–72, II, pp. 238–9.
30. Topham Collection, Eton College. Macandrew, plate 23 (no. 47).
31. *Roma Antica*, 1741, p. 270 ('Ficoroni').
32. Vertue, III, p. 45.
33. Sitte, p. 156.
34. Montaiglon (*Correspondance*), IX, p. 438.
35. Northall, p. 342.
36. [Russel], II, p. 240.
37. *Roma Antica*, 1741, p. 270 ('Ficoroni').
38. Northall, p. 342 (published 1766, but the editor notes that the author was in Rome in 1752).
39. Ovid, *Metamorphoses*, IX, 454–665.
40. *Ibid.*, IV, 285–389 (especially 329–36).
41. *Roma Antica*, 1741, p. 270 ('Ficoroni').
42. Righetti (see Appendix); but see Schiller, XX, pp. 104–5.
43. Harris, C., p. 9. Bronze signed F. Righetti and dated 1790, no. 34, Heim Gallery (London), autumn 1972.
44. E.g. Petersen, 1901.

27. Curtius flinging himself into the Gulf
(Fig. 99)

ROME, VILLA BORGHESE

Marble
Height: unmeasured

This very high relief was mentioned in 1648 by a visitor to Rome as being on the outside of the Villa Borghese.[1] In 1650 Manilli's guide to the Villa gave its exact location as the centre of the southern facade overlooking the orange garden (that is the facade to the left of the main entrance), high up between the second and third floors:[2] it had almost certainly been there since before 1623 by which date the Villa was virtually complete.[3] During the 1770s when Prince Marc Antonio IV Borghese transformed the Villa it was brought inside the newly decorated entrance hall and placed high above the door facing the entrance, and it was certainly in place there by September 1779.[4]

99. *Curtius flinging himself into the Gulf* (Villa Borghese, Rome).

In January 1606 Cardinal Scipione Borghese took the unusual step of going on horseback to visit the victims of one of the worst of the frequent floods of the Tiber.[5] Seven years later, when writing of the palace in the Via di Borgo Nuovo in which the Cardinal then lived, a poet attached to his court gave an elaborate, pompous (and possibly fanciful) description of one of the bronze panels on the door on which this momentous scene was represented. The post compared Cardinal Borghese's action to that of the legendary Marcus Curtius who had heroically flung himself and his horse into an abyss in order to save Rome,[6] whose destruction had been foretold by the soothsayers unless what constituted her greatest force were thrown into the chasm which had appeared in the Forum.[7] The analogy must have appealed to Cardinal Borghese and his heirs, for at various times at least three sculptural versions of the legend were to be found in the Villa: a gilded bronze Curtius against a lapis lazuli background enclosed in a jasper frame was kept in the room of the *Hermaphrodite*;[8] a bas-relief (whose identity was not quite certain) was on one of the facades;[9] and, by far the most famous, the present relief. The subject was an unusual one, though a smaller and tamer relief in the Palazzo dei Conservatori had been quite well known since the middle of the sixteenth century,[10] and the eighth Earl of Pembroke acquired a very flamboyant version for the great hall at Wilton in Wiltshire.[11]

The Borghese *Curtius* was noted and enthusiastically admired by most guides and visitors to Rome in the seventeenth and eighteenth centuries.[12] It was engraved not only in the standard books on the Villa[13] but also in de Rossi's anthology of the most important statues on the grounds that it was in such high relief that it qualified for inclusion—(Perrier, however, did not illustrate it among either the statues or the reliefs which he published in 1638 and 1645). Maffei's commentary praised the masterly carving, the heroic expression of Curtius himself and the extraordinary vitality and movement of the group as a whole.[14] Appreciation reached a climax towards the end of the eighteenth century,[15] and much attention was devoted to the psychological states of both horse and rider, which were sometimes seen as complementary and sometimes as conflicting.[16] While it was still on the facade of the Villa one traveller noted that it was 'conveniently placed to be seen and drawn'[17] and, though the absence of replicas is hardly surprising, it is curious that no drawings of it seem to have been traced. When Prince Borghese rearranged his collections, the rooms in which the more famous pieces were placed were decorated with appropriate themes. On the ceiling of the entrance hall presided over by the

Curtius Mariano Rossi's heroic Baroque fresco (the last of its kind in Rome) depicted the achievements of Marcus Furius Camillus, another great saviour of Rome celebrated by Livy,[18] and this setting increased the impact made by the statue.

Yet, though the admiration was constant, as early as the seventeenth century we can find possible doubts about the authenticity of the *Curtius*. In a book mainly completed in 1666 (though only published in 1675), Luigi Scaramuccia, a great admirer of Bernini, singled it out for special praise in a chapter devoted to modern sculptors, though his actual phrasing is ambiguous.[19] In 1744 the antiquarian Ficoroni claimed that because of its stylistic distinction it must have been restored 'at the time of the Empire'[20]—implying, presumably, that in its original state it dated back to the deed which it commemorated. An attempt to create a provenance seems to have been made in this period and Northall's editor added a note that it was found near the place 'where the pretended famous leap was taken'.[21]

At the very end of the eighteenth century Visconti pointed out that the statue, though 'of a good style', must once have formed part of a larger group of fighting horsemen 'arbitrarily restored in modern times' to make a Curtius.[22] Later, when discussing the portraiture of early Roman heroes, he dismissed it ruthlessly.[23] Nineteenth-century scholars agreed, though usually in a less forthright manner,[24] and the relief—which was not sold to Napoleon with the other Borghese antiquities (perhaps for these reasons, perhaps because it was felt to constitute part of the structure of the Villa)—quickly lost the magic it had once possessed, though as late as the 1840s an English traveller could feel that 'to look at this makes one's heart leap'.[25]

Only few modern scholars have troubled to investigate the statue.[26] Lanciani believed that the original fragment may have been excavated at Hadrian's Villa for Cardinal Ippolito II d'Este, and that it could have been one of the same horses, by then restored, which was admired by Aldrovandi in the collection of Antonio Paloso as 'a very beautiful horse which seems to stumble and fall: it is a wonderful and worthy work'.[27] More recently it has been very plausibly (but not quite conclusively) suggested that this was 'the marble relief of a horse' which in 1617 Pietro Bernini was required to restore for Cardinal Borghese's villa for the considerable sum of a hundred and fifty scudi.[28]

1. Raymond, pp. 94–5.
2. Manilli, p. 48.
3. *Villa Borghese*, pp. 18–19, plate 1.
4. Herbert, Lord, p. 276.
5. D'Onofrio, 1967, pp. 208–9.
6. *Ibid.*, pp. 208–12; Francucci, stanzas 45–57.
7. Livy, VII, 6.
8. Manilli, p. 99; Montelatici, p. 304, describes it in another room.
9. Montelatici, p. 178 (but not in Manilli).
10. Stuart Jones, 1926, pp. 36–7.
11. Kennedy, pp. 17–18, plate 1; Michaelis, 1882, p. 689 (no. 87).
12. Mortoft, p. 154; Northall, p. 352; Vasi, 1794, p. 191.
13. Montelatici, facing p. 176; Brigentius, facing p. 60.
14. Maffei, plate LXXXIII.
15. Starke, 1800, II, p. 41, gives it four exclamation marks; cf. Starke, 1820, p. 371, where some doubts creep in.
16. Wright, I, p. 341; [de Guasco], p. 441; Dupaty, II, p. 68.
17. Richard, VI, pp. 189–90.
18. Livy, V.
19. Scaramuccia, pp. 18–19.
20. Ficoroni, 1744 (*Singolarità*), p. 73.
21. Northall, p. 352, note.
22. [Visconti], 1796, I, pp. 29–30 (no. 18).
23. Visconti (*Iconografia Romana*), I, p. 260.
24. Nibby, 1832, pp. 38–9; Nibby, 1841, II, p. 911.
25. Francis, p. 109.
26. It is not, for instance, catalogued by Helbig.
27. Aldrovandi, 1556, p. 189; Lanciani, 1902–12, II, p. 112; Lanciani, 1909, pp. 136–9.
28. D'Onofrio, 1967, pp. 255–8.

28. Weeping Dacia (Fig. 100)

ROME, MUSEI CAPITOLINI (PALAZZO DEI CONSERVATORI)

Marble
Height (keystone): 1.20 m; (panel): 0.75 m
Also known as: Germania, Conquered Province, Weeping Province, Woman Weeping

This relief panel incorporated in a giant keystone is shown in a print published by Lafreri in 1549. It was in the Cesi sculpture garden and served then, as now, as a pedestal for a seated statue restored as Roma.[1] The author of the 'Basle Sketchbook' working after 1536 captioned a drawing of this ensemble 'novamente trovate' and it is probably significant that Marten van Heemskerck did not show it in his view of the Cesi Gardens made between 1532 and 1536.[2] The relief was purchased by Clement XI together with the Roma and two flanking Barbarian Prisoners and placed in the courtyard of Palazzo dei Conservatori in 1719.[3]

The female figure on this relief was described by Aldrovandi as a personification of the province Dacia,[4] and it has generally been called this ever since, although it was sometimes known simply as a Province[5] and occasionally identified as Germania.[6] Although engraved[7] and frequently drawn in the sixteenth century there is no

100. *Weeping Dacia* (Palazzo dei Conservatori—courtyard).

Dacia increased in fame thereafter. Panini included it in his *capricci* and in his ideal galleries of ancient art (Fig. 45),[10] and Pompeo Batoni used it as a prop in his portraits of English milordi—such as Peter Beckford in 1766 (Fig. 47), the Duke of Hamilton in 1775, and William Bankes in 1777.[11] It appears on oval and round tablets and on intaglios of different sizes made by Wedgwood;[12] it was also copied by Marchant on an intaglio,[13] and by Tommaso Righi in the small stucco reliefs in the Room of Phaeton in the Villa Borghese, and by a Berlin jeweller in cast iron set in gold for a necklace of about 1810.[14] In the late eighteenth century Coade's artificial stone factory supplied medallions of the figure, either as a pair with medallions of a kneeling St. Agnes or incorporated into the design of church monuments.[15] Both Thomas Banks and Richard Hayward borrowed the figure for church monuments in marble at the same date.[16]

By 1815 the situation that had prevailed two and a half centuries earlier had been entirely reversed and a popular guidebook could repeat that 'the Colossal figure of *Roma Triumphans* . . . is quite eclipsed by the inimitable beauty of a weeping province carved on its pedestal'.[17] However, the relief attracted less notice later in the nineteenth century.

In Stuart-Jones's catalogue of 1926 the relief, still identified as Dacia, is supposed to have originated as the keystone of an arch in Trajan's Forum.[18] It is not considered of sufficient importance to be catalogued in the latest edition of Helbig.

evidence that it was specially admired other than as an adjunct of the Roma placed above it. As the Cesi family declined in importance, and with the sale in 1622 of many of the finest pieces in their sculpture garden, the collection attracted less notice, and the *Dacia* was not included by either Perrier or Bartoli in their anthologies of prints of the most notable ancient reliefs in Rome.

Even Montfaucon, who went out of his way to inform his readers that the prisoners flanking Roma were only there by a 'coup de hazard', did not seem to appreciate that the relief could not have served as a pedestal for Roma in antiquity[8]—obvious as that seems today. But only three years after the Roma, its pedestal and the Prisoners had been moved to the Palazzo dei Conservatori the Richardsons while unimpressed by the Roma described the relief as 'incomparable'. Six years later in the revised French edition of their book they expanded on its beauty and poignancy quoting the moving opening passage from the Book of Lamentations concerning the city of Jerusalem—'celle qui était grande entre les Nations est devenue comme Veuve . . . Elle ne cesse de pleurer de nuit et les larmes sont sur ses joues.'[9]

1. Lafreri (British Museum copy), fols. 81–2.
2. Michaelis, 1891–2, i, p. 139; iii, p. 84.
3. Stuart Jones, 1926, pp. 17–18.
4. Aldrovandi, 1556, p. 128.
5. E.g. Tofanelli, 1823, p. 132.
6. Forsyth, pp. 231, 235.
7. Cavalleriis (1), plate 1, and (2), plate 19; Lafreri; Vaccaria, plate 36; Lauro, 1612–15, plate 46.
8. Montfaucon, 1724, I, p. 187.
9. Richardson, 1722, p. 114; Richardson, 1728, III, i, pp. 170–1, 175.
10. Arisi, figs. 136, 176, 305, 310, 315.
11. In the Royal Museum of Fine Arts, Copenhagen, and the collections of Lord Barnard and the Duke of Argyll, respectively.
12. Wedgwood, 1779, class I, section II, nos. 33, 273; class II, no. 164; some examples are in the Lady Lever Art Gallery, Port Sunlight—Hobson, pp. 196–7, nos. 1765, 1886.
13. Marchant, p. 30.
14. Evans, J., plate 175b.
15. Coade, 1777–9, plates 25, 28; Coade, 1784, p. 16; see monument to Edward Wortley Montagu (d. 1777) in the cloisters of Westminster Abbey.
16. Bell, C.F., plates VII, XII; Penny, 1977, plates 5, 47.
17. Coxe, p. 207.
18. Stuart Jones, 1926, pp. 17–18.

29. Borghese Dancers (Fig. 101)

PARIS, LOUVRE (RESERVE)

Marble
Height: 0.72 m; Length: 1.88 m
Also known as: Nuptial Chorus, The Hours,
 The Dancing Hours

In 1645 this relief was recorded as in the Villa Borghese,[1] but it seems to have been known in Rome more than a century before, parts of it being precisely imitated in the 1520s.[2] On 27 September 1807 it was purchased, together with the bulk of the Borghese antiquities, by Napoleon Bonaparte, brother-in-law of Prince Camillo Borghese.[3] It was sent from Rome between 1808 and 1811[4] and was displayed in the Musée du Louvre by 1820.[5]

The *Dancers* were included in both Perrier's and Bartoli's anthologies of Roman relief sculpture (Bartoli erroneously giving it to the Medici collection), in both cases together with a relief showing maidens adorning a candelabrum[6] which was then pendant with the *Dancers*, placed above the opposite door in the first room of the Villa.[7] Bronze casts of these two reliefs (together with another showing the sacrifice of a bull, then in the Villa Medici and today in the Uffizi) were made in Paris for Louis XIII in 1641 on the advice of Poussin[8] whose admiration for the *Dancers* was later frequently cited.[9] A cast of the relief displayed in the Salle d'Apollon of the Musée Central des Arts which was specially noticed in the catalogue of antiquities in 1800[10] probably came from the French royal collection and is likely to have been made in the seventeenth century, and the same claim has been made for a

bronze cast in the Wallace Collection, London.[11]

The *Dancers* were certainly more famous than the other reliefs copied for Louis XIII, and its composition, gracefully flowing in both directions (which was believed to have inspired Guido Reni's Aurora) was frequently admired in the highest terms during the eighteenth century.[12] Winckelmann, although he did not believe the *Dancers* to date from the better, that is the earlier, periods of ancient art, declared it to be, in a letter to Stosch, 'ce qu' il y a de plus parfait dans ce genre'.[13] When considered with its pendant, the *Dancers* were supposed to be part of a marriage ceremony,[14] but in isolation they could be identified as the Hours accompanied by the Graces.[15] Visconti, however, thought that it was possible that an echo of the *Dancers* painted by Apelles was present in the frieze.[16]

It was obviously suitable for these figures to be arranged as a continuous frieze around a curved surface (especially so if they are conceived of as Hours), and among the earliest records of the *Dancers* are the copies of them around two of the vases painted by Polidoro da Caravaggio in the chiaroscuro decoration of Palazzo Milesi in Rome (*c.* 1524–7).[17] The figures also dance around a vase used as a prop in English portraits of the 1750s and 1760s by Francis Hayman of Mr. and Mrs. Tyers (Yale Center for British Art) and Nathaniel Dance of Sir James Grant and friends (Philadelphia Museum of Art). In the early 1770s a version of the frieze without the columnar divisions was used on a lavish Italian chimney-piece of statuary marble and porphyry installed at Badminton in Gloucestershire,[18] and a lengthened version of the frieze with nine figures

101. *Borghese Dancers* (Louvre).

instead of five was employed against a lapis ground in another such chimney-piece at Moor Park (now in the Lady Lever Art Gallery, Port Sunlight).[19] Later in the century, François Bélanger, among others, also proposed using the frieze on a chimney-piece.[20] An enlarged copy was repeated four times as a decoration on the facade of Pietro Tomba's Casa Piani-Pasi in Faenza, completed in 1807. Lequeu had wanted full-size versions of each dancing figure distributed between columns in front of his projected Temple of Silence.[21]

Although far less noticed by travellers and no longer adapted for ornamental vases and chimney-pieces, the *Dancers* were among the very few reliefs of which casts were provided by the leading London plaster-cast merchant of the mid-nineteenth century,[22] and today it is still copied on composition window boxes although the relief itself has been relegated to the reserve of the Louvre and has been considered since the late nineteenth century as poor quality neo-Attic work.[23]

1. Perrier, 1645, plate 20.
2. Loewy, 1896, pp. 246–51.
3. Boyer, 1970, p. 202.
4. Arizzoli-Clémentel, pp. 13–14, note 60.
5. Clarac, 1820, pp. 12–13.
6. Perrier, 1645, plates 19, 20; Bartoli, 1693, plates 63–4 (plates 74–5 in the first edition).
7. Manilli, pp. 56–7; Montelatici, pp. 188–9.
8. Bellori, pp. 443f. The Medici relief is Mansuelli, I, plate 146.
9. E.g. Montaiglon (*Correspondance*), II, p. 17.
10. *Notice*, An IX (1800), p. 90.
11. Mann, p. 57.
12. Northall, p. 351; Lalande, III, p. 480; Dalmazzoni, p. 258; Gibbon, p. 249.
13. Winckelmann (*Briefe*), I, p. 254.
14. E.g. Bartoli, 1693, plate 63.
15. Winckelmann (ed. Fea), I, p. 321.
16. Visconti (*Monumenti Borghesiani*), plates XXIV, XXV.
17. The vases are the first and fourth from the left in the frieze of vases recorded in prints and drawings made of the facade before it deteriorated.
18. Stillman, 1977, plate 5, pp. 86–8.
19. *Ibid.*, pp. 88–9.
20. Wilton-Ely, plate 215; cf. Stillman, pp. 88–9.
21. Braham, plate 311.
22. Brucciani, 1864.
23. Hauser, pp. 46–7.

30. Diane Chasseresse (Fig. 102)

PARIS, LOUVRE

Marble
Height: 2.00 m
Also known as: Diana of Ephesus, Diane à la Biche, Diane de Versailles

The statue is first recorded for certain at Fontainebleau in February 1586 by the Dutch traveller Van Buchell but was said in the seventeenth century to have been taken there from the chateau of Meudon.[1] In 1602 Barthélemy Prieur revised its restorations and it was moved to Paris and made chief ornament of a specially decorated marble chamber—the Salle des Antiques—in the Louvre.[2] Under Louis XIV it was transferred to the Grande Galerie at Versailles.[3] Its removal to Paris was decreed at the end of 1792[4] and on 6 February 1798 it was taken to the Musée Central des Arts (later Musée Napoléon, now Musée du Louvre)[5] where, however, it is not catalogued as on display at the inauguration in 1800, though it was certainly on view by 1802.[6]

Alone amongst the statues exported from Italy before the second half of the seventeenth century the *Diane Chasseresse* acquired a reputation outside Italy equivalent to the masterpieces in the Belvedere or the Villa Borghese. Peacham in 1634 described it as 'that famous Diana of Ephesus',[7] Evelyn a decade later added that it was 'said to be the same which utterd Oracles in that renowned Temple'[8]—and Eustache Le Sueur painted it at the same date in an antique temple.[9] The confusion with the Ephesian fertility idol, was also mentioned as a vulgar belief by de Bisschop,[10] and survived in the caption to Thomassin's print of the statue in a volume, compiled between 1689 and 1694,[11] causing some embarrassment to the French Academy in Rome.[12] The idea was formally refuted by Piganiol de la Force.[13]

The first recorded copy of the statue is the bronze cast in 1605 by Barthélemy Prieur for a fountain at Fontainebleau (adorned with dogs and spouting stags' heads) which was intended as a durable substitute for the marble when that was removed to the Louvre.[14] This bronze was admired in the eighteenth century at Fontainebleau but was removed to Malmaison, was then taken to the Louvre, and has now returned to Fontainebleau.[15] Another full-size bronze copy (now at Windsor Castle) was made for Charles I of England in 1634 by Hubert Le Sueur.[16] A marble copy was made for Marly by Guillaume Coustou in 1710[17] and the series of 'compagnes de Diane' commissioned for Marly from French sculptors in the same year were perhaps conceived of specifically as companions of this copy of what was then considered to be one of France's greatest treasures.

102. *Diane Chasseresse* (Louvre).

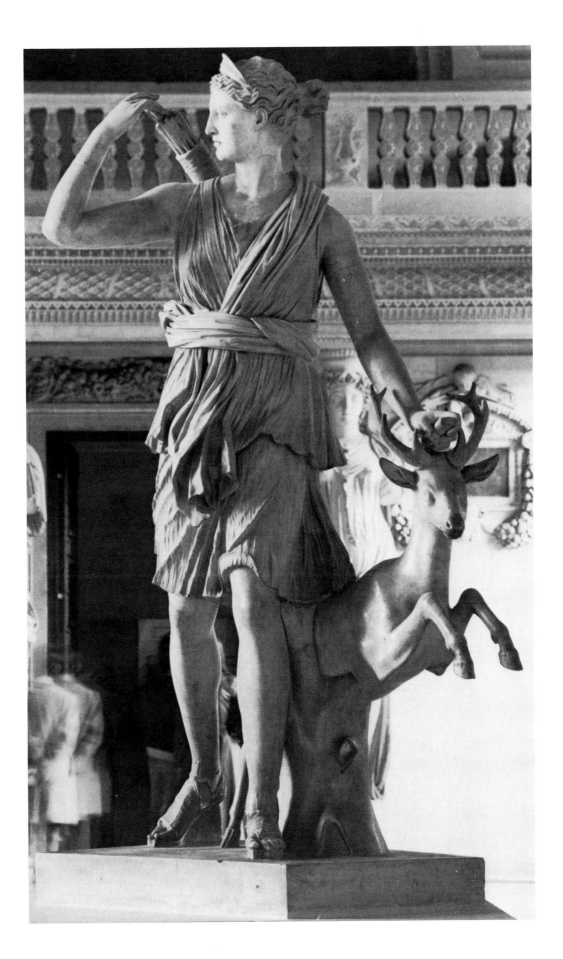

Although it had been in France for nearly two hundred years the *Diana* was featured in a *capriccio* painted by Panini in Rome which included the sacrifice of Iphigenia at the shrine of this goddess (Holburne of Menstrie Museum, Bath).[18] In the second half of the eighteenth century the *Diana* was also reproduced large and small in bronze, plaster and lead. It was even reproduced rather crudely in the 1770s in earthenware by Ralph Wood of Burslem.[19] In the late nineteenth century it was still included in most large sets of plaster casts and in some small ones (that at Pittsfield, Massachusetts, or at the Whitworth Art Gallery, Manchester). In sets of casts and copies as also in the writings of artists and scholars as early as the middle of the seventeenth century[20] the *Diana* was frequently paired with the *Apollo Belvedere*. For Robertson they are both copies executed under the Roman Empire of bronze originals of the second half of the fourth century, perhaps intended as companions and perhaps, as has been much proposed, the work of Leochares.[21]

1. Favier, 1970, pp. 72, 76.
2. *Ibid*, pp. 71, 74.
3. Thomassin, p. 12.
4. Soulié, I, p. liv.
5. Picard, IV, ii, p. 186.
6. *Le Louvre de Hubert Robert*, pp. 48, 62.
7. Peacham, 1634, p. 105.
8. Evelyn, II, p. 105.
9. Museum of Fine Arts, Boston, 98.16.
10. Episcopius, plate 99.
11. Thomassin, plate 5.
12. Montaiglon (*Correspondance*), I, p. 378.
13. Piganiol de La Force, I, pp. 163–4.
14. Favier, 1970, pp. 74–6.
15. Nugent, IV, p. 139; Hubert, 1977, p. 36.
16. Peacham, pp. 107–8.
17. Souchal, 1977, I, p. 135.
18. Arisi, fig. 47.
19. Victoria and Albert Museum, C.26–1930.
20. Chantelou, p. 202.
21. Robertson, I, pp. 460–1; II, plate 143d (caption to plate of *Apollo*).

31 Diane de Gabies (Fig. 103)

PARIS, LOUVRE

Marble
Height: 1.65 m
Also known as: Diana Robing, Diana Succinct

This statue was excavated by Gavin Hamilton in 1792 on Prince Borghese's property at Gabii outside Rome,[1] and was displayed (with other sculptures found there) in the gardener's house (now the Casino dell'Orologio) in the grounds of the Villa Borghese which had been radically transformed by Nicola Fagioli the year before.[2]

On 27 September 1807 it was purchased (together with the bulk of the Borghese antiquities) by Napoleon Bonaparte, brother-in-law of Prince Camillo Borghese.[3] It was sent from Rome between 1808 and 1811[4] and by 1820 it was displayed in the Louvre.[5]

This statue was admired from the time it was excavated and was always included among the most important pieces found at Gabii.[6] But at first neither Visconti nor other writers of the late eighteenth and early nineteenth centuries showed any special enthusiasm for it, though (as Visconti acknowledged) the existence of at least one other example of the Diana in Rome showed that the type had been esteemed in antiquity.[7] After the statue had arrived in Paris, however, Visconti threw caution to the winds and wrote about the *Diana* in terms of unqualified rapture.[8] He saw in the goddess's 'agreeable, noble and pensive' physiognomy indications of her taste for the 'dangerous pleasures' of the chase for which she was preparing herself; he found similarities between this statue and the *Diane Chasseresse* which proved beyond doubt that it was indeed the sister of Apollo and not one of her attendant nymphs who was represented; he admired the naïvety of her expression and the impeccable execution of her draperies: the statue was in fact an undoubted masterpiece.

Visconti's immediate successor at the Louvre, the Comte de Clarac, was much more reticent,[9] but the popularity of this *Diana* grew remarkably during the course of the nineteenth century. On the advice of Sir Thomas Lawrence a plaster cast was placed in the entrance hall of the Athenaeum in London[10] and in 1857 a copy was made for the Cour Carré in the Louvre.[11] Many smaller commercial replicas were also manufactured—in bronze, in basalt stoneware (by Copeland) and in terracotta (by Blashfield in 1857) and in plaster (by Brucciani, in a variety of sizes, before 1864).[12] In the 1880s the *Diana* was given a star in Baedeker,[13] and Fröhner's catalogue of ancient sculpture in the Louvre echoed Visconti's earlier enthusiasm, describing it as 'one of the pearls of the Museum . . . among the most admired masterpieces produced by Greek sculpture'.[14]

'This statue', writes Bieber, 'is generally recognized as a copy of the image made by Praxiteles for the temple of Artemis Brauronia on the Acropolis of Athens (Pausanias, I, 23.7). Actual dresses were dedicated to this Artemis, who was a special protectress of women, parti-

cularly of mothers. The temporary arrangement of both dresses is meant to show how the goddess accepts and uses the garments offered by her votaries.'[15]

1. Visconti (*Monumenti Gabini*), p. 6 and plate XII (no. 32).
2. *Villa Borghese*, pp. 57–8.
3. Boyer, 1970, p. 202.
4. Arizzoli-Clémentel, pp. 13–14, note 60.
5. Clarac, 1820, p. 113.
6. Salmon, II, pp. 347–8; Dallaway, 1800, p. 381.
7. Visconti (*Monumenti Gabini*), plate XII (no. 32), refers to an example in the Verospi collection drawn by Lebrun and reproduced in Montfaucon, 1724, III, plate 10, no. 3. See also the prints by Perrier (1638, plate 64) and Sandrart (1680, p. 53).
8. Visconti (*Opere varie*), IV, pp. 75–7.
9. Clarac, 1820, p. 113; 1830, p. 112.
10. *Survey of London*, Vol. XXIX, The Parish of St. James, Westminster—Part One: South of Piccadilly, p. 398.
11. Pingeot, tableau 6.
12. Blashfield, 1857, no. 202; also Blashfield, 1858, no. 157 (1st day), no. 149 (2nd day); Brucciani, 1864.
13. Baedeker, 1881, p. 109.
14. Fröhner, pp. 120–2.
15. Bieber, p. 21.

32. Discobolus (Fig. 104)

ROME, MUSEO NAZIONALE ROMANO (MUSEO DELLE TERME)

Marble
Height (excluding modern plinth): 1.55 m

The *Discobolus* was discovered on 14 March 1781 at the Villa Palombara on the Esquiline Hill, a property of the Massimo family.[1] After restoration by Angelini the statue was placed in Palazzo Massimo delle Colonne in a room named after it. By the end of the nineteenth century it had been moved to the palace in Via dei Coronari of the extinct Lancellotti family whose title had been assumed by a branch of the Massimi.[2] Adolf Hitler began his campaign to obtain the statue in 1937, but the Italian High Commission for Science and Art declared that the work must on no account leave the country. On 18 May 1938 it was, however, sold to him for five million lire, Galeazzo Ciano, the Minister for Foreign Affairs, ignoring the protest of Giuseppe Bottai, the Minister of Education. It had arrived in Germany by 29 June 1938 and was displayed in the Glyptothek, Munich. Returned to Italy on 16 November 1948, it was placed in the Museo Nazionale on 2 April 1953.[3]

The bronze statue by Myron of the stooping discus-thrower was famous from the descriptions of it in Lucian and Quintilian,[4] but notable torsoes of antique marble copies of the

103. *Diane de Gabies* (Louvre).

Greek statue were not at first recognised—one was admired in the sixteenth century as a torso of a gladiator, and restored as such by Monnot in the eighteenth century and acquired for the Capitoline Museum;[5] another, now in the Uffizi, was restored first as an Endymion blinded by the beauty of the moon and then as a fearful Niobid;[6] and a third torso was in 1775, soon after its discovery, restored as a Diomedes for Gavin Hamilton who sent it in the following year to Lord Shelburne (today it is at Bowood in Wiltshire).[7]

When the term 'Discobolus' was applied to statues in the seventeenth and early eighteenth centuries it was generally to standing figures holding a discus, but not stooping to throw it. One such example was sufficiently esteemed to be cast in bronze for Philip IV.[8] It was later said that the owner so feared that he would be compelled to sell the marble itself to the Spanish King that he decapitated it, claiming that the head had been stolen.[9] Just over a century later Cavaceppi sold this statue to William Lock of Norbury (it is now at Queen Mary's School, Duncombe Park),[10] but in 1771 it was replaced in Rome by another, finer, example of the same type, which was discovered at Hadrian's Villa and acquired in the following year for the Vatican[11] where it was identified by Visconti as the Discobolus by Naukydes of Argos, mentioned by Pliny.[12] This statue was greatly admired and extensively reproduced,[13] but its fame was to be eclipsed by the replicas of the *Discobolus* with which it is so easily confused in the literature. It was in 1781 that the most important of these was discovered, almost complete, on the Esquiline Hill.

This marble was recognised and published by Fea and by the elder Visconti[14] and instantly became famous. The figure does not seem to have been copied full-scale but in less than a decade the pose was familiar enough for it to be parodied by one of the gymnastic putti in the Romulus Room of the Palazzo Altieri in Rome, and it was this statue which the French were desperate to acquire for the Musée Napoléon[15] and which Ludwig of Bavaria was equally keen to obtain for his Glyptothek (a room was planned for its reception there as early as 1815).[16] In 1791 two more replicas were found at Tivoli, one of which, much inferior, was acquired for the Vatican, and the other for Charles Townley.[17]

A cast of the Discobolus together with one of the *Antinous* was found by Samuel Butler rel-

egated on account of their nudity to a lumber room in the Museum of Natural History in Montreal in 1875—but, despite the impression given by his satirical poem 'A Psalm of Montreal', the Discobolus was not 'the good one',[18] which means, probably, that it was either the standing Discobolus (a good pair with the *Capitoline Antinous* as can be seen from the bronze copies on the steps of University College, London) or the Townley version. This latter was considered inferior to the Villa Palombara *Discobolus* chiefly because its head did not belong and was wrongly turned (a fact which Townley's friend Richard Payne Knight reluctantly admitted, but which the British Museum tried to deny).[19] Casts of it were, however, freely available, which was not the case with the Villa Palombara statue.[20] Furthermore, since Townley's statue was acquired by the British Museum, it could easily be seen, whereas the palaces of the Massimo family were almost inaccessible; but all the same the reputation of the Massimo statue was greater[21]—indeed it acquired a certain special glamour on account of the extreme difficulty of seeing it.

Interest in the *Discobolus* was further stimulated by the discovery of yet another replica, this time in the ruins of a Roman villa at Tor Paterna in the royal estate of Castel Porziano, in April 1906.[22] Soon afterwards this version (now in the Museo Nazionale together with the Villa Palombara statue) served as the basis for the cast made by G.E. Rizzo (now in the Museo dei Gessi, Rome). To it were added feet cast from the Townley version, an arm cast from a version in Casa Buonarroti, Florence, and the head cast from the moulds of the Villa Palombara version made a century earlier by the French because Prince Lancellotti had not permitted Rizzo to make new casts.[23]

As well as exercising the ingenuity of archaeologists, the *Discobolus* continued powerfully to excite the imagination of art lovers. For Walter Pater, writing in 1894, it embodied 'all one had ever fancied or seen in old Greece or on Thames' side, of the unspoiled body of youth',[24] and as an ideal of healthy young manhood it had evidently lost none of its glamour when Leni Riefenstahl made her film of the 1936 Olympic Games.[25] And Hitler pursued the statue with the same passion that Napoleon had devoted to acquiring the *Venus de' Medici*.

The *Discobolus* is, with the *Apollo Sauroctonus*, the first case of an antique statue attaining enormous fame at the same time as being con-

104. *Discobolus* (Museo Nazionale Romano).

sidered as a copy. Both the elder and the younger Visconti, and Fea, were sure that the Villa Palombara statue was not the work of Myron himself, because it was not of bronze and because of various aspects of the handling. Filippo de la Barthe's pamphlet on the statue, written as a reply to these scholars, shows how distressed old-fashioned antiquarians were by this ardent homage paid to a statue not because it was beautiful, but because it was a reflection of some greater unknown original.[26]

The views of leading scholars as to the identity and status of the Villa Palombara *Discobolus* expressed when it was first discovered still coincide with those to be found in Helbig.[27]

1. Cancellieri, 1806, pp. 1, 19.
2. Càllari, pp. 195, 361–2.
3. *Second National Exhibition of the Works of Art Recovered in Germany*, pp. 13, 34–5.
4. Lucian, *Philospseudes*, 18; Quintilian, II, 13, viii-x.
5. Stuart Jones, 1912, pp. 123–4.
6. Ficoroni, 1744 (*Vestigia*), pp. 56–7; Cancellieri, 1806, p. 24; Howard, 1962, p. 333.
7. Michaelis, 1882, pp. 467–8; Howard, 1962, p. 332; Pietrangeli, 1958 (*Scavi*), p. 114.
8. Harris, E., pp. 119–20, plate VII.
9. Baretti, pp. 20–1.
10. Cavaceppi, I, 1768, plate 42; Michaelis, 1882, p. 295; Vermeule, 1955, p. 135, fig. 13.
11. Amelung and Lippold, p. 536.
12. Visconti (*Pio-Clementino*), III, p. 119 (citing Pliny, XXXIV, 80).
13. E.g. Montaiglon (*Correspondance*), XIV, pp. 159, 182, 190, 208, 216–17, 222, 235, 238, 249–50, 261, 357, 439, 450, 455.
14. Cancellieri, 1806.
15. Paris, Arch. Nat., AF IV 1050.
16. Pölnitz, pp. 59–60, 236.
17. Amelung and Lippold, II, pp. 88–91, 536; Smith, A.H., 1892–1904, I, pp. 90–1.
18. Jones, H.F., I, pp. 218–19.
19. [Knight], 1809, plate XXIX; *Description of Marbles in the British Museum*, part XI, 1861, plate XLIV.
20. Brucciani, 1864.
21. E.g. Müller and Oesterley, A139b; Perry, W.C., p. 159.
22. Paribeni, p. 202.
23. *Second National Exhibition of the Works of Art Recovered in Germany*, p. 34.
24. Pater, 1895, pp. 303–4 (the paper 'The Age of Athletic Prizemen' was first published in the *Contemporary Review* in February 1894).
25. *Olympiad Film* (1936–8).
26. Cancellieri, 1806, pp. 8–18.
27. Helbig, 1963–72, III, pp. 176–80.

33. The Barberini Faun (Fig. 105)

MUNICH, GLYPTOTHEK

Marble
Height: 2.15 m
Also known as: Bacchus, Drunken Faun, Sleeping Faun, Sleeping Pan, Satyre Malade

The *Faun* is first recorded in a receipt for its restoration dated 6 June 1628. It belonged to Cardinal Francesco Barberini, and both in this document and in an inventory of the Cardinal's sculptures drawn up between 1632 and 1640 it is said to have been discovered at the Castel S. Angelo,[1] work on the fortification of which had begun in 1624 at the instigation of his uncle Pope Urban VIII. It was kept in the Palazzo Barberini until it was sold shortly before 30 July 1799 to the sculptor Vincenzo Pacetti, who offered it to various English and French clients.[2] The Barberini brought legal action to annul the sale and despite an appeal to Lucien Bonaparte, who had approached Pacetti to buy the statue in 1802,[3] Pacetti was obliged to return it in 1804.[4] It was acquired from the Barberini after protracted negotiations, and much competition from Pacetti, by Crown Prince Ludwig of Bavaria on 29 April 1814.[5] Cardinal Pacca placed a ban on its export which was vigorously supported both by Canova, the leading artist in the city (and in Europe), and by one of the leading antiquarians, Carlo Fea; but after the intervention of Ludwig's sister, the Empress of Austria, the ban was lifted on 16 October 1819, and on 6 November the statue set off, pulled by a team of nine mules, for Munich, where it arrived on 6 January 1820.[6] A special room in the Glyptothek had been planned as early as 1815—it was completed with the *Faun* in place by July 1827,[7] and was accessible to the general public when the museum opened three years later.

The changing fortunes of the *Faun*'s reputation cannot be separated from its changing appearance. When described in 1628 the *Faun* was 'seated',[8] but in a print published in 1642 it is shown as lying on its back, thus no doubt making it a suitable companion for the modern Pan (or Satyr) in a similar posture now in St. Louis and attributed to Montorsoli.[9] By then the right leg, truncated at the thigh, had already been completed, probably with stucco, perhaps by Arcangelo Gonelli.[10] In 1679 the *Faun* was again restored, this time by Giuseppe Giorgetti and Lorenzo Ottoni, who made some additions enabling the antique left leg to be refixed, provided a new right leg (in stucco), the hanging left arm (in stucco, but replaced in marble by 1738), and an elaborate support involving tree branches, which enabled it to sit again.[11] This restoration is recorded by the print published in de Rossi's anthology of 1704 (Fig. 16).[12] A modello which has been attributed to Bernini

seems to be preparatory for this stage of the restoration[13] but there is no evidence for the tradition that Bernini was in any way involved with the statue. On 6 July 1799 Vincenzo Pacetti was at work on models for a thigh and a leg in marble different in several respects from the earlier stucco restorations of these parts. These he attached on 22 August 1799.[14] The result was a significant change of posture, and he also altered the base. This stage too is recorded by a modello.[15] Pacetti's most radical addition, the left leg, has been removed and replaced in recent years. At the time of writing the *Faun* is displayed without it, and without the hanging arm.

The *Faun* was much esteemed in the seventeenth century when the great patron, collector and scholar Cassiano dal Pozzo considered it 'not inferior to the Belvedere Torso',[16] but it was most widely admired in the second half of the eighteenth century when the Barberini Palace seems to have become much more accessible to travellers. Baron Stosch must have esteemed it enormously, for Winckelmann writing to him in 1756 insisted that he did so too, but added that he could not find in it the ideal of the *Apollo*, the science of the *Laocoon*, or the grandeur of the *Torso*.[17] For the Marquis de Sade it was a 'sublime statue grecque',[18] for Burney the 'fifth or sixth statue in Rome',[19] and, according to Mrs. Piozzi in 1789, it was 'by some accounted the first statue in Rome'.[20] The international competition for it in the early nineteenth century must have added to its fame. There were rumours of fabulous sums offered by the English.[21] The Crown Prince Ludwig of Bavaria was obsessed by the idea of possessing it—'eifrigst, eifrigst lieber Wagner', he wrote on 10 July 1811 to his agent in Rome, three years before he purchased it and nine years before he got it to Munich.[22] In 1816 Croker claimed that he had heard it called 'the most perfect statue in the world'.[23]

Winckelmann noted Procopius's claim that during the Siege of Rome in 537 the citizens had hurled the statues adorning Hadrian's Mausoleum (the Castel S. Angelo) down on to the Goths and that the condition of this statue and the place of its discovery made it probable that it had served as such a projectile.[24] 'Who knows', remarked Peter Beckford, 'but Belisarius himself might have thrown this very Fawn at the head of Vitiges.'[25] Thus, as was also the case with the statues found for the most part a century or more later at Hadrian's Villa, the *Faun* owed some of its glamour to the site where it was excavated.

Teti, the first to describe the statue, pointed out that confronted by something so excellent one naturally supposed it divine. Only on careful inspection could one detect the hints of vice: the pointed ears and the tail emerging unwillingly.[26] Maffei claimed that this tail was a modern addition and professed to discern in the hair the remains of a crown which together with the tiger skin upon which the figure rested suggested that an intoxicated Bacchus was intended.[27] Winckelmann, aware of these attempts to elevate the figure's status, insisted that it was a Faun, adding that although its beauty could not, therefore, be of the highest ideal type it was sufficient to refute Watelet's theory that the Greeks conceived of these creatures as heavy and clumsy brutes.[28] Kotzebue's feeling that the pose was indecent was unusual,[29] but one modern authority refers to the coarseness of the features and 'has the impression that he is snoring'.[30]

It is curious that the *Faun* does not seem to have been reproduced as a small bronze in late eighteenth-century Rome at the very moment when its reputation was highest, but it was reproduced in biscuit by Volpato (Fig. 56),[31] and, later, as a decoration on the 'onyx' porcelain service produced by the Nymphenburg Factory in the mid-1830s.[32] The reluctance of the Barberini family to permit the duplication of their treasure and the difficulty of finding a suitable domestic setting for the sprawling figure may account for the scarcity of casts and full-scale copies. One plaster cast, however, apparently dating from the eighteenth century, survives in the Accademia at Bologna, and one marble copy was very famous—that which Edmé Bouchardon began to carve when at the French Academy in Rome in 1726. The model for this so delighted Cardinal Barberini that he wanted to keep for himself a plaster cast of it in addition to the original antique, and when the marble copy reached France in 1732 it was enthusiastically admired there as well.[33] In 1775 it was sold to the Duc de Chartres for whom Carmontelle was then planning, at the Parc Monceau, one of the most elaborate gardens of the late eighteenth century, and the *Faun* is illustrated (and so was probably at least intended) as an ornament of the Salle des Marroniers there.[34] This copy taken to the Musée Central des Arts, then to Saint-Cloud, then to the Luxembourg Gardens, is now in the Louvre.[35] Another large copy was designed to be placed, obviously with humorous intentions, in a Temple du Repos proposed for the Marquis de Marigny's estate at Menars.[36] In 1857 a large

gilt electrotype was made for the Russian court and installed in 1861 in the Grande Grotte of Peterhof.[37]

Unlike most other statues in our catalogue the *Faun* is still admired. For Robertson 'it is no doubt a fine copy or studio replica of a Pergamene bronze of the late third or early second century; or even an original creation of that time in marble'.[38]

1. Lavin, pp. 19, 132.
2. Pacetti MS., 30 [July] 1799; Kotzebue, III, pp. 89–90.
3. *Ibid.*
4. Kotzebue, III, pp. 89–90; Pölnitz, pp. 58–9.
5. Pölnitz, p. 106.
6. *Ibid.*, pp. 106–11.
7. *Kunstblatt*, Vol. 58, 1827, p. 229; Pölnitz, p. 238.
8. Lavin, p. 133.
9. Teti, pp. 182–4, plate 215; Lavin, p. 133 (nos. 81–2).
10. Paul, J., pp. 90–3 (citing a paper read by Jennifer Montagu).
11. *Ibid.*
12. Maffei, plate XCIV.
13. Dean Paul collection, Miami.
14. Pacetti MS., 6 July, and 22 [August] 1799—see also 26 September 1799. Honour, 1960, p. 177; Paul, J., pp. 90–3 (citing a paper read by Jennifer Montagu).
15. Private collection, West Germany.
16. Lumbroso, p. 177.
17. Winckelmann (*Briefe*), I, p. 257.
18. Sade, p. 327; cf. Gray, T. (ed. Mitford), IV, pp. 280–1; Starke, 1800, II, pp. 34–5, note.
19. Burney, p. 153.
20. Piozzi, p. 287.
21. Urlichs, L., p. 26.
22. Pölnitz, p. 57.
23. [Croker], p. 544.
24. Winckelmann (ed. Fea), II, pp. 378–9, 420.
25. Beckford, II, p. 152.
26. Teti, pp. 182–3.
27. Maffei, plate XCIV.
28. Watelet, p. 74; Winckelmann (ed. Fea), I, p. 293.
29. Kotzebue, III, pp. 89–90.
30. Bieber, p. 112.
31. Molfino, II, plate 94.
32. *Residenz München*, p. 36, plate 23.
33. Montaiglon (*Correspondance*), VII, pp. 270, 286, 291; VIII, pp. 118–19, 309.
34. *De Bagatelle à Monceau*, no. 42.
35. Lami, 1910–11, I, p. 104.
36. Mosser, plate 8.
37. Znamenov, p. 349 (no. 114).
38. Robertson, I, p. 534.

34. Dancing Faun (Fig. 106)

FLORENCE, UFFIZI (TRIBUNA)

Marble
Height: 1.43 m
Also known as: Faun with clappers, Faun with crotale, Medici Faun, Le Petit Faune

The first known record (and schematic reproduction) of this statue occurs in a book on Roman costume by Rubens's son Albert published in 1665, eight years after his death: it is there mentioned as being in the collection of the Grand Duke of Tuscany in Florence.[1] About three years later it was engraved by Jan de Bisschop who wrote that it was in the Villa Borghese, but he was almost certainly relying on some other draughtsman for his copy and his information, and he acknowledged that Rubenius had said that it was in the Grand Duke's collection in Florence.[2] In 1684 it is recorded (in a letter about Foggini who was then working in Florence) as being in the 'Cabinet de Son Altesse'[3] (Grand Duke Cosimo III of Tuscany); and by 1688 it was certainly in the Tribuna of the Uffizi.[4] In September 1800 it was sent with other treasures to Palermo to escape the French, but it was returned to the Tribuna in February 1803.[5]

In 1695 the Florentine sculptor Massimiliano Soldani wrote to Prince Liechtenstein that the 'Faun is the most beautiful statue to be seen';[6] for the young Goethe a cast of the *Faun* in Leipzig was the first example of ancient sculpture that he had come across, 'dancing for joy, clashing his cymbals', and years later he could still clearly visualise its every detail;[7] in 1817 the ultra-critical Scotch surgeon John Bell wrote that it 'is perhaps the most exquisite piece of art of all that remains of the ancients'.[8] Like the *Venus de' Medici*, near which it stood in the Tribuna and with which it was so frequently paired in copies, the *Faun* emerged in the seventeenth century from complete obscurity—but probably not from under the ground—to win universal and lasting admiration; and unlike many of the works in our catalogue its reputation remains high.

Though the *Faun* was not (as was implied as early as 1704)[9] taken to Florence from the Villa Medici in Rome with the *Venus*, the *Arrotino* and the *Wrestlers*, it is possible that it was removed on some earlier, unrecorded, occasion. It is, for instance, worth drawing attention to the description of 'a nude, standing Faun, who looks as if he is dancing, but the arms and head are modern', which in 1556 belonged to a papal official, Eurialo Silvestri, whose collection passed to a branch of the Medici family.[10] Two other versions of the statue were excavated in Rome apparently in the 1630s and were very highly thought of. They were sold to Mazarin[11] and became well known in France.[12] The 'Faune qui danse' which Bernini so much admired when he was in Paris in 1665 was almost certainly one of these (on another occasion he mentioned

both),[13] and the fact that, despite the relish with which he liked to compare the relatively few antique sculptures to be seen in France with those that abounded in Italy, he failed to mention the Florentine 'original' suggests that he did not know of it any more than had the very well-informed Cassiano dal Pozzo who had recorded the discovery of the 'Faune Mazarin'.[14] Thus the inference from the evidence at present available is that the Uffizi statue had indeed (as was claimed in the eighteenth century)[15] long been in Medici possession (though possibly in one of their country houses and not in Rome), but that its exceptional quality was only fully appreciated in the last decades of the seventeenth century when the whole collection was being re-organised with the help of sculptors from Rome such as Ercole Ferrata whose knowledge and understanding of ancient art was far greater than that of anyone in Florence.

As was the case with many other works, the *Faun* was traditionally held to have been restored by Michelangelo who supposedly provided the head and the arms—and these additions greatly added to the fascination exerted by the statue.[16] Though this attribution is almost certainly wrong, these modern features are of very high quality and may well date from the sixteenth century:[17] this at least could be confirmed (and hence add to our knowledge of the *Faun*'s history) if we could trace the lost picture painted by Alessandro Allori in 1564 for the church of S. Lorenzo on the occasion of the memorial service held in honour of Michelangelo, for among the great artists depicted there as paying homage to him was Praxiteles, identified, so we are told, by an exact copy of the Uffizi *Faun*.[18]

Visitors to the Tribuna enthusiastically em-phasised the 'thoughtless, pleasing folly . . . in the countenance, [the] strength and agility in the limbs',[19] but the *Faun* also provided plenty of opportunities for the learned to speculate on the nature of music making in the ancient world. Montfaucon commented that it would be hard to judge what sort of harmony would be pro-vided by the simultaneous playing of the 'crot-ala' (in the hands) and the 'scabellum' or 'crou-pezion' (under the right foot).[20] Dr. Burney later pointed out that the former were similar to the cymbals (which he had seen and heard at Figline) introduced from Turkey into the Prussian, and then the Florentine, army—'but the cymbalists have all deserted, and at present this instrument is not used by the troops here'.[21]

Foggini made a mould, and then a marble copy, of the *Faun* for Versailles (where it remains today) in 1685–6,[22] and ten years later Soldani began a full-scale bronze version for Prince Liechtenstein.[23] In 1708 Foggini produced a cast for the Elector Palatine's gallery at Mannheim,[24] and in 1710 Soldani also returned to the *Faun* to provide a bronze for the Duke of Marlborough which still remains at Blenheim (Fig. 33).[25] It is not surprising that in 1722 Richardson (who considered that the figure was 'take it all to-gether, the best in the Tribunal') noted that it had 'been changed in two or three places by Mould-ing, especially the Face, which is the reason that none are allow'd to be taken off now'.[26]

The *Faun*, however, continued to be repro-duced in a wide variety of sizes and materials throughout the eighteenth and much of the nineteenth century, often (as has been said) as a pair with the *Venus* whose popularity it rivalled—and sometimes surpassed as far as the cognoscenti were concerned. Simon Vierpyl made a marble for Wentworth Woodhouse in Yorkshire in 1751;[27] there is a small terracotta high relief by Paolo Spinazzi, son of the chief restorer of sculpture of the Grand Duke's col-lections, dated 1781 in the David Carritt col-lection in London; there are examples in Doccia porcelain at the Museo di Doccia (Sesto Fioren-tino) and elsewhere;[28] small bronzes were made by Zoffoli and Righetti;[29] intaglios by Wedg-wood[30] and by Marchant.[31] Most surprising of all is the cream-coloured earthenware centre-piece modelled by Antonio Agostinelli for the Nove works at Bassano del Grappa in the late eighteenth century in which the *Faun* is sur-rounded by barrels of wine and bunches of grapes and tipsy putti with musical instru-ments.[32]

Numismatic evidence suggested to Klein in the first decade of this century that the *Faun* was conceived of as part of a group, and was neither dancing nor playing the cymbals, but clicking his fingers and inviting a seated nymph, who adjusts her sandal, to dance:[33] the best-known copy of such a nymph is also in the Uffizi,[34] and this one and others were imitated in a number of sixteenth-century bronzes.[35] The theory is now accepted, though it has been acknowledged that the relationship between the two figures must have been a tenuous one and that they may have been copied separately.[36] The *Faun* is catalogued by Mansuelli as a third-century copy of a bronze original.[37]

106. *Dancing Faun* (Uffizi).

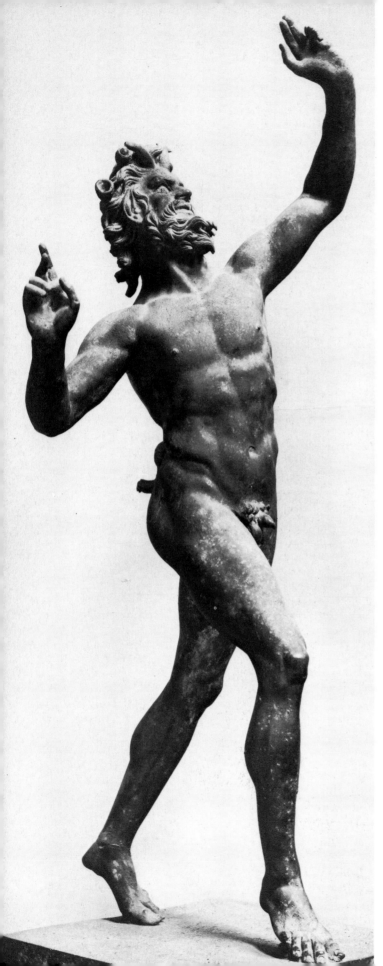

1. Rubenius, p. 187.
2. Episcopius, plates 1–3.
3. Alazard, p. 134.
4. Baldinucci, II, pp. 497–8 (life of Buontalenti, first published in 1688).
5. Florence, AGF, Filza XXX, 1800–1801, n. 23; Paris, Archives Nationales: F²¹ 573 (letter from L. Dufourny to Minister of the Interior, 9 fructidor, an 9); *Galerie Impériale*, p. 10.
6. Lankheit, p. 329 (doc. 645).
7. Goethe, XXXII, p. 324 (*Italienische Reise*).
8. Bell, J., p. 282.
9. Maffei, plate XXXV (caption to plate).
10. Aldrovandi, 1556, p. 278; Lanciani, 1902–12, II, p. 212.
11. Lumbroso, p. 178.
12. They were engraved by Mellan in 1671 in the anthology published in [Félibien] in 1679, plates XIV, XV. The latter, which is much closer to the Uffizi statue, is also reproduced by Thomassin, plate 24—it is still at Versailles (Salle des Hocketons).
13. Chantelou, pp. 116, 214.
14. Lumbroso, p. 178.
15. Gori, 1734, p. xii; Bencivenni Pelli, II, pp. 9–10, note viii.
16. Montesquieu, II, p. 1335 (*Voyage en Italie*); Caylus, 1914, p. 315.
17. Mansuelli, I, p. 80.
18. Maffei, plate XXXV, claims to have seen this picture which is described in Vasari, VII, pp. 306–7.
19. Corke and Orrery, p. 76.
20. Montfaucon, 1719, I, ii, p. 253.
21. Burney, pp. 110–11.
22. Alazard, pp. 134–5, 140.
23. Lankheit, pp. 143–5.
24. Lankheit, pp. 145, 272 (doc. 280).
25. Ciechanowiecki and Seagrim.
26. Richardson, 1722, p. 57.
27. This is signed and dated Rome (*sic*) 1751.
28. Ginori Lisci, 1963, p. 162.
29. Zoffoli, Righetti (see Appendix).
30. Wedgwood, 1779, class I, section II, no. I.
31. Marchant, p. 16.
32. Victoria and Albert Museum, 343–1905.
33. Klein.
34. Mansuelli, I, pp. 80–2.
35. See the Girolamo da Cremona in the Wallace Collection—Mann, p. 30.
36. Mansuelli, I, p. 81; Robertson, I, pp. 560–1.
37. Mansuelli, I, pp. 80–2.

35. Dancing Faun (Fig. 107)

NAPLES, MUSEO NAZIONALE

Bronze
Height: 0.71 m
Also known as: The Faun

The *Faun* was discovered at Pompeii on 26 October 1830 and dug up on the following morning.[1] It was at once taken to the Museo Borbonico (later Museo Nazionale).[2]

The fame of this small bronze was instantaneous. It gave its name to the house in which it had been found and its first cataloguer described it as the finest bronze to have been excavated at Pompeii and compared it to the *Barberini Faun*.[3] With even greater enthusiasm an English traveller of

107. *Dancing Faun* (Museo Nazionale, Naples).

1838 could declare that it was 'only not the most wonderful statue in the world because a faun is not the most wonderful creation in the world . . . It is, however, the Venus de Medicis of Sylvans begging pardon of the gender.'[4] Its reputation remained constant as the century progressed and was undoubtedly enhanced by its small scale which made copies particularly attractive for modest gardens and interiors. Owners of these must have been reassured by an early twentieth-century catalogue of the Naples museum which pointed out that the *Faun* was ecstatic and not in the intoxicated condition of various other bronze Fauns from Herculaneum and Pompeii[5] —one of these, life-size, was especially admired in the eighteenth century.[6]

Robertson has recently stated that this 'is certainly a copy of a Hellenistic work, possibly, as is sometimes asserted, of one from the pioneer circle [of Lysippus's pupils], but it may have been later'.[7]

1. *Bullettino dell'Instituto di Corrispondenza Archeologica per l'anno 1831*, 1831, pp. 19, 25.
2. 'Relazione degli scavi di Pompei' in *Real Museo Borbonico*, VIII (1832), p. 7 and IX (1833), plate XLII.
3. *Ibid.*
4. *Notes on Naples*, p. 174.
5. Ruesch, pp. 201–2, 209.
6. Burney, p. 189.
7. Robertson, I, p. 477.

36. The Marble Faun (Fig. 108)

ROME, MUSEI CAPITOLINI

Marble
Height: 1.705 m
Also known as: The Faun of Praxiteles

The statue is illustrated in Bottari's catalogue of the Capitoline Museum published in 1755,[1] and an inscription on the base records that it was given to the museum by Pope Benedict XIV in 1753. It is thus probably one of the fourteen statues bought by the Pope in that year from the Villa d'Este[2] and it may be the Faun recorded in an Este inventory of 1572.[3] However, other provenances were also suggested.[4] In 1797 it was ceded to the French under the terms of the Treaty of Tolentino[5] and it reached Paris in the triumphal procession of July 1798.[6] It was displayed in the Musée Central des Arts from its inauguration on 9 November 1800.[7] It was removed in October 1815,[8] arrived back in Rome in the first half of 1816, and during the course of the year it was returned to the newly reorganised Capitoline Museum.[9]

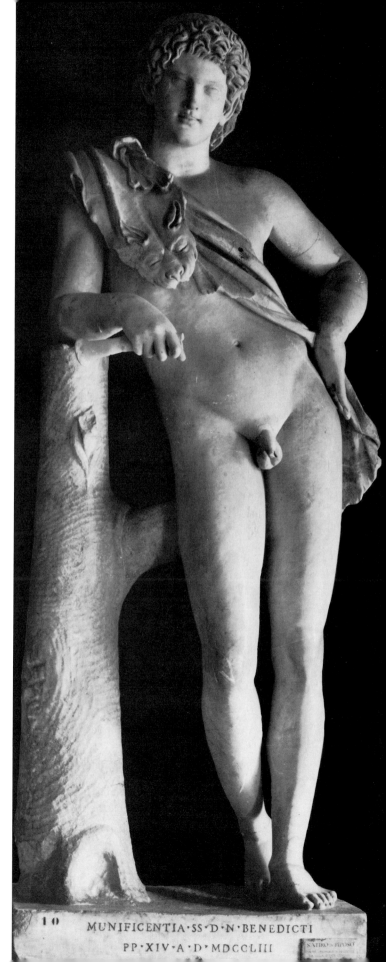

108. *Marble Faun* (Capitoline Museum).

The great uncertainty about the whereabouts of this statue before 1753 is indicative of the lack of interest shown in it (if indeed it was known at all), though in the middle years of the seventeenth century a rather similar Faun in the Giustiniani collection (now in the Museo Torlonia)[10] had been very highly admired, being engraved as 'Faunus meditans' in Perrier's anthology of the most famous statues in Rome[11] and being cast in bronze for Philip IV of Spain.[12] Nor did the present *Faun* at first attract much attention even when it could be seen in the Capitoline Museum. Bottari (who catalogued the sculptures there) made virtually no comment, and, although Winckelmann probably had it in mind when, during the course of a discussion on fauns and satyrs in ancient art, he pointed out that the fact that 'there are in Rome more than thirty statues, similar to each other in pose and attitude, of a young Satyr probably means that these are all copies of the famous Satyr of Praxiteles',[13] we cannot be quite sure for—as Heyne rather cuttingly noted[14]—'he does not say what is the pose or attitude in question'. It is, in any case, significant that Winckelmann did not bother to single out the Capitoline *Faun* in his published writings, and when commenting on it in private he noted that it was not more beautiful than the similar Giustiniani Faun[15]—a view with which some modern scholars have concurred.[16]

Visconti agreed that Winckelmann's hypothesis was 'highly probable'[17] and he much admired the statue.[18] Lalande, on the other hand, found it mediocre.[19] In these circumstances it is perhaps surprising that the French should have taken it for the Musée and the fact that they called it 'Le Faune jouant de la flûte' in their first list of demands made in 1796[20] before their commissioners had reached Rome suggests that they were then not quite clear about its appearance. The *Faun* was probably chosen more for its art historical significance than for its intrinsic beauty, and indeed early in the nineteenth century an attribution to Praxiteles himself came to be more and more accepted—'I know not on what authority', commented Mrs. Jameson after her visit to Rome in 1821–2.[21] With the attribution came growing popularity, but its real celebrity was inspired by other considerations. On 22 April 1858 Nathaniel Hawthorne became 'sensible of a peculiar charm in it: a sylvan beauty and homeliness, friendly and wild at once . . . This race of fauns was the most delightful of all that antiquity imagined. It seems to me that a story, with all sorts of fun and pathos in it, might be contrived on the idea of their species having become intermingled with the human race; a family with the faun blood in them having prolonged itself from the classic era till our own days.'[22] *The Marble Faun* was published in 1860 and the fame of this statue soon became world-wide, as the theme of the novel was taken up (in ways that would have surprised Hawthorne) by generations of writers, painters and photographers who flocked to Italy to admire the beauty of uninhibited pagan youths. As early as 1871 Augustus Hare quoted from Hawthorne's description of the *Faun* of Praxiteles which he ranked with the *Gladiator* and the *Antinous* as one of the three gems of the Capitoline collection,[23] thus reflecting and further promoting the enthusiasm with which this statue was regarded by travellers.

During the excavations carried out by Napoleon III on the Palatine, a torso was found (now in the Louvre) which for a brief period enjoyed great fame as the original on which were supposed to have been based all the many known versions of this figure.[24]

The Capitoline *Faun* is catalogued in Helbig as a Hadrianic copy of a Greek statue of the time of Praxiteles without any necessary connection with the artist himself.[25]

1. [Bottari], plate XXXII.
2. Ashby, 1908, pp. 235, 255.
3. Stuart Jones, 1912, pp. 350–1.
4. Carlo Fea said that it was found on the Aventine in 1749—Fea, 1790, p. clxiv, note e; the cataloguers of the Musée Central des Arts claimed that it had been excavated in 1701 at Lanuvium (Civita Lavinia) where Marcus Aurelius had owned a country house—*Notice*, An XI (1800), p. 2.
5. Montaiglon (*Correspondance*), XVI, pp. 464, 498.
6. Blumer, pp. 241–9.
7. *Notice*, An IX (1800), pp. 1–2.
8. Saunier, p. 149.
9. Either in the consignment of statues which arrived on 4 January (*Diario di Roma*, 6 January 1816) or among those which had reached Civitavecchia from Antwerp by 19 June on H.M.S. *Abundance* (*ibid.*, 19 June 1816); Stuart Jones, 1912, p. 8.
10. Helbig, 1963–72, IV, p. 257.
11. Perrier, 1638, plate 45.
12. Harris, E., pp. 119–20, plate V.
13. Winckelmann (ed. Fea), I, p. 292 (alluding to Pliny, XXXIV, 69).
14. Heyne (*Faunes*), pp. 75–6, note 1.
15. Winckelmann (*Briefe*), IV, p. 23.
16. Rizzo, p. 34.
17. Visconti (*Monumenti Borghesiani*), plate XXI, no. 3.
18. Visconti (*Museo Pio-Clementino*), II, plate XXX.
19. Lalande, IV, p. 183.
20. Montaiglon (*Correspondance*), XVI, p. 464.
21. [Mrs. Jameson], p. 147.
22. Hawthorne, pp. 172–3.
23. Hare, 1871, I, p. 109.
24. Brunne, II, pp. 392ff.
25. Helbig, 1963–72, II, pp. 234–6.

37. Faun with Kid (Fig. 109)

MADRID, PRADO

Marble
Height: 1.36 m
Also known as: Chasseur de la Reine de Suède,
 Cyparisse, Petit Faune d'Espagne, Queen of
 Sweden's Faun

In a memorandum of 1676 the Oratorians listed, among the antiquities which had been found during the opening of a road adjoining the Chiesa Nuova in the two previous years and which had subsequently been sent to the sculptor Ercole Ferrata, 'a torso of a statue representing a young satyr without arms and without one foot which was sold to the Queen of Sweden'.[1] Pietro Santi Bartoli, the antiquarian, draughtsman and engraver who died in 1700, referred in a note to 'the very beautiful Faun which was acquired by the Queen of Sweden and restored by Ercole Ferrata' and said that it had been found during the opening of a new road adjoining the Chiesa Nuova;[2] later writers wrongly assumed that the statue must have been discovered during the building of the church itself which took place just a hundred years earlier in 1575.[3] It is listed in an inventory of the Queen of Sweden's antiquities probably drawn up before her death in 1689;[4] it was bequeathed with the rest of her collection to Cardinal Azzolini who died a few weeks later and whose heir, Marchese Pompeo Azzolini, sold most of its contents in 1692 to Don Livio Odescalchi, nephew of Pope Innocent XI and (from 1693) Duke of Bracciano. Don Livio died in 1713, and his cousin and heir Baldassare d'Erba (who assumed the name Odescalchi) sold the *Faun* with the other antiquities to Philip V of Spain on 4 September 1724.[5] It was kept in the country palace of San Ildefonso until 1839 when it was taken to the Prado.[6]

From the description of the *Faun* when discovered it is apparent that Ferrata's restorations were extensive, but—as so often both in Rome and Florence—he showed remarkable flair for making just the kind of attractive additions to a mutilated statue which most appealed to connoisseurs. The *Faun* was copied both for Versailles (the copy is still there) by Anselme Flamen in 1685–6[7] and for Marly by Le Pautre.[8] In 1704 it was included in de Rossi's anthology of the most admired statues,[9] and in 1719 'one of the best sculptors in Rome' copied it for Peter the Great.[10] While still in Rome it was always singled out for praise by visitors to the Odes-

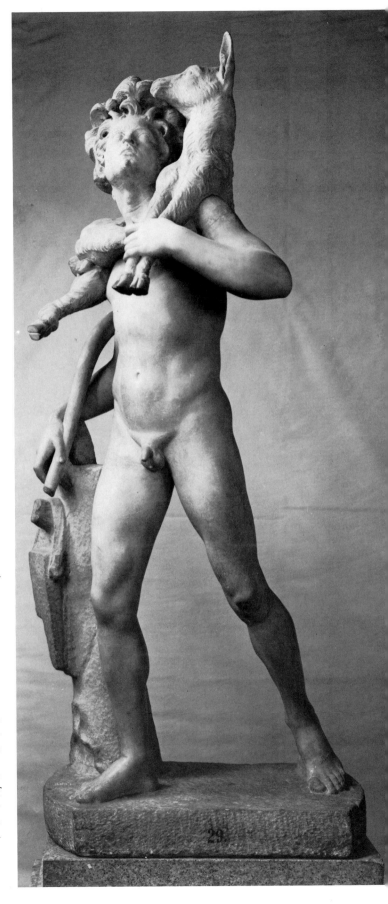

109. *Faun with Kid* (Prado).

calchi collection[11] and its reputation remained high in the city long after the Pope had been prevailed upon to allow its export. This was due largely to the existence of a plaster cast in the French Academy; in 1732, after this had been accidentally destroyed, Wleughels, the director, counted himself lucky to be able to find another which he immediately bought.[12]

The Royal Academy in London had acquired one by 1781, but the guide to the collections was unclear whether the original had survived and, if so, where it was kept and how much of it was modern work.[13] The *Faun* was often copied, both full-scale (in lead—reversed—at Chatsworth (Fig. 41), and in gilded bronze in 1817 for the gardens at Peterhof from a model by Martos)[14] and reduced in size (as in a marble statuette about three feet high also at Chatsworth in Derbyshire which is signed by Isidoro Franchi, a pupil of Foggini). Tiepolo included a marble copy of the statue in a garden setting in his 'Triumph of Flora' of 1743 (De Young Memorial Museum, San Francisco), and a plaster cast is among those which were placed (probably in the eighteenth century) in the gallery of the Palazzo Sacchetti in Rome.[15] Another cast was recorded in 1770 among those in the gallery opened twelve years earlier by the Duke of Richmond in Whitehall,[16] and one still adorns Goethe's house in Weimar.[17] The *Faun* was also reproduced in biscuit de Sèvres[18] and, frequently, as a bronze statuette. There are superb examples in Paris[19] and Florence[20]—the former is signed by Soldani, and the latter is almost certainly the one which this sculptor is known to have made for the Grand Prince Ferdinand de' Medici and which was noticed by Lalande in the Uffizi.[21] The bronze statuette sold by Righetti in the late eighteenth century refers to the original as being in the Capitoline collection,[22] and it therefore seems likely that a cast was kept there.

The idea that the statue represented Cyparissus (the son of Telefos who inadvertently killed his favourite stag and was metamorphosed into a cypress) which was favoured by the French in the late seventeenth and early eighteenth centuries was evidently based on a misinterpretation of the animal carried, encouraged perhaps by the fact that Flamen (who copied the *Faun*) also executed a statue, based on a small model by Girardon, of Cyparissus for Versailles.[23]

The *Faun* has been catalogued by Blanco as a second-century Roman copy of a bronze original of the early third century B.C., perhaps of the Pergamene school.[24]

1. Corbo, pp. 181, 184.
2. Bartoli, Mem. 68.
3. Lanciani, 1902–12, IV, p. 68.
4. Boyer, 1932 ('Christine de Suède'), p. 266 (no. 116).
5. *Documenti inediti*, IV, p. 336; Montaiglon (*Correspondance*), VII, p. 59; *Christina Queen of Sweden*, pp. 433–4, 438.
6. Blanco, p. 8.
7. Montaiglon (*Correspondance*), I, pp. 162–3; Souchal, 1977, p. 283.
8. Louvre, MR 1808.
9. Maffei, plate CXXII.
10. Neverov, p. 46—the copy can no longer be traced.
11. Richardson, 1722, p. 167; Wright, I, p. 310; Caylus, 1914, p. 279.
12. Montaiglon (*Correspondance*), VIII, p. 390; IX, p. 252.
13. Baretti, p. 28.
14. Znamenov, p. 356 (no. 191).
15. Salerno, Spezzaferro and Tafuri, fig. 215.
16. Edwards, 1808, p. xvii (no. 21).
17. Erlich, p. 15.
18. Bourgeois, p. 8 (no. 292).
19. Musée Carnavalet, H. Bouvier collection.
20. *Twilight of the Medici*, p. 112 (no. 73).
21. Lalande, II, p. 193; Honour, 1963, plate 3.
22. Righetti (see Appendix)—'Faon du Capitole ayant un Chevreau sur les épaules'.
23. Souchal, 1977, I, p. 283 (no. 23).
24. Blanco, p. 33.

38. The Faun with Pipes (Fig. 110)

PARIS, LOUVRE

Marble
Height: 1.25 m
Also known as: Faun playing on a fife, The Little Fluter, Le Petit Faune, Piping Faun

The *Faun* was certainly in the Villa Borghese by 1638.[1] It remained there until 27 September 1807 when it was purchased, together with the bulk of the Borghese antiquities, by Napoleon Bonaparte, brother-in-law of Prince Camillo Borghese.[2] It was sent from Rome between 1808 and 1811[3] and was displayed in the Musée by 1815.[4]

The fame of this statue in the seventeenth century, already suggested by its presence in Perrier's anthology of the most admired statues in Rome in 1638,[5] is supported by the fact that it was copied for Louis XIV by both Simon Hurtrelle and by Jean-Baptiste Goy.[6] In the eighteenth century it was frequently admired by travellers[7] and frequently reproduced—in engravings,[8] in grisaille decorations,[9] in plaster casts,[10] in artificial stone,[11] and on a Wedgwood tablet four inches by three.[12] Towards the end of the century, however, there were critics of the work[13] and it is not to be found among the sculptures listed by the French as the most valuable items in the Borghese collection.[14] By the early nineteenth century scholars were increasingly aware that there were other antique

statues of the same type.[15] Another Faun, the *Marble Faun* in the Capitoline, was attracting more attention on account of its supposed reflection of an original by Praxiteles, and similar claims were soon made for the *Faun with Pipes*.[16] However, Visconti's suggestion that it might be related to a famous painting of a Faun by Protogenes described by Strabo[17] was more likely to intrigue the scholar than dazzle the visitor to the Villa Borghese or the Louvre.

The *Faun* in the Louvre is today the most reproduced and among the less disparaged of the twenty or so examples of this type of statue all of which are considered to be Roman copies of a bronze original of the second half of the fourth century—Robertson has suggested that the original was perhaps the one in Athens by Lysippus mentioned by Pliny.[18]

1. Perrier, 1638, plate 48.
2. Boyer, 1970, p. 202.
3. Arrizoli-Clémentel, pp. 13–14, note 60.
4. *Notice*, supplément, 1815, p. 26.
5. Perrier, 1638, plate 48.
6. Thomassin, plate 44; Lami, 1906, p. 222.
7. E.g. Northall, p. 353.
8. Montelatici, facing p. 301; Maffei, plate LXXX; Brigentius, facing p. 83.
9. Great staircase, Houghton Hall in Norfolk.
10. Harris, C., p. 3; Baretti, p. 21.
11. Coade, 1777–9, plate 5; Coade, 1784, p. 3 (a 'Piping-Boy').
12. Wedgwood, class II, no. 45.
13. E.g. Falconet, I, p. 239.
14. Boyer, 1970, p. 200.
15. Examples at Holkham (Brettingham, 1773, p. 4; Michaelis, 1882, p. 305), and in the Capitoline Museum (Stuart Jones, 1912, p. 93).
16. *Notice*, supplément, 1815, p. 26.
17. Visconti (*Monumenti Borghesiani*), plate XII (no. 3).
18. Robertson, I, p. 468 (citing Pliny, XXXIV, 64).

39. Faun in Rosso Antico (Fig. 111)

ROME, MUSEI CAPITOLINI

Rosso Antico
Height: 1.68 m

The *Faun* is described in 1741 as having been excavated five years earlier,[1] and all early sources agree that it was found at Hadrian's Villa.[2] It was given to the Capitoline Museum by Benedict XIV in 1746. In 1817 it was placed in a room which was specially named after it.[3]

The description of the *Faun* in 1741 comes in an appendix consisting of a miscellany of extracts from earlier published sources, chiefly from Francesco Ficoroni. The context clearly implies that it was excavated by monsignor Furietti,[4] but it seems unlikely ever to have belonged to him,

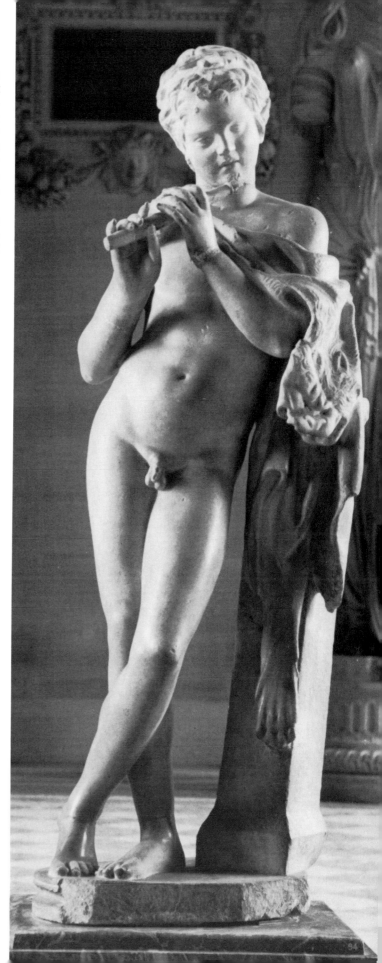

110. *Faun with Pipes* (Louvre).

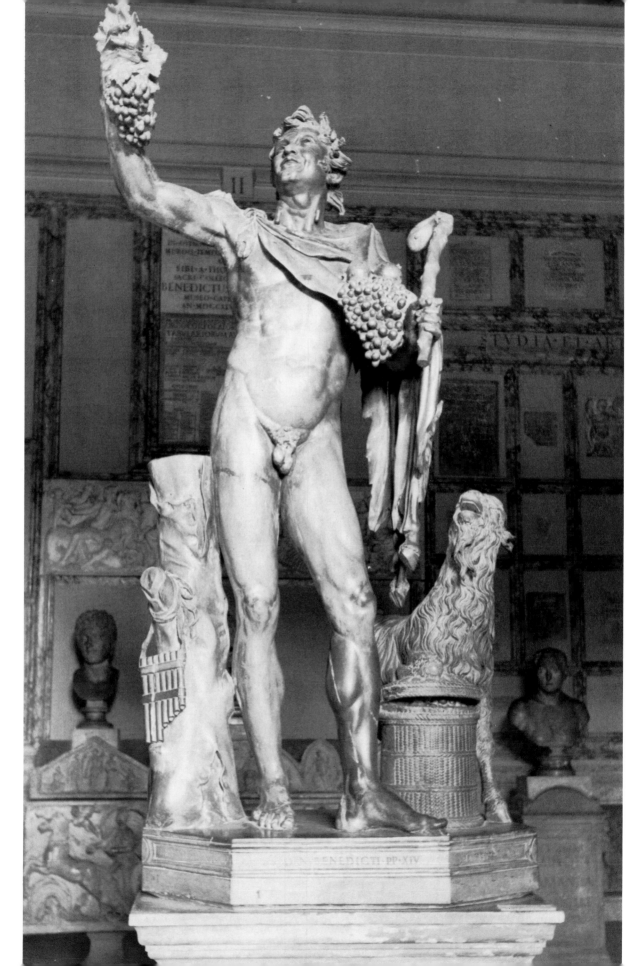

for he was always keen to publicise his possessions—above all the *Centaurs* and a mosaic of pigeons, both from Hadrian's Villa—but he never refers to this. Moreover, Ficoroni does not mention the *Faun* in his account of Furietti's collection in 1744[5] and the mid-eighteenth-century catalogues of the Capitoline Museum which in other cases refer to Furietti provenances do not mention that this once belonged to him.[6]

The reputation of the *Faun* was partially dependent on the particularly admired variety of close-grained dark-red marble out of which it was made. This marble was seldom found in large pieces and no other full-size figures made of it were then known.[7] Travellers and cataloguers of the Capitoline Museum were also enthusiastic about the quality of the carving,[8] and so too were the museum officials of the early nineteenth century who removed the previously much esteemed Hercules and Hydra from a specially named room to award that honour to the *Faun* instead[9]—thus anticipating the later taste for the less heroic themes of classical art—and Mrs. Starke, author of one of the most popular travel books of the time, who awarded it more exclamation marks[10] than the *Wolf*, the *Brutus* or the *Furietti Centaurs*. The *Faun* was also copied full size in marble by Cavaceppi[11] and on a reduced scale in bronze by Righetti and Zoffoli (Fig. 53).[12] But Lalande[13] and Ramdohr[14] were respectful rather than enthusiastic about it; Winckelmann does not mention it; the French did not remove the statue to Paris; and Visconti only referred to it in passing when discussing a similar but better preserved Faun in the Museo Pio-Clementino which had also been discovered at Hadrian's Villa.[15] Despite its special room few travellers in the mid-nineteenth century were much attracted by it. Even Nathaniel Hawthorne who was so taken by 'these strange, sweet, playful, rustic creatures' seems hardly to have noticed it, so obsessed was he by the *Marble Faun* in the same room.[16] However, a gilt electrotype was made for the Russian court in 1857 and installed in the Grande Grotte at Peterhof in 1861,[17] and Taine stressed the 'charming good humour and total lack of vulgarity' of the *Faun* when illustrating how 'in antiquity physical joy is not degraded as with us, relegated to workmen, bourgeois and drunkards!'[18]

The *Faun* is catalogued in Helbig as a copy possibly made in the workshops of Aristeas and Papias (authors of the *Furietti Centaurs*) of a bronze original.[19]

1. *Roma Antica*, I, 1741, p. 271 ('Ficoroni').
2. [Russel], II, p. 55; [Bottari], plate XXXIV; Cavaceppi, I, plate 28.
3. Stuart Jones, 1912, p. 309.
4. *Roma Antica*, I, 1741, p. 271 ('Ficoroni').
5. Ficoroni, 1744 (*Singolarità*), p. 64.
6. [Lucatelli], 1750, p. 61; [Bottari], plate XXXIV.
7. [Lucatelli], 1750, p. 61.
8. [Russel], II, p. 55; Northall, pp. 147–8; [Lucatelli], 1750, p. 61; [Bottari], plate XXXIV; Rossini, 1771, I, p. 26.
9. Stuart Jones, 1912, p. 309.
10. Starke, 1820, p. 276.
11. Cavaceppi, I, 1768, plate 28.
12. Righetti, Zoffoli (see Appendix). An example signed by the latter is in Schloss Wörlitz (Honour, 1963, plate I). See also *Johan Zoffany*, no. 56.
13. Lalande, IV, p. 181.
14. Ramdohr, I, pp. 241–2.
15. Visconti (*Pio-Clementino*), I, plate XLVI.
16. Hawthorne, p. 167.
17. Znamenov, pp. 177, 349 (no. 114).
18. Taine, I, p. 126.
19. Helbig, 1963–72, II, p. 226.

40. Capitoline Flora (Fig. 112)

ROME, MUSEI CAPITOLINI

Marble
Height: 1.68 m
Also known as: Sabina, Polyhymnia

The statue is mentioned in December 1744 as having just been placed in the Capitoline Museum after being bought by the Pope from the private owner on whose estate it had been discovered.[1] Francesco Ficoroni, who died in 1747, wrote in some notes (posthumously published ten years later) that 1744 was the date of the statue's discovery which—he said—had taken place at Hadrian's Villa,[2] and this was repeated by the first cataloguer of the museum in 1750[3] and by Bottari in 1755.[4] It remained in the Capitoline Museum until 1797 when it was ceded to the French under the terms of the Treaty of Tolentino[5] and it reached Paris in the triumphal procession of July 1798.[6] It was displayed in the Musée Central des Arts from its inauguration on 9 November 1800.[7] It was removed in October 1815[8], arrived back in Rome in the first half of 1816, and was returned to the newly rearranged Capitoline Museum during the course of the year.[9]

This statue became popular very quickly. In December 1744, within months of its discovery, Jean-François de Troy, director of the French Academy in Rome, wrote that it was 'undeniably one of the most beautiful draped figures in Rome' and he was asked by the Pope for a cast of it in addition to the one that he was encouraged to make for the Academy.[10] Bottari also praised

111. *Faun in Rosso Antico* (Capitoline Museum).

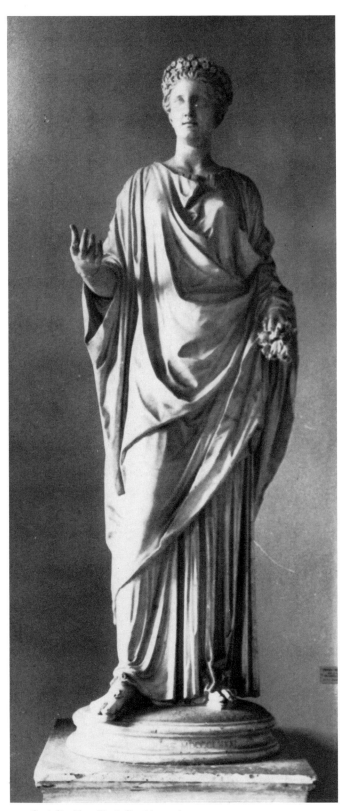

the drapery with enthusiasm and pointed out that the very fact that the *Flora* had been found at Hadrian's Villa suggested that it must be 'by some famous master': it was, he claimed, as worthy of esteem as the *Farnese Flora*, long one of the best-known statues in Rome.[11] Though Lalande noted that some people did not find the figure agreeable,[12] copies were in great demand almost as soon as it was discovered. In 1750 a full-scale marble version was carved by Filippo della Valle for Wentworth Woodhouse in Yorkshire[13], and a little later Brettingham supplied a cast for Holkham Hall in Norfolk.[14] In 1767 John Cheere supplied another (now in the Los Angeles County Museum)[15] for Croome Court in Worcestershire and by 1770 there was yet another in the select collection in the Duke of Richmond's art academy at his house in Whitehall.[16] Both Zoffoli and Righetti provided bronze statuettes,[17] and one such by the former, companion with the *Farnese Flora*, is to be found on the chimney-piece of the Saloon at Saltram in Devon.[18] A somewhat weathered copy may still be seen on the attic of the Philharmonic Hall, Islington, of 1860.

The figure's popularity was not matched by certainty about its exact significance, though scholarly discussions about this made little impact on the generally accepted name of 'Flora'. This had, however, been in doubt from the very first when we are told that 'some people called it Flora, some Sabina, and some someone else'.[19] Lucatelli supported the idea that the statue represented Sabina, the wife of Hadrian: he found that the head differed in style from the rest of the body and deduced that the statue was probably a portrait in which the sculptor would have 'had to conform to the truth of a face while in the other parts he could follow the more exact rules of the art'.[20] Bottari was anxious to clear the statue of disreputable associations with the courtesan Flora (much aired in connection with the Farnese sculpture) who had won the admiration of the Roman people by leaving to the Senate her ill-gotten earnings to found the floral games: these, he said, dated back to a much earlier period and in any case the goddess Flora herself could be identified with Venus.[21] Winckelmann, however, was scornful about the idea that the figure was Flora on the grounds that both the left hand and the flowers it held were modern restorations and as this garlanded statue lacked ideal beauty he proposed that it was the portrait of a beautiful girl represented as Spring.[22] Visconti changed his mind on a number of occasions. At one time

112. *Capitoline Flora* (Capitoline Museum).

216

he thought that the figure was the Muse Poly-hymnia,[23] but later he came to the conclusion that though the flowers were modern, nonetheless Ficoroni's comments on the state of the statue when excavated implied that they did replace badly damaged originals: if Flora herself was not represented, the figure might be Juno[24] (who, as he pointed out on another occasion,[25] had been presented with a flower by Flora). Visconti also discussed the drapery whose execution had always aroused admiration, but whose nature had caused some bewilderment, and he suggested that it was of silk, which was something of a novelty under the Roman emperors. This disposed of the idea that the statue could, as some people had proposed, be a copy or an imitation of a Flora by Praxiteles.[26]

The *Flora* is catalogued in Helbig as being possibly an eighteenth-century pastiche of an antique statue, or, if not, one whose drapery has been so reworked in the Baroque period as to make a convincing attribution impossible.[27]

1. Montaiglon (*Correspondance*), X, p. 77.
2. Ficoroni, 1757, p. 136.
3. [Lucatelli], 1750, pp. 46–7.
4. [Bottari], plate XLV.
5. Montaiglon (*Correspondance*), XVI, pp. 464, 498.
6. Blumer, pp. 241–9.
7. *Notice*, An IX (1800), pp. 5–6.
8. Saunier, p. 149.
9. Either in the consignment of statues which arrived on 4 January (*Diario di Roma*, 6 January 1816) or among those which had reached Civitavecchia from Antwerp by 19 June on H.M.S. *Abundance* (*ibid.*, 19 June 1816); Stuart Jones, 1912, p. 8.
10. Montaiglon (*Correspondance*), X, p. 77.
11. [Bottari], plate XLV.
12. Lalande, IV, p. 185.
13. Honour, 1959, p. 178.
14. Brettingham MS., pp. 94, 96; Brettingham, 1773, p. 2.
15. *The Man at Hyde Park Corner*, no. 79; Norman-Wilcox, p. 26, fig. 3.
16. Edwards, 1808, p. xvii.
17. Zoffoli, Righetti (see Appendix).
18. Honour, 1961, p. 205. There is another example in the Ashmolean Museum, Oxford.
19. Ficoroni, 1757, p. 136.
20. [Lucatelli], 1750, pp. 46–7.
21. [Bottari], plate XLV.
22. Winkelmann (ed. Fea), I, p. 323.
23. Visconti (*Pio-Clementino*), I, plate XXIII (p. 149).
24. Visconti (*Opere varie*), IV, pp. 101–4.
25. Visconti (*Pio-Clementino*), I, plate IV, p. 26.
26. Visconti (*Opere varie*), IV, pp. 101–4.
27. Helbig, 1963–72, II, pp. 239–40.

41. Farnese Flora (Fig. 113)

NAPLES, MUSEO NAZIONALE

Marble
Height: 3.42 m
Also known as: Courtesan, Dancer, Erato, Hope, Hour, Muse, Terpsichore

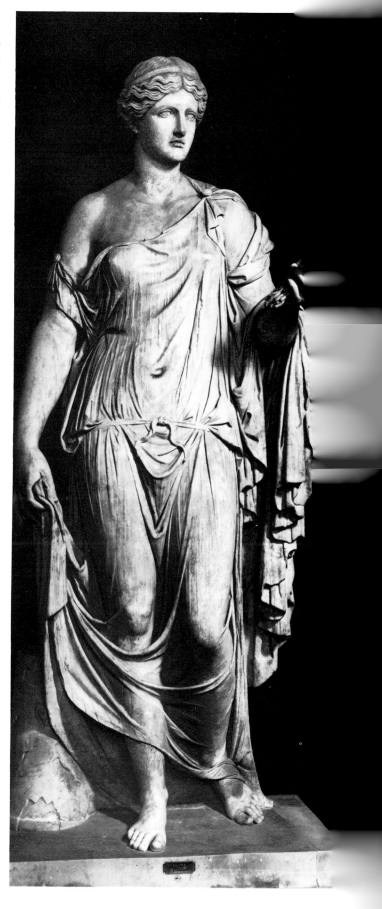

113. *Farnese Flora* (Museo Nazionale, Naples).

The statue is drawn three times from different angles together with another statue (also to be called a Flora and also now in Naples) by Heemskerck who was in Rome between 1532 and 1536.[1] In a text published in 1556 but based on notes made in Rome six years earlier, both statues still in an unrestored condition were recorded by Aldrovandi, as in the courtyard of the Palazzo Farnese, Rome.[2] The *Flora* is shown in a restored condition by Cavalleriis by 1561.[3] It remained in the palace courtyard until 30 June 1787 when it was removed to the studio of the Roman restorer Carlo Albacini who sent it on to Naples on 28 February 1800.[4] By 1805 it was in the Museo degli Studi (later Museo Borbonico, now Museo Nazionale).[5]

The unrestored statue was noted by Aldrovandi on account of its size but was not considered by him to be any more remarkable than the other colossal draped female torso displayed with it then, and, to judge from Heemskerck's drawings, more than a decade earlier.[6] Aldrovandi described both statues as Muses, but the second of the two, which had fruit and flowers in the fold of the dress, was renamed Flora, and the first (the *Farnese Flora*) was restored as her companion, so that there were a pair of Floras and a pair of Herculeses in the palace courtyard—popularly believed to be the results of competitions in antiquity between 'two perfect cunning masters'.[7] By the seventeenth century however the *Farnese Flora* and the *Farnese Hercules* had far surpassed their companions in fame. The tradition was established that they had been discovered together—although there is no evidence that the *Flora* was even found in the Baths of Caracalla—and Guglielmo della Porta who restored the *Hercules* was later credited with the restoration of the *Flora*.[8]

When Lord Elgin's chaplain, Dr. Philip Hunt, was astonished by the delicacy of the drapery of the pedimental statues of the Parthenon he could only liken it to that of the *Farnese Flora*, the beauty of which was proverbial.[9] To Maffei such drapery was clearly the transparent material appropriate for a courtesan, and he related the statue to the Flora who allegedly left her ill-gotten gains to the Senate to endow the games named after her and who was, according to the third-century Christian author Lactantius, honoured by the embarrassed Senate as a goddess.[10] Confusingly Aldrovandi had associated the same tradition with a head also in the Farnese collection.[11] This courtesan, however, was Roman and by 1755 some scholars believed that

the *Flora* was a statue by Praxiteles mentioned by Pliny.[12]

The restorations were criticised in the late eighteenth century,[13] and awareness of them led to speculation as to the statue's original identity. Winckelmann suggested Erato or Terpsichore (Muses of lyric arts), or one of the Hours, whilst Visconti revived a sixteenth-century idea that it was a personification of Hope.[14] Tagliolini, before 1819, exchanged the statue's chaplet for a nosegay, but this did nothing to change its identity[15] and in 1825 Finati remarked that 'Flora' was as good a name as any.[16]

Because of the colossal size, full-scale copies of the *Flora*, such as the one at the Imperial Russian palace of Tsarkoe Selo, companion with a copy of the *Farnese Hercules*,[17] are rare, but there were many marble copies reduced to life-size—those made by French sculptors in the 1670s and 1680s are early examples,[18] and there is an excellent one made by Rysbrack for the Pantheon at Stourhead in Wiltshire between 1759 and 1762 (Fig. 43).[19] *Flora* was also very popular as a statuette, both in bronze, as in the example cast by Zoffoli after Pacetti's model of 1773,[20] and in Bow porcelain, sometimes with some enamel colours added.[21] After Tagliolini's alterations the statue was still being reproduced in white earthenware in Italy,[22] and the figure was adapted by W. Wyon in England for an agricultural prize medal in 1824.[23] Praxiteles was still being suggested as the sculptor as late as 1842.[24]

The *Flora* is now displayed as a Roman copy of a Greek statue of Aphrodite of the fourth century B.C.

1. Hülsen and Egger (Text), I, pp. 33–4 and (Tafeln), I, fol. 62v; for the other 'Flora', see Ruesch, p. 15.
2. Aldrovandi, 1556, p. 149.
3. Cavalleriis (1), plate 11.
4. De Franciscis, 1946, p. 97. Stolberg, II, p. 6, confusingly refers to the other Flora which had arrived earlier.
5. *Documenti inediti*, IV, p. 164.
6. Aldrovandi, 1556, p. 149; Hülsen and Egger (Tafeln), I, fol. 62v.
7. 'True Description', p. 28.
8. E.g. Burney, p. 134; De Brosses, II, p. 105.
9. Rothenberg, p. 163; cf. Raguenet, pp. 97–101; Northall, p. 310; Rossini, 1771, I, p. 63; Pistolesi, 1842, I, p. 97.
10. Maffei, plate LI (citing Lactantius, *Divinae Institutiones*, I, 20). The story was made popular by Boccaccio (see Held, pp. 208–10).
11. Aldrovandi, 1556, p. 152.
12. Bottari, III, p. 109; Pliny, XXXVI, 4, 23, mentions a Flora together with Demeter and Triptolemus in the Gardens of Servilius and XXXIV, 19, 70, refers to a 'stephanusum' which has been taken to mean a woman presenting a wreath.
13. Burney, p. 134.
14. Winckelmann (ed. Fea), I, pp. 322, 414; cf. Cavalleriis (1), plate 11 ('Spes'), but subsequently, e.g. Cavalleriis (2), plate 32, it is simply a goddess ('Deae simulacrum, etc.').
15. Finati I, ii, p. 5.

16. *Real Museo Borbonico*, II (1825), plate XXVI (entry by Finati).
17. Rae, plates 13, 16.
18. Thomassin, plate 31; Souchal, 1977, I, p. 1.
19. Webb, p. 126.
20. Honour, 1961, p. 199 (Ashmolean Museum, Fortnum bequest).
21. *The Man at Hyde Park Corner*, no. 35.
22. Victoria and Albert Museum, c128–1917.
23. Norwich Castle Museum.
24. Pistolesi, 1842, I, p. 97.

42. Germanicus

(Fig. 114)

PARIS, LOUVRE

Marble
Height: 1.80 m
Inscribed: ΚΛΕΟΜΕΝΗΣ ΚΛΕΟΜΕΝΟΥΣ ΑΘΗΝΛΙΟΣ ΕΠΟΙΗΣΕΝ
Also known as: Augustus, Brutus, M. Marius Gratidianus, Man playing morra, Mercury, Roman Orator

The statue is first recorded in the form of a bronze copy, made for Philip IV of Spain and still in the royal palace in Madrid, which was signed by the Roman bronze-founders Cesare Sebastiani and Giovanni Pietro del Duca and dated 1650;[1] but we have no indication of the whereabouts of the original at that time. In 1655, however, it was almost certainly in the Villa Peretti-Montalto (later Negroni) which, in that year, was inherited—with its collections—by Prince Savelli from the Peretti family;[2] and by the early 1660s it was quite certainly there.[3] It was sold from the Villa to Louis XIV in 1685–6[4] (together with the *Cincinnatus*) and was installed in the Grande Galerie at Versailles.[5] At the end of 1792 the statue's removal to the Musée Central des Arts in Paris was decreed,[6] and it was on display there when the Musée was inaugurated on 9 November 1800.[7]

The *Germanicus* is not included in Perrier's anthology of the most admired statues in Rome published in 1638, and it had perhaps not then been discovered. Little more than ten years later Velázquez must have thought very highly of it to have had a bronze cast made for Philip IV of Spain (Fig. 17), and not long after that it began to be singled out by visitors to Rome.[8] But its real celebrity came only with its export to France which aroused the most bitter indignation and forced the Pope to impose stringent new regulations.[9] It was, despite its absence abroad, included by de Rossi among his plates of the most distinguished antique sculptures,[10] and this, together with the plaster cast in the French Academy in Rome, paradoxically did more to

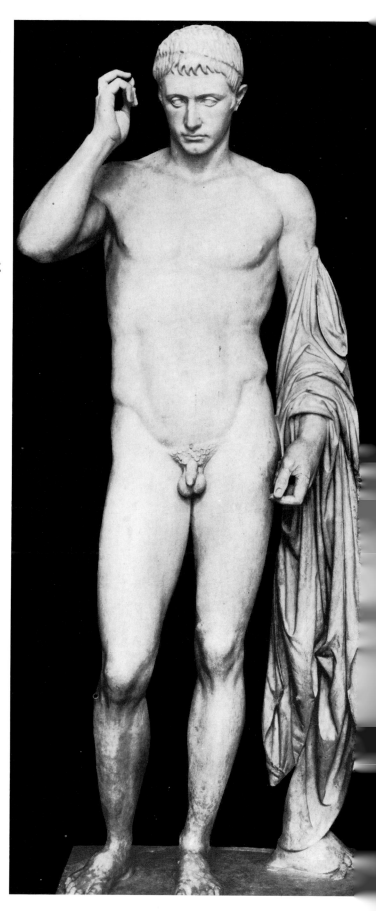

keep its fame alive among connoisseurs than did the original sculpture which was seen by relatively few. Indeed a number of further casts were taken, some certainly and others probably, from this one,[11] and Winckelmann, who never went to Versailles and who despised the print published by de Rossi, relied on a cast for his discussion of the statue about which he was at first enthusiastic though he later adopted a tone of non-committal caution.[12]

The *Germanicus* was inscribed in Greek by 'Cleomenes, son of Cleomenes, Athenian', but although this fact was vaguely known the inscription appears not to have been accurately recorded until the statue was taken to the Musée,[13] and until then very little was made of its implied relationship with the *Venus de' Medici* (also inscribed 'Cleomenes'). On the other hand, the subject of the sculpture aroused much interest. Both the Peretti inventory in 1655 and Bellori in 1664 were almost certainly referring to this statue when they listed a 'nude Augustus'.[14] In the latter year, however, the English traveller Philip Skippon called it 'Germanicus',[15] as did Spon and Wheler eleven years later,[16] and on the whole it retained this name for over a century—the heroic virtue of the nephew of Tiberius adding to its appeal.[17] But in Spain Palomino, who was writing at the beginning of the eighteenth century long after Velázquez had had the cast made, implied that 'the owner of the original in Rome' thought that it represented a man playing the popular game of morra, while others claimed that it was 'Brutus, the head of the conspirators against Julius Caesar'.[18] Much later Peter Beckford, the sporting enthusiast, helped to give currency to what was presumably a local tradition in Rome by stating that the statue did indeed portray Germanicus, who was, however, shown displaying his new invention 'the game of *Mora*, the present amusement of the lowest class of people in Italy, in order to keep his soldiers employed';[19] other travellers also mentioned this story.[20]

Visconti's theory was more plausible. On the evidence of the plaster cast he suggested[21] that the head had been added from some other statue and that the pose of the body recalled that of a Mercury, such as the one in the Ludovisi collection (now in the Museo Nazionale Romano):[22] this hypothesis was, he felt, confirmed by the tortoise which was a symbol of that god. The actual figure represented was most probably some Roman general—of whom he mentioned a number[23]—to whom the Greeks

might have felt reason for gratitude. In Paris the statue became known as a Roman Orator, portrayed in the guise of Mercury, the god of eloquence.[24] But Visconti's successor at the Musée, the Comte de Clarac, who considered that this was one of the most beautiful of all works to survive from antiquity, argued that the figure could well represent M. Marius Gratidianus, the initiator of monetary reforms, portrayed here as Mercury, the god of commerce. He pointed out that Pliny had said that large numbers of statues had been erected in honour of this ambitious politician (who flourished in 87 B.C), and he claimed to be able to see in his right hand some sort of calculating bead or device for estimating the content of metals.[25] The old name died hard, however, and when a full-scale marble copy was made for Chatsworth in the mid-nineteenth century it was inscribed 'Germanico' on the pedestal.[26]

The sculpture, according to Bieber, 'is most likely a portrait statue of the young Augustus in the type of a Hermes, created in the early classical period around 460 B.C.'[27]

1. Passeri, p. 256, note 2; Harris, E., pp. 119–20, plate VI.
2. *Documenti inediti*, IV, p. 4 ('Statua una di Cesare Augusto del naturale grande ignuda'); Massimo; *Roma*, XVII, p. 233.
3. Skippon, p. 670; d'Onofrio, 1969, p. 326.
4. Montaiglon (*Correspondance*), I, pp. 153–4; VI, pp. 390–405.
5. Thomassin, plate 4, p. 12; Piganiol de La Force, I, p. 157.
6. Soulié, I, p. lxv.
7. *Notice*, An IX (1800), pp. 21–3.
8. Skippon, p. 670; Massimo, pp. 163, 263; Harris, E., pp. 119–21, plate VI (for cast in Spain).
9. Montaiglon (*Correspondance*), I, pp. 153–4; VI, pp. 390–405.
10. Maffei, plate LXIX.
11. Montaiglon (*Correspondance*), X, pp. 434, 438 (for Farsetti, 1753); Brettingham MS., p. 139; Beckford, I, p. 187 (Florence); Schiller, II, p. 105 (Mannheim); also the Academy at Bologna.
12. Winckelmann, 1764 (*Geschichte*), p. 389; Winckelmann, 1767, II, pp. 53–4; Winckelmann (ed. Fea), II, p. 338.
13. *Notice*, An IX (1800), pp. 21–3.
14. *Documenti inediti*, IV, p. 4; [Bellori], p. 51 ('fra le statue l'heroica di Augusto ignuda di mirabile lavoro').
15. Skippon, p. 670.
16. Spon and Wheler, I, p. 404.
17. Maffei, plate LXIX.
18. Palomino, p. 915.
19. Beckford, I, p. 187.
20. Berry, I, p. 116.
21. Visconti (*Monumenti Borghesiani*), plate XIX, pp. 143–4.
22. Helbig, 1963–72, III, pp. 246–7.
23. Visconti (*Opere varie*), IV, pp. 223–8, 317–18; Clarac, 1821, p. 58.
24. *Notice*, An IX (1800), pp. 21–3.
25. Clarac, 1821 (alluding to Pliny, XXXIV, 27).
26. Probably from Bienaimé's Carrara studio which supplied the statues placed in the gardens between 1841 and 1844 and seems to have continued to do so for some years—Chatsworth MS., Sculpture Accounts of the Sixth Duke, p. 23; [Cavendish], p. 168.
27. Bieber, p. 174.

43. Borghese Gladiator (Fig. 115)

PARIS, LOUVRE

Marble
Length (from head to left heel): 1.99 m
Inscribed: ΑΓΑΣΙΑΣ ΔΩΣΙΘΕΟΥ
ΕΦΕΣΙΟΣ ΕΠΟΙΕΙ
Also known as: Discobolus, Fighting Gladiator,
Hector, Héros Combattant, Borghese Warrior

This statue is first recorded on 11 June 1611 when it was being restored after having just been found at Nettuno (near Anzio); it was then to be taken to Cardinal Borghese's estate.[1] In 1613 it was certainly in the Borghese collection,[2] and by 1650 it was in a room named after it on the ground floor of the Villa Borghese.[3] On 27 September 1807 it was purchased (together with the bulk of the Borghese antiquities) by Napoleon Bonaparte, brother-in-law of Prince Camillo Borghese.[4] It was sent from Rome in 1808[5] and by 1811 it had been placed in the Salle d'Apollon in the Musée Napoléon.[6] By 1815 it was in a room specially named after it.[7]

As early as 1622 an English visitor was told that the *Gladiator* was one of the two chief sculptures in the Villa Borghese (the other was a 'Venera'),[8] and it remained the most admired work of antiquity in the Villa for the two centuries of its installation there: 'it is, according to some connoisseurs,' observed Lalande, 'tout ce que l'on connoît de plus beau dans l'antique',[9] and soon after it had left for Paris a traveller commented that it was 'the last of those great preceptive statues which served at Rome as canons of the art'.[10]

Within twenty years of its discovery a bronze cast had been made for Charles I (now at Windsor),[11] and this in itself became one of the most famous sculptures in England.[12] Another bronze cast, probably also by Le Sueur and presumably made by special permission of the King, had before 1645 been installed in the oval circus of the gardens designed by Isaac de Caus for the fourth Earl of Pembroke at Wilton, where it was described as 'the most famous statue of all that Antiquity hath left'.[13] This in turn was given to Sir Robert Walpole by the eighth Earl and it still stands on the grand, but somewhat awkward, temple-like structure devised for it by William Kent in the stairwell at Houghton Hall in Norfolk.[14]

In 1638 Perrier published no less than four views of the *Gladiator* (more than the number given to any other figure) in his selection of the finest statues in Rome, and a quarter of a century later Bernini (who as a young man had measured his talents against it when carving his 'David' which was also kept in the Villa Borghese) told his hosts in France that it ranked with the most beautiful of statues.[15] But, though a cast was made for Philip IV[16] and there was naturally a plaster of the *Gladiator* in the French Academy in Rome,[17] it does not seem to have been copied in marble for Louis XIV.

Towards the end of the seventeenth century a version in gilded bronze was installed among the copies after the antique in the gardens of Herrenhausen at Hanover[18] and somewhat later two pairs of the figure, lightly draped, were used to make an imposing entrance to the gardens at Schloss Mirabell which were laid out, in part by Fischer von Erlach, for the Archbishop of Salzburg—another pair confront each other on the gate piers in the forecourt of Schloss Charlottenburg, Berlin. Copies of the *Gladiator* were also paired to serve as fountains (the water issuing from serpents coiled round the extended arms) on the terrace near the base of the Grand Cascade at the royal palace of Peterhof outside St. Petersburg, and in 1800 these versions in lead were replaced by others of gilded bronze (Fig. 51).[19] Full-size copies were to be found in the grounds of many English country houses during the eighteenth and early nineteenth centuries: at the Duke of Bedford's Woburn Abbey in Bedfordshire (a cast by Sir Richard Westmacott erected in 1827)[20] and at the Duke of Dorset's Knole in Kent, for instance.[21] And there were others in France.[22] In fact the demand for copies was so great that towards the end of the eighteenth century Prince Borghese tried to prevent the taking of further moulds. In 1770 Burney wrote that 'crowned heads are refused the privilege of having it cast, the Empress of Russia among the rest',[23] and eighteen years later Ménageot, director of the French Academy in Rome, pointed out that there was only one mould of the *Gladiator* in Rome, and that was badly worn.[24]

As the *Gladiator* was particularly admired for the truthful rendering of anatomy, we find a cast of the statue prominently displayed both in Natoire's watercolour (Montpellier, Musée Atget) of a life class at the Académie Royale de Peinture et de Sculpture in Paris in 1745[25] and in Henry Singleton's painting (London, Royal Academy) of the general assembly of the Royal Academicians in London in 1795.[26] Moreover, many artists made small versions for their own

use: Nicolas Coustou's terracotta of 1683 eventually reached the Louvre, some two centuries later, from the collection of his descendants,[27] and the small copy in painted wood (Munich, Bayerisches Nationalmuseum) made by Ignaz Günther in 1753 seems to have been based on a cast in Vienna.[28] Bronze statuettes were also popular: by 1700 the Borghese themselves owned one which was gilded,[29] and by the end of the century they could be obtained from both Zoffoli and Righetti in Rome.[30]

Mengs, who played so important a role in lowering the credit of some of the most famous antiquities by insisting that they were copies, had nothing but praise for the *Gladiator*.[31] Indeed, enthusiasm for the statue was unanimous—and also very repetitious; the travels of Misson and Moore were separated by a century but both men agreed that the figure represented an ideal mean between the 'effeminate softness' of the *Belvedere Antinous* and the 'brawny strength' of the *Farnese Hercules*.[32] Its precise significance, however, aroused more controversy.

Seventeenth-century observers seem to have had no doubts that the subject was a gladiator, and Maffei pointed out that the original would have held a sword or shield[33] (one or both of these had already sometimes been supplied to casts made from the statue). Even much later it is not always easy to be certain whether it is to this or to the *Dying Gladiator* that writers are referring when they speak only of 'the gladiator', and the two are associated in the gardens of Timon's Villa, as described by Pope, where 'gladiators fight, or die, in flowrs'[34] and in some *capricci* by Panini where they are placed together outside the Colosseum.[35]

However, at much the same time as such pictures were being painted, doubts began to arise. Raguenet had emphasised that only a gladiator could have such well-formed muscles,[36] and the Richardsons took much the same view about that profession's need for agility and suppleness.[37] Montfaucon, however, mentioned in passing that he considered the subject to be a pugilist.[38] Stosch, among others, thought that it was a Discobolus,[39] and thereafter archaeologists and travellers, both sedentary like Winckelmann (Fig. 60)[40] and sporting like Peter Beckford (Fig. 47),[41] displayed boundless energy in discussing the technical details of fighting and gymnastics in the ancient and modern world. Winckelmann acknowledged that the statue lacked the ideal beauty of the *Apollo* but thought that naturalistic art could scarcely go higher. He suggested that

the sculpture was of some warrior who had distinguished himself in a particularly valiant action—partly on the grounds that the Greeks would never have erected a statue to a gladiator and that, in any case, gladiators probably did not exist at the time of Agasias, the script of whose signature showed him to be very early in date. Carlo Fea, Winckelmann's Italian editor, went further and proposed some possible candidates: Ajax outside the walls of Troy; or Ajax, son of Oileus (or Ileus), who is sometimes portrayed in a similar way on the coins of Locri; or Leonidas the Spartan.[42]

Visconti, however, was reluctantly forced to acknowledge that even some connoisseurs, and certainly the public in general, continued to think of this 'extremely noble and incomparable sculpture' as a gladiator—an 'absurdity' which he set out to demolish with devastating logic. No surviving representation of a gladiator, he pointed out, looked remotely like the figure, and in any case as nudity was the proper convention for heroes there was no need to suppose him to be an athlete. The man is shown looking up, as if being attacked by someone on horseback, and (admitting that he was now entering the realm of speculation) Visconti proposed that this was an Amazon. Various reasons suggested to him that Telamon, father of Ajax and companion of Hercules, could be the heroic warrior in question. Visconti concluded his long (and perhaps his most impassioned) article by giving reasons which might account for the neglect of so distinguished an artist by the writers of antiquity.[43]

The figure continued to be keenly admired, though the more elaborate of these theories were soon forgotten. In 1818, the year that Visconti died, Richard Payne Knight claimed that the statue would 'scarcely have been quite naked, had it represented any event of history' and suggested that it might have been of a dancer, for the highest form of dancing in antiquity 'exhibited military exercises and exploits . . . excellence in which was often honoured by a statue in some distinguished attitude'.[44] By 1830 the room in which it had been placed was called merely the 'Salle du Héros Combattant, dit le Gladiateur', and the Comte de Clarac made no attempt to identify the hero.[45] In 1867 Théophile Gautier wrote that after one had seen the *Venus de Milo* one could only look absentmindedly at 'les *Apollons sauroctones*, les *Antinoüs* . . . les *Faunes*, les *Vénus* . . . les *Grâces* . . . les *Germanicus* . . . et même ce *Gladiateur*, merveille

115. *Borghese Gladiator* (Louvre).

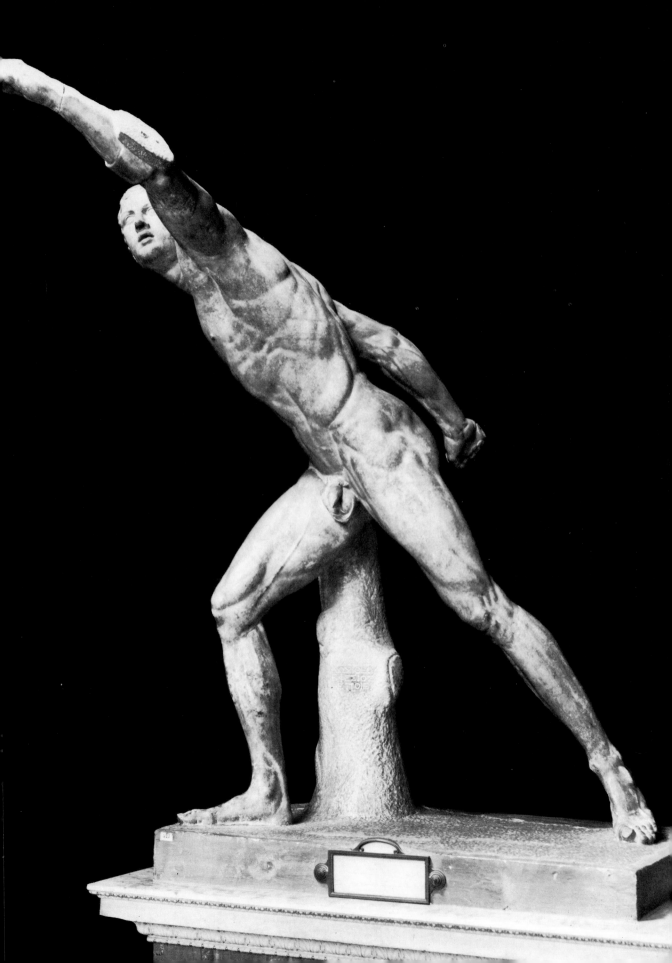

d'anatomie: on garde dans l'oeil l'éblouissement de la beauté suprême'[46]—and as a marvel of anatomy it was repeatedly studied by young artists (Fig. 67).

Robertson has recently written of the 'harsh and unappealing character' of the work. 'The proportions, and the extraordinarily hard, dry musculature, recall in an exaggerated form the Apoxyomenos, and the work must belong in some sense to the following of Lysippos. I should be inclined to suppose it a copy of a statue from his school—there are points of resemblance also to the sandal-binder [*Cincinnatus*]—rather than a late Hellenistic essay in his manner.'[47]

1. Orbaan, p. 190.
2. Francucci, stanza 77.
3. Manilli, p. 80.
4. Boyer, 1970, p. 202.
5. *Magasin Encyclopédique*, 1808, V, p. 388.
6. *Ibid.*, 1811, III, p. 387.
7. *Notice*, supplément, 1815, p. 26.
8. Yeames, p. 485.
9. Lalande, III, p. 484.
10. Forsyth, p. 238.
11. Peacham, pp. 107–8; British Library, Harleian MS. 4898, fol. 301v.
12. Skippon, p. 654; Misson, 1691, II, p. 55; Northall, p. 351.
13. De Caus, plate 2 (for description)—the statue itself is shown in plates 4, 20.
14. Walpole, 1752, p. 44; Watson, pp. 231–2.
15. Perrier, 1638, plates 26–9; Chantelou, p. 26.
16. Palomino, p. 916.
17. Montaiglon (*Correspondance*), I, p. 129.
18. Meyer, pp. 145–7.
19. Znamenov, pp. 199, 350 (no. 134).
20. Westmacott Papers, IV, p. 197.
21. Neale, I; this bronze was apparently acquired in Italy by the third Duke—Sackville-West, p. 15.
22. Lalande, III, p. 484, note, and Pariset, p. 84 and fig. 3 (for Guiard's marble); there is a bronze at Fontainebleau.
23. Burney, p. 208.
24. Montaiglon (*Correspondance*), XV, p. 245.
25. *Charles-Joseph Natoire*, p. 80 (no. 42).
26. Hutchison, plate 21.
27. Souchal, 1977, I, p. 153.
28. Woeckel, pp. 25–6.
29. Montelatici, p. 304.
30. Zoffoli, Righetti (see Appendix).
31. Mengs, pp. 296, 363.
32. Misson, 1691, II, p. 55; Moore, I, p. 504.
33. Maffei, plates LXXV–LXXVI.
34. Pope, *Epistle to Richard Boyle, Earl of Burlington*, line 124.
35. Indianapolis Art Museum (Arisi, fig. 153). See also Arisi, fig. 154.
36. Raguenet, pp. 33–4.
37. Richardson, 1728, III, ii, pp. 554–5.
38. Montfaucon, 1719, III, ii, p. 292.
39. Winckelmann (ed. Fea), II, p. 361; Winckelmann (*Briefe*), I, p. 255.
40. Winckelmann (ed. Fea), II, pp. 360–2.
41. Beckford, II, p. 247.
42. Fea in Winckelmann (ed. Fea), III, pp. 461–3.
43. Visconti (*Monumenti Borghesiani*), plate I.
44. Knight, 1818, p. 153.
45. Clarac, 1830, p. 117.
46. *Paris Guide*, Ière partie, p. 410.
47. Robertson, I, p. 543.

44. Dying Gladiator (Fig. 116)

ROME, MUSEI CAPITOLINI

Marble

Height (with plinth): 0.93 m; Length (of plinth): 1.865 m; Breadth: 0.89 m

Also known as: Dying Gaul, Gladiator, Roman Gladiator, Wounded Gladiator, Myrmillo Dying

The statue is first recorded in an inventory of the Ludovisi collection in Rome drawn up on 2 November 1623 and it then lay on a painted and gilded wooden pedestal on which were carved the arms of Cardinal Ludovisi.[1] In the absence of any earlier reference it has been inferred that it was discovered shortly before 1623 probably when the Villa Ludovisi was being built in an area, on the site of the gardens of Sallust, which when it was redeveloped in the late nineteenth century proved to be particularly rich in antiquities. In 1633 it was in the Palazzo Grande on the Ludovisi estate on the Pincio.[2] In about 1688–9 it was seized for a short period by Don Livio Odescalchi to whom it had been pledged against a debt,[3] but it was returned to the Ludovisi until 1695–6 when it was once again removed by the Odescalchi in settlement of an outstanding debt.[4] The Odescalchi kept it concealed, and it was even thought to be lost,[5] but in 1715–16 it was returned to the last surviving Ludovisi, Ippolita, wife of Gregorio Boncompagni, Duke of Sora. To avoid its entailment with the rest of the collection she kept it—on a new pedestal—in the Palazzo Boncompagni in the Piazza de Sora.[6] Some time before 1737 it was acquired by Pope Clement XII (1730–40) for the Capitoline Museum from the heirs of the Princess of Piombino (the inherited title of Ippolita Boncompagni).[7] It remained in the museum until 1797 when it was ceded to the French under the terms of the Treaty of Tolentino.[8] It reached Paris in the triumphal procession of July 1798[9] and was displayed in the Musée Central des Arts when it was inaugurated on 9 November 1800.[10] It was removed in October 1815,[11] arrived back in Rome in the first half of 1816 and was returned to the reorganised Capitoline Museum (in a room named after it) during the course of the year.[12]

Throughout its history this figure has been greeted with universal enthusiasm, and—as was so often the case—a legendary restoration by Michelangelo (of the right arm) added to its fame for some two hundred years.[13] It quickly entered

an inner sanctum of the 'musée imaginaire' of educated Europe and it is one of the few statues in our catalogue whose reputation remains high. When Giambattista Ludovisi was thinking of selling it in 1670 he valued it at seventy thousand scudi (second only to the ninety thousand he wanted for the two figures of *Paetus and Arria* and almost twice as much as for anything else in his collection).[14] In 1638 it was reproduced—for the first of countless times—among Perrier's engravings of the finest sculptures in Rome,[15] and when writing up his travel notes many years after his visit to Italy in 1644–5 Evelyn claimed that the *Gladiator* was 'so much followed by all the rare Artists, as the many Copies and Statues testifie, now almost dispers'd through all Europ, both in stone & metall'.[16] The first copy of which we know is the plaster cast made for the King of Spain in 1650.[17] Another was made for the French Academy in Rome,[18] and by 1684 a marble copy for Louis XIV had been carved by Michel Monnier (who was in Rome between 1672 and 1682) and sent to France; it remains at Versailles.[19] About a century later Chinard made another which has been lost.[20] Large-scale copies were also to be found in eighteenth-

century England—carved in stone (very badly) by Scheemakers in 1743 for the garden designed by Kent at Rousham in Oxfordshire,[21] and in marble by Vierpyl for Lord Pembroke's Wilton in Wiltshire before 1769,[22] and cast in bronze by Luigi Valadier for the great hall in the Duke of Northumberland's mansion of Syon in 1773 (Fig. 49),[23] to mention only three. Jefferson wanted a copy for his proposed gallery at Monticello.[24]

Small bronzes were made in the seventeenth century by Gianfrancesco Susini[25] and in the eighteenth by Zoffoli (not, surprisingly, by Righetti).[26] In the nineteenth century the *Gladiator* could be bought as an iron paper weight or a Parian ware ornament.[27] Reproductions had also been made in other media: in 1776, for instance, a hanged smuggler, having been dissected by William Hunter for the benefit of the Royal Academy, was cast in the pose by Agostino Carlini and was affectionately nicknamed 'Smugglerus'.[28] More appealingly, the statue is given greater prominence than any other piece of sculpture in Panini's ideal gallery of ancient art (Fig. 45).[29]

Although Audran included two plates of the

116. *Dying Gladiator* (Capitoline Museum).

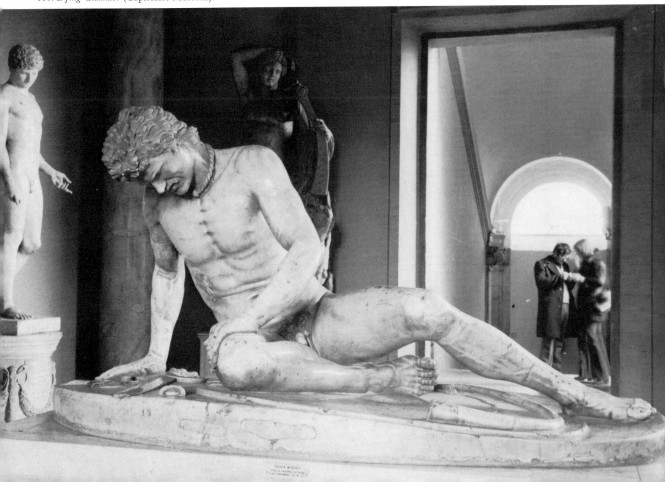

figure among his illustrations of the perfect proportions of the human body[30] and although budding artists were encouraged to draw it from every angle (as can be seen in a charming vignette by Campiglia in Bottari's catalogue of the Capitoline Museum—Fig. 46),[31] there can be no doubt that it was primarily the poignancy of the expression that attracted the attention of most visitors: 'the strongest expression of any Statue I have seen', in the words of the Richardsons,[32] and many analyses were made of the way in which 'the very lips seem to quiver as in the agony of death . . . They [the Romans] had frequent opportunities of making such calculations; we, I thank God, have not.'[33] The most famous tribute to the pathos inherent in the subject is to be found in the fourth canto of *Childe Harold* (1818):[34]

I see before me the Gladiator lie:
 He leans upon his hand—his manly brow
Consents to death, but conquers agony,
And his drooped head sinks gradually low—
And through his side the last drops, ebbing
 slow
From the red gash, fall heavy, one by one,
Like the first of a thunder-shower; and now
The arena swims around him—he is gone,
Ere ceased the inhuman shout which hailed the
 wretch who won.

He heard it, but he heeded not—his eyes
 Were with his heart—and that was far away;
He recked not of the life he lost nor prize,
But where his rude hut by the Danube lay—
There were his young barbarians all at play,
There was their Dacian mother—he, their
 sire,
Butchered to make a Roman holiday—
All this rushed with his blood—Shall he
 expire
And unavenged?—Arise! ye Goths, and glut
 your ire!

However, by Byron's time, the theory that the statue represented a gladiator had long been dismissed by scholars, though they admitted that this remained (as it still does) the name by which the figure was generally known.

Though in 1671 Colbert's son, the Marquis de Seignelay, called it merely a 'dying soldier',[35] the idea that it actually represented a gladiator, either wounded or dying, had been current ever since it was first mentioned.[36] Perrier added a more erudite note when he called it by the name (which was very widely adopted) of

'Myrmillo'—a special class of gladiator. In 1755 Bottari acknowledged that it was strange to erect a statue to a defeated rather than a victorious gladiator, but he explained this by referring to a comment by Livy on the admiration felt by the Romans for a noble death.[37] Before he came to Italy Winckelmann appears to have accepted the traditional name,[38] but he later produced a farfetched theory of the kind which he would surely have ridiculed had it been preferred by any of his predecessors (as it might well have been). No artist of the best period—to which this statue clearly belonged—would, he argued, conceivably have wished to portray such a low subject, and in any case gladiators had not flourished during the best period. He did, however, know of a Greek inscription which made clear that heralds at the Olympic games wore ropes round their necks to prevent the strain on their voices leading to burst blood vessels. Though it was true that no evidence existed to show that this was also the case with military or diplomatic heralds, nonetheless the so-called *Gladiator* must be just such a herald, as was shown by the rope and the trumpet on the plinth. But why portray a dying herald? This could only be because of his importance, and various candidates presented themselves: Polyphontes, herald of Laius King of Thebes, who had been killed with his royal master by Oedipus; or Copreas, the most famous herald of Greek mythology, who had been killed by the Athenians; or Artemocritus, the Athenian herald massacred by the inhabitants of Megara.[39] No one seems to have taken Winckelmann's theory very seriously, but it served the purpose of making people think again about the true subject of the statue. Carlo Fea, Winckelmann's Italian editor, suggested that it was a Spartan trumpeter who had distinguished himself in some special way.[40] Visconti, however, argued that the physical characteristics of the figure proved that he was a barbarian warrior, either a Gaul or a German, who had presumably died heroically on the battlefield.[41]

In a lecture and pamphlet of 1821 the Roman antiquarian Antonio Nibby agreed that the figure was a Gaul (a conclusion he claimed to have reached independently) and pointed out that on only one occasion had the Gauls made any real impact on the Greeks. This was at the beginning of the third century B.C. when, under Brennus, they had attacked Delphi. As the excellence of the style would suggest just such a date for the carving of the statue it must surely

represent one of the Gauls wounded during the course of that onslaught.[42] Since the late nineteenth century the figure has in fact been considered by many scholars to be a copy (or at least a derivation) of one of the bronzes dedicated by Attalus I in the first half of the third century B.C. after his victories over the Gauls,[43] and Nibby can be seen to have been as close to recognising this as was possible before a general awareness of the Pergamene school. Inspired by the fame of the Parthenon marbles in London and by Cockerell's attempted reconstruction of the *Niobe Group* Nibby further proposed that the shape of the figure made it eminently suitable for placing at the corner of the pediment of some temple. Here, however, Nibby was further from modern theory than Visconti who had maintained that it could have adorned a monument together with the *Paetus and Arria*,[44] and indeed according to Robertson these statues are 'of the same scale and of the same general character, and probably record works of the same dedication but hardly of the same hand'.[45]

As early as the seventeenth century the statue had been associated with the sculptor Ctesilas (spelt in a variety of different ways) whose fame—according to Pliny—rested on the sculpture of a dying man.[46] Maffei lent his authority to this theory[47] which proved very popular until it was effectively demolished by Winckelmann. The statue is catalogued in Helbig as a copy of the bronze which, together with the original of the *Paetus and Arria*, was made for Attalus of Pergamon (241–197 B.C.) to adorn a monument recording his victories over the Gauls.[48]

<center>★ ★ ★</center>

Another statue, occasionally known as the Dying[49] (but more usually as the Wounded) Gladiator was also in the Capitoline Museum from about 1737 onwards.[50] It had originally been a torso, known since 1513, of a copy of Myron's *Discobolus*, but it was restored by Pierre-Étienne Monnot (1658–1733) to portray a gladiator supporting himself with his left arm as he stumbles to the ground.[51] For some years this basked in the reflected glory of the more famous *Gladiator* (they were placed in close proximity), but it was not selected by the French to be taken to the Musée, and in 1817 it was removed from the Salone to the Galleria of the Capitoline Museum[52] and its fame declined precipitately.

1. Felici, pp. 236–7.
2. Schreiber, p. 30.
3. Montaiglon (*Correspondance*), VI, p. 425; Felici, p. 234.
4. Felici, pp. 234–5.
5. Raguenet, p. 319; Caylus, 1914, p. 279.
6. Caylus, 1914, p. 279; Bruand, 1959, p. 87.
7. Montaiglon (*Correspondance*), IX, p. 307.
8. *Ibid.*, XVI, pp. 464, 498.
9. Blumer, pp. 241–9.
10. *Notice*, An IX (1800), pp. 32–3.
11. Saunier, p. 149.
12. Either in the consignment of statues which arrived on 4 January (*Diario di Roma*, 6 January 1816) or among those which had reached Civitavecchia from Antwerp by 19 June on H.M.S. *Abundance* (ibid., 19 June 1816); Stuart Jones, 1912, p. 8.
13. [Bottari], plates LXVII–LXVIII; Starke, 1820, p. 277; Tofanelli, 1843, pp. 92–3.
14. Bruand, 1959, p. 83.
15. Perrier, 1638, plate 91.
16. Evelyn, II, p. 235.
17. Palomino, p. 915; Bottineau, p. 179.
18. Montaiglon (*Correspondance*), I, p. 130.
19. *Ibid.*; Lami, 1906, p. 380.
20. Lami, 1910–11, I, p. 199.
21. Gunnis, p. 342.
22. *Ibid.*, p. 410.
23. *Syon House*, p. 40.
24. Howard, 1977, pp. 593–4.
25. Baldinucci, IV, p. 118 (there is a signed one in the Museo Nazionale in Florence).
26. Zoffoli (see Appendix)
27. *Berlin und die Antike*, p. 243; Birmingham City Art Gallery, M 95 76.
28. Baretti, p. 24; Smith, J.T., II, pp. 305–6.
29. Arisi, fig. 305.
30. Audran, plates 22–3.
31. [Bottari], p. i.
32. Richardson, 1722, p. 301.
33. Beckford, II, p. 125; cf. Bachaumont, pp. 40–1.
34. Byron: *Childe Harold*, IV, stanzas 140–1.
35. Seignelay, p. 164.
36. Schreiber, p. 30; Felici, pp. 236–7.
37. [Bottari], plates LXVII–LXVIII (alluding to Livy, IX, 40); cf. Baretti, p. 23.
38. Winckelmann, 1968, p. 34 (*Gedanken*).
39. Winckelmann (ed. Fea), II, pp. 203–7.
40. Fea in Winckelmann (ed. Fea), II, pp. 207–8, note A.
41. Visconti (*Opere varie*), IV, p. 325.
42. Nibby, 1821.
43. Helbig, 1891, I, pp. 410–13.
44. Visconti (*Opere varie*), IV, pp. 325–6.
45. Robertson, I, p. 531.
46. Evelyn, II, p. 235 (probably alluding to Pliny, XXXIV, 74).
47. Maffei, plate LXV.
48. Helbig, 1963–72, II, pp. 240–2.
49. Rossini, 1771, I, p. 29 ('l'altro che cade morto').
50. Montaiglon (*Correspondance*), IX, p. 307.
51. Howard, 1962, pp. 330–1.
52. Stuart Jones, 1912, pp. 123–4.

45. Bronze Hercules (Fig. 117)

ROME, MUSEI CAPITOLINI (PALAZZO DEI CONSERVATORI)

Bronze
Height: 2.41 m

This statue is first recorded, in the Palazzo dei Conservatori, in 1510,[1] and all the early sources agree that it was excavated during the papacy of Sixtus IV (1471–84), most probably in the Foro

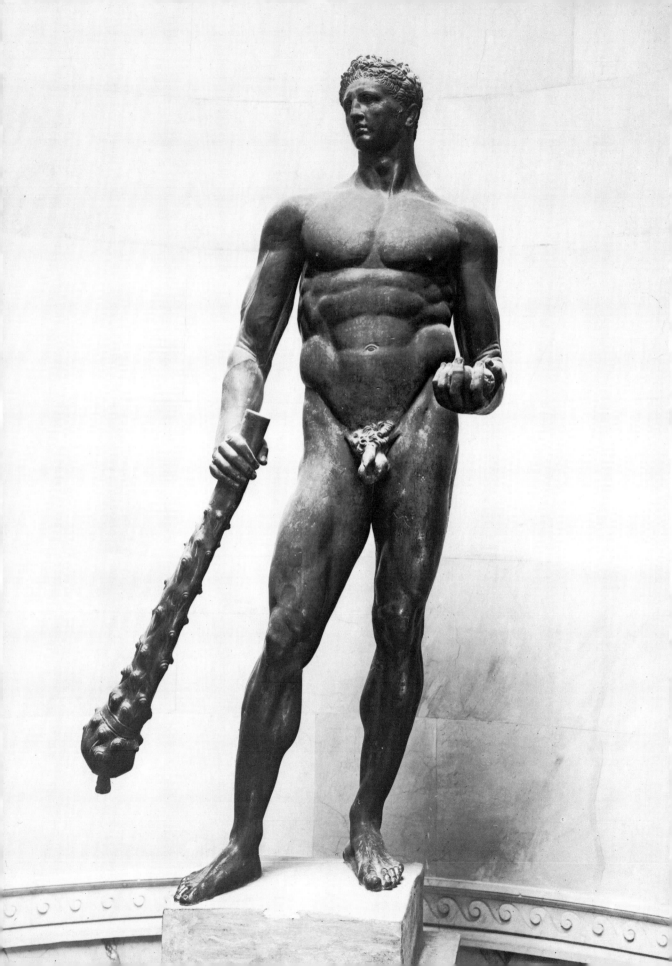

Boario,[2] and taken to the palace in his day.[3] By 1556 it was in a room adjoining the main hall, placed on a (quite independent) circular altar dedicated to Hercules.[4] In 1578 it was given a new base and in 1627 transferred to a room which was named after it. Between 1816 and 1846 it was in the Salone of the Capitoline Museum but was later moved back to the Palazzo dei Conservatori.[5]

This statue was always very famous, but although it was sometimes warmly admired[6] its celebrity depended more on its distinction as a large and relatively intact bronze than on its aesthetic merit. Thus it is illustrated, along with a dozen other well-known works, in Felini's guidebook to Rome of 1610,[7] but not in Perrier's anthology, a quarter of a century later, of the finest statues in the city. It was, however, frequently engraved,[8] and Maffei (who spoke highly of it)[9] and most guidebooks[10] stress its importance and the feelings of wonder that it should arouse in the visitor. Visitors themselves, however, tended to be rather more reserved. They single out the statue,[11] but in neutral, descriptive terms, and the Richardsons found that the way the club was held was rather 'bizarre'.[12] It was not among the works chosen by the French under the terms of the Treaty of Tolentino.

The statue is catalogued in Helbig as an adaptation of a bronze by Lysippus made in the second century B.C., and perhaps the one brought to Rome by Pompey or Lucullus and recorded by Pliny in the Temple of Hercules Victor near the Foro Boario.[13]

*　　*　　*

This statue was sometimes associated with a basalt Child Hercules in the Capitoline Museum, which had been purchased by the Conservators in 1570 and which was often said to represent the son of Hercules: it was known as the Ercole Aventino from its supposed place of discovery.[14]

1. Albertini (*De Statuis*) in Valentini and Zucchetti, IV, p. 491.
2. Maffei, plate XX, discusses the various theories.
3. Stuart Jones, 1926, p. 284.
4. Aldrovandi, 1556, p. 273.
5. Stuart Jones, 1926, p. 284.
6. Aldrovandi, 1556, p. 273.
7. Felini, p. 324.
8. Stuart Jones, 1926, p. 284, lists a number and gives references.
9. Maffei, plate XX.
10. [Roisecco], II, p. 262; Venuti, R., 1767, II, p. 701.
11. Caylus, 1914, p. 181; Lalande, IV, p. 174.
12. Richardson, 1728, III, i, p. 179.
13. Helbig, 1963–72, II, pp. 573–4.
14. Vacca, Mem. 90; Maffei, plate XIX; Stuart Jones, 1912, pp. 275–6.

46. Farnese Hercules (Fig. 118)

NAPLES, MUSEO NAZIONALE

Marble
Height: 3.17 m
Inscribed: ΓΛΥΚΩΝ ΑΘΗΝΑΙΟC ΕΠΟΙΕΙ

This statue is first definitely recorded in 1556, when it was in the Palazzo Farnese, by Aldrovandi, whose published work on the ancient sculptures of Rome was based on notes he had made six years earlier: he said that it had been found in the Baths of Caracalla.[1] Jean Matal (Johannes Metellus), a French antiquarian who was in Italy collecting epigraphical material in the middle of the sixteenth century and who died in 1597, records that it had been discovered there in 1546.[2] Writing in about 1569 the sculptor Guglielmo della Porta was probably referring to this 'statue of a Hercules' when he mentioned that its head had been found, six years before the body, in a well in Trastevere and had been acquired for the Farnese through his agency.[3] The *Hercules* was displayed in the first courtyard of the Palazzo Farnese until shortly before 5 February 1787 when it was taken to Carlo Albacini's studio for restoration[4] and then sent to Naples where it had arrived by June. It was placed at first in the old porcelain factory at Capodimonte,[5] but by 1792 it had been taken to the Museo degli Studi[6] (later Museo Borbonico, now Museo Nazionale).

This gigantic figure, inscribed by Glycon, was enormously admired from the time of its discovery until the end of the last century. Addison called it one of 'the Four finest Figures perhaps that are now Extant',[7] while for Northall, some fifty years later, it was one of 'the three finest statues in all the world'.[8] Napoleon told Canova that its absence from the Musée was the most important single gap in the collection,[9] but in fact it very nearly came to Paris, for in 1799 it had already been packed and only the collapse of the Revolution in Naples led to its remaining there.[10] The French had even made the plaster cast which was to replace the original,[11] and, ironically, it was probably this, along with one of the *Flora*, that was used to decorate the 'temple' which welcomed the royal family back to Naples.[12] In 1806, when pressing Napoleon to seize it, Vivant Denon said that 'three times it has been earmarked for France'.[13]

It would be tedious to record the panegyrics with which amateurs and experts greeted the

229

Hercules, but some features which aroused special interest (and, occasionally, concern) may be singled out. There was, first, the exaggerated musculature. Hogarth insisted that all the parts were 'finely fitted for the purposes of the utmost strength the texture of the human form will bear', and that this accounted for some otherwise baffling anatomical distortions.[14] Winckelmann, however, saw these exaggerations as the result of poetic licence rather than naturalistic observation.[15] By 1780, when the 'large brawny limbs' were disconcerting many ladies, John Moore pointed out that 'the Farnese Hercules is faulty both in his form and attitude: the former is too unwieldy for active exertion, and the latter exhibits vigour *exhausted*'.[16] Significantly it was another medical man, the Scotch surgeon John Bell, who in 1817 launched what is probably the most ferocious attack on the statue until our own times: 'His coarse, clumsy, vast trunk, loaded with superfluous masses of muscle, his knotted calves, and long ankles, designate the strength of a heavy cumbrous body, calculated to work the lever, or sustain the ponderous weight, which the gift of rude material forms enables it to raise, but without any portion of energetic powers of action, to struggle, throw, or strike . . .'[17] But such a view was exceptional, and Schiller had easily been able to visualise *Hercules* struggling with the Nemean lion.[18]

The narrative significance as well as the appropriateness of the pose aroused discussion. Winckelmann claimed that *Hercules* was resting after fetching the apples of the Hesperides which he held in his hand;[19] others suggested that he was exhausted after strangling the Nemean lion;[20] the cataloguer of the Museo Borbonico proposed that he was suffering from generalised fatigue as a result of all his Labours.[21]

It is strange that Hogarth should have based so much of his theory on the tapering legs of the *Hercules*, since these were not original and in the case of no other piece of antique sculpture did the question of restoration play so significant a part in furthering its reputation. On the recommendation of Michelangelo, Guglielmo della Porta had made legs for the *Hercules* and it was said that even when the originals were found soon after, the Farnese accepted Michelangelo's advice to retain the limbs made by his protégé 'in order to show that works of modern sculpture can stand comparison with those of the ancients'.[22] The French were more sceptical and casts of the true legs were apparently attached to the plaster version of the statue which, in the middle of the seventeenth century, was kept in the Académie in Paris.[23] Eventually in 1787 the original legs (which had been acquired by the Borghese and later given by them to the King of Naples) were put in place on the sculpture itself, and Goethe commented that 'one cannot understand why, for years and years, people found the substitute ones by Porta so good'.[24] By 1802 'brazen foliage' had also been attached to the statue.[25]

Other versions were known to travellers, artists and antiquarians.[26] One indeed (now also in Naples) stood beside the more famous *Hercules* in the courtyard of the Palazzo Farnese and was usually acknowledged to be inferior to it in quality.[27] There was another in the courtyard of the Palazzo Pitti in Florence (where it still remains), inscribed in Greek with the name of Lysippus.[28] It had apparently been dug up on the Palatine and sold to Cosimo I for eight hundred scudi.[29] Though Winckelmann rightly pointed out that the inscription must be a forgery (but one which possibly dated back to antiquity),[30] modern scholars do think it likely that the type is of Lysippic derivation.[31] Mengs cast doubt on the authenticity of the signature of Glycon on the Farnese statue,[32] but Visconti and Éméric-David suggested that this artist had been responsible only for improving, and not for originating, the type.[33]

The enormous size of the *Farnese Hercules* made it difficult to see properly—let alone to copy. Bernini insisted that it should be viewed from a distance,[34] while Montesquieu thought that this was true of the front, but that the back should be inspected from close to[35]—indeed, the back was drawn and engraved almost as much as was the front (Fig. 5). Obtaining a distant view of the *Hercules* presents no problem to the visitor to the park at Wilhelmshöhe outside Cassel, where on a pyramid-shaped pavilion 63 metres high was placed a copper copy of the statue 9.20 metres high (nearly three times the size of the original) made by the Augsburg goldsmith Johann Jacob Anthoni between 1713 and 1717.[36] In the seventeenth century plaster casts had been made for Louis XIII[37] and Philip IV,[38] as well as for the French Academies in Rome and Paris.[39] Above all, Le Nôtre placed what seems to have been a full-size copy in the gardens of Vaux-le-Vicomte (now replaced by a gilded lead replica of 1891) as the climax to a suite of gardens and lakes that extended from the chateau,[40] in one of whose rooms Lebrun painted scenes from the life of Hercules, the symbol of Foucquet's power.[41]

118. *Farnese Hercules* (Museo Nazionale, Naples).

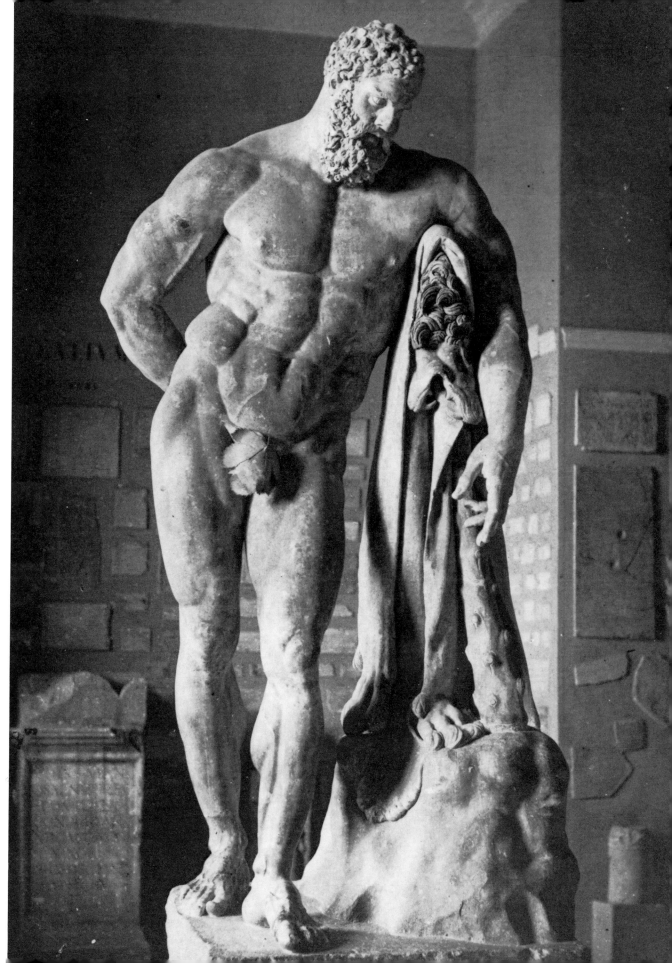

In 1684–6 Jean Cornu made a marble copy the size of the original for Versailles (where it still remains).[42] In England a full-scale copy by C. H. Smith was carved out of a single block of Portland stone early in the nineteenth century (Geological Museum, London).[43] He was no doubt using the cast which in 1798 had reached the Royal Academy and was causing controversy as to where it could be installed.[44]

Many copies, such as the one which can be seen in the painting of an early seventeenth-century Antwerp art collection (Fig. 18)[45] or the one placed in the South Garden at Chatsworth in the nineteenth century, were reduced to life-size. Smaller versions were enormously popular: the fine example in gilt bronze in the Metropolitan Museum in New York dates from the late sixteenth century and has been attributed to Pietro da Barga.[46] There is a terracotta copy, signed and dated 1617, by Stefano Maderna in the Ashmolean Museum in Oxford. In the eighteenth century both Zoffoli and Righetti offered bronze statuettes.[47] On a yet smaller scale were the intaglios, cameos and oval tablets produced by Wedgwood (Fig. 57),[48] and also gems including a famous one which was engraved by Flavio Sirletti before 1737.[49]

Modern scholars believe that the *Hercules* is an enlarged version, made by Glycon for the Baths of Caracalla in the early third century A.D., of a statue of the same hero produced by Lysippus or his school.[50]

1. Aldrovandi, 1556, pp. 157–8; the fact that the *Bull* was at first thought to represent a Labour of Hercules has led to some confusion in interpreting early references to the statue.
2. Lanciani, 1902–12, II, p. 181; [Kaibel], p. 322; Michaud, XXVII, pp. 244–5.
3. Gramberg (Text), p. 126.
4. Correra, p. 52.
5. Goethe, XXX, pp. 6, 7 (*Italienische Reise*—1 June 1787).
6. Stolberg, II, p. 6; and see *Documenti inediti*, I, p. 166.
7. Addison, p. 349.
8. Northall, p. 309.
9. Missirini, p. 244.
10. *Napoli Nobilissima*, n.s., III, 1923, pp. 175–6.
11. De Franciscis, 1944–6, p. 195.
12. *Napoli Nobilissima*, n.s., III, 1923, pp. 175–6.
13. Paris, Archives Nationales: A.F. IV 1050 (2ème dossier); Boyer, 1970, pp. 199–200, 202, 236.
14. Hogarth, pp. 15–16.
15. Winckelmann (ed. Fea), II, p. 285.
16. Moore, II, pp. 10–12.
17. Bell, J., pp. 258–9; cf. Robertson, I, p. 467.
18. Schiller, XX, pp. 102–3.
19. Winckelmann (ed. Fea), II, p. 285.
20. Giovambattista Finati in *Real Museo Borbonico*, III, 1827, plates XXIII–XXIV.
21. *Ibid.*
22. Baglione, p. 151.
23. Chantelou, p. 138.
24. Goethe, XXX, pp. 254–5; XXXII, p. 6 (*Italienische Reise*); cf. de Franciscis, 1944–6, p. 176.
25. [Engelbach], pp. 14–15.
26. Apart from those cited in the text and in Note 28, there was one formerly in the Pio da Carpi collection (Michaelis, 1891–2, i, p. 140; Canedy, 1976, R138, T92, T149) and now in the Villa Borghese, and another in the Guarnacci in Volterra—Ficoroni, 1744 (*Singolarità*) p. 62.
27. Evelyn, II, p. 216; Mortoft, pp. 146–7; Wright, I, pp. 282–3.
28. This should not be confused with another, somewhat smaller, version in the Uffizi—Mansuelli, I, pp. 58–9 (no. 35).
29. Vacca, Mem. 77; Maffei, plates XLIX, L.
30. Winckelmann (ed. Fea), II, pp. 239–40; but see *Briefe*, I, p. 258.
31. Robertson, I, p. 467.
32. Mengs, p. 363 (second letter to Fabroni).
33. *Musée Français*, Discours, p. 88.
34. Chantelou, p. 26.
35. Montesquieu, II, p. 1171 (*Voyage d'Italie*).
36. Dehio, p. 462.
37. Bellori, pp. 443–4; Poussin, p. 349.
38. Palomino, p. 914; Bottineau, p. 178.
39. Montaiglon (*Correspondance*), I, p. 129.
40. Cordey, p. 94; Vogüé, p. 36.
41. Cordey, pp. 48–50.
42. Souchal, 1977, I, p. 115.
43. Gunnis, p. 355.
44. Barry, p. 9.
45. Speth-Holterhoff, plate 32.
46. Hackenbroch, pp. xxxi, 22, plate 70; *Renaissance Bronzes from Ohio Collections*, no. 153.
47. Zoffoli, Righetti (see Appendix).
48. Wedgwood, 1779, class I, sect. II, no. 24; class II, nos. 42, 157. An oval tablet is in the Lady Lever Art Gallery, Port Sunlight—Hobson, p. 190 (no. 1631); another in the Wedgwood Museum, Barlaston.
49. Mariette, I, p. 140; see also Marchant, pp. 16–17.
50. Bieber, p. 37; Robertson, I, p. 467.

47. Hercules and Antaeus (Fig. 119)

FLORENCE, PALAZZO PITTI (PRINCIPAL COURTYARD)

Marble
Height: 2.90 m

The group is recorded in 1509 as among the statues taken by Pope Julius II to the Vatican,[1] and is mentioned forty years later by Aldrovandi as lying on the ground in the statue court near the niche containing the *Cleopatra*—Antaeus lacking head and arms and Hercules with no legs.[2] Its battered and fragmentary condition, confirmed by contemporary drawings,[3] perhaps accounts for its being neglected by other writers.[4] By the 1560s it was no longer in the Belvedere,[5] and in 1568 it was recorded under a loggia of the Palazzo Pitti in Florence.[6]

Despite its condition the *Hercules and Antaeus* was greatly admired during the High Renaissance, and the attribution to Polyclitus was published as early as 1510.[7] The sculptor nicknamed Antico

referred to it in 1518 as 'the most beautiful work of antiquity that ever was' and made a small bronze reduction of it in a restored state for the 'grotta' of Isabella d'Este (now in the Kunsthistorisches Museum, Vienna),[8] whereas what looks like a replica of the actual battered original may be seen in Lotto's portrait of the famous Venetian art collector Andrea Odoni painted in 1527 (and now at Hampton Court).[9] However, the question of early copies is not an easy one, for there may have been other versions of the compositions and there is, in any case, no firm evidence as to when it was discovered. Certainly some drawings which appear to depict it probably predate its arrival in the Vatican.[10]

It has been assumed but never proved that the group was among the statues given by Pope Pius IV to Cosimo I of Florence when he visited Rome in 1560, and this seems likely,[11] especially in view of the great symbolical significance for Florence and the Medici of the Labours of Hercules,[12] the subject of a series of modern groups commissioned for the Palazzo Vecchio and of a series of statuettes commissioned from Giambologna for the Uffizi where an antique marble group of Hercules and the Centaur Nessus extensively restored by Caccini was also admired.[13]

Eventually the fame of *Hercules and Antaeus* would far transcend any parochial or political considerations. Maffei in his text to de Rossi's anthology of plates of the most admired antique statues put aside his usual scholarly caution and iconographic preoccupations to rhapsodise over every detail of this 'Greek' sculpture which again was ascribed to Polyclitus.[14] His esteem and this attribution were repeated by Montfaucon and Spence,[15] whilst William Cheselden, the surgeon, published a plate of 'the famous statue of Hercules and Antaeus' with the muscles exposed as one of the illustrations in his *Anatomy of the Human Body*.[16] It seems to have been Cheselden's book which gave Thomas Jefferson the idea of obtaining a copy of the group for his projected art gallery at Monticello.[17] He would perhaps have been able to buy a plaster statuette in London,[18] but the work is not listed at the end of the century amongst those pieces copied by the Roman bronze-founders which suggests that it was losing international popularity by then. Authors in Florence however were still hinting that it was an original by Polyclitus.[19]

The group has been little discussed by modern scholars, but it is listed in Arndt and Lippold as derived from a Hellenistic prototype.[20]

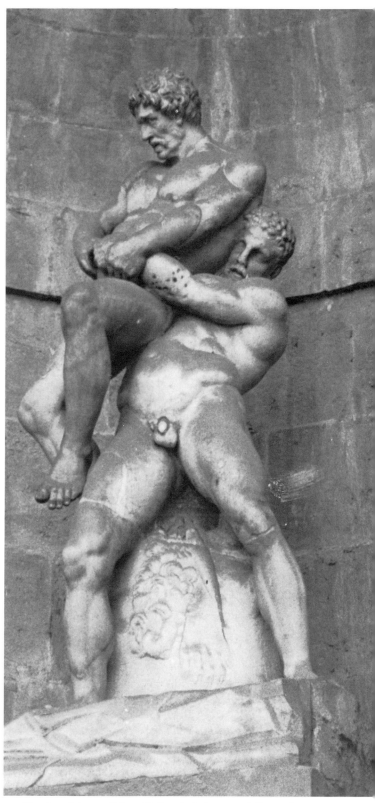

119. *Hercules and Antaeus* (Palazzo Pitti—principal courtyard, Florence).

233

1. Albertini (*De Statuis*) in Valentini and Zucchetti, IV, p. 490.
2. Aldrovandi, 1556, p. 118.
3. Michaelis, 1891–2, iv, p. 91; Hülsen and Egger (Text), I, p. 32 and (Tafeln), I, fol. 59r; Brummer, pp. 139–41; Bober, pp. 72–3.
4. Marlianus, fol. 159v; Gamucci in Brummer, pp. 271–2.
5. Michaelis, 1890, pp. 39, 40, note 149.
6. 'Sotto loggia da basso ci è Hercole, che scoppia Anteo' added to the unpaginated list of 'Anticaglie, che sono nella Sala del Palazzo de' Pitti' among table of contents in Vol. III of the 1568 edition of Vasari's *Vite*.
7. Albertini (*De Statuis*) in Valentini and Zucchetti, IV, p. 490.
8. Hermann, pp. 264–5; Brown, 1976, pp. 326, 329, 335.
9. Bober, p. 73; Berenson, plate 219.
10. Bober, p. 73.
11. Michaelis, 1890, pp. 39, 40, note 149.
12. Ettlinger.
13. Mansuelli, I, pp. 152–3.
14. Maffei, plate XLIII.
15. Montfaucon, 1724, I, p. 137; Spence, pp. 121–2.
16. Cheselden, plate 20.
17. Howard, 1977, pp. 593–5.
18. Harris, C., p. 9.
19. Soldini, pp. 10–11.
20. Arndt and Lippold, XIII, p. 23 (no. 3714).

48. The Hermaphrodite (Fig. 120)

PARIS, LOUVRE

Marble
Length: 1.47 m

On 9 March 1620 'Mr. Lorenzo Bernini' was recorded in the Borghese accounts as being paid 'sessanta scudi' for restoring and making a 'matarazzo' for a statue.[1] This must refer to the *Hermaphrodite* despite the fact that the mattress beneath the statue was being ascribed to Gian Lorenzo Bernini's father, Pietro, only thirty

years later.[2] The statue was not mentioned in Francucci's account of the Borghese collection in 1613. According to notes made by Pietro Santi Bartoli, who died in 1700, it was discovered near the Baths of Diocletian in the gardens of S. Maria della Vittoria when an espalier was planted.[3] This was unlikely to have been long before 1620. Maffei, however, writing later, claimed that it was discovered when the church foundations were dug[4]—that is, in 1608[5] (which would make it possible that the drawings of the statue attributed to Rubens might have been made by him prior to his departure from Rome).[6] Both Bartoli and Maffei agree that the *Hermaphrodite* was presented to Cardinal Scipione Borghese, who was supposed to have paid for the facade of the church[7]—which was erected between 1625 and 1627[8]—in return. By 1638 the statue was on display in the Villa Borghese[9] and certainly by 1650 in a room named after it.[10] This was adorned, during the redecoration of the Villa in the late eighteenth century, with Buonvicini's frescoes of the story of Salmacis and Hermaphroditus.[11] Purchased on 27 September 1807, together with the bulk of the Borghese sculpture collection, by Napoleon Bonaparte, brother-in-law of Prince Camillo Borghese,[12] the *Hermaphrodite* was sent from Rome between 1808 and 1811,[13] and was displayed in the Musée Napoléon by the latter year.[14]

The *Hermaphrodite* was, in the seventeenth and eighteenth centuries, one of the most admired statues in the Borghese collection. The subject was obviously intriguing. Lady Townshend said

120. *Hermaphrodite* (Louvre).

of a copy in the mid-eighteenth century that it was 'the only happy couple she ever saw'.[15] Dupaty warned visitors to the Villa not to look at it if they did not wish to blush with pleasure and shame simultaneously.[16] The distaste expressed by Moore,[17] and, later, Kotzebue,[18] was unusual, but it is not surprising that the penis is not visible in some versions (for instance the small marble at Petworth in Sussex), so that the figure could be thought of as a nymph. On occasion copies were given female companions[19] and contemporaries recognised that a Nymph by Canova had been inspired by the *Hermaphrodite*.[20] Swinburne's poem 'Hermaphroditus' is the most explicit response to the erotic appeal of the figure in which 'sex to sweet sex with lips and limbs is wed', but it was written in 1863 by which date the statue was generally less highly praised than before.

During the period of the statue's greatest celebrity the marble mattress was an important additional attraction, not only for the common travellers (who still incredulously prod it) but for connoisseurs. For Smollett the mattress was 'the most curious circumstance' of the work.[21] Many antique statues were admired because of restorations and additions, but in no other case were these so consistently acknowledged to be modern.

The *Hermaphrodite* was most commonly reproduced on a reduced scale. A small bronze version was signed by Giovanni Francesco Susini as early as 1639 (Metropolitan Museum, New York),[22] and a small ivory copy by Duquesnoy was purchased by Evelyn in Rome in the 1640s;[23] a bronze statuette was acquired a century later by Horace Walpole[24] and both leading Roman bronze-founders in the late eighteenth century sold copies of it.[25] Full-size copies were hard to accommodate in a domestic setting but some nevertheless are recorded: one in bronze was ordered in Rome in 1650 by Velázquez for Philip IV of Spain (now in the Prado, Madrid)[26] and one in marble was made for Versailles between 1679 and 1680 by Martin Carlier.[27] Plaster casts were rare, but one was in the collection opened at Mannheim in 1767.[28]

It was known to scholars in the eighteenth century that Pliny had mentioned a famous Hermaphrodite by Polycles:[29] Visconti, however, pointed out that Polycles worked in bronze, so that the Borghese statue (and the other versions to be discussed below) were probably all derivations from it.[30] Together with the version now in the Museo Nazionale which was discovered in 1880 the Borghese *Hermaphrodite* is considered by Robertson as a good copy executed under the Roman Empire of a bronze original of the mid-second century B.C. by the later of the two artists called Polycles, who are mentioned by Pliny.[31]

<p style="text-align:center">★ ★ ★</p>

Although the Borghese *Hermaphrodite* was most admired, three other antique versions of the statue were sometimes compared with it during the eighteenth and early nineteenth centuries, and can easily be confused with it today:

1. An Hermaphrodite, restored for the Ludovisi between 1621 and 1623 by Ippolito Buzzi, using the Borghese statue as his model, was purchased in 1669 by Grand Duke Ferdinand II of Tuscany,[32] and taken to the Uffizi where it may still be seen.[33] There it was often admired, both by travellers and scholars, but usually as the second-best statue of its kind.[34] However, in the mid-eighteenth century, positive attempts were made by the Florentines to promote it. Gori and Bianchi both claimed that it was unrestored[35]—and seem to have been believed by Caylus;[36] but not long after alternative strategies were preferred. A popular tradition was invented which admitted that the statue was restored but ascribed the additions to Michelangelo,[37] whilst Bencivenni Pelli pointed out that the restoration had been done in a manner closer to the spirit of the antique than had Bernini's.[38]

2. Another version of the Hermaphrodite, with a mattress and rumpled sheets supplied by Bergondi in the mid-eighteenth century, was also in the Borghese collection. In 1764 Winckelmann recorded it as in the vaults of the Villa,[39] but by 1791 it was in a special room in the Palazzo Borghese, Rome.[40] It has now replaced the Louvre statue in the Villa Borghese.[41]

3. Another version of the Hermaphrodite, found at Velletri at the close of the eighteenth century, was acquired by the French for the Musée Central des Arts where it was displayed by 1803-4,[42] and was later joined by the Borghese *Hermaphrodite*.

1. Faldi, 1953, pp. 142, 146 (Document VI).
2. Manilli, p. 99.
3. Bartoli, Mem. 32.
4. Maffei, plate LXXVIII.
5. Hibbard, p. 140.

6. *Rubens: Drawings and Sketches*, p. 31 (no. 18); Jaffé, pp. 81–2, plate 290.
7. Bartoli, Mem. 32; Maffei, plate LXXVIII.
8. Hibbard, p. 141.
9. Perrier, plate 90.
10. Manilli, p. 99.
11. Della Pergola, 1962, p. 80, plates 95–7.
12. Boyer, 1970, p. 202.
13. Arrizoli-Clémentel, pp. 13–14, note 60.
14. *Notice*, supplément, 1811, p. 3
15. Walpole (*Correspondence*), XVIII, p. 342.
16. Dupaty, I, pp. 132–3.
17. Moore, II, p. 367.
18. Kotzebue, I, p. 104; III, p. 143.
19. Souchal, 1973, p. 41 (Girardon's collection); Library chimney-piece, Rousham, Oxon.
20. Matthews, I, p. 142 (referring either to the statue in the Royal Collection, London, or to the one now in the Metropolitan Museum, New York).
21. Smollett, p. 265 (letter XXXI).
22. *Giambologna* (Vienna), pp. 267–8 (no. 189).
23. Evelyn, II, p. 253.
24. Walpole (*Correspondence*), XVII, pp. 213, 395; XVIII, pp. 214, 292.
25. Zoffoli, Righetti (see Appendix). One signed by Zoffoli is in the National Museum, Stockholm—Honour, 1963, plate 4.
26. Harris, E., pp. 117–19, plate III.
27. Souchal, 1977, I, p. 78.
28. Schiller, XX, p. 105.
29. Pliny, XXXIV, 80.
30. Visconti (*Monumenti Borghesiani*), plate XIV.
31. Robertson, I, pp. 551–2.
32. Bruand, 1956; Bruand, 1959, p. 130.
33. Mansuelli, I, pp. 82–3.
34. E.g. Addison, p. 423; but see Gibbon, p. 249.
35. Gori, 1734, p. xv, plates XL–XLI; Bianchi, pp. 225–6.
36. Caylus, 1752–67, III, 1759, pp. 114–15.
37. Lalande, II, p. 200.
38. Bencivenni Pelli, I, p. 230, note.
39. Winckelmann, 1764, p. 368.
40. Vasi, 1791, II, p. 380.
41. Inventory no. CLXXII.
42. *Notice*, supplément, An XII (1803–4), p. 175.

49. The Horses of St. Mark's (Figs. 121–2)

VENICE, S. MARCO

Gilded bronze
Height (of each horse to withers): 1.71 m
Also known as: The Horses of Corinth

The Horses are first definitely recorded, when already on the Basilica of S. Marco in Venice, in a letter of Petrarch dated 1364.[1] However, it has never been disputed that, as claimed in sixteenth-century books on Venice (based on many earlier accounts), they had been taken from Constantinople after its sack by the Venetians in 1204 during the Fourth Crusade. The *Horses* were kept for many years in the Arsenal of Venice (where they were later said to have risked being melted down to make weapons) before being attached to the extensively rebuilt and re-decorated facade of St. Mark's, probably under Doge Raniero Zeno between 1253 and 1268:[2] a mosaic, which can be dated to the middle of the thirteenth century, in the portal of S. Alipio in the Basilica itself appears to show them already in place.[3] On 13 December 1797 they were removed by the French and they arrived in Paris on 17 July 1798; ten days later they were the most prominently displayed of all the antiquities carried in the triumphal procession through the city.[4] It was at first proposed to erect them in the Place du Carrousel at the entrance to the Tuileries,[5] and then two years later in the Place des Victoires, where they were to be harnessed to a chariot.[6] In fact they were kept in the Invalides until 1802 when they were installed on four separate piers punctuating the railings over-looking the Rue de Rivoli in front of the Tuileries.[7] In 1807–8 they were fitted on to the newly built Arc de Triomphe du Carrousel drawing a gilded lead chariot, designed by Lemot, in which stood two personifications of Victory.[8] They were removed on 1 October 1815, reached the Austrian city of Venice on 7 December (an occasion recorded in a picture by Chilone commissioned by Metternich) and on 13 December they were replaced on the Basilica.[9] Wars and the need for restoration have led to their being taken down on a number of occasions since.

From Petrarch's day until the present the *Horses* have nearly always been admired and have always aroused controversy, for neither their date, their place of origin nor the nationality of the artist who made them has ever been satisfactorily determined. Cyriac of Ancona, who visited Venice in 1436 and who was the first to give these matters serious thought, attributed them to the symbolic name of Phidias and claimed that they had at one time been in Rome.[10] The name of Lysippus (which is still invoked) entered the controversy quite early, for by 1492 they had already been compared to the quadrigas that were sometimes reproduced on coins, gems and reliefs,[11] and, soon after, it was noted that Pliny had discussed a quadriga made by Lysippus for the inhabitants of Rhodes.[12] It was often claimed that the *Horses* had adorned a triumphal arch built by Nero; some antiquarians proposed that they had been presented to him, along with *Alexander and Bucephalus*, by Tiridates King of Armenia (who was sometimes identified with one of the *Farnese Captives*) before being taken by the Emperor Constantine to his new capital.[13] This theory was not seriously shaken by evidence from Constantinople, first published in the middle of the sixteenth century, which

suggested that they had stood in the Hippo-drome there.[14] In fact the more new suggestions that came to light (from literary evidence, both old and new, and from coins) the more elaborate were the theories constructed to accommodate them all. On a more popular level were many variants of a legend that they had been placed on the Basilica in fulfilment of a vow made by Frederick Barbarossa that he would make of St. Mark's 'a stable for their [the Venetians'] horses'.[15]

Indeed, the political symbolism of the *Horses* was lost on no one and survived for many centuries. In Paris Fontaine, architect of the Arc du Carrousel, at first found distasteful the idea of placing such 'inimitable sculpture' on a monument dedicated to the glory of France, but was won round by Vivant Denon[16] who wished to include a statue of Napoleon in the chariot—an idea angrily rejected by the Emperor himself.[17]

In 1827 the Arc du Carrousel was dedicated anew to French successes in the recent war in Spain, and bronze casts of the *Horses* were made by the famous founder Crozatier from moulds specially taken in Venice so that once again the arch could be suitably crowned: a figure by Bosio of the Restoration of the Monarchy was placed in a new chariot designed by Percier and Fontaine, and twin statues of Victory and Peace were added to the group.[18]

In Paris it was sometimes felt that in the mid-day sun the gilded accessories added to the *Horses* were too dazzling.[19] In Venice, however, their superb placing had nearly always been admired. In 1611 the English traveller Thomas Coryat could observe that their situation 'yeeldeth a marvailous grace to this frontispice of the Church',[20] and the vivid and poetic use made of the *Horses* by generations of painters from Gentile Bellini to Francesco Guardi shows that this

121. *Horses of St. Mark's* (Basilica of St. Mark's, Venice).

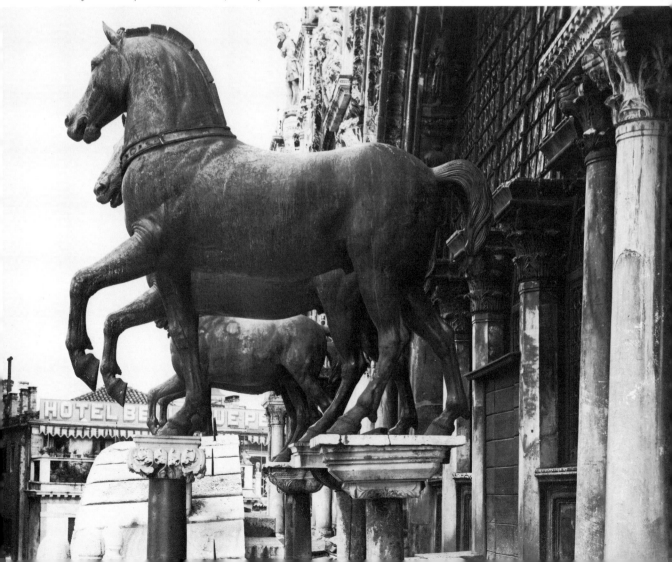

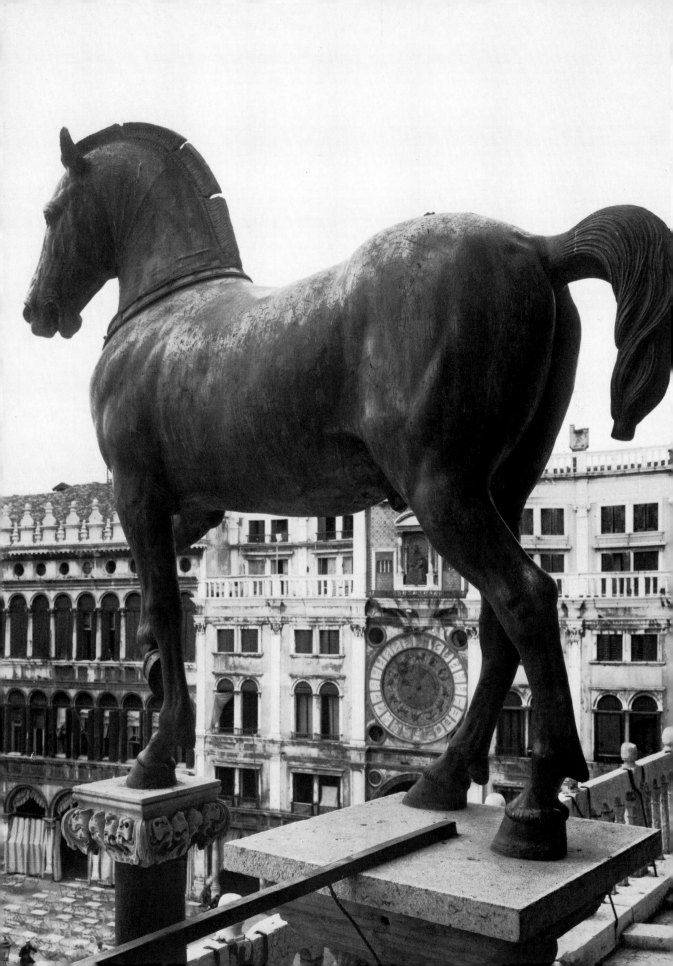

feature was fully appreciated. However, both foreigners and Venetians occasionally suggested alternative sites for them. Grosley thought that they could only have been placed on the Basilica out of a disdain for horses or, at best, a concern for their safety: 'the natural location was at the four corners of the Piazza or opposite the church facing the flagpoles which carry the standards of the Republic';[21] in a *capriccio* of 1743 (now in the Royal Collection) Canaletto imagined them on high pedestals in front of the Doge's Palace facing Sansovino's Libreria;[22] and in 1815 Canova proposed that, rather than being returned to their original position, they should be divided into two pairs to flank the entrance of the palace.[23]

The motive behind all these suggestions was respect for the quality of the sculptures and a desire that they should be more easily visible, for in the eighteenth century the *Horses* themselves began to be studied by a few scholars as closely as had been the literary evidence in earlier years. Both the Zanetti cousins (who published fine plates of them)[24] and Winckelmann[25] thought they they dated from the age of Nero but did not question their great beauty, as did some writers who thought that the gilding was 'a barbarous example of luxury directed against good taste',[26] and as did Falconet, who never saw them.[27] But though it had always been possible to approach the *Horses*—Goethe did so and commented on the scratching of the surface[28] (an issue that has since given rise to many theories)[29]—it was their removal in 1797 from a relatively inaccessible position that really led to heated discussions about their date and origins. Nationalism and politics played as great a part in these debates as did disinterested examination of style and technique, and the battle of the pamphlets (which became increasingly bad tempered in tone) reached a climax in the months immediately following the return of the *Horses* to Venice.[30] Though many connoisseurs took part and many issues were raised, the two principal protagonists (at least in the eyes of posterity) were the Italian historian of sculpture Leopoldo Cicognara and the German theorist and scholar August Wilhelm von Schlegel, and the main issue at stake was the original nationality of the *Horses*. With the most elaborate arguments Cicognara claimed that they had been cast in Rome (though perhaps by Greek sculptors)[31] whereas Schlegel insisted that they could only have been made in Greece.[32] Outside observers could afford to be more casual. The Austrian press settled the

matter briefly enough by referring to the 'Horses of Corinth',[33] while an Englishman, Major Frye, musing on their restitution to Venice, merely asked 'who knows whether they may not be destined to return one day to their original country, Greece, under perhaps Russian auspices?'[34]

A new dimension was given to the controversy by reactions to the arrival in London of the Elgin marbles which included the particularly fine head of a horse from the Parthenon. In 1818 the pugnacious English painter Benjamin Robert Haydon entered the fray by having printed as a pamphlet in French an article he had previously written for an English journal in which he compared the Elgin horse with one of those from St. Mark's.[35] Basing himself on a detailed examination of the expressive power of both animals he concluded that the horse in London was incomparably superior to the one that had by now returned to Venice. But he did not challenge that this too was Greek, and might have been by Lysippus. It is interesting that before the Elgin marbles became generally known some French writers had thought that the *Horses*, then in Paris, must date from before the age of Pericles because of the stiffness of their manes.[36]

The *Horses* were obviously studied with great care by sculptors from Donatello and Verrocchio onwards and their impact can also be traced in a large number of paintings, drawings and engravings.[37] Small bronze replicas of them appear to have been popular in the sixteenth and seventeenth centuries,[38] and what could be a very early example can be seen standing on the ledge of St. Augustine's study as painted by Carpaccio (in the Scuola di S. Giorgio in Venice) at the beginning of the sixteenth century.[39]

Scholars appear to be no surer today than they have been in the past about the dating of the *Horses* which in recent publications has varied between 300 B.C. and A.D. 400.[40]

1. *I Cavalli di S. Marco*, p. 78.
2. Perry, M., pp. 27–8; *I Cavalli di S. Marco*, p. 78.
3. Pavan, 1974 ('Canova'), p. 83; *I Cavalli di S. Marco*, plate 107.
4. Pavan, 1974 ('Canova'), p. 90; *I Cavalli di S. Marco*, p. 127.
5. Pavan, 1974 ('Canova'), p. 92 (referring to *Moniteur*, An VI, 18 Thermidor).
6. *Ibid.* (referring to *Moniteur*, An VIII, 13 Brumaire).
7. Biver, 1964, p. 99; *I Cavalli di S. Marco*, plate 104.
8. Biver, 1963, pp. 179–82.
9. Pavan, 1974 ('Canova'), p. 97; *I Cavalli di S. Marco*, plate 105.
10. Perry, M., p. 33.
11. *Ibid.*, pp. 33–4.
12. Pliny, XXXIV, 63.

122. *Horse of St. Mark's* (Basilica of St. Mark's, Venice).

13. *I Cavalli di S. Marco*, pp. 139–40.
14. *Ibid.*, p. 140.
15. Perry, M., pp. 29–33.
16. Biver, 1964, pp. 99–100.
17. Biver, 1963, pp. 181–2.
18. *Ibid.*, pp. 185–6.
19. Eustace, 1814 (*Letter*), p. 20; Schlegel, II, p. 38.
20. Coryat, pp. 207–8.
21. [Grosley], II, pp. 72–4.
22. Constable (ed. Links), no. 451.
23. Pavan, 1974 ('Canova'), pp. 95–6.
24. Zanetti, I, plates XLIII–XLVI.
25. Winckelmann (ed. Fea), II, p. 354.
26. [De Guasco], p. 152.
27. Falconet, III, pp. 61–2 (*Notes sur le XXXIV livre de Pline*, chapter VII).
28. Goethe, XXX, p. 136 (*Italienische Reise*).
29. Vittori and Mestitz.
30. Pavan, 1974 ('Canova'), pp. 110–11.
31. Cicognara, III, pp. 164–70.
32. Schlegel, II, pp. 30–62.
33. Pavan, 1974 ('Canova'), p. 93 (referring to *Wiener Zeitung*, 12 October 1815).
34. Frye, p. 73.
35. Haydon.
36. Pavan, 1974 ('Canova'), p. 92 (referring to *Magasin Encyclopédique*, 1806, VI, pp. 299ff.).
37. *I Cavalli di S. Marco*, pp. 78–119.
38. Weihrauch, pp. 49–51.
39. *I Cavalli di S. Marco*, p. 109.
40. *Ibid.*, pp. 144–6.

50. The Idol (Fig. 123)

FLORENCE, MUSEO ARCHEOLOGICO

Bronze
Height (without plinth): 1.50 m
Also known as: Apollo, Bacchus, Buon Evento, Ganymede, Genius, Idolino, Mercury

The statue was dug up at Pesaro in October 1530 during building operations carried out by Alessandro Barignano. By 6 November of the same year he had presented the statue to Francesco Maria della Rovere who was then building his Villa Imperiale near Pesaro.[1] The inscriptions for this building and for the statue, evidently placed in it, were planned by Cardinal Bembo by 28 July 1533.[2] A century later the 'Bacco di bronzo' was inherited, with all the moveable property of Francesco II, the last della Rovere Duke of Urbino, by Vittoria della Rovere, wife of Ferdinand II de' Medici. The aged Duke had in fact sent both the statue and its pedestal to Ferdinand, together with a collection of armour, on 29 July 1630, a couple of years before his death.[3] It is recorded in the Uffizi by 1646–7.[4] In September 1800 it was sent, with other treasures, to Palermo to escape the French, but it was returned in February 1803.[5] In 1889 it was still in the Uffizi, but by 1892 it was no longer on view there, and by 1897 it was on display in the Museo Archeologico in Palazzo della Crocetta in a room named after it.[6]

From the moment of its discovery the *Idol* was enormously admired, and in 1542 Alberto del Bene assured his friend Bembo that it was not only 'antica e bella', but worthy of comparison with the bronzes which were marvelled at in Rome—'il Nudo dello spino' (the *Spinario*) and 'la Feminetta', its companion (almost certainly the *Camillus*).[7] It was often mentioned and sometimes praised after its arrival in Florence in the seventeenth century,[8] and in the eighteenth century its 'lightness and elegance of pose' and 'canonical' proportions enabled some writers to praise it as highly as they did the statues of the Tribuna,[9] although there is evidence that it was more admired by connoisseurs than by the 'common spectator'.[10]

Plaster casts of the statue were available in Florence.[11] One such was in the Duke of Richmond's gallery,[12] whilst a bronze replica was amongst those in the collection of the da Passano family in Genoa.[13] In the early nineteenth century a plaster cast was among those chosen to adorn the Salone of Prince Borghese's palace in Florence.

The identity of the statue was not at first disputed. The earliest accounts agree in describing it as a Bacchus,[14] and this is reflected in the decorations of the modern pedestal (much praised by eighteenth-century travellers who persistently ascribed it to Ghiberti)[15] and in the inscription ('Ut potui huc/veni/Delphis et/Fratre Relic-/to') composed for the pedestal by Bembo.[16] The interpretation was encouraged by the crown of vine leaves and the bronze branch with which the statue was, reputedly, unearthed, but which some have supposed were embellishments made for it immediately after.[17] The inscription was sometimes so interpreted as to provide the statue with a spectacular provenance—the Temple of Apollo at Delphi.[18] The embellishments were removed by the eighteenth century when numerous other names were suggested. Gori proposed simply that a guardian deity was intended, for such short hair was appropriate neither for Apollo nor for Bacchus, but he later published it as an Etruscan Genius.[19] Others considered it 'Il Buon Evento'—the God of Luck—but Bianchi, who disputed this, preferred to call it the Idol of an unknown god.[20] Winckelmann noted that Pesaro had been a Greek colony and pointed out that the 'fish scale' treatment of the boy's hair was similar to that found on several Greek and Roman heads in bronze and basalt. He said that it was believed to be a 'Genius.[21] Visconti sug-

gested Mercury.[22] And others, presumably supposing the extended hand to have held a cup, thought of Ganymede.[23]

The *Idol* was displayed in the Uffizi together with the bronze Minerva, the bronze Chimaera, and the bronze portrait statue known as the Arringatore or Orator (but called by Gori an Etruscan Haruspex, and earlier identified as a Consul or as Scipio Africanus), all of which were considered as Etruscan.[24] Perhaps for this reason Gori's theory enjoyed significant popular currency—thus in Mrs. Starke's account it is 'an Etruscan statue of a Genius, or perhaps a Bacchus'[25]—but scholars did not think of it as Etruscan,[26] and these other bronzes were moved first to the Museo Egizio in Via Faenza, and then to the Museo Archeologico,[27] where they were not displayed together with the Idolino (Little Idol) as it was by then known. The statue is still so-called (although in inverted commas) by modern scholars, some of whom follow Furtwängler and Amelung, considering it a Greek original of the school of Polyclitus,[28] but most of whom agree with Robertson in preferring to see it as a Roman work in the Polyclitan manner, probably originally holding a lamp.[29]

1. Kekulé, 1889, pp. 3, 15 (document).
2. *Ibid.*, pp. 15–16 (document).
3. Menichetti, pp. 116–17.
4. Raymond, pp. 32–3.
5. Paris, Archives Nationales: F²¹ 573 (letter from L. Dufourny to Minister of Interior, 9 fructidor, an 9); Florence, A.G.F., Filza XXX 1800–1801, n. 23; *Galerie Impériale*, p. 10; Boyer, 1970, pp. 187–91.
6. Baedeker, 1889, p. 401; 1892, p. 370; Amelung, 1897, pp. 272–5.
7. Kekulé, 1889, p. 16 (document).
8. Raymond, pp. 32–3.
9. Richardson, 1722, pp. 46–7; Gori, 1734, plates XLV, XLVI; Cochin, II, p. 45; Winckelmann (ed. Fea), I, p. 180.
10. Smollett, p. 234 (letter XXVIII); Baretti, p. 24.
11. Walpole (*Correspondence*), XX, p. 547.
12. Edwards, 1808, p. xvii.
13. Hallo, pp. 193, 220.
14. Kekulé, 1889, pp. 3 and 15 (documents).
15. E.g. Richardson, 1722, pp. 46–7; Gori, 1734, plates XLV, XLVI; Bianchi, p. 84.
16. Kekulé, 1889, pp. 15–16 (document).
17. Bencivenni Pelli, I, p. 238, note; Hallo, pp. 207–8.
18. E.g. Raymond, pp. 32–3.
19. Gori, 1734, plates XLV, XLVI; Gori, 1737, I, plate LXXXVII; II, pp. 207–8.
20. Bianchi, pp. 84–5.
21. Winckelmann (ed. Fea), I, p. 180.
22. Visconti (*Pio-Clementino*), II, plate XXVIII.
23. Smollett, p. 234 (letter XXVIII).
24. For the origins and fortunes of these statues, see Cristofani, 1979; for the changing names of the Arringatore, see Evelyn, II, p. 189; Lassels, I, p. 161; Richardson, 1722, p. 48; Addison, p. 413.
25. Starke, 1820, p. 112.
26. Dennis, 1848, II, p. 104.
27. Baedeker, 1874, p. 351; Dennis, 1878, II, pp. 75–115; Baedeker, 1879, p. 401.
28. Furtwängler, 1895, p. 286; Amelung, 1897, p. 274.
29. Robertson, I, p. 332.

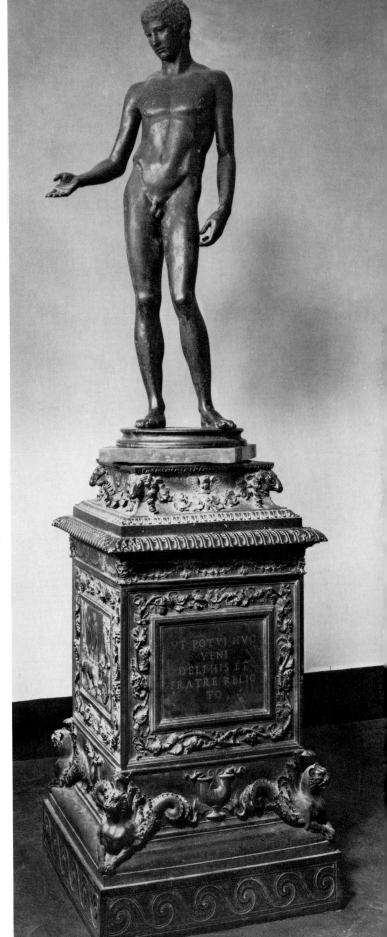

123. *Idol* (Museo Archeologico, Florence).

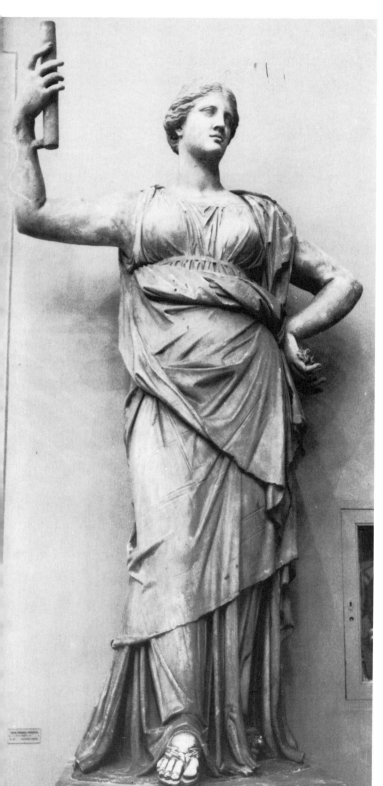

124. *Cesi Juno* (Capitoline Museum).

51. Cesi Juno (Fig. 124)

ROME, MUSEI CAPITOLINI

Marble
Height: 2.28 m
Also known as: Amazon, Berenice, Melpomene

The statue is described as in the Cesi sculpture garden by Aldrovandi in his account of the antique statues in Rome published in 1556 but based on notes made six years earlier.[1] By 1733 it was in the Albani collection which was purchased in that year by Clement XII for the Capitoline Museum.[2] Under the terms of the Treaty of Tolentino in 1797 it was ceded to the French.[3] It reached Paris in the triumphal procession of July in the following year,[4] and was displayed in the Musée Central des Arts when it was inaugurated on 9 November 1800.[5] The *Juno* was removed in October 1815,[6] arrived back in Rome in the first half of 1816, and was returned to the rearranged Capitoline Museum during the course of that year.[7]

Aldrovandi who saw this statue without arms described it as an Amazon and mentioned that Michelangelo praised it as the most beautiful object in Rome and that the King of France had frequently had copies made from it.[8] Casts of at least the head had, it seems, been made for Marco Benavides before 1543 (an example is in the Museo del Liviano, Padua).[9] Michelangelo's admiration was still being recorded in the early seventeenth century,[10] and it is surprising that the statue is not included in Perrier's anthology of the most admired antique statues in Rome. Later in the century, however, it was given two plates in Jan de Bisschop's anthology[11] and it was copied in marble for Versailles by Lespingola.[12] This copy (now in the Tuileries Gardens) was engraved as a Berenice,[13] but in de Rossi's anthology of prints in 1704 the statue is still called an Amazon,[14] as it is also in the 1733 inventory of the Albani collection.[15] Maffei, however, in his commentary on de Rossi's plates suggested that the figure, which he praised very highly, represented Juno, or possibly a portrait of one of the family of Augustus in the guise of that goddess,[16] and the Albani inventory gives Juno as an alternative name.[17] Both a Juno and an Amazon appear on the late eighteenth-century sale catalogue of the bronze-founder Francesco Righetti probably referring to the same statue[18] (there are other double listings of this type).[19]

Despite the copy of the *Juno* formerly at Versailles, and today in the Tuileries and its

inclusion in Righetti's lists, the *Juno* was not much reproduced, and its merits were perhaps more apparent to the connoisseur than to the general traveller. The drapery was especially admired—in fact the Germans called it the 'beautifully draped' (schön bekleidete) Juno[20]— and so too was the head, although Visconti, who thought that the figure perhaps represented Melpomene, considered this to be an addition.[21] But the arms were not highly thought of and the Surintendant des Bâtiments, the Comte d'Angiviller, although in general unsympathetic to attempts to improve upon antiquity, did not insist that Michallon should imitate them exactly in the copy which he had taken over from Chardigny.[22] Sir Joshua Reynolds also changed their position when he took the statue as the model for Fortitude in the window he designed for New College, Oxford.

Although the cast which was amongst those presented by the Pope to the Prince Regent in 1816 (when the original returned to Rome) was highly praised by Flaxman[23] and prominently displayed in the entrance hall of the Royal Academy[24] the *Juno* does not feature in the lists of the leading plaster cast merchant in mid-nineteenth-century London, nor was the original much noticed by English travellers. On the other hand 'die majestätliche Junostatue, wundervoll drappirt' as it is described in the text to *Carl Frommel's pittoreskes Italien* of 1840[25] certainly continued to be admired by Germans abroad. By the late nineteenth century, after the German excavations at Pergamon and in particular the discovery there of the Tragoidia (Altesmuseum, Berlin), it had become clear that this was either an original or a good copy of a Hellenistic original close to the school of Pergamon.[26]

It is catalogued in Helbig as a copy of a Pergamene statue dating from before the second half of the second century B.C.[27]

1. Aldrovandi, 1556, p. 123.
2. Stuart Jones, 1912, pp. 341, 396.
3. Montaiglon (*Correspondance*), XVI, pp. 464, 498.
4. Blumer, pp. 241–9.
5. *Notice*, An IX (1800), pp. 88–9.
6. Saunier, p. 149.
7. Either in the consignment of statues which arrived on 4 January (*Diario di Roma*, 6 January 1816) or among those which had reached Civitavecchia from Antwerp by 19 June on H.M.S. *Abundance* (ibid., 19 June 1816); Stuart Jones, 1912, p. 8.
8. Aldrovandi, 1556, p. 123.
9. Candida, pp. 29–32, 96.
10. Lauro, 1612–15, plate 46.
11. Episcopius, plates 36–7.
12. Lami, 1906, p. 332.
13. Thomassin, plate 37.

14. Maffei, plate CXXIX.
15. Stuart Jones, 1912, p. 396.
16. Maffei, plate CXXIX.
17. Stuart Jones, 1912, p. 396.
18. Righetti (see Appendix).
19. *Ibid.*—e.g. the Altieri Mercury and Cupid, and the Vatican Possidipius and Menander formerly known as the Marius and Scylla at the Villa Negroni.
20. Meyer—quoted in Goethe, XXXII, p. 150 (*Italienische Reise*).
21. *Musée Français*.
22. Montaiglon (*Correspondance*), XIV, p. 442; XV, pp. 39, 49, 76, 80.
23. Flaxman, p. 27.
24. Hutchison, plate 20.
25. Lüdemann and Witte, p. 327.
26. Stuart Jones, 1912, p. 341.
27. Helbig, 1963–72, II, pp. 233–4.

52. Laocoon (Fig. 125)

ROME, MUSEI VATICANI (BELVEDERE COURTYARD)

Marble

Height (from Laocoon's right hand to the base of the statue): 2.42 m

The Laocoon was discovered on 14 January 1506 on the property of Felice de' Freddi near S. Maria Maggiore, Rome.[1] It was bought by Pope Julius II soon afterwards, taken to the Belvedere, and by 1 June was being installed in a niche in the courtyard.[2] It was ceded by Pope Pius VI to the French under the terms of the Treaty of Tolentino of February 1797,[3] arrived in Paris in the triumphal procession of July 1798[4] and was displayed in the Musée Central des Arts when it was inaugurated on 9 November 1800.[5] It was removed in October 1815,[6] arrived back in Rome on 4 January 1816[7] and was returned to the Belvedere courtyard by the end of February.[8]

Writing on 28 February 1567, Francesco, the son of Pope Julius II's architect Giuliano da Sangallo, recalled how, over half a century earlier, his father had been summoned to inspect the newly discovered sculpture and invited Michelangelo to accompany them, and how his father had instantly recognised the group as that referred to by Pliny (as an ornament of the palace of Titus, the work of Hagesandrus, Polidorus and Athenodorus of Rhodes 'of all paintings and sculptures, the most worthy of admiration').[9] Pliny's enthusiasm was echoed, and by 1523 the *Laocoon* was held to have eclipsed even the fame of the *Apollo*.[10] For several centuries these two statues were ranked together. In 1843 Dickens could expect even an uneducated public to appreciate what he meant when he likened Scrooge struggling with his stockings in *A Christmas*

243

Carol to this statue.[11] Today, unlike the *Apollo*, the *Laocoon* retains much of its original reputation.

In about 1510, Bramante arranged for four of the leading sculptors in Rome to copy the *Laocoon* in large wax models and invited Raphael, then newly arrived in the city, to judge them—the work of the youthful Jacopo Sansovino was considered to surpass those of the others by far and it was cast in bronze at the suggestion of Cardinal Grimani, to whom it was presented and who held that it was as dear to him as the antique would have been.[12] By 1523 the earliest and most famous full-size marble copy was being carved by Bandinelli, intended by Pope Leo X as a present for François Ier. This was Cardinal Bibiena's suggestion, according to Vasari,[13] but, according to another account, the French King demanded the original from the Pope and this was a substitute.[14] Even before Pope Julius II acquired the group, other collectors had been competing for it (with money, however, rather than through diplomatic pressure)—Cardinal Galeotto della Rovere and Federigo Gonzaga amongst them.[15] Bandinelli's copy eventually went to the Florentine court (and is now in the Uffizi). A bronze copy, however, was made for Fontainebleau,[16] and Sansovino's bronze, which had been bequeathed by Cardinal Grimani to the Signoria of Venice was presented in 1534 to the Cardinal of Lorraine and hence also went to France.[17] A marble copy by Jean-Baptiste Tuby was made for Versailles in 1696 (now at the entrance to the Tapis Vert)[18] and a bronze version made from casts prepared by the Kellers under Girardon's direction was acquired by Sir Robert Walpole's son Robert who was in Paris in the early eighteenth century, and was given a special niche in the great hall at Houghton in Norfolk.[19]

Despite the examples mentioned, large versions of *Laocoon* are relatively scarce due to the difficulty of taking and transporting casts and the problem of accommodating replicas. For academic purposes, a cast of Laocoon alone had sometimes to suffice,[20] and in domestic circumstances, a marble copy of Laocoon's head sometimes served—there are examples by Wilton[21] and Chinard[22] in the eighteenth century, and an earlier one in Palazzo Spada, Rome, was once believed to be by Bernini.[23] Most popular of all were the small versions of the group in bronze or terracotta. And there were also precious miniature reproductions—among them a gold cap badge made by Caradosso and thought suitable

for Isabella d'Este[24] (who had two bronze *Laocoons* in her 'grotta'),[25] the amethyst cut by Flavio Sirletti for the Duke of Beaufort in the first half of the eighteenth century[26] and the agate cut by his son Francesco for the Duke of Leeds in the second.[27] The most mysterious reproduction of the statue is the sixteenth-century Venetian woodcut of three monkeys mimicking the group.[28] The most unlikely copy must be the large one in glazed earthenware made at the Doccia factory in the eighteenth century.[29]

The *Laocoon* was admired for the realism of the anatomy and physiognomy (it was observed in 1523 that Laocoon himself bore a close resemblance to 'messer Girolamo Marcello').[30] The variety of expression in the figures, one suffering, one dying, one moved by compassion, was frequently commented upon from Aldrovandi onwards.[31] The action and emotions of the figures were described vividly in Sadoleto's Latin poem on the statue published in 1532,[32] but written soon after the statue's arrival in the Belvedere and circulating in manuscript by June 1506,[33] and this poem was well known in subsequent centuries. In the eighteenth century, the exact nature of Laocoon's emotion and indeed the exact nature of his pain was not only described but debated at great length, usually with reference to the famous description of the Trojan priest's death in Virgil's *Aeneid*.[34] This debate, at its most elevated, concerned the proper limits of the literary and visual arts, the statue usually exciting praise for the dignified restraint and taste with which the dying Laocoon's agony was rendered—a restraint contrasted with the death throes so painfully and explicitly described by Virgil. Lessing's celebrated essay of 1766 is the best-known contribution to this debate in which, however, Schiller, Herder, Goethe and Hirt all joined.[35]

Despite Winckelmann's insistence on Laocoon's 'Väterliche Mitleiden' and claim that his eyes were raised to heaven to implore mercy for his children,[36] there were those in the late eighteenth century who felt that the moral value of the work would have been increased had the priest taken a more obvious interest in the fate of his children,[37] and, although Sir Joshua Reynolds suggested that such a display of feeling would have enfeebled the clear and intelligible expression appropriate for sculpture,[38] Nollekens remedied this apparent lack of paternal sensibility in drawings and a small terracotta sketch of the subject.[39] He also made the sons more infantile—a change which reflects another

125. *Laocoon* (Vatican Museum), prior to the removal of the restorations.

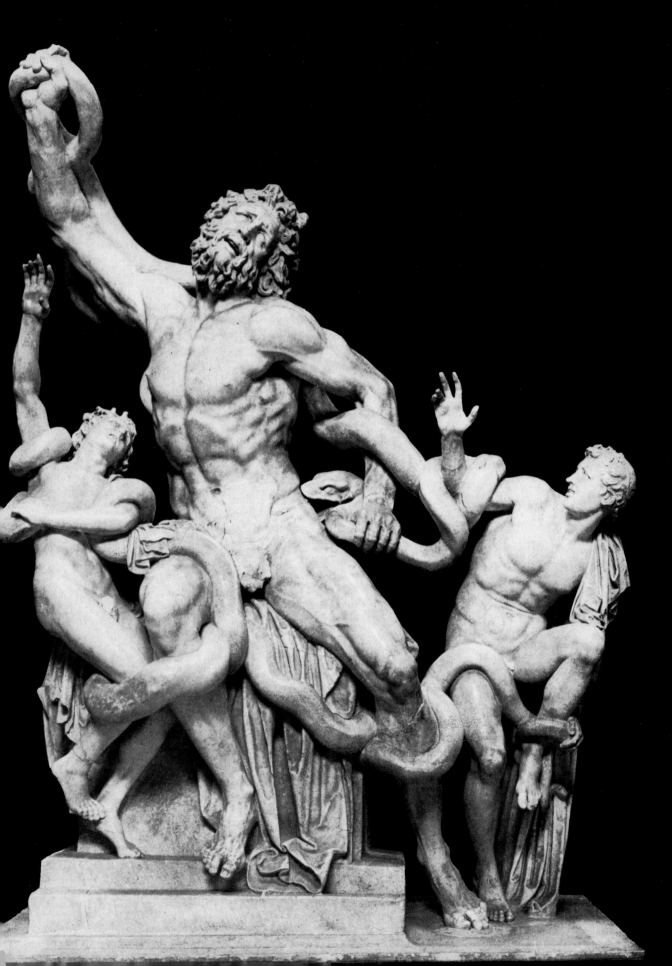

criticism of the antique group that the children were 'little men'.[40] The positivism of the second half of the nineteenth century prompted a more peculiar modification than the sentimentality of the late eighteenth: a cast of the head was revised by the French neurologist Duchenne de Boulogne in accordance with his experiments with electricity on human faces as part of his attempt to codify the principal passions.[41]

Two problems caused special anxiety to admirers of the *Laocoon*. In the first place, Pliny had specifically claimed that the group had been carved from a single block of marble; but disparities in the type of marble and some joins were noted soon after its arrival in the Belvedere,[42] and later in the sixteenth century Fulvio Orsini and Pirro Ligorio continued to direct attention to the joins and referred to fragments which they had seen of a large version which they believed to be the original statue mentioned by Pliny.[43] Such doubts were revived by Montfaucon[44] and were discussed by Richardson, Falconet and Winckelmann, all of whom held that the evidence was indecisive.[45] As for the joins, Winckelmann maintained that they would have been so fine as to escape casual scrutiny.[46] It was thus Pliny's reputation, and not that of the statue, which suffered. As early as 1 June 1506, Cesare Trivulzio had remarked in a letter that some sculptors were suggesting that Pliny may have been deceived—or even that he had set out to deceive others in order to boost the statue's fame.[47]

The conclusion that the statue might be a copy could be deduced not only by the learned, and Peter Beckford also supposed that if not original it 'may be a copy by Polycletus himself'.[48] It was felt by connoisseurs that the tooled surface conveying 'the trembling elasticity and palpitation of the flesh, and even the grain of the skin' could only be the work of a great artist.[49] And in fact there has never been general agreement that the statue is a copy.

The second problem concerned whether or not the work was inspired by the celebrated passage in Virgil with which it was so frequently contrasted. If it was a work contemporary with Virgil, or later, it was clear that it could not have been a product of the 'purest times' (as they were understood in the later years of the eighteenth century). The dilemma could of course be evaded by proposing that Virgil was inspired by the sculpture or by an earlier, lost, literary source. Winckelmann felt that the statue's perfection was such that it must be dated to the

period of Alexander the Great.[50] But Éméric-David and Visconti having rejected the idea that art declined after Alexander felt free to place the group in the early Imperial period.[51]

The date and status of the *Laocoon* are still unsettled, but in recent years, evidence has emerged to suggest that it is a reconstruction by Pliny's sculptors (now believed to have been working in the second half of the first century A.D.) of an earlier two figure group of Pergamene type involving only the father and the younger son.[52] In this connection, it is interesting that doubts about the proportions of the elder son had been expressed in both the sixteenth and the eighteenth centuries.[53]

The statue is catalogued in Helbig as a late Hellenistic group more recent in date than the mid-first century A.D.[54]

★ ★ ★

A concise account of the complex history of the restorations of the statue which has so exercised modern art historians must be added to our account of the statue's critical fortune since it in some respects reflects it. On discovery, Laocoon lacked his right arm, and the elder son's right hand and that of the younger son were also missing. The sons seem to have been restored in marble by 1523,[55] but these restorations were amended two centuries later by Cornacchini.[56] Various ideas as to the position of Laocoon's right arm may be found in early copies and prints.[57] In Bandinelli's copy, as also in a roughed-out marble version of a new arm, probably intended to be fitted on the original, the arm is bent—and by the eighteenth century antique gems were referred to in support of this idea.[58] The appearance of the terracotta arm fixed to the statue in the 1530s by Michelangelo's protégé Montorsoli is uncertain, but we know that the terracotta arm, apparently a new one, which was attached to the statue from the mid-sixteenth century until the group was taken to Paris, was extended upwards.[59] This outstretched terracotta arm was often said to be the work of Bernini.[60] The roughed-out marble version mentioned above was displayed near the statue, and attributed in the eighteenth century to Michelangelo who, it was claimed, had left it unfinished because he felt himself unable to match up to so great a work.[61]

All restorations were detached before the *Laocoon* was removed to France, and in Paris, they were replaced by after-casts from a late seventeenth-century cast of a model whose arms

were supposed to be by Girardon (based with some minor changes on the group as it was before Cornacchini altered the boy's arms).[62] A competition among French sculptors for permanent replacements came to nothing,[63] but on the group's return to Rome Cornacchini's marble restorations were fitted once more to the sons and a stucco arm, different in minor respects from the earlier terracotta one, was fitted to Laocoon. In 1942 this stucco arm was removed and a bent arm, battered and without a hand, but antique (found in 1906), was fixed instead. The other restorations were also removed and some faulty resetting rectified.[64] A cast of the group as it was before these last changes was set up in an adjacent niche of the Belvedere where it remains today.

1. Van Essen, pp. 1–5.
2. Bottari (ed. Ticozzi), III, p. 475 (letter from Cesare to Pomponio Trivulzio).
3. Montaiglon (*Correspondance*), XVI, pp. 462, 498.
4. Blumer, pp. 241–9.
5. *Notice*, An IX (1800), pp. 43–5.
6. Saunier, p. 149.
7. *Diario di Roma*, 6 January 1816.
8. *Ibid.*, 24 February 1816.
9. Fea, 1790, pp. cccxxix–cccxxxi (citing Pliny, XXXVI, 37).
10. Venetian Ambassadors in Albèri, p. 116.
11. Dickens: *A Christmas Carol*, stave V (opening page).
12. Vasari, VII, p. 489; Brummer, pp. 101–7.
13. Vasari, VI, p. 145.
14. Venetian Ambassadors in Albèri, p. 116.
15. Bottari (ed. Ticozzi), III, p. 475 (for Cardinal of S. Pietro in Vincoli); Renier, p. 209, note 4; p. 210 (for Federico Gonzaga).
16. Pressouyre, 1969 ('Fontes'), pp. 223–4.
17. Vasari, VII, p. 489.
18. Lami, 1906, p. 477.
19. Walpole, 1752, p. 74; Francastel, 1928, p. 83.
20. Goethe, XXVIII, p. 84 (*Dichtung und Warheit*).
21. Victoria and Albert Museum, A.84–1949.
22. Lami, 1910–11, I, p. 199.
23. Zeri, p. 14.
24. Plon, 1883, nouvel appendice, pp. 29–30; Pastor, VI, p. 489; Cartwright, II, p. 46.
25. Brown, 1976, pp. 328–9.
26. Mariette, I, p. 141.
27. Raspe, II, no. 9488.
28. Muraro and Rosand, pp. 114–15.
29. Molfino, I, plate 469.
30. Venetian Ambassadors in Albèri, p. 116.
31. Aldrovandi, 1556, pp. 119–20; cf. Palomino, p. 913.
32. Sadoleto.
33. Bottari (ed. Ticozzi), III, p. 476.
34. E.g. Richardson, 1722, pp. 277–9.
35. Lessing; Schiller, VIII, pp. 196–221, especially pp. 205–10 (*Ueber das Pathetische*); Herder, III (*Kritische Walder*); Goethe, XLVII, pp. 101–17 (*Uber Laokoon*); Hirt.
36. Winckelmann (ed. Fea), II, p. 243; Winckelmann, 1968, p. 150 (*Erinnerungen*).
37. Moore, II, pp. 16–18 (quoting the view of Lock of Norbury); see also Beckford, II, pp. 272–3; [Jameson], pp. 144–5; Shelley, pp. 310–11.
38. Reynolds, J., p. 180 (Discourse X).
39. Victoria and Albert Museum, A.12–1966; Whinney, 1971, p. 124.
40. Bell, J., pp. 274–5; Matthews, I, p. 155; Herder, VIII, p. 85; Starke, 1820, p. 330.
41. Jammes, pp. 218–19.
42. Bottari (ed. Ticozzi), III, p. 475; cf. d'Arco, pp. 281–2.
43. For Orsini's doubts, see Bencivenni Pelli, I, p. 52, note b.
44. Montfaucon, 1702, pp. 128–30.
45. Richardson, 1722, p. 277; Richardson, 1728, III, ii, pp. 583–4; Falconet, IV, p. 402; Winckelman (ed. Fea), II, p. 241.
46. Winckelmann (ed. Fea), II, p. 241.
47. Bottari (ed. Ticozzi), III, p. 475.
48. Beckford, II, p. 272–3.
49. [Knight], 1809, p. 1; cf. Knight, 1795, p. 9.
50. Winckelmann (ed. Fea), II, p. 240.
51. *Musée Français*; ibid., Discours, p. 95.
52. Robertson, I, pp. 541–2.
53. D'Arco, pp. 281–2; Mengs, p. 360.
54. Helbig, 1963–72, I, pp. 162–6.
55. Prandi, p. 89.
56. Enggass, I, p. 196.
57. Brummer, pp. 107–8, figs. 88, 97.
58. Mariette, II, p. 95; Falconet, II, p. 297.
59. Vasari, VI, p. 633 (for Montorsoli); Magi; Brummer, pp. 88–101.
60. Winckelmann (ed. Fea), II, p. 242; de Brosses, II, p. 143.
61. De Brosses, II, p. 143; Amelung, 1903–8, II, p. 205; Magi, pp. 46–50; Brummer, p. 89.
62. Aulanier, p. 70.
63. Michon, 1906.
64. Magi.

53. Medici Lions (Figs. 126–7)

FLORENCE, LOGGIA DEI LANZI

Marble
Height (ancient lion): 1.26 m
Modern Lion inscribed: OPUS FLAMINII VACCAE ROMANI

The antique *Lion* of the pair is first recorded by Flaminio Vacca in 1594 by which time it had been acquired by Grand Duke Ferdinando for the Villa Medici in Rome;[1] four years later an inventory of the sculptures in the Villa mentions it as being in the Loggia.[2] It had, according to Vacca, been taken from the Via Prenestina outside the Porta S. Lorenzo and he implies that this had occurred well before his own day;[3] we know that the area was being rebuilt during the pontificate of Paul IV (1555–9).[4] Vacca also tells us that the *Lion* had originally been in high relief and had been cut from its ground by the Tuscan sculptor Giovanni Sciarano,[5] of whom nothing much seems to be known except that he had made a name for himself in Florence by 1591.[6] By 1594 Vacca had himself carved a companion *Lion* (which he signed) out of a giant marble capital found behind the Palazzo dei Conservatori.[7] By 1598 this too was in the Loggia of the Villa Medici.[8] The pair flanked the top of the steps leading into the gardens of the Villa (Fig. 14),[9] but in 1787 they were taken to Florence and

two years later they were displayed at the entrance to the Loggia dei Lanzi.[10]

As a rule the two *Lions* were discussed and copied together, though it seems that a reference to the *Medici Lion* in the singular was, in the seventeenth century at least, usually applied to Vacca's modern version.[11] A mould of this was made for Louis XIV before 1696[12] and it was this one also that Pompeo Batoni drew for Richard Topham's 'paper museum' of antiquities between 1727 and 1730.[13] Panini depicted Vacca's *Lion* in his ideal gallery of modern art where it features prominently alongside the masterpieces of Michelangelo and Bernini, but he did not include the ancient *Lion* in his companion picture of some of the most esteemed sculptures of antiquity (now in the Boston Museum of Fine Arts and the Staatsgalerie Stuttgart).[14]

Indeed it became a commonplace to compare the two, and in the eighteenth century most travellers seem to have preferred Vacca's sculpture.[15] Edward Wright, for instance, thought his to be 'much the better of the two',[16] and Lalande commented that while Vacca's was beautiful, the antique one was not very highly thought of. He pointed out, however, that as Vacca's was broken in many places some people thought that it too was a restored antique rather than a modern work.[17] In his *History of Italian Sculpture* Leopoldo Cicognara claimed that Vacca's was 'the finest lion carved by any Italian before Canova'.[18] However, when, on the advice of Mengs, both *Lions* were taken to Florence, Filippo Aurelio Visconti (brother of the famous Ennio Quirino) dismissed Vacca's as being no more than an imitation of the other which was 'of perfect Greek workmanship'.[19]

As a pair the *Lions* served admirably to flank a doorway, a staircase or a monument and they were sometimes copied for this purpose[20]—very impressively, for instance, in copper in 1832 to

126. *Medici Lion*—antique (Loggia dei Lanzi, Florence).

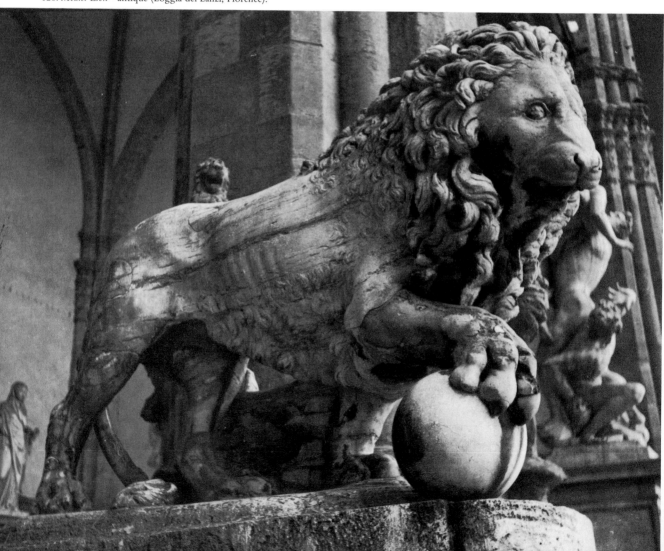

stand at the top of a short flight of steps leading down to a quay on the Neva adjoining the Winter Palace in St. Petersburg (this pair is now in front of one of the pavilions of the Admiralty).[21] Some fifteen years earlier Paolo Triscornia of Carrara had carved slightly modified versions of the *Lions* which were placed outside the Lobanov-Rostovsky palace also in St. Petersburg,[22] and it was on one of these that Evgeny in Pushkin's *Bronze Horseman* sought refuge from the floods and cursed the advancing Peter the Great.[23] But small replicas were also common and both *Lions* were copied in porcelain.[24]

In commenting on the removal to Florence of the *Medici Lions* Filippo Aurelio Visconti also discussed some of the other Lions in Rome which had become well known.[25] Among these were the two of granite which had been found in front of the Pantheon in the fifteenth century and which were much later incorporated by Pope Sixtus V (1585–90) into the Fountain of Moses[26]

and also the two basalt Lionesses found at S. Stefano del Cacco and moved by Pope Pius IV (1559–65) to the bottom of the Capitoline steps, where in about 1588 they were adapted as fountains.[27] Both sets were copied in the eighteenth century either in bronze or in porcelain.[28] In the Palazzo Barberini was (and still remains) another much admired Lion which had been excavated at Hadrian's Villa;[29] while in Venice the larger of the two Greek Lions outside the Arsenal demonstrated according to at least one eighteenth-century traveller 'how far our artists have moved away from antique simplicity and how far they show off their spirit, while the Greeks thought it right to economise theirs'.[30]

But, for all this rivalry, Vacca's *Lion* continued to hold a very high place in the pantheon of honorary antiques, and it and its companion were certainly better known than any of the others. The antique *Lion* is now thought to date from the second century A.D.[31]

127. *Medici Lion*—by Vacca (Loggia dei Lanzi, Florence).

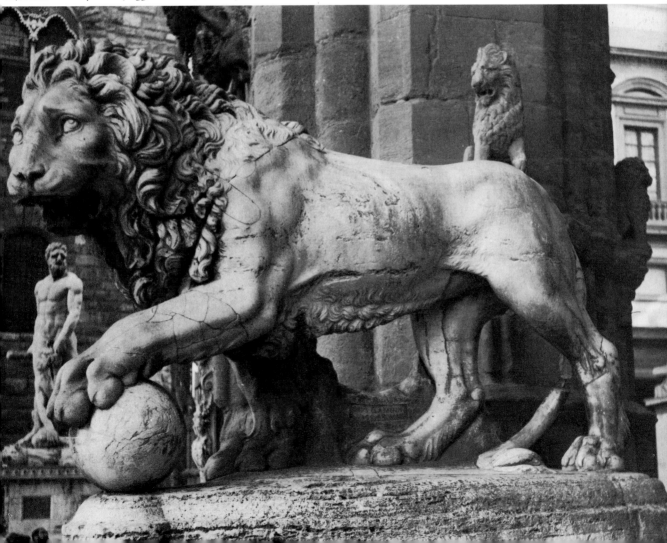

1. Vacca, Mem. 75.
2. Boyer, 1929, p. 263, nos. 81–2.
3. Vacca, Mem. 75.
4. Lanciani, 1902–12, III, p. 151.
5. Vacca, Mem. 75.
6. Bocchi, p. 133.
7. Vacca, Mem. 64.
8. Boyer, 1929, p. 263, nos. 81–2.
9. Venturini, plate 9.
10. *Documenti inediti*, IV, pp. 77–8; Capecchi, p. 174.
11. Montaiglon (*Correspondance*), I, p. 371.
12. *Ibid.*, II, p. 207.
13. Macandrew, p. 145, plate I.
14. Arisi, figs. 305–6.
15. Richardson, 1722, p. 127; [Magnan], p. 157.
16. Wright, I, pp. 327–8.
17. Lalande, IV, p. 22.
18. Cicognara, 1813–18, II, p. 364.
19. *Documenti inediti*, IV, p. 78; Capecchi, p. 175.
20. E.g. for Arakcheev's palace at Grouzino in Russia in the 1830s—Wrangel, Makowsky and Troubnikoff, p. 448; and at Chatsworth in Derbyshire flanking steps leading from the east terrace to the south front of the house.
21. Petrov, Borisova and Naumenko, p. 318.
22. *Ibid.*, p. 163.
23. Pushkin: *The Bronze Horseman*, parts 1 and 2.
24. Harris, C., pp. 7–8; Victoria and Albert Museum—Schreiber Collection, II, 313, Burslem, *c.* 1800 (antique Lion).
25. *Documenti inediti*, IV, p. 78.
26. Vacca, Mem. 35; d'Onofrio, 1962, pp. 91–2, plates 70–1. In the nineteenth century they were taken to the Vatican Museum and replaced by copies.
27. Vacca, Mem. 27; d'Onofrio, 1962, pp. 123–4.
28. Wedgwood, 1779, class XII, section II, no. 10; *Besançon*, p. 97 (no. 219—Inv. D.863.3.37, 38 bronzes), for the Capitoline lionesses. For these and for the lions of the Fountain of Moses, see Righetti (Appendix).
29. De Brosses, II, p. 53; Boselli, fol. 12v, p. 73.
30. [Grosley], II, pp. 71–2.
31. Capecchi, pp. 174–5 (with references to the relevant literature).

54. Lion attacking a Horse (Fig. 128)

ROME, MUSEI CAPITOLINI (GIARDINO DEL MUSEO NUOVO)

Marble
Height: *c.* 1.40 m; Length: *c.* 2.40 m

This group is recorded in 1347 and 1363 as being on a staircase leading up to the Loggia Senatoria on the Capitol.[1] In a book published in 1556 (based on notes made six years earlier) Aldrovandi wrote that it was then on the Piazza del Campidoglio:[2] it had probably been moved there a few years earlier during Michelangelo's reconstruction of the whole area. In 1594 it was taken to the Palazzo dei Conservatori, where it remained until shortly before 1926.[3]

Some fourteenth-century documents indicate that death sentences were then pronounced near the *Lion*[4] (the fragmentary *Horse* must have been much less visible before the restoration of the late sixteenth century), and, although it was drawn (with some alterations) by Jacopo Bellini,[5] it is only in the late Renaissance that we begin to find evidence that it was noticed as a work of art of great expressive power. It was one of a very limited number of statues (such as the *Torso* and the *Cesi Juno*) said by his own contemporaries to have been particularly admired by Michelangelo, who apparently called it 'meravigliosissimo'[6] and 'praised it to the skies'.[7] And Michelangelo was also sometimes credited with the radical restorations[8] which were in fact carried out by the Milanese sculptor Ruggiero Bescapè in 1594:[9] their extent may be seen by comparing the statue as it now is with the engraving published by Cavalleriis before 1584.[10] From the late sixteenth century onwards it came to be highly esteemed and widely known. Vacca (who was wrong in suggesting that it had been discovered under Paul III during whose pontificate it was certainly moved) said that it was by an 'excellent artist',[11] and Michelangelo's reported views reached the standard guidebooks.[12]

Its exact appearance may have presented some confusing problems to those not familiar with the original. It was not illustrated by Perrier or de Rossi, and the reproductions of it that were most current were not necessarily the most accurate. The print by Andrea Ghisi, which was almost certainly published even before the group had been restored, is more vivid than realistic.[13] The many small bronzes produced by Giambologna and his followers (who frequently supplied a companion group of a Lion attacking a Bull) were only based very freely on the Capitoline prototype.[14] It was probably these bronze variants which were used as models for the picturesque staffage in a number of 'Italian views' painted by Northern artists such as Jan Weenix who never went to Rome but who depicts the *Lion attacking a Horse* very powerfully in a painting now in the museum at Brest.[15] In the eighteenth century the group continued to be much admired by visitors to Rome and to be reproduced in paintings and in the form of bronze and plaster reductions[16]—but these now tended to be more accurate as in the *capriccio* by Panini in the Louvre[17] or in the statuettes made by Zoffoli.[18]

Large copies were obviously rarer (there was, for instance, no suggestion that one should be made for Louis XIV), but in 1607 a very close imitation (if not an exact replica) of the group, carved after drawings by G. B. Albergati, was used as a companion to a group of the Wolf with Romulus and Remus. These were placed on

either side of a personification of Rome, and together constituted a fountain which stood in the gardens of the Villa d'Este at Tivoli in front of a miniature reconstruction of the principal buildings of Rome. Vacca tells us of a story current in the late sixteenth century that the Capitoline group 'belonged to the history of the inhabitants of Tivoli',[19] and in 1611 it was explained that the version in the Villa d'Este symbolised the domination of Rome (the Lion) over Tivoli (the Horse). It no longer exists but can be seen in a seventeenth-century engraving.[20]

In England Peter Scheemakers made a full-size copy in stone for Rousham Park in Oxfordshire in 1743,[21] and above all Stubbs returned to the more imaginative attitude of Giambologna and his followers by using the group as the basis for a number of pictures showing lions attacking horses in ostensibly 'real' settings.[22] Most eighteenth-century travellers admired the animation of the statue,[23] though the Richardsons had doubts.[24] Northall commented acidly on the current legend that it had been made to honour a horse that had performed specially well in the amphitheatre by pointing out that 'the lion has got the advantage in this representation'.[25]

The group is catalogued in Helbig as similar in style to those on the Pergamon Altar but earlier in date and possibly of the third century B.C.[26]

1. Bober, p. 176.
2. Aldrovandi, 1556, p. 270.
3. Stuart Jones, 1926, p. 250.
4. *Ibid.*
5. Goloubew, I, plate IX (ii).
6. Aldrovandi, 1556, p. 270.
7. Boissard, p. 47.
8. [Lucatelli], 1771, p. 9; Lalande, IV, p. 168.
9. Stuart Jones, 1926, p. 250.
10. Cavalleriis (2), plate 79.
11. Vacca, Mem. 70.
12. Scoto, II, fol. 54v.
13. Bartsch, XV, p. 429, no. 107.
14. *Giambologna* (London), pp. 186–90.
15. *Renaissance du Musée de Brest*, pp. 27–8 (no. 26).
16. Harris, C., p. 9.
17. Arisi, fig. 141.
18. Zoffoli (see Appendix).
19. Vacca, Mem. 70.
20. Coffin, pp. 27, 105–6, plate 23.
21. Gunnis, p. 342.
22. Taylor.
23. De Brosses, II, p. 174; Gibbon, p. 239.
24. Richardson, 1722, pp. 59, 114.
25. Northall, p. 144.
26. Helbig, 1963–72, II, pp. 562–3.

28. *Lion attacking a Horse* (Palazzo dei Conservatori—garden).

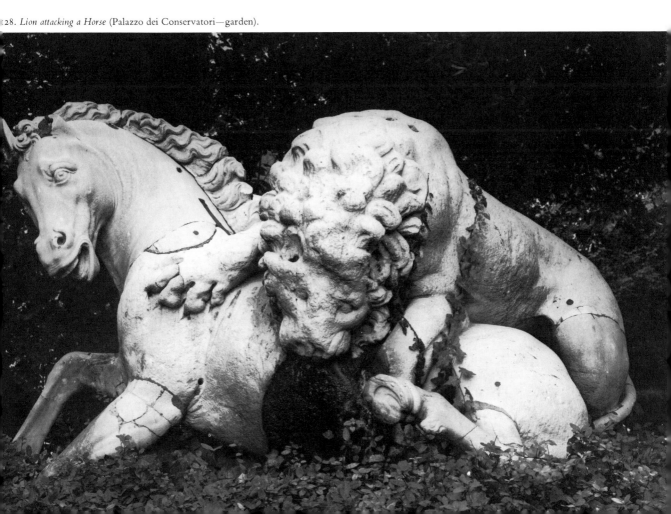

55. Marcus Aurelius (Fig. 129)

ROME, PIAZZA DEL CAMPIDOGLIO

Bronze
Height: 4.24 m
Also known as: Antoninus Pius, Commodus, Constantine, Hadrian, Septimius Severus, Theodoric, Lucius Verus, 'il gran Villano'

The history of this statue can probably be traced back to the tenth century, or even much earlier, but the vague literary sources on which such assumptions have to be based could also be referring to other equestrian statues then in existence.[1] In 1187, however, Pope Clement III when aggrandising the Lateran Palace 'also caused a bronze horse to be made'—a clearly inaccurate statement which must, however, refer to the installation of the *Marcus Aurelius* (which was perhaps already in the neighbourhood),[2] for from this period onward we are very fully informed that the statue was indeed in front of the palace.[3] Like the other antique sculptures in the area it was probably supported on columns[4] and what are likely to be the remains of these may be seen in a drawing by Heemskerk who was in Rome between 1532 and 1536.[5] Between 1466 and 1468 Pope Paul II had the statue restored[6] and in 1474 Pope Sixtus IV arranged for it to be placed on a marble base.[7] In 1538 Pope Paul III put into effect his plan of the previous year and had it transferred to the Capitol.[8] By 1539–40 Michelangelo (who used it as the focal point around which he planned the whole piazza)[9] had already designed for it a new marble base (fashioned from part of an entablature from Trajan's Forum),[10] for this appears in a drawing made by a visitor to Rome at that date,[11] though its actual construction seems not to have been carried out before 1561.[12]

Apart from the groups of *Alexander and Bucephalus* this was the most important statue to survive unburied from antiquity, and during the Middle Ages it attracted a number of fanciful legends and a wide variety of names.[13] By far the most important of these was that of Constantine, for—as Carlo Fea pointed out in 1784[14]—it was probably due to this association with Christianity that it survived virtually intact after the downfall of paganism and the collapse of the Western Empire. However, by the late twelfth century the name of Constantine was repeatedly refuted[15] (though it lingered on for several hundred years more),[16] and the statue was identified (probably for political reasons) with

various heroes of the ancient Roman Republic[17]—either Marcus Curtius, whose valour in plunging into a chasm in order to save the State had been celebrated by Livy,[18] or a heroic peasant (*villano*)[19] or a warrior (*armiger*),[20] whose deeds were variously recorded but who was credited with having captured a foreign king besieging Rome 'during the time of the consuls and senators'. For this he had been rewarded with the equestrian statue which he had asked for. It showed him with his arm outstretched to seize the king while a cuckoo sat on the horse's head—this was a misinterpretation of the foretop of the horse's mane—because that bird's cry had signalled the whereabouts of the king, while the king himself, reduced to the size of a dwarf and his hands tied behind his back, lay underfoot[21] (as, no doubt, had some bound barbarian captive when the statue was in its original state).[22] A visitor to Rome early in the thirteenth century explained that one or other of these stories (with some variations) was believed by the cardinals and officials of the Curia, while pilgrims thought that the figure was Theodoric and the people clung to the name of Constantine.[23] In the fifteenth and sixteenth centuries various emperors were proposed: Septimius Severus,[24] Lucius Verus,[25] Antoninus Pius,[26] and Hadrian[27] among them. The humanist Bartolomeo Platina, who became librarian to Sixtus IV, is credited with having been the first to suggest Marcus Aurelius,[28] but it was not until about 1600 that this became almost universally accepted.

Mid-fifteenth-century admiration for this sculpture is shown by Filarete's bronze statuette (now in Dresden)—the first Renaissance reproduction of an antique and one that was closely, though not precisely, based on the original. It was dedicated to Piero de' Medici in 1465 but it may well have been cast some thirty years earlier,[29] long before Sixtus IV's new installation and at a time when (so it came to be believed in the late sixteenth century)[30] the statue was totally neglected. Antico is known to have made another bronze statuette by 1496,[31] and others were produced by both Italian and Northern sculptors during the course of the sixteenth century.[32] The *Marcus Aurelius* was also engraved more than any other work of antiquity (separately as well as in collections of prints),[33] and when, against the advice of Michelangelo who thought that 'it looked better where it was',[34] it was taken to the Capitol, the canons of the Lateran chapter protested bitterly and for

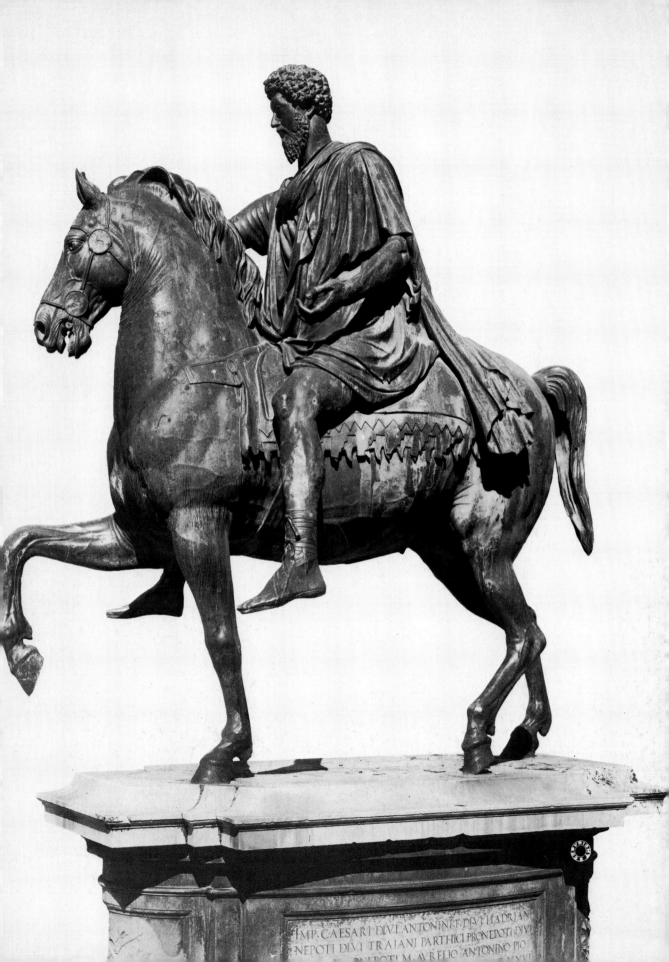

nearly a century efforts were made to retrieve it.[35]

As in the Renaissance so in the eighteenth century small copies were frequent—in bronze,[36] in plaster,[37] and on cameos and intaglios.[38] Much more important were the large-scale versions. A plaster cast was probably made for François Ier and sent to Fontainebleau,[39] and another was the chief feature of Leone Leoni's house in Milan.[40] One of the very first tasks of the French Academy in Rome was to have a mould taken from this statue and eventually this was sent to Paris in eighteen packing cases[41]: it may have been from this that a cast was made which, in Perrault's time, was standing in the Palais Royal.[42] It also seems likely that a full-scale bronze replica of the *Marcus Aurelius* had by then already been erected on a wooden triumphal arch in the gardens which Isaac de Caus designed at Wilton for the fourth Earl of Pembroke and it is perhaps just possible to identify the statue in a painting of the gardens which dates from about 1700; it can certainly be seen there in drawings of twenty years later.[43] In 1758 this arch was replaced by a grander one in stone built by Sir William Chambers and in 1801 James Wyatt re-erected it (with the *Marcus Aurelius*) to make a triumphal entry to the north forecourt.[44] Also at Wilton was 'an Equestrian Statue of Marcus Aurelius, made at Athens and so esteemed, that the Sculptor was sent for to Rome to make that, which is there in Copper, as big as the Life'.[45] The claim made for this much-restored relief of a barbarian came to the notice of Winckelmann and aroused his ridicule.[46]

Enthusiastic praise of the *Marcus Aurelius* can be found in every century, perhaps reaching a peak between the middle of the seventeenth and the early years of the eighteenth. A very similar story was repeated of Michelangelo, of Pietro da Cortona, of Bernini and of Carlo Maratta, each one of whom was supposed to have addressed the statue with the words 'Move on, then; don't you know that you are alive?'[47] In 1671 Colbert's son found it 'one of the most beautiful statues in Rome';[48] in the next generation Addison thought that it was one of 'the Four finest Figures perhaps that are now Extant',[49] while Caylus noted that it was 'magnificent . . . it gives me infinite pleasure'.[50] Yet there was always an undercurrent of criticism which needed only a small stimulus to bring it out into the open. As early as 1549 Doni thought that, though by 'a most excellent master', the very limitations of sculpture (as opposed to drawing) were res-

ponsible for the horse's belly being swollen in relation to the rest of its anatomy;[51] and as soon as the *Balbus* was excavated in 1746 claims were made that it was superior to the *Marcus Aurelius*. In 1764 Gibbon wrote that 'Horse connoisseurs admire the animal: others criticise it.'[52]

Before he came to Rome Winckelmann accepted the view, already proposed by the Abbé Du Bos,[53] that the ancients had been unfamiliar with the nobler breeds of horses (especially English ones) and that this accounted for some limitations in the statue.[54] Later he changed his mind about the quality of horses in antiquity, but his theories about the necessary decline of art in Imperial times inhibited him from expressing enthusiasm for the statue, or even giving it any serious consideration at all.[55] Dupaty thought highly of the *Marcus Aurelius* but acknowledged that the horse was short, heavy and thick;[56] while early in the nineteenth century Joseph Forsyth could write that 'the great statue of Marcus Aurelius, or rather of his horse, which was once the idol of Rome, is now a subject of contention. Some critics find the proportion of the animal false, and his attitude impossible. One compares his head to an owl's; another his belly to a cow's . . .'[57] Ironically, the comparison of the foretop of the horse's mane to an owl (rather than, as previously, to a cuckoo) had earlier played an important part in promoting the statue's significance, for some travellers and guidebooks in the seventeenth and eighteenth centuries had seen in this use of the traditional emblem of Athens evidence that the sculptor must have been a Greek.[58]

No man had played a greater part in stimulating controversy about the quality of the statue than the sculptor Étienne-Maurice Falconet. Resenting criticism of the bronze equestrian monument of Peter the Great which he was creating in St. Petersburg, he began to launch his provocative attack on what he considered to be blind, thoughtless admiration for antique art—and especially for the *Marcus Aurelius*—in about 1769.[59] He himself had in fact never seen it and his impressions of its appearance were derived partly from the Russian painter Anton Losenko who returned from Rome in that year with a series of very careful drawings after the leading antiquities[60] and partly from a plaster cast which was specially made for him from the one in the French Academy in Rome.[61] Using this evidence (and deriding the claim that the materials out of which a statue was made had any great significance) he criticised the horse for being

254

badly observed, unnatural, ill-proportioned and heavy[62]—and in so doing he aroused much scorn,[63] but (as we have seen) he also inspired much revision of conventional responses.

In one respect, however, Falconet's own 'bronze horseman' was indebted to the *Marcus Aurelius*, for he went out of his way to insist on his enlightened interpretation of Peter the Great's mission,[64] and it was the pacifying gesture of Marcus Aurelius which had struck Andrea Fulvio when he wrote about the statue in 1527.[65] Not everyone agreed and in the early nineteenth century the Prussian diplomat and scholar Baron Bunsen was to amuse his children by claiming that what Marcus Aurelius was really saying was 'Quiet everybody—Rome belongs to me!' (*Zitto tutti—Roma è mia*).[66]

Vasari first pointed out the great importance of the *Marcus Aurelius* for Andrea Verrocchio,[67] and its influence has been detected in numerous statues from the Renaissance onwards, though with the exception of Sir Richard Westmacott's statues of George III in Liverpool and Windsor Great Park such influence has usually been more generalised than precise. 'Every spectator', observed the *Gentleman's Magazine*, 'feels real delight in viewing George the Third in the character of Marcus Aurelius: stretching forth his paternal hand over his people.'[68]

The *Marcus Aurelius* is catalogued in Helbig as being Roman work contemporary with the Emperor himself (A.D. 161–80).[69]

1. Fea in Winckelmann (ed. Fea), III, pp. 410–16.
2. Fea in Winckelmann (ed. Fea), III, p. 412.
3. Rushworth, pp. 21–3; Scherer, pp. 133–5.
4. Hecksher.
5. Fehl.
6. Müntz, 1878–82, II, pp. 92–3.
7. *Ibid.*, III, p. 177.
8. Barbieri and Puppi, pp. 886–7.
9. Ackerman, 1964, pp. 54–74.
10. Vacca, Mem. 18.
11. Ackerman, 1964, catalogue, p. 51.
12. Barbieri and Puppi, p. 890.
13. Ackerman, 1957.
14. Fea in Winckelmann (ed. Fea), III, p. 414.
15. Valentini and Zucchetti, III, pp. 91–2.
16. Smollett, p. 287 (letter XXXIII).
17. Ackerman, 1957, pp. 72–3.
18. Livy, VII, 6.
19. Valentini and Zucchetti, IV, p. 408.
20. *Ibid.*, III, pp. 32–3.
21. Rushworth, pp. 21–2, 46–9; Ackerman, 1957, p. 72; Tommasini, pp. 12–13.
22. Montfaucon, 1702, p. 301, note 27.
23. Rushworth, p. 46.
24. Fulvio, 1527, fol. lxxix verso (for lxxiiii).
25. *Ibid.*
26. Doni, fol. 19v (of facsimile).
27. 'True Description', p. 29.
28. Weiss, 1969, p. 80.
29. Pope-Hennessy, 1958, p. 332.
30. Vacca, Mem. 18.
31. Hermann, p. 206.
32. Baldinucci, III, p. 591; Weihrauch, p. 344.
33. Bartsch, XIV, nos. 514–15; XV, p. 263, no 87; Hind, plates 656, 802, 869.
34. Gronau, p. 9.
35. Vacca, Mem. 18; Winckelmann (ed. Fea), II, p. 395, note ★.
36. Zoffoli, Righetti (see Appendix).
37. Harris, C., p. 9.
38. Wedgwood, 1779, class I, section I, no. 1078; class I, section II, no. 242.
39. Pressouyre, 1969 ('Fontes'), pp. 224–5; but see Adhémar, 1949.
40. Vasari, VII, p. 541.
41. Montaiglon (*Correspondance*), I, pp. 17, 145.
42. Perrault, 1964, I, pp. 185–6 (of facsimile).
43. Harris, J., 1979, plate 129; and see the two drawings of the gardens at Wilton by William Stukeley dated 1721 and 1723 in the Bodleian Library, Oxford (MS. Top. Gen. d. 13, fol. 10, and Gough Maps, 33, fol. 19).
44. Harris, J., 1970, p. 41.
45. Kennedy, pp. 57–8; Michaelis, 1882, p. 679.
46. Winckelmann (ed. Fea), II, p. 395.
47. Vasi, 1791, I, p. 109 (for Michelangelo); Falconet, I, pp. 166, 208, note (for Pietro da Cortona and Bernini); Burney, p. 137 (for Maratta).
48. Seignelay, p. 137.
49. Addison, p. 349.
50. Caylus, 1914, p. 181.
51. Doni, fol. 19v (of facsimile).
52. Gibbon, p. 239.
53. Du Bos, I, pp. 372–3.
54. Winckelmann, 1968, pp. 54–5 (*Gedanken*).
55. Winckelmann (ed. Fea), I, p. 388; II, p. 395; III, p. 225.
56. Dupaty, II, pp. 4–5.
57. Forsyth, p. 227.
58. Skippon, p. 651; Winckelmann (ed. Fea), I, pp. xxv–xxvi, note b.
59. Dieckmann and Seznec, p. 205.
60. Falconet, I, p. 256; Kaganovich, pp. 46–93.
61. Falconet, I, p. 162.
62. Falconet, I, pp. 157–348; and II, pp. 1–38.
63. Fea in Winckelmann (ed. Fea), III, p. 416; Stendhal, 1973, p. 735 (*Promenades dans Rome*).
64. Falconet, II, pp. 181–92.
65. Fulvio, 1527, fol. lxxix verso (for lxxiiii).
66. Hare, 1879, I, p. 158.
67. Vasari, III, p. 359.
68. *Gentleman's Magazine*, 1822, XCII, ii, p. 453.
69. Helbig, 1963–72, II, pp. 3–4.

56. Marcus Aurelius Reliefs (Figs. 130–3)

ROME, MUSEI CAPITOLINI (PALAZZO DEI CONSERVATORI)

Marble
Clementia: 3.12 × 2.21 m; Triumph: 3.24 × 2.14 m; Sacrifice: 3.14 × 2.10 m; Hadrianic relief: 3.10 × 2.17 m

As is recorded in an inscription of 1515 Pope Leo X transferred the first three of these reliefs from the church of S. Martina in the Forum to the Capitol.[1] By 1536 they had been fitted into one of the walls in the courtyard.[2] In 1572, or shortly before, they were taken to their present position on a stair landing in the Palazzo dei Conserva-

tori.[3] In 1573 the Conservators bought the fourth relief (representing the reception of an emperor by Roma) which had been built into the wall of a house in Piazza Sciarra, and this too was placed above the stairway on the first floor of the Palazzo dei Conservatori.[4]

The theory (which is now very strongly disputed) that the three *Marcus Aurelius Reliefs* belong to a set originally including eight more which in late antiquity had been reworked and incorporated into the Arch of Constantine was not proposed until the end of the nineteenth century,[5] although the panels of this period on the arch were also greatly admired during the Renaissance and later.[6] It was also towards the end of the nineteenth century that Helbig established that the slab which had been acquired by the Conservators in 1573 was quite unrelated to the ones presented to them nearly sixty years earlier;[7] and in the light of his discovery the head of Marcus Aurelius, which had been fitted on to the emperor in that relief (perhaps during the restoration by Ruggiero Bescapè of 1595),[8] was replaced by one of Hadrian in accordance with current scholarly views.[9] Until then the four panels were looked upon, and reproduced in the standard volumes of prints after the most admired antique bas-reliefs, as an independent set showing events from the life and times of Marcus Aurelius.[10] Only from Aldrovandi do we hear of the theory that the emperor might be Antoninus Pius or Lucius Verus, but Aldrovandi reported the same suggestions about the bronze *Marcus Aurelius* in the piazza.[11]

As sarcophagi tended to depict more generalised or mythological subjects and as most of the scenes from the great storiated columns and even those on the damaged triumphal arches were not easily visible, while other 'historical' reliefs were mostly fragmented or scattered (such as those from the Ara Pacis in the Medici collection), these on the Capitol probably provided the most accessible and certainly the most convenient records of the life, customs and even architecture of ancient Rome. On them could be found details of sacrificial ceremonies, military uniforms, triumphal processions and other matters of the very greatest fascination to artists and antiquarians. Moreover Marcus Aurelius was himself greatly admired and the installation in 1538 of his bronze statue in the adjoining piazza added to the interest of these further memorials of him.[12]

The reliefs were very frequently drawn,

sometimes rather freely and sometimes only in part, in the sixteenth and seventeenth centuries, and it is not surprising to find the names of Polidoro da Caravaggio and Pietro da Cortona among the artists who were interested in them.[13] Cassiano dal Pozzo (1587–1657), who was so absorbed by the customs of ancient Rome and who so promoted the classicising culture of his own day, owned drawings of them,[14] and the reliefs were also engraved independently and for anthologies,[15] for they were deeply admired for their own sakes as well as for the light that they shed on ancient Rome. Thus in the sixteenth, seventeenth and eighteenth centuries we find them described as '*pulcherrimo*',[16] 'excellent',[17] 'so extreme lively that the least of them can not be valued',[18] '*superbes*',[19] 'charming sculpture',[20] 'considered the most beautiful surviving',[21] and they continued to be highly thought of in the nineteenth century. In 1882, however, Ernest Renan, lamenting the debilitation of art in this period, noted that 'everyone, even the barbarians, seems virtuous; the horses have an expression of gentle melancholy and philanthropy'.[22]

In Helbig the *Marcus Aurelius Reliefs* are catalogued as almost certainly forming part of a set which included the eight re-worked ones on the Arch of Constantine: they are of very high quality and must have been made originally for the triumphal arch of Marcus Aurelius dating from A.D. 176, of which we know from literary sources.[23] The 'Rome welcoming an Emperor' is considered to be a work of the late Hadrianic period.[24]

1. Michaelis, 1891, pp. 24–5.
2. *Ibid.*, p. 25.
3. Stuart Jones, 1926, p. 371.
4. Vacca, Mem. 28; Lanciani, 1902–12, II, p. 83.
5. Ryberg, pp. 1–5.
6. Vasari, I, p. 224.
7. Helbig, 1891, II, pp. 421–2.
8. Lanciani, 1902–12, II, p. 93.
9. Stuart Jones, 1926, p. 29.
10. Perrier, 1645, plates 43–4, 46–7; Bartoli, 1693, plates 6–9 (plates 32–5 in the first edition).
11. Aldrovandi, 1556, pp. 268, 271.
12. Richardson, 1722, pp. 110–11.
13. Bober, p. 73; Vermeule, 1960 ('Dal Pozzo-Albani'), p. 22 (no. 194).
14. Vermeule, 1960 ('Dal Pozzo-Albani'), p. 22 (no. 194).
15. Bartsch, XV, p. 264, no. 88; Hind, plate 895.
16. Lafreri (British Museum copy), fol. 56—dated 1583 and added by Duchet.
17. Lassels, II, p. 142.
18. Mortoft, p. 66.
19. Caylus, 1914, p. 181.
20. Burney, p. 137.
21. Lalande, IV, p. 169.
22. Renan, p. 770.
23. Helbig, 1963–72, II, pp. 255–61.
24. *Ibid.* pp. 261–3.

130–3. *Marcus Aurelius Reliefs*—(top) Sacrifice, Clementia; (bottom) Triumph, Hadrianic Relief (Palazzo dei Conservatori).

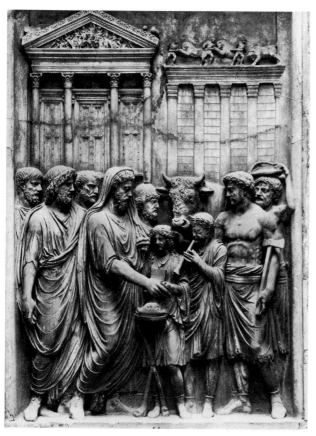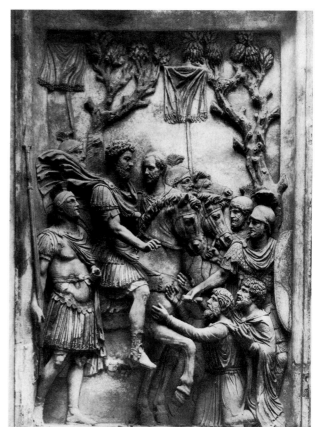
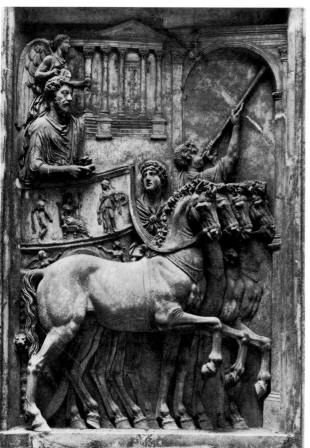

57. Marforio (Fig. 134)

ROME, MUSEI CAPITOLINI

Marble

Height (from head to surface of plinth): 2.42 m

Also known as: Danube, Jove Panario, Marfoi, Marfoli, Mars, Nar, Neptune, Ocean, Rhine, Tiber

'Marfoi' was a landmark in Rome recognised by the late twelfth century[1] and it is clear from Giovanni Cavallini's *Polistoria de virtutibus et dotibus Romanorum* written between 1342 and 1352 that it was this colossal reclining statue which was meant.[2] Poggio Bracciolini writing about a century later in his *De Varietate Fortunae* listed it amongst the sculpture which had survived since antiquity,[3] and the statue is generally supposed to have remained throughout the Middle Ages where these authors reported it, near the Arch of Septimius Severus. It is probable but unprovable that it is identical with the statue of Tiber recorded near this arch in an itinerary of the city preserved in the Monastery of Einsiedeln which was compiled in the late eighth or early ninth century.[4]

The statue was moved to the Piazza di S. Marco in 1588.[5] Flaminio Vacca writing six years later recorded that there had been plans to move it to Piazza Navona together with the colossal basin of black and white granite which stood before it.[6] This basin, however, was, in 1593, formed into a fountain for watering cattle in the Campo Vaccino (and was much later moved to a position in front of the *Alexander and Bucephalus*) whilst it was decided, in 1592, to remove *Marforio* to the Capitol where, between 1594 and 1595, it was restored and made part of a fountain designed by Giacomo della Porta in a niche in the wall opposite the rebuilt Palazzo dei Conservatori. In 1645 the building of the Palazzo Nuovo enclosed this fountain, and *Marforio* was moved to the Palazzo dei Conservatori. By 1657 it had been restored to the fountain which was now the focal point of the new palace courtyard, but without the colossal marble head (today identified as a portrait of Constantine) which had been formerly placed above it. The decision to alter the fountain and repair the statue was made in 1679 and work was undertaken in 1693. The fountain was further adapted in 1734.[7]

134. *Marforio* (Capitoline Museum—courtyard).

Marforio was not listed with the *Marcus Aurelius* or the colossal groups of Monte Cavallo (*Alexander and Bucephalus*) by the pilgrims' guides to Rome from the mid-twelfth century onwards, but it was grouped with these works by Poggio Bracciolini, writing between 1430 and 1448,[8] and an indication of its fame throughout Italy is given by the fact that in Florence in around 1500 the child Bandinelli (whose marble copy of the *Laocoon* some years later was to be the first full-scale replica of a large antique statue recorded since antiquity) was applauded for the spirit, rather than the success, with which he and other boys responded to the challenge to make 'a Marforio' eight braccia long out of snow.[9]

To Cavallini in the fourteenth century the statue was the son of Mars ('filii Martis') which had been corrupted to Marfoli,[10] but by the early fifteenth century its vulgar name was apparently Marforio.[11] It was then that Flavio Biondo proposed that the statue had in fact nothing to do with Mars but represented Jove Panario (or of the Bakers), to whom an altar had been erected on the Capitol.[12] He supposed the lumpy rocks by which the figure reclines to be the loaves which the Romans defending the Capitol pelted upon the besieging Gauls (hence deceiving them into supposing that they had an inexhaustible bread supply).[13] This interpretation was challenged by Fulvio who, in 1527, proposed that the popular name Marforio was a corruption of Nar Fluvius,[14] Nar being the Roman name for the river Nera, a tributary of the Tiber. This idea was prompted by Fulvio's recognition that the statue must be a river god— a class of antique statue unknown in the quattrocento.[15] Marlianus in 1534 suggested that the river was not the Nera but the Rhine.[16] A statue of this river was described by Statius as supporting the feet of an equestrian statue of Domitian,[17] and the interpretation was perhaps also encouraged by the barbarian moustache.

These theories were reiterated by subsequent antiquaries and some others were also proposed. The sea shell in the restored hand—the work, it was believed in the eighteenth century, of Michelangelo[18]—suggested a salt-water god and Perrier's print of 1638 is entitled 'Neptunus in Capitolo'.[19] Both Danube and Tiber were also mentioned.[20] Not everyone accepted Fulvio's etymology and Maffei believed that 'Marforio' was a corruption of Forum Martis, the statue coming from the Forum of Augustus, where there had been a temple of Mars.[21] The most common eighteenth-century view was that it

was once part of a fountain in the Forum of Augustus,[22] and it was widely held to represent Oceanus,[23] an idea much favoured in the last century[24] and not derided in this.

Marforio had always been more famous for the antiquarian controversies it stimulated than admired as a work of art. However, in the early eighteenth century travellers can still be found describing it as 'of a great Style'[25] or 'masterly'.[26] But later both controversy and admiration declined and it was declared to be 'not good',[27] 'point bonne'[28] or, as Smollett wrote, 'remarkable only as being the conveyance of the answers to the satires which are found pasted upon Pasquin'.[29] In fact, however, the dialogue between the two statues had also by then ceased. And Smollet was mistaken, for it had been *Marforio* who posed the questions.[30] Cancellieri felt obliged to explain that Greek artists did not think that colossal figures needed to be finished with the same care as life-size ones.[31]

It is catalogued in Helbig as a Roman sculpture of the mid-Imperial period.[32]

1. Valentini and Zucchetti, III, p. 226.
2. *Ibid.*, IV, p. 51.
3. *Ibid.*, IV, p. 241.
4. *Ibid.*, II, p. 177 and note.
5. Rossi, 1928.
6. Vacca, Mem. 69.
7. Rossi, 1928; Rossi, 1929 ('Tazze'); Rossi, 1929 ('A proposito').
8. Valentini and Zucchetti, IV, p. 241.
9. Vasari, VI, p. 135.
10. Valentini and Zucchetti, IV, p. 51.
11. *Ibid.*, IV, p. 119.
12. *Ibid.*, IV, p. 312.
13. Livy, V, 48, IV, for the loaves and V, 50 and 51, for the honours paid to Jupiter after the defeat of the Gauls (the two episodes are not, however, linked by Livy).
14. Fulvio, 1527, fol. lxxxiii (for lxxix).
15. The point was made by Ruth Rubinstein in a paper read at the 1979 conference of the Association of Art Historians—*Bulletin of the Association of Art Historians*, No. 9, October 1979.
16. Marlianus, fol. 59 r and v.
17. Statius, *Silvae*, I, i, 51.
18. Venuti, 1763, I, pp. 53–4.
19. Perrier, 1638, plate 98.
20. Maffei, plate XXVI.
21. *Ibid.*
22. Venuti, 1763, I, pp. 53–4; Nardini, II, p. 698; [Bottari], plate I.
23. This view was said to be common by Venuti and Bottari (cited in former note) although neither shared it—cf. [Cancellieri], 1789, p. 9.
24. E.g. Tofanelli, 1843, p. 9.
25. Wright, I, p. 321.
26. Northall, p. 144.
27. Gray (ed. Mitford), IV, p. 301, writing in 1740.
28. Lalande, IV, p. 176.
29. Smollett, pp. 287–8 (letter XXXIII).
30. Misson, 1691, II, p. 46.
31. Cancellieri, 1789, p. 8.
32. Helbig, 1963–72, II, pp. 41–2.

58. Ludovisi Mars

(Fig. 135)

ROME, MUSEO NAZIONALE ROMANO (MUSEO DELLE TERME)

Marble

Height: 1.56 m

Also known as: Adonis, Carinus, The Gladiator, Mars in love, Seated Mars

This statue had been acquired by the Ludovisi by the first half of 1622 and it was recorded as having been restored by 20 June of that year.[1] Pietro Santi Bartoli who died in 1700 recorded in some notes that it had been found near the Palazzo Santa Croce in the rione of Campitelli during the digging of a drain.[2] In 1633 it was in the Palazzo Grande in the Ludovisi estate on the Pincio.[3] It remained there until the early years of the nineteenth century, when, with most of the other statues, it was installed in a casino on the estate which was transformed into a museum.[4] Between 1885 and 1890 it was taken with the other statues in the collection to the new palace on the Via Veneto built for the Prince of Piombino (the inherited title of the Ludovisi descendants).[5] It was purchased with the bulk of the collection by the Italian government in 1901 and moved in that year to the Museo Nazionale.[6]

The *Ludovisi Mars* was famous in the seventeenth century. It was included in Perrier's anthology of the most admired antique statues,[7] and was one of those of which casts were ordered for Philip IV of Spain by Velázquez in 1650.[8] Its reputation was quite as high in the eighteenth century, despite the limited access to the Villa Ludovisi, and the rarity of casts or full-scale copies. No copy had been made for Versailles, but the French were keen to rectify this, and in 1726 Nicolas Wleughels reported to the Duc d'Antin that the Princess of Piombino had given permission for a cast to be made for their Academy in Rome.[9] From this in 1730 Lambert-Sigisbert Adam made a marble version (now in Sanssouci at Potsdam) which was kept in the Salle des Antiques at the Louvre until 1752 when Louis XV presented it to Frederick the Great.[10] The cast, however, remained in the Academy in Rome and in the following year, 1753, the Abbé Farsetti was obliged to beg for an aftercast from it, for he had been refused permission to mould the original[11]—one does seem to have been made for Bologna (where it may still be seen). Casts are more common in the nineteenth century and are found not only in the great teaching collections but in at least one private one (that

of Wilhelm von Humbolt at Schloss Tegel, Berlin).[12]

The repose of the *Mars* was particularly praised by Winckelmann[13] and the statue's popularity in the period when his influence was greatest is supported by the plaster statuettes, just less than two feet high, sold of it in London,[14] and by the still smaller reproductions in bronze[15] and biscuit[16] sold in Rome, as well as by the hope expressed by the French Minister of the Interior in 1801 that the statue could be acquired for Paris.[17] The versions in biscuit do not include the Cupid seated by the figure's foot. Nor does an earlier reproduction in bronze by Giovanni Francesco Susini (Fig. 32).[18] The extra figure would of course have greatly complicated the moulds, but it is also excluded from the prints of the statue in de Rossi's anthology[19] and this must reflect knowledge of the fact that it was largely an addition by Bernini. It may also be related to the various theories as to the statue's identity.

The statue is referred to as an Adonis in the documents concerning its restoration in 1622, but as the seated gladiator in the inventory of the following year and as a seated Mars in an inventory of 1633.[20] It was appropriate for both Adonis and Mars to be portrayed unarmed and accompanied by Cupid—in reference to the way both were subdued by love—and it seems that the gladiator was supposed to be an amorous one, 'who got Commodus on Faustina', as Skippon bluntly put it in the seventeenth century,[21] or, as he is described in accounts of a century and more later, 'the famous gladiator, whom Faustina the younger was so fond of, and whom M. Aurelius her husband at last caused to be killed'.[22] The statue was often described together with its companion in the collection, another similarly seated but much more extensively restored figure, generally called a Gladiator and hence easily confused.[23] It was almost as highly valued as the *Mars* in the seventeenth century.[24] The *Mars* was also related to the *Dying Gladiator* when that sculpture was in the Ludovisi collection.[25]

The *Ludovisi Mars* is now considered in Helbig to be a copy of the Antonine period of an original statue of that god invented by an artist who was influenced by both Scopas and Lysippus. The Cupid (doubtless different in pose and character to that of Bernini), was the invention of the copyist.[26]

1. Bruand, 1956; Bruand, 1959, pp. 109–10.
2. Bartoli, Mem. 109.

135. *Ludovisi Mars* (Museo Nazionale Romano).

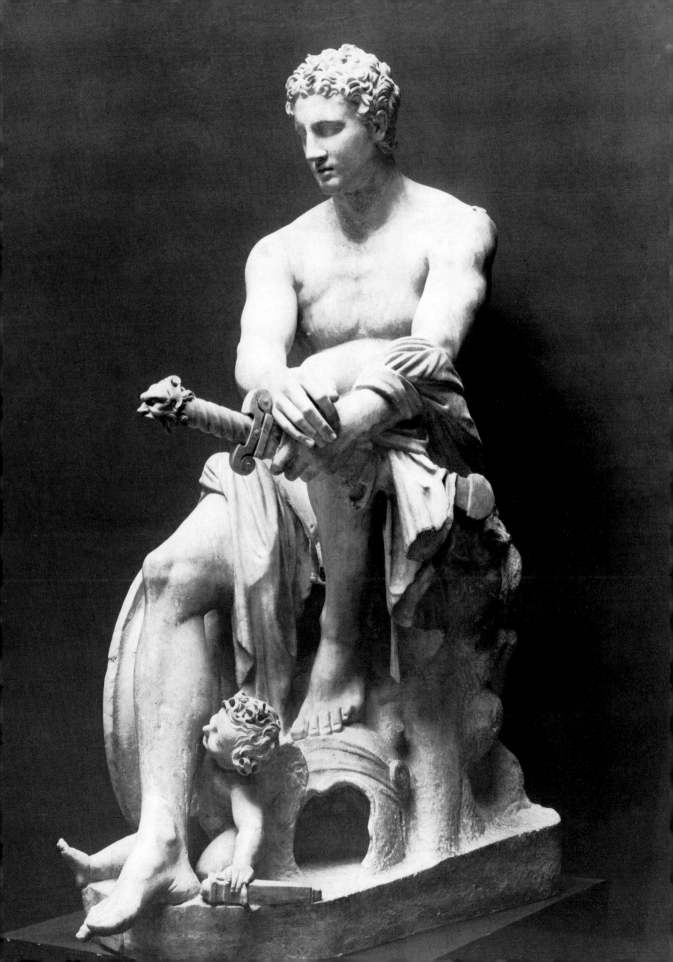

3. Schreiber, pp. 29, 82–5.
4. Mayne, p. 217; Felici, pp. 240–1; Bruand, 1959, p. 88.
5. Bruand, 1959, pp. 95–6.
6. Paribeni, p. 79.
7. Perrier, 1638, plate 38.
8. Palomino, p. 916.
9. Montaiglon (*Correspondance*), VII, p. 297.
10. *Ibid.*, VIII, p. 9; Lami, 1910–11, I, p. 4.
11. Montaiglon (*Correspondance*), X, p. 442.
12. Rave, plate 26.
13. Winckelmann (ed. Fea), I, p. 298.
14. Harris, C., p. 8.
15. Righetti (see Appendix).
16. Molfino, II, plate 93.
17. Montaiglon (*Correspondance*), XVII, p. 301.
18. Ashmolean Museum, Oxford, *Report of the Visitors*, 1953, p. 53.
19. Maffei, plates LXVI, LXVII.
20. Schreiber, p. 29; Bruand, 1956.
21. Skippon, p. 652.
22. Rossini, 1771, II, p. 258; Dalmazzoni, p. 180.
23. Nugent, III, p. 256; Ficoroni, 1744 (*Singolarità*), p. 66; Rossini, 1771, II, p. 258.
24. Bruand, 1959, p. 83.
25. Misson, 1691, II, p. 56; cf. Jefferson in Howard, 1977, pp. 593–4.
26. Helbig, 1963–72, III, pp. 268–9.

59. Marsyas (Fig. 136)

FLORENCE, UFFIZI

Marble
Height: 2.43 m

In a publication of 1556 (based on notes made in Rome six years earlier) Aldrovandi described this statue of *Marsyas* as in the Capranica collection[1] and it is clearly shown in Jerome Cock's print of the Palazzo Della Valle-Capranica dated 1553.[2] It was sold with that collection to Cardinal Ferdinando de' Medici on 15 July 1584 when Pope Gregory XIII overruled the *fidecommisso*,[3] and it is mentioned in 1598 in an inventory of the Villa Medici in Rome.[4] It was removed from there to Florence in 1780 and displayed in the Uffizi.[5]

With the exception of the three colossal porphyry Captives (which together with one marble one were valued at two thousand ducats) the *Marsyas* was (at four hundred ducats) the most highly valued of the della Valle antiquities at the time of their purchase by the Medici,[6] and it remained a famous statue, reproduced in major anthologies of prints,[7] and highly praised by both travellers and connoisseurs in the seventeenth and eighteenth centuries—it seemed 'very singular' to Mortoft;[8] 'exceeding good' to Wright;[9] 'si bella scultura' to Maffei;[10] 'excellent' to Northall.[11] On the other hand although the French Academy had acquired a cast of the

136. *Marsyas* (Uffizi).

statue by December 1684,[12] neither casts nor copies of it were common. They would have been difficult to instal appropriately in a domestic or garden setting. Andrea Violani did, however, copy the statue for the gardens at Caserta in 1762 together with an Apollo—the group was apparently based on modelli by Le Gros—but he added new hands and feet to the *Marsyas* (the Medici statue was only partially restored in the extremities) and also a tree trunk (added to the original after it came to Florence).[13]

Other antique statues of Marsyas were known, and one, in red and white marble, and grimacing, which excited the admiration of some visitors to the Uffizi[14] where it has been since 1586 (and which is possibly the statue restored for the Medici by Verrocchio although it does not correspond with the conventional hyperbole of Vasari's description of that sculpture),[15] is easily confused with the *Marsyas* which the Medici acquired from the della Valle collection.

General acceptance of the theory that the *Arrotino* should be grouped with the *Marsyas*, which was first proposed when both statues were in the Villa Medici,[16] was perhaps delayed partly because they were separated soon afterwards. The *Marsyas* and the *Arrotino* have now been catalogued by Mansuelli as copies or derivations of two of the three figures in a bronze group of the Pergamene school showing Apollo ordering a Scythian slave to flay his rival Marsyas.[17]

1. Aldrovandi, 1556, pp. 181, 217.
2. Michaelis, 1891–2, ii, p. 228.
3. *Ibid*, p. 224.
4. Boyer, 1929, p. 263, no. 115.
5. *Documenti inediti*, IV, p. 77.
6. Michaelis, 1891–2, ii, p. 228.
7. Perrier, 1638, plate 18; Maffei, plate XXXI.
8. Mortoft, p. 119.
9. Wright, I, p. 331.
10. Maffei, plate XXXI.
11. Northall, p. 346.
12. Montaiglon (*Correspondance*), I, p. 129.
13. Petrelli, pp. 207–8 (nos. 13, 16).
14. Corke and Orrery, p. 89; Frye, p. 194.
15. Mansuelli, I, pp. 88–9.
16. Agostini, II, pp. 21–2.
17. Mansuelli, I, pp. 87–90.

60. Meleager (Fig. 137)

ROME, MUSEI VATICANI (SALA DEGLI ANIMALI)

Marble
Height: 2.10 m
Also known as: Adonis, Pighini Meleager

The statue is recorded in 1546 in the house of Francesco Fusconi from Norcia,[1] doctor to Popes Adrian VI, Paul III and Julius III, who in 1523–4 acquired a palace just opposite what was to become the Palazzo Farnese. The early sources disagree as to whether it was discovered on the Esquiline or the Janiculum.[2] On his death in 1553 the palace and collections were inherited by his nephew Adriano, who was made Bishop of Aquino in 1554. After his death without male heir in 1579 the palace and statues, now under entail, came into the possession of Marzia Fusconi. She was married to a member of the Pighini family, and the *Meleager* remained in the palace[3] until early in 1770 when it was bought by Pope Clement XIV.[4] By 1792 it had been installed in the Sala degli Animali (Fig. 38) in the Museo Pio-Clementino (presumably on the strength of the dog and the boar's head).[5] In 1797 it was ceded to the French under the terms of the Treaty of Tolentino[6] and it reached Paris in the triumphal procession of July 1798.[7] It was displayed in the Musée Central des Arts from its inauguration on 9 November 1800.[8] It was removed in October 1815,[9] and must have arrived back in Rome in the first consignment of statues on 4 January 1816[10] because it had been returned to the Vatican Museum by the end of May.[11]

In 1546 this statue was described as one of the most beautiful in Rome 'not excluding those in the Belvedere'; indeed, the owner himself claimed that it was one of the most beautiful in the whole world and seems to have praised it at the expense of the *Laocoon*.[12] About three years later Anton Francesco Doni when writing to a friend of the most worthwhile things to see in Rome singled out Michelangelo's 'Last Judgment', Raphael's Stanze, a few other modern works, and seven antique statues—the *Laocoon*, the *Apollo Belvedere*, the *Torso*, the *Marcus Aurelius*, the *Spinario*, the *Antinous* and the present statue which he called *Meleager*;[13] many other writers of the sixteenth and seventeenth centuries—including its first owner—described it as an Adonis, for no one was quite sure whether the boar's head was that of the animal which had killed the latter or been killed by the former.[14] Only in the eighteenth century did it come to be generally agreed that the figure was a Meleager.

The statue was carved out of an ivory coloured marble which was identified as Parian and specially recorded as such in a print dated 1555.[15] Many visitors commented (usually without much enthusiasm) on its yellowish brown complexion.[16] However, the statue itself was very

highly admired, and by the Richardsons' time it was considered to rank among the seven most famous antiquities in the world which, as a century and a half earlier, included the *Apollo*, the *Laocoon* and the *Antinous*, though the others on Doni's list had by now been replaced by the *Farnese Hercules*, the Borghese (or the Dying) *Gladiator* and the *Venus de' Medici*.[17] It was engraved in all the leading anthologies, Pierre Le Pautre's marble copy was installed by Louis XIV at Marly,[18] and a lead copy adorns the skyline of Lyme Park in Cheshire. Casts were to be found in the principal academies[19] (one survives at Bologna) and one was included among those of other celebrated statues in the great hall which Robert Adam designed at Kedleston in Derbyshire. Small marble versions were also made, Righetti supplied bronze statuettes,[20] and Wedgwood offered cameos.[21]

It was not only the statue's beauty that aroused interest. During much of the seventeenth century it was rumoured to be for sale (despite the entailment), and there was speculation as to how the Pope would react were it to be acquired by a foreign collector. Lord Arundel's repeated attempts in 1636 to buy it for a huge sum were well known to English visitors;[22] in 1664 it was reported that Cardinal Chigi was trying to buy it ostensibly for the King of France, but in fact for his own family;[23] and shortly afterwards Bernini managed to be both encouraging and non-committal in his assurances that he would think about trying to purchase it for Louis XIV.[24] All this justifies Maffei's claim in 1704 that it was famous throughout Europe.[25] In the end the *Meleager* proved to be one of the very first acquisitions made by Clement XIV for his new museum in the Vatican, though he had possibly intended to place it (and perhaps briefly did) in the Capitoline Museum.[26]

When it was taken to the Museo Pio-Clementino it was described as a miracle of Greek art.[27] Visconti claimed that it was fit to hold its own against the finest statues in the Belvedere courtyard,[28] and he again spoke very highly of it when it came to Paris.[29] But in fact the proximity to more familiar masterpieces led to a slow but perceptible decline in the *Meleager's* reputation. It was often compared to the *Antinous* usually (though not in every respect)[30] to its disadvantage,[31] and both eighteenth and nineteenth-century visitors were troubled by its lack of 'finish'.[32] Privately Winckelmann noted that its execution did not match its conception and said that it looked like a copy.[33] Its remarkable completeness, however, continued to arouse enthusiasm, as did the almost inevitable story that Michelangelo had been unwilling,[34] or unable,[35] to supply a left hand to be attached to the stump which had therefore been left unrestored. Nonetheless, despite the fact that after its return from Paris the statue was placed in a room (or, rather, vestibule) specially named after it,[36] visitors found much to criticise. Valery found the legs and drapery 'hard and mannered', though he thought the boar's head 'perfect'.[37] For Burckhardt, on the other hand, Meleager himself was lithe and agile while the boar was clumsy.[38] And eventually it became increasingly common to omit the statue altogether from accounts of the most impressive sights in Rome.

The *Meleager* is catalogued in Helbig as a Roman copy of the early Antonine period of a Hellenistic figure of the middle of the fourth century B.C., the dog and boar's head being added by the copyist.[39]

1. D'Arco, pp. 281–2.
2. Aldrovandi, 1556, p. 167; Vacca, Mem. 84, note a.
3. Lanciani, 1902–12, II, pp. 89–92; Frommel, II, pp. 189–94.
4. Montaiglon (*Correspondance*), XII, p. 272.
5. Vasi, 1792, p. 19; Massi, pp. 192–3.
6. Montaiglon (*Correspondance*), XVI, pp. 463, 498.
7. Blumer, pp. 241–9.
8. *Notice*, An IX (1800), pp. 53–4.
9. Saunier, p. 149.
10. *Diario di Roma*, 6 January 1816.
11. Friedländer, II, p. 147.
12. D'Arco, pp. 281–2.
13. Doni, fol. 51v (of fascimile), p. 82, note 225.
14. Aldrovandi, 1556, p. 167; Cavalleriis (2), plate 95; and Vacca, Mem. 84, all call it Adonis. Perrier, plates 51–2, calls it Meleager. Lord Arundel (Springell, pp. 237–8, 247, 251) and Maffei, plate XLI, give it both names. For Fusconi's view, see D'Arco, pp. 281–2.
15. Lafreri (British Museum copy), fol. 73.
16. Northall, pp. 342–3; Gray, T. (ed. Mitford), IV, p. 254.
17. Richardson, 1722, p. 156.
18. Montaiglon (*Correspondance*), I, pp. 163, 169, 180–1, 307; IV, p. 418.
19. Lalande, III, p. 211; Baretti, p. 22.
20. Righetti (see Appendix).
21. Wedgwood, 1779, class I, section II, no. 175.
22. Lassels, II, p. 224.
23. *Roma*, 1939, XVII, p. 376 (for *avviso* of 19 April 1664).
24. Chantelou, pp. 117, 197.
25. Maffei, plate CXLI.
26. Montaiglon (*Correspondance*), XII, p. 272; Amelung, 1903–8, II, p. 37; Pietrangeli, 1951–2, p. 92.
27. Vacca, Mem. 84 (note in Nardini edition).
28. Visconti (*Pio-Clementino*), II, plate XXXIV.
29. *Notice*, An IX (1800), pp. 53–4.
30. Bell, J., pp. 325–6.
31. Lalande, III, pp. 210–11.
32. Gray (ed. Mitford), IV, p. 254; Bell, J., pp. 325–6.
33. Winckelmann (*Briefe*), I, p. 258.
34. Visconti (*Pio-Clementino*), II, plate XXXIV.
35. Lalande, III, p. 210.
36. Vasi (rectifié Nibby), II, p. 464.
37. Valery, III, p. 36.
38. Burckhardt, p. 437.
39. Helbig, 1963–72, I, pp. 74–5.

137. *Meleager* (Vatican Museum).

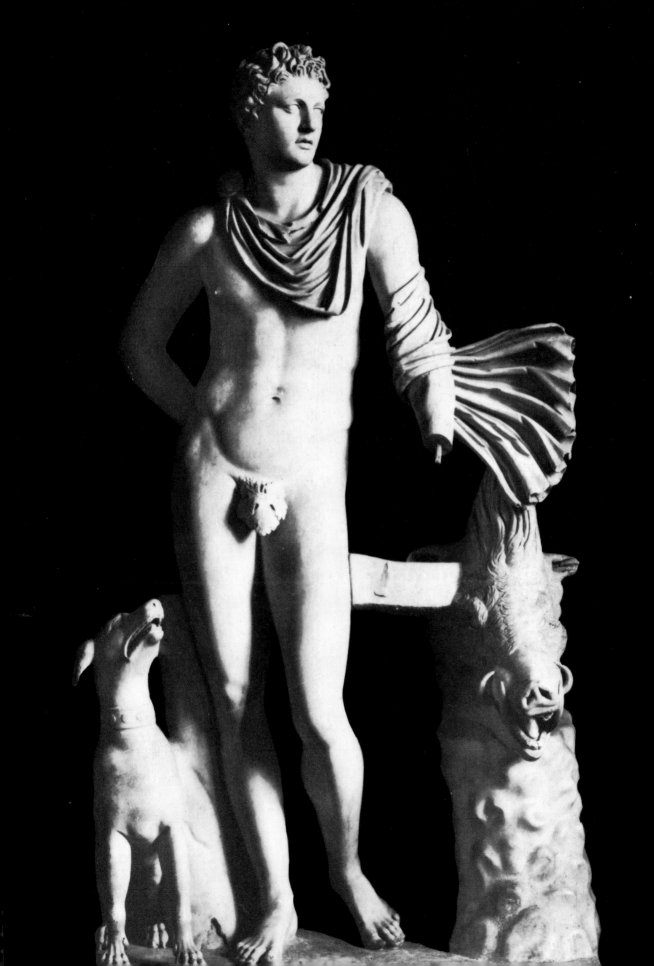

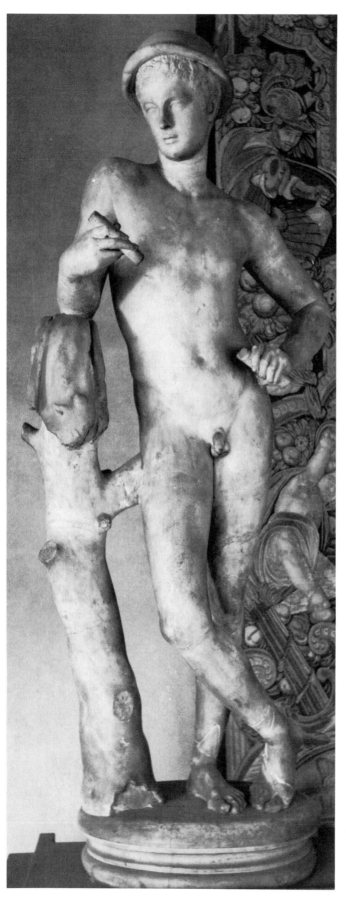

61. Mercury (Fig. 138)

FLORENCE, UFFIZI

Marble
Height: 1.55 m

The statue is first recorded in 1536 when it was in the statue court of the Belvedere.[1] Twenty years later it was said by Aldrovandi (whose account was based on notes made in 1550) to be in a covered loggia just behind the court itself.[2] It is not referred to again in Rome, and a traveller who was probably there in the 1560s said that it had been 'removed to Florence under the late Julius III',[3] i.e. between 1550 and 1555. By 1568 it was in the Palazzo Pitti[4] and by 1734 in the Uffizi.[5]

Aldrovandi who saw the *Mercury* already fully restored (*intiero*) thought very highly of it,[6] and a bronze copy (now in the Louvre) is recorded at Fontainebleau in 1585–6;[7] this may have been made when the statue was still in Rome, though it is not among those documented as having been cast by Primaticcio and Vignola for François Ier. However, despite the *Mercury*'s distinguished provenance, and despite the fact that Duke Cosimo I apparently presented a bronze cast of it (now in the National Gallery of Art in Washington and perhaps the one recorded in the Palazzo Pitti in 1568) to Antonio Montalvo, his favourite courtier,[8] the statue attracted surprisingly little attention in Florence for many years. But in 1734 Gori could claim that the painters and sculptors of his day were deeply fascinated by it,[9] and it is indeed true that at about this time the type was frequently reproduced, though (as we will see) it is not certain that it was to the version in Florence that the copyists looked. Twenty-five years later Giuseppe Bianchi, who was in charge of the Grand Duke's antiquities, devoted most of his account of the *Mercury* to the problems raised by the god's attributes[10] (problems which had earlier intrigued Montfaucon),[11] but he dutifully claimed that 'every connoisseur agrees that it is antique and very beautiful'. The more rigorous Luigi Lanzi, writing after the reorganisation of the Uffizi in 1780–1, said only that it had been 'found worthy of being copied in bronze and placed in the royal Farnese collection'.[12]

It was this sixteenth or seventeenth-century replica which may have kept alive the composition of the once-famous Belvedere marble more than the original itself. Maffei appears to have confused the two when he described the

138. *Mercury* (Uffizi).

Farnese bronze as being of marble (though the medium is correctly identified on the caption of his plate) and he clearly thought of it as being antique,[13] as did Caylus and some other travellers to Rome.[14] For this reason it is difficult to tell whether the versions (rather than exact copies) of the *Mercury* made by Barthélemy de Melo for Versailles in 1684–5 (and there now)[15] and by William Kent in grisaille for Chicheley Hall in Buckinghamshire in about 1725,[16] for Houghton Hall in Norfolk and other English country houses are derived from the Uffizi original or the Farnese bronze (or a print after the latter). Certainly Matthew Brettingham the Younger had a mould taken from the Farnese statue;[17] and the bronze copy at Pavlosk near St. Petersburg may also have been made from the Farnese version.

Winckelmann was aware that the bronze then in Rome reproduced the marble in Florence, but he refers to both only to illustrate instances of the cross-legged pose in antique sculpture;[18] and in England and Ireland, where there were probably more copies of the *Mercury* than elsewhere,[19] the figure's pose may have inspired that of a common portrait type. However, purely literary references to the popularity of a Mercury, even when specifying that the statue is in Florence, can be deceptive, for they are at least as likely to be alluding to the famous bronze by Giambologna (of which many versions had been in existence since the sixteenth century)[20] which was frequently included among sets of copies after the antique—not least by Zoffoli and Righetti, neither of whom provided statuettes of the *Mercury* here catalogued. When, however, Sir Horace Mann wrote from Florence in 1756 that 'there is no gesso of the Apollo Medici . . . There are, I think, but five figures in gesso of about the same size, which are the Venus, the Faun, the Mercury, Bacchus [by Michelangelo], and the Idol' as upright figures suitable for the decoration of a country house,[21] he is surely referring to our statue since a plaster or marble of Giambologna's Mercury would have been impracticable.

Cochin (who admired much in the statue but found the head 'mesquin') noted that the hands had been restored.[22] In fact, the hands and the much-debated attributes which they hold and the winged helmet were all created during the Renaissance, and there is no reason to believe that the statue had originally been intended to represent Mercury. Mansuelli has catalogued it as the statue of a youth, possibly a satyr, made up

of a combination of Praxitelean elements probably in the generation after the death of Praxiteles himself, but possibly much later.[23]

1. Ackermann, 1954, p. 147 (quoting Fichard).
2. Aldrovandi, 1556, p. 121.
3. Michaelis, 1890, p. 39, note 142.
4. 'Un Giovanetto ignudo fatto per un Mercurio il quale era già in Bel vedere di Roma' in the unpaginated list of 'Anticaglie, che sono nella Sala del Palazzo de' Pitti' among table of contents in Vol. III of the 1568 edition of Vasari's *Vite*.
5. Gori, 1734, plates XXXVIII, XXXIX.
6. Aldrovandi, 1556, p. 121.
7. *La Collection de François Ier*, p. 46 (no. 58).
8. A press release issued by the Washington National Gallery says that the history of the cast is recorded in the Montalvo archives. In the nineteenth century it belonged to Fréderic Mylius of Genoa and it was acquired from his descendants. For Montalvo, see Ginori Lisci, 1972, II, pp. 487–90. The Pitti cast is included in the list cited in Note 4.
9. Gori, 1734, plates XXXVIII, XXXIX.
10. Bianchi, pp. 57–9.
11. Montfaucon, 1719, I, i, p. 128.
12. Lanzi, p. 39.
13. Maffei, plate LVII.
14. Caylus, 1914, p. 257; Lalande, IV, p. 110.
15. Lami, 1906, p. 373.
16. Lees-Milne, p. 233, plate 365.
17. Brettingham MS., p. 68.
18. Winckelmann (ed. Fea), I, p. 334.
19. A marble at Russborough, County Wicklow (initialled B.S.); casts at Holkham Hall, Kenwood House, Chiswick House.
20. *Giambologna* (London), pp. 83–8.
21. Walpole (*Correspondence*), XX, p. 547.
22. Cochin, II, p. 40.
23. Mansuelli, I, pp. 50–1.

62. Seated Mercury (Fig. 139)

NAPLES, MUSEO NAZIONALE

Bronze
Height: 1.05 m

The *Mercury* was discovered on 3 August 1758 at Herculaneum in the peristyle of the Villa dei Papiri and kept in the royal palace of Portici.[1] Although it was possibly among the antiquities removed to Palermo in December 1798 to escape the French, it was recorded at Portici again in October 1816.[2] It was transferred to the Museo Borbonico (later Museo Nazionale) by 1819.[3] In 1943 it was removed to Monte Cassino to escape the Germans, who, however, captured it and took it to Germany. In transit, it was damaged and the head had to be extensively restored (or rather the old restorations had to be extensively revised) after its return to Naples in 1947.[4]

This statue was probably the most celebrated work of art discovered at Herculaneum and Pompeii in the eighteenth century, and, although knowledge of it was at first limited by

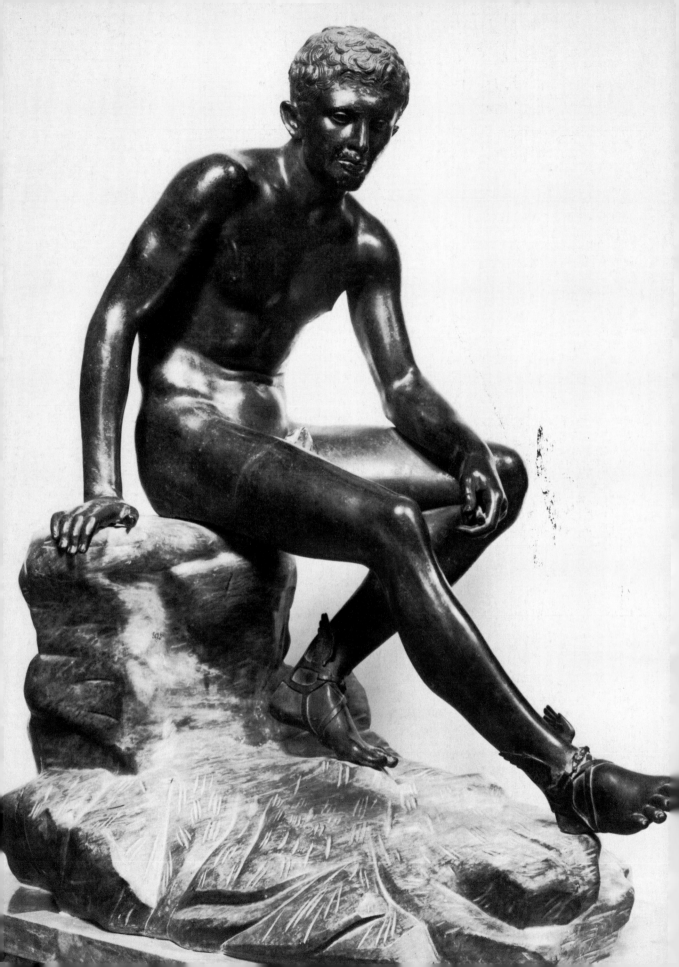

the prohibition on reproductions, four superb plates by Fiorillo after drawings by Vanni appeared in 1771 as part of the official catalogue[5] and the French obtained a plaster cast eleven years later.[6] To Burney, the *Mercury* seemed to be 'equally perfect with any of the finest statues in the world',[7] but he and some of his contemporaries[8] ranked with it a Drunken Faun and Two Wrestlers (also known as Discus Throwers and Athletes)[9]—other bronzes found at Herculaneum whose reputations endured less well. Vivant Denon when in the French Embassy in Naples in 1782 described the *Mercury* to D'Angiviller as the most beautiful bronze to have survived.[10] In 1806 the *Mercury* appeared, slightly embellished, on a medal made by Droz under Denon's direction.[11] In the same year, Denon, as director of the Musée Napoléon, expressed the hope that the statue could be expropriated.[12] However, the German Carl Friedrich Benkowitz, who was in Portici in December 1802, does not mention it as amongst the statues remaining there,[13] and neither does Kotzebue two years later, so it was probably, as the French had feared, in one of the fifty-two chests which Kotzebue noted as having been taken to Palermo.[14]

Winckelmann, although fully aware of the extensive restoration, considered the *Mercury* to be the most perfect of the bronzes at Portici, but noted that the figure lacked the caduceus which it was intended to hold and that no such attribute had been found nearby and deduced that the statue must have been transported to Herculaneum—inferring that it came originally from Greece.[15] For a cataloguer, a century later, it was still a work of magical beauty and he repeated an observation made in the eighteenth century that the resting god seemed to catch his breath from his recent exertions[16]—'the young resting, slightly-panting Mercury', Henry James called him.[17] In February 1922 the marine biologist, minor poet and proprietor of Parker's Hotel, Naples, George Bidder, presented a bronze of the *Mercury* by Sommer to Trinity College, Cambridge, to be placed in Whewell's Court where he had lived as an undergraduate. Not only did Bidder consider the original statue to be 'one of the most beautiful in the world' but he fancied that if seated on a boulder on the grass, the god would appear 'as if he were really a being which had descended from the air'.[18]

For Robertson, the statue is a copy made before A.D. 79, of a late fourth or early third-century original in the tradition of Lysippus.[19]

1. *Antichità di Ercolano*, VI, 1771, pp. 113–22.
2. Frye, p. 263.
3. Starke, 1820, p. 417 (account based on visit made in 1819).
4. Maiuri, 1948, pp. 181–3.
5. *Antichità di Ercolano*, VI, 1771, pp. 113–22.
6. Montaiglon (*Correspondance*), XIV, p. 256.
7. Burney, pp. 188–9.
8. Moore, II, p. 171; Forsyth, p. 319.
9. *Antichità di Ercolano*, VI, 1771, pp. 159–63, 223–30.
10. Montaiglon (*Correspondance*), XIV, p. 256.
11. Edwards, 1837, p. 56, plate XV (no. 8).
12. Boyer, 1970, p. 237.
13. Benkowitz, pp. 130–4.
14. Kotzebue, I, p. 250; Boyer, 1970, p. 85.
15. Winckelmann, 1764 (*Lettre*), pp. 36, 42; Winckelmann (ed. Fea), I, p. 372; III, p. 226.
16. Monaco, p. 74; [Grosley], III, pp. 244–5.
17. James, p. 355.
18. Trinity College, Cambridge, MS. letter from Bidder to the Master of Trinity, 18 February 1922.
19. Robertson, I, p. 474.

63. Minerva Giustiniani (Fig. 140)

ROME, MUSEI VATICANI (BRACCIO NUOVO)

Marble
Height: 2.23 m
Also known as: Athena, Minerva Medica, Pallas, La Dea Salus

The *Minerva* is first recorded in a set of engravings of the Giustiniani collection published in 1631.[1] It remained in this collection until early in 1805 when it was bought by Lucien Bonaparte[2] who had moved to Rome in the previous year and installed his collection in the Palazzo Nunez.[3] It was made the main ornament of the great hall.[4] In 1817 Lucien Bonaparte sold the statue to Pope Pius VII[5] who commissioned a new extension of the Vatican Museum, the Braccio Nuovo, in the same year.[6] This was opened to the public in 1822 with the *Minerva* as one of its chief ornaments.[7]

The statue was stated in the late seventeenth century to have been found in the Orto di Minerva, adjacent to the church of S. Maria Sopra Minerva,[8] the site of a temple of Minerva erected in 62 B.C. by Pompey the Great. But according to an alternative tradition it was found at the so-called Temple of Minerva Medica (a decagonal nymphaeum in the Licinian gardens near Porta Maggiore).[9] Both locations seem suspiciously appropriate and the latter may have been suggested by the connection between the snake and Aesculapius, the god of Medicine, whereas it is fitting for Minerva because it is the guardian of olive groves. According to a 'family tradition', the head was discovered separately in

139. *Seated Mercury* (Museo Nazionale, Naples).

the foundations of the Collegio Romano and sold to the Giustiniani for a great price by the Jesuits.[10]

From the first, the *Minerva* was one of the most highly regarded works belonging to the Giustiniani. It was the first statue reproduced in the first volume of the engravings of this collection,[11] and was also included in the anthologies of prints by Perrier[12] and Sandrart[13] (but not, surprisingly, in that published by de Rossi), and travellers noted that it was 'reckoned at 20,000 pistols'[14] and that it had cost '60,000 crowns'[15] but was deemed 'priceless'.[16] It does not seem, however, to have been copied.

The idea that in antiquity the statue had been a cult object rather than simply a work of art gave it special glamour. The editor of Northall's *Travels through Italy* reported the legend that 'the youth of Rome used to come and kiss the hand of the statue before they went to their schools',[17] and Goethe, many years later, was told by the custodian of the Giustiniani collection that the English (whom she believed to be heathens) still worshipped it and kissed one of its hands, which was indeed apparently whiter than the rest of the statue.[18]

But not all the English were so devout. ''Tis not very fine', observed the Richardsons, 'and has no Sweep.'[19] Winckelmann never mentioned the statue, to the surprise of Goethe who considered it a late example of the 'high austere style' which Winckelmann had been the first to describe,[20] and which was so much admired in the late eighteenth century. Pacetti in an inventory of the collection which he made in 1793 specifies the remarkable Greek style,[21] and in the year of its purchase by Lucien Bonaparte its fame received two further fillips: its derivation from the Athena made by Phidias for the Parthenon was proposed,[22] and its 'ideal beauty to which only Greece attained' was said to have been particularly admired by Canova.[23] One still seeks in vain for casts or marble copies of this 'Tochter des Himmels ... unbeschreiblich schöne Gestalt', as Hermann Friedländer called it in 1816,[24] but in miniature the head was engraved by Marchant on a sardonyx intaglio for Charles Long (later Lord Farnborough)[25] and it may be seen, only a little larger, standing in an aedicule on the reverse of the Wedgwood jasperware vase decorated with Flaxman's 'Apotheosis of Homer',[26] whilst Wicar, in a painting of *c.* 1819, places it in a niche behind Livia as with the Imperial family she listens to Virgil reading the *Aeneid* (Villa Carlotta, Cadenabbia). Full-size

140. *Minerva Giustiniani* (Vatican Museum).

copies may have been easier to make after the statue's arrival in the Vatican and one probably dating from later in the nineteenth century survives in the garden at Chatsworth in Derbyshire.[27]

The *Minerva* is catalogued in Helbig as an Antonine adaptation of a bronze original of the fourth century B.C.[28]

1. *Galleria Giustiniani*, I, plate 3.
2. Amelung, 1903–8, I, p. 143.
3. Boyer, 1970, p. 228.
4. Kotzebue, III, p. 151.
5. Amelung, 1903–8, I, p. 143.
6. Pistolesi, 1829–38, IV, 1829, p. 57.
7. Amelung, 1903–8, I, p. 143.
8. Bartoli, Mem. 112.
9. Ficoroni, 1744 (*Vestigia*), p. 119; Starke, 1800, I, p. 367; II, p. 28, note; Lanciani, 1897, p. 403.
10. Richardson, 1722, p. 155; Amelung, 1903–8, I, p. 143.
11. *Galleria Giustiniani*, I, plate 3.
12. Perrier, 1638, plate 54.
13. Sandrart, 1675–9, plate S; Sandrart, 1680, p. 19.
14. [Bromley], p. 247.
15. Richardson, 1722, p. 155.
16. Montesquieu, II, p. 1134 (*Voyage d' Italie*).
17. Northall, p. 328.
18. Goethe, XXX, pp. 250–1 (*Italienische Reise*); Goethe (*Briefe*), VIII, pp. 130–1.
19. Richardson, 1722, p. 155.
20. Goethe, XXX, pp. 250–1 (*Italienische Reise*).
21. *Documenti inediti*, IV, p. 434.
22. Boyer, 1970, p. 228.
23. [Guattani], *Monumenti antichi inediti per l'anno MDCCCV*, pp. lix–lxvi.
24. Friedländer, II, p. 165.
25. Marchant, p. 9.
26. A copy in the British Museum was presented by Wedgwood in 1786. A pair are in the Lady Lever Art Gallery, Port Sunlight—Hobson, p. 173, no. 1450. See also the oval plaque, City Art Gallery, Manchester, 1906–79.
27. Probably from Bienaimé's Carrara studio which supplied the statues placed in the gardens between 1841 and 1844 and seems to have continued to do so for some years—Chatsworth MS., Sculpture Accounts of the Sixth Duke, p. 23; [Cavendish], p. 168.
28. Helbig, 1963–72, I, pp. 343–4.

64. Narcissus　　　　　　　　(Fig. 141)

NAPLES, MUSEO NAZIONALE

Bronze
Height (including pedestal): 0.63 m

The *Narcissus* was discovered in August 1862 in a humble Pompeian house and was displayed soon afterwards in the Museo Nazionale.[1]

The statue was quickly acclaimed as a masterpiece—the 'pearl' of the Neapolitan collection.[2] It was the last antique statue to be discovered in Italy which enjoyed enormous fame, and the last antique statue to be discovered anywhere which has been extensively copied. The *Narcissus* was eminently suitable in size to adorn modest gardens and interiors and it seems

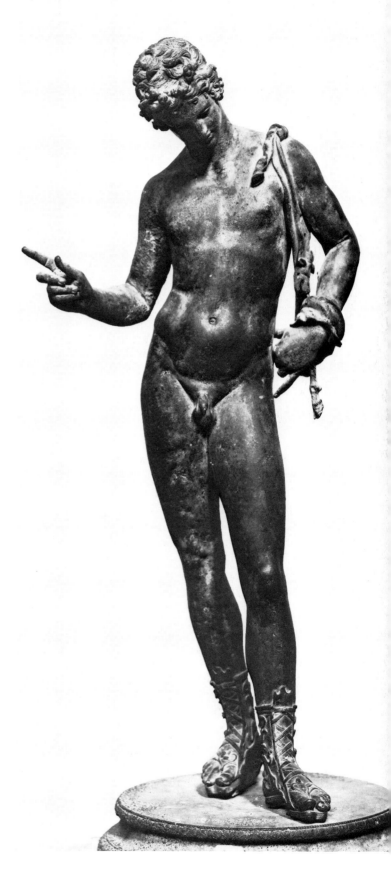

141. *Narcissus* (Museo Nazionale, Naples).

always to have been copied (as is true of no other statue in this catalogue) both in the same size and in the same medium.[3] In a book sponsored by Chiurazzi and sons, one of the largest manufacturers of such bronzes, Luigi Conforti, secretary of the Naples Museum, maintained that it was the most beautiful bronze ever to have been discovered at Pompeii and 'unique par sa merveilleuse beauté'.[4]

Giuseppe Fiorelli, director of the Museum between 1863 and 1875, named the figure 'Narcissus'[5] doubtless because its attitude seemed equally appropriate for the attentive lover of Echo, rapt by her faint repetitions, as for someone enchanted with his own reflection, but by the end of the century it was considered that the crown of ivy and the nebrid could only be suitable for Dionysius.[6] Bieber finds it Praxitelean in character and suggests that it was acquired in Magna Graecia and is thus Hellenistic rather than Roman (which may be taken as a compliment).[7]

1. *Real Museo Borbonico*, XVI, plate XXVIII (despite the title-page carrying the date of 1857).
2. Monaco, p. 68.
3. De Angelis; Fonderie Artistiche Riunite; Sommer.
4. Conforti, p. 9.
5. *Real Museo Borbonico*, XVI, plate XXVIII.
6. Amelung, 1897, p. 76; Ruesch, p. 202.
7. Bieber, p. 170.

65. Nile (Fig. 142)

ROME, MUSEI VATICANI (BRACCIO NUOVO)

Marble
Height: 1.65 m; Length: 3.10 m

The *Nile* was first recorded for certain in 1523 when it was installed as a fountain in the middle of the Belvedere statue court, facing the *Tiber*.[1] When the Museo Pio-Clementino was created in the 1770s, the *Nile* was put in a room named after it formed out of what had, until then, been part of the villa of Pope Innocent VIII adjoining the statue court.[2] Under the terms of the Treaty of Tolentino in 1797, the statue was ceded to France,[3] and, after being stored in Rome, it eventually reached Paris on 14 July 1803.[4] It was displayed in the Salle des Fleuves of the Musée Central des Arts in 1811, together with the *Tiber*,[5] but unlike the *Tiber* it was returned after Waterloo. It arrived in Rome in the first half of 1816[6] and was displayed in the Braccio Nuovo of the Vatican Museum, work on which began in

1817 and was completed in 1822 by Pius VII.[7]

It is almost certain that, like the *Tiber*, the *Nile* was excavated between S. Maria sopra Minerva and S. Stefano del Cacco, the site of the sanctuary of Isis and Serapis, probably about a year later (that is in 1513).[8] The critical fortunes of the two statues are similar, and they were, not surprisingly, copied together. Vasari tells us that Polidoro da Caravaggio (who left Rome in 1527) and Maturino his partner included them in fresco decorations of the life of Alexander the Great.[9] The *Nile*, however, was generally considered more curious from an antiquarian point of view and more admirable as a work of art. It is the *Nile*, for instance, which Vasari singled out for special praise.[10]

The numerous prints of the *Nile* which testify to the esteem with which it was regarded are also often misleading because the putti are either depicted intact or altogether removed.[11] In reality, these putti existed only as broken fragments (Fig. 9) until repaired by Gaspare Sibilla (a commission given to him by Pope Clement XIV shortly before his death in 1774).[12] An early theory was that there had been originally seventeen putti, representing the seventeen Kingdoms of Egypt watered by the Nile.[13] The correct interpretation was that the sixteen putti clambering over the god referred to the sixteen cubits by which the river could rise in the rainy season, and came from Pliny. He, however, was describing a different statue, one fashioned out of the largest known piece of basanite and dedicated by Vespasian in the Temple of Peace.[14] Some writers seem to have supposed that the Vatican statue might be the one Pliny meant.[15] The obvious conclusion that the Vatican statue was probably a copy or derivation of Vespasian's statue, does not seem to have been stated before Mariette in the early eighteenth century.[16]

Part of the fascination of the *Nile* lay in the allegory and in the exoticism of the river god's attributes, some of which are to be seen on a frieze behind the statue: crocodile, hippopotamus, sacred Ibis, sphinx and so on.[17] But the quality of execution and design were also admired, if at less length.[18] Plaster casts were made both for François I[er][19] and for Philip IV;[20] and a marble copy was carved by Lorenzo Ottoni for Louis XIV between 1687 and 1692, which, however, because of wars and other disturbances, could only be delivered in 1715 when the King ordered it to be placed in the gardens of Marly (today it is companion with a

copy of the *Tiber* in the Tuileries Gardens).[21] In 1768 Mengs was anxious to obtain a cast of the head for the Spanish Royal Academy.[22]

In general, and for obvious reasons, the *Nile* was reproduced on a small scale. Bronze statuettes were made in seventeenth-century Paris, without the putti in some cases.[23] A copy in relief about a foot high appears on the pedestal of Thomas Banks's monument in St. Paul's Cathedral of 1804–5 commemorating George Blagdon Westcott killed in the Battle of the Nile in 1798. Further indication of the *Nile*'s reputation in the early nineteenth century is shown by the attempts made after Waterloo by the French to retain it in Paris, offering to the Vatican in exchange the somewhat embarrassing colossal nude Napoleon by Canova.[24]

The *Nile* has been praised, faintly, by modern scholars—the execution is 'skillful'; the pose contains 'an echo of grandeur'; the allegory is 'pretty enough'; the idea has a 'mild academic charm'.[25] It is catalogued in Helbig as a sculpture copied under the Roman Empire from a Hellenistic statue probably of Alexandrian origin, perhaps with some elaboration.[26]

1. Venetian Ambassadors in Albèri, p. 115.
2. Rossini, 1776, I, pp. 275–7.
3. Montaiglon (*Correspondance*), XVI, pp. 463, 498.
4. Lanzac de Laborie, VIII, pp. 275, 277.
5. *Notice*, supplément, 1811, pp. 8–10.
6. Considering its size, it was surely among those taken from Antwerp by H.M.S. *Abundance* which had reached Civitavecchia by 19 June (*Diario di Roma*, 19 June 1816).
7. Pistolesi, 1829–38, IV, 1829, p. 57; Amelung, 1903–8, I, p. 133. Vasi (rectifié Nibby), II, p. 482, and Fea, 1822, II, p. 125, refer to another Nile also formerly in the Belvedere courtyard.
8. Michaelis, 1890, p. 24; Brummer, p. 192.
9. Vasari, V, p. 148.
10. Vasari, I, p. 118.
11. Cavalleriis (2), plate 3; Maffei, plate VII; Brummer, pp. 196–204.
12. Amelung, 1903–8, I, p. 133.
13. Brummer, p. 271 (quoting Gamucci).
14. Pliny, XXVI, 58.
15. Maffei, plate VII.
16. Mariette, I, p. 39.
17. E.g. Montfaucon, 1702, pp. 278–9; Visconti (*Pio-Clementino*), I, plate XXXVII.
18. Visconti (*Pio-Clementino*), I, plate XXXVII.
19. Pressouyre, 1969 ('Fontes'), pp. 225–6.
20. Palomino, p. 914.
21. Montaiglon (*Correspondance*), I, pp. 171–2, 285; IV, p. 418 and frequent references; Enggass, 1972, p. 318.
22. Mengs (*Briefe*), p. 7.
23. Mann, p. 69; Souchal, 1973, pp. 35–6, 44, nos. 7, 35.
24. Boyer, 1970, pp. 140–1.
25. Beazley and Ashmole, p. 70; Robertson, I, p. 548.
26. Helbig, 1963–72, I, pp. 338–9.

2. *Nile* (Vatican Museum).

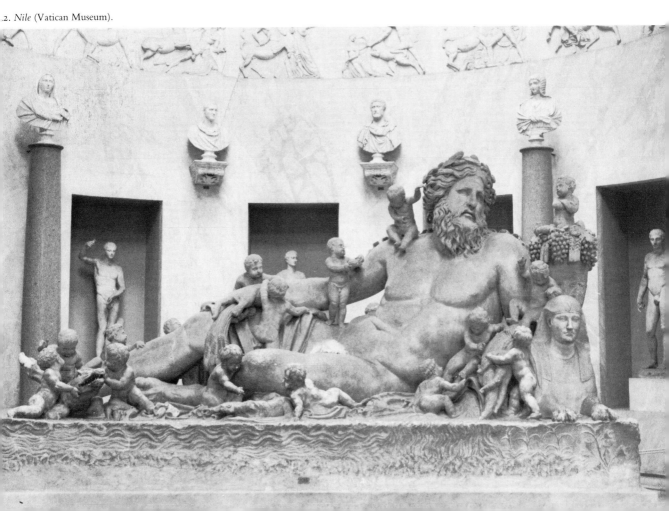

66. The Niobe Group (Figs. 143–7)

FLORENCE, UFFIZI

Marble

Height (Niobe and her youngest daughter):
2.28 m

According to a letter of 8 April 1583 written by
Valerio Cioli, a sculptor and restorer, to the
secretary of the Grand Duke, Francesco I, of
Tuscany, most of the statues which compose the
Niobe Group had been discovered, together with
the *Wrestlers*, a few days before in a *vigna*
belonging to the Tommasini de Gallese family
near Porta S. Giovanni, Rome. On 25 June of
the same year, they were purchased by Cardinal
Ferdinando de' Medici from the Varese family.[1]
Prints of the statues in their fragmented state
were published in 1594, but they had probably
been restored by 1588 when plaster casts of the
group arrived in Florence;[2] once restored, the
statues were displayed in the garden of the Villa
Medici in Rome where they are described in an
inventory of 1598.[3] They were removed from
Rome in 1769,[4] and recorded at Livorno on 14
May 1770, and were certainly in Florence by the
end of June 1770 when they were entrusted to
the restorer Innocenzo Spinazzi whose work on
the group continued until 1776.[5] By 1781 they
were displayed in a room in the Uffizi specially
designed for them and adorned with modern
reliefs illustrating the same legend.[6] Four other
statues connected with the group were moved
from the Villa Medici in 1788.[7] One of the
daughters of Niobe and the recumbent son were
removed with other treasures from the Museum
to Palermo in September 1800 to escape the
French. They were returned in February 1803.[8]

For Perrier in 1638, the statues of the *Niobe
Group* were the work of either Praxiteles or
Scopas[9]—a reference to Pliny's description of
such a group of statues removed from Seleucia to
the Temple of Apollo Medicus in Rome, the
authorship of which he says was disputed, some
claiming it for Praxiteles, some for Scopas.[10]
Over two centuries later, Winckelmann was sure
that if the Medici statues were not by Scopas then
they were exact imitations of his work. Later,
however, he changed his mind, considering
some to be Scopaic and some Praxitelean in
character.[11] Fabroni, in his treatise on the statues,
was certain that they were at least Greek, and in
this he followed Mengs who had held that the
hardness of contour and relative inelegance of
drapery in some of the figures was evidence of

their antiquity.[12] Mengs, however, changed his
mind and shortly before his death drafted replies
to Fabroni in which he proposed that the statues
were copies, and attributed their varied quality
to the mixed abilities of the copyists.[13] His view
had been anticipated by the Richardsons who
were sure that some figures were incongruous
and noted different styles of carving and types
and marble[14] and by the editor of Northall's
Travels who pointed out that even had the group
corresponded with one described in detail by
Pliny (which it did not) then 'this would not
absolutely decide the point, as many copies were
made by the ancients from one admired original,
and at present not distinguishable from it'.[15]

Mengs's doubts were supported by Falconet,
Fea and Quatremère de Quincy and broadcast in
a popular travel book by Lalande.[16] By the
first decades of the nineteenth century most
scholars were convinced that the sculptures were
copies and more and more questions had by then
been asked about the quality of some of the
statues in the group.[17] Some travellers such as
Kotzebue felt bold enough to declare his dislike
for the group.[18] Nonetheless, the French Minister
of the Interior, writing in 1799, had placed
the group immediately after the *Venus de' Medici*
in a list of statues which he felt desirable to
expropriate from Florence;[19] Mrs. Starke, al-
though rather worried about the status of the
group in 1800, felt able to assure her readers in
1820 that it was 'generally considered as the most
interesting effort of the Grecian Chisel Italy can
boast';[20] and Shelley convinced himself that the
face of Niobe was, with the entire figure of the
Apollo Belvedere, 'the most consummate per-
sonification of loveliness . . . that remains to us of
Greek Antiquity'.[21]

An engraving of the Villa Medici published in
1628 shows six Niobids and a horse arranged
together in a special compartment of the gar-
den.[22] The detail is small and at the edge of the
plate and it is probable that more figures were
there—almost certainly the fifteen of them des-
cribed in the inventory of 1598. These were arran-
ged, according to later travellers, in five groups of
three figures in this same part of the garden
'upon a vast Rock-like Heap of Stone, about the
bigness of an ordinary Room'.[23] Perrier's print
showing the figures disposed more spaciously in
a landscape with Diana and Apollo added in the
sky (Fig. 10),[24] although obviously fanciful, as
several travellers needlessly insisted,[25] reflects the
picturesque arrangement. Similar groupings of
figures, rocks and horses may be found in the

274

143. *Niobe and her Daughter* (Uffizi).

144–6. *Daughters of Niobe* (Uffizi).

famous Sala del Parnasso designed about 1603 for the Villa Aldobrandini and, earlier, in the Parnassus at the Medici villa of Pratolino.

The room in the Uffizi to which the statues were removed was not considered suitable for their display—it was 'like an appurtenance to a Church' thought Horace Mann,[26] and too like a 'drawing room' according to Peter Beckford,[27] whilst the arrangement of the figures around the sides of the room was found to be unimaginative and disjointed.[28] As early as 1747, Spence, dissatisfied with the picturesque composition in the Villa Medici remarked that the ancients would have preferred a more planar grouping,[29] and when in 1836 C. R. Cockerell, just returned from exploring the temples of Greece, published an etching with the figures arranged as in a temple pediment, it was much acclaimed.[30] Many scholars since have felt that the originals must have filled a pediment; others have preferred a similar planar grouping which is, however, free-standing.[31]

Copies of the *Niobe Group* were made—there are full-size bronzes in the park at Pavlovsk cast by Mozhalov from models by Gordeyev for Catherine the Great in the 1780s,[32] and Bartolini was at work on two sets in marble in 1808,[33] probably for Napoleon who realised that he could not expropriate the Uffizi statues—but such copies were obviously more common on a small scale. By 1666 the German ivory carver Balthasar Stockamer had made models of the entire group.[34] Bronze statuettes were offered for sale by Righetti[35] and alabaster ones may still be seen at Stourhead in Wiltshire. Casts of all the figures arrived in the Uffizi in 1588 and were displayed there from 1595 until they were replaced two centuries later by the marbles.[36] A complete set of casts was presented to the Prince Regent after the Napoleonic Wars in exchange for casts of the Elgin marbles,[37] and before passing these on to the Royal Academy, he and Sir Richard Westmacott tried out Cockerell's arrangement in the royal stables and were not happy with it.[38] Nevertheless casts of the statues were later arranged in this way in the Greek Court of the Crystal Palace[39] and in the cast rooms of the Whitworth Art Gallery in Manchester.

Very often one figure only was cast or copied. A cast of the fleeing daughter was ordered for Philip IV of Spain in 1650,[40] a cast of the recumbent son, together with heads of Niobe and one daughter, adorned the Elector Karl Theodor's Antikensaal at Mannheim opened in

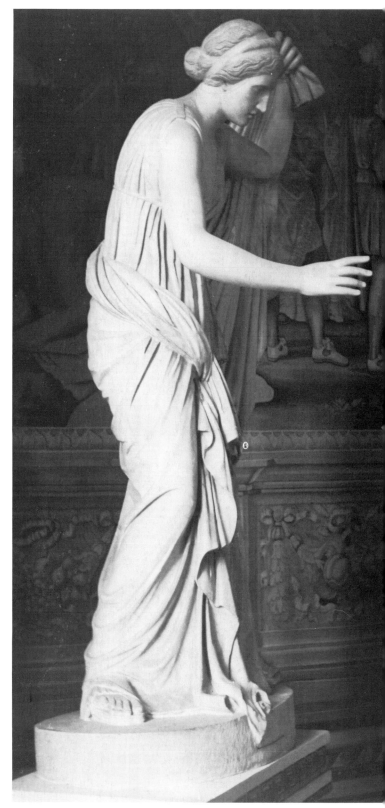

277

1767[41] and a century later, the leading London cast merchant provided casts and statuettes of Niobe herself.[42] Statuettes were also available in terracotta.[43] Most common of all, however, were busts, usually of Niobe, but also of some of her daughters.[44]

It was indeed the passions expressed by the heads—grief, dread and supplication—which were particularly admired in the *Niobe Group*.[45] The sculptor's taste in contriving to convey such distress without detracting from beauty was especially commended[46] and inspired numerous paintings of Magdalenes, Lucretias and female martyrs with parted lips and eyes rolled up to heaven—most notably those by Guido Reni.[47] Herder commended the sculptor for putting expression before beauty, but he emphasized its restraint—'learn from the face of suffering Niobe true, silent suffering and do not squeal in a puerile and servile way'.[48]

To most archaeologists today, the *Niobe Group* in Florence is of less interest than the three figures in the Terme Museum, Rome, and the two in Copenhagen, which were found in Rome on the site of the Gardens of Sallust in 1873, 1886 and 1906 and which are thought to have originally adorned the pediment of the Temple of Apollo at Bassae.[49] The Florentine statues are catalogued by Mansuelli as antique copies—some accurate and others modified—some of which are widely believed to derive from important originals by Scopas or Praxiteles or their contemporaries and to be at least related to those which were known to Pliny.[50]

★ ★ ★

Even during the time of the group's greatest fame, it was never entirely clear exactly which statues belonged to it and notes are provided below on (1) figures found with the group but probably not belonging with it, (2) figures added to the group, and (3) some duplicate figures:

1. A figure believed to be Niobe's husband but then called her son and later 'the pedagogue' was probably found with the group and was displayed with it after its discovery (and also perhaps in antiquity) although it is now thought to be incongruous.[51] A statue of the Muse Polyhymnia was also probably found with the group and seems to have been regarded as a part of it in the late sixteenth century, although not in the early seventeenth.[52] Similarly accepted and then separated were the *Wrestlers*. These were presumed to be the two sons, Phaedimus and Tantalus, who, in Ovid's account, were shot by Apollo as they wrestled. Fabroni wanted them to be re-incorporated but they were not.[53] Also almost certainly found with the group and certainly engraved with it in the sixteenth and seventeenth centuries was a statue of Psyche with holes in its back for wings (which were sported by two other versions of the figure—one of them known in the sixteenth century).[54] It was displayed as a daughter of Niobe but questions were asked in the late eighteenth century.[55]

2. A statue of a rearing horse fished up on the coast near Magliana was added to the *Niobe Group* by 1588 to contribute to the general air of panic and perhaps to be taken for one of the horses from which, according to Ovid, some of the sons fell when struck by the arrows of the god.[56] Another recruit was the 'Anchirrhoe' (Fig. 146) which Cardinal Ferdinando de' Medici had acquired with the della Valle collection a year after the discovery of the *Niobe Group*,[57] and yet another, the 'Trophós', another standing female figure, originally a nymph or Muse, known before 1583, but of unknown provenance.[58] Two centuries later in Florence, a torso of a stooping Discobolus restored as an Endymion was briefly added as a crouching Niobid.[59]

Later still, at the suggestion of Thorvaldsen, a statue which was originally a Niobid, but which was not found with the others and had been converted into a Narcissus, was also added.[60]

3. The problems posed by duplicates must have been hard for the Medici to avoid, for at the very moment that the *Niobe Group* was discovered Cardinal Ferdinando was also negotiating for the della Valle collection which seems to have included a duplicate of the son who has fallen on one knee.[61] The provenance of the other duplicate in the Medici collection—of the son with one foot raised upon a rock—is unknown.[62] The recumbent son (Fig. 147) was already known in another version drawn by Heemskerck in the courtyard of the Casa Maffei, and by 1589 this was in the Bevilacqua collection in Verona where it was described as an Endymion and, later, as a gladiator. Acquired for Crown Prince Ludwig of Bavaria in 1811, it is still in the Glyptothek, Munich.[63] (Another recumbent son was acquired for Dresden from the Albani collection in the first half of the eighteenth century.)[64] Above all,

by the time the Medici group was discovered, the beautiful statue of the fleeing daughter was to be seen in Ippolito d'Este's gardens on the Quirinal, having been discovered at Tivoli—clearly a more elaborate variant of the prototype of one of the most admired of the Medici statues (Fig. 144), and (since it was taken in the last century to the Museo Chiaramonti in the Vatican) more highly esteemed than any of the statues in the Niobid room of the Uffizi.[65]

1. Gaye, III, pp. 451–3; Mandowsky, 1953, pp. 251–3; Mansuelli, I, pp. 101–2.
2. Cavalleriis (3), plates 9–19 (for prints); Mandowsky, 1953, pp. 256–9 (for casts—but she supposes they were taken from the statues before they were restored).
3. Boyer, 1929, p. 268 (nos. 349–60); see also p. 260 (nos. 18, 19, 22) and p. 267 (no. 316), for statues in the Sala Grande and the Loggia.
4. Nardini, IV, p. xxxviii (note by Andreoli in 1771).
5. Villani, pp. 63–4, 80–1, note 43.
6. Walpole (*Correspondence*), XXV, pp. 170–1.
7. *Documenti inediti*, IV, p. 80.
8. Paris, Archives Nationales: F[21] 573 (letter from L. Dufourny to Minister of Interior, 9 fructidor, an 9); Florence, A.G.F., Filza XXX, 1800–1801, no. 23; *Galerie Impériale*, p. 10; Boyer, 1970, pp. 187–91.
9. Perrier, 1638, plate 87.
10. Pliny, XXXVI, 28.
11. Winckelmann (*Briefe*), I, p. 259; Winckelmann (ed. Fea), II, pp. 199–201.
12. Fabroni, p. 9; Mengs, p. 139 (*Riflessioni*).
13. Mengs, pp. 358–9, 367–8 (letters to Fabroni).
14. Richardson, 1722, pp. 125, 354.
15. Northall, p. 345, note.
16. Lalande, II, pp. 197–9.
17. E.g., [Knight], 1809, plates XXXV–XXXVII.
18. Kotzebue, I, p. 104.
19. Boyer, 1970, p. 81.
20. Starke, 1800, I, p. 257, note; Starke, 1820, p. 113.
21. Shelley, p. 330.
22. Lauro, 1628, plate 162.
23. Boyer, 1929, p. 268; see also Mortoft, p. 121; Richardson, 1722, p. 124.
24. Perrier, 1638, plate 87.
25. Richardson, 1728, III, i, pp. 202–6; Northall, pp. 345ff.
26. Walpole (*Correspondence*), XXV, pp. 170–1, 177.
27. Beckford, I, p. 168.
28. Dupaty, I, pp. 135–6; Forsyth, p. 47.
29. Spence, p. 99.
30. Reproduced in Mansuelli, I, p. 101.
31. Bieber, pp. 74–7; but see Robertson, I, p. 461.
32. Kuchumov, plates 79, 80 (Gardens).
33. Marmottan, p. 38.
34. Giglioli, p. 460.
35. Righetti (see Appendix).
36. Mandowsky, 1953, pp. 256–9.
37. *Lorenzo Bartolini*, p. 202.
38. Royal Academy, London, Lawrence MS., Letterbooks, III, p. 5 (Law/3/8).
39. Phillips, p. 34.
40. Palomino, p. 915.
41. Schiller, XX, pp. 104–5.
42. Brucciani, 1864.
43. Blashfield, 1857, no. 210; Blashfield, 1858, 1st day, no. 74; 3rd day, no. 42.
44. Richardson, 1722, p. 125; Harris, C., pp. 13, 15; Baretti, pp. 13, 23, 30; Lami, 1910–11, II, p. 79; Boyer, 1970, p. 31.
45. E.g., Evelyn, II, p. 232; Montfaucon, 1702, p. 230.
46. Moore, I, p. 502.
47. Bellori, p. 529.
48. Herder, VIII, pp. 20, 92.
49. Cook, pp. 30–40.
50. Mansuelli, I, pp. 104–9.
51. Cavalleriis (3), plate 10; Fabroni, p. 10; Mandowsky, 1953, p. 259; Mansuelli, I, p. 121 (no. 82).
52. Cavalleriis (3), plate 11; but not Perrier, 1638; Mandowsky, 1953, p. 259; Mansuelli, I, p. 122 (no. 83).
53. Ovid, *Metamorphoses*, VI, 239–47; Fabroni, p. 19.
54. Cavalleriis (3), plate 16; Stuart Jones, 1912, pp. 95–6, 98–9; Mansuelli, I, pp. 122–3 (no. 84).
55. Fabroni, p. 18.
56. Ovid, *Metamorphoses*, VI, pp. 218–38; Fabroni, pp. 14–15; Mandowsky, 1953, p. 262; Mansuelli, I, pp. 125–6 (no. 87).
57. Perrier, 1638, plate 59; Mandowsky, 1953, pp. 260–2; Mansuelli, I, pp. 103, 131 (no. 95).
58. Mansuelli, I, pp. 130–1 (no. 94)—however, on p. 103 Mansuelli suggests that statue no. 269 (old inventory) came from the Della Valle-Bufalo, and this seems to be a mistake for no. 296 which is his no. 94.
59. *Ibid.*, I, p. 32 (no. 5).
60. *Ibid.*, I, p. 120 (no. 81).
61. *Ibid.*, I, pp. 102, 117 (no. 78).
62. *Ibid.*, I, pp. 118–19 (no. 79).
63. Michaelis, 1891–2, i, p. 134; Franzoni, pp. 35–6, 46–7.
64. Leplat, plate 117; Stark, p. 262.
65. Amelung, 1903–8, I, p. 426; Bieber, p. 76.

147. *Son of Niobe* (Uffizi).

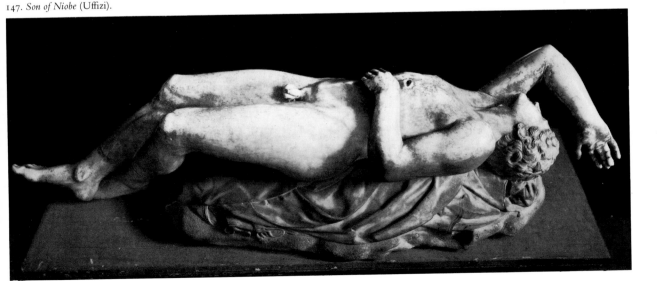

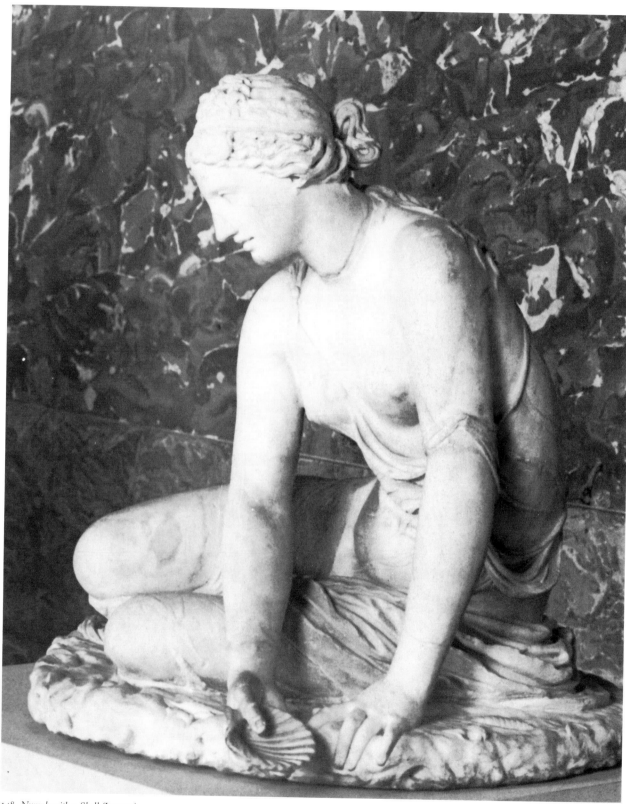

148. *Nymph with a Shell* (Louvre).

67. Nymph with a Shell (Fig. 148)

PARIS, LOUVRE

Marble

Height: 0.60 m

Also known as: Latona, Thetis, Vénus à la
 coquille, Venus and the cockle shell, Venus
 Marina

The statue is recorded by Perrier in 1638 as being
in the Villa Borghese[1] and by 1650 it was in the
Stanza della Zingara on the upper floor.[2] On 27
September 1807 it was purchased (together with
the bulk of the Borghese antiquities) by Nap-
oleon Bonaparte, brother-in-law of Prince
Camillo Borghese.[3] It was sent from Rome
between 1808 and 1811[4] and was on display
in the Musée Napoléon in Paris by the latter
year.[5]

The *Nymph* was especially admired in the
seventeenth century when it was engraved both
by Perrier[6] and by Sandrart,[7] a bronze cast was
made for Philip IV of Spain (still in the royal
palace in Madrid)[8], and an enlarged and elab-
orated marble version was produced by Coyse-
vox for Louis XIV between 1683 and 1687—
since 1891 this has been in the Louvre and has
been replaced at Versailles by a copy.[9] Thereafter,
at least for the French, Coysevox's version
became better known and better liked than the
original.[10] Certainly interest diminished in the
eighteenth century: the *Nymph* is not repro-
duced in de Rossi's anthology and it is discussed
neither by the Richardsons nor by Winckel-
mann. Artists and collectors, however, seem to ·
have been more enthusiastic than scholars: the
'Venus and cockle shell' was noted by Vertue as
among the dozen or so models after the antique
which Peter Scheemakers brought back from
Rome in the early 1730s;[11] in about 1769
Wright of Derby painted a group of art students
examining a cast of it by lamplight with the
Borghese Gladiator in the background (Mr. and
Mrs. Paul Mellon collection, Upperville, Vir-
ginia);[12] and a bronze statuette of the 'Venere
della Conchiglia' could be bought from
Zoffoli.[13]

In 1732 something of a sensation was caused
by the discovery in the grounds of the Vigra
Giustiniani of a variant, claimed to be of higher
quality, which was 'snatched from the hands of
an Englishman' by Wleughels, director of the
French Academy in Rome, and bought by him
for the French ambassador, Cardinal de Polig-
nac, who thanked him with the words 'If you
had given me an abbey with an income of thirty

thousand livres, I could not feel more obliged to
you'. The head, it was claimed, looked like a
Correggio, was less severe than the usual antique
and must certainly be a portrait of Julia, the
daughter of Augustus, playing knuckle-bones, a
game of which she was particularly fond.[14] This
whimsical hypothesis was given scholarly sanc-
tion in a publication illustrating the statue by the
antiquarian Francesco Ficoroni.[15] A cast was
taken for the French Academy in Rome, and a
number of marble copies were made from this
and from the original[16]—among these was one
(now lost) by Pigalle which was very highly
esteemed.[17] 'Julie' was sent to Paris and then
acquired in 1742 by Frederick the Great with the
remainder of the Polignac collection:[18] it was
seized for the Musée Napoléon in 1807 and
displayed there until 1815,[19] when it was re-
turned to Berlin (where it remains). Like the
Nymph, and sometimes as a pair to it, 'Julie' was
reproduced in biscuit de Sèvres[20] and small
bronzes.[21] And evidence that statues of this type
had been displayed as pairs in ancient Rome
came to light later in the eighteenth century
when two further versions were excavated from
the same site[22]—one of these (now in the British
Museum) was acquired by Charles Townley and
enjoyed much success in England where it was
reproduced in Coade stone.[23]

Almost from the first there was uncertainty as
to the precise significance of the Borghese statue.
Perrier called it a Venus,[24] and Sandrart a
Latona;[25] in Spain it was known as a Venus, a
Nymph, and a young girl (*moza*);[26] Manilli's
guide to the Villa Borghese of 1650 referred to it
as a Sea Nymph,[27] while Montelatici's of 1700
thought that it might be either Venus or a
Nymph;[28] a later book on the collection called it
Thetis.[29] Montfaucon, however, suggested that
the idea of a girl playing with a shell by the
waterside smacked of a workman (*ouvrier*) who
wished to display his art without any reference to
a specific historical or poetic source.[30] Towards
the end of the eighteenth century Heyne insisted
that it was only a Nymph[31] and this was
accepted by Visconti who, however, pointed out
that 'the very celebrated' German scholar had
only seen reproductions or copies of the statue
and might have been led to his conclusion by the
shell in the right hand of the figure which was a
modern addition.[32]

The 'Nymphe à la Coquille' is catalogued by
Charbonneaux as a good example of the art of
the second century B.C., derived from an original
representing a girl playing knuckle-bones.[33]

1. Perrier, 1638, plate 89.
2. Manilli, p. 101.
3. Boyer, 1970, p. 202.
4. Arizzoli-Clémentel, pp. 13–14, note 60.
5. *Notice*, supplément, 1811, pp. 11–12.
6. Perrier, 1638, plate 89.
7. Sandrart, 1680, p. 51.
8. Harris, E., pp. 118–19, plate IV.
9. Keller-Dorian, I, pp. 35–6.
10. Lalande, III, p. 487.
11. Vertue, III, p. 44.
12. Nicolson, I, p. 234 (no. 189).
13. Zoffoli (see Appendix).
14. Montaiglon (*Correspondance*), VIII, pp. 311–12, 330 and many further references.
15. Ficoroni, 1734, pp. 151–8.
16. Montaiglon (*Correspondance*), VIII, pp. 321, 325, 469; IX, p. 58; XV, pp. 39, 49 and other references.
17. Rocheblave, p. 18.
18. Paul, P., pp. 374–5.
19. *Statues, Bustes, Bas-Reliefs*, p. 12 (no. 72); Visconti (*Opere Varie*), IV, p. 169, note 1.
20. Bourgeois, p. 11 (nos. 609 and 370).
21. Zoffoli (see Appendix)—as 'Putta che gioca con l'ossetto'.
22. Smith, A. H., 1892–1904, III, pp. 80–2.
23. Coade, 1777–9, plate 4.
24. Perrier, 1638, plate 89.
25. Sandrart, 1680, p. 51.
26. Harris, E., pp. 118–19.
27. Manilli, p. 101.
28. Montelatici, pp. 284–5.
29. Brigentius, p. 80.
30. Montfaucon, 1719, I, i, p. 74.
31. Heyne (*Venus*), pp. 59–60.
32. Visconti (*Monumenti Borghesiani*), plate XVIII, no. 1.
33. Charbonneaux, 1963, p. 84 (no. 18).

68. Paetus and Arria (Fig. 149)

ROME, MUSEO NAZIONALE ROMANO (MUSEO
DELLE TERME)

Marble

Height (without base): 2.11 m

Also known as: Fulvius and his Wife, Gaul and
his Wife, Macareus and Canace, Menofilus
and his Charge, Pyramus and Thisbe, Sextus
Marius

This group is first recorded in an inventory of the Ludovisi collection in Rome drawn up on 2 November 1623.[1] In the absence of any earlier reference it has been inferred that it was discovered shortly before 1623 probably when the Villa Ludovisi was being built in an area, on the site of the gardens of Sallust, which when it was redeveloped in the late nineteenth century proved to be particularly rich in antiquities.[2] In 1633 it was recorded in the Palazzo Grande in the family estate on the Pincio.[3] It remained there until the early years of the nineteenth century, when, with most of the other statues, it was installed in a casino on the estate which was transformed into a museum.[4] Between 1885 and 1890 it was taken with the other statues in the collection to the new palace on the Via Veneto

built for the Prince of Piombino (the inherited title of the Ludovisi descendants).[5] It was purchased with the bulk of the collection by the Italian government in 1901 and moved in that year to the Museo Nazionale.[6]

The Ludovisi inventory of 1633 describes the group as 'un certo mario ch'ammazza la figlia e se stesso.'[7] This was given more precision by some later seventeenth-century sources which refer to the 'Sextius Marius killing his daughter, and then himself'[8]—Marius was a wealthy patrician who seeking to protect his daughter from the lust of Tiberius was himself accused of incest with her.[9] However, when the statue was first published (and illustrated) in 1638 it was described as a group of Pyramus and Thisbe,[10] although in Ovid's version of the story Thisbe's suicide followed that of Pyramus (who had killed himself because he thought her dead), which is not the situation in the Ludovisi group.[11] By about 1670 Paetus and Arria had been tentatively proposed as the subject,[12] and although this idea was challenged it remained popular for well over a century.[13] Caecina Paetus was involved in the conspiracy of Camillus Scribonianus in A.D. 42 and taken to Rome where he was ordered to commit suicide. To encourage him his wife Arria killed herself with the words, made famous in antiquity by an epigram of Martial, 'non dolet . . . Paete'. (The son-in-law of this couple, Thrasea Paetus, a righteous senator sentenced to death for treason under Nero killed himself in A.D. 56 forbidding his wife, Arria the younger, to follow her mother's example, but it is the earlier episode which was supposed to be illustrated by the Ludovisi group.)[14]

Among other ingenious attempts to 'find' the subject, we must mention Maffei's suggestion that it was the loyal eunuch Menofilus killing himself and his charge, the daughter of Mithridates, to save her from dishonour at the hands of victorious Roman soldiers,[15] and Gronovius's cautious suggestion that it was Macareus and Canace, the children of Aeolus forced to kill themselves for their incestuous passion.[16] The latter interpretation was mythological rather than historical and attracted Winckelmann for that reason—he, however, thought that, if this was the story illustrated, then the man's base appearance was more appropriate for the guard sent by Aeolus to deliver the weapon with which Canace was to kill herself.[17] There seems, however, to have been no antique source for the idea

149. *Paetus and Arria* (Museo Nazionale Romano).

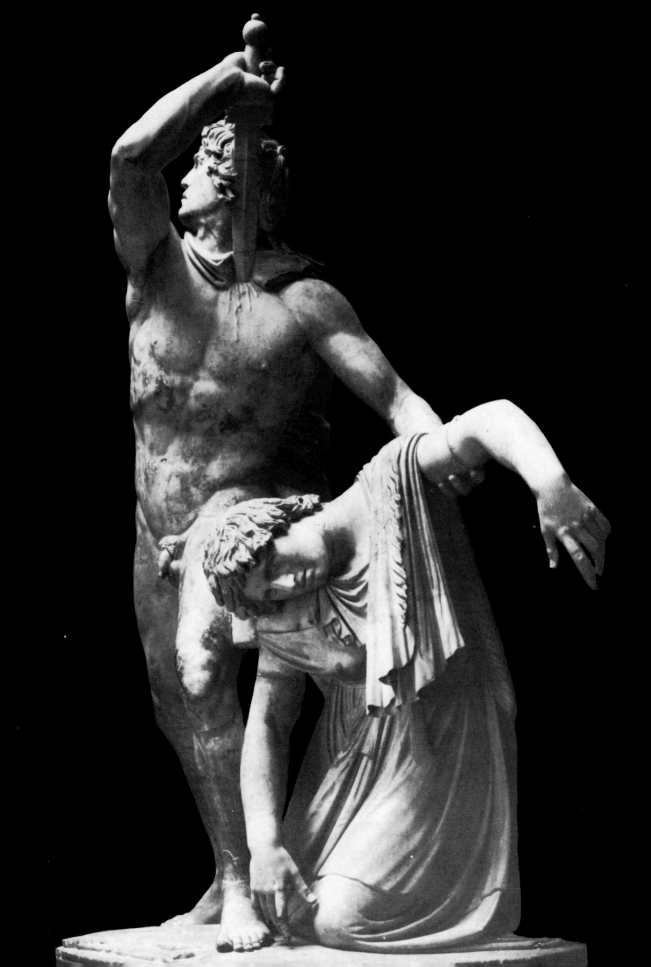

that the guard killed himself, or for the idea that brother and sister killed themselves together. Rather more typical of the eighteenth century was the idea that the subject concerned a conflict of loyalties between family and state. Rossini believed that it showed Fulvius killing himself after his wife had stabbed herself, distraught at the realisation that she had disgraced her husband by betraying to Livia the secret opinion of Augustus concerning Tiberius which Fulvius had confided to her.[18] The statue was also connected with Roman history in a different way for in the mid-seventeenth century certain marks on it were shown as scorchings made by 'the fire that Nero caused to be made for the burning of Rome'.[19]

Such associations with incest and rape and pyromania were however not invented as sensational publicity for a mediocre work of art. The group was consistently admired by travellers, and was reproduced in anthologies of the most esteemed statues.[20] It was copied in the seventeenth century by Lespingola in marble for Louis XIV (the copy is now companion with the *Laocoon* at the entrance to the Tapis Vert at Versailles),[21] and as a bronze by Gianfrancesco Susini,[22] and by Le Pileur after Garnier[23]—small bronzes were also cast by both Zoffoli and Righetti in late eighteenth-century Rome.[24] The cast made for the French Academy in Rome in connection with Lespingola's copy seems to have served as the prototype for other replicas during the eighteenth century when the Ludovisi heirs refused to allow new casts to be taken[25]—the cast made for the Duke of Richmond,[26] and the one recorded by Matthew Brettingham[27] probably originated in this way. Between 1816 and 1819, however, Prince Luigi Boncompagni Ludovisi very briefly reversed his family's previous policy and had a number of plaster casts made of some of his most admired sculptures which he presented to influential people in various parts of Europe—and *Paetus and Arria* was sent to the Prince Regent, the Grand Duke of Tuscany, Metternich and Wilhelm von Humbolt.[28]

The subject of the statue is now agreed to be a Gaul who stabs himself having already killed his wife to prevent her from falling captive. It was first identified as such by Visconti who supposed that together with the *Dying Gladiator* it had adorned a monument in Rome erected by some conqueror of the Gauls or Germans such as Caesar or Germanicus.[29] The group is still connected with the *Dying Gladiator* and is cat-

alogued in Helbig as a copy of the Trajanic or early Antonine period of one of the bronze groups dedicated by Attalos I after his victory over the Gauls in the second half of the third century B.C.[30]

1. Bruand, 1956; Bruand, 1959, p. 112 (no. 35).
2. Schreiber, pp. 112–15.
3. *Ibid.*, p. 29.
4. Mayne, p. 217; Felici, pp. 240–1; Bruand, 1959, p. 88.
5. Bruand, 1959, pp. 95–6.
6. Paribeni, p. 79.
7. Schreiber, p. 29; Bruand, 1959, p. 112.
8. Skippon, p. 652; Landais, 1958. Lassels, II, p. 181, says that he is killing himself, having discovered his daughter's suicide.
9. Dio Cassius, LVIII, 22, recorded that father and daughter 'perished together'; however, according to Tacitus, *Annals*, VI, 19, the father was thrown from the Tarpeian rock.
10. Perrier, 1638, plate 32; also Audran, plates 8, 9.
11. Ovid, *Metamorphoses*, IV, 55–166.
12. Seignelay, p. 164.
13. E.g. Richard, VI, pp. 159–60; Wright, I, p. 344; Starke, 1800, II, p. 39, note; Dalmazzoni, p. 180.
14. Dio Cassius, LX, 16; Pliny the Younger, *Letters*, III, 16; Martial, I, 13; Tacitus, *Annals*, XVI, 21–35.
15. Maffei, pp. 58–9, but not captions to plates LX, LXI (citing Ammianus Marcellinus, XVI, 7, ix–x).
16. Gronovius, III, 1698, plate XXX (citing Ovid, *Heroides*, XI and Hyginius, *Fabulae*, CCXLII, CCXLIII).
17. Winckelmann (ed. Fea), II, pp. 341–4.
18. Rossini, 1771, II, pp. 258–9. The story comes in Plutarch's *Concerning Talkativeness*, 508. A similar indiscretion was made by Fabius Maximus according to Tacitus, *Annals*, I, 5.
19. Mortoft, p. 126.
20. Perrier, 1638, plate 32; Audran, plates 8, 9; Maffei, plates LX, LXI.
21. Thomassin, plate 57; Lami, 1906, p. 332; Montaiglon (*Correspondance*), IV, p. 419.
22. Baldinucci, IV, p. 118.
23. Landais, 1958.
24. Zoffoli, Righetti (see Appendix).
25. Montaiglon (*Correspondance*), X, p. 442.
26. Edwards, 1808, p. xvii.
27. Brettingham MS., pp. 34, 58, 121.
28. Felici, p. 244.
29. Visconti (*Opere varie*), IV, pp. 325–6.
30. Helbig, 1963–72, III, pp. 255–6.

69. Pallas of Velletri (Fig. 150)

PARIS, LOUVRE

Marble
Height: 3.05 m

The statue was discovered in September 1797 on the estate of Giovanni de Santis near Velletri.[1] Doubts as to whom it belonged were resolved in the most pragmatic way by the French who seized it after their arrival in Rome in 1798.[2] It was in store in Rome when the Neapolitans occupied the city in 1799. They sequestered the statue, but it was relinquished to the French under a specific term of the Treaty of Florence of 28 March 1801.[3] It reached Paris in December

1803 and was specially visited by Napoleon and Josephine on 19 December a few days after its installation in the Musée.[4] As a diplomatic concession to the restored French monarchy the *Pallas*, together with the equally gigantic *Tiber* and Veronese's 'Wedding Feast at Cana', was not claimed by the papal government after Waterloo.[5]

Few statues have been greeted with such immediate and universal enthusiasm as the *Pallas*. Three contestants claimed possession of it: Duke Braschi, the Pope's nephew; Prince Augustus (later Duke of Sussex), the sixth son of George III; and Vincenzo Pacetti, the sculptor (and briefly owner of the *Barberini Faun*) to whom the French paid an indemnity in order to secure their legal rights.[6] In 1801 it was rated as highly as the *Apollo Belvedere* and the *Laocoon*,[7] and the Neapolitan court was told that Napoleon would relinquish it only in return for the *Venus de' Medici*.[8] From the first it was also compared with the *Minerva Giustiniani*[9] and it appealed to the same taste for austere grandeur. In the popular catalogue of the Musée this 'sublime' statue was once again likened to the *Apollo*[10] and later in the century it continued to be mentioned by visitors to the Louvre, where it stood in a room named after it,[11] but with more respect than enthusiasm.

Two casts of the statue were made at the French Academy in Rome when the *Pallas* was first taken there by the army:[12] the Accademia at Bologna also acquired one which still survives on their premises, as did the Prince Regent, who donated his to the Royal Academy in London.[13] This latter cast doubtless enabled E. H. Baily to make the full-scale gilt replica which was placed above the entrance of the Athenaeum (Club) in Waterloo Place, London, in 1830.[14] On a quite different scale was the tribute paid to the statue by the French when it was copied on the reverse of a medal by Brenet specially minted on 22 September 1804 to commemorate the Code Civil.[15]

Visconti and Éméric-David believed that the statue had been discovered on the site of one of the retreats of the Emperor Augustus and suggested that he had removed it from Greece,[16] but Flaxman, finding in it the 'severe and simple beauty' of Phidias, suggested that it was a copy of a famous Greek original[17] and this has been the view of most scholars since.[18] The statue is described by Picard as 'imposing', but wrongly restored in the arms. 'It is legitimate to think it a

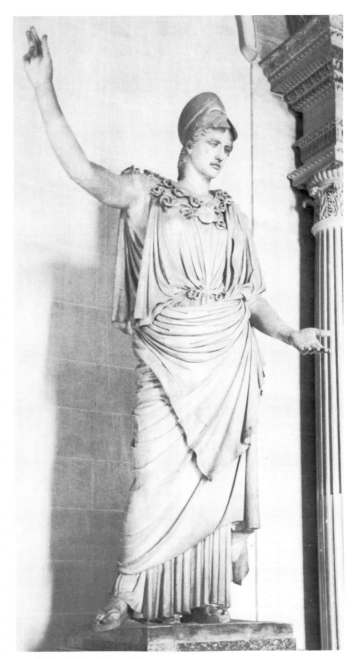

150. *Pallas of Velletri* (Louvre).

copy of a bronze by Cresilas', he observes, and he places the original confidently in the second half of the fifth century B.C.[19]

1. Fea, 1836, pp. 76–88.
2. Montaiglon (*Correspondance*), XVII, pp. 356–8.
3. *Ibid.*
4. Lanzac de Laborie, VIII, p. 280.
5. Quatremère de Quincy, 1834, p. 282.
6. Montaiglon (*Correspondance*), XVII, pp. 356–7.
7. *Ibid.*, XVII, p. 298.
8. Boyer, 1970, p. 189.
9. Fea, 1836, p. 87.

10. *Notice*, An 11 (1802–3), pp. 25–6,
11. Clarac, 1830, pp. 132–4.
12. Montaiglon (*Correspondance*), XVII, p. 358; Kotzebue, II, p. 78.
13. Flaxman, p. 26.
14. Gunnis, p. 34.
15. Edwards, 1837, p. 8; plate II, nos. 9, 10.
16. *Musée Français*.
17. Flaxman, p. 26.
18. Fröhner, pp. 144–6; Furtwängler, 1895, pp. 141–6.
19. Picard, II, ii, pp. 610–11.

70. Pan and Apollo (Fig. 151)

ROME, MUSEO NAZIONALE ROMANO (MUSEO DELLE TERME)

Marble
Height: 1.32 m
Also known as: Marsyas and Olympos, Pan and Daphnis, Satyr and Boy, Satyr and Faun, Silenus and Bacchus

The group of *Pan and Apollo* was recorded in the Cesi sculpture garden by Aldrovandi in an account of the antique statues of Rome published in 1556 but based on notes made six years earlier.[1] It was given to the Ludovisi in the summer of 1622[2] and eleven years later was recorded in the 'Bosco delle Statue' outside the Palazzo Grande in the family estates on the Pincio.[3] It remained there until the early years of the nineteenth century when, with most of the other statues it was installed in a casino on the estate which was transformed into a museum.[4] Between 1885 and 1890 it was taken with the other statues in the collection to the new palace built for the Prince of Piombino (the inherited title of the Ludovisi descendants).[5] It was purchased with the bulk of the collection by the Italian government in 1901 and moved in that year to the Museo Nazionale.[6]

This group survived in several versions. Aldrovandi, who seems to have been particularly fascinated by the subject, described that in the Farnese collection (now in the Museo Nazionale, Naples) with almost as much enthusiasm as he did the Cesi version,[7] whilst a version of the boy alone in the della Valle collection (now in the Uffizi) was the subject of early sixteenth-century prints.[8] Du Bellay's description of a Satyr tempting a boy with a gift which the boy likes 'although the wild giver does not find favour with him'[9] may refer to either the Cesi or the Farnese group both of which he could have seen in Rome between 1553 and 1557. It is also hard not to believe that Riccio's bronze statuette of a Satyr couple, although the approaches here are both heterosexual and reciprocal, was made

without knowledge of some version of this group.[10]

After the Cesi version entered the Ludovisi collection it became the best known and was reproduced in the anthologies of the most admired antique statues.[11] It is therefore likely that this is the version that can just be discerned together with the *Nile*, the *Spinario* and the *Antinous* in a Flemish painting of an ideal cabinet,[12] and which was copied for Versailles by Goy.[13] It was less highly praised and was not much reproduced in the eighteenth century. The homosexual character of the group may have discouraged travellers from a too enthusiastic response. Pan's excitement was ostentatiously concealed in Thomassin's plate of the statue at Versailles,[14] and Spence 'for a very obvious reason' only illustrated the face of the god.[15] J.-P. Cortot's Daphnis and Chloe of 1825–7 (now in the Louvre) is a heterosexual and neoclassical adaptation of the theme.[16]

The exact subject was much debated. For Lafreri and Perrier it represented Pan teaching Apollo.[17] Montfaucon recorded this as the common view in Rome, but pointed out that Apollodorus does not record that Pan taught Apollo music but rather the arts of divination.[18] Maffei with reference to a painting by Polygnotus of Marsyas with Olympos suggested that this was the subject.[19] For others it was a Satyr and a young Faun,[20] simply a Satyr and a Youth,[21] or Silenus and Bacchus.[22] In this century the group has been generally considered as of Pan with either Daphnis or Olympos and sometimes linked with a group of Pan struggling with Olympos mentioned by Pliny as in the Saepta Julia and companion with a Chiron teaching Achilles. Another treatment by Heliodorus of the same subject (perhaps another version of the same statue) was recorded by Pliny in the Portico of Octavia and described as the second-best 'symplegma'. The fact that at least eight complete versions of the marble group have survived strongly suggests that this statue by Heliodorus was the prototype, even though this depends on a somewhat metaphorical meaning being given to 'luctantes' (struggling). Scholars now suppose Pliny confused Olympos for Daphnis.[23] The boy had in fact been identified as Daphnis in the captions to sixteenth-century prints of both the Farnese and Ludovisi (then Cesi) versions.[24]

The Ludovisi group along with the Farnese one, is considered by Robertson to be a copy of the Imperial period of a Hellenistic original.[25] It is not included in Helbig.

286

151. *Pan and Apollo* (Museo Nazionale Romano).

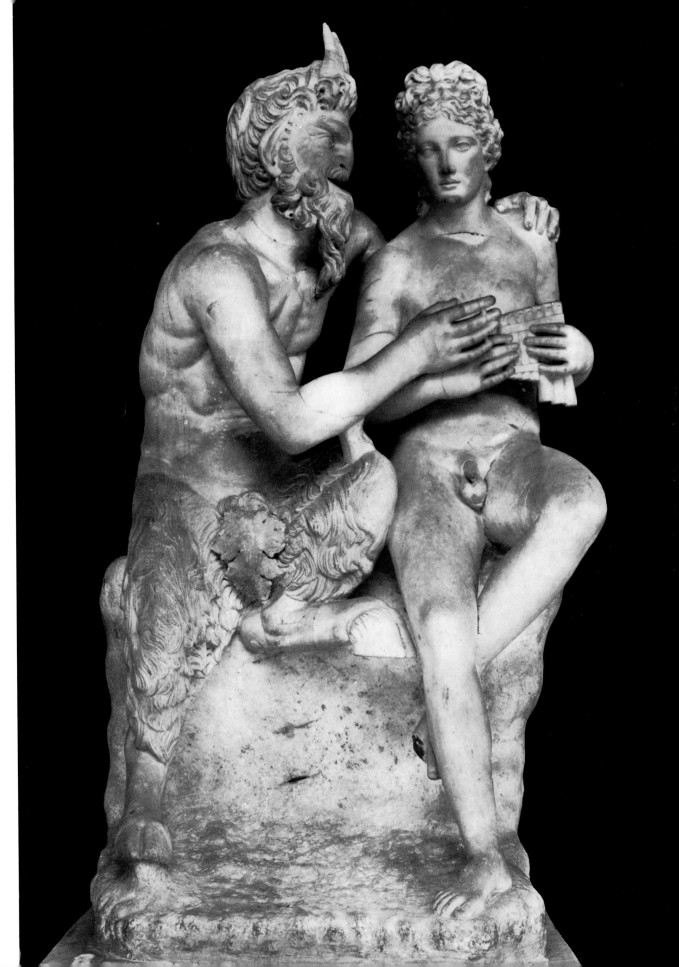

1. Aldrovandi, 1556, p. 131.
2. Bruand, 1956; Bruand, 1959, p. 114.
3. Schreiber, pp. 34, 44–5.
4. Mayne, p. 217; Felici, pp. 240–1; Bruand, 1959, p. 88.
5. Bruand, 1959, pp. 95–6.
6. Paribeni, p. 79.
7. Aldrovandi, 1556, p. 159; for the provenance of this statue, see Bober, p. 49.
8. Gardey, Lambert and Oberthür, no. 337; the statue is Mansuelli, I, p. 137.
9. Du Bellay, *Romae Descriptio*, lines 99–100.
10. *Italian Bronze Statuettes*, no. 55.
11. Perrier, 1638, plate 44; Maffei, plate LXIV.
12. Speth-Holterhof, plate 28.
13. Lami, 1906, p. 222.
14. Thomassin, plate 59.
15. Spence, p. 254, plate XXXV, fig. 10; cf. Frye, p. 194.
16. Lami, 1914–22, I, p. 429.
17. Lafreri (British Museum copy), fol. 77; Perrier, 1638, plate 44.
18. Montfaucon, 1719, I, i, p. 101.
19. Maffei, plate LXIV.
20. Macandrew, p. 146 (inscription on Batoni drawing in Topham collection, Eton College).
21. Spence, p. 254.
22. Richardson, 1728, III, i, p. 209.
23. Bieber, p. 147 (citing Pliny, XXXVI, 29 and 35).
24. Cavalleriis (3), plate 81; Vaccaria, plates 37–8.
25. Robertson, I, pp. 556, 584.

71. Papirius (Fig. 152)

ROME, MUSEO NAZIONALE ROMANO (MUSEO
DELLE TERME)

Marble

Height (female figure): 1.92 m; (male figure):
1.70 m

Inscribed: ΜΕΝΕΛΑΟΣ ΣΤΕΦΑΝΟΥ
ΜΑΘΗΤΗΣ ΕΠΟΙΕΙ

Also known as: Amity, Concord, The Fraternal
Greeting, Marcus Aurelius and Lucius Verus,
Merope and Aepytus, Orestes and Electra, La
Paix des Grecs, Papirius and his Mother,
Penelope and Telemachus, Phaedra and Hyp-
polytus, Young Senator and his Mother

This group is first recorded in an inventory of the
Ludovisi collection in Rome drawn up on 2
November 1623.[1] In the absence of any earlier
reference it has been inferred that it was dis-
covered shortly before 1623 probably when the
Villa Ludovisi was being built in an area, on the
site of the gardens of Sallust, which when it was
redeveloped in the late nineteenth century
proved to be particularly rich in antiquities. In 1633
it was in the Palazzo Grande on the Ludovisi
estate on the Pincio[2] and it remained there until
the early years of the nineteenth century when,
with most of the other statues, it was installed in a
casino on the property which was transformed
into a museum.[3] Between 1885 and 1890 it was
taken with the other statues in the collection to
the new palace on the Via Veneto built for the

Prince of Piombino (the inherited title of the
Ludovisi descendants).[4] It was purchased with
the bulk of the collection by the Italian govern-
ment in 1901 and moved in that year to the
Museo Nazionale.[5]

The very great popularity of this group through-
out the seventeenth, eighteenth and most of the
nineteenth centuries—a popularity reflected in
illustrated anthologies, in copies (obtained, be-
cause of the owner's obstructions, only with the
utmost difficulty) and in the comments of
travellers—was, from about 1700 onwards, close-
ly linked to fascination with the subject repre-
sented. This was at first described merely as
'friendship'[6]—a name which for a time satisfied
many visitors[7]—and in 1638 Perrier was scarcely
more informative when he wrote of it as a
'fraternal greeting' (fratres sese complectentes)[8]
—the sex of the taller figure being con-
fused on account of her short hair. In his
caption to a print of the marble copy made
for Louis XIV by Martin Carlier and Michel
Monnier (at Versailles),[9] Simon Thomassin
eloquently entitled the group 'La Paix des
Grecs'—a name earlier suggested by Audran for
one of the figures of the *Castor and Pollux*[10]—but
in his explanatory notes he followed Sandrart[11]
in identifying the two brothers as Marcus Aure-
lius and Lucius Verus.[12] By 1704, however,
'some people' were already giving it the name of
'Papirius' by which it came to be generally
known[13]: the reference was to a comic anecdote
(transmitted by Aulus Gellius in his *Noctes Atticae*
of the second century A.D.) describing the in-
genuity with which the young Papirius, nick-
named Praetextatus, had, in the early days of
Rome when sons were allowed to accompany
their fathers to the Senate, fobbed off his
mother's curiosity about what had been dis-
cussed there by telling her that the debate had
centered on the issue as to whether it was better
for the State for one man to have two wives or
one woman two husbands.[14] It is interesting that
Maffei who tells us of this new title given to the
group was not himself convinced by it on the
grounds that the figures (one of whom is
virtually nude) were clearly Greek. For this
reason he preferred the name of Phaedra and
Hyppolytus.[15]

Once the subject of Papirius had been sug-
gested, most connoisseurs were eager to detect
the appropriate subtlety of expression. In 1719
the Abbé Du Bos, the extremely influential
theorist who had visited Rome in 1700–1, de-

152. *Papirius* (Museo Nazionale Romano).

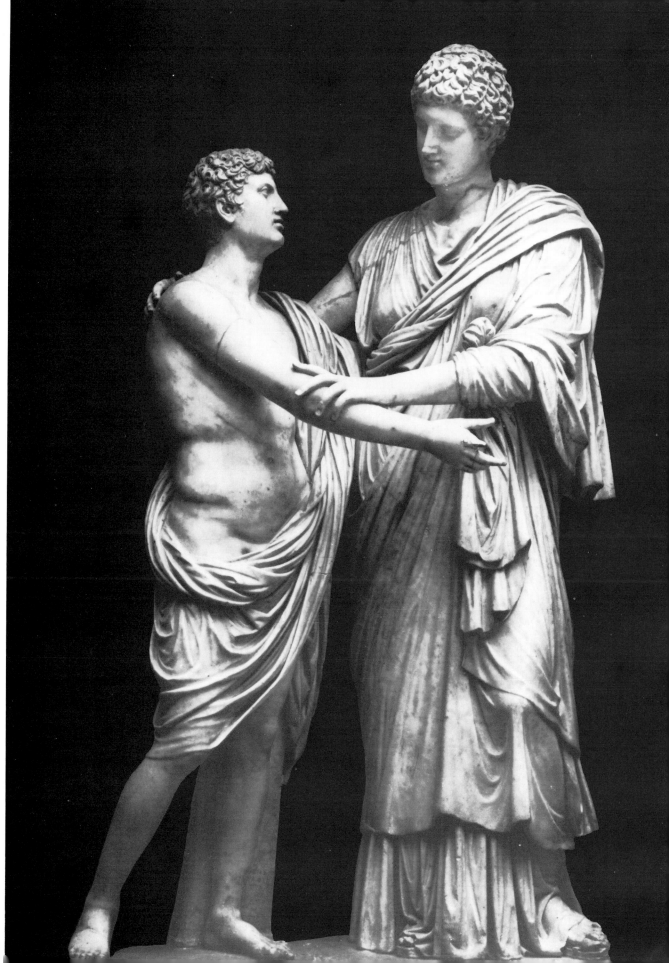

rided the name 'La Paix des Grecs' and exclaimed that 'no feeling has ever been better expressed than the curiosity of the mother of the young Papirius. The very soul of this woman can be seen in her eyes which pierce and caress her son at the same time . . .' and he continued in this vein at some length.[16] Twenty years later de Brosses was equally struck by the complexity of emotions depicted,[17] and such readings continued well into the nineteenth century. Even Winckelmann, who ridiculed Du Bos, could not escape their spell. Following Maffei he saw that the figures must be Greek and, like him (but without acknowledging the fact), he at first thought that they were Phaedra and Hyppolitus, though he was puzzled to note that in the Ludovisi group (but not in the relevant scene of the play by Euripides) Phaedra appeared to be revealing to her stepson her guilty passion for him.[18] In a letter of 1756 he dismissed Stosch's idea that the figures represented the bereaved Andromache and Astyonax (widow and son of Hector),[19] but it may well have been this suggestion that drew his attention to their cropped hair—a ritual of mourning and respect for the dead which, he recalled, had been stressed on two occasions in the *Electra* of Sophocles. This led him to claim (in a theory that is still accepted by some authorities)[20] that the sculptor Menelaos had illustrated the scene from this play when Orestes, who has come to avenge his dead father, reveals himself to his sister Electra who had thought that he too was dead. On her physiognomy could be read 'joy mixed with tears, tenderness joined to despair'.[21] It was when commenting on the *Papirius* ('for I prefer the popular name') in 1813 that Joseph Forsyth acutely pointed out that 'the ancient artists seldom aimed at mixt passion. They knew practically the limited powers of art; they were content to bring forth one strong sentiment, and left to us the amusement of analysing that one into fifty'.[22]

Nevertheless, Winckelmann's general argument prevailed, and the search for the true subject turned from Rome to Greece, from comedy to tragedy, from history to myth. Some writers suggested Penelope and her son Telemachus[23] or Aethra and her son Theseus,[24] and in 1854 Otto Jahn published the last theory to enjoy a long life outside scholarly circles: the group represented Merope and her son Aepytus (whose story had been told in a lost play of Euripides), and it was a particularly dramatic moment of sudden recognition of the son by the mother that was portrayed.[25] More original was the reaction of

Herder who saw in the group a purely general theme: the relationship of the figures provided poignant proof of the power of immobile sculpture to convey feelings of quiet and mutual trust between friends, lovers or members of a family;[26] and indeed to many modern scholars it has seemed that no more specific narrative is intended than is to be found on Attic grave stele (from which the Ludovisi group appears to be derived) showing couples solemnly greeting each other or bidding farewell.[27]

Until the early nineteenth century casts were very rare, for the Ludovisi refused to allow moulds to be taken from the statues in their possession. It seems to be a reduced copy, and not a cast, which stands in front of the Colosseum in the portrait of Mr. and Mrs. Izard which Copley painted in Rome in 1775 (Fig. 48), and the fact that a drawing of the group is also prominently displayed suggests that, under one of its guises, it may have had some special meaning for the couple.[28] There was a cast in the French Academy in Rome[29] and the Roman bronze-founder Francesco Righetti was desperate to obtain an after-cast from it in 1782,[30] perhaps because he had been commissioned by a Dutchman to make a full-size version in metal of the *Papirius* and a number of other popular classics of ancient and modern times.[31] Permission was refused, and as the casts have not been traced it is not clear whether or not the *Papirius* could be included in the set sent to Holland. Certainly Righetti was able to supply small statuettes of the group, as also was Zoffoli;[32] and plasters, two feet high, could be bought in London at about the same time.[33] It was also copied on gems of which paste impressions were available,[34] and on cameos (Fig. 58), tablets and intaglios by Wedgwood.[35] And in the Palazzo Mangilli in Venice Giambattista Canal painted in the 1790s a fanciful variation on the theme in which the two figures were definitely shown as Roman.[36]

Between 1816 and 1819 Prince Luigi Boncompagni Ludovisi very briefly reversed his family's previous policy and had a number of plaster casts made of some of his most admired antique sculptures which he presented to influential people in various parts of Europe: thus *Papirius* was sent (still under that name) to the Prince Regent, to the Grand Duke of Tuscany, to Metternich and to Wilhelm von Humboldt.[37] These casts were mostly given by their recipients to their respective art academies, but Humboldt's can still be seen in the antique room of his residence Schloss Tegel near Berlin, where

it is paired with a cast of the *Paetus and Arria* which was distributed at the same time.[38]

The group is catalogued in Helbig as a very skillful and eclectic work derived in part from Greek funerary art of the fourth century B.C. but itself dating from not earlier than the first century A.D.: to the untrained eye the cataloguer points out it will appear to be affected in pose and emptily sentimental in expression.[39]

1. Bruand, 1956, p. 407; Bruand, 1959, p. 114.
2. Schreiber, pp. 29, 89–92.
3. Mayne, p. 217; Felici, pp. 240–1; Bruand, 1959, p. 88.
4. Bruand, 1959, pp. 95–6.
5. Paribeni, p. 79.
6. Schreiber, pp. 29, 89–92.
7. Skippon, p. 652; Mortoft, p. 126.
8. Perrier, plate 41.
9. Souchal, 1977, I, p. 80.
10. Audran, plate 13.
11. Sandrart, 1680, p. 43.
12. Thomassin, p. 20, plate 56.
13. Maffei, plates LXII, LXIII.
14. Aulus Gellius, I, 23.
15. Maffei, plates LXII, LXIII.
16. [Du Bos], I, pp. 361–3.
17. De Brosses, II, p. 55.
18. Winckelmann (ed. Fea), II, p. 345.
19. Winckelmann (*Briefe*), I, p. 254.
20. Paribeni, p. 100; Bieber, p. 182.
21. Winckelmann (ed. Fea), II, pp. 344–7.
22. Forsyth, p. 245.
23. Flaxman, p. 27.
24. See the resumé by Lübke quoted in Hare, 1903, II, p. 32.
25. Kékulé, 1870, p. 4, note 3 (citing Jahn); Murray, II, p. 391; Hare, 1903, II, p. 32.
26. Herder, 1806, VII, i, p. 172.
27. Helbig, 1963–72, III, pp. 274–5.
28. Prowne, II, pp. 251–2, fig. 342.
29. Montaiglon (*Correspondance*), XI, p. 226.
30. Ibid., XIV, pp. 239, 249–50, 261.
31. Righetti, R., p. 7.
32. Zoffoli, Righetti (see Appendix).
33. Harris, C., p. 9.
34. Raspe, II, nos. 10764, 10765, 15613.
35. Wedgwood, 1779, class I, section I, no. 1038; class I, section II, no. 222; class II, no. 62. An intaglio is in the City Art Gallery, Manchester, 1922–1466.
36. *Venezia nell'età di Canova*, p. 283.
37. Felici, p. 244.
38. Rave, plate 29.
39. Helbig, 1963–72, III, pp. 274–5.

72. Pasquino (Figs. 153–5)

ROME, PIAZZA DEL PASQUINO
FLORENCE, LOGGIA DEI LANZI AND PALAZZO PITTI

Marble

Height: (Rome group): 1.92 m; (Loggia group, with base): 2.53 m

Also known as: Ajax carried by a Soldier, Ajax carrying the body of Patroclus, Alexander the Great supported by a Soldier, Charité Romaine, Gladiator, Hercules, Menelaos carrying the body of Patroclus, Pietas Militaris

Three fragmented versions of the same group of a standing figure with a youth in his arms need to be discussed under this title, and it will avoid confusion if they are considered separately despite the fact that the close relationship between them was recognised in the sixteenth and seventeenth centuries[1] and made absolutely clear in the eighteenth.[2]

1. The most battered—and also the most famous—is first recorded by 'Prospettivo Milanese', who was probably writing in 1499–1500.[3] In 1501 Cardinal Caraffa had it placed on a base at one of the angles of the palace near the Piazza Navona in Rome which he had rented from the Orsini.[4] It remains there today, though in 1790 the palace was demolished to make way for the new Palazzo Braschi which was completed a few years later.

The very first reference to this statue gives it a Latinate form of the name by which it is still known, and in 1509 it was explained that before being erected by Cardinal Caraffa the statue had lain for many years abandoned and covered in dirt next to the house of a schoolmaster called Pasquino, after whom it was christened. This was particularly appropriate because each year on 25 April, the Feast of St. Mark, the statue was decorated in some different mythological guise by a painter in the service of the Cardinal, and Latin verses, strictly supervised as regards grammar and style, were attached to it in order to encourage the study of humane letters. From 1509 onwards selections of these verses were published at yearly intervals. With the passage of time Italian poems also began to be added to what had hitherto been an essentially erudite venture, and, as freedom of speech was allowed, these tended to become increasingly satirical in tone and were no longer confined only to St. Mark's day. By the middle years of the sixteenth century this bias was so noticeable that a completely new account of the origins of *Pasquino* was published, and it was this version that won general acceptance until the end of the nineteenth century. It was—so it was claimed—near the shop of a particularly outspoken and irreverent tailor, remembered even after his death for the freedom with which he used to criticise the pope and cardinals, that the statue had been found, and as he had been called Pasquino, this name was given to the sculpture to which—so it was wrongly supposed—libellous epigrams had been attached from the first.[5]

153. *Pasquino* (Piazza Pasquino, Rome).

and so did Adrian VI who was even accused by humanists of wanting to throw *Pasquino* into the Tiber. The Counter-Reformation popes were also obstructive.[9]

The statue, when first discussed, was thought to represent Hercules overcoming Geryon,[10] and Du Bellay's line 'Je fus jadis Hercule or Pasquin me nomme'[11] reflects the confusion, apparent then and later, between antiquarian research and contemporary folk lore. The caption to the plate published by Cavalleriis claimed that the group portrayed a soldier of Alexander the Great holding up his wounded master[12] and this theory remained popular: a neat, if muddled, compromise later suggested that the soldier in question had been called Pasquino.[13] In 1597 Boissard thought that there was not enough evidence to enable him to choose between Hercules and Alexander the Great[14] and guidebooks were prepared to agree that the matter was uncertain.[15] From time to time new suggestions were made (Mars, a Roman soldier, a gladiator)[16], but Winckelmann hinted that he accepted the original designation of Hercules,[17] and—as we will see—it was not until the late eighteenth century that Menelaos and Patroclus was proposed and widely supported.[18]

Pasquino was very highly admired—though more by Italian connoisseurs[19] than by foreign visitors, at least one of whom thought that it disfigured rather than embellished the palace against which it stood.[20] In the early seventeenth century both Felini and Totti claimed that 'for its excellence it is considered the equal of the' *Torso Belvedere*, which had also not been restored.[21] Bernini must certainly have had in mind Michelangelo's reported enthusiasm for the *Torso* when he expressed his very influential and widely publicised opinion (which sometimes aroused hostility) that the *Pasquino*, which he assumed to represent Alexander the Great and a soldier, was the finest piece of antique sculpture in Rome.[22] But, although frequently illustrated from the sixteenth century onward, replicas of this statue were not (unlike the *Torso*) made even for art students.

Pasquino's humanist and satirical functions had rivals at different periods—Andrea Sansovino's St. Anne in the church of S. Agostino for the former[6] and a column outside St. Peter's for the latter[7]—but its fame, combined with that of *Marforio* who often posed the leading questions to which *Pasquino* gave his biting answers, was more lasting than any of these: examples are recorded as late as the First Vatican Council of 1870,[8] and local variations of the word 'pasquinade' had entered most European languages by the end of the seventeenth century. Naturally the statue attracted hostility on these grounds. Leo X banned the festival for one year in 1519,

2. In 1594 or earlier Vacca wrote that a far more complete version of *Pasquino* had been discovered (by implication not long before 1570) on the estate of Antonio Velli not far from Porta Portese; it had, he said, been acquired in Rome by Cosimo I, Grand Duke of Tuscany, in 1570 and taken to Florence, and it is recorded in an inventory drawn up on his

154. *Pasquino* (Loggia dei Lanzi, Florence).

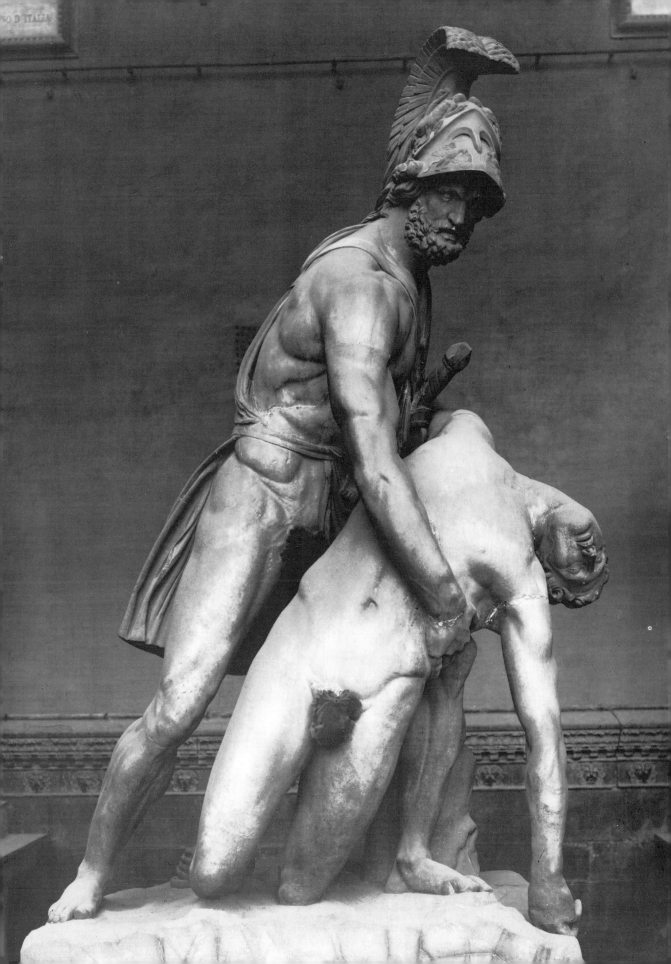

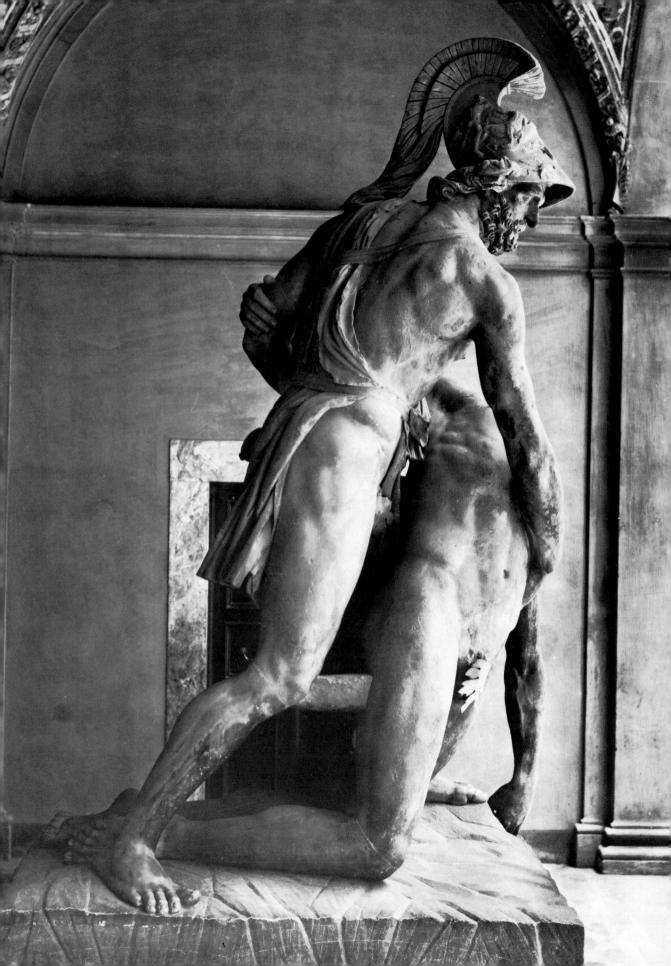

death in 1574.[23] We next hear of this statue in 1677 by which date we know that it had been restored, on the instructions of Grand Duke Ferdinand II who ruled from 1620 until 1670, by Lodovico Salvetti using a model made by Pietro Tacca,[24] and placed on the south side of the Ponte Vecchio, on the site of an equestrian statue which had been mentioned by Dante and subsequently swept away in a flood[25]—a legend that later caused much confusion.[26] Either from the first or perhaps only later it served as part of a fountain.[27] It was apparently taken away to be repaired in 1798[28] and it is not mentioned in early nineteenth-century descriptions of Florence,[29] though in an illustration published in 1802 it is shown in a restorer's studio.[30] In 1838 it was installed in the Loggia dei Lanzi (where it had been proposed to move it as early as 1763)[31] after having undergone another restoration at the hands of Stefano Ricci.[32]

The account given above of the version of *Pasquino* in Rome will have made clear that the precise subject was still a matter of controversy when, some time after 1620, Tacca and Salvetti began their restoration of this rather more complete group from the Porta Portese which Cosimo I had had sent to Florence fifty years earlier. Their solution (which can be seen in a plaster cast in Dresden[33] and in a plate published by de Rossi)[34] was to convert the trunk into a very generalised group of a grief-stricken old warrior supporting a dead or dying nude youth whose left arm hangs limply down to the rocky base. It was just these features, all of them the work of the restorers and evidently derived from the imagery of a Descent from the Cross, which particularly appealed to most visitors to Florence, and Cochin was exceptional in commenting on the modernity of the group which he attributed to Tacca's master Giambologna[35]—although there was also a tradition that Michelangelo had carved the statue. This was recorded by Burney who thought that the group showed Alexander with Clitus dying in his arms.[36] The older 'Roman' theories about the identity of the figure still held their ground, but the learned increasingly insisted that the statue showed Ajax, either supporting Patroclus or himself being supported by a soldier.[37] The bronze statuettes supplied by Righetti were called simply 'l'Ajax de Florence',[38] and Vincenzo Pacetti neatly avoided the issue altogether when in his prize-winning entry of 1773 for the Concorso Balestra

he produced a terracotta variant which changed the sex of the younger figure, naming the group Achilles and Penthelisea.[39] He gave the Achilles a head copied from the *Dying Alexander*.

The general impression produced by the statue itself is made clear by Montesquieu who described it merely as a soldier carrying the body of his dead comrade and who was deeply moved by its expressiveness,[40] as were many other travellers most of whom shared his assumption that it was antique and unrestored—a view held also by the French commissioners who, in 1799, thought seriously of seizing the statue for Paris: 'if political reasons stand in the way of its removal, at least a very exact mould should be taken from it'.[41] Its impact survived well into the nineteenth century, long after Stefano Ricci's more 'purist' reconstruction had removed some of its pathos. In 1847, when some Florentine guidebooks were still claiming that the group was 'believed to be the work of a Greek chisel' and giving no hint of any restoration,[42] an English traveller wrote that 'one group is here worth walking all the way from Turin to look at, but it is antique . . . It seems to me that no chisels have ever come up to the Greek in depicting tenderness.'[43] A reduced version in silver was made by Vincenzo II Belli for the fifth Earl of Jersey between 1828 and 1848,[44] but the most memorable record of the poignant responses evoked by the group is to be found in the drawing by Menzel (Fig. 68), made during the tense year of 1848, of the store-room of the cast gallery in Berlin, in which the 'soldier carrying the body of his dead comrade' stands out in the centre foreground, prominent among a generalised group of anonymous antiquities.[45] And in the 1860s a place of honour was projected for a cast of the group in the Griechischer Kuppelsaal of Berlin's new museum.[46]

3. Vacca wrote in 1594 or earlier that in 1570 Cosimo I, Grand Duke of Tuscany, had bought in Rome a second version of *Pasquino* from Paolo Antonio Soderini and that this had been discovered at the mausoleum of Augustus. This too is recorded in the inventory drawn up on Cosimo's death in 1574,[47] and by 1677 it was certainly in the principal courtyard of the Palazzo Pitti where it formed a pair with the *Hercules and Antaeus*.[48] In the 1830s this too was given a new restoration by Stefano Ricci, and it was taken to another courtyard of the palace (adjoining the Sala degli Argenti) where it now remains.[49]

155. *Pasquino* (Palazzo Pitti—Cortile dell'Ajace, Florence).

The appearance of this group before the nine-teenth century is recorded in rare drawings and engravings.[50] From these, and from various pieces of circumstantial evidence, it seems almost certain that its resuscitation in Florence was carried out well before Tacca set to work on the group that was placed beside the Ponte Vecchio. The restorer may have been Giovanni Caccini who died in 1612.[51] But though there are considerable differences in the reconstruction of the two groups—notably the upright legs of the youth and the helmet placed under the foot of the warrior in the Pitti version—there are also striking similarities: above all, the hanging arm. In general, travellers agreed that the statue in the Pitti courtyard was 'not a copy, but an imitation' of the version near the Ponte Vecchio, and that it was much inferior to it.[52] In 1824 even a Florence guidebook was prepared to concede that it 'must once have been admirable but . . . is now in a bad state thanks to the many restorations it has undergone'.[53] After it was removed from its prominent position and re-placed by a Hercules leaning on his club it was virtually forgotten.

In 1788 Visconti discussed the three versions together and, drawing on the evidence of some fragments recently discovered in Hadrian's Villa and taken to the Museo Pio-Clementino, he argued persuasively that the theme of the *Pasquino* statues was Menelaos holding up the body of Patroclus after he had been fatally wounded by Hector—the figures corresponded exactly to those in Homer's detailed description in Books XVI and XVII of the *Iliad*.[54] And, although in the nineteenth century the statues continued to be given a variety of names, Visconti's theory has been accepted by most modern scholars (by now able to study the fragments of nine different versions),[55] who believe that all three groups are replicas of a Pergamene original dating from between 240 and 230 B.C.[56]

1. Vacca, Mems. 29, 97; Bocchi (ed. Cinelli), p. 116.
2. Cancellieri, 1789, p. 27.
3. Govi, pp. 40, 52 (stanza 111).
4. Lanciani, 1902–12, I, p. 106; Pietrangeli, 1958 (*Palazzo Braschi*), p. 10.
5. Gnoli, pp. 164–84, 300–8.
6. *Ibid.*, pp. 152–3.
7. De Blainville, II, pp. 411–12.
8. *The Times*, 16 January 1870—quoted in Hare, 1887, II, p. 200.
9. Ferrucci in Fulvio (ed. Ferrucci), fol. 315v; Gnoli, pp. 302, 307.
10. Govi, pp. 52 (stanza 111), 64.
11. Du Bellay, *Les Regrets*, CVIII (edition of Marcel Hervier, 1954).

12. Cavalleriis (1), plate 52—taken from Lafreri (British Museum copy), fol. 62.
13. Stone, p. 176.
14. Boissard, p. 34.
15. Scoto, II, fol. 50v.
16. Ferrucci in Fulvio (ed. Ferrucci), fol. 315r.
17. Winckelmann, 1767, II, p. 82.
18. Visconti in [Cancellieri], 1789, pp. 27–30.
19. Aldrovandi, 1556, p. 312.
20. Du Mont, I, p. 263.
21. Felini, p. 341; Totti, p. 235.
22. Baldinucci, V, pp. 663–4; Bernino, pp. 13–14; Perrault, pp. 103–4; Lalande, IV, p. 74; Chantelou, p. 26.
23. Vacca, Mem. 97; Cristofani, 1980, p. 22.
24. Baldinucci, IV, pp. 90–1.
25. Bocchi (ed. Cinelli), p. 115.
26. Schweitzer, p. 2.
27. Burney, p. 104.
28. Starke, 1800, I, pp. 297–8 (note to a letter of March 1798).
29. *Guida della Città di Firenze*, 1822; *Guide de la Ville de Florence*, 1824.
30. Carradori, plate XIII.
31. Walpole (*Correspondence*), XXII, pp. 123–4 (Mann to Walpole, 26 March 1763).
32. Fantozzi, pp. 34–5.
33. Schweitzer, fig. 26.
34. Maffei, plate XLII.
35. Cochin, II, p. 56.
36. Burney, p. 104.
37. Bocchi (ed. Cinelli), p. 115; Maffei, plate XLII.
38. Righetti (see Appendix).
39. Honour, 1960, pp. 174–5, plate 1.
40. Montesquieu, II, p. 1354 (*Voyage d'Italie*); cf. Mariette, II, p. 114.
41. Boyer, 1970, p. 82.
42. Formigli, p. 181.
43. Francis, pp. 18–19.
44. Bulgari, I, p. 1; II, p. 620; Honour, 1971, p. 200.
45. Ladendorf, fig. 102; *Berlin und die Antike*, p. 96.
46. *Berlin und die Antike*, pp. 97–8.
47. Vacca, Mem. 97; Cristofani, 1980, p. 22.
48. Bocchi (ed. Cinelli), p. 116.
49. Mandowsky, 1946, p. 118.
50. Chiari, II, plate I; Mandowsky, 1946, pp. 116–18.
51. Mandowsky, 1946, p. 117.
52. Montesquieu, II, p. 1354 (*Voyage d'Italie*); Gray, T. (ed. Tovey), p. 217 (1740).
53. *Guide de la Ville de Florence*, 1824, p. 370.
54. Visconti in [Cancellieri], 1789, pp. 27–30.
55. Schweitzer, pp. 1–6; but see Capecchi, pp. 175–7.
56. Pietrangeli, 1958 (*Palazzo Braschi*), p. 10, note 5; Capecchi, pp. 175–7.

73. Pompey (Fig. 156)

ROME, PALAZZO SPADA

Marble
Height: 3.45 m
Also known as: Augustus, Julius Caesar, Domitian, Trajan

The statue is referred to, in a legal document of 1560, as 'statuam marmoream magnam' in the great hall of the Palazzo Capodiferro (later Mignanelli and, as from 1632, Spada) in Rome.[1] According to Vacca, writing in 1594 or earlier, it was given to Cardinal Capodiferro by Pope Julius III (i.e. between 1550 and 1555).[2] It remained in the Palazzo Spada until 1798 when it

156. *Pompey* (Palazzo Spada, Rome).

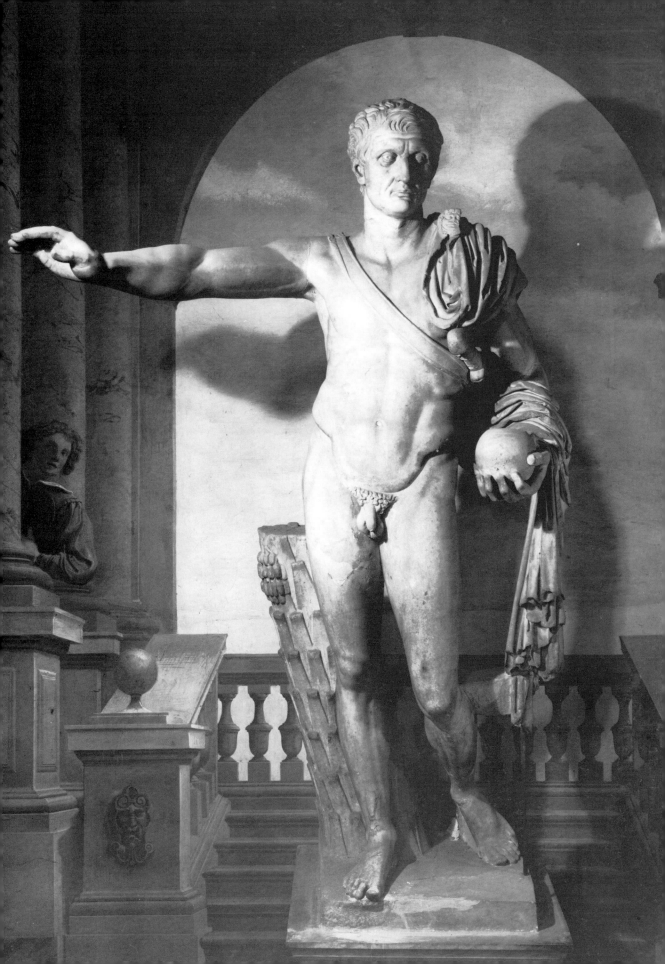

was taken, with the *Wolf* from the Capitol, to the Teatro Apollo (formerly Tordinona) to serve as a prop for a performance there on 22 September of Voltaire's *La Mort de César*,[3] after which it was returned to the palace.

For some two centuries this was among the most famous statues in Rome, but there is also a good deal of evidence to show that many others shared the response of Mrs. Jameson who was 'pleased to find contrary to my expectations, that this statue has great intrinsic merit, besides its celebrity, to recommend it'.[4] However, although a cast of the head is surprisingly listed among those in the Royal Academy in 1781,[5] the reason why 'cultivated and sensitive spirits spend longer in front of this statue than in front of the Apollo Belvedere, the Hercules of Glycon and the Gladiator of Agasias'[6] was that it was widely believed to be not just the only surviving large-scale representation of Pompey but also the 'very Statue at the foot of which Julius Caesar fell'.[7] This last theory, which soon hardened into dogma, seems not to have originated until the second decade of the eighteenth century, but a summary of the fortunes of the *Pompey* in general can give a most revealing insight into many of the themes discussed elsewhere in our book.

The first engraving of the figure in 1584 described it as Trajan,[8] but thereafter it was called Julius Caesar.[9] In 1658 the third edition of a standard guidebook to Rome referred to it as Pompey (for the first time in print),[10] and henceforward this denomination remained at the centre of all discussions of the statue. The author of the guidebook had had access to the unpublished memoirs (completed in 1594) of the sculptor Flaminio Vacca, and Vacca's picturesque account of the discovery of the statue[11] was, two and a half centuries later, to be scrutinised with the sort of attention more usually associated with the higher criticism of the Bible. The *Pompey* (no reason was given for the name) had, he said, been found under a cellar in the Via de' Leutari near the Palazzo della Cancelleria; a party wall ran directly above the neck of the colossal figure, and as the two neighbours could not agree as to who should keep it (the body was larger, but the head more important), a judge decided that it should be beheaded and each should take the share found on his property. Cardinal Capodiferro, hearing of this decision, told Julius III who was outraged. The Pope sent the neighbours five hundred scudi to be divided between them, ordered the statue to be carefully excavated and gave it to the Cardinal to whose palace it was taken.

The statue had probably been called Pompey because Pompey's theatre was in the area, and when Vacca's manuscripts became more widely available[12] and eventually published,[13] his story was repeated to tourists and his attribution won general acceptance, as did the later gloss that this was the statue at whose feet Caesar had fallen assassinated. Winckelmann had doubts (the nudity was surprising for a statue of the Roman Republic, even though Pompey's portrait on the rare medals to be found was similar to the head of the Spada sculpture), but he expressed them with uncharacteristic caution.[14] Gibbon was not wholly convinced and thought the figure more likely to be that of an emperor.[15] And some other travellers and antiquarians remained sceptical.[16] But Giambattista Visconti who persuaded Pope Pius VI to try to buy it for the rotonda of the new Museo Pio-Clementino[17]— the offer was rejected as not big enough—and, above all, his son and successor in charge of the papal collections, Ennio Quirino Visconti, were quite certain of its authenticity.[18] In 1793 Visconti acted as adviser to Vincenzo Camuccini who had been commissioned by Lord Bristol to paint a vast picture of the 'Death of Caesar' (now in the Museo di Capodimonte, Naples) in which this statue was directly reproduced to give verisimilitude to the scene;[19] and as a Consul of the Roman Republic Visconti must have been involved in the extraordinary events of 22 September 1798 when, together with the Capitoline *Wolf*, *Pompey* was taken to the stage of the Teatro Apollo for a performance of Voltaire's *La Mort de César*.[20]

However, this association with the 'modern assassins of Caesar', as Kotzebue tartly called them,[21] marked the climax of the statue's reputation. It could now be investigated carefully for the first time and, in the presence of a group of interested artists, the sculptor Angelo Malatesta removed the head, examined the wooden join inside, and suggested that the head did not belong to the body.[22] His opinion soon became known, and severely damaged the validity of the statue's main claim to fame.[23] Despite this, in the next decade, Napoleon himself, who made no secret of his interest in anything that had to do with Caesar, made a series of attempts to buy the *Pompey* from the Spada family whose Francophile sympathies did not, however, deter them from asking an exorbitant price. Napoleon's

advisers were divided: Visconti remained convinced of the statue's authenticity, Denon's interest rapidly waned, and Canova (possibly stimulated by his desire to keep the statue in Italy) repeated the evidence that the head and body did not belong together.[24] It was in these circumstances, and perhaps inspired by them, that in 1812 and 1813 there took place one of the most intense of all antiquarian controversies about this or any other statue.

The debate (which began with icy courtesy and degenerated into bitter insult) between the two most prominent antiquarians in Rome, Carlo Fea who challenged and Giuseppe Antonio Guattani who defended the traditional attribution, centered on a number of issues, some basic to later archaeological studies, some more trivial.[25] There was the question of Vacca's veracity: if a foolish judge had indeed ordered the *Pompey* to be beheaded, then the statue must actually have been found intact. True, there were evident signs that the head had at some stage been clumsily joined to the body, but this could only have been to repair a later break, dating from after Vacca's notes. And, in any case, why replace an authentic with a false head? The marble was the same in both body and head, and if there was no longer any sign on the head of the garland which the fillets still visible on the shoulders demonstrated must once have existed, this could only be because some brutal restorer had made a bad job of it. If the head was too big for the body, that was for reasons of symbolism—and, besides, Pompey was known to have had a lot of brains. If the carving of the pubic hair was quite different in technique from that on the head, that was because of the different states of preservation of these two parts of the statue. If a nude statue was unusual, so too had been Pompey's importance and vanity, and in any case nudity did not shock people in ancient Rome as it did now. The Via de' Leutari, where the statue had been found, was a very long street and could as easily have extended to Pompey's theatre as to the series of artists' studios which had recently been excavated there—and it was to that theatre that Augustus had had the statue removed from the Curia after the death of Caesar.

With such arguments did Guattani fight back as the battle raged, with each author recruiting artists and poets, scientists and antiquarians to help his cause.[26] Fea (who thought that the head was a battered Trajan and the body a Domitian) ended his first intervention with an eloquent appeal to the noble traditions of archaeology, which must always put the truth first, even when this was painful, as had been Mengs's opinions about the status of the *Niobe Group* or the *Apollo Belvedere* itself.

That the controversy damaged the statue's reputation is obvious: nonetheless, the most characteristic response to its repercussions probably remains that of Charles Greville writing on 4 April 1830. After freely acknowledging that 'people doubt this statue' and adding further doubts of his own, he continues, without the slightest awareness of any contradiction: 'It is impossible for the coldest imagination to look at this statue without interest, for it calls up a host of recollections and associations, standing before you unchanged from the hour when Caesar folded his robe round him and "consented to death" at its base. Those who cannot feel this had better not come to Rome.'[27] But although the authenticity of the *Pompey* continued to be asserted, often by authoritative scholars,[28] until almost the end of the nineteenth century, it is significant that in 1857 Gérôme, no less meticulous than Camuccini as a painter of history, had his Caesar fall to his death at the feet of a quite different statue of Pompey (Walters Art Gallery, Baltimore).

Faccenna claims that the statue is a heavily restored Imperial piece (deriving from a Doryphoros type) of indifferent quality, dating from between the end of the first and the beginning of the second century A.D., and that the head is a sixteenth-century copy (possibly by Vacca himself!) of the Menander–Virgil type.[29]

1. Neppi, pp. 56, note 258.
2. Vacca, Mem. 57.
3. Sala, II, p. 169.
4. [Jameson], p. 208. Maffei, plate CXXVII, called it 'bella'; Gray, T. (ed. Mitford), IV, p. 227, wrote in 1740 that it was 'in a great taste'.
5. Baretti, pp. 13–14.
6. [Guattani] in *Monumenti antichi inediti . . . per l'anno MDCCCV*, Roma 1805, pp. clxxv–clxxvi.
7. Richardson, 1722, p. 191.
8. Vaccaria, plate 74.
9. Cavalleriis (3), plate 89.
10. Martinelli, 1658, pp. 66–9; see also Faccenna, p. 193.
11. Vacca, Mem. 57.
12. Montaiglon (*Correspondance*), I, p. 371 (1693).
13. Montfaucon, 1702.
14. Winckelmann (ed. Fea), II, pp. 321–2.
15. Gibbon, p. 251.
16. Lalande, IV, pp. 115–16, reports an opinion that it was Augustus.
17. Guattani, 1813, p. 28; Pope Benedict XIV had also wanted to buy the statue—Boyer, 1970, p. 213.
18. Visconti (*Iconografia Romana*), I, pp. 153–60.
19. Hiesinger ('Camuccini'), p. 299. The painting in Naples is Camuccini's second version (eventually completed in

1818), as dissatisfaction with its colouring led him to destroy the first.

20. Sala, II, p. 169.
21. Kotzebue, III, pp. 192–3.
22. Fea, 1813, p. 33.
23. Dalmazzoni, pp. 249–50.
24. Boyer, 1970, pp. 211–17.
25. Fea, 1812; Fea, 1813; Guattani, 1813.
26. Guattani, 1813, pp. 46–7, and the literature listed pp. 49–54.
27. Greville, I, p. 412.
28. See the references in Faccenna.
29. Faccenna; Neppi, p. 56, note.

74. Pudicity (Fig. 157)

ROME, MUSEI VATICANI (BRACCIO NUOVO)
Marble

Height: 2.09 m

Also known as: Faustina, Livia, Livia Mattei, Livia as Melpomene, Melpomene, Sabina, Sabina as Juno Matrona

The *Pudicity* was published in an anthology of prints published by Domenico de Rossi in 1704.[1] It was then in the Villa Mattei. Together with the other antiquities in this collection, it is likely to have been discovered on the family's Roman estates in the last third of the sixteenth century. An inventory of the collection was made in 1614 in accordance with Ciriaco Mattei's will of 16 July 1610 and this includes several statues of 'Empresses'.[2] Ciriaco forbade his heirs to alienate any of the contents of the family villa on the Celio ('daily visited and praised by foreigners as well as Romans'), but his *fidecommisso* was overruled by Pope Clement XIV and this statue, together with the other highly valued pieces in the collection, was sold to the Pope by Don Giuseppe Mattei in September 1770.[3] By 1774 it was placed in the Museo Pio-Clementino but it was moved to the Braccio Nuovo in the mid-nineteenth century.[4]

None of the statues in the Villa Mattei which could be identified with the *Pudicity* seems to have been singled out for special praise in early seventeenth-century accounts of the collection,[5] but in the eighteenth century, it became perhaps the most celebrated of all Roman female portraits. De Brosses, although he hastened to remark on some less pudic statues in the garden 'qui pissent des fontaines par d' incroyables vagins', drew special attention to 'la belle *Livia Augusti*, autrement nommée *Pudicitia*'.[6] Misson, or at least the editor of the fifth edition of his *Voyage d'Italie*, had by then declared the face of the Mattei Faustina to be the finest he 'ever saw upon

a statue'[7] and the Richardsons had judged it one of the 'finest Figures in Rome', and compared it with the *Venus de' Medici*.[8] Northall recorded that some thought it the 'finest antique statue in all Italy'.[9]

By the middle of the eighteenth century, the statue was generally held to represent Livia, the wife of Augustus, but it was also known as Pudicity or Pudicitia.[10] On account of the veil worn by Livia on the reverse of well-known Roman coins, numerous sculptures of veiled women were considered to represent her.[11] And at least one other well-known statue was also described as Pudicity—the mourning figure sometimes known as 'La Pleureuse' placed on the staircase of the Capitoline Museum.[12] Further confusion can be caused by the Capitoline statue being sometimes identified as a portrait of Faustina the younger,[13] wife of Marcus Aurelius, with whom the Mattei *Pudicity* was sometimes identified.[14] To complicate matters, the *Pudicity* was considered, later, to represent the elder Faustina, the wife of Antoninus Pius.[15] Yet another distinguished possibility was felt to be Trajan's niece, Hadrian's wife, Sabina[16]—but dressed, according to one commentator, 'exactly like the Juno Matrona'.[17]

Winckelmann referred to the statue as the Livia 'so praised in the literature' which may suggest that he did not share this esteem. He made no negative criticism, however, and merely proposed that she was represented as Melpomene, the Tragic Muse, on account of her solemn air and high shoes.[18] Visconti believed that either Melpomene or Pudicity might have been meant, but was not sure that it was a portrait at all, for the head, he pointed out, was modern. He admired the drapery but felt that the statue, perhaps as a result of restorations, was awkwardly narrow in the shoulders.[19]

Despite the statue's fame, it does not seem to have been much copied, perhaps because it was considered as a portrait. Horace Walpole, however, had a copy carved by Filippo della Valle in 1740–1 which he erected in 1754 in Westminster Abbey as a monument to his mother, who, like Livia, Sabina and both Faustinas, had been the consort of a great stateman.[20] By the end of the nineteenth century, scholars had realised that the draperies and attitude of this statue originated in sepulchral sculptures in Asia Minor in the second century B.C.[21]—so Walpole's idea was perhaps more judicious than he realised.

The *Pudicity* is catalogued in Helbig as a portrait of the late first century A.D.[22]

1. Maffei, plate CVII.
2. Lanciani, 1902–12, III, pp. 83–6 (will), 87 (for probable place of discovery), 89, 91, 92, 94 (Empresses).
3. Hautecoeur, p. 71 (as Melpomene).
4. Amelung, 1903–8, I, pp. 36–7.
5. E.g. Totti, pp. 437–8.
6. De Brosses, II, p. 185.
7. Misson, 1731, III, p. 259.
8. Richardson, 1722, pp. 132–5, 177–8.
9. Northall, p. 359.
10. E.g. De Brosses, II, p. 185; Ficoroni, 1744 (*Singolarità*), p. 69.
11. Visconti (*Monumenti Borghesiani*), plate XXII, no. 1.
12. Stuart Jones, 1912, pp. 82–3.
13. De Blainville, II, p. 478; Maffei, plate XVII.
14. Richardson, 1722, pp. 133–5.
15. Venuti, R., 1779, I, pp. 56–8, plate LXII.
16. Maffei, plate CVII; Montfaucon, 1719, III, i, p. 39.
17. Spence, p. 55, plate III (fig. 1).
18. Winckelmann (ed. Fea), II, p. 329.
19. Visconti (*Pio-Clementino*), II, plate XIV.
20. Honour, 1959, pp. 177–8.
21. Amelung, 1903–8, I, pp. 35–6.
22. Helbig, 1963–72, I, pp. 321–2.

75. Della Valle Satyrs (Figs. 158–9)

ROME, MUSEI CAPITOLINI

Marble
Height: 2.83 m

These statues are recorded as belonging to a member of the della Valle family by 'Prospettivo Milanese' writing in about 1499–1500,[1] but they were certainly known before then because they are illustrated in drawings which can (on grounds of style) be dated to a generation or so earlier.[2] They remained in one of the della Valle palaces (where from the 1530s, and perhaps earlier, they were attached to two pilasters supporting a loggia in the courtyard—Fig. 6)[3] until at least 1704.[4] In 1733 they were included in an inventory of Cardinal Albani's sculptures sold to Pope Clement XII.[5] They were supplied with arms before being taken to the courtyard of the Capitoline Museum and placed on either side of *Marforio*.[6]

The extraordinary fame enjoyed by these figures in the first half of the sixteenth century is shown by the exceptionally large numbers of surviving drawings which record them.[7] In 1513 they were among a number of antique sculptures inserted into the triumphal arch erected by the della Valle family in honour of Leo X's accession to the Papacy and they were then described as 'ancient statues of the greatest beauty that can possibly be stated'—higher praise than that given to any of

157. *Pudicity* (Vatican Museum).

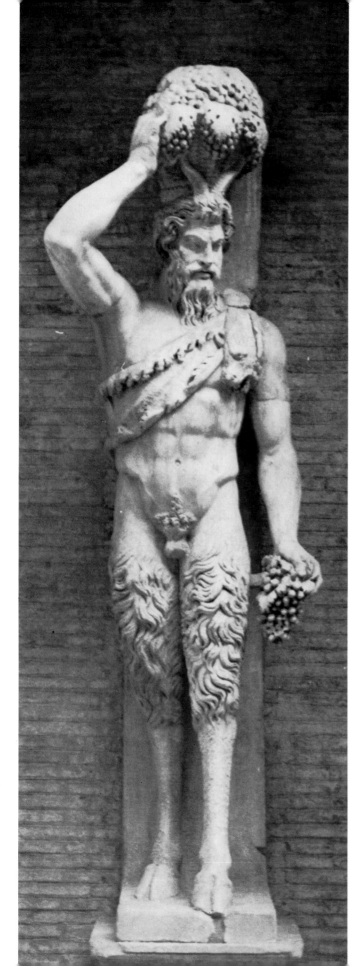

the other figures exhibited.[8] In 1540 they were cast in bronze for François Ier (these casts were destroyed in 1792 and have recently been replaced by new ones), but at Fontainebleau they were used by Philibert Delorme to support a mantelpiece in the Salle de Bal and were not displayed with the other copies of antique statuary.[9] The fact that they were a matching pair made them very suitable to act in this way, and sixteenth-century commentators on Vitruvius pointed out that, like the *Farnese Captives*, they too must have served this purpose in Roman times.[10] Indeed, by the end of the eighteenth century their fame had come very largely to depend on the light that they could throw on ancient architecture.[11]

The *Satyrs* were illustrated in the standard anthologies of ancient sculpture and often picked out for special praise. Thus in 1704 Maffei wrote that 'people who understand art have recognised in them the utmost perfection of craftsmanship'.[12] It is not, however, until the early nineteenth century that we first find the theory according to which they gave their name to the Piazza dei Satiri, near the theatre of Pompey, where it was said (without any evidence) that they had been found.[13]

The *Satyrs* were reproduced in small bronzes—in an imaginatively restored form—in the sixteenth century[14] and possibly later,[15] though neither Zoffoli nor Righetti offered examples of them. They were not copied in marble for Louis XIV, but in 1754 Matthew Brettingham had moulds taken of at least one of them.[16]

The *Satyrs* are catalogued in Helbig as decorative work of the second century A.D. made for the rebuilding of Pompey's theatre.[17]

1. Govi, p. 49 (stanza 15).
2. Michaelis, 1891–2, ii, p. 237.
3. Hülsen and Egger (Text), II, pp. 15–16; (Tafeln), II, fol. 20r.
4. Maffei, plate CXL.
5. Stuart Jones, 1912, p. 396 (no. 2).
6. [Bottari], plate XXXV and frontispiece before plate I.
7. Vermeule, 1956 ('Dal Pozzo-Albani'), p. 44, note 67; Pressouyre, 1969 ('Fontes'), p. 237, note 3; Bober, pp. 74–5.
8. Cancellieri, 1802, pp. 78–9.
9. Pressouyre, 1969 ('Fontes'), pp. 237–9.
10. Vitruvius, 1586, p. 9; Rusconi, p. 5.
11. [Roisecco], 1745, II, p. 264; Lalande, IV, p. 176.
12. Maffei, plate CXL.
13. Hülsen and Egger (Text), II, p. 16.
14. Weihrauch, p. 176, fig. 213.
15. Lalande, II, p. 193, for possible reference to copies in Florence.
16. Brettingham MS., pp. 82, 130, 145.
17. Helbig, 1963–72, II, pp. 40–1.

158–9. *Della Valle Satyrs* (Capitoline Museum—courtyard).

76. Dying Seneca (Figs. 160–1)

PARIS, LOUVRE

Blackish brown marble (bigio morato) with
 enamelled eyes, and belt of antique alabaster
Height (with vase): 1.184 m
Also known as: The Fisherman, The Slave

The *Seneca* is recorded in Francucci's poem on
the Borghese collection of 1613[1] and by 1625 it
was certainly in the Villa Borghese.[2] It is prob-
able that this is the 'Seneca di marmo nero'
which Vacca, writing in 1594 or before, re-
membered as having been found with other
fragments on an estate between S. Matteo and S.
Giuliano in Rome.[3] The statue was purchased on
27 September 1807, together with the bulk of the
Borghese sculpture collection, by Napoleon
Bonaparte, brother-in-law of Prince Camillo
Borghese,[4] and was transported from Rome
between 1808 and 1811.[5] It was recorded in the
Louvre by Mrs. Starke who visited it in the
spring of 1817[6] and was catalogued as on display
there in 1820.[7]

The *Seneca* was much restored (the arms, the belt
and one thigh were added) and was placed on a
vase of africano marble, unhollowed so that it
seemed full of water, and reddened in imitation
of blood. The intention was to portray Seneca
committing suicide in a bath, his limbs weaken-
ing as the blood drains out of his cut veins. The
idea was presumably inspired by the similarity of
the head with the type of portrait bust (Fig. 28)
which Fulvio Orsini identified as Seneca because
it resembled an inscribed portrait on a con-
torniate (now lost). Although this identification
was only published in 1598[8] (when a bust of
Seneca was also recorded in an inventory[9]) it was
likely to have been current at an earlier date and
Vacca had probably described this statue as a
Seneca four years earlier.[10] The Borghese statue
was drawn in its restored state by Rubens
probably in 1608, and his painting of the 'Death
of Seneca' of not much later (Alte Pinakothek,
Munich) was closely based on the antique pro-
totype, as was Sandrart's painting of the subject
in the following generation:[11] in both the
modern vase was reverently introduced like the
attribute of a Christian martyr. If our sculptors,
wrote the Abbé Raguenet in 1700—oblivious to
the large contribution modern sculptors had
indeed made to the statue—'If our sculptors
knew how to make a comparably expressive
CHRIST it could be depended on to bring tears to
all Christian eyes, for the expression alone of this

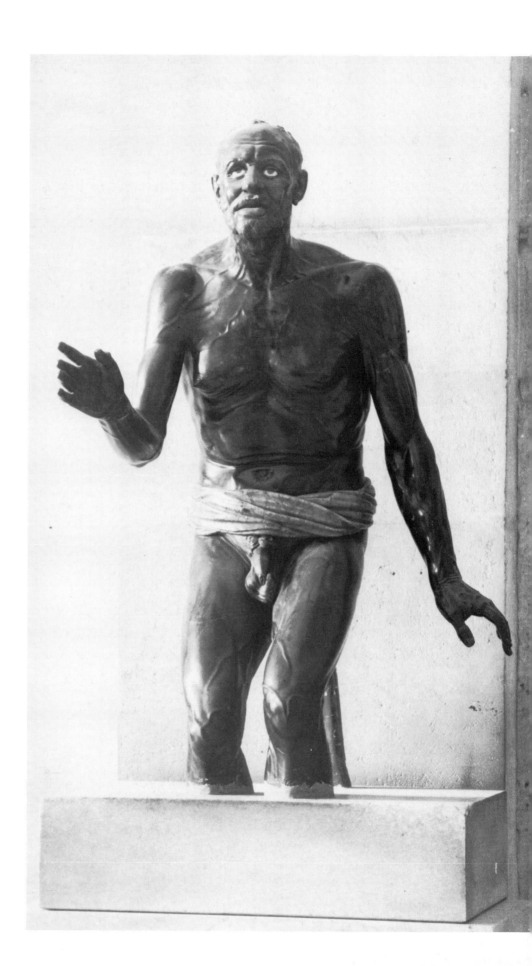

160. *Dying Seneca*
(Louvre).

dying pagan excites sorrow in all who see him.'[12]

Although there were many prints of the statue (Fig. 12) it does not seem to have been copied—at least on a large scale (an intaglio of the subject was offered for sale by Wedgwood)[13]—and it was obviously no more suitable than a decapitated saint as an ornament for the dining room or pleasure garden, at least in the eighteenth century. As the Richardsons observed, 'His Air is savage and very Disagreeable; so that if this statue has any Fault, I think it is that he seems to be a Criminal that has been long kept in a Dungeon before his Execution; for his Hair is all neglected and nasty.'[14] De Brosses also found the figure distasteful.[15] But Lalande later in the century, still considered it to be a masterpiece and remarked, typically, on how edifying it was to witness the death of the virtuous,[16] and Burney in 1770 thought it 'wonderfully fine', although too young to be the dying philosopher.[17] For Herder, writing in the previous year, it was 'the false Seneca',[18] but then he, unlike Burney, had read Winckelmann's *Monumenti antichi inediti* of 1767.

Winckelmann pointed to the similarity between the Borghese statue and several similar figures in Roman collections (two in the Villa Albani and one in the Pamfili collection which was acquired for the Museo Pio-Clementino). These were all of old men holding baskets or pails and were, he proposed, meant as slaves from ancient comedies.[19] Some people wished to associate them with slaves who served at the Roman Baths, but Visconti, accepting the theory in general, believed them to be the old fishermen who featured in Greek comedy and in the *Rudens* of Plautus,[20] and this has remained the usual interpretation ever since. By 1800 it seemed obvious that 'the abject expression of the face, and the stiff inclination of the body' were 'fitter for the wash-tub than for the solemn act of libation to Jove', and if there was some resemblance with the busts of Seneca then, the Scottish traveller Joseph Forsyth continued breezily, 'these busts are all anonymous, authenticated by no model, and as questionable as the genius and virtue of Seneca himself'.[21] No one seems to have clung to the old idea and it is surprising that the figure was not separated from the vase until after 1896,[22] even though the guidebooks to the Villa Borghese and some of the statue's keenest admirers had not only admitted that this accessory was modern[23] but disliked it.[24] The startling change of identity led to a corresponding decline of interest and even Mrs. Starke awarded it only one exclamation mark.[25] Moreover, sensational polychrome realism was never less appreciated than in the early nineteenth century and in the Louvre catalogue of 1820 sculptors were warned not to imitate the statue.[26]

The *Seneca* is considered by Bieber to be a Roman copy of an original Hellenistic statue of a fisherman.[27]

1. Francucci, stanzas 428–30.
2. Crulli de Marcucci, fol 50v.
3. Vacca, Mem. 85.
4. Boyer, 1970, p. 202.
5. Arrizoli-Clémentel, pp. 13–14, note 60.
6. Starke, 1820, p. 16 (letter of 1817).
7. Clarac, 1820, pp. 232–3.
8. Gallaeus, no. 131.
9. Boyer, 1929, p. 260, no. 5.
10. Vacca, Mem. 85.
11. Staatliche Museen, Berlin (destroyed 1945)—Klemm, figs. 2, 3.
12. Raguenet, pp. 44–5.
13. Wedgwood, 1779, class I, section II, no. 180.
14. Richardson, 1722, pp. 296–7.
15. De Brosses, II, p. 37.
16. Lalande, III, pp. 479–80.
17. Burney, p. 207.
18. Herder, VIII, p. 92.
19. Winckelmann, 1767, II, p. 256.
20. Herbert, Lord, pp. 276–7; Winckelmann (ed. Fea), I, p. 139, note; II, p. 352; Visconti (*Pio-Clementino*), III, plate XXXII.
21. Forsyth, p. 239.
22. Villefosse, p. 79. The removal had taken place by 1922—Villefosse and Michon, pp. 75, 77.
23. Manilli, p. 62; Montelatici, pp. 254–5.
24. Lalande, III, pp. 479–80.
25. Starke, 1820, p. 16.
26. Clarac, 1820, p. 233.
27. Bieber, p. 142.

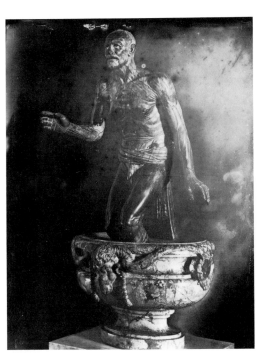

161. *Dying Seneca* photographed before removal of vase.

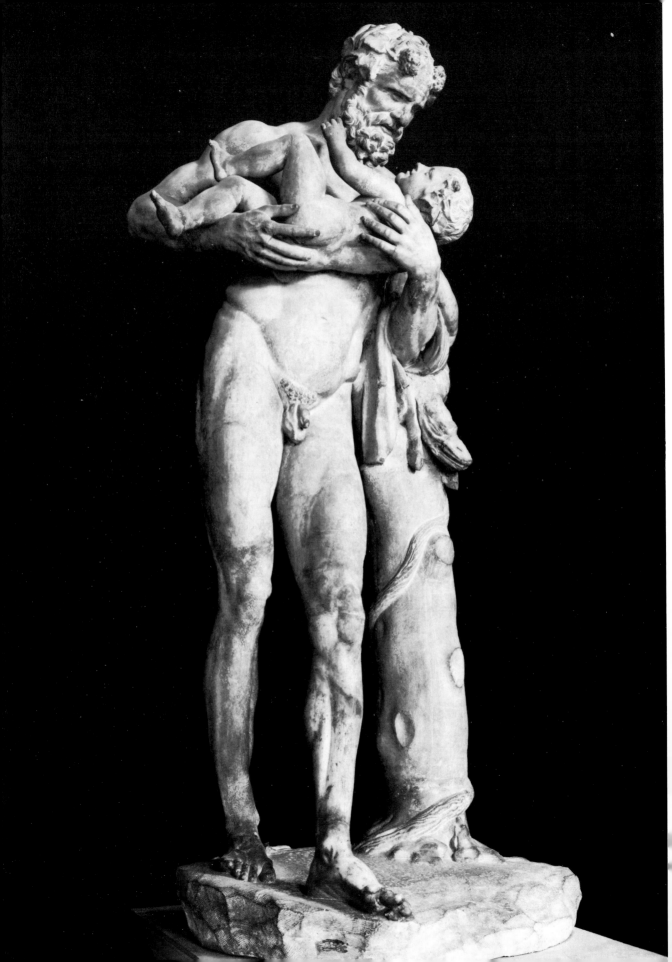

77. Silenus with the Infant Bacchus

(Fig. 162)

PARIS, LOUVRE

Marble

Height: 1.90 m

Also known as: Acrasius nursing Bacchus, Faun with the infant Bacchus, Borghese Faun, Saturn, Silenus.

An engraving published in 1594 states that this statue was in the collection of Carlo Muti who, according to Flaminio Vacca, writing in the same year or earlier, had discovered it together with the *Borghese Vase* at his estate near the present Casino Massimo, part of the site of the gardens of Sallust[1]—this must have been before 18 September 1569 when Cardinal Ferdinando de' Medici wrote to Carlo Muti thanking him for permission to have his Faun moulded.[2] The statue is described by Francucci as in the Borghese collection in 1613;[3] it was in the Villa Borghese by 1638,[4] and by 1650 was in a room there named after it.[5] The *Silenus* was purchased on 27 September 1807,[6] together with the bulk of the Borghese antiquities, by Napoleon Bonaparte, brother-in-law of Prince Camillo Borghese. It was sent from Rome between 1808 and 1811[7] and was recorded in the latter year in the Salle d'Apollon in the Musée Napoléon.[8] By 1815 it was in a room named after it.[9]

In the early seventeenth century the statue was sometimes melodramatically interpreted as showing Saturn (with 'horrid hair and shady brow') holding in his arms a baby who smiles in poignant ignorance that he is about to be devoured;[10] and this interpretation was still current *volgarmente* in the late eighteenth and even early nineteenth centuries.[11] But the statue was generally described as a Faun holding a child, the Faun frequently considered as Silenus and the child as Bacchus. Brigentius (perhaps tongue-in-cheek) deplored the child's contact with a drunkard (Heu puer infelix!) but such moralising was unusual.[12]

The *Silenus* was one of the most consistently admired antique statues in Rome both for the quality of the design and the charming (or to some alarming) sentiment. It was classed on occasions with the *Venus de' Medici*, the *Farnese Hercules* and the *Antinous*,[13] and it was frequently reproduced. A full-size bronze copy of superb quality, with the tree trunk embellished by a far more complex vine than in the original, was cast in the 1570s for Cardinal Ferdinando de' Medici who planned to adapt it as a fountain.[14] It was admired in subsequent centuries together with a bronze Mars (also known as Coriolanus) in the loggia of the Villa Medici (Fig. 14);[15] these were moved to Florence in 1787[16] and are now on the grand staircase of the Uffizi. A plaster cast of the statue was made for Philip IV of Spain in 1650.[17] A marble copy was made in 1684 by Simon Mazière for Versailles where it was joined a year afterwards by a bronze copy by the Kellers,[18] and where, confusingly, an antique restored in imitation of the Borghese statue which was formerly at Marly is now also to be found.[19]

Casts and copies of the *Silenus* continued to be popular in the eighteenth and nineteenth centuries: a cast is still to be seen in the Accademia at Bologna and one was prepared by Vierpyl for a marble copy for Lord Charlemont;[20] a reduced marble copy was made by Albacini (private collection, Italy); small bronzes were offered for sale by both Righetti and Zoffoli, the leading Roman bronze-founders of the late eighteenth century;[21] a large bronze copy by Valadier adorns the ante-room at Syon House in Middlesex; later bronze copies stand inside the sculpture gallery at Petworth in Sussex and outside the sculpture gallery at Woburn in Bedfordshire, whilst in 1858 a plaster cast was purchased in Rome for the Boston Athenaeum by William Wetmore Story.[22]

For Robertson the *Silenus* is a copy made under the Roman Empire of a bronze original of the late fourth century, by Lysippus or one of his followers.[23]

1. Cavalleriis (3), plate 75; Vacca, Mem. 59; Lanciani, 1897, p. 419.
2. Document to be published by Suzanne Brown Butters.
3. Francucci, stanza 449.
4. Perrier, 1638, plate 6.
5. Manilli, pp. 86–7; see also Montelatici, pp. 206–7.
6. Boyer, 1970, p. 202.
7. Arrizoli-Clémentel, pp. 13–14, note 60.
8. *Magasin Encyclopédique*, 1811, III, p. 387.
9. *Notice*, supplément, 1815, p. 25.
10. Francucci, stanza 449.
11. Rossini, 1771, II, p. 247; Vasi, 1791, I, p. 288; Kotzebue, III, p. 143.
12. Brigentius, p. 71.
13. Diderot in *Correspondence littéraire*, V, p. 248.
14. Documents to be published by Suzanne Brown Butters.
15. Venturini, plate 9; Ficoroni, 1744 (*Singolarità*), p. 65; Evelyn, II, p. 286.
16. *Documenti inediti*, IV, pp. 77–8.
17. Palomino, p. 915.
18. Lami, 1906, p. 370.
19. Pinatel, pp. 129–31, plate 1.
20. Charlemont Papers, pp. 218, 221.
21. Zoffoli, Righetti (see Appendix).
22. Swan, p. 157.
23. Robertson, I, p. 467; II, plate 147b (caption).

162. Silenus with the Infant Bacchus (Louvre).

78. Spinario (Fig. 163)

Bronze

Height (without plinth): 0.73 m

Also known as: Absalom, Corydon, Il Fedele, Cneius Martius, Nudo alla spina, Pastorello, Cneius Pecoranus, Pickthorne, Priapus, Slave removing a thorn from his foot, Jeune Vainquer à la course.

The *Spinario* was recorded between 1165 and 1167 as outside the Lateran Palace[1] and it must have been among the bronzes transferred from there to the Palazzo dei Conservatori on the Capitol by Pope Sixtus IV after 1471.[2] It was recorded there for certain in 1499–1500.[3] The *Spinario* was ceded to the French under the terms of the Treaty of Tolentino in 1797,[4] reached Paris in the triumphal procession of July 1798[5] and was displayed in the Musée Central des Arts when it was inaugurated on 9 November 1800.[6] It was removed in October 1815,[7] arrived back in Rome in the first half of 1816 and was returned to the Palazzo dei Conservatori in the course of the same year.[8]

During the early Renaissance the *Spinario* was very celebrated, and with the *Marcus Aurelius* it was one of the first antique statues to be copied—often rather freely, sometimes in reverse and occasionally with an inkwell (Fig. 3). Half a dozen small bronze versions have been attributed to the late fifteenth and early sixteenth century bronze-founder Severo da Ravenna;[9] Antico, a sculptor of the same period, had cast a bronze statuette of the figure by March 1501 for Isabella d'Este—and in 1503 he made a pendant (perhaps the figure in reverse) for her;[10] whilst a larger bronze copy by Antonello Gagini adorned a fountain dated 1500 at Messina (probably the copy now in the Metropolitan Museum, New York).[11] On at least two occasions in the sixteenth century bronze copies were thought of as suitable royal presents: one cast, made by Giovanni Fancelli and Jacopo Sansovino, was presented by Ippolito II d'Este to François Ier—a transaction conducted through Benvenuto Cellini;[12] another cast was given by Cardinal Ricci to Philip II of Spain.[13] In the seventeenth century a bronze copy is recorded in the royal collection in England[14] and another was made for King Philip IV of Spain from a model acquired for him in Rome by Velázquez.[15] Marble copies, naturally enough, were less

frequent, but one seems to have been in the collection of Margaret of Austria in Antwerp at the remarkably early date of 1524;[16] a celebrated one was acquired by the Borghese in 1608;[17] and examples by Boudard and Ramey are recorded in eighteenth-century France.[18] It was also crudely reproduced in Staffordshire salt-glazed earthenware in the mid-eighteenth century.[19]

The Spanish Jew Benjamin ben Jonah of Tudela who was in Rome between 1165 and 1167 described the *Spinario* as Absalom,[20] the best-known male beauty of the Old Testament (without blemish from 'the sole of his foot even to the crown of his head'). However, 'Magister Gregorius' about fifty years later recorded that it was called Priapus and was 'ridiculosus'. The statue was then placed on a column so that the boy was seen from below but it is curious that Gregorius writes 'mire magnitudinis virilia videbis' since the genitals are of ordinary dimensions.[21] Despite the scorn of the learned such as Maffei,[22] the story that it had been ordered by the Roman Senate to commemorate a shepherd boy called Martius, who bore a message to them with such conscientious dispatch that he only stopped to remove a thorn from his foot after his arrival, was popular even with the erudite during the seventeenth and for much of the eighteenth century, and it survived into the nineteenth.[23] By the end of the eighteenth century scholars were trying to convince their readers that the statue was one of the earliest monuments commemorating a victor in the Greek games,[24] but as late as 1882 the popular title in Rome remained 'Il Fedele'.[25]

The *Spinario* has always been admired, but contradictory themes may be detected in the descriptions of it: the subject was a shepherd boy but a heroic story was attached to him; the easy naturalism of the unstudied pose was appreciated,[26] but some, looking at the head, found in it a certain archaic stiffness[27] and Rubens in his treatment of the theme changed the head completely.[28] During the last century the status of the sculpture has been enormously disputed. Other antique versions in marble have been discovered which are Hellenistic inventions with nothing archaic about the head and it has been proposed that the *Spinario* is a pastiche of the late Republican or early Imperial period in which the naturalism of this Hellenistic prototype is made more piquant by the addition of a head copied (or, possibly, literally taken) from an earlier Greek statue.[29] As such it is catalogued in Helbig.[30]

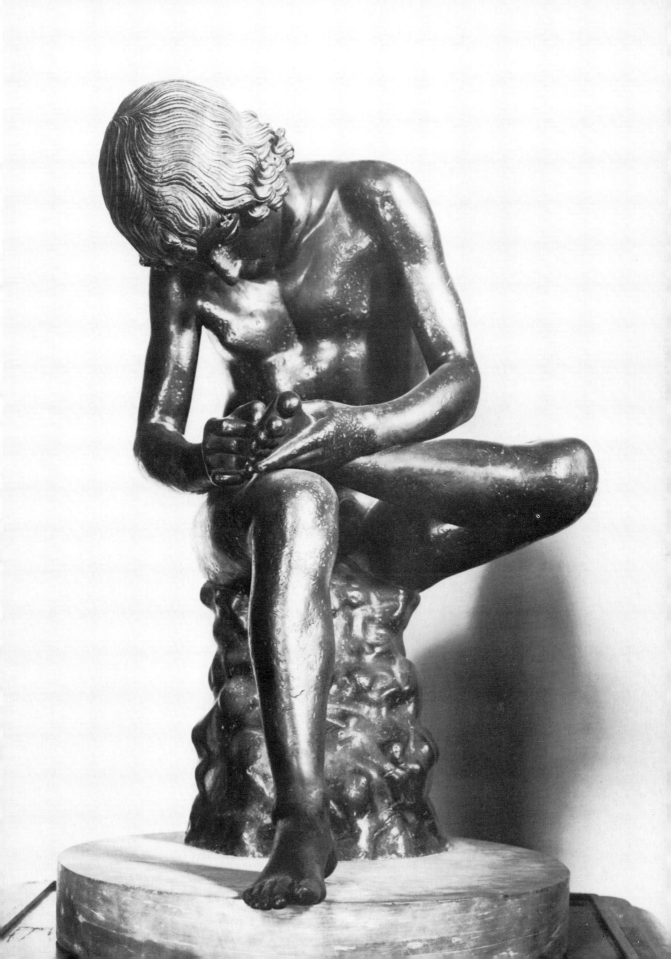

1. Borchardt.
2. Stuart Jones, 1926, p. 47.
3. Govi, p. 51 (stanza 62).
4. Montaiglon (*Correspondance*), XVI, pp. 464, 498.
5. Blumer, pp. 241–9.
6. *Notice*, An IX (1800), p. 3.
7. Saunier, p. 149.
8. Either in the consignment of statues which arrived on 4 January (*Diario di Roma*, 6 January 1816) or among those which had reached Civitavecchia from Antwerp by 19 June on H.M.S. *Abundance* (ibid., 19 June 1816); Stuart Jones, 1926, p. 47.
9. *Severo Calzetta called Severo da Ravenna.*
10. Brown, 1976, p. 333.
11. Draper.
12. Dimier, 1899, pp. 71–2; Lanciani, 1902–12, II, p. 77.
13. Harris, E., p. 120.
14. British Library, Harleian MS. 4898, p. 302; Harleian MS. 7352, fol. 122v.
15. Harris, E., pp. 120–1, plate VIII.
16. Zimerman, p. cxviii, no. 834 (II).
17. Faldi, 1954, pp. 12–13.
18. Lami, 1910–11, I, p. 115; II, p. 279.
19. Victoria and Albert Museum, Schreiber Collection, II, 257. Other examples in the Fitzwilliam Museum, Cambridge, and City Art Gallery, Manchester.
20. Borchardt (see Samuel II, XIV, 25).
21. Rushworth, pp. 24, 49.
22. Maffei, plate XXIII.
23. E.g. Lassels, II, pp. 144–5; Misson, 1691, II, pp. 98–9; de Blainville, II, p. 476; d'Uklanski, II, p. 18; Caylus, 1914, p. 181.
24. Lanzi, pp. 146–8; *Musée Français*.
25. Rayet, 1882 (Tireur d'Épine), p. 2.
26. Éméric-David, 1805, pp. 232–4.
27. Richardson, 1728, III, i, p. 180.
28. *Rubens: Drawings and Sketches*, no. 14.
29. Carpenter, pp. 35–41; Robertson, I, pp. 559–60.
30. Helbig, 1963–72, II, pp. 266–8.

79. Tiber (Fig. 164)

PARIS, LOUVRE

Marble
Height: 1.63 m; Length: 3.17 m

This statue was excavated in January 1512 between S. Maria sopra Minerva and S. Stefano del Cacco, Rome—the site of the sanctuary of Isis and Serapis—where the Dominicans were engaged in building operations.[1] It has been suggested that it had been known in the middle of the fifteenth century and in some way rediscovered in 1512, but the evidence for this is not convincing.[2] By 2 February it had been acquired by Pope Julius II,[3] by August 1513 it was certainly in the middle of the statue court of the Belvedere,[4] and by 1523 it had been installed as a fountain.[5] When the Museo Pio-Clementino was created in the 1770s the *Tiber* was placed in a room named after it, adjacent to the statue court in what had formerly been the villa of Innocent VIII.[6] Under the terms of the Treaty of Tolentino (19 February 1797) it was ceded to France,[7] and after being stored in Rome for some years it eventually reached Paris on 14 July 1803.[8] It was displayed by 1811 in the Salle des Fleuves of the Musée Napoléon, together with the *Nile*,[9] but unlike the *Nile* it was not returned after Waterloo.

164. *Tiber* (Louvre).

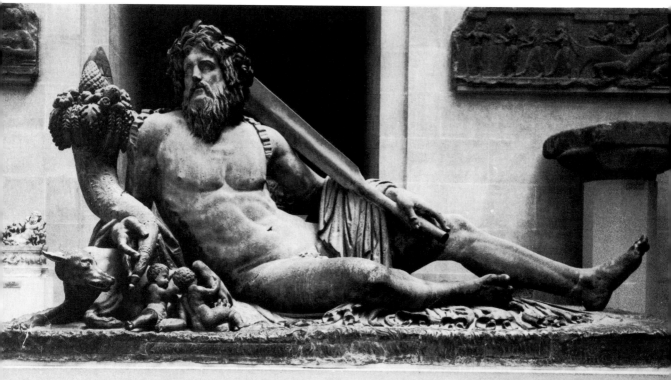

The *Tiber* was famous even before its removal to the Vatican and Grossino who reported its discovery to the Court at Ferrara dwelt on its great size and on the excellent preservation of the head and the cornucopia almost as a miracle, adding 'I have seen it with my own eyes and touched all of it with my own hands.'[10] No early account of the Belvedere statue court neglects to mention it[11] and we learn from Vasari that by 1527 it had been copied, together with the *Nile*, in fresco decorations by Polidoro da Caravaggio and his partner Maturino showing the life of Alexander the Great.[12] It was also repeatedly drawn and engraved by both Italian and Northern artists, especially during the sixteenth and early seventeenth centuries;[13] and it was included in the major anthologies of prints of the most admired antique statues.[14] Travellers frequently contrasted it (almost invariably favourably) with the smaller statue of the river god which after 1517 could be seen on the Capitol and which was later transformed into a Tiber.[15]

A bronze copy of the *Tiber* was made for François Ier between 1540 and 1543 and installed at Fontainebleau (destroyed in 1792).[16] Early English travellers tended in their descriptions of Fontainebleau to isolate the Wolf with Romulus and Remus which may be seen beside the cornucopia of the river god.[17] A marble copy by Pierre Bourdy, apparently begun in 1688, eventually reached France in 1715 and was placed by Louis XIV at Marly.[18] It was removed under the Regency to the Tuileries Gardens where it remains today. These, not surprisingly, seem to have been the only full-scale copies to have been made and when commissioning casts for the Spanish Royal Academy Mengs ordered one of the head alone.[19] Bronze statuettes on the other hand, such as those in the collection of François Girardon,[20] were not uncommon. They frequently include variations on the original—the seventeenth-century statuette in the Wallace Collection, London, for instance, is furnished with a more elaborate style of oar.[21]

The *Tiber* is thought by Robertson to date from the early Roman Empire and to be an original statue specially designed as a companion for the *Nile*.[22]

1. Luzio, 1886 ('Gonzaga Ostaggio'), pp. 534–5 (documents).
2. Brummer, p. 191.
3. Luzio, 1886 ('Gonzaga Ostaggio'), pp. 534–5, 535–6, note.
4. Brummer, p. 273 (quoting Gianfrancesco Pico della Mirandola).
5. Venetian Ambassadors in Albèri, p. 115.
6. Rossini, 1776, I, p. 275; Vasi, 1792, pp. 21–4.

7. Montaiglon (*Correspondance*), XVI, pp. 463, 498.
8. Lanzac de Laborie, VIII, p. 275.
9. *Notice*, supplément, 1811, pp. 10–11.
10. Luzio, 1886 ('Gonzaga Ostaggio'), pp. 534–5.
11. Brummer, p. 273 (for della Mirandola); Albèri, p. 115 (for Venetian Ambassadors); Aldrovandi, 1556, p. 115.
12. Vasari, V, p. 148.
13. Brummer, pp. 191–204.
14. Perrier, 1638, plate 92; Maffei, plate VI.
15. Stuart Jones, 1912, p. 2.
16. Pressouyre, 1969 ('Fontes'), pp. 223–4, 231–2.
17. Coryat, p. 39; Evelyn, II, p. 119.
18. Montaiglon (*Correspondance*), I, pp. 171–2; IV, p. 418; Souchal, 1977, I, p. 66.
19. Mengs (*Briefe*), p. 7.
20. Souchal, 1973, pp. 37, 44.
21. Mann, p. 69.
22. Robertson, I, p. 548.

80. Belvedere Torso (Fig. 165)

ROME, MUSEI VATICANI (ATRIO DEL TORSO)

Marble
Height: 1.59 m
Inscribed: ΑΠΟΛΛΩΝΙΟΣ ΝΕΣΤΟΡΟΣ ΑΘΗΝΑΙΟΣ ΕΠΟΙΕΙ
Also known as: Hercules, School of Michelangelo, Torso of Michelangelo

This statue is recorded as being in the collection of Cardinal Colonna by Ciriaco d'Ancona (or someone in his circle) between 1432 and 1435.[1] An engraving of it (with the legs restored) by Giovanni Antonio da Brescia (active between 1490 and *c.* 1535) is inscribed 'in mo[n]te cavallo', and as this phrase was sometimes used to locate the Colonna palace, it has generally been assumed that the *Torso* must have remained in that family's collection.[2] However, 'Prospettivo Milanese', writing in 1499–1500, refers to 'a nude body without arms or neck, than which I have never seen a better work in stone' as being in the house of 'a certain Master Andrea'.[3] It seems almost certain that this must be the sculptor (and collector of antiquities) Andrea Bregno, who also lived in the region of Monte Cavallo;[4] and as there has recently come to light a drawing of the *Torso*, datable on stylistic grounds to about 1500 and inscribed 'Maestro Andrea', it seems possible that the Colonna sold the sculpture to him—they certainly disposed of some of their statues.[5] Bregno died in 1506;[6] the *Torso* is next heard of in the statue court of the Belvedere:[7] it may have been acquired from Bregno's widow or some other unknown collector. When in the Vatican, it was at first described (and drawn) as lying flat on the ground, but it seems to have been mounted on a base, in a seated position, soon afterwards.[8] It remained in the court,

though not in a niche, until early in the reign of Pope Clement XI (1700–21) when it was removed to a small adjoining room and surrounded by iron railings.[9] With the creation of the Museo Pio-Clementino in the 1770s it was placed in the newly designed 'round vestibule'.[10] In 1797 it was ceded to the French under the terms of the Treaty of Tolentino[11] and it reached Paris in the triumphal procession of July 1798.[12] It was displayed soon after 17 February 1801 in the antiquities section of the Musée Central des Arts which had been inaugurated three months earlier.[13] It was removed in October 1815,[14] arrived back in Rome on 4 January 1816[15] and had been returned to the Vatican Museum by the end of February.[16]

Although the *Torso* was highly esteemed from at least the early sixteenth century, as can be seen from the number of drawings that have survived and from other evidence,[17] there can be no doubt that thereafter its great fame depended closely on the admiration that Michelangelo was said to have expressed for it; and this admiration must have been well known to connoisseurs even before Aldrovandi published it to the world in 1556 during the artist's lifetime.[18] A century later a story was current that he had been surprised by a cardinal kneeling in front of it (though only to examine it as closely as possible),[19] and not long afterwards such reports were themselves embellished in a variety of fanciful ways.[20]

Equally significant was the fact that the *Torso* was left unrestored. Michelangelo, who failed to 'finish' so many of his own sculptures, may well have played a part in this decision, but in the early eighteenth century visitors to Florence were shown a wax model belonging to the Grand Duke which, it was claimed, was the project he had made to restore the statue had he lived longer—or had he been asked, depending on who told the story.[21] The model was said to have come from the collections of Vasari (who despite his admiration for both Michelangelo and the *Torso*[22] failed to mention it) and of the painter Baldassare Franceschini, il Volterrano.

Most visitors paid their homage to the *Torso*, but one of the earliest references to it makes it clear that it was not admired by the uncultivated (*goffi*),[23] and its reputation was essentially an academic one. The fact that Michelangelo had not merely admired the *Torso* in the abstract but had actually 'discover'd a certain principle [in it] . . . which principle gave his works a gran-

deur of gusto equal to the best antiques'[24] led to its becoming known as 'the school of Michelangelo'.[25] This made a great impact on artists, as Maffei acknowledged[26]—and as can be observed in many paintings and some statues.[27] 'Hence you see alwaies a world of sculptors designing it out', wrote one seventeenth-century visitor to Rome.[28] A very early small-scale (and somewhat restored) copy of the *Torso* is being held by Fabio, nephew of Bernardino Licinio, in that artist's group portrait of his brother and family (Villa Borghese, Rome)[29] which can be dated to the early 1530s;[30] and a fine terracotta version of somewhat later can be seen in the Ashmolean Museum in Oxford.[31] Francavilla and Duquesnoy are both recorded as having made small replicas of this kind in the sixteenth and seventeenth centuries,[32] and in the eighteenth Hogarth mentioned that 'there are casts of a small copy of that famous trunk of a body to be had at almost every plaster-figure makers'.[33]

Though the Holy Roman Emperor Rudolph II appears to have owned a copy of the *Torso* in Prague,[34] these were naturally to be found more frequently in art academies than in the collections of princes. There was a cast in the French Academy in Rome;[35] and at the Royal Academy in London, to which Nollekens presented one specially brought from Rome,[36] Reynolds told the students that 'a mind elevated to the contemplation of excellence perceives in this defaced and shattered fragment, *disjecti membra poetae*, the traces of superlative genius, the reliques of a work on which succeeding ages can only gaze with inadequate admiration'.[37] Well over a hundred years earlier the *Torso* had been turned into the very symbol of the art of Sculpture: we find it, for instance, in Jacques Buirette's 'Union of Painting and Sculpture' (Louvre)—a marble relief presented by him to the Académie Royale de Peinture et de Sculpture in 1663 as a reception piece,[38] and thereafter it is included in many allegories of the arts until well into the nineteenth century.[39] Its fragmentary condition also gave the *Torso* symbolic overtones of a quite different kind: the frontispiece of Perrier's anthology of 1638 portrayed a gaunt figure of Time remorselessly devouring the stump of its arm as it had, and would continue to devour, the other famous statues which he illustrated. And, more recently, this sculpture has been seen as heralding such self-consciously uncompleted works as were produced by Rodin in the late nineteenth century.[40]

The fact that the *Torso* was never actually restored did not discourage attempts to visualise its original state. The earliest accounts all agreed that the figure's anatomy and the animal skin (thought to be that of a lion) on which he sat proved that he had been a Hercules, but there were considerable differences as to his precise stance and activity: holding a club according to one sixteenth-century bronze, stretching a bow according to another.[41] A drawing (in the École des Beaux-Arts, Paris) by Baldung Grien, dated 1533 and clearly based on the *Torso* which he had never seen, shows Hercules with a distaff while Omphale holds his club;[42] and some later writers also claimed that he must have been spinning—quite wrongly according to Mengs for whom this fragment united the beauties of all other statues.[43] Winckelmann who—in the words of Visconti—'has left us a poem rather than a description'[44] believed that the statue had originally shown Hercules resting after all his Labours and deified, as he had been shown in a celebrated relief in the Villa Albani.[45] Visconti himself used the evidence of an intaglio to suggest that Hercules had formed part of a group and had been shown contemplating (or caressing) Hebe.[46] This idea was publicised by the Baron d'Hancarville, the French adventurer and archaeologist, and in 1792 John Flaxman produced a bronze-coloured plaster of just such a reconstructed Hercules and Hebe (now on loan to the Victoria and Albert Museum) in preparation for a marble which had been commissioned by 'young Mr. Hope of Amsterdam'.[47] News of this unusual (perhaps unprecedented) collaboration between an artist, an archaeologist and a well-known art collector reached Visconti during the Napoleonic Wars and fascinated him, but he was unable to find a reproduction of it.[48]

The signature aroused interest because, as so often, the sculptor had not been recorded by Pliny or other ancient authorities—if the unknown Apollodorus could produce so great a work, it was asked rhetorically, what must have been the masterpieces of such celebrated artists as Praxiteles, Scopas or Lysippus?[49]

Winckelmann's attempt to date the statue demonstrates neatly the nature of his approach to such issues, which was based on a combination of erudition, aesthetic sensitivity and ideology: the form of the lettering of the signature showed that the work had been carved well after the reign of Alexander the Great, but as the quality was sublime it could not have been produced after the Greeks had lost their freedom. Hence it must be among the last masterpieces they had created

just before the Roman conquest of 146 B.C.[50] After the statue reached Paris Visconti also made use of evidence derived from the script (and from a dubious account of its place of discovery) to deduce that it dated from late Republican times.[51] In England Payne Knight suggested that it might be a reduced copy of a colossal bronze by Lysippus[52]—thus removing it from the class of original masterpieces but linking it to a very celebrated name.

There have been only rare exceptions to the praise given to the *Torso*. On Stendhal 'it produced no real effect. We recognised that this was the piece of marble so admired by Michelangelo and by Raphael who reproduced it in the torso of the Eternal Father in his "Vision of Ezechiel"; we studied it like something from China, but it aroused neither pain nor pleasure.'[53] More characteristic was the verdict of the archaeologist Raoul-Rochette, writing a few years later, who maintained that the *Torso* was 'perhaps the only one of all the masterpieces of ancient art that have come down to us which has lost none of its reputation since the appearance of the sculptures of Phidias which have driven down into the second rank everything which had previously been admired'.[54]

The *Torso* is catalogued in Helbig as the work of an eclectic artist of great virtuosity of the first century B.C., reflecting a conception of the third century B.C.[55]

166. *Borghese Vase* (Louvre).

1. Andrén, p. 2; Schmitt, pp. 109, 123, note 33.
2. Hind, V, pp. 42–3 (Vol. II of catalogue).
3. Govi, p. 7 (stanza 13).
4. Schmitt, p. 123, note 20.
5. *Ibid.*, pp. 100–12.
6. Pope-Hennessy, 1958, p. 336; Schmitt, p. 112, gives the date as 1503.
7. Brummer, p. 144.
8. See the drawings by Heemskerck in Hülsen and Egger (Text), I, pp. 34, 40; (Tafeln), I, fol. 63r, 73r.
9. Maffei, plate IX.
10. Vasi, 1792, p. 7.
11. Montaiglon (*Correspondance*), XVI, pp. 462, 498.
12. Blumer, pp. 241–9.
13. *Magasin Encyclopédique*, An IX (1801), IV, p. 545; Michon, 1914–15, pp. 264–5.
14. Saunier, p. 151.
15. *Diario di Roma*, 6 January 1816.
16. *Ibid*, 24 February 1816.
17. Brummer, pp. 146–8.
18. Aldrovandi, 1556, p. 121.
19. Chantelou, p. 26.
20. Vasari (*Michelangelo*), IV, pp. 2102–3.
21. Richardson, 1722, p. 75; Wright, I, p. 268; Condivi, p. 76 (for Mariette).
22. Vasari, IV, p. 10.
23. Doni, fol. 51v (of facsimile).
24. Hogarth, p. v.
25. Wright, I, p. 268.
26. Maffei, Plate IX.
27. Salis, pp. 165–89.
28. Lassels, II, pp. 68–9.
29. Della Pergola, 1955, I, p. 116 (no. 207).
30. Vertova, pp. 429–30.
31. Ashmolean Museum, *Report of the Visitors*, 1961, pp. 63–4.
32. Baldinucci, VII, pp. 32–3; Bellori, p. 289; Richardson, 1722, p. 10.
33. Hogarth, p. 64.
34. Kaufmann, p. 24, figs. 2, 4.
35. Montaiglon (*Correspondance*), I, p. 129.
36. Smith, J. T., I, p. 15.
37. Reynolds, pp. 177–8 (Discourse X).
38. Ladendorf, fig. 88; Souchal, 1977, I, p. 70.
39. Schmoll gen. Eisenwerth, 1959, fig. 49.
40. Von Einem; Schmoll gen. Eisenwerth, 1954; 1959.
41. Andrén, pp. 10–14.
42. *Baldung Grien*, pp. 83–4 (no. 178).
43. Mengs, pp. 151–2.
44. Visconti (*Pio-Clementino*), II, plate X.
45. Winckelmann (ed. Fea), II, pp. 283–4; see also Winckelmann, 1968, pp. 169–73, 280–5 (*Beschreibung*).
46. Visconti (*Pio-Clementino*), II, plate X.
47. Whinney and Gunnis, p. 53.
48. *Notice*, An XI (1802–3), p. 84; Visconti (*Pio-Clementino*), II, plate X.
49. Visconti (*Pio-Clementino*), II, plate X.
50. Winckelmann (ed. Fea), II, pp. 282–3.
51. *Notice*, An XI (1802–3), pp. 84–5.
52. [Knight], 1809, pp. xlvii, lii.
53. Stendhal, 1973, p. 778.
54. Quoted by Andrén, p. 9.
55. Helbig, 1963–72, I, pp. 211–13.

81. The Borghese Vase (Fig. 166)

PARIS, LOUVRE

Marble
Height: 1.71 m

The *Vase* was recorded in the garden of Carlo Muti in notes compiled in 1594 by Flaminio Vacca who added that it had been discovered together with the *Silenus with the Infant Bacchus* on Muti's estate near the present Casino Massimo, part of the site of the gardens of Sallust[1] — we know that the *Silenus* was discovered before 18 September 1569.[2] In 1645 the *Vase* was in the Villa Borghese.[3] On 27 September 1807 it was purchased, together with the bulk of the Borghese antiquities, by Napoleon Bonaparte, brother-in-law of Prince Camillo Borghese.[4] It was sent to Paris between 1808 and 1811,[5] and was on display in the Musée Napoléon by the latter year.[6]

From the mid-seventeenth until the mid-nineteenth century the *Borghese Vase* was, with the *Medici Vase*, the most admired of antique marble vases, and, like the *Medici Vase*, it was sometimes ascribed to Phidias.[7] The two were often compared and copies of them were arranged as companions. Both were copied three times for the Bassin de Latone at Versailles,[8] but in the version of the *Borghese Vase* closest to the copies of the *Medici Vase* the krater form of the latter is borrowed in the interests of symmetry. Such a combination is also found on the set of eight silver gilt wine coolers made by Paul Storr in 1808 for the Prince Regent,[9] and, perhaps earlier, in a version in alabaster in the Great Hall at Houghton Hall in Norfolk, and in one of bronze at Osterley Park in Middlesex, both of which are paired with copies of the *Medici Vase*.

In addition to numerous other marble copies and, of course, prints, the *Borghese Vase* was copied on a reduced scale in bronze in the early eighteenth century,[10] and, smaller still, at a later date, by both Zoffoli and Righetti,[11] and in jasperware by Wedgwood[12] and in artificial stone by Coade[13] and by Blashfield.[14] The frieze of ecstatic Bacchantes escorting a staggering Silenus was adapted for a silver goblet designed by Schinkel in 1820[15] and was engraved on the side of one made by Henry Archer and Co. in 1866.[16] It was also sometimes reproduced on flat tablets.[17] In the mid-nineteenth century it was still observed that this vase and the *Medici Vase* were 'the grandest Greek sculptural vases now in existence'.[18]

Since the late nineteenth century it has been acknowledged as an important example of neo-Attic workshop sculpture,[19] and on the grounds that two versions of the vase were found with other marbles in the wreck of a ship bound from Athens shortly after the time of Sulla it is considered likely that the workshop was Athenian.[20]

1. Vacca, Mem. 59; Lanciani, 1897, p. 419.
2. Document to be published by Suzanne Brown Butters.
3. Perrier, 1645, plates 10, 11.
4. Boyer, 1970, p. 202.
5. Arizzoli-Clémentel, pp. 13–14, note 60.
6. *Notice*, supplément, 1811, pp. 13–14.
7. Brigentius, p. 78.
8. Montaiglon (*Correspondance*), I, pp. 90, 94, 96, 100, 110, 113–15, 117–19; Souchal, 1977, I, p. 114.
9. Udy, plate 40, p. 828.
10. Walpole, p. 74 (at Houghton Hall in Norfolk).
11. Zoffoli, Righetti (see Appendix).
12. Lady Lever Art Gallery, Port Sunlight — Hobson, p. 162, plate 94, no. 1335.
13. Coade, 1777–9, plate 10; 1784, p. 5.
14. Blashfield, 1857, no. 263.
15. *Berlin und die Antike*, pp. 281, 283.
16. Sheffield City Museum.
17. Coade, 1777–9, plate 21; Hobson, p. 184, no. 1545. See Udy, p. 828.
18. Blashfield, 1857, nos. 262, 263.
19. Hauser, pp. 84–7.
20. Bieber, pp. 184–5.

167. *Medici Vase* (Uffizi).

82. The Medici Vase (Fig. 167)

FLORENCE, UFFIZI

Marble
Height (with pedestal): 1.73 m

This vase must be the 'pilo di marmo biancho storiato delle historie d'Ifigenia' in the inventory of the Villa Medici in Rome made in 1598,[1] and there is evidence to suggest that it was in the Medici collection nearly thirty years earlier.[2] It was removed to Florence in 1780[3] and displayed soon afterwards in the Uffizi.[4] In September 1800 it was taken to Palermo with other treasures to escape the French, but it was returned in February 1803.[5]

The celebrity of the *Medici Vase* in the second half of the seventeenth century is suggested by the many prints of it, and especially by the earliest and most beautiful one, by Stefano della Bella, dated 1656 (Fig. 29), showing a well-dressed boy drawing it (plausibly identified as a compliment to the fourteen-year-old Medici heir, later Grand Duke Cosimo III, who was then della Bella's pupil).[6] Bellori labelled Bartoli's print of the *Vase* 'Arte Phidiaca'.[7]

Three copies of the vase were made for the Bassin de Latone, Versailles,[8] paired with copies of the *Borghese Vase*, and copies, often paired in this way, were popular garden ornaments throughout the eighteenth and nineteenth centuries. A full-size copy by Bartolini, in which lamps were lit, was placed in the orangery at Chatsworth in Derbyshire;[9] there were sixteen large-size marble copies at Woburn in Bedfordshire by 1822;[10] and there were as many smaller cast-iron ones at Alton Towers in Staffordshire (probably dating from a little later).[11] Towards the end of the eighteenth century miniature versions became immensely popular in bronze,[12] alabaster[13] and biscuit.[14] The status of the vase had hardly altered in the mid-nineteenth century when Blashfield in his catalogue of terracotta reproductions listed it, together with the *Borghese Vase*, with the note that the two were 'the grandest Greek sculptural vases now in existence'.[15]

The subject of the frieze had been described by the late sixteenth century as the story of Iphigenia[16] and this was repeated by Sandrart,[17] by Bellori who identified the figures of Achilles, Ulysses and Agamemnon to the right of Iphigenia who is crouching below the statue of Diana,[18] and by numerous travellers and scholars until it was pointed out by Amelung that the

statue of Diana was a restorer's addition,[19] since when many theories have been proposed, none of which has been widely accepted.

The *Medici Vase* has been catalogued by Mansuelli as neo-Attic work of the second half of the first century A.D.[20]

1. Boyer, 1929, p. 268, no. 336.
2. Documents to be published by Suzanne Brown Butters.
3. *Documenti inediti*, IV, p. 77.
4. Lanzi, pp. 97–9.
5. Paris, Archives Nationales: F21 573 (letter from L. Dufourny to Minister of the Interior, 8 fructidor, an 9); Florence, A. G. F., Filza XXX, 1800–1801, n. 23; *Galerie Impériale*, p. 10; Boyer, 1970, pp. 187–91.
6. De Vesme, I, pp. 42, 128; II, no. 832.
7. Bartoli, 1693, plates 18, 19.
8. Souchal, 1977, I, p. 114.
9. [Cavendish], p. 108.
10. *Woburn Abbey Marbles*, final page before appendix.
11. The 'elegant vases' at Alton were cast by the Britannia foundry at Derby—Noble, II, p. 425.
12. Zoffoli, Righetti (see Appendix).
13. Great Hall, Houghton Hall in Norfolk; also formerly Malmaison—Hubert, 1977, p. 40.
14. Savage, plate 62a; Victoria and Albert Museum, 396–1874 (without handles).
15. Blashfield, 1857, no. 262.
16. Boyer, 1929, p. 268, no. 336.
17. Sandrart, 1675–9, I, i, IV.
18. Bartoli, 1693, plates 18, 19.
19. Amelung, 1897, pp. 79–80.
20. Mansuelli, I, pp. 189–92.

83. The Callipygian Venus (Fig. 168)

NAPLES, MUSEO NAZIONALE

Marble
Height: 1.52 m
Also known as: La Bergère Grecque, Vénus aux belles fesses, Venus drying herself, Venus leaving the bath, Shifting Venus, La Belle Victorieuse

The statue is recorded as in the Farnese collection in the caption of a print published in 1594.[1] It might be the Venus which Aldrovandi described as in the Palazzo Farnese in 1556 and as holding a towel having just come out of a bath,[2] and the Venus, draped and life-size, which is recorded in an inventory of 1568 as in the Camerino Secreto of the mezzanine floor of the palace.[3] By 1697 it was certainly in the Sala dei Filosofi (surrounded by eighteen ancient sages)[4] where it remained until the second half of the eighteenth century when it was taken with other marbles to the Farnesina where it is recorded for certain in 1767.[5] It was decided to move the statue to Naples in 1786, but it went first to the Roman restorer Carlo Albacini and it is not recorded at Capodimonte until February 1792.[6] By May

1802 it was in the Museo degli Studi (later Museo Borbonico, now Museo Nazionale).[7]

The *Venus* was not included in Perrier's anthology of prints of the most celebrated statues in Rome of 1638, but Evelyn recorded the statue in January 1645 as 'that so renouned piece of a Venus pulling up her smock, and looking backwards on her buttocks'[8]—and the statue's reputation remained high for more than a century and a half after that. A bronze statuette in the Ashmolean Museum, Oxford, attributed to the Flemish sculptor Hans Mont, who left Rome in 1571, would thus appear to be the earliest known copy of the *Venus*.[9] About a century later it was copied by Clérion and Barois in marble for Louis XIV: the former, whose work is at Versailles, made a replica; the latter, whose work was at Marly but is now in the Louvre, made an improved version (perhaps partially motivated by recognition of the extensive restoration of the original—Fig. 20).[10]

The statue was sometimes in the late seventeenth and early eighteenth centuries described as Venus leaving the bath, or drying herself,[11] but it was more commonly known then and later as 'la Bergère Grecque' or 'La Belle Victorieuse',[12] in reference to a story told by the late second or early third-century author Athenaeus,[13] and retold by Cartari in his popular guide to mythology,[14] in which two daughters of a peasant settled a dispute concerning which had the more shapely buttocks by accosting a young man on the highway who was unknown to both of them and inviting him to judge. His choice was his reward, and his brother hearing of the contest preferred and thus won the other girl. The double marriage that ensued so improved the girls' fortunes that they dedicated a temple to Venus Callipygos at Syracuse. It seems to have been supposed that the cult statue of the goddess commemorated the exhibitionism of her votaries and there were travellers such as Gibbon (for whom the *Venus* was 'a country girl . . . well-formed, plump and healthy') who stressed the mortal character of the statue,[15] although bronze-founders, ceramic manufacturers, marble copyists and plaster-cast merchants listed it as Venus.

Copies of the statue in all these media are found in the eighteenth century,[16] and it was also reproduced in miniature on Wedgwood's tablets and cameos.[17] Charles de Wailly proposed a copy of the statue as a suitable ornament for a Temple de l'Amour projected in 1770 for the

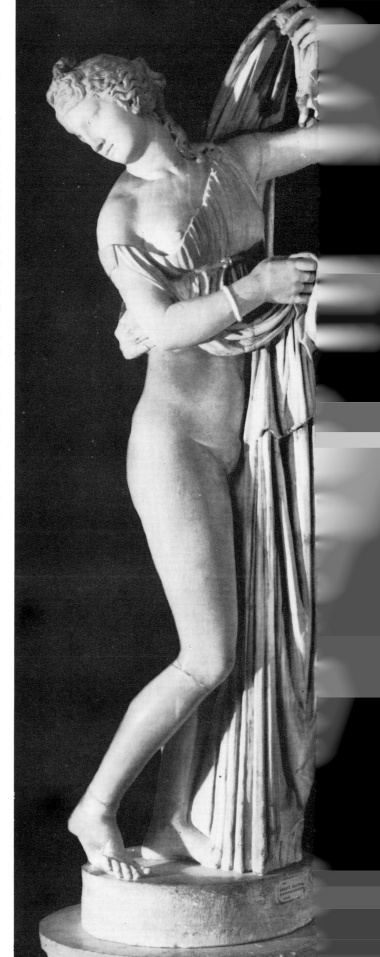

168. *Callipygian Venus* (Museo Nazionale, Naples).

gardens of the Marquis de Marigny at Menars.[18] Gustavus III of Sweden a decade later commissioned Sergel to copy the statue in marble, as a pair to an earlier copy of the *Apollino*, to be placed in the Hall of Mirrors of the Royal Palace in Stockholm. Sergel, presumably at the King's suggestion, gave the goddess the features of the royal mistress, Countess Ulla von Höpken.[19] Neither de Wailly's project nor Sergel's adaptation suggest that any elevated ideal was felt to be embodied in the statue—nor, certainly, does the fact that Rowlandson has the statue preside over his ribald print ('The Exhibition Stare-Case') in which a group of inadvertently exhibitionist ladies cascade headlong down the Royal Academy staircase in Somerset House.[20]

Although Watelet apologised for the statue's proportions by suggesting that it was Diana or a nymph and had the right build for the hunt or the dance,[21] the *Venus* was criticised in the eighteenth century for the 'uninventive' drapery, the 'good for nothing' restoration of the head, and the shortness of arms and legs.[22] Albacini revised the restorations of the head, both arms and one leg in deference to some of these objections[23] (nothing, however, was done about the bosom which Galiffe considered to have been copied from that of a nursing mother).[24] Vivant Denon in 1806 could still describe the *Callipygian Venus* as almost the equal of the *Venus de' Medici*,[25] but when the British traveller the Reverend G. W. D. Evans repeated this verdict thirty years later, he added that she ranked so high 'notwithstanding the indelicacy of her attitude'.[26] Writing in a catalogue of 1819, Giovambattista Finati had conceded that the statue's appeal was somewhat meretricious,[27] and subsequent writers found the statue more and more deficient in moral dignity.[28] Perhaps alone amongst the statues included in this catalogue its decline in favour was significantly assisted by its erotic character.

The statue is considered by Robertson as a heavily restored copy of a Hellenistic original and possibly connected with the shrine of Aphrodite Kallipygos at Syracuse.[29]

1. Cavalleriis (3), no. 66.
2. Aldrovandi, 1556, p. 158.
3. *Documenti inediti*, I, p. 76.
4. *Ibid.*, II, p. 381.
5. *Ibid.*, III, p. 192, as 'Venere in Piedi mezza nuda' the same height as the 'Venere in piedi delle belle Chiappe', recorded in the same room in 1775—*ibid.*, III, p. 195.
6. Stolberg, II, p. 7; see also *Documenti inediti*, I, p. 169.
7. [Engelbach], p. 15.
8. Evelyn, II, p. 309.
9. *Giambologna* (Vienna), pp. 89–90, no. 7a.

10. Montaiglon (*Correspondance*), I, p. 158; II, p. 17; Souchal, 1977, I, pp. 31–2, 106.
11. E.g. Thomassin, plate 33; Maffei, plate LV.
12. E.g. Audran, plate 14; De Brosses, II, p. 212.
13. Athenaeus, *Deipnosophistae*, XII, 554.
14. Cartari, pp. 537–8.
15. Gibbon, p. 245.
16. Marble by G. B. Maini, 1750, Wentworth Woodhouse in Yorkshire; plaster Holkham Hall in Norfolk (Brettingham MS., p. 104); plaster statuette (Harris, C., pp. 3, 4); bronze by Righetti (Honour, 1963, plate 9); figurine in biscuit de Sèvres (Bourgeois, p. 12, no. 608) and in porcelain (Rackham, I, p. 415, no. 3213, II, plate 265b).
17. Wedgwood, 1779, class II, nos. 49, 66, 156.
18. Mosser, plate 7.
19. Säflund, pp. 12–14, 59–61.
20. Grego, II, pp. 217–18.
21. Watelet, p. 73.
22. Richardson, 1722, pp. 134, 144; Winckelmann (*Briefe*), IV, p. 28; Lalande, IV, p. 323.
23. Säflund, pp. 15–21.
24. Galiffe, II, p. 96.
25. Boyer, 1970, p. 237.
26. Evans, G. W. D., II, p. 151.
27. Finati, I, ii, pp. 69–70.
28. Starke, 1820, p. 415; Monaco, p. 38.
29. Robertson, I, p. 553.

84. Capitoline Venus (Fig. 169)

ROME, MUSEI CAPITOLINI

Marble
Height: 1.87 m

The *Venus* is recorded in notes compiled by the antiquarian Pietro Santi Bartoli, who died in 1700, as having been found during the pontificate of Pope Clement X (1670–6) in the gardens belonging to the Stazi near S. Vitale.[1] The attractive theory that this statue was the Venus which 'Magister Gregorius' saw on the Quirinal in the Middle Ages but of which there are no later records depends on the supposition that it was walled up in response to ecclesiastical hostility,[2] but Bartoli states that it was found in antique interiors together with other sculpture.[3] Pope Benedict XIV bought the statue from the Stazi family in 1752 and presented it to the Capitoline Museum.[4] In 1797 it was ceded to the French under the terms of the Treaty of Tolentino[5] and it reached Paris in the triumphal procession of July 1798.[6] It was displayed in the Musée Central des Arts from its inauguration on 9 November 1800,[7] was removed in October 1815,[8] arrived back in Rome in the first half of 1816 and was returned to the rearranged Capitoline Museum during the course of that year.[9]

Although Bartoli—possibly writing when the *Venus de' Medici* was removed to Florence, or not long afterwards—claimed that this statue was fully as good,[10] the reputation of the *Capitoline*

Venus, which was discovered at a time when there were few recruits to the higher order of antique statues, grew up very slowly even after its display in the Capitoline Museum. Rossini, for instance, in his popular guidebook, *Il Mercurio errante*, simply listed it,[11] and Burney even noted that it was 'not very beautiful'.[12] Winckelmann, however, admired the excellent state of the statue's preservation[13] at a time when sensitivity about restorations was beginning to impair the reputation of the *Venus de' Medici* and in notes made in 1762 he called the statue 'più Donna di quella di Firenza'.[14] Sir Richard Colt Hoare in Rome in about 1785 also thought that the Capitoline statue was 'a more perfect model of nature than the Medicis'[15] and Heyne recorded that it had already eclipsed the fame of its Florentine rival.[16] This new reputation was reflected in the statue's part in the triumphal procession into Paris in 1798 when its case, like the *Apollo*'s, was crowned with a garland,[17] and, once in the Musée, it was copied for the Emperor Napoleon by Chinard (now at Compiègne),[18] and a cast was among those selected for the Society of Fine Arts in New York.[19] The cast made to replace the *Venus* in the Capitoline Museum was sent to England after the statue's return and Flaxman drew the attention of his students to it and maintained that the *Venus* was 'certainly' a copy from one of the three Venuses 'enumerated by Pliny among the work of Praxiteles'.[20] By 1822 a copy of the *Venus* had been installed as a fountain in the palace which Prince Borghese built for himself in Florence.[21]

The special room in which the statue is displayed ensures that it continues to impress, and it is less disparaged in modern scholarly literature than is the *Venus de' Medici*. It is catalogued in Helbig as a copy of the early Antonine period of a late Hellenistic statue ultimately derived from the Cnidian Aphrodite of Praxiteles.[22]

1. Bartoli, *Mem.* 27.
2. Rushworth, pp. 24–6, 51.
3. Bartoli, *Mem.* 27.
4. Stuart Jones, 1912, p. 183.
5. Montaiglon (*Correspondance*), XVI, pp. 464, 498.
6. Blumer, pp. 241–9.
7. *Notice, An IX* (1800), pp. 69–70; Boyer, 1970, p. 184.
8. Saunier, p. 149.
9. Either in the consignment of statues which arrived on 4 January (*Diario di Roma*, 6 January 1816) or among those which had reached Civitavecchia from Antwerp by 19 June to H.M.S. *Abundance* (*ibid.*, 19 June 1816).
10. Bartoli, *Mem.* 27.
11. Rossini, 1771, I, p. 30.
12. Burney, p. 138.
13. Winckelmann (ed. Fea), I, pp. 314–15.

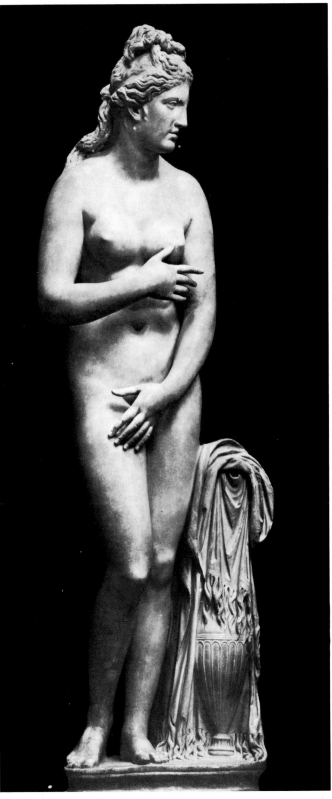

169. *Capitoline Venus* (Capitoline Museum).

14. Winckelmann (*Briefe*), IV, p. 24.
15. Hoare MS., p. 24.
16. Heyne ('Venus'), pp. 34–5.
17. Blumer, p. 242, note 4.
18. Paris, Archives Nationales: 0²836, Musée Napoléon, Budget 1811.
19. Dunlap, II, p. 105, note.
20. Flaxman, p. 25.
21. Corsini, p. 219 (document).
22. Helbig, 1963–72, II, pp. 128–30.

85. Celestial Venus (Fig. 170)

FLORENCE, UFFIZI

Marble
Height: 1.44 m
Also known as: Chaste Venus, Venus Pudica,
 Vénus sortant du bain, Venus Urania

The *Venus* is first recorded in 1656 as in the Palmieri collection in Bologna to which it had, apparently, come by inheritance from the Bolognini family in the same city. In 1657 it was acquired (at a low price) by Grand Duke Ferdinand II of Tuscany through his agent in Bologna, Marchese Ferdinando Cospi, and taken to Florence.[1] By 1664 it was displayed in the Uffizi[2] and by 1688 it was in the Tribuna[3] where it remained until the reorganisation of 1780–1 when it was placed in the Stanza dell'Ermafrodito.[4] It was later moved to various other locations in the museum.

A very full report on the condition of the statue in 1656, made by the English Catholic antiquary Peter Fitton who was employed by the Medici, describes it as being of 'an exquisite Greek style and not inferior to the most beautiful that can be seen in Rome'.[5] Guercino is supposed to have been among its great admirers when it was in Bologna,[6] and by 1664 a French visitor to Florence had attributed it to the sculptor of the *Venus de' Medici*, which was then still in Rome, and pointed out that it was of equal quality and better preserved.[7] The comparison between these Venuses (and also the *Venus Victrix*) became a commonplace,[8] and though this one ranked slightly lower than the other from Rome once they could be seen together in the Tribuna, it continued to be warmly admired throughout most of the eighteenth century. Cochin, however, noted that though 'quite good' it was 'much inferior' to the *Venus de' Medici*,[9] and in the next generation its reputation began to sink. It was not depicted in Zoffany's famous (though in part fanciful) view of the Tribuna of 1772 (Fig. 30), and a few years later it was actually removed

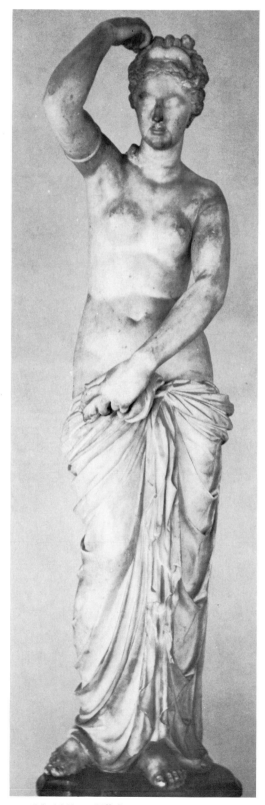

170. *Celestial Venus* (Uffizi).

from that sanctuary because it was not considered excellent enough to stand up to the competition of its neighbours.[10] Nor were copies of it ever very frequent. However, the cast of it in the Royal Academy was much admired in the late eighteenth century,[11] and that which in 1834 Basevi planned to include, alongside such accepted masterpieces as the *Dying Gladiator* and the *Cleopatra*, in the entrance hall of the Fitzwilliam Museum,[12] and the marble replicas made for the Duke of Devonshire (still at Chatsworth) in the 1840s[13] and the Cour Carré of the Louvre in the 1850s[14] demonstrate that it remained popular even after its 'demotion' in Florence.

Besides the issue of quality two other questions were of interest to connoisseurs: the precise subject[15] (as indicated by the variety of names listed above) and the degree of restoration.[16] Cellini and, more predictably, Michelangelo were credited with having made one or a pair or two pairs of arms for her,[17] and, just as predictably, it was said that those carved by Algardi were so admirable that they were retained even after the antique ones had been found.[18] In 1797 the French antiquarian Antoine Mongez tackled both these issues by emphasising that while the original torso was of the very highest quality, the degree of restoration elsewhere was so extensive that the true subject could not be ascertained and he therefore called it merely 'statue de femme'.[19]

The original part of the statue is catalogued by Mansuelli as a fragment of a Hellenistic Aphrodite, while the head (which Fitton in 1656 knew to have been taken from another figure) is dated a little earlier.[20]

1. Bencivenni Pelli, I, pp. 232, 264 (with documents).
2. Monconys, III, p. 491 (referring to visit to Florence in June 1664).
3. Baldinucci, II, pp. 497–8 (life of Buontalenti, first published in 1688).
4. Lanzi, pp. 77, 170.
5. Bencivenni Pelli, I, p. 264.
6. *Ibid*, I, p. 232.
7. Monconys, III, p. 491.
8. Richardson, 1722, p. 57; Burney, p. 110.
9. Cochin, II, p. 36.
10. Lanzi, p. 170.
11. Baretti, p. 29.
12. *The Triumph of the Classical*, plate 24.
13. It probably came from Bienaimé's Carrara studio which supplied the statues placed in the gardens of Chatsworth between 1841 and 1844, and seems to have continued doing so for some years—Chatsworth MS., Sculpture Accounts of the Sixth Duke, p. 23; [Cavendish], p. 168.
14. Pingeot, tableau 8.
15. Bianchi, pp. 196–7.
16. Bencivenni Pelli, II, pp. 197–8, note cxxv.
17. Legati, p. 519; Baretti, p. 29.
18. Gori, 1734, pp. x–xi.
19. Mongez, 1789–1807, I, 6ème livraison.
20. Bencivenni Pelli, I, p. 264; Mansuelli, I, pp. 97–8.

86. Crouching Venus

(Fig. 171)

FLORENCE, UFFIZI

Marble
Height: 0.78 m
Also known as: Venere nel bagno, Venere nella conchiglia

The statue is first definitely recorded in 1704 when it was in the Villa Medici in Rome,[1] but it can perhaps be traced back through references in inventories of the sculpture collections there to 1670 ('una statua d'una venere minore del naturale chinata che siede sopra una chiociola')[2] or even to 1598 ('Venere di marmo a sedere al nat^le che si lava').[3] It was taken to Florence in 1787[4] and placed in the Uffizi.

This figure is one of a large number of versions—often with significant variations—which are believed by many contemporary scholars to be copies of a statue referred to in a corrupt passage of Pliny (emended to 'Venerem lavantem sese') as being by Doidalses and placed in one of the temples of the Portico d'Ottavia in Rome.[5] Although the Medici version seems to have been the most noted during the later part of the period covered by our book, others were certainly known from the early sixteenth century onwards;[6] it is thus by no means certain that the many references to a 'Crouching Venus' (or similar title) and the many imitations that can be found at least from the time of Giambologna necessarily derive from this one. A version (now on loan to the British Museum), acquired by Charles I from the Gonzaga collection, was described in 1631 as the 'figure of a woman sitting in marble; some say *Venus delli Ely*, others *Helen of Troy*. It is the finest statue of all [at Mantua], and estimated at 6000 *escus*.'[8] In the second half of the eighteenth century another version was excavated at Salone and acquired for the Vatican Museum.[9] The latter was among a number of celebrated antique statues engraved by Francesco Piranesi, but it is indicative of the uncertainty felt about the relative standing of the various replicas of the composition that even though this was among the statues seized by the French in 1797,[10] Vivant Denon later proposed that the version in Florence should also be taken[11]—although the Florentines themselves had not thought it worthy of being sent (with other famous works in the Uffizi) to safety in Palermo. A further indication that it was more the type than any actual version that was spec-

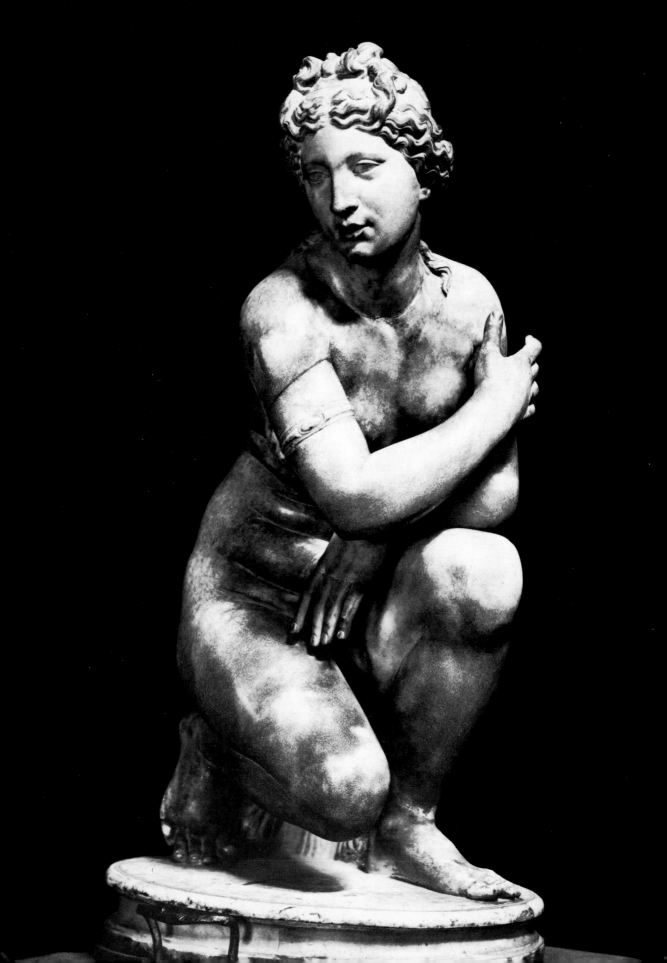

ially admired is provided by the comment of the antiquarian Antoine Mongez that, although the statue in Florence 'was produced by an artist of the second or even third rank, it would nonetheless honour the chisel of any modern'.[12]

The most famous imitation is certainly the marble by Coysevox, completed in 1686 and signed not only with his own name but also with that of Phidias (in Greek)—but this departs from the original in so many ways (Venus, for instance, here rests on a tortoise instead of on a shell) that it hardly belongs with the general run of copies commissioned for Versailles. It was, however, much admired (sometimes more than the antique prototype)[13] and a bronze was cast by the Keller foundry for Marly: since 1871–3 the marble has been in the Louvre and the bronze at Versailles (Fig. 22)[14] where it is paired with the *Arrotino* (a statue—also crouching—with which it has sometimes been linked stylistically by modern scholars).[15]

In 1762 Tommaso Solari made a more faithful marble copy for the gardens of Caserta[16] and small bronzes seem to have been offered by Zoffoli and Righetti.[17] Towards the end of the nineteenth century another version (which had come to light in France in 1828) was frequently drawn by Cézanne in the Louvre[18] and adapted for his version of 'Les Grandes Baigneuses' now in Philadelphia. The figure had been popular with painters from Rubens onwards, but tended to stimulate rather perfunctory praise from visitors to Italy.[19] Mrs. Eaton was being more generous than most (though her tone was characteristic) when in 1816 she noted that of all the Venuses in the Uffizi, apart from that of the Medici, 'a pretty little crouching Venus alone caught my fancy'.[20] Winckelmann seems not to have mentioned it at all.

The statue was at first believed to represent Venus immediately after her birth about to be carried to land on the sea shell[21] (which was in fact the work of a modern restorer).[22] Later in the eighteenth century the precise subject was of much less concern than the general charm, as is suggested by the Abbé Richard's reference to it in 1766 as 'Vénus dans l'attitude d'une personne qui est dans le bain'.[23] However, Visconti, when discussing the version in the Vatican, pointed to the 'sublimity of the idea of the goddess of beauty who takes her divine limbs from out of the bath', though he no longer believed that it was the actual birth of Venus that was represented. And Visconti was the first to indicate that this composition might be the one referred to by

Pliny, but he later rejected this idea on the grounds that this *Venus* was shown coming out of the bath rather than washing herself.[24]

Since the war the 'literature on this subject [the *Crouching Venus*] has been increasing at an astounding rate'.[25] Robertson has dismissed the 'airy construction' accepted by many scholars that the original was the work ascribed 'to a hypothetical Bithynian sculptor, Doidalses, active in the third century' and relates it to Pergamene sculptures such as the *Arrotino*.[26] The best versions are generally considered to be those in the Louvre, excavated at Vienne in 1828, and in the Museo Nazionale delle Terme, excavated at Hadrian's Villa in the 1920s.

1. Maffei, plate XXVIII.
2. Mansuelli, I, pp. 83–4.
3. Boyer, 1929, p. 268, no. 338.
4. *Documenti inediti*, IV, p. 80.
5. Lullies, pp. 10–17; and the review by Vermeule, 1956, pp. 460–2.
6. Gardey, Lambert and Oberthür, no. 112 (for Marcantonio Raimondi); Hülsen and Egger (Text), I, p. 6 and (Tafeln), I, fol. 6v (for Heemskerck drawing of the version now in Naples).
7. *Giambologna* (London), pp. 74–6.
8. Sainsbury, p. 337; Vermeule, 1955, pp. 149–50; Vermeule, 1956 (Review), p. 461.
9. Helbig, 1963–72, I, pp. 148–9.
10. Montaiglon (*Correspondance*), XVI, pp. 463, 498.
11. Paris—Archives Nationales, AF IV 1050, 4ème dossier (letter of 31 October 1808).
12. Mongez, 1789–1807, IV, 45ème livraison.
13. *Ibid.*
14. Souchal, 1977, I, pp. 191–2.
15. Vermeule, 1956 (Review), p. 461; Robertson, I, p. 557.
16. *Civiltà del settecento a Napoli*, pp. 124–5.
17. Zoffoli, Righetti (see Appendix). Zoffoli mentions 'Venere, nata dalla Spuma' without indicating its whereabouts; Righetti lists a 'Venus Marine de Médicis'.
18. Chappuis, I, pp. 250–1; II, figs. 1096–1100.
19. Northall, p. 344 ('a beautiful statue'); Richard, VI, pp. 151–2 ('excellent ouvrage grec').
20. [Eaton], I, p. 12.
21. Maffei, plate XXVIII.
22. *Documenti inediti*, IV, p. 80; Mansuelli, I, p. 83.
23. Richard, VI, pp. 151–2.
24. Visconti (*Pio-Clementino*), I, plate X.
25. Vermeule, 1956 (Review), p. 460.
26. Robertson, I, p. 557.

87. Venus Felix (Fig. 172)

ROME, MUSEI VATICANI (BELVEDERE COURTYARD)

Marble
Height: 2.14 m
Inscribed on base: VENERI FELICI . . . SACRUM/ SALLUSTIA . . . HELPIDUS. D.D.

Also known as: Empress Sallustia Barbia Orbiana as Venus, Venus Coelestis, Venus and Cupid, Victorious Venus

171. *Crouching Venus* (Uffizi).

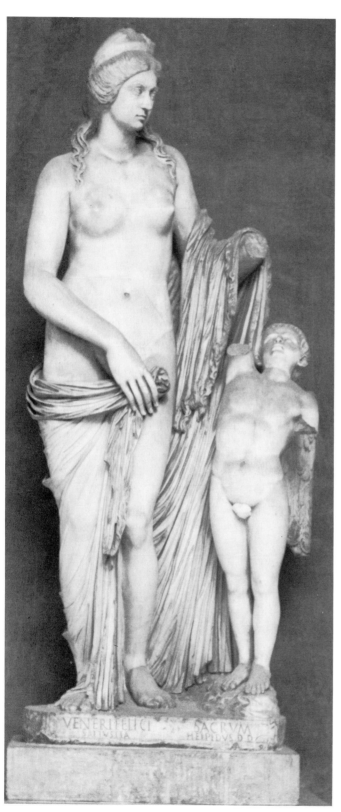

172. *Venus Felix* (Vatican Museum).

The *Venus* was recorded in the papal collections by 1509[1] and described in the Belvedere court-yard in 1523.[2] The date and location of the statue's discovery are unknown. Ficoroni in the eighteenth century claimed that it was excavated near S. Croce in Gerusalemme.[3] The hall of the Imperial residence, the 'sessorianum', of which the apse survives in the gardens of S. Croce, was known as the Temple of Venus and Cupid, perhaps because the statue was discovered there.[4] However, Ficoroni gave no source and there were rival theories as to the original nature of the building.[5]

The group was esteemed by visitors to the Belvedere in the sixteenth century,[6] and in the seventeenth century it was illustrated by Perrier among the most admired statues in Rome[7] and cast in plaster for Philip IV of Spain,[8] whilst the Cupid was described by the enthusiastic Rague-net as a work of genius.[9] However, it was not copied for Louis XIV and was not included in de Rossi's anthology of 1704. From the eighteenth and nineteenth centuries we have met with no casts or copies of it and no evidence of travellers admiring it, and, although its position in the Belvedere courtyard ensured that it was usually listed, some travellers even neglected to do this.

The inscription on the statue's base has of course always interested the learned. The identi-fication of the figure with Sallustia Barbia Or-biana, supposed consort of Alexander Severus (whose family dwelt in the Imperial residence where the statue was supposed to have been found) was, however, no guarantee that it was of anything other than mediocre artistic quality.

Neither Winckelmann[10] nor Visconti[11] ex-pressed any enthusiasm for the statue and the fact that the broken arm of the Venus and the two broken arms of the Cupid (which Visconti believed to have held either an apple or the helmet of Mars) were not repaired during the extensive compaign of restoration associated with the formation of the Museo Pio-Clementino also reflects a lack of interest in the work. The French did not want it.

The statue is regarded in Helbig as an Imperial portrait, probably of the second half of the second century, perhaps of the younger Faustina.[12]

1. Albertini in Valentini and Zucchetti, IV, p. 490.
2. Venetian Ambassadors in Albèri, p. 116.
3. Ficoroni, 1744 (*Vestigia*), p. 121.
4. Lanciani, 1897, p. 400.
5. Venuti, R., 1763, I, p. 130.
6. Venetian Ambassadors in Albèri, p. 116.

7. Perrier, 1638, plate 86.
8. Palomino, p. 915; Bottineau, p. 289.
9. Raguenet, pp. 310–12.
10. Winckelmann (ed. Fea), II, p. 136.
11. Visconti (*Pio-Clementino*), II, plate LII.
12. Helbig, 1963–72, I, p. 186.

88. Venus de' Medici (Fig. 173)

FLORENCE, UFFIZI (TRIBUNA)

Marble
Height: 1.53 m
Inscribed on base:

ΚΛΕΟΜΕΝΗΣ ΑΠΟΛΛΟΔΩΡΟΥ
ΑΘΗΝΑΙΟΣ ΕΠΩΕΣΕΝ

Also known as: Grecian Venus, Marine Venus,
 Venus Pontia

The *Venus* is recorded for certain in the Villa
Medici in Rome in 1638 when Perrier included
prints of it in his anthology of the most beautiful
statues.[1] It is probable that it is the Venus singled
out by Celio in his account of the Villa in 1620[2]
but, although it is possibly one of the Venuses
recorded in the inventory of the Villa in 1598,[3]
and even possibly identical with the Venus
acquired by the Medici from the Palazzo Valle-
Rustici-Bufalo, there is no good evidence for
this.[4] The statue was sent to Florence in August
1677 and by 1688 had been placed in the Tribuna
of the Uffizi.[5] In September 1800 it was shipped
with other treasures to Palermo to escape the
French.[6] Talleyrand negotiated for the return of
these on behalf of Luigi I, newly created King of
Etruria, but with the understanding that the
French would claim the *Venus*. However, in
February 1802, Luigi refused to accept this
proviso, and the French had to apply diplomatic
pressure on the Neapolitan court to send the
Venus to France rather than to Tuscany. The
Neapolitans agreed in September and the *Venus*
was sent to Marseilles together with the *Pallas of
Velletri*.[7] At six a.m. on 16 August 1803 the First
Consul arrived at the Musée in Paris to pay his
respects.[8] The statue was removed in October
1815,[9] and arrived back in Florence on 27
December 1815.[10] Canova's 'Venere Italica'
which had occupied its place of honour in the
Tribuna was then moved to the Palazzo Pitti
and the *Venus de' Medici* resumed its exalted
position.[11]

The *Venus* must have been very highly esteemed
in 1638 for Perrier to devote three plates to it in
his anthology of the most admired statues in
Rome[12] but its reputation seems to have grown

up gradually and the place and date of the statue's
discovery remain unknown. A variety of glam-
orous provenances were proposed in the late
seventeenth and eighteenth centuries, but with
no evidence.[13]

Pope Innocent XI surprised his contemporaries
by permitting the removal of this 'miracle of
art'[14] to Florence: he was supposed to have done
so because of the lewd behaviour which she
excited.[15] Once installed in the Tribuna the
statue was revered as the most beautiful Venus
and one of the half-dozen finest antique statues to
have survived. Luca Giordano copied her from
every possible angle, from close to and from a
distance, 'centinaia di volte';[16] the younger
Richardson could not take his eyes off her for ten
hours;[17] Spence paid her 'perhaps a hundred
visits';[18] and the poet Samuel Rogers, a hundred
years or so later, was to be seen 'every day about
eleven or twelve' seated opposite her.[19] Writer
after writer recited litanies of praise for the
'Softness of the Flesh, the Delicacy of the Shape,
Air and Posture, and the Correctness of Des-
ign',[20] and so on, many prefacing their remarks
with comment on the inadequacy of any words
to 'describe the indescribable' (Byron's phrase
which concluded his five stanzas of description in
Childe Harold).[21] Every detail of the goddess's
anatomy was specially examined. Spence, who
was particularly taken by the breasts ('small,
distinct and delicate to the highest degree'),
recorded an English lady's initial worry that the
waist was not fine enough, which was dispelled
when her taste was improved.[22] Nearly a cen-
tury later the size of the goddess's ankles and
head prevented Charles Greville from working
himself into 'a proper enthusiasm', but he was
told to keep visiting her and four days later he
began to like the statue 'better, best of all the
statues'.[23]

The Richardsons recorded in 1722 that owing
to anxiety as to the damage which moulds might
cause to the statue none had been made since
those taken for the Duke of Marlborough's
bronze copy.[24] The numerous plaster casts of the
statue made in the eighteenth century were
generally after-casts: those which were not (such
as the one supplied by Torrenti to Lock of
Norbury)[25] were much prized. The *Venus* is one
of the most copied sculptures of all time. No less
than five were made for Louis XIV: in marble by
Carlier, Clerion, Coysevox, Frémery (complet-
ing a work started by Monnier), and in bronze
by the Keller brothers;[26] and it was probably the
most popular of all the lead copies produced for

English eighteenth-century gardens. Copies were also immensely popular on a small scale in bronze. Founders of these statuettes frequently excluded the dolphin support which was of course unnecessary in this medium, and it is remarkable that the very existence of the dolphin was not then considered as evidence that the statue was a copy of a bronze, especially since its inferior quality was commented on by Richardson[27] and by Montesquieu (who suggested that an apprentice had worked on it).[28]

When copies of the *Venus* were paired off her companion was generally one of the statues in the Tribuna such as the *Dancing Faun* (as in the early eighteenth-century entrance hall at Towneley in Lancashire). A small alabaster copy at Stourhead in Wiltshire is paired with the *Callipygian Venus*, as are figurines of these two statues in biscuit de Sèvres.[29] Not all imitations of the statue were inanimate. A 'living warm representation' was given in October 1814 in Florence (when the marble itself was in Paris) in a ballet entitled *Il Pittore Amoroso*. 'It is evident', observed the English traveller John Mayne, 'that such an exhibition could not often find a lady capable of giving it effect', but he indignantly admitted that the first dancer was equal to the part.[30]

Great significance was at first attached to the Greek signature of Cleomenes son of Apollodorus on the statue's base and for this reason the *Venus* was known as the 'Grecian Venus',[31] and the name Cleomenes forged on indifferent pieces to enhance their value.[32] Such was the reputation of the statue in the eighteenth century, however, that the originality of the signature was questioned in order that the *Venus* could be ascribed to Phidias (an attribution already made by Sandrart in the seventeenth century);[33] Praxiteles (there was a possibility, some thought, that it was the Cnidian);[34] or Scopas.[35] The signature is not original, but it might be a copy of one that was, as Visconti suggested.[36]

There were, during the eighteenth century, a few heretics: de Brosses, for instance, who was sure the statue was by Phidias and dismissed the signature, was not struck by the beauty of the face. However, 'mylord Sandwich' who chanced to be in the Tribuna at the time was able to inform him that all the women who were considered beautiful in Greece when he was there had a similar look.[37] Later, Smollett claimed not only that the features lacked beauty, but that the attitude was 'awkward and out of character', and although he conceded that 'the limbs and proportions' and especially 'the back

parts' were admirable his views were considered outrageous.[38] The qualifications which Winckelmann was to mingle with his praise were far more significant. The navel, he thought, was too deep and the face perhaps a portrait and therefore lacking in the ideal.[39] Like Cochin before him he also drew attention to the restorations,[40] and in fact the arms (credited in the eighteenth century to Bandinelli[41] and in the nineteenth century to Bernini,[42] but known to have been remade by Ercole Ferrata when the statue arrived, damaged, from Rome) were looking out of place to more and more observers. As early as 1700 the Duke of Shrewsbury felt that the arms 'were not so vigorous a shape as the rest of her body';[43] in 1722 the Richardsons criticised the long tapering fingers;[44] and in 1739 the date of the English translation of the fifth edition of Misson's *Nouveau Voyage* we find the rhapsody on the 'decent Bashfulness . . . spotless Modesty and Chastity . . . Sweetness, Beauty and Delicacy and Air of Youth' of the *Venus* (which had appeared in this popular guide since 1691)[45] accompanied by a marginal note disowning this as the language of an 'excessive' admirer, and deploring the hands and, oddly, the feet.[46] Some also suspected that the head, which had been broken and re-set, was the work of a different artist.[47] The various breaks in the statue were bound to be noticed by those who examined her with devotion, and Montesquieu records the tradition that St. Gregory had attacked the statue.[48] Worries about the extent of restoration and repair, however, although they became more serious,[49] hardly, in the eighteenth century, affected the status of the *Venus*.

Several statues of the same type as the *Venus de' Medici* were known in the eighteenth century and travellers debated as to which was the next most beautiful.[50] One of these, in the Barberini collection, was deliberately promoted as a rival by the dealer Thomas Jenkins who had purchased it from Gavin Hamilton and had it restored. The 'Jenkins Venus' was sold for an undisclosed, but supposedly fabulous, sum in 1765 to William Weddell, but even though there seems to have been a cast of it at Hanover its location at Newby Hall in Yorkshire (Fig. 35) gave it no chance of attracting international admiration.[51] Nor could the Venus in Dresden, despite the fact that it adorned a royal collection in a major city and was superbly published,[52] compete with the statue in the Tribuna of the Uffizi. It was only in the first years of the nineteenth century that a scholar suggested that a

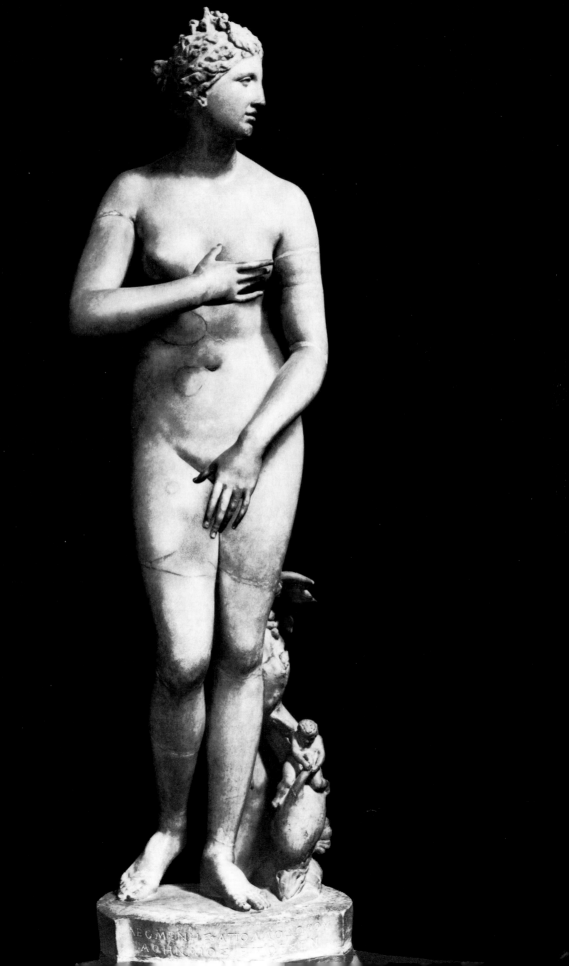

similar type of head (the 'Leconfield Aphrodite' at Petworth, Sussex) was part of a Greek original from which the *Venus de' Medici* was copied,[53] an idea later taken up by German archaeologists.[54]

The desperate attempts by the Florentines to keep the statue and the determination of the French to possess it demonstrate that its glamour was undiminished, but more and more travellers yielded to the temptation to blaspheme against something that had been worshipped so ardently for so long, and the *Venus* was also subjected to cooler scrutiny from a new generation of scholars. Kotzebue dared to assert that the ladies' maids in Berlin were more attractive—for which he was called not only a 'great fool' but a 'real sinner'.[55] To Hazlitt she seemed 'somewhat insipid'.[56] Flaxman, who in 1795 considered that it 'derived its reputation from its superior excellence not from its originality',[57] later informed his students that the statue was a 'deteriorated' version of the Cnidian Venus, or a copy of another Praxitelean original, and preferred the *Capitoline Venus* because its beauty was less 'insinuating'.[58] For others, however, her charms were like those of the angels 'who are of no sex',[59] and even in 1840 when it was almost fashionable to disparage the statue the young John Ruskin could declare it 'one of the purest and most elevated incarnations of woman conceivable'.[60] Copies continued to be mass-produced throughout the century.

The *Venus* which has recently been dimissed as 'among the most charmless remnants of antiquity',[61] is catalogued by Mansuelli as a copy, perhaps Athenian and of the first century B.C., of a bronze original derived from the type of the Cnidian Venus of Praxiteles perhaps by one of the sons or immediate followers of that master.[62]

1. Perrier, 1638, plates 81–3.
2. Celio, p. 139 (of facsimile). This was written in 1620.
3. Boyer, 1929, p. 261 (no. 32); p. 263 (no. 111); p. 267 (no. 308).
4. Bencivenni Pelli, I, p. 159; II, pp. 98–9; Michaelis, 1891–2, ii, p. 236; Reinach, 1902, p. 52; Bober, p. 50; Mansuelli, I, p. 70.
5. Florence, Archivio di Stato, Med. Princ. 3943, 24 August 1677; Baldinucci, II, pp. 497–8 (life of Buontalenti, first published in 1688).
6. Florence, A.G.F., Filza XXX, 1800–1801, n. 23.
7. Zobi, III, pp. 518–22 and appendix, pp. 243–50; Boyer, 1970, pp. 187–92, 196.
8. Lanzac de Laborie, VIII, p. 278.
9. Saunier, p. 149.
10. *Diario di Roma*, 6 January 1816.
11. Honour, 1972.
12. Perrier, 1638, plates 81–3.
13. Sandrart, 1680, p. 16; Bartoli, Mem. 108; Acton, p. 54; Bianchi, pp. 192–6.
14. Evelyn, II, p. 286.
15. Bencivenni Pelli, II, pp. 206–7, note cxxxiii.
16. Meloni Trkulja, p. 31.
17. Richardson, 1722, p. 56.
18. Spence, p. 68.
19. [Jameson], p. 98.
20. Addison, p. 421; see also Hale.
21. Byron: *Childe Harold*, canto IV, stanzas xlix–liii.
22. Spence, pp. 66–7.
23. Greville, I, pp. 397, 398.
24. Richardson, 1722, p. 57.
25. Dallaway, 1800, p. 393.
26. Lami, 1906, p. 381; Keller-Dorian, I, pp. 40–2; Souchal, 1977, I, pp. 80, 104, 301.
27. Richardson, 1722, p. 166.
28. Montesquieu, II, pp. 1332–3 (*Voyage d'Italie*).
29. Bourgeois, p. 12 (nos. 608, 610).
30. Mayne, pp. 144–5.
31. Stone, pp. 193, 196; Van Nost, nos. 19, 46, 66; Hogarth, p. 66.
32. Michaelis, 1882, pp. 46–7 and note.
33. Sandrart, 1680, p. 16; cf. Gori, 1734, plates XXVI, XXVII, XXVIII; Bianchi, pp. 194–6.
34. Beckford, I, pp. 167–8; Starke, 1800, I, p. 254.
35. Heyne ('Venus'), p. 9.
36. *Musée Français*, Discours, p. 92. See also Loewy, 1885, pp. 339–42.
37. De Brosses, I, p. 220.
38. Smollett, p. 236 (letter XXVIII).
39. Winckelmann (ed. Fea), II, pp. 314–15, 386; Winckelmann, 1968, p. 152 (*Erinnerung*).
40. Cochin, II, p. 37.
41. Wright, II, p. 406.
42. *Specimens of Antient Sculpture*, II, pp. xxxiii, lix.
43. Shrewsbury Journal, p. 104.
44. Richardson, 1722, pp. 55–6.
45. Misson, 1691, II, pp. 151–2.
46. Misson, 1739, II, i, p. 285.
47. Spence, p. 66.
48. Montesquieu, II, p. 1333 (*Voyage d'Italie*).
49. E.g. Bell, J., pp. 284–5.
50. Misson, 1691, II, p. 35; Richardson, 1728, III, ii, p. 525; Northall, p. 318; De Brosses, II, p. 39.
51. Winckelmann (*Briefe*), III, pp. 42, 44, 103–4, 106; Heyne ('Venus'), pp. 33–4, note; Michaelis, 1882, pp. 527–9.
52. Le Plat, plates 28–32; Heyne ('Venus'), p. 35.
53. [Knight], 1809, plates XLV, XLVI.
54. Amelung, 1897, p. 47.
55. Raumer, I, p. 336.
56. Hazlitt, p. 148.
57. Farington, II, p. 445.
58. Flaxman, pp. 25, 91, 93–4, 190.
59. Matthews, I, p. 47.
60. Ruskin, I, p. 433.
61. Robertson, I, p. 549.
62. Mansuelli, I, pp. 71–3.

89. Venus de Milo (Fig. 174)

PARIS, LOUVRE

Marble
Height: 2.038 m

The *Venus* was excavated by a peasant in an 'espèce de niche' close to the property of the Crown Prince Ludwig of Bavaria on the island of Melos at the end of March or in very early April 1820. It was seen soon afterwards by D'Urville, a French naval lieutenant, who together with Brest, French vice-consul on the island, assisted the Vicomte de Marcellus to

acquire the statue on behalf of the latter's superi-or, the Marquis de Rivière, French ambassador to the Porte. It was already on board a Turkish vessel ready for dispatch to Prince Morosini when the negotiations were concluded. It was shipped from the island on 24 May 1820 by the French. De Rivière gave the sculpture to Louis XVIII who in turn presented it to the Louvre where it was displayed in 1821.[1]

The discovery of the *Venus* and its arrival in the Louvre (where it was given the pedestal of the *Diane Chasseresse*)[2] occurred soon after the *Venus de' Medici* had been returned to Florence and it comes as no surprise that the French considered her charms to be superior to those of the goddess they had just lost. The statue was found in two main pieces (it had in fact been carved out of two blocks) which were hastily and incorrectly joined together and had to be re-set in 1871,[3] but the statue was not restored. In this respect it differed from the *Venus de' Medici* and resembled the sculpture from the Parthenon in London—and the French authorities considered the *Venus* to be a comparable, and emphatically Greek, acquisition.[4]

But in fact the *Venus de Milo* would have been restored had it not been for uncertainty as to the form this should take. According to the Comte de Clarac, the Conservateur of the Musée, the statue was a Venus Victrix and originally held the apple of Paris;[5] according to Éméric-David it was originally either a Muse holding a lyre or the guardian deity of the island holding, as her attribute, a fruit;[6] according to Millingen the figure originally supported a shield like the Capuan Venus in Naples;[7] and according to Quatremère de Quincy it was part of a group showing Venus detaining the warrior Mars with her charms[8]—a composition, crudely re-flected in allegorical Roman portraiture of the Imperial family, which had inspired a greatly admired group by Canova being executed in marble at the very moment of the discovery of the *Venus* on Melos.[9]

In 1846 Leconte de Lisle wrote a rhapsodic poem on the statue:

Pure comme un éclair et comme une harmonie
O Vénus, ô beauté, blanche mère des Dieux![10]

Daumier's amateur, in a poignant watercolour in the Metropolitan Museum, sits mesmerised by one of the numerous reduced copies of it,[11] but it is much more significant that a cast of the *Venus* had been set up in the Berlin Academy as early as

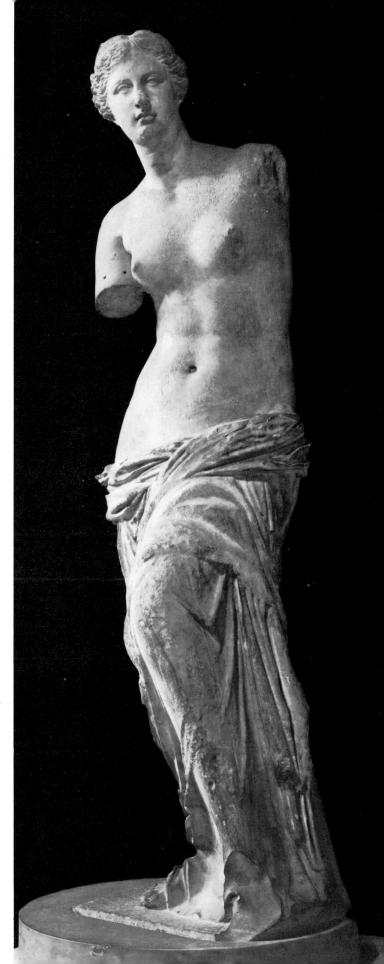

174. *Venus de Milo* (Louvre).

1822[12] and that the English, then so reluctant to acknowledge any form of French cultural priority, gave a cast of the statue pride of place in the Greek court of the Crystal Palace, with the *Discobolus*, the *Laocoon*, the *Cleopatra* and the *Barberini Faun* around it, and described the statue in the catalogue as 'unrivalled' and affording 'perhaps the most perfect combination of grandeur and beauty in the female form'.[13] Walter Pater, in his essay on Luca della Robbia of 1872, was particularly attracted by the statue's unrestored condition, its frayed surface and softened lines making it seem as if 'some spirit in the thing' was 'on the point of breaking out'—'as though in it classical sculpture had advanced already one step into the mystical Christian age'.[14]

A block inscribed with the signature '. . . andros of Antioch on the Maeander' was found with the *Venus* and was recorded in a drawing of the statue made by a pupil of Baron Gros for the exiled French painter David.[15] But some of those who wished to exalt the work (and in particular to associate it with Praxiteles) followed Quatremère in questioning whether the block had anything to do with the statue, and Clarac, despite his position in the Louvre, was rudely ignored because be believed that the inscription did belong.[16] The convenient loss of the block rather strengthened the suspicion that Clarac had been right—and some German archaeologists in the late nineteenth century accused the French of deliberately destroying the evidence.[17]

The statue remains one of the most famous in the world, 'on sale in white plastic in the gift shops of Athens and everywhere else', but the author of a recent study of Aphrodite suspects that most of his readers are 'unmoved' or 'even repelled' by the 'rather chill giantess in the Louvre'.[18] Moreover, its reputation, 'which, started by propaganda, has become perpetuated by habit',[19] perplexes the scholars who since the late nineteenth century have tended to place it in the second century B.C. and believe it to represent a revival of earlier pre-Hellenistic ideals.[20] Such is Robertson's view and he also considers that the fragment bearing the name '. . . andros of Antioch' and another fragment of a hand holding an apple (a punning reference to Melos) belonged.[21]

1. Clarac, 1820, 2ème supplément, pp. 6ff; Ravaisson, pp. 3–6; Loewy, 1885, p. 213 (quoting Dumont D'Urville).
2. Ravaisson, p. 23.
3. *Ibid.*, pp. 5–25.
4. Saint-Victor, I, p. 19.

5. Clarac, 1821.
6. Éméric-David, 1821.
7. Millingen, pp. 7–8.
8. Quatremère de Quincy, 1821.
9. Buckingham Palace, London—Pavanello, no. 307.
10. Leconte de Lisle, *Poèmes antiques*, 1852, no. XVI.
11. Maison, II, pp. 126–7, plate 118.
12. *Berlin und die Antike*, p. 95.
13. Phillips, p. 32.
14. Pater, 1873, pp. 56–7.
15. Loewy, 1885, pp. 214–15 (quoting Longpérier).
16. Furtwängler, 1895, p. 369.
17. Friederichs, 1868, p. 334; for a full discussion of the problem, see Loewy, 1885, pp. 209–15.
18. Grigson, pp. 156–7.
19. Robertson, I, p. 554.
20. Murray, II, pp. 275–6; Furtwängler, 1895, pp. 367–401.
21. Robertson, I, pp. 553–4.

90. Standing Venus (Fig. 175)

ROME, MUSEI VATICANI (STORE)

Marble
Height (including base): 2.50 m
Also known as: Venus emerging from the bath, Pudic Venus

This statue is referred to in a document of 1536 recording payment for the decoration of a niche 'where is to be placed the Venus which the Governor of Rome gave to his Holiness'.[1] In the same year it was described in the Belvedere statue court.[2] From 1792 until 1832 it was in the Galleria delle Statue of the Museo Pio-Clementino, but about then—certainly before 1839—Pope Gregory XVI ('nemico di ogni nudità dell'arte'), who was not satisfied by the stucco drapery which had been given to the statue, put it in store and forbade all access to it.[3]

In the sixteenth and early seventeenth centuries the *Venus* was certainly a very famous and widely admired statue. A small woodcut was made of it immediately after its installation in the statue court to accompany a set of poems on 'the Laocoon, the Venus, and the Apollo';[4] it was cast in bronze for François Ier;[5] it was no doubt the 'Venere di Fidia', the subject of a poem in the second part of Marino's *Galleria* of 1616, which the poet specified as being in the Vatican; it was included by Perrier in 1638 in his anthology of prints of the most famous antique statues;[6] and it was praised by the English traveller Mortoft in the highest terms.[7] In 1704 Maffei, in his commentary on the plate in de Rossi's anthology, made clear that he felt the statue to be immoral.[8] Approval of the work on artistic grounds was also rarer thereafter. And it comes as no surprise

to discover that the Richardsons did not bother to comment on it in their first account of works of art in Italy.

In 1728, however, in the enlarged French edition of this work, the Richardsons pointed out that a coin of Caracalla and Plautilla in the French royal collection indicated that the Vatican statue might be a copy of the Venus of Cnidos by Praxiteles, the most famous statue of the ancient world.[9] Falconet found himself unable to accept this idea,[10] but Mengs, noting the clumsy carving of the body, compared with the head, and struck by the superior quality of a similar head in Madrid, also concluded that the Vatican statue must be a copy.[11] Two years after Mengs's death four Venuses were presented to Pope Pius VI by the Conestabile Colonna, and the best of these, a statue of the same type as the *Standing Venus*, was published by Visconti as a copy of the Cnidian Venus,[12] and entirely eclipsed the once famous statue of the Belvedere.

Although some scholars found it possible, even in 1835, to believe that statues of the Medici type were closer to the Cnidian Venus,[13] Visconti's idea was generally accepted and the statue he published has remained the best-known copy of Praxiteles' masterpiece. Archaeological enthusiasm was no match for moral alarm, however, and by the early nineteenth century the Colonna statue, although displayed, was clad in tin drapery. Photographs without this protection were not allowed, and it was not removed until 1932 when the statue was moved to the Gabinetto delle Maschere where it remains today.[14] Meanwhile the *Standing Venus* has been rediscovered by a succession of experts, and they have sometimes preferred it to the Colonna statue.[15] It has been described by the cataloguers of the Vatican reserve as a Roman copy of the Cnidian Aphrodite.[16]

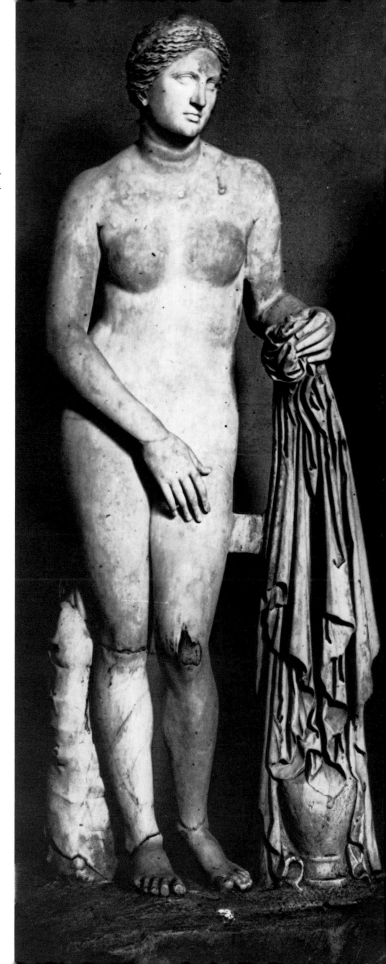

1. Ackerman, 1954, p. 158 (doc. 34e).
2. Brummer, p. 267 (quoting Fichard).
3. Kaschnitz-Weinberg, I, pp. 116–19.
4. Brummer, p. 209.
5. Pressouyre, 1969 ('Fontes'), p. 229.
6. Perrier, 1638, plate 85.
7. Mortoft, p. 130.
8. Maffei, plate IV.
9. Richardson, 1728, III, ii, pp. 520–1.
10. Falconet, II, p. 330.
11. Mengs, pp. 87, 358.
12. Visconti (*Pio-Clementino*), I, plate XI.
13. *Specimens of Antient Sculpture*, II, p. lix.
14. Amelung and Lippold, II, pp. 526–31; also p. 113, note 2, of Vol. I of the French edition of the complete works of Visconti, and, for the question of photography, Gardner, II, p. 362, note.
15. Furtwängler, 1895, p. 322, note 3; Rizzo, pp. 48–54.
16. Kaschnitz-Weinberg, I, pp. 116–19.

175. *Standing Venus* (Vatican Museum).

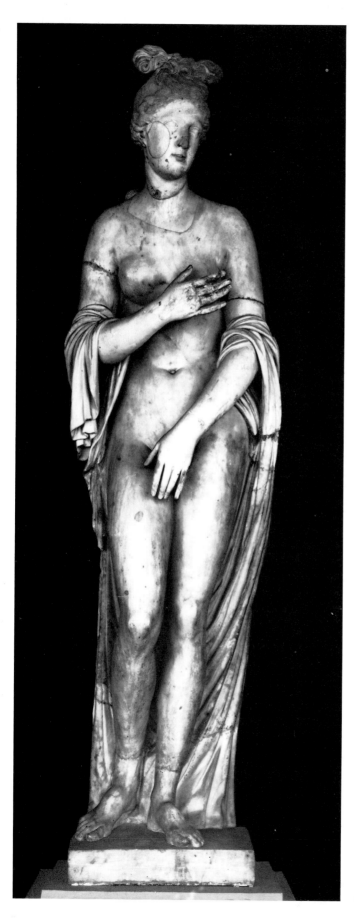

91. Venus Victrix (Fig. 176)

FLORENCE, UFFIZI

Marble
Height (without head): 1.89 m

Also known as: Venus with the apple, Belvedere
 Venus, Venus Maritata

This statue is first noted in 1677 as being in the
Grand Duke of Tuscany's collection when Er-
cole Ferrata, who was engaged on restoring the
sculpture, claimed to be able to recognise it as the
mutilated and badly repaired fragment of a
statue of Venus which had once been in the
Belvedere in Rome and of which he himself
owned a plaster cast made when it was still
comparatively undamaged. On being consulted
Bellori and Pietro Santi Bartoli said that
they had read 'in some book' that Pope
Pius V (1566–72)—others suggested Pius IV
(1559–65)—had planned to give all the statues in
the Belvedere to the Grand Duke, and that,
though he had been prevented by death from
carrying out his intentions, this must have been
one of those that was sent.[1] The story is perfectly
possible, but it is almost certain that this Venus
was never actually in the statue court. By 1688 it
had been placed in the Tribuna of the Uffizi,[2] but
by 1782 it had been removed to the Stanza
dell'Ermafrodito.[3] It has since been placed in
different locations in the museum.

This statue was frequently compared with the
other Venuses in the Tribuna,[4] and was thus very
well known throughout most of the eighteenth
century. It was also much admired, though
Gori's extreme enthusiasm was (as so frequently)
rather exceptional and his reinforcement of
Maffei's tentative attribution to Phidias did not
find much support.[5] The extent of Ferrata's
restoration was generally known and generally
praised,[6] but it was not until 1759 that Giuseppe
Bianchi pointed out that, as Ferrata had had no
cast of the head and arms of the Belvedere
original, he had had to invent these features for
himself, whereas for the rest of the body he had
been able to rely on sound evidence: there was,
therefore, no convincing reason for believing
that the ancient artist had wished to portray the
victorious Venus holding the apple which Paris
had awarded her. Bianchi also alluded to an old
story that the Venus had been flung into the
Tiber 'out of zeal for religion'.[7]

Like the Celestial Venus this one too declined
in reputation towards the end of the eighteenth

176. Venus Victrix (Uffizi) before removal of early nineteenth-
century restoration.

century. It was not depicted in Zoffany's famous (though partly fanciful) view of the Tribuna of 1772 (Fig. 30), and, not long after, it was removed from the Tribuna itself. Nor was it taken to Palermo in 1800 to escape the French. Soon afterwards, however, a curious proposal was apparently made to promote the status of this 'creation of Phidias' by altering the arms in such a way as to make it conform to the posture of the *Venus de' Medici*, by then in Paris. Kotzebue, in Florence in 1804, found this plan 'sehr drollig'.[8] The necessary surgery was, however, effected.

The statue is catalogued by Mansuelli as belonging to the generic type of a Venus pudica probably deriving from an original of the fourth century B.C.[9]

1. Florence, Archivio di Stato, Med. Princ. 3944; Lankheit, p. 255 (doc. 127); Baldinucci, V, pp. 385–6.
2. Baldinucci, II, pp. 497–8 (life of Buontalenti, first published in 1688).
3. Lanzi, p. 77.
4. Richardson, 1722, p. 56; Wright, II, p. 406; Burney, p. 110.
5. Maffei, plate XXVII; Gori, 1734, plate XXXI.
6. Wright, II, p. 406; Montesquieu, II, pp. 1333–4 (*Voyage d'Italie*); Bianchi, pp. 205–6; Caylus, 1914, p. 315.
7. Bianchi, pp. 205–6.
8. Kotzebue, I, p. 103.
9. Mansuelli, I, pp. 127–8.

92. The Winged Victory of Samothrace

PARIS, LOUVRE

(Fig. 177)

Marble
Height (figure): *c.* 2.00 m

The *Victory* was discovered in April 1863 on the island of Samothrace by a small team of excavators led by Charles Champoiseau, the French Consul at Adrianople. The statue was sent to Paris in the same year and erected four years later in the Salle des Caryatides of the Louvre after the wings and parts of the drapery had been reassembled (and in part patched with plaster). A French expedition to the island in 1866 found nothing more but when Champoiseau returned in 1879 he succeeded in reconstructing from the marble debris the statue's rostral pedestal.[1] This was also removed to France and in the spring of 1884 the *Victory* was placed upon it in a position dominating the Escalier Daru where it remains today.[2] Excavations in 1950 brought to light the palm and the end of the second finger of the goddess's right hand and in the same year her thumb and the lower part of her second finger were found in the reserve collection of the Kunsthistorisches Museum in Vienna (trophies

of the Austrian excavations at Samothrace in 1873 and 1875).[3] A fragmentary left hand, which, although different in scale, may belong to the statue, was discovered in 1967.[4]

Fröhner considered the *Victory* comparable in quality to the Parthenon sculpture in London,[5] though, he admitted, it was of a later period. Champoiseau, when he first published the statue, considered that it was set up by Demetrios I between 295 and 287 B.C., when a supposedly similar Nike featured on his coinage, and proposed that it was the work of one of the best disciples of Lysippus.[6] Others maintained that it was by pupils of Scopas.[7]

At first purists in France felt that the *Victory* was decorative work of 'une époque assez basse'[8] and outside France purists continued to disparage the work as a 'sensational' virtuoso performance.[9] But once the statue was removed from a gloomy corner of the Salles des Caryatides to the Escalier Daru[10] its popularity with visitors to the Louvre was assured. No classical education is needed to appreciate the personification, nor is it hard to grasp the drama of the figure's action given its superb position—and this is so despite the absence of arms and head; indeed perhaps its maimed condition has helped make the life it retains seem more miraculous. The statue was available in casts in foreign academies such as the one at Bologna (where one still survives), it was the subject of rapturous poetry (including a sonnet by d'Annunzio),[11] and it was singled out by Marinetti in his Futurist manifesto of 20 February 1909 as the symbol of the classical culture which the heroic new age of the machine gun and racing car would supercede.[12]

The right hand of the *Victory* was originally supposed to have held a trumpet, and a model was made in support of this theory.[13] Another idea was that a victor's crown was in the raised hand, and a bronze version of the statue thus equipped was made for the collector Engel-Gros by Cordonnier and published by the French archaeologist Reinach.[14] The recently discovered fragments suggest that the statue held nothing—or, as one authority has proposed, at most a metal taenia between index finger and thumb.[15] The ceramic evidence uncovered in recent excavations has revealed that the pedestal was set up around 200 B.C.[16]

1. Rayet, 1881 ('Victoire'), p. 3; Champoiseau; Reinach, 1891, pp. 89–96.
2. Reinach, 1891, p. 96.
3. Charbonneaux, 1952.
4. Lehmann, 1973, p. 184, note.

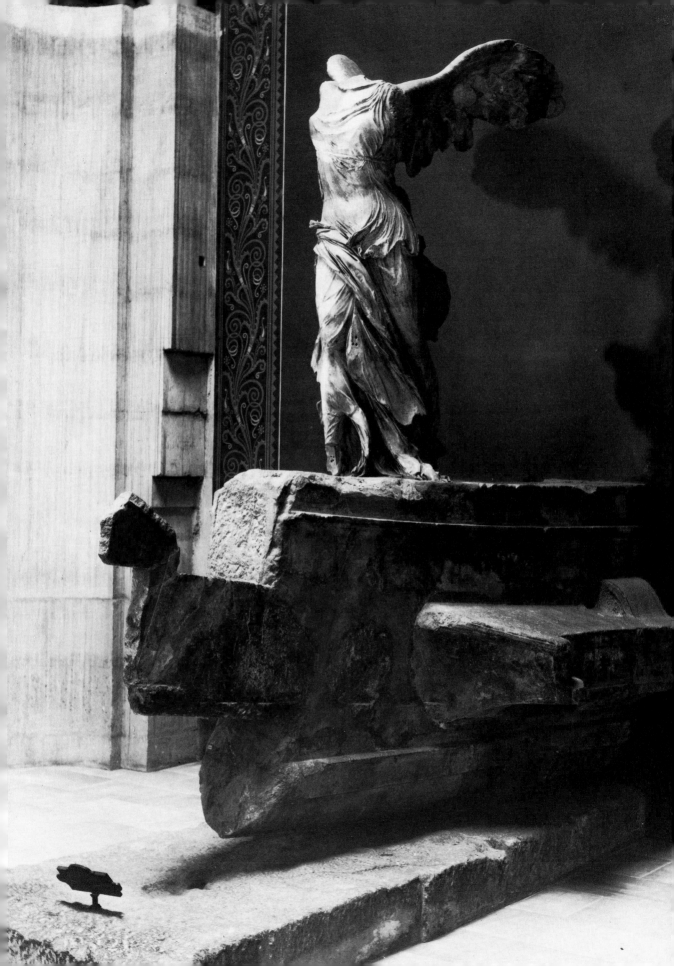

5. Fröhner, p. 434.
6. Champoiseau.
7. Newton, p. 90; Rayet, 1881 ('Victoire'), pp. 10–11.
8. Rayet, 1881 ('Victoire'), p. 3.
9. Gardner, II, pp. 485–7; Murray, II, p. 375.
10. Rayet, 1881 ('Victoire'), p. 3.
11. D'Annunzio, *Sonnets Cisalpins*, no. XII; Kranz, pp. 31–40.
12. Apollonio, p. 21.
13. Villefosse and Michon, p. 129; Reinach, 1891, pp. 93, 96–7.
14. Reinach, 1891, p. 103.
15. Charbonneaux, 1952; Lehmann, 1973, p. 184, note.
16. Lehmann, 1952, p. 20; Lehmann, 1973, p. 183.

93. Wolf (Fig. 178)

ROME, MUSEI CAPITOLINI (PALAZZO DEI CONSERVATORI)

Bronze
Height: 0.75 m; Length: 1.14 m

This statue is first mentioned at the very end of the tenth century as being at the Lateran where executions were carried out—as they still were four centuries later.[1] In the late twelfth or early thirteenth century the body of the *Wolf* stood in the portico at the entrance to the palace, represented as if stalking a bronze ram (which has long disappeared), from whose mouth came a stream of water for washing one's hands: the *Wolf* had apparently served the same purpose, the water coming from the teats, but by the time of this description it had been broken off at the feet, which (with the pedestal) probably remained in the open air in front of the palace.[2] In 1471 the *Wolf* was given to the Conservators of Rome by Pope Sixtus IV,[3] and by 1509 the figures of Romulus and Remus had been added.[4] We know that by about 1536 it had been placed above the entrance to the Palazzo dei Conservatori[5] and that by 1544 (when the whole area was being radically reconstructed by Michelangelo) it had been taken inside.[6] By 1627 it was in a room named after it, but it was subsequently moved to various other rooms in the palace.[7] In 1798 it was taken, with the *Pompey* from the Palazzo Spada, to the Teatro di Apollo (formerly Tordinona) to serve as a prop for a performance there on 22 September of Voltaire's *La Mort de César*.[8] During part of the nineteenth century it was kept in the Capitoline Museum, but it was returned to the Palazzo dei Conservatori after 1876.[9]

Until Winckelmann made the point almost in passing[10] no one seems to have been aware of the fact that the figures of Romulus and Remus were modern additions to the antique statue, and this ignorance helped to confuse an already very confusing situation. The earliest commentators were content to observe and admire,[11] but by the middle of the sixteenth century antiquarians felt the need to relate so portentous an image to some work referred to in the literature of antiquity.[12] Of the several possible references that could be found two assumed special importance.[13] Livy described how in the year 296 B.C. the aediles Gnaius and Quintus Ogulnius, having denounced a group of usurers, made use of the fines imposed upon them in order to place near the Rumanilis figtree 'the statues of the Children, the Fathers of the City, beneath the mammals of a Wolf'[14]—the ambiguity of the phrasing which left it unclear whether only the Children or the whole group of Wolf and Children were then made troubled no one until the investigations of modern scholars.[15] In addition Cicero referred—in circumstances to be discussed below—to a Wolf with Romulus (and, presumably, Remus) which was on the Capitol in his day. Throughout much of the sixteenth and seventeenth centuries antiquarians and travellers seems to have assumed that both writers were alluding to the same Wolf (though they usually singled out the one discussed by Livy) and that this was the one that could be seen in the Palazzo dei Conservatori.[16]

Some time towards the end of the seventeenth century the implications of the literary texts were examined much more closely than before. It was then pointed out that Cicero's reference to the Wolf on the Capitol had been very precise. Followed, with only slight variations, by Dio Cassius,[17] Cicero claimed that as an omen of Catiline's conspiracy against the State in 65 B.C. a tremendous thunderstorm had burst over Rome and that among the monuments struck by lightning had been 'Romulus, Founder of our City . . . I mean that gilt one you remember in the Capitol, representing him a little Sucking Child, stretching his Lips towards the Dugs of a Wolf.'[18]

From the end of the seventeenth century, and especially after the second decade of the eighteenth, travellers to Rome were shown traces of damage, apparently caused by fire, on one of the hind legs of the *Wolf* and were told that this was proof that the animal was indeed the one mentioned by Cicero as having been struck by lightning.[19] These travellers seem to have been unimpressed at best and sometimes downright sceptical.[20] During the next half century, however, ever, the story changed radically. By 1740 it was

335

being claimed that the *Wolf* had certainly been struck by lightning as mentioned by Cicero—the marks were there for all to see—but that this had occurred on the very day that Julius Caesar had been assassinated.[21] The fact that there was no exact authority for this to be found anywhere in ancient literature (let alone in the works of Cicero, whose name was always invoked) worried only a few of those who were told the story[22] which was repeated by all guides and travellers to Rome.[23] This legend reached its climax on 22 September 1798, during the short-lived Roman Republic, when, in order to give verisimilitude to a performance of Voltaire's *La Mort de César*, the *Pompey* from Palazzo Spada, at whose feet Caesar was supposed to have fallen after his assassination, and the *Wolf* from the Capitol were both brought onto the stage of the Teatro di Apollo.[24] It was perhaps to exorcise these revolutionary associations that in 1819 the *Wolf* was placed on the centre of the table during the course of a banquet for a thousand guests given on the Capitol in honour of the Emperor of Austria and his chief minister, Prince Metternich.[25] Later, during the course of the nineteenth and twentieth centuries, the *Wolf* often became identified with the cause of Italian nationalism and 'Romanità'.[26]

The need to maintain the status of the *Wolf* led to some curious experiments and conclusions. In 1820 Carlo Fea, who had played such a leading role in 'demoting' the Spada *Pompey* and who was not wholly convinced that the Capitoline *Wolf* was the one mentioned by Cicero, nonetheless claimed that 'physico-chemical proofs' demonstrated that it must have been struck by lightning[27]—and, after further analysis, this claim was repeated in 1909.[28] Paradoxically some travellers who were sceptical about the lightning began in the first decades of the nineteenth century to notice traces of the gilding referred to by Cicero.[29] 'What fire, and when?' Miss Berry had asked in 1784, but she then continued: 'No matter; I like to believe any stories that tend to a supposition that the Almighty sometimes deigns to interest Himself in the fate of mortals.'[30] So too did some of the greatest nineteenth-century historians who remained awe-inspired by the prodigious associations of the *Wolf* (which they increasingly linked to Catiline rather than to Caesar), despite their distaste for it on aesthetic grounds: 'a very rude work of art', wrote Macaulay to Richard Westmacott the Younger in 1843: 'I am quite sure that you would without the least difficulty produce one infinitely superior', but he added

178. *Wolf* (Palazzo dei Conservatori).

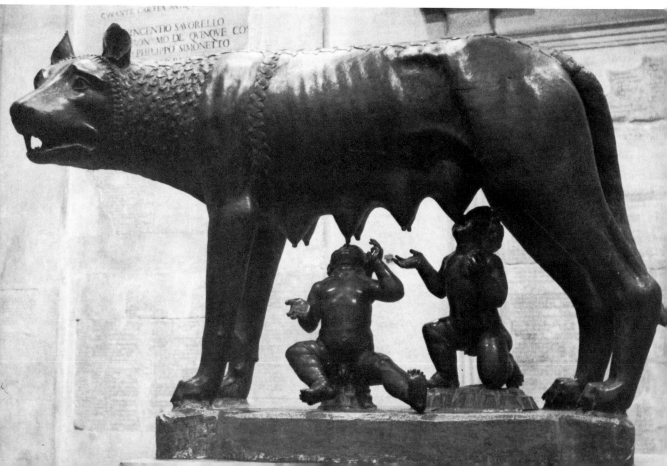

that he would not 'suffer any sculptor, whatever his genius, to lay a finger on the Capitoline Wolf—the identical Wolf of which Cicero and Dionysius have made mention'.[31] Two years later the young Mommsen acknowledged that he was more moved by this 'horrible' object than by all the beautiful things which surrounded it.[32] And when, in the second half of the nineteenth century, German scholars claimed that the *Wolf* had actually been made in the Middle Ages and, for a time, a cast of it was exhibited in the mediaeval Italian section of the Berlin Museum,[33] there was a storm of protest.[34]

In the early sixteenth century the artistic quality of the *Wolf* seems to have aroused some genuine admiration, as can be seen both from the comments of the Venetian Ambassadors in 1523[35] and of Aldrovandi some thirty years later[36] and also from the existence of a number of replicas and variants which appear to date from about then, including at least one large bronze.[37] But when copies of other antique statues were circulating widely in the eighteenth century, the *Wolf*—though examined by every visitor to Rome—was clearly looked upon as a relic, and not therefore an object to be reproduced.

Winckelmann thought that the *Wolf* was of Etruscan origin,[38] and indeed it is catalogued in Helbig as probably Etruscan work made under the influence of Greek sculpture, not in any way connected with Romulus and Remus, having perhaps served as a sepulchral sentinel.[39]

1. Carcopino, pp. 10–12.
2. Rushforth, pp. 28–9, 58.
3. Stuart Jones, 1926, p. 58.
4. Albertini (*De Statuis*) in Valentini and Zucchetti, IV, p. 491.
5. Hülsen and Egger (Text), II, pp. 41–2 and (Tafeln), II, fol. 72r.
6. The 1544 edition of Marlianus, cited by Stuart Jones, 1926, p. 58.
7. Stuart Jones, 1926, p. 58.
8. Sala, II, p. 169.
9. Stuart Jones, 1926, p. 58.
10. Winckelmann (ed. Fea), I, p. 202.
11. Venetian Ambassadors in Albèri, p. 109.
12. Marlianus, fol. 31v; Aldrovandi, 1556, p. 275.
13. Carcopino, pp. 20–35.
14. Livy, X, 23.
15. Rayet, 1881 ('Louve'), pp. 2–3; Stuart Jones, 1926, p. 57; Carcopino, pp. 21–4.
16. Fulvio, 1543, fol. 51r; Felini, p. 325.
17. Dio Cassius, XXXVII, 9.
18. Cicero, *In Catilinam*, III, 8, 19—translated by Wright, I, pp. 324–5.
19. Misson, 1691, II, p. 98; Richardson, 1722, p. 115; Wright, I, pp. 324–5.
20. Misson, 1714, II, i, p. 147; Wright, I, p. 325.
21. Hartford and Pomfret, II, p. 295.
22. *Ibid.*, III, pp. 138–9; Keysler, II, pp. 244–5, note.
23. Venuti, 1767, II, i, p. 697; Richard, VI, p. 19; Lalande, IV, p. 172; Beckford, II, p. 125.
24. Sala, II, p. 169.
25. Silvagni, II, pp. 543–4.
26. See, for instance, the cover of the journal *Roma* which flourished between the wars, and the banner above which Mussolini is addressing the crowd on the Capitol—Saxl, p. 213 and plate 142c.
27. Fea, 1836, pp. 316–18.
28. Carcopino, pp. 38–40.
29. Matthews, I, p. 136.
30. Berry, I, p. 103.
31. Westmacott Papers, II, p. 179 (letter of 19 July 1843).
32. Carcopino, p. 15.
33. *Ibid.*, pp. 12–13.
34. Rayet, 1881 ('Louve'), pp. 3–6.
35. Albèri, p. 109.
36. Aldrovandi, 1556, p. 275.
37. Pope-Hennessy, 1965, pp. 145–6.
38. Winckelmann (ed. Fea), I, pp. 201–2.
39. Helbig, 1963–72, II, pp. 277–81.

94. The Wrestlers (Fig. 179)

FLORENCE, UFFIZI (TRIBUNA)

Marble

Height: 0.89 m

Also known as: Antique Boxers, Grecian Boxers, Gladiators, La Lotta, Lottatori, Roman Wrestlers

According to a letter of 8 April 1583 written by Valerio Cioli, a sculptor and restorer, to the secretary of the Grand Duke Francesco I of Tuscany, the *Wrestlers* had been discovered, together with the *Niobe Group*, a few days before, near Porta S. Giovanni, Rome. On 25 June of the same year they were purchased by Cardinal Ferdinando de' Medici from the Varese family,[1] and they are described as in the Villa Medici in Rome in a print of 1594[2] and an inventory of 1598.[3] The group was sent to Florence in August 1677 and by 1688 had been placed in the Tribuna of the Uffizi.[4] In September 1800 it was removed, together with other treasures to Palermo to escape the French. It was returned to the Tribuna in February 1803.[5]

The *Wrestlers* were first thought to have belonged to the *Niobe Group* and were engraved as such in the late sixteenth century before the restoration of the heads and of the right arm of the uppermost figure (Fig. 11).[6] Neither head belongs, but the lower of the two, upon which the other, modern, one is based is antique and close in character to the heads of the sons of Niobe.[7] By 1638 the *Wrestlers* had been detached from the Niobids[8] and although it was later suggested that they did belong together,[9] the idea was not a popular one and for most of the

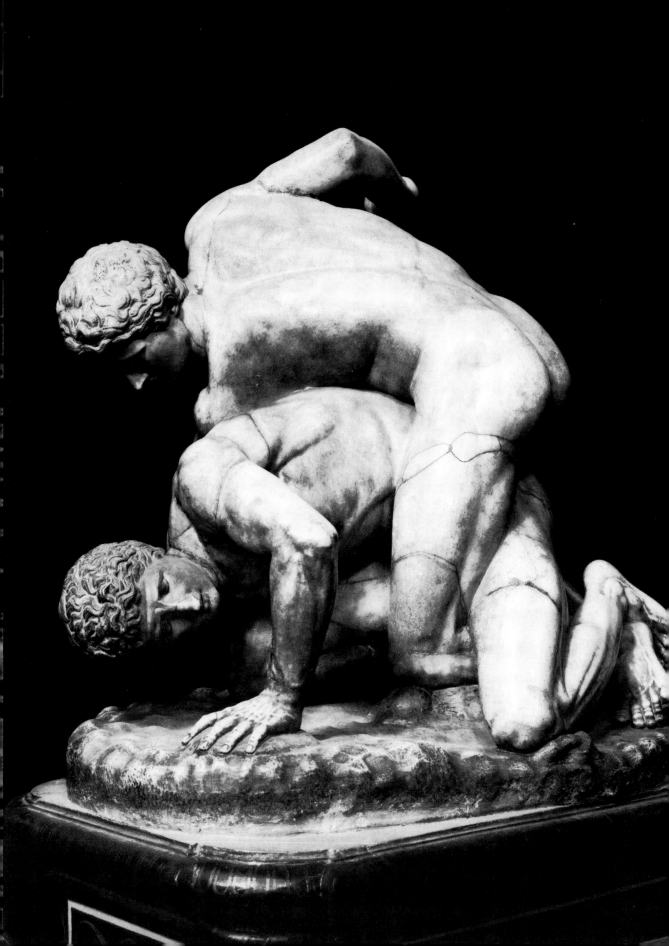

eighteenth century the two groups were in any case in separate cities.

The group was famous as soon as it was discovered. A copy (in wax by Caccini) is recorded as early as 1585;[10] a cast was ordered in 1650 for Philip IV of Spain;[11] the group was twice copied in marble for Louis XIV, by Jean Cornu between 1675 and 1679 for Versailles (now lost), and by P. Magnier between 1684 and 1687 for Marly;[12] Soldani made full-scale bronze copies[13] and in the eighteenth century lead statues (an example is at Studely Royal in Yorkshire) and plasters were common.[14] 'The famous group of antique boxers' was also known, Hogarth tells us parenthetically, as 'Roman wrestlers',[15] but scholars discussing them loved to exhibit their knowledge of Greek athletics.[16] Gori in his catalogue of the Medici collection ventured to suggest the name of Myron,[17] whilst Winckelmann thought it worthy of Kephisodotos or Heliodorus, sons of Praxiteles, mentioned by Pliny as sculptors of *symplegmata* (closely involved groups).[18]

The 'inextricable mixture with each others armes and leggs', which Evelyn noted as 'plainely stupendious',[19] was considered to be of great academic value—hence the grisaille study of the group prominent in Pierre Subleyras's 'Studio of the Artist' of about 1743 (Akademie der Bildenden Künste, Vienna), the small copy in terracotta made by Canova from the cast in the Farsetti collection,[20] and the lengthy analysis of the muscles in Flaxman's lectures.[21] Much more surprisingly the heads were also held up as academic models for the portrayal of 'le violent et terrible'[22]—although Canova in his copy had made them more expressive and, as Reynolds commented, their 'serenity of countenance' was hardly appropriate (and, he thought, 'not recommended for imitation').[23] The *Wrestlers* also delighted the dilettanti who enjoyed gauging the group's qualities against those of the other famous antique statues in the Tribuna.[24] Both Zoffoli and Righetti offered bronze statuettes of the *Wrestlers*[25] and the leading London plaster-cast merchant offered in 1864 not only casts of the original (which would have been sold to art schools) but casts of statuettes and of machine reductions of the 'Boxers, Grecian (group), from Florence'.[26]

The *Wrestlers*, as Mansuelli points out in his catalogue, are now considered to be a copy of a bronze group perhaps related to the Pergamene school, perhaps to the school or the imitators of Lysippus.[27]

1. Gaye, III, pp. 451–3; Mandowsky, 1953, pp. 251–3.
2. Cavalleriis (3), plate 11.
3. Boyer, 1929, p. 260 (no. 22).
4. Florence, Archivio di Stato, Med. Princ. 3943, 24 August 1677; Baldinucci, II, pp. 497–8 (life of Buontalenti, first published in 1688).
5. Paris, Archives Nationales: F²¹ 573 (letter from L. Dufourny to Minister of the Interior, 9 fructidor, an 9); Florence, A. G. F., Filza XXX, 1800–1801, n. 23; *Galerie Impériale*, p. 10; Boyer, 1970, pp. 187–91.
6. Cavalleriis (3), plate 11.
7. Mansuelli, I, p. 93.
8. Perrier, 1638, plates 35–6, come after plates of the sons of Niobe, but the *Wrestlers* are not included in plate 87.
9. Fabroni, p. 19; Winckelmann (ed. Fea), II, p. 200.
10. Mansuelli, I, p. 94 (document).
11. Palomino, p. 916.
12. Souchal, 1977, I, p. 112.
13. Ciechanowiecki and Seagrim.
14. Harris, C., p. 9; Gunnis, p. 83.
15. Hogarth, p. 80; cf. Palomino, p. 915.
16. Maffei, plate XXIX; Bianchi, pp. 203–5.
17. Gori, 1734, plates LXXIII, LXXIV.
18. Winckelmann (ed. Fea), II, p. 200.
19. Evelyn, II, p. 286.
20. *Venezia nell'Età di Canova*, p. 17.
21. Flaxman, pp. 112–13.
22. Lebrun, p. 29.
23. Reynolds, J., p. 181 (Discourse X).
24. Smollett, p. 237 (letter XXVIII).
25. Zoffoli, Righetti (see Appendix).
26. Brucciani, 1864.
27. Mansuelli, I, pp. 92–4.

95. Zingara (Fig. 180)

PARIS, LOUVRE (DEPOSITED AT VERSAILLES)

Marble and bronze
Height: 1.58 m
Also known as: La Petite Bohémienne, Diana, Egyptian Woman, Fortune-Teller, Gipsy, Zingarella

The statue is recorded in the Villa Borghese in 1638 as an 'Egyptian Woman'[1]: a piece of sculpture, presumed to be the present one before its restoration (or reconstruction), is mentioned by Aldrovandi in 1556 as being in Domenico Capotio's collection in Rome: 'a statue without a head, dressed in the Moorish fashion, and it is a Diana'.[2] By 1650 it was in a room in the Villa Borghese which was named after a group of Castor and Pollux.[3] By 1796 it had been placed in the 'Egyptian room' in the Villa.[4] On 27 September 1807 it was purchased (together with the bulk of the Borghese antiquities) by Napoleon Bonaparte, brother-in-law of Prince Camillo Borghese.[5] It left Rome in July 1810[6] and was displayed in the Musée in Paris by 1820.[7] It was put on deposit in the Versailles Museum before 1939.[8]

179. *Wrestlers* (Uffizi).

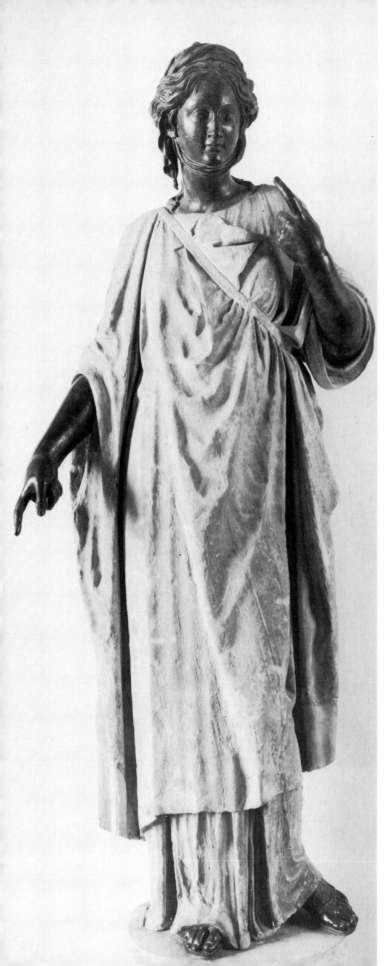

This statue, one of a number of gipsies and Oriental figures in the Borghese collection (with one of which it has sometimes been confused—see below), was the product of some drastic doctoring of an early marble trunk, and in the eighteenth century Bernini was credited (on the basis of no serious evidence known today) with having made and added the bronze head, hands and feet.[9] Early in the nineteenth century these were attributed to Algardi, and this although just possible (and constantly repeated) has never been proved and is quite unconvincing.[10] The most likely creator of the statue in its present form is either the French sculptor Nicolas Cordier (1567–1612), who was much employed by the Borghese in producing just such work, or an artist working in his style.

The *Zingara* was certainly very much admired in the seventeenth century, as is shown by its inclusion in Perrier's anthology, but its real fame became established in the eighteenth. Maffei, who acknowledged that it was 'deservedly held in great esteem', devoted most of his commentary on it to expressing his distaste for gipsies,[11] but this attitude was unusual and tolerant amusement is the more common reaction. Although generally (but by no means always[12]) known to be modern, it was the expression of the head 'with a Chin-cloth'[13] that especially appealed. For Gibbon it had the 'true character of impudence and low cunning suitable to a fortune-teller'[14] and for Moore 'a great look of some modern gypsies I have seen, who have imposed most egregiously on the self-love and credulity of the great'.[15] Richard found her 'charming; one can see the fire coming out of her eyes with all the cunning of her state which is only on the look-out for dupes'.[16] According to Baretti, the statue was not only 'much valued on account of its being a fine piece of sculpture, but also a representation of a character not to be met with in any other antique Remain but this'.[17]

The *Zingara* was illustrated in the standard books on the Borghese collection[18] and also in more general sets of engravings.[19] It features in a set of grisaille statues at Moor Park in Hertfordshire of about 1730 where it is to be seen between the *Dancing Faun* and the *Farnese Hercules*, and it appears in a tapestry (now in the Museo Civico, Turin) woven for the Castello di Rivoli in the late 1740s.[20] In the saloon at Stourhead in Wiltshire there is a marble copy (half life-size), and it was among the plaster and bronze statuettes sold in the last decades of the century in London[21] and Rome.[22] But it was the head

180. *Zingara* (Louvre—deposited at Versailles).

alone that was most commonly reproduced, in France (there is a colossal example with porto venere drapery in the reserve collection at Versailles) and especially in England, in marble by itself,[23] and as the head on marble chimney-piece herms (Powderham Castle in Devon), in Derby biscuit porcelain,[24] in cameos and gems,[25] in earthenware by Ralph and Enoch Wood,[26] in black basaltes by Wedgwood,[27] and in sets of plaster casts made by Scheemakers, by Cheere and by Charles Harris.[28] The head remained popular in the middle years of the nineteenth century when it was listed by Brucciani in his catalogue of plasters both under 'Modern Busts' and under 'Busts from the Original Antique'.[29] However, by 1820 Clarac had dismissed it as characterless.[30]

Long before this Visconti had approached the statue in a radically different manner from his predecessors and contemporaries. Paying little attention to the modern bronze additions he wrote with enthusiasm about the superb carving of the marble draperies and after closely examining the clothing and trappings he demonstrated that the figure must originally have had a quiver slung across her shoulder. From this, and from other evidence, he argued that she must be a Diana[31]—the name by which she seems to have been known to Aldrovandi before her transformation.[32]

Linfert had accepted Visconti's conclusion and like him has laid great stress on the quality of the carving: he believes that the statue is a fine Greek (though not Attic) work contemporary with Lysippus.[33]

<center>⋆　　⋆　　⋆</center>

There was another, somewhat similar, 'Zingara' in the Villa Borghese (where it still remains) and this was sufficiently famous to have a room named after it, though visitors preferred the version discussed above. This statue had a hand and feet of bronze attached to a grey and white marble trunk, and most seventeenth and eighteenth-century descriptions of it prudently avoid the question of whether it was thought to be antique or modern: since 1948 it has usually been attributed to Nicolas Cordier.[34] As early as 1613 a companion piece to this figure was known to be by Cordier, though the attribution was soon lost sight of and the two figures were separated. This was a 'Moor' of coloured marbles (now at Versailles) who was supposedly inviting the 'Zingara' to dance.[35] And there were a number of related pieces in the same collection,

notably 'a young Moorish girl with a child and a dog' in black and white marble which belonged to the Borghese by 1617 (it is still in the Villa)—in the nineteenth century this too was said to be the work of Algardi.[36] There were also two elaborate copies of the *Camillus* which, until the end of the seventeenth century, was often thought to represent a gipsy. Cardinal Borghese's taste for these exotic figures was echoed by that of Prince Marc Antonio Borghese who, in the 1770s, employed the architect Antonio Asprucci to build for them a special 'Egyptian room' in the Villa. By 1796 the statues just mentioned were, with the exception of the two copies of the *Camillus* (whose true identity was by now acknowledged) united in this room together with the *Zingara*, which forms the subject of this entry, and a few other related figures.[37] But this spectacular display lasted only until 1807 when the collection was dispersed.

1. Perrier, 1638, plate 67.
2. Aldrovandi, 1556, p. 263.
3. Manilli, p. 78; Montelatici, pp. 223–4.
4. Arizzoli-Clémentel.
5. Boyer, 1970, p. 202.
6. Paris, Archives Nationales, F I^c 147.
7. Clarac, 1820, p. 193.
8. Arizzoli-Clémentel, p. 9, note 40.
9. Winckelmann (ed. Fea), I, p. XXVI; Burney, p. 207.
10. Meyer, 1809—referred to by Linfert, p. 185, who thinks this likely; see also Fröhner, p. 119; but see Arizzoli-Clémentel, p. 9, note 40.
11. Maffei, plate LXXIX.
12. Ficoroni, 1744 (*Singolarità*), p. 72, calls the head antique.
13. Wright, I, p. 341.
14. Gibbon, p. 249.
15. Moore, I, p. 496.
16. Richard, VI, p. 197.
17. Baretti, p. 23.
18. Montelatici, facing p. 223; Brigentius, following p. 72.
19. Preisler, plate 16.
20. *Mostra del Barocco Piemontese*, II (Arazzi), p. 17 (no. 36), plate 22a.
21. Harris, C., p. 4.
22. Righetti (see Appendix).
23. Examples in the library ante-room, Stourhead, Wiltshire; the Lady Lever Art Gallery, Port Sunlight; and the Victoria and Albert Museum (Reserve).
24. *The Man at Hyde Park Corner*, no. 111.
25. Raspe, II, nos. 14719, 14721.
26. Victoria and Albert Museum, 70–1874; also *The Man at Hyde Park Corner*, no. 111.
27. Hobson, p. 157, and, as an intaglio, Wedgwood, 1779, class I, section II, no. 358.
28. *The Man at Hyde Park Corner*, no. 111; Harris, C., pp. 13–15.
29. Brucciani, 1864.
30. Clarac, 1820, p. 193.
31. Visconti (*Monumenti Borghesiani*), plate II, no. I.
32. Aldrovandi, 1556, p. 263.
33. Linfert, p. 201.
34. Faldi, 1954, pp. 48–9. (no. 47).
35. Pressouyre, 1969 ('Le "Moro"'); but cf. Crulli de Marcucci, fol. 50v, where he is described as a page of Nero!
36. Faldi, 1954, p. 48 (no. 46).
37. Arizzoli-Clémentel.

Appendix

THESE PRINTED LISTS of the bronze copies of some of the most admired statues (nearly all of them antique) supplied in Rome by Giovanni Zoffoli and Francesco Righetti were sent by Charles Heathcote Tatham to Henry Holland between November 1794 and August 1796 (Victoria and Albert Museum Print Room, D.1479–1898, page 7). The list by Zoffoli was first published by Honour in 1961 with notes identifying the originals and indicating the whereabouts of some of the copies. In 1963 Honour also discussed some of the statuettes in Righetti's list which is dated 1794. We have alluded to further copies by both men in the course of this book but we have not been able to track down all those that are listed, nor can we even be certain that all the bronzes were actually produced.

Printed list of the small bronzes offered for sale by Giovanni Zoffoli.

(facing page) Catalogue of the bronzes offered for sale by Francesco Righetti.

AUX AMATEURS DE L'ANTIQUITE
ET DES BEAUX ARTS

François Righetti Sculpteur & Fondeur en bronze à Rome Rüe la Purification a *Capo le Case* donne avis au Public qu'il a considérablement augmenté la collection de models soit en Groupes, Statues, Bustes, Animaux, soit enfin en morceaux précieux de toute espece que l'on admire a Rome, à Florence, & ailleurs. Après les avoir fidélément copiés, on les a réduits à une juste proportion, & chaque Groupe, ou Statüe est d'un palme sept onces mésure Romaine.

On en trouve ci joint le Catalogue avec le prix de chaque piéce en *Séquins Romains*. worth nearly 10.sh english.

GROUPES

	Séquins Romains
D'Apollon & Daphné du Bernin à la Villa Borghese	60
De Mercure & de l'Amour du Prince Altieri	30
Ajax de Florence	38
Laocon de Belvedere	60
Pœtus & Arrie de la Villa Ludovisi	38
Venus avec un Cupidon de Rondanini	30
Lucius Papirius dit Prætextat de la Villa Ludovisi	35
Castor & Pollux en Espagne	33
La Collection de Niobé avec la Famille	300
Amour & Psyché du Comte Foy	33
Lutte de Florence	33
Bacchus & un Faune de Florence	33
Ariadne & Bacchus	35
Castor & Pollux de Monte Cavallo	100
Le Taureau de Farnese	180
Marc Aurele a cheval au Capitole	45
Mars assis avec un enfant de la Villa Ludovisi	25
Les deux Centaures du Capitole	60
Le Centaure de Borghese avec un enfant	35
La Déesse triforme faite d'après l'antique	25
Silene de Borghese	25
Les trois Graces de la Villa Borghese	50
Diomitre du Museum du Vatican	40
Lutte de deux enfants, qui fait de pendant de la Lutte de Florence	33
Lutte de Mercur avec l'amour du palais Altieri	30

FIGURES SIMPLES

Deux Consuls du Museum du Vatican	40
Deux Esclaves de Farnese	36
Ganimede du Museum du Vatican	20
Agrippine de Naples	18
La Junon de la Villa Albani sur un globe doré avec son piedestal de Marbre garni en bronze doré	60

Pos-

Possidipe du Museum Vatican	20
Mencandre du Museum Vatican	20
Un Enfant qui dortservant de pendant a l'Hermafrodite	18
Le David lançant la pierre avec la fronde à la Villa Borghese	20
Petit Amour au Capitole	18
Hercule Farnese	28
Apollon de Belvedere	20
Petit Apollon de Medicis	18
Sybille de la Villa Medicis	18
Venus Marine de Medicis	18
Venus Callipige de la Farnesine	18
Muse assise en Angleterre	18
Nerva assis du Vatican	25
Une Victoire ailée sur un globe, formée d'après l'antique avec son piédestal de marbre orné de métaux dorés	60
Mercure volant de Medicis avec son Piedestal enrichi des ornemens en bronze dore	50
Mercure en forme de Berger du Museum du Vatican	18
Antinoüs du Capitole	18
Lœda du Capitole	20
Junon du Capitole	18
Pandore du Capitole	18
Sardanapale du Vatican	18
Zénon du Capitole	18
Agrippine du Capitole	18
Amazone du Capitole	18
Jupiter assis du Vatican	20
Faune avec une chevre du Capitole	25
Marius assis de la Villa Negroni	20
Scylla assis de la Villa Negroni	20
Gladiateur combattant de Borghese	20
Bacchus de Medicis	18
Le Berger Paris du Vatican	18
Deux enfans de Borghese l'un avec un oiseau, l'autre avec le nid en main	30
Achille de Borghese	18
Faustine assise de Borghese	18
Junon assise en Angleterre	18
Néron à Paris	18
Cléopatre de Belvedere	18
Flore du Capitole	25
Flore de Farnese	18
Fortune qui sait pendant au dit Mercure	18
Les neuf Muses & Apollon du Vatican	25
L'Athléte de la Gentili	200
Marsyas écorché de Medicis	18
Faune aux palors de Florence	18
Méleagre du Museum Vatican	18
Petite Bohémiene de Borghese	25
Germanicus du Vatican	18
Antinous de Belvedese	18
Hermaphrodite de Borghese	18

Lu-

Lucrece de Jean Bologna qui fait pendant a la Cléopatre	20
Vénus débout du même	18
Vénus à génoux du même	18
Mars du même	18
Chéval ecorché de Mattei	20
Tibere du Museum Vatican	22
Jules-Cæsar du Museum Vatican	22
Auguste du Museum Vatican	22
Idole en forme d'Antinoüs du Capitole	18
Discobol du Museum Vatican	18
Faon du Capitole ayant un Chevreau sur les épaules	20
Fidele qui s'arrache l'epine du pied au Capitole	18
Deux Cariatides de Villa Albani	36
A lenaïde du Museum du Vatican	18
Julie Pic	18

BUSTES AVEC LEUR BASE DOREE, EN TOUT, HAUTS D'UN PALME, CINQ ONCES

Lucius Verus de la Villa Borghese	15
Marc Aurele de la Villa Borghese	15
Les douze Césars posés sur des trophées isolés en bronze & differens l'un de l'autre, ayant chacun une base de divers marbres ornés en métaux dorés, à raison de 32 séquins l'un	384
Une Suite complete des philosophes dont l'un se vend	15
Les douze Césars à 12 séquins l'un	144
Marc Aurele jeune	12
Commode	12
Ariadne	12
Lisimaque	12
Bacchus	12
Marcus Brutus	12
Jupiter Capitolin	12
Hercule	12
Alexandre du Capitole	15
Ajax du Vatican	20
Les deux têtes de Castor & Pollux colossales du Quirinal	36
Les deux fameuses Bacchantes colossales du Museum Vatican	30
Le Jupiter du Museum Vatican	15
La fameuse Junon colossale en Angleterre	15
Un enfant assis avec une masque de Théatre en main formé sur l'antique proportion de trois palmes	50
Les deux Vases de Borghese & de Medicis hauts d'environ deux palmes & démi	300
Les deux Fleuves du Belvedere le Nil & le Tibre assis, proportion de deux palmes & démi environ	120
Les deux Lionnes de la Fontaine des Thermes d'un palme	16
Le Sanglier de Florence	13
Les Trophées du Capitole, de Marius hauteur 3 palmes	550
Les deux Lionnes, qui sont aubas de l'escalier du Capitole	30

STA-

STATUES DE TROIS PALMES

Ceux qui desireront toutes les susdites copies, chacune de trois palmes Romains coutéra	65

N.B. Si l'on désire différentes copies d'animaux de la fameuse collection du Museum Vatican, comme Chevaux, Lions, Pantheres, Taureaux, Vaches, Cerfs, Dains, Chévres, & autres, proportion d'un palme environ, chaque piéce coute 13 sequins & comme dans la ditte collection en trouve des modeles de toutes les copies ci-devant mentionnées de trois palmes de haut on les vend chacune . . . 60

Si l'on y desiroit des piedestaux de differens marbres avec les garnitures en metal doré dans le gout antique on les aura à un prix raisonnable c'est à dire 8, 10, 12, 14, 18, & 20, 25, 30 sequins l'un, suivant grandeur & garniture respective.

Ceux qui desiréroient faire garnir des Deserts, des Sécrétaires, des Horloges, des Vases, des Urnes, des Obelisques, & autres objets avec des ornemens en Bronze dans le gout antique & les avoir dorés a differentes couleurs, imitant parfaitement les belles dorures de France, pourront être pleinément satisfaits dans le même attelier.

On trouve encore chez le même differens trepieds de la hauteur de trois palmes parmi lesques on voit le fameux trepied de Naples à Portici soutenu de trois chimeres sur lesquelles posent trois Sphinx ailés, le tout orné de la manière la plus délicate & la plus élégante. Nous serions trop longs si nous voulions en decrire en detail toutes les beautés.

On trouve aussi chez le même Professeur des Fontaines du Bernin, celles de la place Navone, une autre de Barberini, une autre antique de la Villa Albani, une autre de la place Mattei, toutes formées de marbres durs & tendres, garnies de Statues, Basreliefs, & autres ornemens en metal doré avec la patine qu'exigent de pareils ouvrages.

Il y a dans le même gout le fameux grouppe de Monte Cavallo, l'Obeliseue & la base le tout enrichi de basreliefs & ornemens du meilleur gout possible, & a des prix raisonables.

STATUES EN GRANDEUR NATURELLE

Qui voudroit encore des Statues grandes comme les originaux qui se cónservent dans les Museum de Rome, Florence, Naples, & ailleurs, on les fournira comme on a déja fait par le passé aux prix suivans.

Statues de la grandeur & proportion de l'Apollon de Medicis ou de Florence. *Séquins Rom.*	400
Statues grandes comme la Venus de Medicis	550
Statues-hautes comme l'Apollon du Vatican	1300

Ces trois grandeurs indiquées suffisent pour donner une idée differens prix de toute autre Statue qui pourroit être ordonnée par les Amateurs.

On peut leur fournir encore des bustes en grand formés sur les originaux, comme portraits ou Bustes des Philosophes, Consuls, Empéreurs, Imperatrices, Hommes & Femmes célébres; le prix séra proportionné à leur grandeur, & il séra de 30, 40, 50 séquins l'un. Il est bon d'observer qu'il ne s'agit ici que des Bustes de grandeur naturelle, & en dessous; car si l'on demanderoit des têtes colossales, le prix augmenteroit necessairement.

Bibliography

The titles of articles and manuscripts in the following list of sources consulted are given in full. Those of the earlier books have sometimes been abbreviated, and where relevant we have added explanatory information. In many illustrated works of the sixteenth to the nineteenth centuries the text consists of a commentary on the Plates, and when referring to an author's opinions on a piece of sculpture it is often more convenient to give his Plate rather than his page reference as such references tended to remain constant through different editions.

Ackerman, James S. *The Cortile del Belvedere*, Vatican City 1954.

Ackerman, James S. '*Marcus Aurelius* on the Capitoline Hill', *Renaissance News*, 1957, X, no. 2, pp. 69–75.

Ackerman, James S. *The Architecture of Michelangelo*, revised edition, 2 vols., Harmondsworth 1964.

Acton, William *A New Journal of Italy*, London 1691.

Addison, J. *Remarks on several Parts of Italy, &c. in the years 1701, 1702, 1703*, London 1705.

Adhémar, Jean 'Le Cheval blanc de Fontainebleau', *Gazette des Beaux-Arts*, 1949, XXXVI, pp. 297–300.

Adhémar, Jean 'Aretino: Artistic Adviser to Francis I', *Journal of the Warburg and Courtauld Institutes*, 1954, pp. 311–18.

The Age of Neo-Classicism, catalogue of the 14th exhibition of the Council of Europe, London 1972.

Agostini, Leonardo *Le Gemme antiche figurate*, 2 vols., Rome 1657–69.

Alazard, Jean *L'Abbé Luigi Strozzi: correspondant artistique de Mazarin, de Colbert, de Louvois et de La Teulière*, Paris 1924.

Albèri, Eugenio (ed.) 'Sommario del viaggio degli Oratori Veneti che andarano a Roma a dar l'obbedienza a Papa Adriano VI 1523' in *Relazioni degli Ambasciatori Veneti al Senato*, VII (vol. III of 2nd series), Florence 1846, pp. 77–120.

Alberti, Romano (ed.) *Origine, et progresso dell'Academia del Dissegno, de Pittori, Scultori, & Architetti di Roma*, Pavia 1604.

Albertini, Francesco degli *Opusculum de Mirabilibus novae & veteris urbis Romae*, in Valentini and Zucchetti, IV. [Composed 1506–9, published 1510.]

Aldrovandi, Ulisse 'Delle Statue Antiche, che per tutta Roma, in diversi luoghi, & case si veggono' in Lucio Mauro, *Le Antichità della Città di Roma*,

Venice 1556, pp. 115–316. [This seems to be the earliest edition, but it is based on notes made in Rome in 1550.] *Ibid.*, Venice 1558, pp. 115–315. [Although it occupies fewer pages, this edition repeats that of 1556 and includes a number of important additions, at least some of which had already appeared in an extremely rare edition of 1556 published by Lucio Fauno which we have not been able to trace. The 1558 edition was republished in 1562 as the fourth edition.]

Aldrovandi, Ulisse 'La Vita . . . cominciando dalla sua nativítà sin' a l'età di 64 anni vivendo ancora', edited by L. Frati in *Per il III Centenario: Intorno alla vita e alle opere di Ulisse Aldrovandi*, Bologna 1907, pp. 3–27.

Algarotti, Francesco *Opere*, 17 vols., Venice 1791–4.

Amayden *La Storia delle famiglie Romane*, edited by C. A. Bertini, 2 vols., Rome [1915].

Ambra, Raffaeli d' *see* Lauzières, A. de.

Amelung, Walther *Führer durch die Antiken in Florenz*, Munich 1897.

Amelung Walther *The Museums and Ruins of Rome*, I (The Museums), London 1906. [The text of this edition was revised by the author and his translator Mrs. S. Arthur Strong.]

Amelung, Walther *Die Sculpturen des Vaticanischen Museums*, 2 vols., Berlin 1903–8.

Amelung, Walther and Lippold, Georg *Die Sculpturen des Vaticanischen Museums*, III (in 2 parts), Berlin 1935–56. [A continuation of Amelung 1903–8.]

Andrén, Arvid 'Il Torso del Belvedere', *Opuscula Archeologica*, 1952, VII, pp. 1–45.

Angelis, de (père and fils) Untitled catalogue of bronze reproductions, Naples 1900.

Antichità di Ercolano, edited by the Accademia Ercolanense, 8 vols., Naples 1755–92.

Apollonio, Umbro (ed.) *Futurist Manifestos*, London 1973.

Arco, Niccolò d' *Nicolai Archii comitis Numerorum Libri IV*, Verona 1762.

Arisi, Ferdinando *Gian Paolo Panini*, Piacenza 1961.

Arizzoli-Clémentel, Pierre 'Charles Percier et la Salle Egyptienne de la Villa Borghèse' in *Piranèse et les Français*, edited by Georges Brunel, Rome 1978, pp. 1–32.

Armenini, Gio. Battista *De' veri precetti della pittura*, Ravenna 1587. [Some copies have a dedicatory epistle dated 1586.]

Arndt, Paul and Lippold, Georg *Photographische Einzelaufnahmen antiker Sculpturen*, text in 17 parts, Munich 1893–1947.

Ashby, Thomas 'La Villa d'Este at Tivoli and the Collection of Classical Sculptures which it Contained', *Archaeologia*, 1908, LXI, i, pp. 219–56.

Ashby, Thomas 'Antiquae Statuae Urbis Romae', *Papers of the British School at Rome*, 1920, IX, pp. 107–58.

Ashmole, Bernard *see* Beazley, J. D.

Audran, Gérard *Les Proportions du corps humain mesurées sur les plus belles figures de l'antiquité à Paris*, [Paris] 1683.

Aufklärung und Klassizismus in Hesse-Kassel unter Landgraf Friedrich II, 1760–1785, catalogue of exhibition held at the Orangerie, Kassel 1979.

Aulanier, Christiane *Histoire du Palais et du Musée du Louvre*, V (La Petite Galerie, etc.), Paris 1955.

Aurigemma, Salvatore *Villa Adriana*, Rome 1961.

Bacchini, Benedetto *De sistris, eorumque figuris, ac differentia dissertatio*, Trajecti ad Rhenum 1696.

[Bachaumont, Petit de] *Essai sur la peinture, la sculpture et l'architecture*, 2nd edition, [Paris] 1752.

Baedeker, Karl *Paris*, Coblenz 1865.

Baedeker, Karl *Northern Italy*, 3rd edition, revised, Coblenz 1874; 5th edition, remodelled, Leipzig 1879; 8th edition, remodelled, Leipzig 1889; 9th edition, remodelled, Leipzig 1892.

Baedeker, Karl *Paris and Environs*, Leipzig 1881.

Baglione, Giovanni *Le Vite de' pittori scultori et architetti dal pontificato di Gregorio XIII del 1572*, Rome 1642 (facsimile edition, Rome 1935).

Baldinucci, Filippo *Notizie dei Professori del Disegno da Cimabue in qua*, edited by F. Ranalli, 5 vols., Florence 1846–7 (facsimile edition, Florence 1974–5, with an appendix in 2 volumes, edited by Paola Barocchi).

Baldung Grien, Hans, catalogue of exhibition held at Staatliche Kunsthalle, Karlsruhe 1959.

Balfour, Sir Andrew *Letters written to a Friend . . . containing excellent Directions and Advices for Travelling thro' France and Italy*, Edinburgh 1700.

Barbieri, Franco and Puppi, Lionello 'Catalogo delle opere architettoniche di Michelangelo' in *Michelangelo Architetto*, edited by Paolo Portoghesi and Bruno Zevi, Turin 1964, pp. 813–1019.

Baretti, Joseph [Giuseppe] *A Guide through the Royal Academy*, London [1781].

Barocco Piemontese, catalogue in 3 volumes, edited by Vittorio Viale, of exhibition held in Turin 1963.

Barrett, F. A. and Thorpe, A. L. *Derby Porcelain, 1750–1848*, London 1971.

Barry, James *A Letter to the Dilettanti Society*, London 1798.

Barthélemy, Abbé [Jean Jacques] *Voyage en Italie . . . imprimé sur ses lettres originales écrites au Comte de Caylus*, Paris 1801.

Bartoli, Pietro Santi *Colonna Traiana . . . con l'espositione latina d'Alfonso Ciaccone . . . accresciuta di medaglie, inscrittioni e trofei, da Gio. Pietro Bellori*, Rome [1665]. [The 1704 edition includes an address to the reader declaring that work on the book began in 1667 but other evidence enables us to date the first edition to 1665 – see our Chapter VII, note 26.]

Bartoli, Pietro Santi *Admiranda Romanarum Antiquitatum . . . Notis Io. Petri Bellorii illustrata*, Rome 1693. [The first edition, probably published nearly twenty years earlier, also includes prints of the reliefs on the arches of Constantine and Titus. Instead the edition of 1693 has a number of new prints, stylistically distinct and with the name of Domenico as well as Giovanni Giacomo de Rossi in their captions.]

Bartolini, Lorenzo, catalogue of exhibition held in Prato, Florence 1978.

Bartsch, Adam *Le Peintre graveur*, 21 vols., Vienna 1803–21.

Battelli, Guido 'L'Albo delle *Antichità d'Italia* di Francesco de Hollanda', *La Bibliofilia*, 1939, XLI, pp. 27–35.

Bayardi, O. A. *Catalogo degli antichi monumenti dissotterati della discoperta Città di Ercolano*, Naples 1755.

Beazley, J. D. and Ashmole, Bernard *Greek Sculpture and Painting*, Cambridge 1932.

Beckford, Peter *Familiar Letters from Italy to a friend in England*, 2 vols., London 1805. [The author notes that many of the letters were written in 1787 and most of them before the French invasion of Italy.]

Bell, C. F. *Annals of Thomas Banks, Sculptor, Royal Academician*, Cambridge 1938.

Bell, John *Observations on Italy*, London and Edinburgh 1825. [Bell was in Italy in 1817 – the *Observations* were published posthumously.]

Bellicard *see* Cochin le fils.

[Bellori, Giovanni Pietro] *Nota delli musei, librerie, gallerie & ornamenti di statue, e pitture, ne' palazzi, nelle case, e ne' giardini di Roma*, Rome 1664 (facsimile edition with commentary by Emma Zocca, Rome 1976).

Bellori, Giovan Pietro *Le Vite de' pittori, scultori e architetti moderni*, Rome 1672. [Republished together with the biographies which appeared after 1672 and with notes by Evelina Borea, Turin 1976.]

Bencivenni, Giuseppe (già Pelli) *Saggio istorico della Real Galleria di Firenze*, 2 vols., Florence 1779.

Benkowitz, Carl Friedrich *Reisen von Neapel in die umliegenden Gegenden*, Berlin 1806.

Benoist, Luc *Coysevox*, Paris 1930.

Berenson, Bernard *Lorenzo Lotto*, new edition, London 1956.

Berlin und die Antike, catalogue of exhibition held at Schloss Charlottenburg, Berlin 1979.

Berliner, Rudolf 'Zeichnungen von Carlo und Filippo Marchionni', *Münchner Jahrbuch der Bildenden Kunst*, 1958–9, IX–X, pp. 267–396.

Bernino, Domenico *Vita del Cavaliere Gio. Lorenzo Bernino*, Rome 1713.

Bernouilli, Johann Jakob *Römische Ikonographie*, 2 parts in 3 vols., Stuttgart 1882–94.

Berry [Mary] *Extracts of the Journals and Correspondence of Miss Berry from the year 1783 to 1852*, edited by Lady Theresa Lewis, 3 vols., London 1865.

Berti, Luciano *Il Principe dello Studiolo: Francesco I dei Medici e la fine del Rinascimento fiorentino*, Florence 1967.

Besançon—le plus ancien musée de France, catalogue of exhibition held at the Musée des Arts Décoratifs, Paris 1957.

Bianchi, Giuseppe *Ragguaglio delle antichità e rarità che si conservano nella Galleria Mediceo-Imperiale di Firenze*, I, Florence 1759. [The only volume published.]

Bieber, Margarete *The Sculpture of the Hellenistic Age*, revised edition, New York 1961.

Biondo, Flavio [Blondus, Flavius] *Roma Instaurata* in Valentini and Zucchetti, IV.

Biver, Marie-Louise *Le Paris de Napoléon*, Paris 1963.

Biver, Marie-Louise *Pierre Fontaine premier architecte de l'Empereur*, Paris 1964.

Blainville, M. de *Travels through Holland, Germany, Switzerland, and other parts of Europe, but especially Italy*, 3 vols., London 1743–5.

Blanco, A. *Museo del Prado: Catálogo de la Escultura*, I (Esculturas Clasicas), Madrid 1957.

Blashfield, J. M. *An Account of the History and Manufacture of Ancient and Modern Terra Cotta*, London 1855.

Blashfield, J. M. *A Catalogue of Five Hundred Articles*, London 1857.

Blashfield, J. M. *Catalogue of the Stock of J. M. Blashfield's Praed Street Galleries sold in three lots peremptorily by Auction by Messrs. Rushworth and Jarvis*, [London] 1858.

Bloch, Vitale *Michael Sweerts*, The Hague 1968.

Blumer, M.-L. 'La Commission pour la recherche des objets de sciences et arts en Italie (1796–1797)', *Revolution Française*, 1934, pp. 62–88, 124–50, 222–59.

[Blundell, Henry] *Account of the Statues, Busts, Bass-Relieves, Cinerary Urns, and other Ancient Marbles, and Paintings, at Ince, collected by H.B.*, Liverpool 1803.

[Blundell, Henry] *Engravings and Etchings of the Principal Statues, Busts, Bass-Reliefs, Sepulchral Monuments, Cinerary Urns, &c in the collection of Henry Blundell Esq. at Ince*, 2 vols., [Liverpool] 1809.

Blunt, Anthony 'Poussin Studies VI', *Burlington Magazine*, 1951, pp. 369–76.

Blunt, Anthony *Nicholas Poussin* (text) Washington 1967.

Bober, Phyllis Pray *Drawings after the Antique by Amico Aspertini*, London 1957.

Bocchi, Francesco *Le Bellezze della Città di Fiorenza*, Florence 1591 (facsimile edition, London 1971); edited, with extensive additions, by Giovanni Cinelli, Florence 1677 (facsimile edition, Bologna 1974).

Boislisle, M. de 'Les Collections de sculptures du Cardinal de Richelieu', *Memoires de la Société Nationale des Antiquaires de France*, 1881, XLII, pp. 71–128.

Boissard, Jean Jacques *I Pars Romanae Urbis Topographiae & Antiquitatum*, Frankfurt 1597.

Bonnaffé, Edmond *Les Amateurs de l'ancienne France: Le Surintendant Foucquet*, Paris and London 1882.

Bonucci, Carlo *see* Verde, Francesco.

Borboni, Gio. Andrea *Delle Statue*, Rome 1661.

Borchardt, Paul 'The Sculpture in front of the Lateran as described by Benjamin of Tudela and Magister Gregorius', *Journal of Roman Studies*, 1936, XXVI, pp. 68–70.

Borisova, E. A. *see* Petrov, A. N.

Borromeo, Federico *Musaeum*, edited by Luca Beltrami, Milan 1911. [First published in 1625.]

Borsari, Luigi 'Notizie inedite intorno a scoperte di antichità in Roma e suo territorio', *Bullettino della Commissione Archeologica comunale di Roma*, 1898, XXVI, pp. 18–39.

Boselli, Orfeo *Osservazioni della scoltura antica*, edited by Phoebe Dent Weil, Florence 1978.

Bothmer, D. von *see* Vermeule, C.

[Bottari, Giovanni Gaetano] *Musei Capitolini*, III (Statue), Rome 1755.

Bottari, Giovanni Gaetano *Raccolta di lettere sulla pittura, scultura, ed architettura*, edited and continued by Stefano Ticozzi, 8 vols., Milan 1822.

Bottineau, Yves 'L'Alcazar de Madrid: Aspects de la cour d'Espagne au XVIIe siècle', *Bulletin Hispanique*, 1956, LVIII, pp. 421–52; 1958, LX, pp. 30–61, 145–79, 289–326, 450–83.

Boucher, Bruce 'Leone Leoni and Primaticcio's Moulds of Antique Sculpture', to be published in the *Burlington Magazine*.

Bourgeois, Émile *Le Biscuit de Sèvres: Recueil des modèles de la manufacture de Sèvres au XVIIIe siècle*, Paris 1909.

Boyer, F. 'Un inventaire inédit des antiques de la Villa Médicis (1598)', *Revue Archéologique*, 1929, XXX, pp. 256–70.

Boyer, F. 'Les Antiques de Christine de Suède à Rome', *Revue Archéologique*, 1932, XXXV, pp. 254–67.

Boyer, F. 'Le Transfert des antiques de Médicis de Rome à Florence', *Gazette des Beaux-Arts*, 1932, VII, pp. 211–16.

Boyer, Ferdinand *Le Monde des arts en Italie et la France de la Révolution et de l'Empire*, Turin 1970.

Braham, Allan *The Architecture of the French Enlightenment*, London 1980.

Brettingham, Matthew 'Accounts of Works of Art Bought in Rome', Holkham MS. 744.

Brettingham, Matthew *The Plans, Elevations and Sections of Holkham in Norfolk . . . also a descriptive account of the Statues, Pictures and Drawings; not in the former edition*, London 1773.

Breval, J. *Remarks on Several Parts of Europe*, 2 vols., London 1726.

Brigentius, Andrea *Villa Burghesia, vulgo Pinciana, poeticè descripta*, Rome 1716.

Brilliant, Richard *Roman Art from the Republic to Constantine*, London 1974.

[Bromley, William] *Remarks in the Grand Tour of*

France & Italy, lately Performed By a Person of Quality, London 1692.

Brosses, Charles de *Lettres d'Italie*, 2 vols., Dijon 1927. [De Brosses was in Italy in 1739–40.]

Brown, C. Malcolm '"Lo insaciabile desiderio nostro de cose antique": New Documents for Isabella d'Este's Collection of Antiquities' in *Cultural Aspects of the Italian Renaissance: Essays in honour of Paul Oskar Kristeller*, edited by Cecil H. Clough, Manchester 1976.

Brown, Clifford M. (with A. M. Lorenzoni) 'The Grotta of Isabella d'Este', *Gazette des Beaux-Arts*, 1978, XCI, pp. 72–82.

Brown, C. Malcolm (with Anna Maria Lorenzoni) 'Marten van Heemskerck, the Villa Madama Jupiter and the Gonzaga Correspondence Files', *Gazette des Beaux-Arts*, 1979, XCIV, pp. 49–60.

Bruand, Yves 'La Restauration des sculptures antiques du Cardinal Ludovisi (1621–1632)', *Mélanges d'Archéologie et d'Histoire*, 1956, LXVIII, pp. 397–418.

Bruand, Yves 'Les Sculptures antiques et modernes de la collection Ludovisi-Boncompagni (1621–1901)', thesis at École du Louvre, Paris 1959.

Brucciani, D. *Catalogue of Reproductions of Ancient and Modern Sculpture on Sale at D. Brucciani's Galleria delle Belle Arti*, London 1864 (reprinted with additions in 1874).

Brucciani *Catalogue of Casts for Schools including casts of most of the Statues which the Board of Education have approved, in their Regulations for the Art Examinations, as suitable for Study in Schools of Art*, London 1914.

Brummer, Hans Henrik *The Statue Court in the Vatican Belvedere*, Stockholm 1970.

Brunn, Heinrich *Kleine Schriften*, edited by Herman Brunn and Heinrich Bulle, 3 vols., Leipzig 1898–1906.

Bulgari, C. G. *Argentari gemmari e orafi d'Italia*, Rome 1958.

Burckhardt, Jacob *Der Cicerone: Eine Anleitung zum Genuss der Kunstwerke Italiens*, Basle 1855.

Burnet, G. *Some Letters containing, An account of what seemed most remarkable in Switzerland, Italy, &c.*, Rotterdam 1686.

Burney, Charles *Music, Men, and Manners in France and Italy, 1770—being the Journal written by Charles Burney*, edited by H. Edmund Poole, London 1969.

Cailleux, Jean (ed.) *Un album de croquis d'Hubert Robert, 1733–1808*, published together with the catalogue of the exhibition at the Galerie Cailleux, Geneva, 30 October–15 December 1979.

Càllari, Luigi *I Palazzi di Roma*, 3rd edition, revised, Rome 1944.

Campori, G. *Memorie biografiche degli scultori, architetti, pittori ec. nativi di Carrara e di altri luoghi della provincia di Massa*, Modena 1873 (facsimile edition, Bologna 1969).

[Cancellieri, Francesco] *Notizie delle due famose statue di un fiume e di Patroclo dette volgarmente di Marforio e di Pasquino*, Rome 1789.

Cancellieri, Francesco, *Storia de' solenni possessi*, Rome 1802.

Cancellieri, F. (ed.) *Dissertazioni Epistolari di Giovanni*

Battista Visconti e Filippo Waguier de la Barthe sopra la statua del Discobolo . . . con le illustrazioni della medesima publicate da Carlo Fea e Giuseppe Ant. Guattani, Rome 1806.

Candida, Bianca *I calchi rinascimentali della Collezione Mantovana Benavides*, Padua 1967.

Canedy, Norman W. 'The Decoration of the Stanza della Cleopatra' in *Essays in the History of Art presented to Rudolf Wittkower*, edited by Douglas Fraser, Howard Hibbard and Milton J. Lewine, London 1967, pp. 110–18.

Canedy, Norman W. *The Roman Sketchbook of Girolamo da Carpi*, London 1976.

Canova, Antonio *I Quaderni di viaggio, 1779–1780*, edited by Elena Bassi, Venice 1959.

Capecchi, Gabriella 'Le Statue antiche della Loggia dei Lanzi', *Bollettino d'Arte*, 1975, pp. 169–78.

Caprino, Catia 'Un nuovo contributo alla conoscenza dello Hermes che si allaccia il sandalo', *Bollettino d'Arte*, 1974, pp. 106–14.

Carcopino, Jérome 'La Louve du Capitole', extract from *Bulletin de l'Association Guillaume Budé*, 1925.

Carpenter, Rhys *Observations on Familiar Statuary in Rome*, Rome 1941.

Carradori, Francesco *Istruzione elementare per gli studiosi della scultura*, Florence 1802.

Cartari, Vincenzo *Le Imagini, con la spositione de i dei de gli antichi*, Venice 1556.

Cartwright, Julia *Isabella d'Este*, 2 vols., London 1903.

Casotti, Maria Walcher *Il Vignola*, 2 vols., Trieste 1960.

Catalogue des moulages en vente au Musée National du Louvre, Paris 1932.

Caus, Isaac de *Le Jardin de Vuillton, construit par tres noble et tres puissant seigneur Philippe Comte de Pembrooke et Mongomeri*. [The work must date from after 1626 when Pembroke was made Lord Steward and before 1630 when he died.]

Cavaceppi, Bartolomeo *Raccolta d'antiche statue, busti, teste cognite ed altre sculture antiche*, 3 vols., Rome 1768–72.

Cavalleriis *Antiquae Statuae Urbis Romae*, Liber Primus. [A set of 58 plates first published before 1561, referred to here as Cavalleriis (1).] Liber Primus et Secondus. [A set of 100 plates first published before 1584 which includes all items in Cavalleriis (1) but entirely renumbered and in some cases re-engraved, referred to here as Cavalleriis (2).] Liber Tertius et Quartus, 1594. [A set of 100 plates, a sequel to Cavalleriis (2), referred to here as Cavalleriis (3).]

I Cavalli di San Marco, catalogue of the exhibition held at the Convento di Santa Apollonia, Venice 1977.

[Cavendish, William Spencer, sixth Duke of Devonshire] *Handbook of Chatsworth and Hardwick*, 1844.

Caylus, Comte de *Recueil d'antiquités égyptiennes, étrusques, grecques et romaines*, 7 vols., Paris 1752–67.

Caylus, Comte de 'De la sculpture et des sculpteurs anciens selon Pline', *Mémoires de Littérature tirés des Registres de l'Academie Royale des Inscriptions et Belles Lettres*, 1759, XXX, pp. 302–34. [The text of a paper read on 1 June 1753.]

Caylus, Comte de *Correspondance inédite . . . avec Le P.*

Paciaudi, Théatin (1757–1765) suivie de celles de l'Abbé Barthélemy et de P. Mariette avec le même, 2 vols., Paris 1877.

Caylus, Comte de *Voyage d'Italie, 1714–1715*, edited by Amilda-A. Pons, Paris 1914.

Celano, Carlo *Delle notizie del bello, dell'antico, e del curioso della Città di Napoli*, 4th edition, 4 vols., 1792.

Celio, Gaspare *Memoria delli nomi dell'artefici delle pitture che sono in alcune chiese, facciate, e palazzi di Roma*, Naples 1638 (facsimile edition with notes by Emma Zocco, Milan 1967). [The *Memoria* was completed in 1620 according to the dedication.]

Cellini, Benvenuto *Opere*, edited by Giuseppe Guido Ferrero, Turin 1971.

Chacon, Alonso [Ciaccone, Alfonso, also Ciaconus, Alfonsus] *Historia utriusque Belli Dacici A Traiano Cesare Gesti, ex simulachris quae in columna eiusdem Romae visuntur collecta*, Rome 1576.

Champoiseau, Charles 'La Victoire de Samothrace', *Revue Archéologique*, 1880, XXXIX, pp. 11–17.

Chantelou, M. de *Journal du voyage du Cavalier Bernin en France*, edited by Ludovic Lalanne, Paris 1885.

Chappuis, Adrien *The Drawings of Paul Cézanne: A Catalogue Raisonné*, 2 vols., London 1973.

Charbonneaux, Jean 'La Main droite de la Victoire de Samothrace', *Hesperia*, 1952, XXI, pp. 44–6.

Charbonneaux, Jean *La Sculpture grecque et romaine au Musée du Louvre*, Paris 1963.

Charlemont, James, first Earl of 'The Manuscripts and Correspondence', part X of the appendix of the *12th Report of the Historical Manuscripts Commission*, I (1745–83), London 1891.

Chatfield, Judith *see* Gurrieri, Francesco.

Cheselden, W. *The Anatomy of the Human Body*, 5th edition, London 1740.

Chiari, Giovanni *Statue di Firenze*, 3 parts. [Probably published *c.* 1790.]

Chiffinch, Will. 'A lyst of the Statues, in Marble, and Figures in brasse in Whitehall', British Library, Harleian MS. 1890, fols. 87–9.

Christina Queen of Sweden: A Personality of European Civilisation, catalogue of Council of Europe exhibition, Stockholm 1966.

Cicognara, Leopoldo *Storia della scultura dal suo risorgimento in Italia*, 3 vols., Venice 1813–18.

Ciechanowiecki, Andrew and Seagrim, Gay 'Soldani's Blenheim Commission and other Bronze Sculptures after the Antique' in *Festschrift Klaus Lankheit*, 1973, pp. 180–4.

Civiltà del settecento a Napoli, I, catalogue of exhibition held in Naples 1979–80.

Clairmont, Christoph W. *Die Bildnisse des Antinous: Ein Beitrag zur Porträtplastik unter Kaiser Hadrian*, Rome 1966.

Clarac, Comte de *Description des antiques du Musée Royal, commencée par feu M. le Chr. Visconti*, Paris 1820.

Clarac, Comte de *Sur la statue antique de Vénus Victrix . . . et sur la statue antique connue sous le nom de l'Orateur, de Germanicus, et d'un personnage romain en Mercure*, Paris 1821.

Clarac, Comte de *Musée de sculpture antique et moderne ou description historique et graphique du Louvre . . . et de plus de 2500 statues antiques*, Paris 1826–53.

Clarac, Comte de *Description du Musée Royal des Antiques du Louvre*, Paris 1830.

Clark, Kenneth *Rembrandt and the Italian Renaissance*, London 1966.

Clarke, Edward D. *Greek Marbles brought from the Shores of the Euxine, Archipelago, and Mediterranean*, Cambridge 1809.

Coade Untitled set of etchings of products of Coade's Lambeth factory dated 1777–9.

Coade *A Descriptive Catalogue of Coade's Artificial Stone Manufactory at King's Arms Stairs, Narrow Wall, Lambeth*, London 1784.

Coade *A Description of Ornamental Stone in the Gallery of Coade and Sealy*, London 1799.

Cochin, le fils, and Bellicard *Observations sur les antiquités de la ville d'Herculanum*, Paris 1754.

Cochin, [Charles-Nicolas] *Voyage d'Italie, ou recueil de notes sur les ouvrages de peinture de sculpture, qu'on voit dans les principales villes d'Italie*, 3 vols., Paris 1769. [First published in 1758.]

Coffin, David R. *The Villa d'Este at Tivoli*, Princeton 1960.

La Collection de Francois I^er, catalogue, edited by Sylvie Béguin and Janet Cox-Rearick, of exhibition held in Louvre, Paris 1972.

Colvin, H. M. (ed.) *The History of the King's Works*, V (1660–1782), London 1976.

Constable, W. G. *Canaletto*, 2nd edition, revised by J. G. Links, 2 vols., Oxford 1976.

Comstock, Mary B. and Vermeule, Cornelius C. *Sculpture in Stone: The Greek, Roman and Etruscan Collections of the Museum of Fine Arts, Boston*, Boston 1976.

Condivi, Ascanio *Vita di Michelangelo Buonarroti*, 2nd edition, corrected and enlarged, Florence 1746.

Conforti, Louis *Le Musée National de Naples illustré en CLXV gravures*, Naples n.d. [An English edition is dated 1899 by the British Library catalogue.]

Cook, R. M. *Niobe and her Children*, Cambridge 1964.

Cooper, J. Fenimore *Excursions in Italy*, 2 vols., London 1838.

Corbo, Anna Maria 'Apertura di una strada alla Chiesa Nuova nel 1673: Ritrovamenti archeologici e polemiche', *Commentari*, 1972, pp. 181–5.

Cordey, Jean *Vaux-le-Vicomte*, Paris 1924.

Corke and Orrery, John Earl of *Letters from Italy in the years 1754 and 1755*, edited by John Duncombe, London 1773.

Correra, L. 'Il Toro e L'Ercole Farnese: Notizie e Documenti', *Bullettino della Commissione Archeologica Comunale di Roma*, 1900, XXVIII, pp. 44–53.

Correspondance littéraire, philosophique et critique par Grimm, Diderot, Raynal, Meister, etc., edited by Maurice Tourneux, 16 vols., Paris 1877–82.

Corsini, Andrea *I Bonaparte a Firenze*, Florence 1961.

Corti, G. *see* Hartt, F.

Coryat [Coryate, Thomas] *Coryats Crudities Hastily gobled up in five Moneths travells in France, Savoy, Italy . . .*, London 1611.

Cosnac, Comte de *Les Richesses du Palais Mazarin*, Paris 1885.

[Cousin de Contamines] *Eloge historique de M. Coustou l'ainé*, [Paris] 1737.

Coxe, Henry *Picture of Italy, being a Guide to the Antiquities and Curiosities of that Classical and Interesting Country*, London 1815.

Coyer, M. l'Abbé *Voyages d'Italie et de' Hollande*, 2 vols., Paris 1775.

Cristofani, Mauro 'Per una storia del collezionismo archeologico nella Toscana granducale: I. I grandi bronzi', *Prospettiva*, 1979, XVII, pp. 4–15.

Cristofani, Mauro 'Per una storia del collezionismo archeologico nella Toscana granducale: Doni e acquisti di statue antiche nella seconda metà del XVI secolo' in *Le Arti del Principato*, Florence 1980.

Croce, Benedetto 'La Villa di Chiaia', *Napoli Nobilissima*, 1892, I, pp. 3–11, 35–9, 51–3.

[Croker, J. W.] 'Lord Elgin's Collection of Sculptural Marbles', *Quarterly Review*, 1815–16, XIV, pp. 513–47.

Crook, J. Mordaunt *The Greek Revival*, London 1972.

Crulli de Marcucci, Jacomo *Grandezze della Città di Roma antiche e moderne*, Rome 1625.

Crutwell, M. *Verrocchio*, London 1904.

Curiosità di una reggia: Vicende della guardaroba di Palazzo Pitti, catalogue of exhibition held at Palazzo Pitti, Florence 1979.

Dallaway, James *Anecdotes of the Arts in England*, London 1800.

Dallaway, James *Of Statuary and Sculpture*, London 1816.

Dalmazzoni, Angelo *The Antiquarian or the Guide for Foreigners to go the rounds of the Antiquities of Rome*, Rome 1803.

Dalton, O. M. *Catalogue of the Engraved Gems of the Post-Classical Periods in the Department of British and Mediaeval Antiquities and Enthnography in the British Museum*, London 1915.

Davis, Terence *John Nash, the Prince Regent's Architect*, Newton Abbot 1973.

Dawson, J. *The Stranger's Guide to Holkham*, Burnham 1817.

De Bagatelle à Monceau: Les Folies du XVIIIᵉ siècle à Paris, catalogue of exhibition at Domaine de Bagatelle and Musée Carnavalet, Paris 1978–9.

Dehio, Georg *Handbuch der deutschen Kunstdenkmäler: Hessen*, edited by Magnus Backes, Munich and Berlin 1966.

Dennis, George *The Cities and Cemeteries of Etruria*, 2 vols., London 1848; revised edition, 2 vols., London 1878.

Description of the Collection of Ancient Marbles in the British Museum, 11 vols., London 1812–61.

Desgodetz, Antoine *Les Edifices antiques de Rome dessinés et mesurés très exactement*, Paris 1682.

Devigne, Marguerite 'Le Sculpteur Willem Danielsz. van Tetrode, dit en Italie Guglielmo Fiammingo', *Oud Holland*, 1939, pp. 89–96.

Dhanens, Elisabeth 'De Romeinse ervaring van Giovanni Bologna', *Bulletin de l'Institut Historique Belge de Rome*, 1963, pp. 159–90.

Diderot, Denis *Salon de 1765*, edited by Jean Seznec, Oxford 1979.

Dieckmann, H. and Seznec, J. 'The Horse of Marcus Aurelius: A controversy between Diderot and Falconet', *Journal of the Warburg and Courtauld Institutes*, 1952, pp. 198–228.

Dimier, L. 'Le "Tireur d'épine" du Louvre: Fonte florentine de 1540', *Chronique des Arts*, 1899, pp. 71–2.

Dimier, L. *Le Primatice peintre, sculpteur et architecte des rois de France*, Paris 1900.

Documenti inediti per servire alla storia dei musei d'Italia, 4 vols., Florence and Rome 1878–80.

Dolce, Federico *Descrizioni di dugento gemme antiche*, Rome 1792.

Donatus, Alexander *Roma Vetus Ac Recens Utriusque aedificiis ad eruditam cognitionem expositis*, Rome 1639; 3rd edition, Rome 1665.

Doni, Anton Francesco *Disegno*, Venice 1549 (facsimile edition, edited by Mario Pepe, Milan 1970).

Donini, Augusto 'I cavalli di Monte Cavallo a Roma su una medaglia di Sisto V', *Numismatica*, 1960, I, pp. 64–73.

Doort, Abraham Van der 'Catalogue of the Collection of Charles I', edited by Oliver Millar, *Walpole Society*, 1958–60, XXXVII.

Draper, James David 'A Bronze Spinario ascribed to Antonello Gagini', *Burlington Magazine*, 1972, pp. 55–8.

Du Bos, [Jean Baptiste] *Réflexions critiques sur la poesie et sur la peinture*, 2 vols., Paris 1719.

Du Mont [Jean] *Voyages ... en France, en Italie, en Allemagne, à Malthe et en Turquie*, 4 vols., The Hague 1698.

Dunlap, William *History of the Rise and Progress of the Arts of Design in the United States*, new edition, revised and edited by Alexander Wyckoff, 3 vols., New York 1965. [First published in 1834.]

Dupaty *Lettres sur l'Italie, en 1785*, revised edition, 3 vols., Paris 1812.

Dussler, Luitpold *Raphael: A Critical Catalogue of his Pictures, Wall-Paintings and Tapestries*, London 1971.

Dütschke, H. *Antike Bildwerke in Oberitalien*, III, Leipzig 1878.

Eaton, Mrs. Charlotte Ann *Rome in the Nineteenth Century ... In a series of letters written during a residence at Rome in the years 1817 and 1818*, 3 vols., London 1820.

L'École de Fontainebleau, catalogue of exhibition held at Grand Palais, Paris 1972.

Edwards, Edward *Anecdotes of Painters who have resided or been born in England*, London 1808 (facsimile edition 1970).

Edwards, Edward *The Napoleon Medals: A Complete Series of the Medals struck in France, Italy, Great Britain and Germany, from ... 1804, to ... 1815*, I, London 1837. [The only volume published.]

Egger, Hermann (ed.) *Codex Escurialensis: Ein Skizzenbuch aus der Werkstatt Domenico Ghirlandaios*, 2 vols., Vienna 1905.

Egger, Hermann see Hülsen, Christian.

Ehrle, Francesco *Roma prima di Sisto V: La Pianta di Roma Du Pérac-Lafréry del 1577*, Rome 1908.

Ehrlich, Willi *Goethes Wohnhaus am Frauenplan in Weimar*, Weimar 1978.

Eighteenth-Century Italy and the Grand Tour, catalogue of exhibition held at Castle Museum, Norwich 1958.

Einem, Herbert von 'Der Torso als Thema der

bildenden Kunst', *Zeitschrift für Ästhetik und Allgemeine Kunstwissenschaft*, 1935, XXIX, pp. 331–4.

Éméric-David, T. B. *Recherches sur l'art statuaire chez les anciens et chez les modernes*, Paris 1805.

Éméric-David, T. B. *Mémoire sur la statue de femme appelée la Vénus de Milo*, Paris 1821.

Éméric-David, T. B. *Histoire de la sculpture antique*, edited by Paul Lacroix, Paris 1862.

[Engelbach, Lewis] *Naples and the Campagna Felice, in a series of letters addressed to a friend in England in 1802*, London 1815. [First published in Ackermann's *Repository of Arts*.]

Enggass, Robert 'Laurentius Ottoni Rom. Vat. Basilicae Sculptor', *Storia dell'Arte*, 1972, pp. 315–42.

Enggass, Robert *Early Eighteenth-Century Sculpture in Rome*, 2 vols., Pennsylvania State University Park and London 1976.

Episcopius, Johannes [Bisschop, Jan de] *Signorum Veterum Icones*. [This is commonly bound into, and catalogued as part of, Bisschop's *Paradigmata graphices* which is dated 1671, but the first fifty plates were published in 1668 and the second in 1669 —see van Gelder, 1971, p. 230.]

Essen, C. C. van 'La Découverte du Laocoon', *Mededelingen der Koninklijke Nederlandse Akademie van Wetenschappen*, 1955, XVIII, pp. 291–308.

Estignard, A. *A. Pâris: Sa vie, ses oeuvres, ses collections*, Paris 1902.

Ettlinger, Leopold 'Hercules Florentinus', *Mitteilungen des Kunsthistorischen Instituts in Florenz*, 1972, XVI, pp. 119–42.

Eustace, Rev. John Chetwode *A Letter from Paris, to G. Petre, Esq.*, 4th edition, London 1814.

Eustace, Rev. John Chetwode *A Classical Tour through Italy*, 2nd edition, revised, London 1814. [The Tour was made in 1802.]

Evans, Rev. G. W. D. *The Classic and Connoisseur in Italy and Sicily*, 3 vols., London 1835.

Evans, Joan *A History of Jewellery, 1100–1870*, London 1970.

Evelyn, John *The Diary*, edited by E. S. de Beer, 6 vols., Oxford 1955.

Faber, Joannes *Imagines illustrium ex Fulvii Ursini bibliotheca . . . commentarius*, Antwerp 1606. [The commentary accompanies a reprint of Gallaeus.]

Fabroni, Angelo *Dissertazione sulle statue appartenenti alla favola di Niobe*, Florence 1779.

Faccenna, Domenico 'Il Pompeo di Palazzo Spada', *Archeologia Classica*, 1956, VIII, pp. 173–201.

Fagano, Giovanni see Verde, Francesco.

Fagiolo dell'Arco, Maurizio and Marcello *Bernini: Una introduzione al gran teatro del barocco*, Rome 1967.

Falconet, Étienne *Oeuvres*, 6 vols., Lausanne 1781.

Faldi, Italo 'Note sulle sculture borghesiani del Bernini', *Bollettino d'Arte*, 1953, pp. 140–6.

Faldi, Italo *Galleria Borghese: Le Sculture dal secolo XVI al XIX*, Rome 1954.

Fantozzi, Federico *Nuova guida ovvero descrizione storico—artistico—critica della città e contorni di Firenze*, Florence 1842.

Farington, Joseph *The Diary*, edited by Kenneth Garlick and Angus Macintyre, New Haven and London 1978–.

Favier, Suzanne 'A propos de la restauration par Barthélemy Prieur de la "Diane à la Biche"', *Revue du Louvre*, 1970, XX, pp. 71–7.

Favier, Suzanne 'Les Collections de marbres antiques sous François Ier', *Revue du Louvre*, 1974, XXIV, pp. 153–6.

Fea, Carlo *Miscellanea filologica, critica e antiquaria*, I, Rome 1790; II, Rome 1836.

Fea, Carlo *Osservazioni intorno alla celebre statua di Pompeo lette il dì 10 Settembre nell'Accademia Romana d'Archeologica*, Rome 1812.

Fea, Carlo *Osservazioni sull'arena, e sul podio dell'anfiteatro Flavio . . .*, Rome 1813. [The first appendix to this work concerns the so-called *Pompey* of Palazzo Spada.]

Fea, Carlo *Descrizione di Roma e de' Contorni*, 2nd edition, 2 vols., Rome 1822.

Fea, Carlo see Morcelli, Stefano.

Fehl, Philipp 'The Placement of the Equestrian Statue of Marcus Aurelius in the Middle Ages', *Journal of the Warburg and Courtauld Institutes*, 1974, pp. 362–7.

[Félibien, André] *Statues et bustes antiques des maisons royales*, I, Paris 1679.

Felici, Giuseppe *Villa Ludovisi in Roma*, Rome 1952.

Felini, Pietro Martire *Trattato nuovo delle cose maravigliosi dell'alma Città di Roma*, Rome 1610 (facsimile edition, Berlin 1969).

Ferrarino, Luigi (ed.) *Lettere di artisti italiani ad Antonio Perrenot de Granvelle*, Madrid 1977.

Ficoroni, Francesco de' *Le Memorie più singolari di Rome e sue vicinanze, notate in una lettera . . . all'Illustrissimo Signor Cav. Bernard inglese aggiuntavi nel fine la spiegazione d'una medaglia d'Omero*, Rome 1730.

Ficoroni, Francesco de' *I Tali ed altri strumenti lusori degli Antichi Romani*, Rome 1734.

Ficoroni, Francesco de' *Le Vestigia e rarità di Roma antica*, Rome 1744.

Ficoroni, Francesco de' *Le Singolarità di Roma moderna*, Rome 1744. [This serves as the libro secondo of *Le Vestigia*.]

Ficoroni, Francesco de' *Gemmae antiquae litteratae, aliequae rariores*, Rome 1757.

Filangieri, G. 'La Testa di Cavallo in Bronzo', *Archivio Storico per le Provincie Napoletane*, 1882, VII, pp. 407–20.

Filangieri di Candida, A. 'Monumenti ed oggetti d'arte trasportati da Napoli a Palermo nel 1806', *Napoli Nobilissima*, 1901, pp. 13–15.

Filhol *Galerie du Musée Napoléon, publiée par Filhol, graveur, et rédigée par Lavalée (Joseph)*, 10 vols., Paris 1810–15.

Finati, Giovambatista *Il Regal Museo Borbonico*, 3 vols. (the first in 2 parts), Naples 1819–23. [The first edition except for volume I which is the revised edition.]

Firenze e la Toscana dei Medici nell'Europa del cinquecento (Committenza e collezionismo medicei), catalogue of Council of Europe exhibition held in the Palazzo Vecchio, Florence 1980.

Flaxman, John *Lectures on Sculpture*, 2nd edition,

London 1838. [This includes the important introductory lecture not in the first edition.]

Fleming, John 'Cardinal Albani's Drawings at Windsor: Their Purchase by James Adam for George III', *Connoisseur*, November 1958, pp. 164–9.

Fleming, John, and Honour, Hugh 'Francis Harwood: An English Sculptor in XVIII Century Florence' in *Festschrift Ulrich Middledorf*, edited by A. Kosegarten and P. Tigler, 2 vols., Berlin 1968, I, pp. 510–16.

Foggini, Pietro Francesco *Musei Capitolini tomus quartus continens Marmora Anaglypha cum Animadversionibus*, Rome 1782. [The fourth volume of the catalogue of the Capitoline Museum, the first three written by Bottari.]

Fonderie Artistiche Riunite, Naples 1915. [Catalogue of the products of the recently merged firms of J. Chiurazzi & fils and S. de Angelis & fils.]

Fontaine, André *Les Collections de l'Académie Royale de Peinture et de Sculpture*, Paris 1910.

Foote, Henry W. *John Smibert, Painter*, Cambridge (Mass.) 1950.

Fordyce, William *Memoirs concerning Herculaneum, the Subterranean City*, London 1750.

Formigli, Giuseppe *Guida per le Città di Firenze e suoi contorni*, new edition, [Florence] 1849.

Forsyth, Joseph *Remarks on Antiquities, Arts, and Letters during an Excursion in Italy in the years 1802 and 1803*, London 1813.

Francastel, Pierre *Girardon*, Paris 1928.

Francastel, Pierre *La Sculpture de Versailles*, Paris 1930.

Francis, J. G. *Notes from a Journal kept in Italy and Sicily, during the years 1844, 1845, and 1846*, London 1847.

Franciscis, Alfonso de 'Per la storia del Museo Nazionale di Napoli', *Archivio Storico per le Provincie Napoletane*, 1944–6, XXX, pp. 169–200.

Franciscis, Alfonso de 'Restauri di Carlo Albacini a statue del Museo Nazionale di Napoli', *Samnium*, 1946, XIX, pp. 96–110.

Franciscis, Alfonso de *Il Museo Nazionale di Napoli*, Naples 1963.

Franciscis, Alfonso de *Guida del Museo Archeologico Nazionale di Napoli*, Cava di Tirreni 1963.

Francucci, Scipione 'Galleria dell'Illustris. e Reverendis. Signor Scipione Card. Borghese'. [MS. poem of 1613 in Archivio Segreto Vaticano, Fondo Borghese, Ser. IV, 102.]

Franzoni, Lanfranco *Verona: La Galleria Bevilacqua*, Milan 1970.

Fréart, Roland, Sieur de Chambray *Parallèle de l'architecture antique avec la moderne*, Paris 1650.

Fréart, Roland, Sieur de Chambray *A Parallel of the Antient Architecture with the Modern*, London 1664. [The translation is by John Evelyn.]

Friederichs, Carl *Der Doryphoros des Polyklet*, Berlin 1863.

Friederichs, Carl *Bausteine zur Geschichte der griechisch-römishcen Plastik*, Düsseldorf 1868; revised and extended by Paul Wolters, Berlin 1885.

Friedländer, Ludwig Hermann *Ansichten von Italien während einer Reise in den Jahren 1815 und 1816*, 2 vols., Leipzig 1819–20.

Fröhner, W. *Notice de la sculpture antique du Musée National du Louvre*, I, Paris 1884. [Second impression of the only volume published.]

Frommel, Christoph Luitpold *Der römische Palastbau der Hochrenaissance*, 3 vols., Tübingen 1973.

Frye, Major W. E. *After Waterloo: Reminiscences of European Travel, 1815–1819*, edited by Salomon Reinach, London 1908.

Fulvio, Andrea [Fulvius, Andreas] *Illustrium imagines*, Rome 1517 (facsimile edition with commentary by Robert Weiss, Rome 1967).

Fulvio, Andrea [Fulvius, Andreas] *Antiquitates Urbis*, Rome 1527.

Fulvio, Andrea [Fulvius, Andreas] *Opera di Andrea Fulvio delle antichità della Città di Roma . . . Tradotta*, Venice 1543.

Fulvio, Andrea [Fulvius, Andreas] *L'Antichità di Roma . . . corretta & ampliata*, edited by Girolamo Ferrucci, Venice 1588.

Furtwängler, Adolf *Meisterwerk der griechischen Plastik*, Leipzig and Berlin 1893; revised and translated as *Masterpieces of Greek Sculpture*, London 1895.

Furtwängler, Adolf *Beschreibung der Glyptothek König Ludwig I*, Munich 1900.

Galerie Imperiale et Royale de Florence, new edition, Florence 1822.

Galiffe, James Aug. *Italy and its Inhabitants: An Account of a tour in that country in 1816 and 1817*, 2 vols., London 1820.

Gallaeus [Galle, Theodor] *Illustrium Imagines ex Antiquis Marmoribus Nomismatib. et Gemmis Expressae que extant Romae maior pars apud Fulvium Ursinum*, Antwerp 1598.

Galleria Giustiniana del Marchese Vincenzo Giustiniani, I, Rome 1631.

Galt, John *The Life, Studies & Works of Benjamin West, Esq.*, London and Edinburgh 1820. [First published in 1816.]

Gamucci, Bernardo *Libri quattro dell'antichità della Città di Roma*, Venice 1565.

Gardey, Françoise, Lambert, Gisèle, and Oberthür Mariel 'Marc-Antoine Raimondi: Illustrations du catalogue de son oeuvre gravé par Henri Delaborde publié en 1888', *Gazette des Beaux-Arts*, 1978, XCII, pp. 1–52.

Gardner, Ernest Arthur *A Handbook of Greek Sculpture*, 2 vols., London 1896–7.

Gaye, Giovanni [Johan] *Carteggio inedito d'artisti dei secoli XIV, XV, XVI*, 3 vols., Florence 1839–40 (facsimile edition, Turin 1961).

Gelder, J. G. van 'Jan de Bisschop's Drawings after Antique Sculpture' in *Latin American Art and the Baroque Period in Europe* (Acts of the 20th International Congress of the History of Art, III), Princeton 1963, pp. 51–8.

Gelder, J. G. van 'Jan de Bisschop', *Oud Holland*, 1971, pp. 201–88.

Gerber, August *Katalog über künstlerische Nachbildungen klassischer Skulpturen aller Kunstepochen*, Cologne 1904.

Giambologna Sculptor to the Medici, 1529–1608, catalogue, edited by Charles Avery and Anthony Radcliffe, of the exhibition held at the Royal Scottish Museum, Edinburgh, and the Victoria and Albert Museum, London 1978.

Giambologna: Ein Wendepunkt der europäischen Plastik,

catalogue of the exhibition held at the Kunst-historisches Museum, Vienna 1978.

Gibbon, Edward *Journey from Geneva to Rome: His Journal from 20 April to 2 October 1764*, edited by Georges A. Bonnard, London 1961.

Giglioli, Odoardo H. 'Due Sculture in avorio inedite di Baldassare Stockamer nel Museo Nazionale a Firenze', *L'Arte*, 1913, pp. 451–64.

Ginori Lisci, Leonardo *La Porcellana di Doccia*, Milan 1963.

Ginori Lisci, Leonardo *I Palazzi di Firenze nella storia e nell'arte*, Florence 1972.

Giustiniani, Lorenzo and de Licteriis, Cav. Francesco *A Guide through the Royal Bourbonic Museum*, Naples · 1822. [The text is in English and Italian.]

Gnoli, Domenico *La Roma di Leone X*, Milan 1938.

Goethe, Johann Wolfgang von *Werke*, Abteilung I (published works), 63 vols., Weimar 1887–1918; Abteilung IV (*Briefe*), 20 vols., Weimar 1887–96.

Goldstein, Carl 'Art History without Names: A Case Study of the Roman Academy', *Art Quarterly*, 1978, pp. 1–16.

Goloubew, Victor *Les Dessins de Jacopo Bellini au Louvre et au British Museum*, 2 vols., Brussels 1912.

Gombrich, E. H. 'The Belvedere Garden as a Grove of Venus', reprinted in *Symbolic Images*, London 1972, pp. 104–8.

Gori, F. [Gorius, Franciscus] *Museum Florentinum*, III (*Statuae Antiquae Deorum*), Florence 1734.

Gori, Francesco [Gorius, Franciscus] *Museum Etruscum*, 2 vols., Florence 1737.

Gori, Francesco [Gorius, Franciscus] 'Admiranda Antiquitatum Herculanensium descripta et illustrata' in *Symbolae Litterariae Opuscula Varia*, I, Florence 1748.

Gori, Francesco *Notizie del memorabile scoprimento dell'antica città Ercolano*, Florence 1748.

Gori, Francesco [Gorius, Franciscus] *Admiranda Antiquitatum Herculanensium, descripta et illustrata ad annum MDCCL*, 2 vols., Padua 1752.

Govi, G. 'Intorno a un opuscolo rarissimo della fine del secolo XV intitolato: *Antiquarie Prospettiche Romane composte per Prospettivo Milanese Dipintore*', *Atti della Reale Accademia dei Lincei*, 1875–6, III, part 3 (Memorie), pp. 39–66.

Gradara, Costanza *Pietro Bracci Scultore Romano, 1700–1773*, Milan [1920].

Graeven, H. 'La Raccolta di antichità di Giovanni Battista della Porta', *Bulletino dell'Imperiale Istituto Archeologico Germanico* (sezione Romana), 1893, VIII, pp. 236–45.

Graevius, Johannes Georgius *Thesaurus Antiquitatum Romanorum*, 12 vols., Utrecht 1694–99.

Gramberg, Werner *Die Düsseldorfer Skizzenbücher des Guglielmo della Porta*, 2 vols., Berlin 1964.

Gray, John M. *James and William Tassie*, Edinburgh 1894.

Gray, Thomas *The Works*, edited by the Rev. John Mitford, 5 vols., London 1836–43. [IV contains 'Criticisms of Architecture and Painting during a Tour in Italy'.]

Gray, Thomas *Gray and his Friends: Letters and Relics in great part hitherto unpublished*, edited by Duncan C. Tovey, Cambridge 1890.

Grego, Joseph *Rowlandson the Caricaturist*, 2 vols., London 1880.

Grégoire, Abbé 'Rapport sur le Vandalisme, 14 Fructidor, An II', in *Oeuvres*, 16 vols., Liechtenstein, II, pp. 257–78.

Greville, Charles Cavendish Fulke *The Greville Memoirs, 1814–1860*, edited by Lytton Strachey and Roger Fulford, 8 vols., London 1938.

Grigson, Geoffrey *The Goddess of Love*, 2nd edition, London 1978.

Gronau, George 'Die Kunstbestrebungen der Herzöge von Urbino', *Jahrbuch der Königlich Preuszischen Kunstsammlungen*, 1906, XXVII (Beiheft), pp. 1–44.

Gronovius, Jacobus *Thesaurus Graecarum Antiquitatum*, 12 vols., Leyden 1697–1702.

[Grosley, Pierre Jean] *Observations sur l'Italie et sur les Italiens données en 1764, sous le nom de deux gentilhommes suédois*, new edition, 4 vols., London 1770. [The 'authors' left for Italy in mid-1758 and the book was drafted in 1759 and 1760.]

[Guasco, Abbé de] *De l'usage des statues chez les anciens*, Brussels 1768.

Guattani, G. A. *La Difesa di Pompeo ossia risposta . . . alle osservazioni dell' A. C. Fea*, Rome 1813.

Guida della Città di Firenze ornata di pianta e vedute, Florence 1822.

Guide de la Ville de Florence avec la description de la Galerie et du Palais Pitti ornées de vues et de statues, 2nd edition, enlarged, Florence 1824.

Guiffrey, Jules *Comptes des Bâtiments du Roi sous le règne de Louis XIV*, 5 vols., Paris 1881–1901.

Gunnis, Rupert *Dictionary of British Sculptors, 1660–1851*, new revised edition, London 1968.

Gunnis, Rupert *see* Whinney, Margaret.

Gurrieri, Francesco and Chatfield, Judith *Boboli Gardens*, Florence 1972.

Hackenbroch, Yvonne *Bronzes, Other Metalwork and Sculpture in the Irwin Untermeyer Collection*, London 1962.

Hagstrum, Jean H. *The Sister Arts: The Tradition of Literary Pictorialism and English Poetry from Dryden to Gray*, Chicago 1958.

Hakewill, James *A Picturesque Tour of Italy from Drawings made in 1816, 1817*, London 1820.

Hale, J. R. 'Art and Audience: The *Medici Venus*', *Italian Studies*, 1976, pp. 37–58.

Hallo, Rudolf 'Bronzeabgüsse antiker Statuen', *Jahrbuch des Deutschen Archäologischen Instituts*, 1927, XLII, pp. 193–220.

Hamilton, William Richard *Memorandum on the Subject of the Earl of Elgin's Pursuits in Greece*, 2nd edition, corrected, London 1815. [First edition published 1810, second edition 1811.]

Harcourt-Smith, Sir Cecil *The Society of Dilettanti: Its Regalia and Pictures*, London 1932.

Hare, Augustus, J. C. *Walks in Rome*, 2 vols., London 1871; 12th edition, revised, 2 vols., London [1887]; 16th edition, revised, 2 vols., London 1903.

Hare, Augustus J. C. *The Life and Letters of Frances, Baroness Bunsen*, 2 vols., London 1879.

Harris, Charles *A Catalogue of the Statues, Bass Reliefs, Bustos, etc. of Charles Harris, Statuary, Opposite to the New Church in the Strand, London* [n.d.].

Harris, Enriqueta 'La Mision de Velázquez en Italia', *Archivio Español de Arte*, 1960, XXXIII, pp. 109–36.

Harris, John *Sir William Chambers, Knight of the Polar Star*, London 1970.

Harris, John *The Artist and the Country House*, London 1979.

Hartford and Pomfret *Correspondence between Frances, Countess of Hartford (afterwards Duchess of Somerset) and Henrietta Louisa, Countess of Pomfret, between the years 1738 and 1741*, 3 vols., London 1805.

Hartt, F., Corti, G. and Kennedy, C. *The Chapel of the Cardinal of Portugal*, Philadelphia 1964.

Haskell, Francis *Patrons and Painters*, London 1963; 2nd edition, New Haven and London 1980.

Haskell, Francis *Rediscoveries in Art*, London 1976.

Haskell, Francis 'Gibbon and the History of Art' in *Edward Gibbon and the Decline of the Roman Empire*, edited by Bowersock, Clive and Graubard, Cambridge (Mass.) 1977.

Hassall, W. O. and Penny, N. B. 'Political Sculpture at Holkham', *Connoisseur*, July 1977, pp. 207–11.

Hauser, Friederich *Die Neu-Attischen Reliefs*, Stuttgart 1889.

Hautecoeur, L. 'La Vente de la Collection Mattei et les origines du Musée Pio-Clémentin', *Mélanges d'Archéologie et d'Histoire*, 1910, XXX, pp. 57–75.

Hawthorne, Nathaniel *Passages from the French and Italian Notebooks*, London 1883.

Haydon, B. R. *Comparaison entre la tête d'un des chevaux de Venise ... et de la tête du cheval d'Elgin du Parthenon*, London 1818. [First published in the *Annals of the Fine Arts*.]

Haynes, D. E. L. *The Portland Vase*, revised edition, London 1975.

Hazlitt, W. *Notes of a Journey through France and Italy*, London 1826.

Heckscher, W. S. *Sixtus IIII Aeneas Insignes Statuas Romano Populo Restituendis Censuit*, The Hague 1955.

Heikamp, Detlef 'Zur Geschichte der Uffizien-Tribuna und der Kunstschränke in Florenz und Deutschland', *Zeitschrift für Kunstgeschichte*, 1963, XXVI, pp. 193–268.

Heikamp, Detlef 'La Tribuna degli Uffizi come era nel cinquecento', *Antichità Viva*, 1964, III, pp. 11–30.

Helbig, Wolfgang *Führer durch die öffentlichen Sammlungen klassischer Altertümer in Rom*, 2 vols., Leipzig 1891; 2nd edition, 2 vols., Leipzig 1899; 3rd edition, 2 vols., Leipzig 1912–13; 4th edition, 4 vols., Tubingen 1963–72. [Each edition has been enlarged and extensively revised by later scholars.]

Held, Julius 'Flora, Goddess and Courtesan' in *Essays in Honour of Panofsky*, edited by Millard Meiss, 2 vols., New York 1961, pp. 201–19.

Herbert, Lord (ed.) *Henry, Elizabeth and George (1734–1780)—Letters and Diaries of Henry, Tenth Earl of Pembroke and his Circle*, London 1939.

Herbert, Robert L. *David, Voltaire, Brutus and the French Revolution*, London 1972.

Herder, Johann Gottfried von *Zur schönen Litteratur und Kunst (Sämmtliche Werke, VII, i)*, Tubingen 1806.

Herder, Johann Gottfried von *Sämmtliche Werke*, edited by Bernhard Suphan, 33 vols., Berlin 1877–1913.

Hermann, Hermann Julius 'Pier Jacopo Alari-Bonacolsi gennant Antico', *Jahrbuch der Kunsthistorischen Sammlungen des alterhöchsten Kaiserhauses*, 1910, XXVIII, pp. 201–88.

Heyne, M. 'Des differentes manières de représenter Vénus dans les ouvrages de l'art' in *Recueil de pièces intéressantes concernant les Antiquités, les Beaux-Arts, les Belles-Lettres et la Philosophie*, published by Janson, I, Paris 1796, pp. 1–60.

Heyne, M. 'Des distinctions véritables et supposées qu'il y a entre les Faunes, les Satyres, les Silènes and les Pans' in *Recueil de pièces intéressantes concernant les Antiquités, les Beaux-Arts, les Belles-Lettres et la Philosophie*, published by Janson, I, 1796, pp. 61–92.

Hibbard, Howard *Carlo Maderno and Roman Architecture, 1580–1630*, London 1971.

Hiesinger, Ulrich 'Canova and the frescoes of the Galleria Chiaramonti', *Burlington Magazine*, 1978, pp. 655–65.

Hiesinger, Ulrich 'The Paintings of Vincenzo Camuccini, 1771–1844', *Art Bulletin*, 1978, pp. 297–320.

Hind, Arthur M. *Early Italian Engraving: A Critical Catalogue*, 7 vols., Washington, New York and London, 1938–48.

Hirt, Aloys Ludwig 'Laokoon', *Die Horen*, 1797, X, pp. 1–25.

Hoare, Henry 'Roman Notebook', Cambridge University Library Add. MS. 3555. [Catalogued as of 1791, but probably of 1785.]

Hobson, R. L. *Chinese Porcelain and Wedgwood Pottery with other works of Ceramic Art: A Record of the Collection in the Lady Lever Art Gallery, Port Sunlight*, London 1928.

Hodge, Janice McKay 'Colonial America and the Colonial Tradition' in *The Classical Spirit in American Portraiture*, catalogue of the exhibition held at the Department of Art, Brown University, Providence (Rhode Island) 1976.

Hogarth, William *The Analysis of Beauty*, London 1753 (facsimile edition 1969).

Honour, Hugh 'English Patrons and Italian Sculptors in the first half of the Eighteenth Century', *Connoisseur*, May 1958, pp. 220–6.

Honour, Hugh 'Filippo della Valle', *Connoisseur*, November 1959, pp. 172–9.

Honour, Hugh, 'Vincenzo Pacetti', *Connoisseur*, November 1960, pp. 174–81.

Honour, Hugh 'Bronze Statuettes by Giacomo and Giovanni Zoffoli', *Connoisseur*, November 1961, pp. 198–205.

Honour, Hugh 'After the Antique: Some Italian Bronzes of the Eighteenth Century', *Apollo*, 1963, pp. 194–200.

Honour, Hugh 'Statuettes after the Antique: Volpato's Roman Porcelain Factory', *Apollo*, 1967, pp. 371–3.

Honour, Hugh *Goldsmiths and Silversmiths*, London 1971.

Honour, Hugh 'Canova's Statues of Venus', *Burlington Magazine*, 1972, pp. 658–70.

Honour, Hugh see Fleming, John.

Hoogewerf, G. J. 'Intorno al sepolcro di Bacco',

Roma, 1924, II, pp. 119–28.

Howard, Seymour 'Some Eighteenth-Century Restorations of Myron's "Discobolos"', *Journal of the Warburg and Courtauld Institutes*, 1962, pp. 330–4.

Howard, Seymour 'An Antiquarian Handlist and the Beginnings of the Pio-Clementino', *Eighteenth Century Studies*, 1973, VII, no. 1, pp. 40–61.

Howard, Seymour 'Thomas Jefferson's Art Gallery for Monticello', *Art Bulletin*, 1977, pp. 583–600.

Howarth, David 'Lord Arundel as a Patron and Collector', Ph.D. thesis, Cambridge 1978.

Hubert, Gérard *La Sculpture dans l'Italie Napoléonienne*, Paris 1964.

Hubert, Gérard 'Josephine, a Discerning Collector of Sculpture', *Apollo*, 1977, pp. 34–43.

Huebner, P. G. 'Die Aufstellung der Dioskuren von Monte Cavallo', *Mittheilungen des Kaiserlich Deutschen Archäologischen Instituts* (Römische Abteilung), 1911, pp. 318–22.

Huebner, P. G. *Le Statue di Roma*, 2 vols., Leipzig 1912.

Hülsen, Christian and Egger, Hermann (eds.) *Die römischen Skizzenbücher von Marten van Heemskerck*, 2 vols., Berlin 1913–16 (reprinted 1975).

Hussey, Christopher *English Country Houses: Mid-Georgian, 1760–1800*, London 1956.

Hutchison, Sidney, C. *The History of the Royal Academy, 1768–1968*, London 1968.

International Fine Arts Exhibition Rome 1911: Souvenir of the British Section, London [1913].

Ish-Kishor, Shulamith *Magnificent Hadrian*, New York 1935.

Italian Bronze Statuettes, catalogue of the exhibition held at the Victoria and Albert Museum, London 1961.

Jaffé, Michael *Rubens and Italy*, Oxford 1977.

James, Henry *Italian Hours*, Boston 1909 (reprinted New York and London n.d.).

[Jameson, Mrs.] *Diary of an Ennuyée*, new edition, London 1826. [The author was in Italy in 1821–2.]

Jameson, Mrs. *Companion to the Most Celebrated Private Galleries of Art in London*, London 1844.

Jammes, André 'Duchenne de Boulogne, la grimace provoquée et Nadar', *Gazette des Beaux-Arts*, 1978, XCII, pp. 215–19.

Jestaz, Bertrand 'L'Exportation des marbres de Rome de 1535 a 1571', *Mélanges d'Archéologie et d'Histoire*, 1963, LXXV, pp. 415–66.

Jones, Henry Festing *Samuel Butler, author of Erewhon, 1835–1902: A Memoir*, 2 vols., London 1919.

Jones, H. Stuart (ed.) *A Catalogue of the Ancient Sculptures preserved in the Municipal Collections of Rome: The sculptures of the Museo Capitolino*, Oxford 1912; *The sculptures of the Palazzo dei Conservatori*, Oxford 1926.

Jones, Roger B. S. *see* Krautheimer, Richard.

Jongkees, J. H. *Fulvio Orsini's Imagines and the Portrait of Aristotle*, Groningen 1960.

Jouin, Henry *Conférences de l'Académie Royale de Peinture et de Sculpture*, Paris 1883.

Jourdain, Margaret *The Work of William Kent*, London 1948.

Justi, Carl *Diego Velasquez und sein Jahrhundert*, 2nd edition, revised, 2 vols., Bonn 1888.

Justi, Carl *Winckelmann und seine Zeitgenossen*, 2nd edition, 3 vols., Leipzig 1898.

Kaganovitch, A. *Anton Losenko i Russkoe Iskusstvo seredini XVIII stoletiya*, Moscow 1963.

[Kaibel, Georg] *Inscriptiones Graecae Siciliae et Italiae (Corpus Inscriptionum Graecarum, XIV)*, Berlin 1890.

Karpowicz, Mariuse *Sztuka Oświeconego Sarmatyzmü*, Warsaw 1970.

Kaschnitz-Weinberg, Guido *Sculture del magazzino del Museo Vaticano*, 2 vols., Vatican City 1936–7.

Kaufmann, Thomas Da Costa 'Remarks on the Collections of Rudolf II: The Kunstkammer as a Form of Representation', *Art Journal*, 1978, XXXVIII, pp. 22–8.

Kekulé, Reinhard *Die Gruppe des Künstlers Menelaos in Villa Ludovisi*, Leipzig 1870.

Kekulé, Reinhard *Ueber die Bronzestatue des sogenanten Idolino*, Berlin 1889.

Keller-Dorian, Georges *Antoine Coysevox, 1640–1720*, 2 vols., Paris 1920.

Kennedy, C. *see* Hartt, F.

Kennedy, James *A Description of the Antiquities and Curiosities in Wilton-House*, Salisbury and London 1769.

Keutner, Herbert 'Massimiliano Soldani und die Familie Salviati' in *Kunst des Barock in der Toskana*, Munich 1977, pp. 137–64.

Keysler, J. G. *Travels through Germany, Bohemia, Hungary, Switzerland, Italy and Lorrain*, 4 vols., London 1756–7. [A translation of the 2nd German edition.]

Kircher, Athanasius *Enigma Aegyptiana Restituta*, Rome 1643.

Klein, Wilhelm 'Die Aufforderung zum Tanz—eine wiedergewonnene Gruppe des antiken Rokoko', *Zeitschrift für Bildende Kunst*, 1909, XX, pp. 101–8.

Klemm, Christian 'Sandrart a Rome', *Gazette des Beaux-Arts*, 1979, XCIII, pp. 153–66.

Knift, Hanno-Walker 'Concerning the Date of the Codex Escurialensis', *Burlington Magazine*, 1970, pp. 44–7.

Knight, R. P. *The Landscape: A Didactic Poem*, 2nd edition with a postscript, London 1795 (facsimile edition, London 1972).

[Knight, Richard Payne] *Specimens of Antient Sculpture*, I, London 1809. [The date 1810 appears on the cover and it may be that it was only available to the general public in that year having been presented to the Society of Dilettanti who sponsored the publication in 1809—the date on the title-page.]

Knight, Richard Payne *An Inquiry into the Symbolical Language of Ancient Art and Mythology*, London 1818. [Originally intended as the introduction to *Specimens of Antient Sculpture*, II, but published separately when the latter was delayed. It eventually appeared as an appendix to *Specimens*, II.]

Kokkoy, Aggeliki *I Merimna gia tis Archaiotites Stin Ellada kai ta prota Mouseia*, Athens 1977.

Kotzebue, August von *Erinnerungen von einer Reise aus Liefland nach Rom und Neapel*, 3 vols., Berlin 1805.

Kranz, Gisbert (ed.) *Gedichte auf Bilder: Anthologie und Galerie*, Munich 1975.

Krautheimer, Richard and Jones, Roger B. S. 'The

Diary of Alexander VII: Notes on Art, Artists and Buildings', *Römisches Jahrbuch für Kunstgeschichte*, 1975, XV, pp. 199–233.

Kuchumov, A. *Pavlovsk Palace and Park*, Leningrad 1975.

Kurz, Otto 'Huius Nympha Loci—a Pseudo-Classical Inscription and a Drawing by Dürer', *Journal of the Warburg and Courtauld Institutes*, 1953, pp. 171–7.

Kwiatkowski, M. *Lazienki Przewodnik*, Warsaw 1973.

La Coste-Messelière, M. G. de 'Battista della Palla conspirateur, marchand ou homme de cour', *L'Oeil*, September 1965, pp. 19–24, 34.

Ladendorf, Heinz *Antikenstudium und Antikenkopie*, Berlin 1953.

Lafreri, Antonio [Lafréry, Antoine] *Speculum Romanae Magnificentiae*. [Not, properly speaking, a printed book. We have referred to the copy in the Department of Prints and Drawings, British Museum.]

Lalande, M. de *Voyage en Italie*, 2nd edition, enlarged, 7 vols., Yverdon 1787–8. [First published in 1769; the author was in Italy in 1765–6.]

Lambert, Gisèle *see* Gardey, Françoise.

Lami, Stanislas *Dictionnaire des sculpteurs de l'École Française sous le règne de Louis XIV*, Paris 1906.

Lami, Stanislas *Dictionnaire des sculpteurs de l'École Française au dix-huitième siècle*, 2 vols., Paris 1910–11.

Lami, Stanislas *Dictionnaire des sculpteurs de l'École Française au dix-neuvième siècle*, 4 vols., Paris 1914–26.

Lanciani, Rodolfo *The Ruins & Excavations of Ancient Rome*, London 1897.

Lanciani, Rodolfo *Storia degli scavi di Rome e notizie intorno le collezioni romane di antichità*, 4 vols., Rome 1902–12.

Lanciani, Rodolfo *Wanderings in the Roman Campagna*, London 1909.

Landais, Hubert 'Arie et Petus ou le Gaulois se poignardant', *La Revue des Arts*, 1958, VIII, pp. 43–8.

Lankheit, Klaus *Florentinische Barockplastik: Die Kunst am Hofe der letzten Medici, 1670–1743*, Munich 1962.

Lanzac de Laborie, Léon de *Paris sous Napoléon*, VIII (*Spectacles et Musées*), Paris 1913.

Lanzi, Luigi [La Reale Galleria di Firenze] *Giornale de' letterati*, 1782, XLVII, pp. 3–212.

[La Roque] *Voyage d'un Amateur des Arts . . . fait dans les années 1775–76–77–78*, 4 vols., Amsterdam 1783.

Lassels, Richard *The Voyage of Italy, or a Compleat Journey through Italy*, 2 vols., Paris 1670.

Lauro, Giacomo [Laurus, Jacobus] *Antiquae Urbis Splendor*, Rome 1612. [Frequently bound with its sequels, Liber Secundus, 1613, and a supplement of 1615.]

Lauro, Giacomo [Laurus, Jacobus] *Antiquae Urbis Vestigis quae nunc extant*, Rome 1628. [Frequently bound with Lauro, 1612, 1613 and 1615—described above—and mistakenly dated earlier than 1628.]

Lauzières, A. de and d'Ambra, Raffaeli *Descrizione della Città di Napoli e delle sue Vicinanze*, 3 vols., Naples 1863.

Lavin, Marilyn Aronberg *Seventeenth Century Barberini Documents and Inventories of Art*, New York 1975.

Lebrun, J. B. P. *Essai sur les moyens d'encourager la peinture, la sculpture, l'architecture et la gravure*, Paris An II [1795].

Lees-Milne, James *English Country Houses: Baroque, 1685–1715*, London 1970.

Legati, Lorenzo *Museo Cospiano annesso a quello del famoso Ulisse Aldrovandi*, Bologna 1677.

Lehmann, Karl 'Samothrace: Fifth Preliminary Report', *Hesperia*, 1952, XXI, pp. 19–43.

Lehmann, Phyliss Williams and Karl *Samothracian Reflections: Aspects of the Revival of the Antique*, Princeton 1973.

Leplat, B. *Recueil des marbres antiques qui se trouvent dans la galerie du Roy de Pologne à Dresden*, Dresden 1733.

Lessmann, Johanna 'Gli Uffizi: Aspetti di funzione, tipologia e significato urbanistico' in *Il Vasari Storiografo e Artista* (Atti del Congresso Internazionale nel IV Centenario della Morte), Florence 1976, pp. 233–47.

Lewis, Lesley *Connoisseurs and Secret Agents in Eighteenth Century Rome*, London 1961.

Lindsay, Lord *Sketches of the History of Christian Art*, 3 vols., London 1847.

Linfert, A. 'Die Zingarella', *Jahrbuch des Deutschen Archäologischen Instituts*, 1978, XCIII, pp. 184–201.

Lippert, P. D. *Gemmarum anaglyphicarum et diaglyphicarum ex praecipius Europae Musaeis selectarum Ectypa M. ex vitro obsidiano, et massa quadam, studio P. D. Lippert fusa et efficta*, Dresden 1753.

Lippert, P. D. *Dactyliothecae universalis chilias sive scrinium milliarium*, 3 vols., Leipzig 1755–63. [The text of the second volume is by Christ and that of the third by Heyne.]

Loewy, E. *Inschriften griechischer Bildhauer*, Leipzig 1885.

Loewy, Emanuele 'Di Alcune composizioni di Raffaello ispirite a monumenti antichi', *Archivio Storico dell'Arte*, 1896, II, pp. 240–51.

Lomazzo, Gio. Paolo *Idea del Tempio della Pittura*, Milan 1590.

Lorenzetti, Costanza *L'Accademia di Belle Arti di Napoli, 1752–1952*, Florence [1952].

Lorenzino de' Medici *Scritti e Documenti*, edited by Carlo Téoli, Milan 1862.

Lorenzoni, A. M. *see* Brown, C. Malcolm.

Loukomski, Georges *Charles Cameron*, London 1943.

Le Louvre D'Hubert Robert, catalogue by Marie-Catherine Sahut of exhibition held at the Louvre, Paris 1979.

Lowry, Bates 'Notes on the *Speculum Romanae Magnificentiae* and Related Publications', *Art Bulletin*, 1952, pp. 46–50.

[Lucatelli, Giovanni Pietro] *Museo Capitolino, o sia descrizione delle statue*, Rome 1750; Rome 1771.

Lüdemann, W. von und Witte, G. *Carl Frommel's pittoreskes Italien*, Leipzig 1840.

Lullies, Reinhard *Die kauernde Aphrodite*, Munich 1954.

Lumbroso, Giacomo *Notizie sulla vita di Cassiano dal Pozzo*, Turin 1874.

Luzio, A. 'Federico Gonzaga Ostaggio alla Corte di Giulio II', *Archivio della real Società Romana di Storia*

Patria, 1886, IX, pp. 509–82.

Luzio, A. 'Lettere inedite di Fra Sabba da Castiglione', *Archivio Storico Lombardo*, 1886, XIII, pp. 91–112.

Mabillon, Jean and Montfaucon, Bernard de *Correspondance inédite de Mabillon et de Montfaucon avec l'Italie . . . suivie des lettres inédites du P. Quesnel*, edited by M. Valery, 3 vols., Paris 1846.

Macandrew, Hugh 'A Group of Batoni Drawings at Eton College, and some Eighteenth-Century Italian Copyists of Classical Sculpture', *Master Drawings*, 1978, pp. 131–50.

McCook, Katherine *The Sharples*, Knox (New York) 1972.

Maderna, Valentina 'Gli scultori della Reggia di Caserta negli anni della direzione di Carlo Vanvitelli (1773–1790)' in *Le Arti figurative a Napoli nel settecento (Documenti e ricerche)*, edited by N. Spinosa, Naples 1979, pp. 155–70.

Maffei, Paolo Alessandro *Raccolta di statue antiche e moderne, data in luce . . . da Domenico de Rossi*, Rome 1704.

Magi, Filippo 'Il Ripristino del Laocoonte', *Atti della Ponteficia Accademia Romana di Archeologia* (Memorie), 1960, IX, no. 1.

[Magnan, Dominique] *La Ville de Rome, ou Description abrégée de cette superbe ville*, 3rd edition, corrected, Rome 1783. [First published in 1778.]

Maio, Romeo de *Michelangelo e la Controriforma*, Bari 1978.

Maison, K. E. *Honoré Daumier: Catalogue Raisonné of the Paintings, Watercolours and Drawings*, 2 vols., London 1967.

Maiuri, Amedeo *Pompeii ed Ercolano fra case e abitanti*, Padua 1950.

Majewska-Maszkowska Bożenna *Mecenat artystyczny Izabelli z Czartoryskich Lubomirskief, 1736–1816*, Warsaw 1976.

Makowsky *see* Wrangel.

The Man at Hyde Park Corner: Sculpture by John Cheere, 1709–1787, catalogue by Terry Friedman and Timothy Clifford of exhibition at Temple Newsam, Leeds, and Marble Hill House, London 1974.

Mandowsky, Erna 'Two *Menelaus and Patroclus* replicas in Florence and Joshua Reynolds' Contribution', *Art Bulletin*, 1946, pp. 115–18.

Mandowsky, Erna 'Some Notes on the Early History of the Medicean "Niobides"', *Gazette des Beaux-Arts*, 1953, XLI, pp. 251–64.

Mandowsky, Erna and Mitchell, Charles *Pirro Ligorio's Roman Antiquities*, London 1963.

Manilli, Jacomo *Villa Borghese fuori di Pinciana*, Rome 1650.

Mankowitz, Wolf *The Portland Vase and the Wedgwood Copies*, London 1952.

Mankowitz, Wolf *Wedgwood*, London 1953.

Mankowski, Tadeusz *Raczbyzbioru Stanislawa Augusta*, Cracow 1948.

Mann, J. G. *Wallace Collection Catalogues: Sculpture*, London 1931

Mansuelli, Guido A. *Galleria degli Uffizi: Le Sculture*, 2 vols., Rome 1958–61.

Marchant, Nathaniel *A Catalogue of One Hundred Impressions from Gems*, London 1792.

Mariette, P. J. *Traité des pierres gravées*, 2 vols., Paris 1750. [The second volume is entitled *Recueil des Pierres Gravées du Cabinet du Roy*.]

Marlianus, Johannes Bartholomaeus *Antiquae Romae Topographia*, Rome 1534.

Marmottan, Paul *Les Arts en Toscane sous Napoléon*, Paris 1901.

Martelli, Annapaula Pampaloni *Museo dell'Opificio delle Pietre Dure di Firenze*, Bologna 1975.

Martinelli, Fioravante *Roma ricercata nel suo sito*, 3rd edition, Rome 1658.

Martinelli, Fioravante *see* d'Onofrio, 1969.

Massi, Pasquale *Indicazione antiquaria del pontificio museo Pio-Clementino in Vaticano*, Rome 1792. [Text in Italian and French.]

Massimo, Vittorio *Notizie istoriche della Villa Massimo alle Terme Diocleziane*, Rome 1836.

Matthews, Henry *The Diary of an Invalid; being the journal of a tour in pursuit of health in Portugal, Italy, Switzerland and France in the years 1817, 1818 and 1819*, 3rd edition, 2 vols., London 1822. [First published in 1820.]

Mayne, John *The Journal of John Mayne during a Tour on the Continent upon its Reopening after the Fall of Napoleon, 1814*, London 1909.

Meloni Trkulja, Silvia 'Luca Giordano a Firenze', *Paragone*, 1972, no. 267, pp. 25–74.

Memes, J. S. *Memoirs of Antonio Canova*, Edinburgh 1825.

Mengs, Antonio Raffaello *Opere*, edited by Carlo Fea, Rome 1787. [Fea's edition annotates and expands on that of 1780 by Niccola d'Azara.]

Mengs, Anton Raphael *Briefe an Raimondo Ghelli und Anton Maron*, edited by Herbert von Einem, Göttingen 1973.

Menichetti, G. 'Firenze e Urbino: Gli ultimi Rovereschi e la corte medicea,' *Atti e Memorie della R. Deputazione di Storia Patria per le Marche*, 1928, V, pp. 1–117.

Mercati, Angelo 'Pio V e l'arte antica secondo un documento ignorato', *Atti della Pontificia Accademia Romana di Archeologia* (Rendiconti), 1927–9, VI, pp. 113–21.

Mercati, Michaelis *Metallotheca*, 2 vols., Rome 1717–19.

Merivale, Charles *General History of Rome from the Foundation of the City to the Fall of Augustulus*, new edition, London 1886.

Mestitz, Anna *see* Vittori, Ottavio.

Meyer, Karl H. *Königliche Gärten—dreihundert Jahre Herrenhausen*, [Hanover] 1966.

Michaelis, Adolf 'Tre Statue Policletee', *Annali dell'Instituto di Corrispondenza Archeologica*, 1878, pp. 5–30.

Michaelis, Adolf *Ancient Marbles in Great Britain*, Cambridge 1882.

Michaelis, Adolf 'Geschichte des Statuenhofes im Vaticanischen Belvedere', *Jahrbuch des Kaiserlich Deutschen Archäologischen Instituts*, 1890, V, pp. 5–72.

Michaelis, Adolf 'Storia della Collezione Capitolina di Antichità fino all'inaugurazione del museo nel 1734', *Bullettino dell'Imp. Istituto Archeologico Germanico*, 1891, V, fasc. 1.

Michaelis, Adolf 'Römische Skizzenbücher: Marten van Heemskercks und anderer Nordischer Künstler des XVI Jahrhunderts', *Jahrbuch des Kaiserlich Deutschen Archäologischen Instituts*, 1891, VI (part (i) is pp. 125–76, (ii) pp. 219–38); 1892, VII (part (iii) is pp. 83–9, (iv) pp. 89–92 and (v) pp. 92–100).

Michaelis, Adolf 'Monte Cavallo', *Mittheilungen des Kaiserlich Deutschen Archäologischen Instituts* (Romische Abteilung), 1898, XIII, pp. 248–74.

Michaud *Biographie Universelle Ancienne et Moderne*, new edition, 45 vols., Paris [1842–65].

Michelet, J. *Histoire de France*, new enlarged edition, 17 vols., Paris 1874.

Michon, E. 'La Restauration du Laocoon et le modèle de Girardon', *Bulletin de la Société Nationale des Antiquaires de France*, 1906, pp. 272–3.

Michon, Étienne 'Bibliographie des catalogues du Musée des Antiques du Louvre', *La Bibliographe moderne*, 1914–15, pp. 241–301.

Milani, Luigi Adriano *Il R. Museo Archeologico di Firenze*, Florence 1923.

Milizia, Francesco *De l'art de voir dans les beaux-arts, traduit de l'italien*, Paris An 6 [1797–8]. [This edition has an appendix on the revolutionary seizures by General Pommereul.]

Millingen, James *Ancient Unedited Monuments*, III (*Statues, Busts, Reliefs, and other Remains of Grecian Art*), London 1826.

Milton, Henry *Letters on the Fine Arts written from Paris, in the year 1815*, London 1816.

Misserini, Melchior [Missirini] *La Piazza del Granduca du Firenze*, Florence 1830.

Missirini, Melchior *Della Vita di Antonio Canova*, Prato 1824.

Misson, Maximilien *Nouveau Voyage d'Italie fait en l'année 1688*, 2 vols., The Hague 1691.

Misson, Maximilien *A New Voyage to Italy*, 2 vols., London 1695. [A translation of Misson 1691.]

Misson, Maximilien *Nouveau Voyage d'Italie*, 5th edition, 3 vols., The Hague 1731.

Misson, Maximilien *A New Voyage to Italy*, 2 vols. (each of 2 parts), London 1739. [A translation of Misson 1731.]

Molfino, Alessandra Mottola *L'Arte della porcellana in Italia*, 2 vols. (I, Il Veneto e la Toscana; II, Il Piemonte, Roma e Napoli), Busto Arsizio 1976–7.

Monaco, Domenico *A Complete Handbook to the National Museum in Naples, according to the New Arrangement*, 3rd edition, London 1883.

Monconys, M. de *Les Voyages . . . en Allemagne et le troisième qu'il a fait en Italie*, III, Paris 1695.

Mongez, [Antoine] *Tableaux, statues . . . de Florence . . . dessinés par M. Wicar*, 4 vols., Paris 1789–1807.

Mongez, A. *Iconographie Romaine*, II–IV, Paris 1824–6. [A continuation of Visconti.]

Montagu, Jennifer *Bronzes*, London 1963.

Montaiglon, Anatole de (ed.) *Correspondance des directeurs de l'Académie de France à Rome avec les Surintendants des Bâtiments*, 18 vols., Paris 1887–1912. [VI–XVII edited with Jules Guiffrey.]

Montaiglon, Anatole de (ed.) *Procès-verbaux de l'Académie Royale de Peinture et de Sculpture, 1648–1792*, 10 vols., Paris 1875–92.

Montelatici, Domenico *Villa Borghese fuori di Porta Pinciana*, Rome 1700.

Montesquieu *Oeuvres complètes*, edited by André Masson, 3 vols., Paris 1950–5.

Montfaucon, Bernard de *Diarium Italicum*, Paris 1702.

Montfaucon, Bernard de *L'Antiquité expliquée et representée en figures*, 5 vols. (each of 2 parts), Paris 1719; Supplément, 5 vols., Paris 1724.

Moore, John *A View of Society and Manners in Italy*, 5th edition, 2 vols., London 1790. [First published in 1780.]

[Morcelli, Stefano and Fea, Carlo] *Indicazione antiquaria per La Villa Suburbana dell'eccellentissima casa Albani*, 2nd edition, Rome 1803. [The first edition, by Morcelli alone, was of 1785.]

Mortoft, Francis *His Book, being his travels through France and Italy, 1658–1659*, edited by Malcolm Letts (Hakluyt Society, LVII), 1925.

Moryson, Fynes *An Itinerary containing his ten yeeres Travell*, 4 vols., Glasgow 1907–8.

Mosser, Monique 'Monsieur de Marigny et les Jardins: Projets inédits des fabriques pour Menars', *Bulletin de la Société de l'Histoire de l'Art Français*, 1972, pp. 269–93.

Müller, C. O. and Oesterley, Carl *Denkmäler der Alten Kunst*, Göttingen 1832–53. [Issued in parts, comprising two sections.]

Müller, C. O. and Wieseler, Friedrich *Denkmäler der Alten Kunst*, 2 parts in 3 vols., Göttingen 1854–81.

München, Residenz, a guide to the former Royal Palace, Munich 1975.

Müntz, Eugène *Les Arts a la cour des Papes pendant le XVe et le XVIe siècle: recueil des documents inédits*, 3 vols., Paris 1878–82.

Müntz, Eugène *Les Collections des Médicis au 15e siècle*, Paris 1888.

Müntz, Eugène 'Les Collections d'antiques formées par les Médicis au XVIe siècle', *Memoires de l'Institut National de France (Académie des Inscriptions et Belles-Lettres)*, 1896, XXXV, ii, pp. 85–168.

Muraro, Michelangelo and Rosand, David *Tiziano e la silografia Veneziana del cinquecento*, Venice 1976.

Murray, A. S. *A History of Greek Sculpture*, 2 vols., London 1880–3.

Musée Français: Recueil complet des tableaux, statues et bas-reliefs, qui composent la collection nationale, 4 (or 5) vols., Paris 1803–9. [The *Musée* was first published in the form of livraisons. These were bound, in a variety of arrangements, in four volumes with title pages dated 1803, 1805, 1807 and 1809—but sometimes there is a separate volume containing the 'Discours Historiques'. It is thus pointless to give volume references for either the plates or the 'explication' of the plates or for the 'Discours', and only the 'Discours' are paginated. All texts on the sculpture are by T. B. Éméric-David and E. Q. Visconti although neither is mentioned on the first two title-pages.]

Nardini, Famiano *Roma Antica*, 3rd revised edition with notes by Andreoli, 4 vols., Rome 1771.

Natoire, Charles-Joseph, catalogue of exhibition at Troyes, Nîmes and Rome 1977.

Naumenko, A. P. *see* Petrov, A. W.

Navenne, Ferdinand de *Rome, le Palais Farnèse et les Farnèse*, Paris [n.d.].

Neale, J. P. *Views of the Seats of Noblemen and Gentlemen*, 6 vols., London 1816–23.

Nebbia, Ugo *La Casa degli Omenoni in Milano*, Milan 1963.

Nelson, Horatio, Lord *The Dispatches and Letters of Vice Admiral Lord Viscount Nelson*, edited by Sir Nicholas Harris Nicolas, 7 vols., London 1844–6.

Neppi, Lionello *Palazzo Spada*, Rome 1975.

Neverov, O. 'Pamiatniki antichnogo iskusstva v Rossii Petrovskogo Vremini' in *Kultura i Iskusstvo Petroskogo Vremini*, edited by G. N. Komelova, Leningrad 1977, pp. 37–53.

Newton, Sir Charles *Essays on Art and Archaeology*, London 1880.

Nibby, A. *Osservazioni artistico-antiquarie sopra la statua volgarmente appellata il Gladiator Moribondo*, Rome 1821.

Nibby, Antonio *Monumenti scelti della Villa Borghese*, Rome 1832.

Nibby, A. *Roma nell'anno MDCCCXXXVIII—parte seconda: Moderna*, 2 vols., Rome 1841.

Nicolson, Benedict *Joseph Wright of Derby: Painter of Light*, 2 vols., London 1968.

Noble, T. (ed.) *History of the County of Derby*, 2 vols., Derby 1829.

Nolhac, Pierre de *La Création de Versailles d'après les sources inédites*, Versailles 1901.

Nolhac, Pierre de *Hubert Robert, 1733–1808*, Paris 1910.

Norman-Wilcox, Gregor 'Two Figures from Croome Court', *Bulletin of the Los Angeles County Museum of Art*, 1965, no. 2, pp. 14–32.

Northall, John *Travels through Italy, Containing New & Curious Observations on that Country*, London 1766. [The journey was made in 1752.]

Nost, Van *A Catalogue of Mr. Van Nost's Collection of Marble and Leaden Figures, Busto's and Noble Vases, Marble Chimney Pieces, and Curious Marble Tables, to be sold by Auction, at his late Dwelling House in Hyde-Park-Road (near the Queen's Mead house) on Thursday the 17th of this Instant, April, 1712*.

Notes on Naples and its Environs and on the Road to it from Rome by a Traveller, London 1838.

Notice des statues, bustes et bas-reliefs de la Galerie des Antiques, Paris An IX [1800]; Paris An XI [1802/3]; Paris 1811. [Also published in 1811 a *Supplément*, separately paginated but often bound together with the *Notice* of 1811.]

Notice—Supplément à la Notice des Antiques du Musée, contenant l'indication des monuments exposés dans la Salle des Fleuves, Paris 1814.

Notice—Supplément à la Notice des Antiques du Musée, contenant l'indication des monuments exposés dans les Salles des Fleuves, de Silène, du Gladiateur et des Muses, Paris 1815.

Nugent, Thomas *The Grand Tour, or a Journey through the Netherlands, Germany, Italy and France*, 2nd edition, 4 vols., London 1756.

Oberthür, Mariel *see* Gardey, Françoise.

d'Onofrio, Cesare *Le Fontane di Roma*, 2nd edition, Rome 1962.

d'Onofrio, Cesare *Roma vista da Roma*, Rome 1967.

d'Onofrio, Cesare *Roma nel seicento: 'Roma ornata dall'architettura, pittura e scoltura' di Fioravante Martinelli*, Florence 1969.

d'Onofrio, Cesare *Mille anni di leggenda: Una donna sul trono di Pietro*, Rome 1978.

Orbaan, J. A. F. 'Documenti sul Barocco in Roma', in *Miscellanea della R. Società Romana di Storia Patria*, 1920.

Orsini, Fulvio [Ursinus, Fulvius] *Imagines et Elogia Virorum Illustrium et Eruditor ex Antiquis Lapidibus et Nomismatib. expressa cum annotationib.*, Rome 1570.

Osborne *Catalogue of the Paintings, Sculpture and other Works of Art at Osborne*, London 1876.

Pacetti, Vincenzo 'Giornale dall'anno 1773 fino all'anno 1803', Biblioteca Alessandrina, Rome MS. 321.

Paciaudi, Paolo Maria *Lettres de Paciaudi au Comte de Caylus*, edited by A. Sérieys, Paris An XI [1802].

Palomino de Castro y Velasco, Antonio *El Museo Pictorico y Escala Optica*, edited by Juan A. Céan y Bermudez, Madrid 1947. [First published in 1715–24.]

Panvinio, Onofrio [Panvinius, Onuphrius] *Reipublicae Romanae Commentariorum*, Venice 1558.

'"Papers Relating to the Late King's Goods", House of Lords Calendar 1660', in *Royal Commission on Historical Manuscripts*, 7th Report, 1879, pp. 88–92.

Paribeni, Roberto *Le Terme di Diocleziano e il Museo Nazionale Romano*, 4th edition, Rome 1922.

Paris Guide, 2 vols., Paris 1867.

Pariset, François-George 'L'Architecte Barreau de Chefdeville', *Bulletin de la Société de l'Histoire de l'Art Français*, 1962, pp. 77–99.

Parronchi, A. 'L'Arrotino opera moderna', *Annali della Scuola Normale Superiore di Pisa* (Classe di Lettere e Filosofia), 1971, pp. 345–74.

Parsons, M. 'A Monument of Rome', *Minneapolis Institute of Arts Bulletin*, 1969, LVIII, pp. 47–54.

Pastor, Ludwig *The History of the Popes from the close of the Middle Ages*, 40 vols., London 1894–1953.

Pater, Walter *Studies in the History of the Renaissance*, London 1873.

Pater, Walter *Greek Studies*, London 1895.

Paul, Jurgen 'Antikenergänzung und Ent-Restaurierung', *Kunstchronik*, 1972, XXV, pp. 85–112.

Paul, Pierre *Le Cardinal Melchior de Polignac, 1661–1741*, Paris 1922.

Pavan, Massimiliano 'Luigi Angeloni, Antonio Canova e Pietro Giordani', *Studi Romani*, 1974, XX, pp. 457–71.

Pavan, Massimiliano 'Canova e il problema dei Cavalli di S. Marco', *Ateneo Veneto*, 1974, XII, pp. 83–111.

Pavanello, Giuseppe *L'Opera completa del Canova*, Milan 1976.

Peacham, Henry *The Complete Gentleman*, 2nd edition, London 1634.

Penny, N. B. *Church Monuments in Romantic England*, New Haven and London 1977.

Penny, Nicholas *Piranesi*, London 1978.

Penny, N. B. *see* Hassall, W. O.

Pergola, Paola della *Galleria Borghese: I Dipinti*, 2 vols., Rome 1955–9.

Pergola, Paola della *Villa Borghese*, Rome 1962.

Perrault, Charles *Mémoires*, edited by P. Patte, Avignon 1759.

Perrault, Charles *Parallèle des anciens et des modernes en ce qui regarde les arts et les sciences*, Paris 1688–97 (facsimile edition, Munich 1964).

Perrier, François *Segmenta nobilium signorum et statuarum que temporis dentem invidium evase*, Rome and Paris 1638.

Perrier, François *Icones et segmenta illustrium e marmore tabularum que Romae adhuc exstant*, Rome and Paris 1645.

Perry, Marilyn 'Saint Mark's Trophies: Legend, Superstition and Archaeology in Renaissance Venice', *Journal of the Warburg and Courtauld Institutes*, 1977, pp. 27–49.

Perry, Walter Copland *Greek and Roman Sculpture*, London 1882.

Petersen, E. 'Eros und Psyche oder Nike', *Mittheilungen des Kaiserlich Deutschen Archäologischen Instituts* (Roemische Abteilung), 1901, XVI, pp. 57–93.

Petrelli, Flavia 'Gli scultori della Reggia di Caserta negli anni della direzione di Luigi Vanvitelli, 1759–1773' in *Le Arti figurative a Napoli nel settecento (Documenti e ricerche)*, edited by N. Spinosa, Naples 1979, pp. 201–15.

Petrov, A. N., Borisova, E. A. and Naumenko, A. P. *Pamiatniki Architekturi Leningrada*, Leningrad 1958.

Pevsner, Nikolaus *Academies of Art Past and Present*, Cambridge 1940.

Pevsner, Nikolaus *A History of Building Types*, London 1976.

Philander, Gulielmus *M. Vitruvii Pollionis de Architectura Annotationes*, Rome 1544.

Phillips, Samuel *Guide to the Crystal Palace*, revised edition, Sydenham 1860.

Piazzo, Marcello del (ed.) 'Documenti' in *Il Palazzo del Quirinale*, edited by Franco Borsi, Chiara Briganti, Marcello del Piazzo and Vittorio Gorresio, Rome 1974, pp. 235–64.

Picard, Charles *Manuel d'Archéologie Grecque: La Sculpture*, 4 vols. (II, III and IV are of 2 parts and there is a separate index volume for vols. III and IV), Paris 1935–66.

Pietrangeli, Carlo 'L'Obelisco del Quirinale', *Roma*, 1942, XXI, pp. 441–52.

Pietrangeli, Carlo 'Il Museo Clementino Vaticano', *Atti della Pontificia Accademia Romana di Archeologia* (Rendiconti), 1951–2, XXVII, pp. 87–109.

Pietrangeli, Carlo *Palazzo Braschi*, Rome 1958.

Pietrangeli, Carlo *Scavi e scoperte di antichità sotto il pontificato di Pio VI*, 2nd edition, Rome 1958.

Piganiol de La Force *Nouvelle description des châteaux et parcs de Versailles et de Marly*, 3rd edition, 2 vols., Paris 1713.

Pinarolo, Giacomo *Trattato delle cose più memorabile di Roma, tanto antiche, come moderne*, 2 vols., Rome 1700.

Pinatel, Christiane *Les Statues antiques des jardins de Versailles*, Paris 1963.

Pingeot, Anne 'Le décor de la Cour Carrée du Louvre', synopsis of paper read at the International Congress of Art History, Bologna 1979.

Piranesi, Giovanni Battista *Trofei di Ottaviano Augusto*, Rome 1753.

Piranesi, Giovanni Battista *Della magnificenza ed architettura de' Romani*, Rome 1761.

Piranesi, Giovanni Battista *Trofeo o sia magnifica colonna coclide di marmo . . . da Traiana*, Rome [n.d. but *c.* 1765].

Piroli, Tommaso *Antichità di Ercolano*, 6 vols., Rome 1789–95.

Piroli, Tommaso *Les Monuments antiques du Musée Napoléon*, 3 vols., Paris 1804–6.

Pistolesi, Erasmo *Il Vaticano descritto ed illustrato*, 8 vols., Rome 1829–38.

Pistolesi, Erasmo *Antiquities of Herculaneum and Pompeii*, 2 vols., Naples 1842. [The text is in French, Italian and English.]

Plon, Eugène *Benvenuto Cellini*, Paris 1883.

Plon, Eugène *Les Maîtres Italiens au service de la maison d'Autriche: Leone Leoni sculpteur de Charles Quint et Pompeo Leoni sculpteur de Philippe II*, Paris 1887.

Pölnitz, Winifrid von *Ludwig I. von Bayern und Johann Martin von Wagner*, Munich 1929 (reprinted 1974).

Pope-Hennessy, John *Italian Renaissance Sculpture*, London 1958.

Pope-Hennessy, John *Renaissance Bronzes from the Samuel H. Kress Collection*, London 1965.

Poznansky, V. V. *Arkhangelskoie*, Moscow 1966.

Portland Museum *A Catalogue of the Portland Museum lately the property of the Duchess Dowager of Portland, Deceased: which will be sold by auction, by Mr. Skinner and Co. on Monday the 24th of April 1786*. [The sale took 37 days.]

Potts, Alexander 'Winckelmann's Interpretation of the History of Ancient Art in its Eighteenth Century Context', Ph.D. thesis, 4 vols., Warburg Institute, University of London 1978.

Poulsen, Frederik *Ny Carlsberg Glyptotek: Katalog over Antike Skulpturer*, Copenhagen 1940.

Poussin, Nicolas 'Correspondance', edited by Ch. Jouanny, *Archives de l'Art Français*, 1911, V.

Prandi, Adriano 'La Fortuna del Laocoonte dalla sua scoperta nelle Terme di Tito', *Rivista dell'Istituto Nazionale d'Archeologia e Storia dell'Arte*, 1954, III, pp. 78–107.

Preisler, Johannes Justin *Statuae Insigniores A. Io. Iust. Preislero in Italico Itinere Delineate*, Nuremberg 1736.

Pressouyre, Sylvia 'Les Trois Graces Borghèse du Musée du Louvre', *Gazette des Beaux-Arts*, 1968, LXXI, pp. 147–60.

Pressouyre, Sylvia 'Les Fontes de Primatice à Fontainebleau', *Bulletin Monumental*, 1969, pp. 223–39.

Pressouyre, Sylvia 'Le "Moro" de l'Ancienne Collection Borghèse: Une sculpture de Nicolas Cordier retrouvée à Versailles', *Fondation Eugène Piot: Monuments et Mémoires*, 1969, pp. 77–91.

Prinz, Wolfram 'The "Four Philosophers" by Rubens and the Pseudo-Seneca in Seventeenth Century Painting', *Art Bulletin*, 1973, pp. 410–28.

Puccini, Tommaso *Dello stato delle Belle Arti in Toscana: Lettera . . . al signore Prince Hoare*, [Pistoia] 1807.

Puppi, Lionello *see* Barbieri, Franco.

[Quatremère de Quincy] *Lettres sur le préjudice qu' occasionneraient aux arts et à la science, le déplacement*

des monumens de l'art de l'Italie, Paris 1796.

Quatremère de Quincy *Sur la statue antique de Vénus découverte dans l'île de Milo en 1820*, Paris 1821.

Quatremère de Quincy *Canova et ses ouvrages, ou mémoires historiques sur la vie et les travaux de ce célèbre artiste*, Paris 1834.

Raccolta di Elogi degli uomini illustri toscani, compilati da vari letterati fiorentini, 2nd edition, 4 vols., Lucca 1770.

Rackham, Bernard *Catalogue of the Glaisher Collection of Pottery and Porcelain in the Fitzwilliam Museum Cambridge*, 2 vols., Cambridge 1935.

Rae, Isobel *Charles Cameron: Architect to the Court of Russia*, London 1971.

[Raguenet] *Les Monumens de Rome, ou descriptions des plus beaux ouvrages . . . qui se voyent à Rome*, Rome 1700.

Ramdohr, Friedrich Wilhelm Basilius von *Ueber Mahlerei und Bildhauerarbeit in Rom für Liebhaber des Schönen in der Kunst*, 3 vols., Leipzig 1787 (facsimile edition, London 1971).

Raspe, R. E. *A Descriptive Catalogue of a general Collection of Ancient and Modern Engraved gems . . . cast in coloured pastes, white enamel, and sulphur, by James Tassie, modeller*, 2 vols., London 1791. [There is a parallel text in French.]

Raumer, Frederic von *Italy and the Italians*, 2 vols., London 1840.

Ravaisson, Félix *La Vénus de Milo*, Paris 1871.

Rave, Paul Ortwin *Wilhelm von Humboldt und das Schloss zu Tegel*, Berlin 1973.

Rayet, Olivier 'Apollon Sauroctone' in *Monuments de l'art antique*, Livraison II, Paris 1881.

Rayet, Olivier 'Louve en bronze' in *Monuments de l'art antique*, Livraison II, Paris 1881.

Rayet, Olivier 'Victoire: Statue en marbre trouvée à Samothrace' in *Monuments de l'art antique*, Livraison II, Paris 1881.

Rayet, Olivier 'Le Tireur d'Épine' in *Monuments de l'art antique*, Livraison IV, Paris 1882.

Raymond, Jo. *An Itinerary contayning a Voyage made through Italy, In the yeare 1646, and 1647*, London 1648.

Real Museo Borbonico, 16 vols., Naples 1824–57. [There are various contributors but most of the texts on sculpture are by G. B. Finati. Several of the volumes contain material inserted at a date later than that on the title-page.]

Reimers, Henri de *L'Académie Impériale des Beaux-Arts à Saint Petersburg*, St. Petersburg 1807.

Reinach, Salomon 'La Victoire de Samothrace', *Gazette des Beaux-Arts*, 1891, V, pp. 84–103.

Reinach, Salomon *Répertoire de la statuaire grecque et romaine*, 6 vols., Paris 1897–1930.

Reinach, Salomon *L'Album de Pierre Jacques sculpteur de Reims dessiné à Rome de 1572 à 1577*, Paris 1902.

Renaissance Bronzes from Ohio Collections, catalogue by William D. Wixom of an exhibition held at the Cleveland Museum of Art, 1975.

Renaissance du Musée de Brest: Acquisitions récentes, catalogue of an exhibition held at the Louvre, Paris 1974–5.

Renan, Ernest *Marc-Aurèle et la fin du monde antique* (Oeuvres complètes, V), Paris 1952.

Renier, Rodolfo 'Joanne Sabadino de li Arienti',

Giornale storico della letteratura italiana, 1888, XI, pp. 205–18.

'Report from the Select Committee on the Earl of Elgin's Sculptured Marbles' in *The Elgin Marbles from the Temple of Minerva*, London 1816.

Revett, Nicholas *see* Stuart, James.

Revill, Philippa and Steer, Francis W. 'George Gage I and George Gage II', *Bulletin of the Institute of Historical Research*, 1958, XXXI, pp. 141–58.

Reynolds, Sir Joshua *Discourses on Art*, edited by Robert R. Wark, New Haven and London 1975.

Reynolds, Ted *The 'Accademia del Disegno' in Florence: Its Formation and Early Years*, Ph.D. thesis, Columbia University, New York 1974 (published photographically, Ann Arbor (Michigan) 1975).

Richard, Abbé *Description historique et critique de l'Italie*, 6 vols., Dijon and Paris 1766.

Richardson, Jonathan (Senior and Junior) *An Account of some of the Statues, Bas-reliefs, Drawings and Pictures in Italy, etc. with Remarks*, London 1722.

Richardson, Jonathan (Senior and Junior) *Traité de la Peinture et de la Sculpture par Mrs. Richardson, Père et Fils*, 3 vols., Amsterdam 1728. [The third volume, an expanded version of the *Account* of 1722, is in two parts.]

Richter, G. M. A. *The Portraits of the Greeks*, 3 vols., London 1965.

Righetti, Romolo 'Fonditori in bronzo romani del settecento e dell'ottocento—i Valadier e Righetti', *L'Urbe*, 1940, V, pp. 1–19.

Rizzo, G. E. *Prassitele*, Milan and Rome 1932.

Robertson, Martin *A History of Greek Art*, 2 vols., Cambridge 1975.

Rocheblave, S. *Jean-Baptiste Pigalle*, Paris 1919.

[Roisecco, Gregorio] *Roma antica e moderna o sia nuova descrizione della moderna città di Roma*, 3 vols., Rome 1745.

Roma antica distinta per regioni secondo l'esempio di Sesto Rufo, Vittore, e Nardini . . ., I, Rome 1741. [This volume contains an anthology of passages relating to the excavation of antique art drawn from the work of Ficoroni 'and others'.]

Roma Giacobina, catalogue of exhibition held at Palazzo Braschi, Rome 1973–4.

Rosand, David *see* Muraro, Michelangelo.

Rossi, Ermete 'Marforio in Campidoglio', *Roma*, 1928, VI, pp. 337–46.

Rossi, Ermete '"Tazze" "Conche" e "Fontane"', *Roma*, 1929, VII, pp. 271–4.

Rossi, Ermete 'A proposito della "Tazza di Marforio"', *Roma*, 1929, VI, pp. 417–19.

Rossini, Pietro *Il Mercurio errante delle grandezze di Roma*, 9th edition, enlarged, 2 vols., Rome 1771; 10th edition, enlarged, 2 vols., Rome 1776.

Rothenberg, Jacob *'Descensus ad terram': The Acquisition and Reception of the Elgin Marbles*, Ph.D. thesis, Columbia University, New York 1967 (published photographically, New York 1977).

Rotili, Mario *La Manifattura Giustiniani*, Benevento 1967.

Rowland, Benjamin, Jr. 'Montecavallo Revisited', *Art Quarterly*, 1967, pp. 143–52.

Rubenius, Albertus *De Re Vestiaria Veterum, praecipue de lato clavo*, Antwerp 1665.

Rubens: Drawings and Sketches, catalogue by John Rowlands of an exhibition held at the British Museum, London 1977.

Ruesch, A. (ed.) Guida illustrata del Museo Nazionale di Napoli—parte prima: Antichità, 2nd edition, Naples 1911.

Rumpf, G. A. 'Der Idolino', Critica d'Arte, 1939, XIX–XX, pp. 19–27.

Rusconi, Gio-Antonio Della Architettura, Venice 1590.

Rushforth, G. McN. 'Magister Gregorius De Mirabilibus Urbis Romae: A New Description of Rome in the Twelfth Century', Journal of Roman Studies, 1919, IX, pp. 14–58.

Ruskin, John Works, edited by E. T. Cook and A. Wedderburn, 39 vols., 1903–12.

[Russel, James] Letters from a Young Painter Abroad to his Friends in England, 2 vols., London 1750. [The letters are dated 1740–9.]

Ryberg, Inez Scott Panel Reliefs of Marcus Aurelius, New York 1967.

Sackville-West, V. Knole, Kent, 1969.

Sade, Marquis de Voyage d'Italie, edited by Gilbert Lely and Georges Daumas, Paris 1967.

Sadoleto, Jacopo [Sadoletus] Eiusdem Laocon: Eiusdem Epistola ad Federicum Fregusium, Bologna 1532.

Säflund, Gösta Aphrodite Kallipygos, Uppsala 1963.

Sainsbury, W. Noël Original Unpublished Papers illustrative of the Life of Sir Peter Paul Rubens, as an Artist and a Diplomatist, London 1859.

Saint-Non, Abbé de Voyage pittoresque ou description des royaumes de Naples et de Sicile, 4 vols., Paris 1781–6.

Saint-Victor, J. B. de Musée des Antiques: Dessiné et gravé par P. Bouillon peintre, avec des notices explicatives, 3 vols., Paris 1818. [Only the 'Discours préliminaire' is paginated. Both the plates and the commentary on them are bound differently in different copies.]

Sala, Giuseppe Antonio 'Diario Romano degli anni 1798–1799', Miscellanea della Società Romana di Storia Patria, 1882 (for parts 1 and 2) and 1886 (for part 3).

Salerno, Luigi Palazzo Rondinini, Rome 1965. [This includes a catalogue of the antique marbles by Enrico Paribeni.]

Salerno, L., Spezzaferro, L. and Tafuri, M. Via Giulia: Una utopia urbanistica del'500, Rome 1973.

Salis, Arnold von Antike und Renaissance, Zurich 1947.

Salmon, J. A Description of the Works of Art of Ancient and Modern Rome, 2 vols., London 1798–1800. [The second volume is entitled An Historical Description of Ancient and Modern Rome.]

Sandrart, J. von L'Accademia Todesca della Architectura Scultura e Pittura: Oder Teutsche Academie der Edlen Bau-Bild und Mahlerey Kunste, 2 vols., Nuremberg 1675–9.

Sandrart, Joachim de Sculpturae Veteris Admiranda, Nuremberg 1680.

Saunier, Charles Les Conquêtes artistiques de la Révolution et de l'Empire, Paris 1902.

Savage, George Seventeenth and Eighteenth Century French Porcelain, London 1960.

Saxl, F. 'The Capitol during the Renaissance: A Symbol of the Imperial Idea' in Lectures, 2 vols., London 1957, pp. 200–14.

Scaramuccia, Luigi Le Finezze de' pennelli italiani ammirate e studiate da Girupeno sotto la scorta e disciplina del genio di Raffaello d'Urbino, Pavia 1674 (facsimile edition, Milan 1965).

Scherer, Margaret R. Marvels of Ancient Rome, New York and London 1955.

Schiller, Friedrich von Werke, Weimar 1943–.

Schlegel, August-Wilhelm Oeuvres, 3 vols., Leipzig 1846.

Schmitt, Annegrit 'Römische Antikensammlungen im Spiegel eines Musterbuchs der Renaissance', Münchner Jahrbuch der Bildenden Kunst, 1970, XXI, pp. 99–128.

Schmoll gen. Eisenwerth, J. A. Der Torso als Symbol und Form zur Geschichte des Torso-Motivs im Werk Rodins, Baden-Baden 1954.

Schmoll gen. Eisenwerth, J. A. 'Zur Genesis des Torso-Motivs und zur Deutung des fragmentarischen Stils bei Rodin' in Das Unvollendete als Künstlerische Form—ein Symposion, edited by the same, Bonn 1959, pp. 117–39.

Schreiber, Theodor Die antiken Bildwerke der Villa Ludovisi in Rom, Leipzig 1880.

Schwarzenberg, Erkinger 'From the Alessandro Morente to the Alexandre Richelieu', Journal of the Warburg and Courtauld Institutes, 1969, pp. 398–405.

Schweitzer, Bernhard Das Original der sogenannten Pasquino-Gruppe, Leipzig 1936.

Scoto, Andrea Itinerario overo nova descrittione de' viaggi principali d'Italia, 2 vols., Venice 1610. [This is a translation with additions of a Latin work published in 1599 or 1600. The original was not in fact by Andrea Scoto—or Andreas Schottus—but by François Schott. See De Beer in The Library, 1942, September–December, pp. 57–83.]

Scott, John Sketches of Manners, Scenery &c. in the French Provinces, Switzerland, and Italy, 2nd edition (posthumous), London 1821.

Second National Exhibition of the Works of Art Recovered in Germany, catalogue by Rodolfo Siviero, 1950.

Seidel, Max 'A Sculpture by Nicola Pisano in the "Studiolo" of Cosimo I de' Medici', Burlington Magazine, 1973, pp. 599–600.

Seignelay, Marquis de L'Italie en 1671: Relation d'un voyage, Paris 1867.

Seznec, J. see Dieckmann, H.

Severo Calzetta called Severo da Ravenna, checklist by Edgar Munhall of an exhibition held at the Frick Collection, New York 1978.

Shelley, Percy Bysshe 'Notes on Sculptures in Rome and Florence' in The Complete Works, edited by Roger Ingpen and Walter E. Peck, VI, London and New York 1965, pp. 309–32.

Shrewsbury, Charles Talbot, Duke of 'Journal, 1700–7 January 1706', MS. 65 (Montagu Volumes) on loan to Northamptonshire Record Office.

Shugborough, revised edition, Stoke-on-Trent 1975.

Silvagni, David La Corte e la Società Romana nei secoli XVIII e XIX, 3 vols., Naples n.d. (reprinted 1967).

Sitte, Heinrich 'Im Mannheimer Antikensaal', Jahrbuch der Goethe-Gesellschaft, 1934, XX, pp. 150–8.

Sizer, Theodore, 'The American Academy of Fine

Arts' in M. B. Cowdrey, *The American Academy of Fine Arts and American Art Union* (Collections of the New-York Historical Society, LXXVI), New York 1953.

Skippon, Philip 'An Account of a Journey made thro' Part of the Low-Countries, Germany, Italy and France' in *A Collection of Voyages and Travels ... printed by Assignment from Messieurs Churchill*, VI, London 1752, pp. 373–749. [Skippon was on the Continent in 1663–6.]

Smith, A. H. *A Catalogue of the Sculpture in the Department of Greek and Roman Antiquities, British Museum*, 3 vols., London 1892–1904.

Smith, A. H. 'Lord Elgin and his Collection', *Journal of Hellenic Studies*, 1916, XXXVI, pp. 163–372.

Smith, J. T. *Nollekens and his Times*, 2 vols., London 1828.

Smollett, Tobias *Travels through France and Italy*, edited by Frank Felenstein, Oxford 1979. [First published in 1766.]

Soldini, Francesco Maria *Il Real Giardino di Boboli*, Florence 1789.

Sommer, G. Untitled photographic catalogue of items reproduced in terracotta and bronze, Naples n.d.

Sotheby's *Old Master and English Drawings and European Bronzes from the Collection of Charles Rogers (1711–1784) and the William Cotton Bequest*, catalogue of an exhibition at London and Torquay 1979.

Souchal, François 'La Collection du sculpteur Girardon d'après son inventaire après décès', *Gazette des Beaux-Arts*, 1973, LXXXII, pp. 1–98.

Souchal, François *French Sculptors of the 17th and 18th Centuries: The Reign of Louis XIV*, I (A–F), Oxford 1977.

Soulié, Eud. *Notice du Musée Impérial de Versailles*, 2nd edition, 3 vols., Paris 1859–61.

Specimens of Antient Sculpture, II, London 1835. [For I, see Knight, Richard Payne. The author of the introductory text was W. S. Morritt, but he was assisted in compiling notes to the plates by Christie, Hope and Westmacott and he also used Knight's papers.]

Spence, Joseph *Polymetis*, London 1747.

Speth-Holterhoff, S. *Les Peintres flamands de cabinets d'amateurs du XVIIe siècle*, Brussels 1957.

Spezzaferro *see* Salerno.

Spon, Jacob *Recherches curieuses d'antiquité*, Lyon 1683.

Spon, Jacob and Wheler, George *Voyage d'Italie, de Dalmatie, et de Grèce, et du Levant fait aux années 1675 & 1676*, Lyon 1678.

Springell, Francis *Connoisseur and Diplomat: The Earl of Arundel's Embassy to Germany in 1636*, London 1963.

Stark, K. B. *Niobe und die Niobiden in ihrer literarischen, künstlerischen und mythologischen Bedeutung*, Leipzig 1863.

Starke, Mariana *Letters from Italy, between the years 1792 and 1798*, 2 vols., London 1800. [The author observes in I, p. 252, note, that in her observations on works of art she was 'materially assisted by the judgment of Mr. Artaud'—a Royal Academy scholar then in Italy.]

Starke, Mariana *Travels on the Continent: Written for the use and particular information of Travellers*, London 1820. [This work repeats much of the material of the *Letters*, which had by 1820 passed through 4 editions, but was revised as a result of the author's travels between May 1817 and June 1819.]

Statius, Achilles *Illustrium Viror. ut exstant in urbe expressi vultus*, Rome 1569.

Statues, bustes, bas-reliefs, bronzes, et autres antiquités, peintures, dessins, et objects curieux conquis par la Grande Armée, Paris 1807.

Stendhal *Correspondance*, edited by Ad. Paupe and P.-A. Chéramy, 3 vols., Paris 1908.

Stendhal *Voyages en Italie*, edited by V. del Litto, Paris (Pléiade) 1973.

Stern, Henri 'Peiresc et le Grand Camée de France', *La Revue des Arts*, 1956, VI, pp. 255–6.

Stillman, Damie 'Chimney-Pieces for the English Market: A Thriving Business in late Eighteenth-Century Rome', *Art Bulletin*, 1977, pp. 85–94.

Stirling, A. M. W. *Coke of Norfolk and his Friends*, 2 vols., London 1908.

Stolberg, Frederic Leopold Count *Travels through Germany, Switzerland, Italy, and Sicily*, translated from the German, 2 vols., London 1797.

Stone, Nicholas (the Younger) 'Diary and Notebooks made in Italy', edited by W. L. Spiers, *Walpole Society*, 1918–19, VII, pp. 158–200.

Stopes, Charlotte C. 'Gleanings from the Records of the Reigns of James I and Charles I', *Burlington Magazine*, 1912–13, pp. 276–82.

Stosch, Philipp von *Gemmae Antiquae Caelate, Sculptorum Nominibus Insignitae ... Delineatae & Aeri incisae per Bernardum Picart*, Amsterdam 1724.

Stuart, James and Revett, Nicholas *The Antiquities of Athens*, 4 vols., London 1762–1816.

Lo Studiolo d'Isabella d'Este: Les Dossiers du département des peintures, catalogue edited by Sylvie Béguin of the exhibition held at the Louvre, Paris 1975.

Swan, Mabel Munson *The Athenaeum Gallery, 1827–1873*, Boston 1940.

Symonds, John Addington *Sketches and Studies in Italy*, London 1879.

Syon House, 1950.

Tafuri, M. *see* Salerno, L.

Taine, Hippolyte *Voyage en Italie*, 2 vols., Paris 1965. [First published in 1866.]

Taja, Agostino *Descrizione del Palazzo Apostolico Vaticano, opera postuma ... rivista ed accresciuta*, Rome 1750.

Tardieu, Ambroise *La Colonne de la Grande Armée d'Austerlitz, ou de la Victoire*, Paris 1822.

Tatarkiewicz, W. *O Sztuce Polskiej XVII i XVIII wieku*, Warsaw 1966.

Taylor, Basil 'George Stubbs: The "Lion and Horse" Theme', *Burlington Magazine*, 1965, pp. 81–6.

Il Tesoro di Lorenzo il Magnifico, I (Le Gemme), catalogue of exhibition held at the Palazzo Medici-Riccardi, Florence 1972.

Teti, Girolamo [Tetius, Hieronymus] *Aedes Barberinae ad Quirinalem ... descriptae*, Rome 1642.

Thiébault, Général Baron *Mémoires*, edited by Fernand Calmettes, 5 vols., Paris 1894–6.

Thirion, Jacques 'Perrier et la diffusion des modèles antiques: Le Meuble du Musée Fabre', *Revue du*

Louvre, 1971, pp. 141–56.

Thomassin, S. *Recueil des figures, groupes, thermes, fontaines, vases, statues, et autres ornemens de Versailles*, Amsterdam 1695. [First published in 1694.]

Thorpe, A. L. *see* Barrett, F. A.

Thuillier, Jacques 'Propositions pour: I. Charles Errard, peintre', *Revue de l'Art*, 1978, pp. 151–72.

Tinti, Mario *Lorenzo Bartolini*, 2 vols., Rome 1936.

Tofanelli, Agostino *Descrizione delle sculture, e pitture che si trovano al Campidoglio*, 5th edition, enlarged, Rome 1823; 6th edition, enlarged, Rome 1829.

Tofanelli, Alessandro *Indicazione delle sculture e pitture che esistono nel museo Capitolino e Palazzo*, new edition, Rome 1843.

Tommasini, O. 'Della storia medievale di Roma e de' più recenti raccontatori di essa', *Archivio della Società Romana di Storia Patria*, 1878, I, pp. 1–46.

Torriti, Piero *Pietro Tacca da Carrara*, Genoa 1975.

Totti, Pompilio *Ritratto di Roma Moderna*, Rome 1638.

Trevelyan, Humphry *Goethe and the Greeks*, Cambridge 1941.

Triumph of the Classical: Cambridge Architecture, 1804–1834, catalogue by David Watkin of an exhibition held at the Fitzwilliam Museum, Cambridge 1977.

Trollope, Frances *Domestic Manners of the Americans*, 5th edition, London 1839. [First published in 1832.]

Troubnikoff *see* Wrangel.

'True Description and Direction of What is most worthy to be seen in all Italy', in *The Harleian Miscellany*, edited by William Oldys and Thomas Park, V, London 1810, pp. 1–41. [This must date from *c.* 1595 to *c.* 1600.]

Twilight of the Medici: Late Baroque Art in Florence, 1670–1743, catalogue of exhibition held at Detroit and Florence 1974.

Udy, David 'Piranesi's "Vasi": The English Silversmith and his Patrons', *Burlington Magazine*, 1978, pp. 820–37.

Uklanski, Baron d' *Travels in Upper Italy, Tuscany, and the Ecclesiastical State in a Series of letters written to a friend in the years 1807 and 1808*, 2 vols., London 1816.

Urlichs, H. L. 'Ueber die Abfassungszeit der *Statue Antiche* des Ulisse Aldrovandi', *Mittheilungen des Kaiserlich Deutschen Archäologischen Instituts* (Roemische Abteilung), 1891, VI, pp. 250–1.

Urlichs, Ludwig *Die Glyptothek seiner Majestät des Königs Ludwigs I von Bayern nach ihrer Geschichte und ihrem Bestande*, Munich 1867.

Vacca, Flaminio *Memorie di varie antichità trovate in diversi luoghi della Città di Roma, scritte da Flaminio Vacca nel 1594*. [Unless otherwise indicated the edition we use is that published by Fea in 1790, pp. li–cvi.]

Vaccaria, Lorenzo della [Vaccarius, Laurentius] *Antiquarum Statuarum Urbis Romae*, Venice 1584. [An enlarged edition was published in about 1608 and again in 1621—by Goert van Schaych. Our references are to the plate numbers in Schaych's edition because in earlier editions the numbering varies.]

Valentini, Roberto and Zucchetti, Guiseppe *Codice Topografico della Città di Roma*, 4 vols., Rome 1940–53.

Valery, M. *Voyages historiques, littéraires et artistiques en Italie*, 2nd edition, 3 vols., Paris 1838. [According to the first edition of 1835, the journeys were made between 1826 and 1828.]

Vanvitelli, Luigi *Le lettere*, edited by Franco Strazzullo, 3 vols., Galatina 1976–7.

Varchi, Benedetto *Storia fiorentina*, edited by Gaetano Milanesi, 3 vols., 1857–8.

Vasari, Giorgio *Le Opere*, edited by Gaetano Milanesi, 9 vols., Milan 1878–85 (reprinted Florence 1973). [Unless otherwise indicated this is the edition we use.]

Vasari, Giorgio *Le Vite de più eccellenti pittori, scultori ed architettori*, I (Gentile da Fabriano e il Pisanello), edited by Adolfo Venturi, Florence 1896.

Vasari, Giorgio *La Vita di Michelangelo nelle redazioni del 1550 e del 1568*, edited by Paolo Barocchi, 5 vols., Milan and Naples 1962.

Vasari, Giorgio *Le Vite de più eccellenti pittori scultori ed architettori*, edited for il Club del Libro, 9 vols., Milan 1962–6.

Vasi, Marien *Description du Musée Pio-Clémentin et de la galerie des tableaux du Palais Vatican*, Rome 1792.

Vasi, Mariano *Itinerario istruttivo di Roma*, Rome 1794 (reprinted in *Roma nel settecento*, edited by Guglielmo Matthiae, Rome 1970).

Vasi, Marien *Itinéraire instructif de Rome à Naples*, Rome 1813.

Vasi, Mariano *Itinerario istruttivo da Roma a Napoli e delle sue vicinanze*, Rome 1816.

Vasi, M. *Itinéraire instructif de Rome ancienne et moderne . . . rectifié par A. Nibby*, 2 vols., Rome 1818.

Vasi, Marien *A New Picture of Rome, and its Environs, in the form of an Itinerary*, London 1824.

Vasiliev, A. A. 'Imperial Porphyry Sarcophagi in Constantinople', *Dumbarton Oaks Papers*, 1948, IV, pp. 1–26.

Venezia nell'Età di Canova, 1780–1830, catalogue of exhibition held at the Museo Correr, Venice 1978.

Venturini, Gio. Francesco *Le Fontane ne' Palazzi e ne' Giardini di Roma*, Rome n.d. [This is the third of four sets of plates of the fountains of Rome and Tivoli published by Gio. Giacomo de Rossi.]

Venuti, Filippo 'Dissertazione sopra il gabinetto di Cicerone presentata alla nobile Accademia Etrusca di Cortona', added to the second volume of *Della Vita Privata de' Romani*, edited by Domenico Amato, 2 vols., Naples 1783.

Venuti, Marcello *Descrizione delle prime scoperte dell'antica città d'Ercolano*, Rome 1748.

Venuti, Ridolfino *Collectanea Antiquitatum Romanarum*, Rome 1736.

Venuti, Ridolfino *Accurata, e succinta descrizione topografica delle antichità di Roma*, 2 vols., Rome 1763.

Venuti, Ridolfino *Accurata, e succinta descrizione topografica e istorica di Roma moderna*, 2 vols., Rome 1767.

Venuti, Ridolfino [Venutus, Ridolphinus] *Monumenta Mattheiana*, revised by Giovanni Amaduzzi [Amadatius], 3 vols., Rome 1779.

Verde, Francesco, Fagano, Giovanni and Bonucci,

Carlo *Guide pour le Musée Royal Bourbon*, Naples 1831.

Vermeule, Cornelius C. 'Notes on a New Edition of Michaelis' Ancient Marbles in Great Britain', *American Journal of Archaeology*, 1955, LIX, pp. 129–50.

Vermeule, Cornelius 'The Dal Pozzo-Albani Drawings of Classical Antiquities: Notes on their Content and Arrangement', *Art Bulletin*, 1956, XXXVIII, pp. 31–46.

Vermeule, Cornelius Review of Reinhard Lullies 'Die Kauernde Aphrodite', *American Journal of Archaeology*, 1956, pp. 460–2.

Vermeule, Cornelius C. 'The Dal Pozzo-Albani Drawings of Classical Antiquities in the British Museum', *Transactions of the American Philosophical Society*, 1960, L, part 5.

Vermeule, C. and Bothmer, D. von 'Notes on a New Edition of Michaelis', part 2, *American Journal of Archaeology*, 1960, pp. 321–50.

Vermeule, Cornelius, C. *see* Comstock, Mary B.

Vertova, Luisa 'Bernardino Licinio' in *I Pittori Bergamaschi dal XIII al XIX secolo, il cinquecento*, I, Bergamo 1975, pp. 373–467.

Vertue, George 'Note Books', 5 vols., *Walpole Society*, XVIII, XX, XXII, XXIV, XXVI, together with XXIX, an Index, and XXX, a supplementary volume.

Vesme, Alexandre de *Stefano Della Bella: Catalogue Raisonné*, revised by Phyllis Dearborn Massar, 2 vols., New York 1971.

Viardot, Louis *Les Merveilles de la sculpture*, Paris 1869.

Vico, Enea *Ex antiquis cameorum et gemmae delineata*, 1550.

Vico, Enea *Le Imagini con tutti i riversi trovati et le vite de gli imperatori*, 2nd edition, Venice 1554. [First published in 1548.]

Vico, Enea *Discorsi . . . sopra le medaglie de gli antichi*, Venice 1555.

Vico, Enea *Le Imagini delle Donne Auguste intagliate, in istampa di Roma*, Venice 1557.

Villa Borghese, catalogue of the exhibition held at the Museo di Roma, 1967.

Villani, Roberta Roani 'Innocenzo Spinazzi e l'ambiente Fiorentino nella seconda metà del settecento', *Paragone*, CCCIX, November 1975, pp. 53–85.

Villefosse, Ant. Héron de *Musée du Louvre: Catalogue sommaire des marbres antiques*, Paris 1896; revised by Étienne Michon, Paris 1922.

Visconti, Ennio Quirino [The principal works—*Museo Pio-Clementino, Monumenti Scelti Borghesiani, Monumenti Gabini, Iconografia Greca* and *Iconografia Romana*—were reissued in Milan in a uniform edition between 1818 and 1837. As this was the most accessible edition and as these volumes incorporate Visconti's revisions to his earlier publications, we have made use of them, unless otherwise indicated. We have followed our usual practice of referring to plates rather than pages, but it should be noticed that the plate numbers in Volume I of the folio edition of the *Museo Pio-Clementino* differ slightly from the one we use. We list below the other works by Visconti which we have consulted.]

Visconti, Ennio Quirino *Sculture del Palazzo della Villa Borghese della Pinciana brevemente descritte*, 2 vols., Rome 1796.

Visconti, Ennio Quirino *Opere varie italiane e francesi*, edited by Giovanni Labus, 4 vols., Milan 1827–31.

Vitruvius *Architecture ou art de bien bastir mis de Latin en Françoys, par Jean Martin*, Paris 1547.

Vitruvius *De architectura libri decem, cum commentariis Danielis Barbari*, Venice 1567.

Vitruvius *De architectura libri decem*, edited by Gulielmo Philander, Lyon 1586.

Vitruvius *Architectura*, edited by Giovanni Poleni, 4 vols., Udine 1825–30.

Vittori, Ottavio and Mestitz, Anna 'Artistic Purpose of some Features of Corrosion on the Golden Horses of Venice', *Burlington Magazine*, 1975, pp. 132–9.

Vogüé, Comte Patrice *Vaux le Vicomte*, n.d.

Wagner, J. M. 'Ueber die Kolosse von Monte Cavallo', *Kunstblatt*, XVIII, 1824, nos. 93–4, 96–8, pp. 369–75, 381–3, 385–91.

Walpole, Horace *Aedes Walpolianae, or, a Description of the Collection of Pictures at Houghton Hall in Norfolk*, 2nd edition, enlarged, London 1752.

Walpole, Horace *The Yale Edition of Horace Walpole's Correspondence*, 38 vols., New Haven and London 1937–74.

Walters, H. B. *Catalogue of the Engraved Gems and Cameos, Greek, Etruscan and Roman in the British Museum*, revised and enlarged edition, London 1926.

Watelet, Claude Henri *L'Art de peindre: Poëme, avec des réflexions sur les différentes parties de la peinture*, Paris 1760.

Watkin, David *Thomas Hope and the Neo-Classical Idea*, London 1968.

Watson, F. J. B. 'The Marquess of Cholmondeley' in *Great Family Collections*, edited by Douglas Cooper, London 1965, pp. 219–40.

Webb, M. I. *Michael Rysbrack, Sculptor*, London 1954.

Wedgwood, Josiah 'A Transcript of the 1779 Wedgwood and Bentley Catalogue', in Mankowitz, 1953, pp. 213–64.

Weihrauch, Hans R. *Europäische Bronzestatuetten 15–18 Jahrhundert*, Brunswick 1967.

Weiss, Roberto *Un umanista Veneziano Papa Paolo II*, Venice and Rome 1958.

Weiss, Roberto 'Andrea Fulvio Antiquario Romano, c. 1470–1527', *Annali della Scuola Normale Superiore di Pisa* (Lettere, Storia e Filosofia), 1959, XXVIII, fasc. I–IV, pp. 1–44.

Weiss, Roberto *The Renaissance Discovery of Classical Antiquity*, Oxford 1969.

Westmacott Miscellaneous Papers, Metropolitan Museum of Art Library, MS. 920.3 W52. [Four albums of manuscript material, mostly correspondence to or from Sir Richard Westmacott or his son, Richard Westmacott the Younger.]

Whinney, Margaret *Sculpture in Britain*, Harmondsworth 1964.

Whinney, Margaret *English Sculpture, 1720–1830*, London 1971.

Whinney, Margaret and Gunnis, Rupert *The Collections of Models by John Flaxman R.A. at University*

College London: A Catalogue and Introduction, London 1967.

Whiteley, J. J. L. 'Light and Shade in French Neo-Classicism', *Burlington Magazine*, 1975, pp. 768–73.

Wieseler, Friedrich *see* Müller, C. O.

Wilton-Ely, John *The Mind and Art of Giovanni Battista Piranesi*, London 1979.

Winckelmann, l'Abbé *Description des pierres gravées du feu Baron de Stosch*, Florence 1760.

Winckelmann, l'Abbé *Lettre de M. L'Abbé Winckelmann ... à Monsieur Le Comte de Brühl ... sur les decouvertes d'Herculanum*, Dresden 1764.

Winckelmann, Johann *Nachrichten von den neuesten Herculanischen Entdeckungen an Hn. Heinrich Fuessli aus Zürich*, Dresden 1764.

Winckelmann, J. J. *Geschichte der Kunst des Altertums*, Dresden 1764. [In fact published late 1763.]

Winckelmann, Giovanni *Monumenti antichi inediti*, 2 vols., Rome 1767.

Winckelmann, Giovanni *Storia delle arti del disegno presso gli antichi*, edited by Carlo Fea, 3 vols., Rome 1783–4. [On account of its excellent annotations and indexes it is to this posthumous edition that we usually refer.]

Winkelmann [Winckelmann] *Histoire de l'art chez les anciens*, 2 vols. (the second in 2 parts), Paris 1794–1803.

Winckelmann, J. *Briefe*, edited by Walther Rehm, 4 vols., Berlin 1952–7.

Winckelmann, J. *Kleine Schriften, Vorreden, Entwürfe*, edited by Walther Rehm, Berlin 1968.

Winnefeld, Herman *Die Villa des Hadrian bei Tivoli*, Berlin 1895.

Winter, Franz 'Der Apollo von Belvedere', *Jahrbuch des Kaiserlich Deutschen Archäologischen Instituts*, 1892, VII, pp. 164–77.

Winterbottom, Thomas *An Account of the Native Africans in the Neighbourhood of Sierra Leone*, 2 vols., London 1803.

Witte, G. *see* Lüdemann.

Woburn Abbey Marbles: Outline Engravings and Descriptions, London 1822. [The engravings are by Henry Moses after Henry Corbould; the descriptions, according to Michaelis, are by Dr. Hunt.]

Woeckel, Gerhard, P. *Ignaz Günther: Die Handzeichnungen*, Weissenhorn 1975.

Wrangel, Makowsky and Troubnikoff 'Arakcheev et l'Art', *Stary Gody*, 1908, pp. 439–63.

Wright, Edward *Some Observations made in Travelling through France, Italy &c. in the years 1720, 1721 and 1722*, 2 vols., London 1730.

Yeames, A. H. S. 'Rome in 1822', *Papers of the British School at Rome*, 1913, pp. 482–6.

Zannoni, G. B. *Reale Galleria di Firenze*, serie IV, Florence 1840.

Zeri, Federico *La Galleria Spada in Roma*, Rome 1952.

Zimerman, Heinrich 'Inventar des gesammten Besitzes der Erzherzogin Margarethe, Tochter Kaiser Maximilians, an Kunstgegenständen und Büchern', *Jahrbuch der Kunsthistorischen Sammlungen des Allerhöchsten Kaiserhauses*, III, pp. xciii–cxxiii.

Znamenov, Vadim (ed.) *Petrodvorets* [Peterhof], Leningrad 1978.

Zobi, A. *Storia civile della Toscana MDCCXXVII al MDCCCCXLVIII*, 5 vols., Florence 1850–2.

Johan Zoffany, 1753–1810, catalogue by Mary Webster of exhibition at the National Portrait Gallery, London 1976.

Zuccaro, Federico *Scritti d'Arte*, edited by Detlef Heikamp, Florence 1961.

365

Index

THE NAMES OF antique sculptures as they appear in the headings of each catalogue entry are given in italics; their alternative names in italics within inverted commas; and other works of art, both ancient and modern, in Roman within inverted commas. Where sculptures have identical names supplementary distinctions are supplied in parentheses. Modern authorities are not indexed, nor, usually, are the contents of notes, though we have sometimes indexed people and places mentioned there. In these cases we have given the number of the note and referred to the page of the text to which it applies rather than to the page where the note itself is to be found—this avoids the confusion occasioned when more than one set of notes appears on the same page. Famous names are indexed in the forms which we believe to be most familiar today, rather than according to any systematic principle. Our spelling of Greek names has, in general, followed the Latinate forms favoured during the period covered by this book.